Biennale di Firenze

The Biennale di Firenze is made possible through the generous assistance of

and

we also wish to thank

and

La Fondiaria
Pitti Immagine
Targetti
Cooperativa Tassisti Fiorentini
SO. CO. TA. Firenze

Biennale di Firenze

Looking at Fashion

Biennale di Firenze

Biennale di Firenze
Looking at Fashion

Curators
Germano Celant
Luigi Settembrini
Ingrid Sischy

Art/Fashion
Curators
Germano Celant
Ingrid Sischy
Pandora Tabatabai Asbaghi

Architecture and Installation
Arata Isozaki
with
Takako Takashima

Coordinator
Judith Blackall
with
Lynne Barton
Carla Ferrari
Christine Sebo

**New Persona/
New Universe**
Curators
Germano Celant
Ingrid Sischy

Installation
Denis Santachiara
with
Kazuyo Komoda

Coordinator
Livia Signorini
with
Lindsay Brant
Ilaria Pietrini

Visitors
Curators
Luigi Settembrini
Franca Sozzani

Installation
Gae Aulenti
with
Vittoria Massa

Coordinator
Francesca Sorace
with
Piergiorgio Leone
Marina Caterina Longo

Emilio Pucci
Curators
Katell le Bourhis
Stefania Ricci
Luigi Settembrini

Installation
Pierluigi Pizzi
with
Massimo Gasparon

Coordinator
Anna Pazzagli
with
Simonetta Mocenni

Bruce Weber Secret Love
Curators
Germano Celant
Martin Harrison

Installation
Adolfo Natalini
with
Giovanna Potestà

Coordinator
Francesca Sorace
with
Dolores Guzman
Piergiorgio Leone

Habitus, Abito, Abitare
Curators
Bruno Corà
Michelangelo Pistoletto

Coordinators
Stefano Pezzato
Maria Pioppi
with
Raffaele Di Vaia

**Elton John
Metamorphosis**
Curators
Germano Celant
David Furnish

Installation
Adolfo Natalini
with
Giovanna Potestà

Coordinator
Francesca Sorace
with
Piergiorgio Leone
Marina Caterina Longo

*The City of Florence is involved in the Biennale di Firenze on the basis of an evaluation of
a cultural order. In fact, the Biennale intends to link fashion with contemporary cultural
expressions, variously choosing themes which are appropriate to the tradition of the city and
its need for modernity.*

*Florence possesses an inestimable patrimony of beauty and elegance which must be
constantly interpreted and experienced, at times provocatively. In every period and age,
the culture of a city is measured in its creativity, its ability to propose new inventive stimuli.
Florence is therefore the ideal place for this operation. To lend its museums, palaces,
buildings, streets and squares for the inventiveness of artists and stylists for a new season
of proposals is a way of placing itself between tradition and the future.*

*Although the Biennale is also a source of wealth, it can be the occasion for new professional
experiences, for the presence in the city of important experiences and skills, for investment.
When taken all round, the creation of a stimulating atmosphere can contribute to
invigorating the overall atmosphere of the city—for both Florentines and their guests.*

*It is for these reasons that Florence views at the development of this initiative with
considerable interest. The City Council, and I myself personally as Mayor, have agreed to
preside over the Biennale. We shall continue in the years to come to promote it and
encourage its initiatives, creating the conditions for its increasingly rooted presence in the
contemporary identity of our city and what it has to offer within the field of culture.*

Mario Primicerio
Mayor of Florence

An ambitious project such as that of interpreting, developing and presenting the culture
of fashion and its role in contemporary creativity has to express itself within a suitable
and absolutely extraordinary setting: on the one hand offering culture and art, both
in the highest and most traditional sense, as in the daily search for style and quality of life;
and, on the other, doing this with a communicative force, an immediacy and a universality
only comparable to those same elements of fashion itself.
Florence and Tuscany are the natural setting. Both enjoy a unique reputation and image
thanks above all to their strong historical, artistic, cultural and environmental style and
personality.
Tuscany is one of the regions best loved by Italians. It is one of the places preferred by
tourists from the world over. It is a profoundly European region, a treasure of the world.
Florence, Prato and the whole of Tuscany historically constitute an important articulation
of the national "Fashion System". Florence is tied to the origins of Italian fashion by way
of the experience of the Sala Bianca of Palazzo Pitti where, beginning in the 1950's, the
fashion shows were held which gave rise to the beginning of the fortunate international
adventure of Italian fashion. Today the city is one of the most active and dynamic trade fair
centers in Italy for international fashion. Prato finds itself at the center of an area amongst
the most important in Italy and Europe for textiles-clothing and for the technological
innovation that these express. The entire region gives an important contribution—and
one of elevated quality—to the production which is variously tied to the fashion sector.
It is thanks to this complex of reasons that the Biennale has been "born" and expresses itself
in Tuscany as the seat of events with which will contribute towards developing
the international mission of these same reasons as an ideal stage and place of elaboration
of a contemporary culture and economy.
The various initiatives which go to make up the Florence Biennale will have an important
impact on the city and the region, both in quantitative and qualitative terms.
To the positive economic supply and services 'spin-off' of the augmented international
prestige and new cultural vitality one will also have the results produced on both the short
and the long-term basis.

In terms of qualified tourism—and all the economic activities connected with it—we shall be able to count on the development of new tourism, one qualitatively important.

In terms of artistic-cultural supply and programming one definitively affirms the dual concept of a contemporary cultural production within museums boasting a centuries-old tradition, in this way ratifying a relationship with other prestigious national and foreign Florentine cultural institutions in such a way as to offer Tuscans and the numerous tourists intense seasons of proposals and events of the highest level.

In terms of the production activities of the textile-clothing sector, qualified creative craft manufacture, the advanced service industries, research, and cultural and professional training connected to fashion, we shall see an increase in stimuli, contacts, work opportunities and production investments on the part of the variously and highly specialized textile industries, the craft 'workshops', in the professional fields and the scientific institutes of research and training forming part of the sector as a whole.

For all of these reasons the Region of Tuscany was among the most convinced supporters of the project for the realization of the Florence Biennale. For us it was an occasion not to be lost. It was from this awareness that one has had the commitment for the realization of the Biennale. With "Looking at Fashion," an ambitious project has been set in motion: Tuscany and Florence once again the protagonists in the culture of fashion.

Vannino Chiti
President of the Region of Tuscany

With the advent of the Florence Biennale from this year our city plays host to an important international event entirely dedicated to contemporary culture and to fashion in particular, the latter being undoubtedly one of the most significant and vital phenomena of today's culture.

The Florentine Center for Italian Fashion has from the very beginning furnished a decisive contribution to the definition, promotion and realization of this ambitious project.

To investigate the relationships between fashion and other contemporary languages does not only serve Italian fashion. It serves fashion as a whole in order to look beyond the brilliant surface of its successes, acquiring a greater awareness of the expressive properties of its language. In short, it serves to both better understand and to give rise to a better understanding of itself so as to be one of the instruments with which to interpret the present-day world.

That an initiative of this kind has been conceived and is being held in Italy is, however, the sign that in this country the reflection upon fashion keeps pace with the international affirmation of its most famous companies and stylists. And, more generally speaking, with attention paid to the values of the style and taste diffused within the most minimal and most personal expressions of life.

The fact of the event being held in Florence, and the fact of taking the name of the city, merely qualifies what we are saying.

The continuous confrontation between our knowledge and the forms of beauty of the past, together with the search for sense and beauty of the present, is a fundamental component of the creativity which Italy has expressed and which Italy continues to express in fashion. And not only in Fashion. Florence, known and loved throughout the world, is immersed within this confrontation every day. It is certainly the ideal place for an event which from the exploration of the most controversial themes of contemporaneity intends to gain useful indications in order to look for new horizons of meaning and beauty—and ones which are equally intense.

Irrespective of the unique fascination of its art and history, Florence is a melting pot of ideas and activities open to the world and to the future in innumerable and diverse sectors.

One of these is fashion, in its broadest meaning and as a system in its own right: with the cultural, trade fair and exhibition events it promotes both in Florence and abroad, our Center forms an integrating part of this dynamic reality of the city.

The idea of the Florence Biennale was consequently not born in an improvised way: the strong impulse which this initiative will impress upon the modern and international image of the city already finds solid bases in it and will certainly serve to stimulate important synergies with other initiatives, other projects, other cultural and economic objectives.

The contemporary culture of fashion, the international promotion of Italian fashion and the active, universal role of Florence are the elements which summarize the strategic mission of our Center. It was therefore impossible for us not to be part of the Biennale di Firenze,, to take part in its exciting adventure.

Vittorio E. Rimbotti
President of the Florentine Center for Italian Fashion

Luigi Settembrini
Managing Director

Acknowledgements

The Biennale di Firenze will explore a number of the central issues of contemporary experience. This exploration will be multidisciplinary, with the contribution of world-class experts and talents, and will take the form of an international festival.

The first Biennale di Firenze is devoted to the theme, "Of Time and Fashion." The purpose of the seven exhibitions that comprise the Biennale is to examine and recount the intersections, affinities, reciprocal influences, and the creative relationship between the world of fashion and the broader universe of the visual arts, industrial design, architecture, film, photography, music, costume, and communications of our time. It is our belief that fashion is one of the most deep-rooted and significant expressions of mass culture, and at the same time, one of the most underrated manifestations—in all its complex and innovative ramifications—of our common sensibility.

It is in this spirit that I would like to begin to express my gratitude to all those who did so much to help launch the Biennale di Firenze; in so doing, I must begin by pausing for a moment to remember a friend who recently died, Marco Rivetti. It was with Marco ten years ago, that we first set out to re-establish Florence as one of the natural settings for the image of Italian fashion and the larger image of Italian style. Marco Rivetti—in his capacity as president of Pitti Immagine—was the great and continual inspiration for the strategies and ideas that, from 1985 on, helped to make this project a reality: ideas from which this Biennale logically developed.

Before I venture into the daunting task of thanking the many people who, in one way or another, have helped to make this undertaking a success, I would like to remember a few special individuals to whom the Biennale di Firenze is particularly indebted.

I am referring to Vannino Chiti, president of the Region of Tuscany, who believed in this project from the very beginning, devoting his personal commitment and, rightly, that of his high office, to help bring about this project; to Vittorio Rimbotti, president of the Centro di Firenze per la Moda Italiana, in the heart of which the project was first conceived, and who was not only the first great proponent of the Biennale, but a constant defender of it during the long phases of planning and implementation; to Alberto Carmi, chairman of the Ente Cassa di Risparmio di Firenze and of the Camera di Commercio

Industria Artigianato e Agricoltura di Firenze, agencies which have given and continue to give fundamental support to the Biennale, and whose personal intervention was decisive in resolving many of the problems that beset us along the way; to Guido Clemente, commissioner for culture of the City of Florence, who worked with determination, intelligence, and spirit to open the impressive and immense artistic and cultural heritage of Florence to this great undertaking ; to the Soprintendente Vicario ai Beni Storici e Artistici di Firenze, Prato e Pistoia, Cristina Acidini Luchinat, who grasped the many possibilities that this project can create for the propagation of fine contemporary culture, and who lent her own personal prestige to accredit the Biennale with the curators of the various museums involved; to Fiamma di San Giuliano and Ferruccio Ferragamo, who have unfailingly and generously offered their support for projects that contribute to the re-establishment of Florence as an international setting for the system of Italian style; and to Raffaello Torricelli, a Florentine who is a citizen of the world, who has helped me to understand, love, and respect his city, and who has always been available with valuable ideas, experience, and vitality.

The various activities of the Biennale di Firenze are overseen by an association founded in Florence on 3 August 1995. The statutory chairman of this association is the Mayor of Florence; the deputy chairman is the president of the Centro di Firenze per la Moda Italiana; the vice president for cultural affairs is, for this edition of the Biennale, Gae Aulenti; the managing director, also for this edition, is the undersigned, who developed the idea of this event with the cooperation of Roberto Rosati.

The board of directors of the Biennale are the following: the chairwoman of the Associazione Centro Amici della Galleria del Costume, Cristina Aschengreen Piacenti (to whom I am particulary indebted for her unflagging assistance during the years in which she was the director of the Galleria del Costume of Palazzo Pitti); the president of Prato Moda Operandi Giuliano Coppini; the chairman of the Associazione Industriali della Provincia di Firenze Ginolo Ginori Conti; the chairman of the publishing house Skira Massimo Vitta Zelman, whose various organizations and companies are partners and promoters of this event. I wish to thank as well the board of syndics of the Biennale: Adriano Sarri, Luana Nannucci Brezzi, and Gino Valenti.

The Biennale di Firenze could not have come into existence without the enlightened joint efforts of the Region of Tuscany; the City of Florence; the Centro di Firenze per la Moda Italiana; the Camera di Commercio Industria Artigianato e Agricoltura di Firenze; the Ente Cassa di Risparmio di Firenze; the Corriere della Sera; the Museo Salvatore Ferragamo; the City of Prato; the Camera di Commercio Industria Artigianato e Agricoltura di Prato; Prato Moda Operandi; the Unione Industriali della Provincia di Prato; the publishing house Skira; the Associazione Centro Amici della Galleria del Costume di Palazzo Pitti; and the Associazione Industriali della Provincia di Firenze. All of these individuals have grasped the importance and the originality of this international and world-class initiative for the exploration of many of the central themes of contemporary culture; they have also seen the potential significance of this body of culture for the standing and development of Italy's cultural power and reputation in the modern global economy. In this context, we all hope that Florence and Tuscany will continue to represent, in Europe and throughout the world, the artistic and cultural values (in new

and modern forms) that have won universal respect and love for this city and this region. I would therefore also like to thank the deputy chairwoman and commissioner for culture, entertainment, and communications of the Region of Tuscany, Marialina Marcucci, and the commissioner for economic and manufacturing activity of the Region of Tuscany; without their assistance and understanding, the Biennale would never have seen the light of day.

Let me extend a special and heartfelt thank-you to the Mayor of Florence, Mario Primicerio, who, despite his many and pressing obligations, has agreed to serve as an effective and hard-working president for the Biennale; to the deputy mayor and the commissioner for economic development of the City of Florence, Alberto Brasca and Piero Roggi; to the director of the Ente Cassa di Risparmio di Firenze Michele Gremigni; to the deputy chairman and general secretary of the Camera di Commercio Industria Artigianato e Agricoltura di Firenze, Adriano Biffoli and Santi Semplici; to the editor-in-chief and the deputy editor of the Corriere della Sera, Paolo Mieli and Ferruccio De Bortoli (as well as to Fiorella Pagani and Giovanna Sassu of the marketing division, and to the journalists Fabio Cavalera and Laura Dubini); to the mayor and the deputy mayor of Prato, Fabrizio Mattei and Antonio Lucchesi, and to the commissioners for economic development and for culture of the City of Prato, Andrea Lulli and Massimo Luconi; to the chairman and to the general secretary of the Camera di Commercio Industria Artigianato e Agricoltura di Prato, Fiorenzo Tempestini and Michele Turchi; to the chairman and the director of the Unione Industriali della Provincia di Prato, Paolo Sarti and Fabrizio Fabrini, and the chairwoman of the Gruppo Giovani Industriali di Prato, Rosella Giorgietti.

Last, but certainly not least, I would like to express my thanks—for their effective, cordial, and generous assistance—the coordinator and director of the commission for economic and manufacturing activities of the Region of Tuscany, Valerio Pelini, and his able colleague and assistant, Leonardo Martini, as well as the assistant to the chairman of the Centro di Firenze per la Moda Italiana, Alberto Scaccioni.

The exhibitions and the installations of the Biennale di Firenze certainly benefit from the reflected glory, the universally acknowledged cultural standing, the enormous historical and monumental value of the museums and exhibition spaces in which these various exhibitions have been held; in general, they have benefited greatly from the hospitality of a city of incomparable beauty, Florence, known and loved throughout the world, and that of Prato, a city of great historical traditions and equally great cultural, social, and economic vigor.

I would therefore like to express my heartfelt gratitude to the heads and directors of the museums in which the exhibitions and installations of this first Biennale di Firenze have been held. Their understanding attitude toward our project has allowed—perhaps for the first time—these remarkable sites (some world famous, others which deserve to be better known and more popular) to be brought together under the umbrella of an initiative that, among other things, is meant to underscore the incredible quality and variety of the artistic and cultural heritage of Florence and Tuscany. Our thanks, then, go to the Soprintendente ai Beni Storici e Artistici di Firenze, Prato e Pistoia, Antonio Paolucci; to the Soprintendente ai Beni Ambientali e Architettonici di Firenze, Prato e Pistoia, Mario

Augusto Lolli Ghetti; the director of the Cappelle Medicee, Licia Bertani; to the president and the director of the Museo Casa Buonarroti, Luciano Berti and Pina Ragionieri; the director of the Galleria d'Arte Moderna di Palazzo Pitti, Carlo Sisi; the director of the Galleria degli Uffizi, Anna Petrioli Tofani; the director of the Galleria dell'Accademia, Franca Falletti; the director and the deputy director of the Galleria Palatina, Marco Chiarini and Serena Padovani; the director of the Museo Bardini and supervisor of the Museo di Palazzo Vecchio, Fiorenza Scalia; the director and the deputy directors of the Museo degli Argenti, Marilena Mosco, Caterina Chiarelli, and Mario Scalini; the director and commissioner of the Museo del Bigallo, Alfredo Bardazzi; the supervisory director and the director of the Museo dell'Opificio delle Pietre Dure, Giorgio Bonsanti and Anna Maria Giusti; the director and the deputy director of the Museo di Storia della Scienza, Paolo Galluzzi and Mara Miniati; the president, the director, and the deputy director of the Museo Horne, Umberto Baldini, Licia Bertani, and Elisabetta Nardinocchi; the president of the Museo Marino Marini, Giò Pomodoro; the director and the curator of the Museo Nazionale di Antropologia ed Etnologia, Guido Chelazzi and Sara Ciruzzi; the director of the Museo di Orsanmichele, Francesca Nannelli; the director and the curators of the Museo Zoologico 'La Specola' Marco Vannini, Claudia Corti, and Marta Poggesi; the director and the curator of the Museo Civico di Prato, Alessandro Pasquini and Maria Pia Mannini.

Further thanks go to the president and the director of the Centro per l'Arte Contemporanea Luigi Pecci di Prato, Paolo Paoletti and Bruno Corà and the director of the Museo Salvatore Ferragamo, Stefania Ricci. Lastly, allow me to express my thanks to the director of exhibition spaces of the Forte di Belvedere, Fiorenza Scalia and the director, for Metropolis spa, of the Stazione Leopolda, Carlo Grana.

A special expression of gratitude, for the remarkable work done in the face of impossible deadlines, should go to the director of the technical office, Piervincenzo Rinaldi, and his able assistants, Martino Duni, Luca Fusani, Giuliana Robecchi, Caterina Rossi, Peter Ryan, and Simona Turi, and the general administrative director, Anna Pazzagli, with her assistants, Giulietta Ciacchi, Simonetta Mocenni, and Stefania Signorini. My thanks also to the director of the press office, Guido Vergani, and to Adriano Donaggio, Antony Shugaar, and Maddalena Torricelli. I wish to thank Beppe Modenese, who, along with Capinetta Nordio, supervised the organization of the events of the inaugural days of the Biennale di Firenze. I also wish to thank the directors of the administrative secretariat, Vickie Panicacci and Cristina Pucci, and their assistant Gabriella Bongiorno; their counterparts in New York, Lindsay Brant and Luisa Guglielmotti; the director of promotion in schools and special audiences, Ester Di Leo; the director of administration and financial planning, Paolo Paoli and his assistant, Alessandra Tarchiani.

In conclusion, I would personally like to thank Massimo Mazza and Roberto Rosati for their help: Mazza, in establishing contacts with institutions and in coordinating and implementing the various special projects of the event; and Rosati, in all the many tasks involving communications for the Biennale.

I would like to thank Roberto Grandi for his contribution to the overall concept of the Biennale; he will direct the follow-up of the Biennale di Firenze, and will supervise the intermediate events, shows, conferences, and publications between editions of the Biennale.

Let me make special mention of Massimo and Lella Vignelli, who conceived the logo of the Biennale, and Pierluigi Cerri, who oversaw the corporate image of the Biennale and the graphic design of the catalogue and other publications (except for the catalogue of *Visitors*, designed and laid out by Luca Stoppini). A thank-you to Franca Gori and Gianni Sinni of LCD Graphics-Firenze for their assistance in the design of the corporate image. My thanks also to Marco Mignani and to RSCG of Milan, who put together the excellent advertising campaign for the Biennale.

A fundamental technical contribution to the first Biennale di Firenze came from Pitti Immagine, La Fondiaria Assicurazioni, Targetti spa, TNT Traco, Bassilichi Group spa, Kaleidoscop Tur, ATAF, and from the taxi collectives of Florence, CoTaFi and SoCoTa. The last-named organizations have proved to be particularly open to cultural undertakings, allowing their taxis to be used as substrates for the work of the American contemporary artists, Jenny Holzer.

I would like to thank the president of Pitti Immagine, Mario Boselli, and his managing director, Raffaello Napoleone, to whom I am personally grateful for the generous assistance he has given this project from the beginning; the president and the director for external relations of La Fondiaria, Alberto Pecci and Pierluigi Berdondini; the president and the general manager of Targetti spa, Paolo Targetti and Alvaro Andorlini; the general manager and the advertising and publicity director of TNT Traco, Giuseppe Smeriglio and Maddalena Marcone; the chairman of the Bassilichi Group spa, Luca Bassilichi; the director and the Italian manager of Kaleidoscop Tur, Irina Timofeeva and Lidia A. Vladimirova; the chairman of the ATAF Aldo Frangioni; the chairman of the Co.Ta.Fi Franco Giani and the chairman of the So.Co.Ta Alessandro Ferroni.

Many individuals contributed ideas, criticisms, and suggestions, during the planning phase and during the phase of implementation; let me begin to try to thank them.

In particular, I would like to thank Cesare Pergola of the Department of Architecture of the University of Florence, for organizing a series of talks with Arata Isozaki and his students.

My thanks to Michele Gesualdi, president of the Provincia di Firenze, and Sandro Belisario, director of professional education for the same organization, who will stage a major performance directed by Giancarlo Cauteruccio in November of this year, in Florence, in Palazzo Medici Riccardi.

I would also like to mention and thank in this connection: Alessandro Bardazzi and Andrea Cavallari of the Accademia San Felice; Marco Bagnoli; the managing director and a consultant of Artex, Alessandro Ricceri and Patrizia Guerrieri; the president of Artificio, Filippo Zevi; the artistic director of the Balletto di Toscana, Cristina Bozzolini; Loretta Caponi; Marco Niccheri and Fabio Vivarelli of the CNA (Confederazione Nazionale Artigianato); the chairman and the director of theEnt-Art Polimoda, Lorando Ferracci and Georgianna Appignani; Andrea Di Bari and Maurizia Settembri of Fabbrica Europa; Gherardo Frassa; Enrico Ghezzi; Leonardo Tozzi of Florence Press; Andrea Zingoni of the GMM; Mario Mariotti; Titti Maschietto and Elisabetta Valentini; Nando Fanutti of the Musicus Concentus; Maurizio Nannucci; the chairman of the ORT Orchestra Regionale Toscana, Giorgio van Straten; Davide Paolini; Luciano Berio and his assistant at Tempo Reale, Fabio Fassone; the director of Toscana Music Pool-ARCI, Gianni Pini;

Giuliano Gargani, known as 'il Garga,' who is not satisfied with serving excellent food in his trattoria, and who works tirelessly to make Florence great and modern and to make the Arno a livable river.

Further, I would like to thank Luciano Aiazzi, director of the communications office of the Region of Tuscany, Vittorio Fossati, communications consultant, and Francesco Pira, of the secreteriat of the vice president of the Region of Tuscany, for their advice and help. A thank-you to Fabrizia Scassellati, who, with Paolo Fiumi, designed the inaugural dinner and conference of the Biennale di Firenze at Palazzo Vecchio. My thanks go also to Vivaio Degl'Innocenti-Firenze, for the decorations and to Natali srl-Firenze, for the multivision that will be used in the inaugural conference.

Let me express my fondness and gratitude to the many friends who were close and helpful: Francesca Antinori; Rosanna Armani; Maria Benelli; Patrizio Bertelli; Chiara Boni; Antonella Boralevi; Cristina Brigidini; Lapo Cianchi; Maria Teresa Clerici; Eva Desiderio; Wanda Ferragamo; Gabriella Forte; Bona Frescobaldi; Carlo Gattai; Sibilla della Gherardesca; Pietro Jozzelli; Carlo and Gioia Marchi; Paola Maugini; Adriana Mulassano; Nathalie McRae; Mariella Pallavicino; and above all: Anna Zegna, for her valuable advice; Patrizia Medail, whose contacts with the Tartaglia Fine Arts-Saima Servizi produced notable technical, organizational, and economic benefits for the Biennale di Firenze; Riccardo Nencini, who brought the Biennale to the attention of the European Parliament; Flavio Pompetti, for the useful introductions he provided to international companies interested in helping to promote the Biennale; Bernabò Bocca of the Unione Regionale Albergatori Toscani.

A particularly affectionate thank-you goes out to Francesca Lenzi, who served as the first secretary of the Biennale, and to the placid and punctual Franco Ricci, in whose car, between Florence and Milan, the idea of the Biennale was born and developed greatly.

A thank-you to *Interview* magazine and its editor, Sandra J. Brant, for allowing us to hold many working meetings in New York and, for her help on these and other occasions, Barbara Carlile; the same thanks go to Condè Nast-Vogue Italia in whose offices in Milan, we often held meetings for the Biennale, and who gave major contributions to the exhibition *Visitors*.

The Biennale di Firenze enjoys the high patronage of the European Parliament, which has recognized the great interest of this cultural undertaking: let me thank the chairman of the European Parliament Klaus Hänsch for thus honoring our organization.

At the end of this list, I could not forget Germano Celant and Ingrid Sischy. Without them, their ideas and experience, without their knowledge and contacts in the diverse worlds of art and creativity, the Biennale di Firenze could never have been the major representative of contemporary culture that we hope it will become.

And it was above all due to the high quality that Germano and Ingrid have brought to this event, that, despite the tiring demands on their time and energy, it has been and will be a magnificent enterprise, of great interest and educational value, but also enormously fun. Which, all things considered, does no harm at all.

Germano Celant
Luigi Settembrini
Ingrid Sischy
Artistic Directors

Thanks from the Artistic Directors

In an effort to provide some indication of the extraordinary substance of the bonds that link fashion and contemporary culture, we have sought out a variety of points of view and themes, bound together by an overriding interest in the human body (let us be more precise: an interest in the great and overarching transformations—on the social, the cultural, and the technico-scientific planes—that the human body, and its second skin, clothing, variously detect and express), and further linked by an experimental approach; in short, in the final analysis, we are raising questions, far more than attempting to provide answers.

With this goal in mind, we have asked a number of internationally respected experts to work with us, and they have assisted us in the conception and development of the exhibitions featured: Pandora Tabatabai Asbaghi, a scholar and historian in contemporary art and the decorative arts, for *Arte/Moda*; Martin Harrison, critic and historian of photography, for *Bruce Weber Secret Love*; David Furnish for *Elton John Metamorphosis*; Katell le Bourhis, veteran director of several of the world's leading museums of fashion and costume, and Stefania Ricci, a highly respected historian of costume, for *Emilio Pucci* (and the curators of this exhibition could not have attained the results they did without the knowledge, sensibility, and memories of Cristina Pucci); Bruno Corà, art critic and director of the Centro per l'Arte Contemporanea Luigi Pecci in Prato, and Michelangelo Pistoletto, artist, for *Habitus, Abito, Abitare*; Franca Sozzani, journalist, editorial director of Conde Nast, Italy, and editorial director of Vogue Italia, for *Visitors*.

We would like to express our heartfelt gratitude to each of them, for the excellent work that they have done with such devotion and cultural awareness, and for the added momentum that they imparted to the project as a whole.

A special thank-you, of course, should be extended to all of the fashion designers, artists, designers, photographers, and musicians, who worked so hard and well to create this noteworthy experiment: Vito Acconci; Azzedine Alaïa; Getulio Alviani; Armand Arman; Giorgio Armani; Nigel Atkinson; Matteo Bambi; Tina Bepperling; Manolo Blahnik; Louise Bourgeois; David Bowie; Andrea Branzi; Massimo Conti; Mauro Ceccanti; Fabrizio Andreella, Luis Banuelos, Adam Broomberg, Aurora Fonda, Dryden Goodwin, Antonio Ros Fernandez, Marius Kavallauskas, Brian McCarty, Gledrus Paulauskis, Sarah Sternau, Nille

Svensson for Fabrica; Jake and Dinos Chapman; Christo; Tony Cragg; Ann Demeulemeester; Jan Fabre; Gianfranco Ferrè; Domenico Dolce; Arnaldo Ferrara; Tom Ford for Gucci; Stefano Gabbana; John Galliano; Valentino Garavani; Werner Gasser; Jean Paul Gaultier; Marcus Geiger; Romeo Gigli; Piero Gilardi; Philip Hämmerle; Oliver Herring; Damien Hirst; Jenny Holzer; Heldrun Holzfeind; Marc Jacobs; Elton John; Donna Karan; Ruth Kaaserer; Rei Kawakubo; Ellsworth Kelly; Peter Kogler; Calvin Klein; Heinrich Kreutz; Yayoi Kusama; Christian Lacroix; Karl Lagerfeld, representing himself, and for Chanel and Fendi; Suwan Lalmanee; Inez van Lamsweerde; Helmut Lang; Charles LeDray; Roy Lichtenstein; Manolo & Arnaldo Ferrara; Martin Margiela; Yukio Kobayashi for Matsuda; Marco Mazzoni; Alexander McQueen; Enzo Mercuri; Mario Merz; Ottavio and Rosita Missoni; Issey Miyake; Gina Monaco; Rossella Jardini for Moschino; Pascal Murer; Massimo Niccolai; Todd Oldham; Tony Oursler; Rifat Ozbek; Nam June Paik; Giuseppe Penone; Gianni Pettena; Cristina Pistoletto; Michelangelo Pistoletto; Pietra Pistoletto; Miuccia Prada; Enrico Rava; Robert Rauschenberg; Charles Ray; Cristina Rizzo; David Rokeby; Costanze Ruhm; Yves Saint Laurent; Chris Sacker; Jil Sander; Isabelle Sandner; Beverly Semmes; Judith Shea; Cindy Sherman; Julian Schnabel; Wiebke Siem; Kiki Smith; Gabriele Adriano, Davide Adriano, Laura Apollonio, Edoardo Boero, Sara Dal Gallo, Giancarlo DellíAquila, Giuseppe Demonte, Roberta Mazza, Erika Morandi, Armona Pistoletto, Alessandro Perri, Anna Torretta for Snodo; Fabrizio Sorano; Daniel Spoerri; Jana Sterbak; Fabio Cirifino, Paolo Rosa and Leonardo Sangiorgio for Studio Azzurro; Anna Sui; Giorgio Taricco; Juergen Teller; Oliviero Toscani; Rosemarie Trockel; Philip Treacy; Richard Tuttle, Richard Tyler; Walter Van Beirendonck; Gianni Versace; Franz Erhard Walther; Bruce Weber; Carrie Mae Weems; Claudia Weinappl; Franz West; Vivienne Westwood; Monica Wührer; Yohji Yamamoto.

We would also like to thank their many colleagues and assistants, who worked directly with the operative staff of the Biennale throughout the time of planning and implementation of the various exhibitions and installations: Olivier Collinet and Maximiliano Modesti for Azzedine Alaïa; Corice Canton for Arman; Kevin Doyle and Cecilia Dessalles d'Epinoix for Giorgio Armani; Kris Ruhs for Nigel Atkinson; Jerry Gorovoy for Louise Bourgeois; Kate Chertavian, Alex Psychopulos, Lavinia Thomas, Davide De Angelis and Eileen Darcy for David Bowie; Jim Rogers, Sabine Klaproth-Falk and Stephan Marianfeld for Tony Cragg; Patrick Robyn and Michelle Montagne for Ann Demeulemeester; Marco Stalla for Dolce & Gabbana; Tijs Visser for Jan Fabre; Rita Airaghi, Angelo Ghilardi and Barbara Ripa di Meana for Gianfranco Ferrè; Giovanna Amadasi and Gaia Battaglioli for Fondazione Prada-Milano; Mash Chribber and Amanda Harlech for John Galliano; Lionel Vermeil for Jean Paul Gaultier; Celeste Morozzi and Michael Wolf for Romeo Gigli; Giulia Masla and Elise Dubial for Gucci; Jen Rork for Jenny Holzer; Thomas Miller for Marc Jacobs, Todd Oldham and Anna Sui; Patty Cohen, Steve Johanknecht, Anjali Lewis, Marina Luri, Angela Pintaldi and Julie Priddell for Donna Karan; Adrian Joffe for Rei Kawakubo; Jack Shear and Raoul Zevaldos for Ellsworth Kelly; Robert L.Triefus for Calvin Klein; Jean Jacques Picart and Jérôme Puche for Christian Lacroix; Eric Wright for Karl Lagerfeld; Adriaan van der Have for Inez van Lamsweerde; Verena Formanek for Helmut Lang; Cassandra Lozano for Roy Lichtenstein; Bob Verhelst and Patrick Scallon for Martin Margiela; Carl Morton for Yukio Kobayashi by Matsuda; Trino Verkade and Sylvia Gaspardo for Alexander McQueen; Beatrice and Marisa Merz for Mario Merz; Luca Missoni for Missoni; Akiko Amazaki, Gwenael

Nicolas, Maryvonne Numata, Midori Kitamura and Masako Omori for Issey Miyake; Lida Castelli for Moschino; Coro Kodaly for Massimo Niccolai; Domenico Caliri, Roberto Cecchetto, Giovanni Maler, U.T.Gandhi for Enrico Rava/Rava Electric Five; Roberto Plate, Isabelle de Courrèges and Dominique Deroche for Yves Saint Laurent; Ina Delcourt for Jil Sander; Greg Bogin, Gwen Williams and Peter Crump for Julian Schnabel; Mei Mei Tuttle for Richard Tuttle; Lisa Trafficante, Jill Nicholson and Heba Matta for Richard Tyler; Marie Helene Cadario, Sergio Salerni and Gabriella Mazzei for Valentino; Elsa Arras, Paul Boudens and Wouter Wils for Walter Van Beirendonck; Patrizia Cucco for Versace; Nan Bush, Erika Sipos, Marcus Burnett, Dimitri Levas, Leslie Lambert, John Scott, Rima Barzdukas, Samantha Schmidt, Reid Williams, Luke Irons, Joseph Sperdini, Estelle Aster for Bruce Weber; Andreas Kronthaler and Andrea Mills-Griffin for Vivienne Westwood; Nathalie Ours, Irene Silvagni and Makiko Morishige for Yohji Yamamoto.

We extend our further thanks to: all those who took part in the project "Parcheggio" in the exhibition *Habitus, Abito, Abitare*, Luca Anastasia, Stefano Braccelli, Chiara Capaccioli, Silvia Caringi, Nicola Caroppo, Michael Dejori, Silvia Falugiani, Paolo Fiori, Mirko Giorgietti, Guido Gori, Rebecca Hayword, Emanuele Milanini, Giuliano Nannipieri, Francesco Paoletti, Pietro Romano, Antonella Sgobba, Lucia Tiralongo, Omar Toni; the members of the Compagnia della Fortezza-Volterra, Pasquale Catalano, Valerio Di Pasquale, Gianni Gronchi, Carmen Lopez Luna, Armando Punzo, Luisa Raimondi, and Nicola Rignanese.

To better define the specific nature of the individual exhibitions, we were helped enormously by the exhibition designs done by Gae Aulenti in the eighteen museums of Florence and Prato involved in *Visitors*; the constructions and installation by Arata Isozaki at the Forte di Belvedere for *Arte/Moda*; the installations by Adolfo Natalini in Palazzo Spini Feroni for *Bruce Weber Secret Love* and at the Reali Poste for *Elton John Metamorphosis*; the installations by Pier Luigi Pizzi in Sala Bianca and in the Sale del Fiorino of Palazzo Pitti for *Emilio Pucci*; the installation by Denis Santachiara at the Stazione Leopolda for *New Persona/New Universe*. The installations for the exhibition *Habitus, Abito, Abitare* at the Museo Pecci in Prato, on the other hand, were done by the staff of the museum itself.

We must thank everyone for their important and generous contribution to the success of the various exhibitions, gratitude that we extend as well to Massimo Gasparon, who assisted Pier Luigi Pizzi; Vittoria Massa and Elena Cumani of the Studio Aulenti; Tohru Uno, Takako Takashima, Yoko Sugasawa, and Yoshiko Amiya of the firm of Arata Isozaki Associates; Giovanna Potestà of the Studio Natalini; and Kazujo Komoda of the Studio Santachiara.

Organizing at the same time seven major exhibitions, in just twelve months' time, was a daunting task, verging on the miraculous. This is all the more impressive if we consider that one of these seven exhibitions, *Visitors*, located in eighteen different museums in Florence and Prato, required twenty different installations, one for each of the fashion designers involved, each one radically different from all the others, and in many cases each as complex as a full-fledged exhibition.

So massive an effort (in theory, set one aside the other, the twenty-six different exhibitions and installations of the Biennale occupy something like 15,000 square meters) could not have been undertaken without the help of a team of first-rate professionals, working in concert in Florence, Milan, and New York, supplementing and assisting in the numerous different fields the work of the three artistic directors and the curators of the various exhibitions, and,

in their turn, supervising and coordinating the work of many, many other contributors and assistants, both Biennale staff and free-lancers.

We therefore extend a particularly fond and sincere thank-you to these individuals and to all the members of the Biennale staff, for their skill, their boundless dedication, their cordial reserves of goodwill:

– for the exhibition *Arte/Moda*: Judith Blackall, supervisory coordinator, and her assistants Lynne Barton, Carla Ferrari and Christine Sebo. Thanks are also due to Elvira Dyangani Ose, Aurora Fiorentini, Anna Maria Gobati, Sophie Jerram, Leonardo Libenzi and Alessandra Pace;

– for the exhibition *New Persona/New Universe*: Livia Signorini, supervisory coordinator, and her assistants Lindsay Brant and Ilaria Pietrini;

– for the exhibitions of *Visitors, Bruce Weber Secret Love* and *Elton John Metamorphosis*: Francesca Sorace, supervisory coordinator, and her assistants Laura Chimenti, Dolores Guzman, Piergiorgio Leone and Marina Caterina Longo;

– for the exhibition *Emilio Pucci*: Anna Pazzagli, supervisory coordinator, and her assistant Stefania Signorini;

– for the exhibition *Habitus, Abito, Abitare*: Stefano Pezzato and Maria Pioppi, supervisory coordinators; Raffaele Di Vaia, Daniela Agresti and the technical staff of the Centro per l'Arte Contemporanea Luigi Pecci. Moreover, we must thank Guelfo Guelfi, for his devoted contributions and efficient communications support.

Alongside sculpture, paintings, installations, photography, film, video, and other types of documentation created specially for the event of the Biennale, most of the seven exhibitions all featured major artworks and materials, which were loaned by museums, art galleries, cultural institutes, archives, private collections, and individual artists in Europa, the United States, and Japan.

A cordial thank-you, then, goes to these institutions, their directors, and their staff, the artists and the private individuals who helped to make our exhibitions possible with their generous loans and other material for our catalogues, often supplying us with information, advice, and precious tips.

For the exhibition *Arte/Moda*: Sara Guelmi and Daniela Simoni of the Museo dellíAeronautica Gianni Caproni, Trento; Gabriella Belli of the Galleria di Arte Moderna and Contemporanea -Trento and Rovereto; Lidia Iovleva, Tatijana Gulbanova and Evgenia Ilioukhina of the Galleria Statale Tretíjakov, Moscow; Dilys Blum, Kristine Haugland and Monica Brown of the Costume and Textiles Department of the Philadelphia Museum of Art, Philadelphia; Lydia Kamitsis, Sylvie Bourrat and Emmanuelle Montet of the Union Centrale des Arts Décoratifs, Paris; Peter Noever and Ursula Hartmann of the Österreichisches Museum für Angewandte Kunst, Vienna; Jurgen Wesseler of the Kunstverein Bremerhaven, Bremen; Steven Beyer and Kippy Stroud-Swingle of the Fabric Workshop and Museum, Philadelphia; Hugh M.Davies and Mary Johnston of the Museum of Contemporary Arts, San Diego; Shirley L.Thomson, Richard Gagnier and Fouad Kanaan of the National Gallery of Canada, Ottawa; Germain Viatte, Jonas Storsve and Nathalie Leleu of the Centre Georges Pompidou, Paris; Gaeta Leboastier, Hélène Vassal and Francoise Cabloc of the Fond National d'Art Contemporain, Puteaux, France; Peter Norton and Bill Begert of the Norton Family Foundation, Santa Monica; Robert J.Shiffler and Peter Huttinger of the Robert J. Shiffler

Collection and Archives, Greenville, SC; Laura Biagiotti; Enrico Crispolti; Ugo Nespolo; Renzo Arbore; Marcella Marchese; Giancarlo Baccoli; Aleksandr Lavrentiev; Jean Louis Delaunay; Angela Brollo; Gordon and Meg Roe; Monique Schneider-Maunoury; Rosita Missoni; Lucien Treillard; Stefano Bini; Giancarlo Calza; Bruno Pisaturo; Gary and Sarah Legon; Carl Solway Gallery, Cincinnati; Mathias Rastorfer and Patricia Edgar of the Galerie Gmurzynska, Cologne; Giorgio Marconi, Giò Marconi and Nadia Forloni of the Galleria Giò Marconi, Milan; Alberto Ronchetti of the Galleria Martini & Ronchetti, Genova; Martina Vergani per Mila Schön Group spa, Milan; Josy Kraft of the Kraft E.L.S AG, Basel; Iwan Wirth and Simon Lenz of the Galerie Hauser & Wirth AG, Zurich; Corrado Tiano and Mimmo Scognamiglio of the Galleria Scognamiglio e Tiano, Naples; Salvatore Galliani of the Galleria Galliani, Genoa; Anna OíSullivan and Wendy Williams of the Robert Miller Gallery, New York; David Gray of the Michael Klein Gallery, New York; Barbara Gladstone of the Barbara Gladstone Gallery, New York; Monika Sprüth of the Galleria Monika Sprüth, Cologne; Chantal Crousel, Sophie Goldberg and Sophie Pulicani of the Galerie Chantal Crousel, Paris; Jay Gorney and Rodney Hill of the Jay Gorney Gallery, New York; Grechen Berggruen of the John Berggruen Gallery, San Francisco; Michael Bliss of the Michael Bliss Gallery, New York; Christine Horeau and Rene Blouin of the Galerie Rene Blouin, Montreal; Fergus McCaffrey of the Michael Werner Gallery, New York and Cologne; Licia Giuli for the Sorelle Fontana, Rome; Giancolombo Studio di Immagini, Milan; Melina Mulas; Piero De Rossi; Dominique Truco of Le Comfort Moderne, Poitiers, France; Bronwyn Jonker and James Corcoran of the C & M Arts Gallery, New York; Richard M. Ader of The Joseph and Robert Cornell Memorial Foundation, Florida; Lorraine Mead and Brian Baltin of Conde Nast Publications, Inc., New York; Joan Kropf of the Salvador Dali Museum, Florida; Harry Ruhé of the Gallerie A, Amsterdam; Robert Descharnes and Nicholas Descharnes, Paris; Daniela Marenbach of the Cecil Beaton Archive, Sotheby's, London; Sherrie Joseph of the Art Gallery of New South Wales, Australia; Woodfin Camp & Associates, New York.

For the exhibition *New Persona/New Universe*: Anise Richey of the Mapplethorpe Foundation, New York; Sandra Brant; Dakis Joannou; Michelle Heithoff; Frank Kolodny; Peter Norton and Bill Begert of the Norton Family Foundation, Santa Monica; Barbara Gladstone, Mark Fletcher and Jay Tobler of the Barbara Gladstone Gallery, New York; Adriaan van der Have of the Torch Gallery, Amsterdam; Janelle Reiring, Tom Heman and Ben Barzune of Metro Pictures, New York; Susan Dunne, Ellen Mahoney and Kate O'Brien of the Pace Wildestein Gallery, New York; Penny Pilkington, Scott Catto, Wendy Olsoff of the P.P.O.W. Gallery, New York; Katy Baggot and Olivia Funnel of Z Photographic and International Marketing, London; Leri Risaliti of the Archivio Fotografico, Museo Pecci, Prato; Victoria Miro and Clare Rowe of the Victoria Miro Gallery, London; Emma Dexter of the ICA-Institute of Contemporary Art, London; Charles Saatchi and Jenny Blyth of the Saatchi Gallery, London; Jeffrey Deitch and Linda Pilgrim of the Jeffrey Deitch Gallery, New York; Maria Grazia Mattei of MGM Digital Communication, Milan; Sky Publishing Corporation of Belmont, USA; The Astronomical Society of the Pacific, San Francisco.

For the exhibition *Visitors*: Dino Trappetti and the Sartoria Tirelli, Rome.

For the exhibition *Emilio Pucci*: Cristina Pucci di Barsento and the Archivio Pucci, Florence.

For the exhibition *Bruce Weber Secret Love*: the Bruce Weber Archive, New York.

For the exhibition *Elton John Metamorphosis*: The Tram, Old Windsor-Berkshire, Great

Britain.

We would also like to thank the Ministero dei Beni Culturali and Ambientali, the Ministero degli Affari Esteri and Luigi Gambardella of the Dogana di Firenze for their courteous assistance in expediting the formalities involved in the loan of the various art works.

Our recognition also goes to all those who helped to install and build the exhibitions themselves and the various installations within the exhibitions:

– for the exhibition *Arte/Moda*: Emilio Bianchi, Ugo Righi; Enrico Bodini of Milani sas, Vittuone (Milan); Daniele Boralevi, Pascal Brault, and Eric Wright for the assistance given in the installation for Karl Lagerfeld; Piero Cantini of the Museo Pecci, Prato; Leopoldo D'Inzeo and Carlo Blasi of Consilium sas, Florence; Luciano Formica for his expertise on restoration; Sergio Frugis for his entomological expertise; Aubert Lee of the Hightech Laser Group, New York for the projections of the work of Jenny Holzer; Duccio Toti of the Comune di Firenze (City of Florence); Cinzia Oliva for her expertise on restoration; Alessio Petrelli and Gianluca Salciccia of Targetti spa, Florence; Marco Pompucci and Carlo Pesci of Sigma, Florence; Paul Miller of Sunrise Systems Inc.- Pembroke, USA for the luminous signs for Jenny Holzer;

– for the exhibition *New Persona/New Universe*: Simone Ciarmoli and Giampiero Lo Curto for Giorgio Armani; Kate Chertavian, Alex Psychopulos for David Bowie; Luca Ghilardosi and John Field for Gucci; Yutaka Kubota and Yukihari Takamatsu for Yukio Kobayashi/Matsuda; Nick Knight and Emma Wheeler for the photographs, and Adel Roostein for having donated the mannequin for the installation of Alexander McQueen; Angelo Jelmini for Missoni; Franco Origoni, Mauro Radaelli and Anna Steiner for Moschino; Kristin Lucas for Tony Oursler; Mark Spye for Vivienne Westwood; Nagato Iwasaki for the sculptures for the installation of Yohji Yamamoto; Giancarlo Martarelli; Marco Pompucci and Carlo Pesci of Sigma, Florence;

– for the exhibition *Visitors*: Alberta Ferretti; Sartoria Tirelli, Rome;

– for the exhibition *Emilio Pucci*: Silvia Aymonino; Lucilla Baroni; Bonaveri Artistic Mannequins, Cento (Ferrara); Giovanna Buzzi; Cappellini, Milan; Julie Guilmette; Giancarlo Martarelli; Franca Prosperi; Pucci, New York; Gigi Saccomandi; Teatro Comunale di Firenze;

– for the exhibition *Elton John Metamorphosis*: Natascia Ugliano;

– for the exhibition *Habitus, Abito, Abitare*: the organizational staff of the Compagnia della Fortezza, Volterra, Anna Cremonini, Cinzia de Felice, Moira Miele, Silvia Montorsi; the organizational staff of Fabrica, Treviso, Alfredo Albertone, Irene Boccetta, Giorgio Collodet, Alessandro Favaron, Francis Kulpers, Vittoria Merrick, Nicoletta Melito, Goran Mimica, Chantal Prod'Hom, Carlo Spoldi, Barbara Tubaro.

Special thanks go to all those who, with their experience, their knowledge, and their ideas, have helped the various curators and their assistants, both in the general orientation of the exhibitions and in the quest for materials for the exhibitions themselves and for the catalogues. For the exhibition *Arte/Moda*: Anne-Marie Sauzeau of the Archivio Alighiero Boetti, Rome; Daniela Barsocchi of the Associazione Italia-Russia, Milan; Catherine Join-Dièterie of the Musée de la Mode et du Costume, Paris; Richard Martin, Diana Cross and Diedre Donahue of the Metropolitan Museum of Art, New York; Beatrice Fassler of Parkett Publisher, Zurigo; Phyllis Riefer of Vogue America; Justine Bulbil of the Michael Werner Gallery, New York and Cologne; David Drogin of the Max Protetch Gallery, New York; Pasquale Leccese of the

Galleria Le Case d'Arte, Milan; Pika Keersevilck and Royce Weatherly of the Barbara Gladstone Gallery, New York; Jay Jopling and Julia Royse of the White Cube Gallery, London; Jorg Jöhnen, Ursula Trübenbach and Karen Ratzel of the Gallerie Jöhnen & Schöttle, Cologne; Paul A. Miller; Paula Cooper of the Paula Cooper Gallery, New York; Laura Carpenter Gallery, Santa Fe; Luca Palazzoli of the Galleria Blu, Milan; Julia Brown Turrell; John Kaldor; Ad Petersen; Roberto Pizzini; Sergio Poggianella; Otto Wollenweber and Caroline Ryan of the Maison Courrèges, New York and Paris; Laura Agnesi of the Triennale di Milano; Mary Westermann-Bulgarella; Petra Serwe; Marino Vismara.

For the exhibition *New Persona/New Universe*: Francesca Alfano Miglietti of Virus; Katie Baggett; Brian Baltin of Conde Nast, New York; Alessandra Borghese; Virginio Briatore; Giulio Ceppi; Channel Four Television, London; Gianni Chimenti and Giulia Martinez of 20th Century Fox, Rome; Paula Cooper of the Paula Cooper Gallery, New York; Massimo De Carlo of the Galleria Massimo De Carlo, Milan; Danilo De Rossi of the Università degli Studi di Pisa-Centro E. Piaggio, Pisa; Fabrica, Treviso; Frum van Egmond of the Galerie Steltman, Amsterdam; Marcel Fleiss of the Galerie 1900-2000, Paris; Frank + Schulte Gallery, Berlin; Niki Galliani of ICA, London; Marco Giusti; Tom Heman and Ben Barzune; Josh Jordan; Pasquale Leccese of the Galleria Le Case d'Arte, Milan; Richard Martin; Maria Grazia Mattei, Marica Motta and Sabina Nenna of MGM Digital Comunication, Milan; Giovanni Minerba; Oliver Morse of Windfall Films, London; Jean Francois Taddei and Jean Michel Jagot of the Frac des Pays de la Loire, Nantes; Janelle Reiring of Metro Pictures, New York; Studio Guenzani, Milan; Jennifer Symons of the Rena Bransten Gallery, San Francisco; Maciej Wisniewski and Marc Pottier of International Contemporary Art, New York.

For the exhibition *Visitors*: Giulio Cappellini; Tom Dixon; Dino Trappetti.

For the exhibition *Elton John Metamorphosis*: Gabriella Pescucci.

Further, we would like to think all those individuals who worked so hard and so long to complete the catalogue of the first Biennale di Firenze and the other publications concerning the various exhibitions; as so often happens, the many delays in the development of the exhibitions brought tremendous pressure to bear on the production of the catalogue: first, let us thank Anna Costantini and Cecilia Torricelli, who, working under brutal deadlines, managed the production work with tranquillity, quality, and organization; then, thanks go to the long-suffering Claudio Nasso, Mariapia Toscano and the entire staff of Skira, which is publishing these catalogues; and last, not least, the translators—Anna Albano, Matteo Codignola, Martyn Drayton, Deborah Hodges Maschietto, Stephen Saltarelli, Marguerite Shore and Antony Shugaar. A big thank-you to Lucia Brignano and Marta Léger.

And of course we must thank the experts and scholars who, along with the artistic directors and the curators of the exhibitions, made brilliant and interesting contributions to the catalogue and the other publications: Cristina Acidini Luchinat, Jenny Blessing, Ozwald Boateng, Virginio Briatore, Mariuccia Casadio, Enrico Crispolti, Deborah Drier, Gillo Dorfles, Maurizio Fagiolo Dell'Arco, Maria Luisa Frisa, Marco Giusti, Richard Martin, Maria Grazia Mattei, Monique Schneider Maunoury, Gianni Pettena, Nancy Spector, Pier Luigi Tazzi, Giovanna Uzzani, and Paolo Vagheggi.

Germano Celant
Luigi Settembrini
Ingrid Sischy

Looking at Art

Upon this occasion we launch the first Biennale di Firenze, a project that began with a meeting between the three of us that we will never forget. It was in the spring of 1994 and it is memorable because the air was full of positive energy that we experienced while we were exploring the reasons why this Biennale needed to be created. It was the kind of must-do conversation that has gone on around art a lot especially when art's been at a changing point, and there's been a strong feeling that the art system was behind the times in terms of what was actually happening in art. That's usually when people have dreamed up all kinds of ways to give new developments in art a chance to be seen, and thought about. What gave our meeting its sense of special excitement and challenge was that we were talking this way about fashion. Luigi had proposed that we explore the possibility of creating a large contemporary exhibition in Florence in which fashion would have a chance to be regarded as the multi-faceted medium that it is. As we talked, the idea started to really grab us, because it embodied a great challenge, and also because it brought out the chance to explore a relationship that is full of the stuff that makes relationships interesting. We are referring, of course, to the worlds of fashion and art.

One may ask, why did we want to take on such a project? After all, there are already so many shows about art. And contemporary fashion already has its own complex system of appearing in the world. There are the collections, the businesses, the stores, the advertisements, the magazines, the media coverage, etcetera. Even with all this, though, we, like many others, felt that something crucial was missing. As many people have observed, fashion has such a hold on our culture, and yet it still isn't really recognized as being a part of *true* culture. Where are the cultural programs for contemporary fashion that are givens in contemporary art, film, and architecture? While contemporary fashion has its occasional shows in museums and galleries and receives plenty of attention, like many individuals, both inside and outside fashion, we were frustrated that the discourse about contemporary fashion is usually so superficial. In our minds a cultural event that was dedicated to looking at the culture of fashion was long overdue, as was an event that engaged the subject of art and fashion, in a deeper way than is

usually done. And we thought that if this event could be established in a manner that nourished the ideas of creativity, exploration, experimentation, it would be a welcome opportunity for those involved, as well as for the public. Out of these seeds grew the first Biennale di Firenze.

This Biennale could never have happened if it weren't for Florence. The city both inspired and graciously provided the framework around which the Biennale is constructed. Right from the beginning it occurred to us that the larger perspective we were aiming for required a suitable environment that could host the kinds of exhibitions that we were thinking about. We were most fortunate that the city of Florence should have responded so admirably, making available museums, exhibition spaces, and historical buildings, as well as approving plans for the new buildings that have been constructed for this occasion. There is no better "stage" than the city of Florence, no place in the world where there are so many beautiful examples of the history of creativity. There is no place where the act of looking is so fulfilling. And ultimately *looking* and thinking is what this Biennale is all about.

It is also very much about connections—between fashion and the world, and between fashion and the world of aesthetics. And this leads to the next part of our story about how the Biennale evolved. We wanted it to have many dimensions, as will become clear in this catalogue, in the exhibitions themselves, and in the other books that have been produced on the occasion of the Biennale. While our focus was on the present, we wanted to include a sense of both the past and the future. And while it has never been our intention to suggest that art and fashion are the same it has been our goal to present them on the same stage as it were, so that they could be looked at together. The Biennale spotlights their relationships in all types of ways; you will find examples of cross-pollination, differences, collaboration, conflict and inspiration.

The conjunction and interweaving of these extremes takes place in real time, which is to say, they are expressed with the presentation of events and constructions, collaborations and installations, that are linked to the most absolutely of-the-moment present, the present time in which they coincide, unusual and unprecedented. Time, then, is the point of reference of this entire event, both because time is a marker, an indicator of the contemporary, and because time is the denominator of historical, environmental, cultural, and social context: we are speaking, then, of "time and fashion."

The best way to explain what we have done is to go back in history to a moment in photography, when the prevailing wisdom about this medium was that it wasn't really an important visual expression. There have been many individuals who have worked to show how limited such a view is, including John Szarkowski, the Curator Emeritus of Photography at the Museum of Modern Art in New York. It was his book of 1973, titled *Looking at Photographs*, that we thought about when it was finally time to look back and see what we have put together in this Biennale. We hope that with all the different exhibitions they add up to something that can be called: *Looking at Fashion*. Szarkowski's book showed the rewards that come with looking at photographs. It's hard to believe that anyone could experience that book, and still think photography isn't an important visual language. Part of the bias against photography came from the facts that it is created with a machine, that it is often achieved very quickly, that it is a great

commercial tool, and that it isn't necessarily something that is meant to last for ever. Fashion also can have these properties, and they have been responsible for some of the biases against it which have prevented people from recognizing it as the complex medium that it is. But, like photography, fashion is a multi-layered, multi-purpose medium and that is what makes it so intriguing as a subject for both aesthetic and social consideration.

Fashion's vocabulary involves many of the same elements that go into art; there are questions of visions, craft, materials, cut, color, etcetera. Like art, fashion can be looked at anthropologically, sociologically, and even philosophically. It is an expression of individual and collective desire. It is a barometer of change. It involves issues of identity and sexuality. It engages with, and even stimulates, technology, science and business, just to name a few of the elements that are a part of fashion. And fashion is obsessively involved with the body—which leads to yet another facet of the Biennale. It is almost the beginning of a new century. Where are we going, and who will we be? It is a moment when creativity, imagination, and invention are of paramount importance. Thus, this Biennale—which has at its center fashion and art—and wants to suggest some of the many ways in which creative individuals can have a role in defining and changing our world, and even opening up new universes.

Biennale di Firenze

Looking at Fashion

SKIRA
EDITORE

General catalogue edited by
Germano Celant

Production coordination
Anna Costantini
Cecilia Torricelli

Editorial coordination
Claudio Nasso

Graphic coordination
Marcello Francone

Editorial staff
Anna Albano
Judith Blackall
Emanuela Di Lallo
Livia Signorini
Maria Pia Toscano

Graphic consultant
Pierluigi Cerri

cover photo
Man Ray
Untitled, 1936
courtesy of Lucien Treillard, Paris

Contents

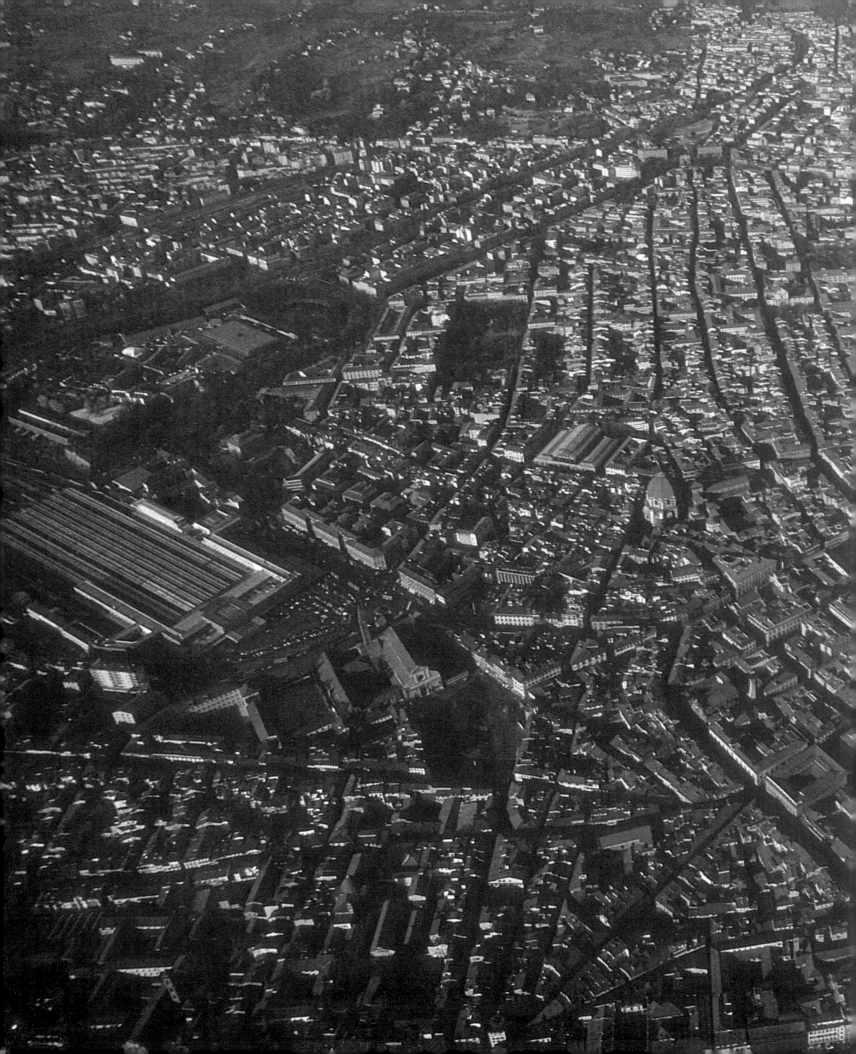

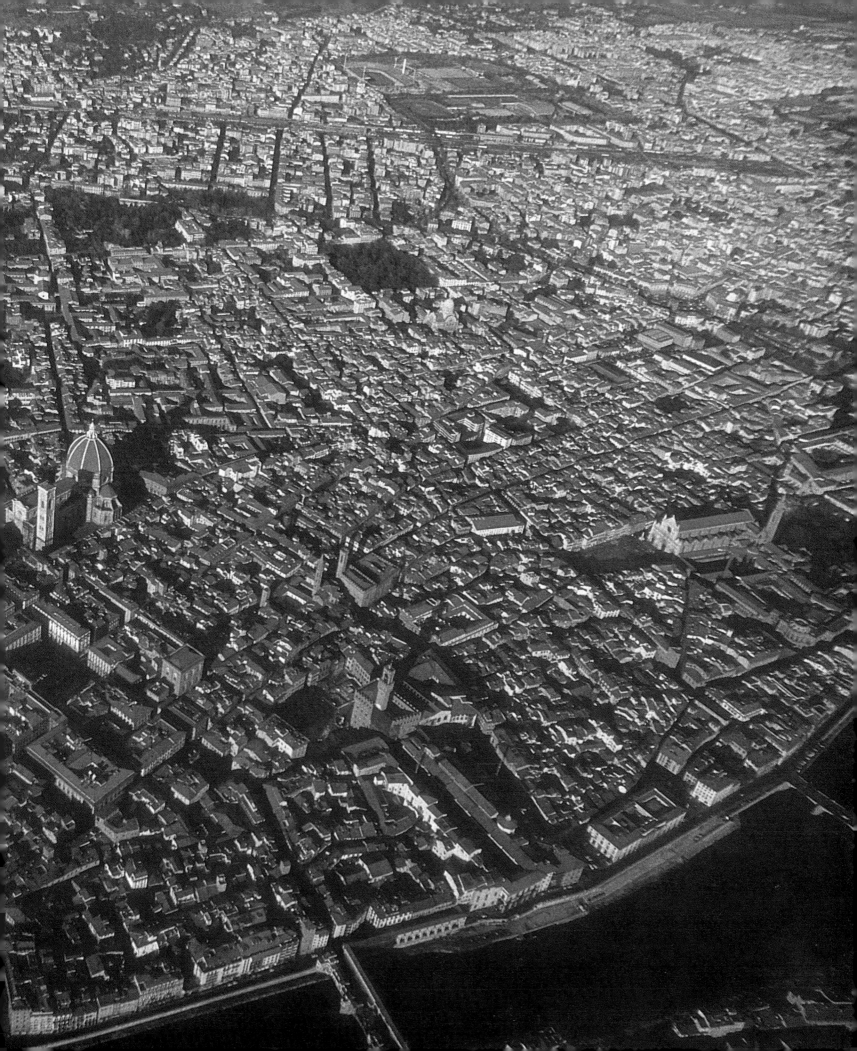

Luigi Settembrini

The Florence Biennale
A Cultural Study of the Contemporary

The Florence Biennale is a cultural study of all contemporary things; considering that actually determining the definition of "the contemporary" is an exceedingly complex thing to do, we feel that this is a rather challenging undertaking.

"If you do not ask what Time is, then I know; but if you ask me, then I no longer know," wrote Augustine of Hippo, saint and philosopher. If this is true of Time, this is doubly true of the contemporary, for the contemporary is part of Time, and yet the contemporary has Time within it (literally, if we consider the origin of the term: "tempo" coming from the Latin "tempus, temporis," meaning "time").

We initially proposed to take the contemporary by the horns; in fact, of course, we are forced to attack the question in the only manner that is possible to approach so multifaceted, multiform, and multidirectional a topic: obliquely, and with a diverse array of disciplines. We plan to explore a variety of major themes in this topic—perhaps we should call it a field, more than a topic—and we intend to summon a number of first-class intellects to consider the problem.

To do all this requires a healthy dose of optimism, and at the same time a few counter-intuitive qualities: the cunning of the dove, and the candor of the fox.

In some sense, we must overcome the paralysis induced by the post-modern condition; we must seek a solid anchorage to withstand the media riptides, and yet we must seek to sail onward, to make headway in our voyage of exploration. This entails making a serious attempt to break out of the increasingly featureless mass culture; to make tracks across the nondescript landscape of the countless, minor distinctions of diversity; to battle the evaporation of reality. All these obstacles are the most notable products of the ongoing expansion of the world economy and of the growing universal domination of electronic communications technology.

And as we scratch the surface of the contemporary, the objective that the Florence Biennale has set for itself is this: to succeed in charting, in the great millennial divide that is fast approaching, a rough cartography of a number of main landmarks and geographic features of the contemporary. The Biennale intends to survey the crossroads, to record the principle directions of movement, in an effort to develop a few navigational hints for

life in this era of events in "real time"—i.e., in a condition in which the concrete and diverse personal time-flows that we experience at our own rate link up with a single, continuous, virtual time-flow. These navigational hints, at the same time, should also be useful to the documentation and exploration of the operative potential of the new sensory and linguistic horizons that are opening up to our startled awareness. As we have already learned from Baudelaire and from *Blade Runner*.

Fashion inhabits the concrete uncertainties of the contemporary. Moreover: if we think of fashion as the logical system whereby shifts take place in the sensibility, tastes, and style of one's own era, then we can consider it as a strong depiction of the contemporary, one of the major nexuses in the network of the present-day. Indeed, fashion, in many ways, is identical with the contemporary; to say that fashion is contemporary is virtually a tautology. Fashion is "temporary" by its very constitution; it must be parsed in the plural, its mood is the imperative, it seeks out the present tense. It is simultaneous, ubiquitous, and non-systematic by character; there is an intrinsic vagueness to fashion's origins and to fashion's destiny. And in this array of contradictions we find a quasi-magnetic field of conflicting tensions: fashion is unrequited, intolerant, and scornful of the present; fashion sees the present as already past; fashion is exclusive and never desists from foreshadowing. Fashion demands that it—and it alone—be crowned as the present-day form of the future. This first Biennale of Florence, then, is devoted to the intricate and manifold relationship of time and fashion.

The new challenge that the Biennale has taken on—the innovative approach that it will be pursuing—involves the exploration of the palimpsest that constitutes the contemporary, through the festival format, i.e., through exhibitions and events that are at once scholarly and spectacular, capable of attracting major names of international culture and—at the same time—capable of speaking to a larger audience than that usually attracted to some of the more open and advanced manifestations of philosophical thought of *avant-garde* art.

Art and philosophy, too, explore the contradictions of the contemporary: they attempt to offer creative expressions of the profound transformations that are being wrought by new technology; they do so with varied media and languages, in an effort to establish a new, human sensibility, while championing the senses that have been negated. In the way that art and philosophy treat their subjects, however, they determine in advance just who their audience will be: they address a specialized and well-prepared public; they tend to restrict their universal capacities to communicate, at times almost perversely.

Things are radically different in key areas of the contemporary such as fashion. Fashion is created not only by those who actually design and manufacture it; fashion is also created by those who wear it and interpret it in a personal manner. Fashion is a planet-wide medium; it is immediate and massively powerful; it lies at the heart of an exceedingly complex and stratified body of economic, social, and individual interests and desires. Fashion may seem like a simple and familiar concept; it is not, however. While philosophy and contemporary art (along with design, music, advertising, and other "languages") now deal with and explore fashion, the result is not an improvement of fashion or an increase in the clarity with which we understand fashion.

If we wish to broaden the context of our discussion, perhaps we could consider, in

communicational terms, the remarkable novelty of a project devoted to the self-investigation of the contemporary. And, for that matter, is it not fair to say that this aspect stands alone among the paradigms of contemporary culture?

The prevalence of the paradigm of communication leads us to extend our cognitive reach well beyond the threshold of the classical separation of mind and body, giving new meaning and value to the purpose and logic of the latter (body). It is, of course, no accident that one of the most significant exhibition-events of this Biennale should be devoted precisely to the body: to the metamorphoses that the body undergoes or intentionally carries out; to the influence that the body exerts through the traditional distinctions between—and among—genders and gender roles.

Now more than ever, our five senses contribute greatly to the endless quest for meaning, significance, Sense. Truth is now sought, and discovered, esthetically, and no longer only in the inner depths of things, because, in a society that constantly laments the shallowness of its values, it may well be that the surface of things has become more densely crowded with meaning and meanings. The project undertaken by the Biennale is, in its small way, at once a testimony to this epochal process, and an instrument of inquiry.

Each edition of the Biennale will constitute an effort to substantiate and articulate these ambitious goals, in increasingly interesting, curious, and amusing forms of high and refined culture. And this effort will not be limited to the biennial festival; alongside the main show, the center ring that will be held every two years, there will be an ongoing activity in the form of individual exhibitions, conferences, research projects, and publications. These single events, initiatives, and shows will follow the same overall approach, while dealing with specific aspects of the general themes that are treated, in depth and in monographic context, every two years. After all, the contemporary must be watched closely—and yet at a sufficient distance to allow for reflection and an ongoing interpretation of its many and contradictory aspects.

The novel aspect of a large-scale project focused on the idea of the contemporary is particularly noteworthy in Italy, a country that is contemporary in spite of its official culture.

In Italy, obviously enough, you can count on the fingers of one hand the institutions and the major artistic and cultural events of international importance that focus upon contemporary reality.

To all intents and purposes, the most significant contribution that Italy has made to what we call "the contemporary" has come in the form of fashion, industrial design, film, and the work of its architects (often built in other countries); that contribution has also comprised specific sensibilities and esthetic qualities, which have penetrated the smallest and most personal expressions of day-to-day life.

Official Italian culture, on the other hand, has largely remained on the sidelines, wasting time and precious energy on didactic commonplaces, rarely aspiring—much less attaining—to an international scope (and often failing even to reach a genuinely national dimension); too often Italian official culture is engaged in a losing, rearguard action, a desperate alliance with the Great Culture of the recent and distant past.

All this has culminated in a paucity of results; save for a few isolated cases, the results of the hard work and personal integrity of rare individuals, even the simple preservation of

the remarkable historical, cultural, artistic, architectural, and environmental heritage of what is now Italy has been hampered and hindered by a lack of resources, by widespread apathy and indifference, by half-baked efforts, by the prevalence of a mass tourism industry, by traffic, by spreading cement, and by the construction of hideous, and often illegal, vacation homes in unspoilt wilderness or within a stone's throw of historical landmarks.

Outside of the country, a linkage has been established between contemporary Italy and traditional Italy, though only through haphazard and spontaneous connections.

To the eyes of Europeans, Americans, and Asians, in fact, the modern image of Italy was immediately reconciled—immediately, which is to say, intuitively and instantaneously—with the image of Italian history and Italian art. This instant identification has helped to gloss over such endemic and pathological *phenomena* as the Sicilian Mafia, or even such merely negative aspects as political gridlock, burgeoning bureaucracy, and outdated and inefficient administrative styles. Thanks to an original, post-modern, and quite *au natural* blend of the past and the future, art and industry, esthetics and marketing, creativity and technology, there has arisen a universal recognition of Italian style. That style has given Italy an uncontested intellectual leadership in areas of the economy that are clearly strategic to any understanding of the crucial transition from the industrial phase to the post-industrial phase, from atomic society to a society based on bits.

There was no institutional foresight or planning involved in the construction of this image. And there was even less awareness of the strategic advantage that was destined to accrue to Italy as a result of its investment in the complex culture that was to serve as the true, lasting, deep-rooted substrate for that culture. Let us not limit our awareness of the phenomenon to the conservation of Italy's traditional cultural heritage—basic prerequisite and initial capital for that investment. Let us consider the way in which that culture has been reconfigured and exploited in a modern sense, the development (economic and otherwise) that has derived from this industry, based on an energy and an end product that are endlessly renewable: goods, services, structural and infrastructural improvements, tourism, entertainment, and high-information-content activities, the industries of esthetics and creativity, advanced technology, scientific research, and education.

Are recent discussions of the possibility of establishing an Italian Ministry of Culture an indication that this strategic awareness has finally reached the minds of the men who rule Italy? For any country that is working to compete internationally, increasingly, the issue of culture and economics (quality of development) is of greater importance than economics and culture (quantity of development); likewise, the issue of culture and technology is more important than that of technology and culture (technology as a means to something else, and not as an end in and of itself). In order to attain those goals, this approach seems obligatory.

What links a Ferrari with the sculpture of Michelangelo? How, in the flow of the contemporary, can the complex relationship with the past—made up of distances and identity—be developed? This is the question that attracts anyone looking at Italy, a country whose own past belongs to Italy herself, but also to the rest of the world. The fact that we do not know the answer and yet we never stop wondering about the question

preserves the contradiction of contemporary Italy alive and wide-open; this state of affairs prevents Italy from being pigeonholed in the fleet of signs and images of the world's collective subconscious, pigeonholed among the various stereotypes with which we gaze back at other, equally alluring countries and civilizations, definitively locked in the past. To invest in culture means this: to continue to maintain as productive resources in the context of the contemporary the substance, styles, and protocols of a past that would otherwise depreciate steadily, rendering posthumous the present. It also means communicating the idea that art, beauty, and quality cannot be considered as superfluous, marginal, or residual aspects of contemporary life; rather, they must be seen as useful, concrete, vital factors, crucial in overcoming the crisis in precisely these values; despite, indeed thanks to their unrequited nature.

This esthetic education (esthetic in the broader sense, in that it requires the intelligence of the five senses, as well as concerning aspects and considerations of art) and all that it helps in solidifying, is the one original universal contribution that Italy can offer the contemporary world. It is worth our while to concentrate upon it.

If we have allowed ourselves to become slightly carried away in speaking of Italy, this may also be for a very good reason: this focus serves to emphasize certain features typical of the overall project that the Florence Biennale intends to pursue. We should be well aware of the broad, international, and interdisciplinary horizons embraced by the problems to be addressed, as well as the similar scope of the possible solutions that may free us from the *cul-de-sac* of the continuous present, the dictatorship of "real time"—solutions that will be sought here.

Under this two-fold aspect, let us also consider Florence, the city that will be home to this Biennale, lending the prestige of its name to this project.

The city Florence is known and loved around the world, and its image is unique; no other city, in Italy or elsewhere, no matter how important and culturally alive, has quite the same allure.

Florence is a universal capital of the soul; it is a solid figuration of utopia, a still-viable model of quality, beauty, and harmonious relations between man, his memory of the past, and the present environment in which he lives. Florence is a paragon, rendered more desirable and even indispensable by the contemporary setting of historical meltdown, desublimation, general vileness, and ecological conflict.

And precisely because of this image, everything of any importance that happens in Florence, for better or worse, has a greater significance and resonance than if it had happened elsewhere.

And for that reason this Biennale is the Biennale of *Florence*.

The fact that this city somehow exists outside of time, the fact that it seems to offer a potential new composition of the most basic reasons and ideas of civil existence and coexistence—in its history, for the past; and in its tradition, for the future—the harmony of form and the intensity of quality that Florence succeeds in conveying: all these aspects constitute a perfect setting in which to put forth our ideas of the most significant aspects of the contemporary, the prefiguring elements of discontinuity and contradiction that emerge from the continuous flow of the contemporary, the profoundly new aspects that mark the sensibilities of our times—all these things constitute the *terrain* that the Biennale

intends to explore. There are cities around the world, larger, and of greater international importance, and even more contemporary, that would not be so well suited for this particular purpose. These cities would dilute or banalize these themes in their great size or in the random shuffle of events to which they play host; or in the *avant-garde* marketplaces for which they are the natural or sometimes the accidental setting.

The choice of Florence as the location for the Biennale, then, was well thought out, in terms of culture, communications, and the overall quality that is required by an event concerning the contemporary, if it is in some way to affect the contemporary.

The interest that has been shown thus far by major international figures in fashion, art, and critical thought in the ideas underlying this first edition of the Biennale is also a product of the remarkable esthetic authority and attraction that Florence continues to exert, and of the fact that Florence is an obliged point of reference in any interaction with modern culture, for anyone who wishes to emerge even slightly from the shell of the standardized version of the contemporary.

The Biennale project may serve as a link between an international exploration of the themes and sensibilities that exist at the far edges of the contemporary, and further research into the features that characterize the universal qualities of the contemporary to be found in a city like Florence: a major cultural project may be, at the same time, an exploration of the city and a project for the city. The Biennale can contribute to a definition of a strong and distinctive idea of Florence, indicating symbolic boundaries to the tourism of the commonplace, undifferentiated and over-simplified, that is mass tourism; an idea that elaborates and emphasizes that strategic connection between the city's traditional culture and its contemporary culture; an overarching idea within which individual projects and major initiatives in a broad array of fields can taken on a greater meaning and a greater promotional power; an idea that is also capable of being distilled into an image that is universally shared, pluralistic in its contents, visionary and concrete at the same time.

Establishing this potential identity is, of course, a collective process that must involve the commitment of the planning capacity of both the administrative collective and of various disciplines—from economics to urban planning, sociology, art, poetry, and even communication sciences—demanding the contributions of Italian and international experts, the citizens at large (the citizens of every country on earth, actually), and the various businessmen involved, geographically or by sector. It is only through this concept of cooperation of the city as a whole that we can achieve a more intense awareness of the privileges and the duties intrinsic to living and working in a city that is known and loved throughout the world, and of the incredible opportunities that attach thereto: these must be "broader" or "longer" reasons than those in question if they are to justify and make acceptable such major choices for the city, if they are not to be derailed by the minor or major considerations of vested and local interests.

The most noteworthy efforts required by a project of this nature are those of mindset, organizational creativity, and efficiency of communication.

The fundamental features that will be needed for the realization of the project are all already in place: these features can be brought out into the complex dimension of living that Florence offers to the contemporary world only if they are considered as a whole, and exploited as such, rather than being kept hidden and separate one from another.

Florence—considered in the broadest sense as the central reference point and the "nerve center" of a network of relationships involving the metropolitan area, shared with Pistoia and Prato, and all of the cities and towns, that are so many jewels encrusting the crown of Tuscany (Siena, Lucca, Pisa, Arezzo, San Gimignano, and so on)—interprets and synthesizes in its way many of the more positive aspects that distinguish around the world the image of modern—and post-modern—Italy: the moderate size of the city, and its "human dimensions," at a time when the myth of the great metropolis as the sole setting for modernity is being questioned and rejected; the pronounced international aspect of the city's cultural viewpoint, as well as the cosmopolitan nature given Florence by the presence of tourists, but especially of sizable communities of non-Italians who live here permanently (Florence and Tuscany have long been home to the largest communities of Americans, Britons, and Germans living in Italy); the lovely interweaving of city and countryside, and the linkage between city and surrounding region (a region with an astonishing variety of landscapes in a relatively small territory), all features that offer testimony of a long-standing tradition of seeking a non-aggressive relationship with the environment, and a strong integration of city and territory overall; the network of light industry, manufacturing and marketing products internationally, products that feature either quality-intensive creativity or notable entrepreneurialism in the high-technology sectors of the world economy; fine craftsmanship, with long-standing ties to restoration workshops that are some of the finest in the world; light agriculture that produces excellent wines and fine foods, part of a tourist industry that is growing thanks to the appeal that Tuscany offers to those interested in agri-tourism and spas; a thriving educational and university network, with active research branches, particularly strong in both scholarship and in the sciences, alongside of which are the local branches of prestigious European and American universities; institutions, associations, and major cultural events, along with various other activities in this field of education and research; sports and athletics, along with other forms of entertainment—all of these various aspects mark the dynamic personality of the city, and contribute to the objective and subjective indices of quality of life in Florence.

A project like this requires the ability to insert these elements, their reciprocal links and bonds—both those that already exist but are not being adequately publicized and new ones, that can develop out of the existing ones—within a strategic framework, and then to communicate to the world at large Florence's commitment to become a workshop for new and more advanced equilibriums between the past and the present. It means updating Florence's role as capital of the spirit, and making it a place in which research is done regarding the quest for possible solutions to the contradictions and conflicts of the contemporary, research that pursues—as an ideal reference point—the high standards of quality found in a model based upon states of equilibrium that have been tested over time. The fact that we are emphasizing investments in preservation, reconstruction, and refinishing, as well as investments in organization and communications—as opposed to investments in expansion and development, which tend to dissipate energy and produce wastage and redundancy—does not mean, certainly, that we intend to close ourselves off to the new, or that we dream of finding shelter from the dissonance and disorder that the new tends to bring with it. Instilling a culture of complexity, creativity, quality, and beauty are so many assurances that the solutions that we will be seeking out will be neither banal

nor pedestrian.

Finally, allow me a few words concerning the *criteria* that guided us in choosing the nearly one hundred artists and designers who are featured in this first edition of the Florence Biennale. The problem of selecting the featured individuals is, traditionally, the agony and the ecstasy of assembling events of this sort. Germano Celant and Ingrid Sischy shared that responsibility with me; and each of them may choose to address this topic in greater depth in the essays that they are writing for this catalogue, but allow me now to say this: in an international festival that is meant to explore the relationships between fashion and other creative idioms and forms of expression, and to explore the ways in which this interface expresses in a significant manner the contradictions of our contemporary condition, we three artistic directors sought out above all artists and designers with the intellectual depth and the inborn predisposition to make the most of this workshop in cultural contamination. What I am trying to say is that we were less interested in the fame or success of a given artist or designer, and more interested in their sensibilities, in their suitability to the four exhibitions in which they would be taking part. In *Art/Fashion*, at the Forte di Belvedere, with a series of intersections of personal creative visions, seven pairs of artists and designers produced an original and shared concept; in *New Persona/New Universe*, at the Stazione Leopolda, with a series of personal meditations upon the theme of mutations that, at the dawn of the third millennium, is affecting the human body and which is being projected onto human figures and traditional sex roles; in *Visitors*, with the relationships of affinity or stark contrast developed by twenty designers with the sites and testimony of art and culture of the past in eighteen different museums in Florence and Prato (and the effects achieved here bring to mind the sense of free experimentation, untethered by rigid functional obligations, that was once found in high fashion); and, lastly, in *Habitus, Abito, Abitare*, at the Museo Pecci in Prato, with a work-in-progress established by artists and other creative individuals concerning mental garb and physical garb, the garb that we wear, think, and the garb that surrounds us in the form of the city.

The three other exhibitions—*Emilio Pucci*, in the Sala Bianca and in the Sale del Fiorino in Palazzo Pitti; *Bruce Weber. Secret Love*, in the Museo Ferragamo in Palazzo Spini-Feroni; and *Elton John. Metamorphosis*, at the Regie Poste in the courtyard of the Uffizi—are dedicated to three major figures in the history and the present of fashion, and to the themes that each of them suggests: Pucci, and the emergence of the style of modern women; Weber, and the relationship between fashion and photography, and the definition of an innovative image of men's and women's bodies; and Elton John, and the combination of pop music and the interplay of changing identities through clothing and dress. Perhaps the subject changes, but the critical and cognitive approach remains the same as that used in the other events—an emphasis on questions, rather than on answers.

None of what I have written here will serve to shelter us from the attacks of critics who might well have chosen differently, or those excluded who feel they should have been included—and nor should it.

We are simply happy that we have been able to deal with the subject of fashion while discussing culture with a number of leading international figures in the fields of art, fashion, architecture, design, photography, entertainment, music, and contemporary thought.

*Germano Celant**

The Fashion and Arts Garden: The Florence Biennale

* The following constitutes a year of work, a year of unanswered questions, or almost. From the time we first began to put together the Biennale di Firenze, I have been asked countless questions about the project. For reasons of informational strategy I have attempted, except in certain cases, to avoid answering them. Mystery, of course, arouses interest and curiosity. Secretly, however, I have "saved" these questions, in the hope of one day being able to answer them. The best venue for fulfilling this task is in the catalogue itself, the tool designed to justify the logic of an exhibition. So I have gathered them all together here, reorganiz-ed them and answered them, seeking to give a reasoned order, from the general to the particular, to their sequence.
My thanks to Pandora Tabatabai Asbaghi (PTA); Gae Aulenti (GA); Judith Blackall (JB); Anna Costantini (AC); Debora Drier (DD); Laura Dubini (LD); Francesca Sorace (FS); Ida Gianelli (IG); Mario Merz (MM); Miuccia Prada (MP); Pier Vincenzo Rinaldi (PVR); Denis Santachiara (DS); Livia Signorini (LS); Cecilia Torricelli (CT); Darryl Turner (DT); Guido Vergani (GV), and to many others for having asked me these questions. May they forgive me for not answering them sooner (GC).

G.A. What is the reason for this Florence Biennale of fashion? What is the philosophy behind this project?

G.C. The first Florence Biennale, with the universe of fashion as its central nucleus, was born of a number of considerations. The first is that the language of fashion has now joined the other languages of contemporary expression, and thus demands to be presented or analyzed no longer from a "news" perspective, but from a cultural and scholarly one. We can no longer continue to consider its presence merely a journalistic concern involving only personal adornment and frivolity. For one hundred years now, fashion has been cutting through surfaces, drawing lines, producing images and colors; our very visions of the body and of sex have taken shape through its formalizations. Fashion is an aesthetic object that implies projections and arguments that are at once sociological and anthropological, psychological and technical, economic and creative. Realizing a Florence Biennale devoted to Fashion means creating an exhibitional and critical space that will periodically confront this phenomenon in all its complexity and richness of communication and philosophy. The premise of its artistic directors—Germano Celant, Luigi Settembrini and Ingrid Sischy—was to present it in all its different codings, which are not the hard and polished crystallizations of production and industry, but rather concern the different individuals whose diversities lie in their cultural, sexual, ethnic and environmental perspectives, which tend to transform the process of the perception of the male and female body. Such persons work according to a vision of theory and practice, of aesthetics and object, that is not exhausted in a simple "catwalk" of models and clothing. It is much more profound than that, because it concerns, both consciously and unconsciously, the seductive, erotic power of the relationship between the nude body and the clothed body. Through the ornamentation of the body, the person becomes conscious of the self as sign or spectacle; for this reason, fashion is useful not only for satisfying functional and decorative needs; it is also an expression of a self, that of the designer and that of his public.

Aware that the levels of meaning of Fashion are endless and complex, the Florence Biennale has sought not so much to define them as to deal with them, to formulate certain questions as to fashion's linguistic relationships with other areas of creativity such as art, photography,

music and architecture. We have also sought to deal with certain responses to sociological and anthropological events, such as the defining of a new personal and sexual identity and the discovery of new universes.

G.V. I seem to understand that the exhibition will seek to avoid, as much as possible, the traditional aspect of fashion—that is, the runway show, the presentation of objects to be worn, and so on. What does that leave?

G.C. Fashion is more than anything else a ritual whose primary need, before being translated into products, is the representation of a figure or image, whose formation arises from the convergence of different creative phases. The final result is always an object, but it is the process and the idea of its realization that interests the Biennale. As a rule, we have asked all the fashion designers invited to come out of their "second skin" and display the material and spirit that support it. In other words, we invited them to exhibit the gravitational center before they arrive at the finished product. The involvement was supposed to come from an inner beauty, whether technical or emotional, expressive or conceptual: pre-fashion. Thus we asked for writing and lyricism, for aggression and participation, all instilled into tactile, material decors in which the fashion designer's "signature" is always recognizable. The request was for an abstraction that might provide information about the threshold which, once crossed, leads to the finished product.

M.M. As people slowly recognize its linguistic contribution to contemporary culture, is Fashion finding similar situations with other languages?

G.C. One might compare its situation with that of photography, whose path toward acceptance on the Olympus of the other arts has been fraught with opposition and controversy. Both disciplines have taken one hundred or more years to be acquired and collected, considered and studied in scholarly fashion. If I may allow myself another analogy: just as photography was considered a mechanical, ephemeral form of work, impersonal and non-creative, a kind of passive, industrial-scale recording of society and people, so too fashion has suffered its image as offering an empty, superficial wrapping for single "portrayals" of the body. In time, historians realized that fashion offered an interpretation of the body, just as the photograph offers an interpretation of reality. For this reason, the time has come, after a century of constant metamorphosis, for fashion to enter once and for all into museums, private collections, and scholarly books.

D.D. Why Florence? And what was it that brought these artistic directors together?

G.C. History is always based on private relationships lending strength to public relationships. For the interdisciplinary exhibition, *The Italian Metamorphosis, 1943-1968*, at the Solomon R. Guggenheim Museum in New York, I had invited Luigi Settembrini to curate the section devoted to the history of Italian fashion from 1951 to 1968. Our encounter was absolutely fruitful, to the satisfaction of us both. When, one year later, after Settembrini came up with idea to do, in Florence, a Biennale devoted to Fashion, a new harmony was born between us. This time, however, we had to open things up to an expert who straddled the two universes of art and fashion. We immediately thought of Ingrid Sischy, editor of "Interview" magazine, with whom I had worked since 1977, as contributing editor, for the magazine "Artforum", which under our direction had become more than an art review, a review of the arts. In February of 1982, for example, we even went so far as to devote our cover to the Japanese designer Issey Miyake, which was a shock to the

"conservative" art world.

Once we decided upon our intents and agreements, we began listing our ideas and visions. It became immediately clear that to highlight the critical-aesthetic reading of the Fashion Biennale, the event would need to be anchored in history and culture. Moreover, its realization would unhinge a certain tradition of interpretation, in that we were attempting to remove fashion temporarily from its restrictive relationship with production. What better site for this than Florence, which is attempting to break out of the conservative view of her ancient self, and at the same time is a perfectly apt stage for providing a cultural-historical context for the ephemerality of fashion and its potential dialogue with art?

P.T.A. Nowadays more and more exhibitions concentrate on the subject of interdisciplinary relations. Why would curators and art historians accept mixing languages now?

G.C. Since the sixties, semiology has predicated an all-inclusive attitude, while pop art opened up a dialogue with comics, photography, design, mass communications and advertisement. What emerged from all this was a horizontality, a dialogic relationship between the arts on the one hand and the visual and graphic production of the world of consumerism on the other. These two worlds had previously been opposed and distinguished from one another by such notions as artistic value and use value, uniqueness and mass production, beauty and functionality, creativity and craft. The commercialization of art did not damage its paradise, and meanwhile mass communications have been thrust into the economy. With Warhol, commercialization and massification, consumerism and glamour found dignity. The overambitious, aristocratic views of art lost strength and coherence. In the difficulty of maintaining a transcendent standpoint in the midst of a consumer socieity, art becomes an exchange commodity.

P.T.A. It is true, many artists take a nervous stand when asked to interrelate to other disciplines of expression. With the exception of Warhol and a few others, why were artists not prepared to participate in this type of confrontation, compared to artists now in the late nineties? Is this attitude more connected to a younger generation?

G.C. I think that artists consider art as an alternative to all worlds of thought and communication. They feel they are autonomous and cannot adapt, for poetic or ideological reasons, to the mechanisms of the market and the economy, of consumption and use.

Nevertheless, starting in the sixties, pop art and the spectacular explosion of the system of the distribution and consumption of art brought about the fierce, commercial consecration of the avant-garde. At the same time a series of trends and fashions in art movements were born in rapid, impressive succession: op art, *nouveau realisme*, minimal art, systematic paintings, eccentric abstraction, arte povera, process art, conceptual art, land art, body art, pattern paintings, neo-expressionism, image paintings, trans-avant-garde, neo-geo, new poverism, and so on… Glamour and commodification became the essence of art, as they are for fashion. This phenomenon was resisted and contested until the seventies, then accepted and developed in the eighties. For this reason, today's generations can take an equal distance between the two positions. They harbor no illusions of being able to solve the world's ills through art, nor of having to renounce a professionalism that has its economic sides. But these two positions are not divided; I maintain that they are compatible, and thus mutual contaminations between creation and money, between autonomy and use, between originality and mass production, are accepted, indeed sought out as tools of

contemporaneity. We must understand that over the course of the last thirty years our philosophical and moral reference-points have changed in accordance with an increased contemplation of death. The experience of failure and defeat felt by prior generations has driven the people of the ninetiesto reject all mythification, all models whatsoever. The dissolution of all definitions has lead to the search for a continuous transition and the subsequent equalization and indistinction of all the various parts in play, whether we are speaking from a linguistic, sexual, social, ethnic, religious or philosophical point of view.

P.T.A. Artists have interrelated with architecture, design, film, theater, TV, photography and now fashion. Is fashion like the last taboo to have been addressed by curators and artists?

G.C. The path that leads to creation always runs contrary to dogmas and taboos, always disavows accepted, established truths, shakes up the coordinates and renounces differences. It is always aimed at assuming a luciferian position toward current principles and rituals. It is a restless soul that wants to distinguish itself and satisfy a desire, even a perverse one, at all costs. At the same time, this perversion is a means employed to push boundaries forward, to prevent the perception of the world from becoming fixed in time. For decades, fashion has been a perverse, latent temptation in contemporary culture. It emerges from time to time, but then is swept away again, like sexuality.

In the nineties, sexual relations and their complex and diverse manifestations have risen to the level of art. One need only think of what Robert Mapplethorpe, Cindy Sherman, Jeff Koons, Robert Gober and David Hammons have done to erode the very essence of such categories as femininity and masculinity, transsexualism and pornography, anality and sadism, gender and ethnicity. The desired abolition of the universe of differences could not help but involve the fashion world as well. For there to be acceptance and integration, one must pass through a metamorphosis: all values become equalized and merged, one element passes over into another, undergoing an alchemical transformation that renders it sublime. The fashion taboo is made to fall by immersing fashion in the chaos of all the other arts: that is where it is transformed.

G.A. How was the project developed and fitted to the city? And what have the results been?

G.C. The primary purpose of the project was to immerse fashion in the arts, and to involve Florence and its history as fully as possible; the secondary purpose was to highlight this cultural and urban immersion by selecting the right players from the worlds of fashion and the arts.

Following these two paths, we began to develop a curatorial logic that would take into consideration the collaboration between the languages involved, as well as the infiltration of the entire city by the exhibition's events. To quote Walter Benjamin, we "lost ourselves" in the city and began to identify certain sites and buildings that might serve as settings for this worldwide *coniunctio oppositorum*. In visiting certain spaces, mostly museums, we had two dreams: that of including Fashion in all the most important municipal and regional museums—a practically feasible thing; and that of finding the cutting-edge thematics—perhaps an easier task—that would confer an unusual, up-to-the-minute meaning on the entire Biennale. Thanks to the unexpected and very generous openness of the museum authorities and managements, the first dream became reality. The second is still unfolding, and remains yet to be verified "analytically".

G.A. After you had all arrived in the city, what direction did the logic of the project take?

Did it become more complicated or clearer? Thinking of space as something that stimulates reactions and behaviors, what sort of indications did historic Florence give you in terms of thematics for the Biennale?

G.C. The physical spaces of history, such as the great museums—from the Uffizi to the Accademia, from the Specola to Casa Buonarroti—suggested the *Visitors* show. Actually, observing the thousands of people come from all over the world to see them, we got the idea of "dreaming up" a group of people dressed entirely "in the fashion of" this one or that. A kind of tableau vivant crystallized in time, where the individual figures, in a hyperrealist dimension, would be dressed in the splendid clothing of Valentino, Yves Saint-Laurent, Ferré, Miyake and other great masters of fashion, and standing in attitudes of rapture in front of the great masterpieces of art, science, and technology. It was a fantastic surprise. Once the initial hypothesis of intervention had been formulated, we asked the individual museums whether they would be available for such a project. Permission was immediately granted. As of that moment, the "Visitors" began to arrive, and with the subsequent contributions of Franca Sozzani and Gae Aulenti, their participation did not limit itself to being a simple invasion of elegantly clad bodies; they took over the space and turned it into a setting, a magical, fantastic nucleus.

FS: Once inside, will the Visitors also transform the museums?

G.C. Not the museums themselves, but the manner in which they are perceived. The sudden appearance of an intervention inconsistent with the museum's logic, such as an installation, an eccentric decoration or a loudly dressed object, in a space that is "sanctified" and "mythified" by its artistic and anthropological relics, will certainly create visual confusion in the serious, enclosed rooms of a museum or ancient palazzo. A transgressive flash, greatly seductive in its use of materials or in the elegance of its forms or in its sensual aspect, will inject an excess of aesthetic "richness" into the space. The contrast between high-fashion decor and banal, everyday decor will explode before the regular visitors' eyes, and at the same time it will enable observers to make historical comparisons between the figures of ladies and knights reproduced in the paintings and sculptures, and the representations of clothing from the present-day.

L.D. There are some who have deplored the entry of fashion designers into the temples of art. In this Biennale, the designers have actually been invited to measure themselves each against a different museum. Don't you fear criticism for this?

G.C. As I was saying, the museum sheds light on fashion and vice versa, but this is not the reason behind the exhibition. What we were most interested in was furthering the dialogue between fashion and art, but within a historical, and not only contemporary, context. It is this context itself that must serve as catalyst to the meanings that arise from the infinite questions.

Does putting a fashion designer in the Uffizi or the Accademia mean "sanctifying" him? Does inviting a designer into the Specola Museum, into the room of anatomical waxes, into Orsanmichele or the Museo Marini mean establishing surreal or sculptural relationships between his work and the place? By putting fashion into the museums of Florence and Prato—into a series of venues ranging from the Medici Chapels to the Casa Bardini, from the Science Museum to the Civic Museum of Prato—the intention is to put it under the stress of a new reading. The eventual responses, whatever they may be, will ultimately further

the linguistic interpretation of fashion.

I.G. The insistence on the crossover between fashion and art passes essentially through the body. Has the language of the body changed, and will the Biennale give an answer to this?

G.C. Since the very first meeting between Ingrid Sischy, Luigi Settembrini and myself, we identified the body as the thematic fulcrum on which the entire Biennale would rest. It is clear that the latent force of all fashion is carnality and sensuality, the eroticism and seduction revolving around the body. The garment may be defined as the body's daily narrative, its second skin. It is a human, feline territory, and when a person crosses through it, it defines his status: his outwardness and spontaneity, his freedom and passion, his narcissism or masochism, his candor or shamelessness, his chaos or orderliness, his sociality or loneliness... Between the nude and the clothed state pass an infinity of messages and meanings. Having to do with the drives motivating everyone, this story, this cognitive, sublimating narrative, has always thrived in every cultural terrain, especially in the world of performance. For this reason, at first the critical gaze turned to the revelations of the personal and collective unconscious, associating fashion with the formation of tribes or social groups defined by the same rite of self-decoration. In every epoch and every culture the socialization process passes through uniformity and homogenization. Fashion distinguishes as well as pacifies. It aspires to a chromatic, sculptural luminosity which, once applied, makes everyone the same. Considering the great quantity of identical but different-sized garments produced by the big names and worn by thousands of people, one could actually imagine whole armies dressed in the uniforms of Armani, Prada, Versace, Klein and Dolce & Gabbana. It's an impressive image, in which elegance is transformed into visual impact as well as an absolute loss of identity; quality passes over into quantity, based on a reading of fashion and its myth as unifier and its mass impact. The thread of this argument was perhaps too sociological, so we turned back to the initial notion of a body marked by color, material, cut and collage, by representations and narratives, the structural elements of art as well as fashion. Questions about the body revolve around the sculptural and chromatic value of the garment, the catalyst of other's glances and invader of spaces.

D.T. So you're talking about different ways of looking at the body?

G.C. Every person is a cosmonaut, making a journey through space and time. Fashion tries to design his space-suit, so that he can survive in every imaginable environmental condition. In order to do this, it must maintain a relationship with the extradisciplinary, it must be open to every sort of innovation and unexpected development. The garment has an expansive function with respect to the body; it presents itself as an instrument of defense and attack. Placed outside the flesh, it devours it and incorporates it, but remains aware of its existential distress. Many designers have always confronted the problem of making the garment reflect the vicissitudes of the flesh, its brilliance and its decay. This second skin functions as an outer nervous system, wearing neuroses and fears on the surface. It is a capsule that registers the body's inner and outer variations, a hypersensitive seismograph recording all variants from homosexuality to heterosexuality, from pleasure to pain, from birth to death. The body is always its total subject.

I.G. If the garment is a visual as well as erotic wrapping, the two spheres overlap. Could one take on all the factual and sexual "deviations" of fashion and conduct an investigation of them?

G.C. The Biennale was born of the very fact of having identified an intermediary zone between the works and comportments of art and fashion, which are not interested in remaining within the customary and the habitual, but rather tend toward the unexpected and unpredictable. On the matter of conveying the factual and visual transformations of clothing, we have put together the historical/contemporary exploration entitled *Arte/Moda,* while on the beginnings of a new sexuality and identity, a new life and new extraterritoriality, we have worked with the theme of displacement and come up with *New Persona/New Universe.*

P.V.R. Art/Fashion is part of a 360-degree interpretation of Art in the twentieth century, a method that has distinguished your work for decades. The Biennale offers the possibility of "unveiling" the most recondite interconnections between art and fashion. In what terms did you decide to confront and document this subject?

G.C. Once we had decided that the multiplicity of the relations, grafts and rapprochements between art and fashion was the guiding thread to be followed to arrive at a reflection on the idea of a second skin as surface, form and color, we tried to study where the first interchange might have come about. The decline of the distinction between art and fashion has its roots in Art Nouveau, with its aspiration to being an all-inclusive aesthetics, but it gained more prominence at the start of this century, with the rise of the avant-garde movements (Futurism, Constructivism, Simultaneity, Surrealism, etc,), and has continued through informal art and pop art up to this very day. The narcissism and very identity of the avant-garde was bound up with the need to create images ex novo, anywhere and everywhere. At first they invested clothing with painterly and sculptural elements, such as violent colors and asymmetrical forms, abstract and dynamic figures; then they added libidinal and sexual drives. In the former case, painting became a decoration of surfaces and an assemblage of fabrics; in the latter, sculpture constructed excessive, sensual forms and figures. The imperative of "all is art" cannibalized everything. From the fifties to the seventies, informal gesturality and neo-dada assemblage, pop commercialism and minimalist reductivism, the process-orientation of conceptualism and the materiality of arte povera further affected the instability of clothing, emphasizing its lack of continuity between inside and outside. These movements sought a progression between artificial and natural skin (Lucio Fontana), between fabric and object (Daniel Spoerri, Christo and Arman), between bodily vehicle and consumer icon, advertisement and cartoons (Andy Warhol, Roy Lichtenstein), between structure and chromatic rhythm (Ellsworth Kelly), between clothing and ideal social locus (Joseph Beuys and Louise Bourgeois), between an orgy of materials and natural camouflage (Piero Gilardi, Alighiero Boetti, Vito Acconci).

These tendencies can be broken down into two successive stages, the first dominated by a harmonious continuity between art and fashion, the second by a heterogeneity and a freer, unbridled disparity, under the sign of a chaotic, uncontrollable energy. The next generation, that of the eighties—represented by Judith Shea and Rosemarie Trockel, Beverly Semmes and Charles Le Dray—works with fabric and wool, with the material and cut of the garment, as if with water. This generation moves not in contrary flows, but in syntony with fashion. Clothing becomes an organized, living form; it covers the body, but suggests an inwardness. In making the journey from inside to outside, some dreams and nightmares, constructions and games, sarcasms and ironies emerge. Art and fashion establish a more active

interrelationship. Sculpture metamorphoses into clothing, turns it into a fantasy or a critique of the social or environmental, sexual or political conditions existing between men and women, humans and animals.

M.P. The *Arte/Moda* exhibition goes so far as to posit a tapestry of collaborations between artists and fashion designers. The in-between no longer exists. Art and fashion display their mutual attraction and try to live together. They not only look at one another, but presuppose a dissolution in each other's identity. Is this a suggestion or a challenge?

G.C. Putting an artist and a fashion designer together means creating an iconoclastic vortex in terms of their respective languages. This is an attempt to call into question or throw into crisis the stability of a certain perception of art and fashion. To throw them into an intellectual and sensual panic made up of textures and threads, of waste and rubbish. We do not want to build a union, but to create a dance, without having one of the dancers lead the step. Of course, this requirement presupposes an externalization and spectacularization of the different characters. For this reason, together with Isozaki we worked on creating a habitat of autonomous form and color, in which the principal figures of this new visual and plastic performance might express themselves. I believe that our project underscores the demand for articulating a perceptible connection between differing identities.

P.V.R. Certainly people are more familiar with the subject of art transposed into fashion—as with Fortuny's Nike and the references to Cocteau and Mondrian in Yves Saint-Laurent—than they are with anything to do with art's specific interest in couture. From the time of the early avant-gardes to the present day, one notes a crescendo of references increasingly sympathetic to the creative identity of high fashion and prêt-à-porter, which are interpreted, translated, quoted and targeted by the artist's irony. Could you briefly talk about the most thrilling moments, names and experiences you have come across in this regard?

G.C. Since artistic endeavor is aimed at presenting unusual objects, the list of wearable things planned and produced by artists is endless. The sense of a new interweaving of art and fashion probably found its highest expression in Surrealism, since, among other things, its principal figures resorted to photography, expanding the diffusion of their inventions and the radicality of their imaginations. Man Ray and Salvador Dalí, Magritte and Horst, Cecil Beaton and George Platt Lynes, in painting or representing surreal landscapes or characters in the thirties, opened up the unexpected horizon of the loss of the body's and the garment's identities. The body was expanded and disintegrated, taking on a skin of stone or becoming a fish-body; the garment was resplaced by collages and assemblages of objects ranging from spoons and lobsters to cages and wheat stalks, as in the series of mannikins displayed at the Exposition Internationale du Surrealisme, Galerie des Beaux-Arts, Paris, 1938. With Surrealism, fashion discovered the significance of clothing as object and eroticism, as a duplication of the ego, of its desires and dreams. Provocation became transformed into a giving and receiving of pleasure through recondite and absent things. Fashion accepted this and made it its own, understanding that lover and beloved use it to come together: the garment, thus, is the intermediary locus of love. Since the thirties, the whole fashion world, from Poiret, Schiaparelli, Chanel and Lanvin right up to Karl Lagerfeld, Vivienne Westwood and Jean-Paul Gaultier, has based its approach on dislocations of images and materials, of sex and role.

For fashion to remain a locus of the present—since it does, after all, receive and recount the same things in a different manner—it must continuously displace itself. It must be precarious, unstable, perverse, radical. In recounting these things, it is forced to multiply endlessly the conjunctions of images and materials, of dream and reality. And this is a surreal process.

J.B. Artists often reject the fashion phenomenon on ideological grounds, or from a theoretically defensive position. Fashion designers, on the other hand, they tend to absorb everything around them: cinema, TV, and art, of course. What are your thoughts about art's invariably self-imposed aloofness in contrast to fashion's widespread popular appeal?

G.C. Fashion is a frenetic aesthetic phenomenon. It cares only about the seasonal shifts. It is based on mass communication, whereas art fosters a slow, long-range protocol. Fashion, by working with frivolity and superficiality, is forced to occupy areas of rapid information. It is a decorative superfluousness that involves a vast quantity of people, even though it wavers between elitist exceptionalism and popular appeal. Art, on the other hand, aspires to autonomy and solitude. It doesn't like the circus-world of mass culture, and therefore keeps a distance from film, television and the performance world. Nevertheless, in recent years art has undergone a dizzying process of erosion and obsolescence, and has attempted to compensate for its exit from center stage by entering onto another stage, that of the theater and cinema. There are more and more artists now—from Jannis Kounellis and Michelangelo Pistoletto to Jan Fabre and Robert Rauschenberg—who are starting to collaborate in theater, opera, and dance. There are also artists directing films, such as Robert Longo, Julian Schnabel, David Salle, and Cindy Sherman. Naturally, such fluctuation and indeterminacy are signs of loss—a loss of meaning and identity—but they also express a desire to break free and to force the limits, and most importantly, they bring greater visibility. Indeed, visibility is one privilege that brings art and fashion together. And by mirroring one another, they are seeking to increase, to multiply their reflections.

I.G. A mirroring between different languages dissolves fixity. But what is created by a mirroring between human beings and universes?

G.C. Anything can be transformed: the male can spill over into the female, the impure into the pure, so long as fixity itself is made to crumble. The fixity of the universe itself has been cast into an abyss by the discovery of billions of new galaxies by the Hubble Telescope and by the possibility that traces of life exist on Mars. We must go back into the womb of the totality, let ourselves be engulfed and cease making distinctions, so that in the end we may find a new persona and new universes. It was such ideas as these that give rise to the exhibition *New Persona/New Universe* (whose governing principles I address in another part of this volume), a show that highlights the exploration of the unknown, whether we are talking about the body or the system of galaxies, personal and astral. It is clear that all levels of sexual, fleshly, cosmic and universal make-up are beginning to crumble. We are engulfed by a flow of technology and information that casts the fragile human existence to the stars, but at the same time is shaping and correcting it. A titanic tension has taken hold of the human being, who is no longer a creature with limits but becoming an eternal material in continuous ferment. Released from all fear and all weakness, the human being wants to experience the freedom of all conjuctions of the ego, the spirit and the body, to travel the labyrinth of technological and sexual interminglings, following them to their most radical

conclusions. *New Persona/New Universe* is an invitation to a journey, in the spirit of the Chapman Brothers and Walter van Beirendonck, the journey of this ferment of persons and things.

A.C. The focus on the body and the person is reminiscent of those years when both elements were used as the very instruments of expression, at times to the most radical extremes. While this use presupposed a theatrical dimension in the self-expression and in the dialogue with the public, today's artists most involved with these themes seem not to offer or to demand communication. Does one get the same feeling from the days of Body Art?

G.C. In the sixties and seventies, artists reached the point of bringing their own bodies to center stage, as part of an extreme desire to take total control of communication. They wanted to eradicate the deception of the surface and the object, to dissolve the impersonal filter existing between one person and another, between artist and public. Body Art was a search for a coincidence between human being and sign, the extreme conclusion of an itinerary which began with the bodily gestures of Jackson Pollock and Lucio Fontana, led to the exhibition of the artist himself in Piero Manzoni and Yves Klein, and reached the point of self-ostentation in Vito Acconci and Gilbert & George's "living sculptures". The coinciding of artist and art object is the extreme limit of a control, which has reached the point of making the art and the person into a single locus, a single identity. Today the artist tends to occupy many places and be many persons at once. A perfect example of this is Michelangelo Pistoletto, whose work and personality tend to multiply like the reflections in one of his mirrors, in real time. The exhibition *Habitus, Abito, Abitare* at the Museo Pecci in Prato revolves around the possibility for art to adapt to any and all situations, for the precise purpose of capturing the unrepeatable uniqueness of time. It is an ongoing search for the passage from the sphere of ideas to that of reality and vice versa. Converging at the center of this surface, which is the museum and the city of Prato, are all the many reflections on the idea of clothing (*abito*), as it is conceived by Andrea Branzi, Oliviero Toscani and other artists who have been given the opportunity to reflect themselves. Compared to the spectacular self-imposition of Body Art, here the artists' approach grows out of the place, a meeting-place among people, and attempts to rediscover an intermediary zone (the mirror, for Pistoletto) in which to make creative energies converge. Art should not be sought in the primacy of one person over another, whether male or female, artist or non-artist, but in the multiplicity of movements flowing toward the language of being and doing.

P.V.R. What criteria of theoretical-aesthetic selection and stage arrangement were followed in mounting the various exhibitions of the Biennale?

G.C. Since we were dealing with a real union, and a real city, full of history, we drew our inspiration from history, particularly from the ephemeral cities created in the 1500s for such occasions as grand marriages, official visits and great political celebrations. In Florence, one had to think of the "politics of Celebrations" and the construction of an ideal city as desired by Lorenzo the Magnificent, or else of the ephemeral adornment of many cities from Milan and Florence to Rome and Palermo, at the behest of Charles V in celebration of his coronation and his victories.

With this sort of ideal city in mind—which is also an artificial city, because it is only temporary—we thought of assigning the task of designing it to a number of internationally celebrated architects: Gae Aulenti, Arata Isozaki, Denis Santachiara and Adolfo Natalini.

Each was asked to interpret and celebrate the city of the arts. Their contributions took on a wide variety of differing characteristics. For her *Visitors*, in the museums of Florence and Prato, Gae Aulenti has created a silent architecture highly respectful of the ancient sites and the history of the institutions. In Palazzo Ferroni and at the Post Office, for the Bruce Weber and Elton John shows, Adolfo Natalini has built a decor combining the reductive and the spectacular, while Pier Luigi Pizzi, for the *Emilio Pucci* exhibit, has created a bold, eccentric choreography in harmony with the extreme creative distinction of the great Florentine tailor. On the other hand, at the Stazione Leopolda, for *New Persona/New Universe*, Denis Santachiara has invented an aleatory organism with an amorphous, sensual body, luminous and primordial. It is a structure without center, constructed for the magnetic spaces of art and fashion, which attract one another by commanding the total involvement of the person lost in the individual creative universes. Arata Isozaki, for his part, drawing his inspiration from the theme of *Arte/Moda* and from the view of Florence as seen from the Forte Belvedere, has created a contemporary reflection on Florentine architecture. The structures he has chosen are Brunelleschi's dome and the elementary forms that constitute the basis of Renaissance construction. Arata's own structures, which range from the cube to the cylinder, reassert the rationality of a primary but total design that may still function today as a threshold between languages, between art and fashion.

I.G. The Florence Biennale looks more and more like a medieval garden, a *hortus conclusus* reflecting the organization of the world (of fashion), with the exhibitions situated at the intersection of the great themes: art, the body, history and the future. The garden is flourishing. Does this mean that the soil of fashion is rich in inspirations?

G.C. The living garden of fashion is enriched each day with grafts and seedings originating in other languages and media. With the Elton John and Bruce Weber exhibits, the intention was to give a hint of the fantastic emanations and imaginings radiating from two prominent figures in the worlds of music and photography. Bruce Weber's manifest inclination toward the iconic aspect of everyday objects and people, animals and views, is the invention of a vision of the "parade" of bodies, nude and clothed, forever filing past. Under Weber's gaze, the skin vibrates in its compactness, but manifests itself in a landscape of gestures and contexts that breathe the air of the everyday. In his photographs the temptations and seductions of beauty, both feminine and masculine, become expressions within everyone's reach. Using such unexpected subjects as dogs or actions such as leaps, in which one loses control of the body, Weber frees his models from all demands of artificiality.

The Elton John exhibition presents the story of a way of being at once a musician, fashion designer, artist and new persona. Elton's eccentricity and his cult of difference have helped him to invent his own rules of appearance, as well as to bend all behavioral and sexual limits. The display of redundancy and essentialism, of irony and elegance, of dandyism and kitsch, of heresy and conformism in stage performance, not only left its mark on rock history; it also expressed the existential, human, and performative vindication of a human being who uses all the languages of creativity in order to exist in his difference.

P.T.A. Are there any interesting subjects left to commingle with fashion and vice versa, which you might like to work with next time?

G.C. I'll let that be a surprise.

Art / Fashion

Florence
Forte di Belvedere

Art/Fashion
Curators
Germano Celant
Ingrid Sischy
Pandora Tabatabai Asbaghi

Exhibition
Coordination
Judith Blackall
with
Lynne Barton
Carla Ferrari
Christine Sebo

Consultants
Aurora Fiorentini
Alessandra Pace

Overall administration
Anna Pazzagli
with
Giorgio Bonvini
Secretariat
Stefania Signorini

Insurance
La Fondiaria-Florence

Transportation
Tartaglia Fine Arts Saima Servizi-Milan
TNT Traco-Milan

Architecture and Installation
Design by
Arata Isozaki
with
Takako Takashima

Technical supervision and installations
Pier Vincenzo Rinaldi
with
Luca Fusani
Caterina Rossi
Peter Ryan
Giusi Viola
Secretariat
Simona Turi

Technical consultants
Consilium sas-Florence; Emilio
Bianchi; Enrico Bodini; Carlo Pesci;
Marco Pompucci

Pavillions
Constructions
NDM Costruzioni srl-Prato; Milani
sas-Milan

Installations
Franco Rubechini & C. sas-Florence

Palazzina
Installations
Biagiotti & Bertini-Florence

Mannequins
Studio Costruttori d'Immagini-Florence

Security systems
Elcon Italia-Prato

Electrical systems
A.M. sas-Florence

Lighting
Targetti spa-Florence

Catalogue
Edited by
Germano Celant

Coordination of production
Anna Costantini
Cecilia Torricelli

Editors
Maria Pia Toscano
Judith Blackall

Graphic design
Marcello Francone

Sculpted Dress

In contemporary culture, avant-garde movements represent a dramatic cut and tear that mark the destiny of aesthetic thought for all twentieth-century culture, for they appear as a unitary and global fact, where the arts are no longer separate and isolated, but a total reality. Beginning with Art Nouveau and with its international diffusion, the attempt to reconcile images with the whole of society has pushed art to infiltrate all territory and environments. It has penetrated the living-rooms of the bourgeoisie and has designed their furniture and flatware, lamps and wallpapers, dresses and hair-styles. Its form of intervention was the serpentine line, which slowly became a functional line, since, according to naturalistic logic, it equalized the way things looked. Furthermore Art Nouveau attempted to reconcile art and industry and thus mixed the creative and commercial worlds, the original and the artificial. Everything was art, and yet nothing was. From this historical moment on, aesthetic propositions become important aspects of the social, art assumes a fantastical but at the same time practical function; it designs the everyday universe, utilizing innovative and irreverent forms and techniques in opposition to traditional logic and technique. Contemporaneously the tension toward a total expression leads it to assume an open position with respect to all objects. One can understand how, beginning with the first two decades of the century, the historic avant-gardes, from Futurism to Constructivism, tended to break with the past in order to definitively affirm the identification between art and life between sculpture and photography, painting and fashion, cinema and architecture.

The Italian Futurists can be credited with both the earliest programs and manifestos tied to polemical externalizations about clothing and the earliest deconsecrations of traditional dress, tying it to the dynamism and the consequent social changes in the machine society. Their obsession with disorder and asymmetry, with luminosity and violent colors, with the renewal of sensibility, led them—from Giacomo Balla to Fortunato Depero—to conceive a mode of dress that integrated the sensations of movement, in order for their dress to reflect the energy of a new urban society. The absolute freedom of their designs broke with modes of dress that had prevailed since the last century and had shaped the European bourgeoisie. Introducing a frenetic rhythm to cut and color shade, the Futurists

discarded models from the past that were based on preciousness of material and founded their design on form and on the cut of fabrics made vibrant by color. The importance attributed to the structuring of fabrics and colors is pioneering with respect to modern haute couture during those same years, characterized by the orientalism of Paul Poiret. While they were interested in new industrial discoveries and mass culture, the Futurists took on the theme of fashion, but still utilized artisan methods tied to Art Nouveau and Werkbund manufacturing traditions. However, they attempted to demonstrate an egalitarian interest in male and female, through the creation of clothing for women and men, and most of all they designed in order to strengthen their spectacular abilities as artists who were using their originality as a weapon for assaulting the period traditionalism. The same can be said for Russian artists such as Alexandra Ekster, Liubov Popova, Varvara Stepanova and Aleksander Rodchenko, and for the French artist Sonia Delaunay, although they came from different ideological perspectives, the former group searching for industrial production set in motion by interdisciplinary activity, the latter, along with Robert Delaunay, tending to promote the theories of synchronism.

From both a decorative and a formal point of view, the innovations of these artists precede any and all fashion and reverberate within the universe of art, until the sixties, with the developments of spatialist and op artists, from Lucio Fontana to Getulio Alviani, whose investigations of passage from outside to inside the canvas or the optical movement of colors and geometries on the surface of fabric recall Futurist dynamism. Likewise, in the eighties fashion designers were inspired by bizarre cuts and montages and decoratively revived the motifs and logic of Italian and Russian Futurism.

With Surrealism the exchange begins to become mutual. Elsa Schiaparelli asked Salvador Dalí and Man Ray for suggestions and contributions to her collections; she was inspired by their designs but also encouraged their photography. The results are radical because they imply the use of dream and surreal figures that transform accessories of clothing into erotic symbols and fabrics for clothing into landscape of paranoid and impulsive visions. The spirit that unites artist and dressmaker is the continual creation of original models, but with the former remaining free to move throughout all areas of activity, and the latter constrained to a freedom limited by the particular nature of the product, tied to the dimension of the human body. Both court provocation and innovation, and thus their destinies continue, at times, to intersect. During the postwar period there were very few examples of transposition from art to fashion or vice versa. Apart from the compelling example of Lucio Fontana, who, along with Enrico Baj, Lucio Del Pezzo and Arnaldo Pomodoro, attempted to apply his method of cuts and holes to clothing, in collaboration with Bruna Bini, the isolated attempt of the Fontana sisters to call on artists such as Carla Accardi, Lucio Fontana and Mimmo Rotella to design clothing, and the later investigations of Getulio Alviani, Giuseppe Capogrossi and Paolo Scheggi, who were asked to design the textiles for Germana Marucelli, the history of contamination is rarefied.

Beginning in the sixties there was a reflowering of activity, when, with the encouragement of feminist and homosexual awareness, fashion underwent a critical and structural analysis that revealed its ideological messages and tools. Fashion designers became aware of possibilities for transpositions between the male and female, creating suits and dresses that blur genders or at least debate rigid boundaries. Meanwhile artists were beginning

to bring out the connection between dress and ideology. The specific clothing of Joseph Beuys, Louise Bourgeois, Nam June Paik and James Lee Byars underlies an aesthetic vision that moves from shamanism to the irony of prolific nature, from the sensualism of communication to the sublimation of the perfect being. At the same, time objects to be worn, designed by Arman, Christo, Spoerri and Kusama on the one hand, and Warhol, Lichtenstein and Rauschenberg on the other, favor the assumption of an environment invaded by signals and mass information, capable of engulfing and dominating human beings, turning them into things.

In the early seventies the eruption of a political and sensorial energism strengthened the power of materials. Artists began to cross deserts and forests, they used nature and culled from it materials swollen with autonomous life. The idea was to have a mimesis or a reabsorption of the world in art. Signs of this fusion can be seen in Piero Gilardi nature-garments and the foam or water and fish designs by Alighiero Boetti, who, in collaboration with Anne-Marie Sauzeau, created mimetic clothing.

The relationship between male and female, conveyed by the media during the eghities through the comparison of naked and clothed, could be defined for all to see as the relationship of power, and artists could not help but take a critical stance. Clothing was transformed into the emblem of a struggle for differentiation and for the recognition of equal yet different natures and genders. The coexistence between identities that can be interchangeably rigid, mechanical, abstract and structured, or soft, organic, figural and destructive, without sexual destruction, pushed Judith Shea to undertake a dialectic between form and non-form, historic and present. Rosemarie Trockel re-theatricalized the relationship of couples, with her symbologies and metaphors, in order to create clothing that is absurd, in that it is based on a union that is ideal, but unreal and non-functional. Once the value and significance—social and political, sexual and psychological, formal and visual—of clothing has been restored, it is not difficult to understand how artists have adopted it as a sculptural means to discuss the enslavement and torture of women (Jana Sterbak); to take back possession of a technique once negated as too fragile and sensitive (Charles le Dray); to portray dream and nightmare creatures (Jan Fabre); to construct marvelous apparitions and figures of light (Oliver Herring); to embellish the body with sculptural decorations (Wiebke Siem); and finally, to homologize the body with architecture and the environment, so that the absent body of woman is transmuted into an all-enveloping and uncontrollable energy (Beverly Semmes). Through their work, art has returned to claim fashion as subject, as the emblem of a society, and has made it a critical tool for a difficult existence.

Today, as we draw near to the century's end, art and fashion have thrown up a bridge, where each can sparkle with its own light or seek to find a reflection in the other's activity. The encounters and collaborations between Tony Cragg and Karl Lagerfeld, Miuccia Prada and Damien Hirst, Jil Sander and Mario Merz, Oliver Herring and Rei Kawakubo, Roy Lichtenstein and Gianni Versace, Azzedine Alaïa and Julian Schnabel, Jenny Holzer and Helmut Lang, move within the tradition of the historic avant-gardes. They are the closing of a circle, one that reopens with infinite questions about the future of art as well as fashion.

To Cut is To Think

To cut is to think and to see. Ever since modern art first posited itself as a manner of making, based on the activities of the hand and eye and aimed at constructing a thing-in-itself, the formal and constructive experience of all things has changed. It has gone from the imitation of reality to the construction of reality: art as an autonomous act of knowing. The Cubists, with Picasso and Braque, were the first to cut out images, disarranging and rearranging them in order to forge new relationships with the object seen and experienced. They sank their scissors into surfaces and images to give direct form and consciousness to an art that, having exhausted and destroyed the representation of reality, created an autonomous reality of its own: a new object that did not interpret the thing, but constructed and produced it.

Cutting up and organizing forms and figures, images and materials, on a surface and in space, was a radical process that changed one's manner of perceiving reality and constructing a new existence. The first modern conceptions of design, photography, graphic art, fashion and cinema spring, in a practical as well as linguistic sense, from Cubism and its cuttings.

Cutting structures language, but also clothing. It is an intervention into the traditional conventions of representing and seeing a body or thing, and thereby produces a new sensation. The cut of the scissor is like the click of a camera or the whirr of a movie camera, like a stroke of the pencil or paintbrush: all these acts decisively isolate a form or representation, marking a surface that generates a reality.

The cut puts an end to the traditional representation of the image, dissolving it and then restoring it as a testimony to the artist's vision and understanding. In this light, the cut confers meaning, and its use unites artists, photographers, designers and tailors, who cut their visions from the magma of their materials, whether these be color or bronze, fabric or film, metal or wool, wood or canvas.

In the history of modernism the cut is an important mechanism that contributes to the crisis of foundations. If reality and nature can be traversed, simultaneously, from different angles and perspectives, the claim to knowing the truth becomes indeterminate and relative. And if the artistic process involves cleaving and delimiting appearances so that

they may be read, then the cut is its soul. It becomes the intimate, sensitive interpreter that can concretely define reality. The cut is the soul of clothing. It severs the endless thread of a garment as the simple container and portrait of the human figure and transforms it into a creative act, a language that builds new objects.

The thinking spawned by the Cubist cut opened up an infinite universe. It even insinuated itself into people's interpretation of the world. It ignores the world's hardness and absoluteness so that it can make and unmake its representation, subjecting it to a whirlwind of furtive, momentary meanings that shun all mummified order.

Futurism, a few years after Cubism, was the first modern art movement to dramatize the logic of an art that cuts and severs, truncates and traverses, clips and separates, chops and facets, crosses and intersects. And the first to make it a weapon of action—of concrete and philosophical action, political and ideological action, theoretical and artistic action, sculptural and painterly action. Its goal was not the formalism of a visual philosophy, but an actual intervention into the world of experience in all its linguistic manifestations. This world had to be changed to fit the new mechanical sensibility: *The Futurist Reconstruction of the Universe.*

The assumption is that of a radical transformation, a change of skin, that would upset and sweep away every surface and every form of seeing and thinking, with no exception made for humanity's second skin, clothing, which itself was subject to cuts and transformations. In Giacomo Balla, the desire to change skin, expressed in the *Antineutral Clothing* manifesto (1914), is distinguished precisely by its cut from the earlier decorative proposals of such architects as Van de Velde and Joseph Hoffman and designers such as Paul Poiret, who had made clothes printed with motifs of Raoul Dufy. While the former sought to rationalize and essentialize clothing—because by now it, too, played a part in the great industrial and social project—the Futurists seemed more interested in bringing disorder to the logic and communication of clothing. The changes they brought were based on the use of asymmetry, clashing colors, and juxtapositions of dynamic forms. These relationships were highlighted by fabric covered with geometric and iridescent motifs (1913), and by the elimination of certain parts or diagonal cuts shattering the concepts of unity and univocality in clothing.

If, in Futurism, clothing thinks and acts, being the result of a cut that synthesizes all the dynamics of eye and mind, of movement and action, in Sonia Delaunay, also in 1914, the garment becomes a harmony of colors and non-homogeneous materials differentiated by weave and hue. Delaunay's assemblage is based on the intertwining and simultaneous co-existence of fabrics created in 1912-13 from the grafting of several different cloths bearing a lively chromatic interrelationship between them. It is a montage of irregular forms and motifs, and reflects the paintings of both Sonia and Robert Delaunay. It does not alter the structure of clothing, nor break it apart in order to transform it, since it does not use a cut that is any different from what was customary at the time. Indeed, if we follow developments through the 1920s, her articles of clothing boast a vast range of compositional and chromatic variants that enrich the joy and superficiality of fashion, but do not affect it at all on the level of formal construction and design. Her goal in fact was to prove *The Influence of Painting on Fashion* (1926), so as to reassert the former's uniqueness and research of surface.

The coincidence of the first and second skins in the Russian Futurists was a way to absolutize a total overlapping between art and life. In 1913, Mikhail Larionov and Ilya Zadanevic asserted the coincidence between painting and the painting of the body, by painting their faces. It was an early example of a creative, eccentric, personalized use of make-up, later followed by the custom, as practiced by Mayakovsky, Berliuk and others, of wearing black-and-yellow striped smocks and jackets during Futurist activities in numerous Russian cities. In this case the equivalence of flesh and fabric, of makeup and clothing, implied a further notion of fashion: the desire to identify the form of the garment with the anatomical perimeter, a tangency between inside and outside. The clothing thus becomes the body, a passage from same to same. The demand is for a constructive possession of one's own body. Whereas Picasso had thought to cut it up into images, now one could decorate it and shape it. An awareness of sports played an active part in this sculpting of the flesh, so much so that Rodchenko, Ekster, and Stepanova, together with the fashion designer Lamanova, designed many athletic costumes and other sportswear in 1923.

If the flesh can think and be designed, then the phase in which its emptiness is transformed into fullness and its silence into a shout is not far off. In Surrealism, the body suggests obscure latent forces, turns desires and nightmares inside out. An imminent explosion threatens, the uncertain sensation that the body is about to disintegrate into thousands of pieces and splinters. Underlying the tearing away of the limbs is a lack of self-possession, and an equation of the body with an object that can be shattered and disassembled. As structural, structurable material, it can be subjected to cuts and cadencings, exchanges and expropriations, attributions and identifications.

In being subjected to a strategy of expropriation and de-personalization, the body can be placed under the sewing machine, as in Joseph Cornell's 1931 collage, or sexually sewn, as in Oscar Dominguez's *Electrosexual Sewing Machine*, 1943. It becomes at once object and antiobject, conscious and unconscious, nude and dressed, masculine and feminine: a locus of equivalence between unstable, aleatory significations.

The imaginary attributions affecting fashion in the age of Surrealism arise from the new relationship between the object and the body, which led to the creation of a new centaur-like figure, part thing, part human. Salvador Dalí's placement, as photographed by George Platt Lynes, of a lobster over the pubic area of a nude female model, not only "dresses" her, but also exalts the enigmatic, aggressive charge of her sexuality. It produces a linguistic shift in the role of the covering object, the garment, and reveals its secret erotic tension. Dalí uses an animal with sharp pincers, symbolizing scissors, to make a cut that creates an article of clothing, symbolizing libido and sex, pleasure and seduction. The spark produced highlights the act of clothing as a process regulated by desire. The violence of desire in the order of fashion is not lost on the Surrealists, who re-introduce it in luxury objects such as half-veils and fans, hats and silks, jewelry and belts, whose consonance with the sense of touch and opening, and with the acts of glimpsing and covering oneself, directly and indirectly suggests eroticism.

The metamorphosis of the thing and the clothed animal broadens a complex circuit of forms of identity. Fluidity among signs makes possible the disguise, the shift and simulation of a mobility between objects and images, things and bodies. The "transmu-

tation" of a man's hat into a vulva, or the identification of a woman's headdress as a breast (Man Ray, 1933), or the transformation of a shoe into a foot (Magritte, *The Red Model*, 1935), or a shoe-shaped cap (Schiaparelli, *Shoe Hat*, 1937), propose a metaphorical principle that engenders and destroys forms, dissolves them and brings them to life. The object and the body make love. The Surrealist cut is a bar that separates but also brings together fragments of bodies and reality in such a way that, by transforming one another, they may serve as metaphors of an active place from which it is possible to set in motion a sequence of bewildering, disruptive images in an interpenetration of conscious and unconscious, outside and inside (Schiaparelli, *Tear-Illusion Dress and Head Scarf*, 1937). The recognition of the gaze in the anthropomorphic and sexual connotations of clothing is the very breath of fashion. It is an offered, fleeting siren, the sign of a troubling body whose dark seduction lives between the murky and the menacing, the fabular and the horrific, the orderly and disorderly. The inverted, symmetrical Man Ray figure—the cover of this volume—is an image of this body's endless variation, based on a game of mirrors that deceives as to diversity because it is a simple representation.

Clothing remains the same, but produces multiple meanings, the true dynamic of fashion. Chanel was the first to invent a figure-image: the "uniform", from whose matrix is organized—through changes of material and ornamentation, of length and accessories—the dream of a variability that satisfies the need for transformation, prolongs its existence, makes it a *perpetuum mobile*.

Starting in 1948, the effect of duplicity and bewilderment occurs in the encounter of form and formless, at the threshold of a propulsive, irrational energy of gesture that aims no longer to represent the scenery of a diffuse desire, but to represent the nascent event of a circumscribed tension. For Lucio Fontana, art is a vital action displayed as creative and anarchic power. It lives freely together with the rise of spatial and energy theories, and exalts behavioral dynamism. For this reason, its movement is related to the need to open new paths and universes of artistic knowledge: to break through and penetrate the black holes of space. The extraordinary emergence, in Fontana's works on paper and later in his paintings, of an unknown universe lying beyond the painted surface, set in motion a mechanism asserting the impalpable world of imagination, not the same world represented in the oneiric figurations of the Surrealists, but the concrete one experienced by anyone moving in the obscurity of the dark.

The desire—developed through the cuts and holes, the rips and crossings of the monochrome surface, which we also find in the clothes Fontana created in collaboration with Bruna Bruni and Fontana sisters—is to question the brushstroke-boundary, the plane joining and separating above and below, fabric and skin, clothing and nudity. Here the cut takes place in the fabric—black, yellow and silver—like his canvases, and reveals the material and fleshly inflow. The stroke of the blade or awl on the cloth is a dialectic between space and energy: the cut as spatial concept.

The garment, however, does not belong to a single series of objects, but rather participates in the universal display of things. More than a frontier between first and second skins, the clothing can be seen as an interval or area of contact between body and surrounding space, place or tertiary system of difference and similarity to the social and cultural, architectural and visual, natural and visible environments.

34

Art never ceases to echo its context, to respond to it from a distance. It is as though it were forever seeking a complicity in order to produce a text that might reveal its hidden cause. Every art object, including articles of clothing, is the hidden meeting-point of artist and context. In 1952 in Paris, Ellsworth Kelly established a relationship of pure otherness between body and city. He freed clothing from all subjectivist demands and inscribed it in the universe of pure and primary elements. He transformed it into a structure that denies the different partitions of the body and turns it into a sequence of surfaces and colors, a repertoire of two- and three-dimensional geometry. Clothing became an occupation of space, a visual schema intervening in the chaos of the environment.

This perception of the garment in space became the concern, from a variety of perspectives, of the artists interested in pure visibility and those concerned with mass communications. Both groups are conscious of the occasional flux of life and events, but the former think it is possible to control and systematize them, while the latter seek to accept and integrate them. The strategy of the "before" interests such artists as Getulio Alviani and Paolo Scheggi, Max Bill and Gabriele De Vecchi, who attempt, in the area of body ornamentation ranging from garments to jewelry, to move about in the interstices between images or, so to speak, between the constituent models of the image, to subject the image to physical-mathematical effects. The investigation of the "after" is the concern of Pop and Neo-Dada artists such as Andy Warhol, Robert Rauschenberg, Arman, Daniel Spoerri, Kusama and Christo, who seek an encounter between art and the mass-cultural context, that of consumer objects and advertisement. Both groups aspire to render the manifest meaning of the city as the pre-iconic matrix and iconic residue of a vision that encompasses design and use. Clothing is transformed into a magnetic surface that, like a three-dimensional camera, attracts things and signals, trademarks and objects, illustrations and quotations drawn from the everyday iconography of advertisement and television, comic books and movies. The garment becomes a secular shroud of mass idolatry, reducing the idol to an opaque, neutral outline to be worn ironically.

The imaginary map of places includes not only artificial nature, but natural nature as well, which knows no rules or procedures, but is full of free energies assigned principally to its physical and material components. Between 1966 and 1980, the pregnancy of natural materials—from the human organism to deserts to composites of flesh and bark, snow and wind, water and sand—emerges as the residual element of an environment yet to be discovered. With the advent of Land Art, Body Art, and *Arte Povera*, the attribution passed from the object to the factual significance of real things, as natural, vegetal and animal entities. These art forms are ways of intensifying the environment and are a far cry from any sort of objective, iconic, optical or popular apologia. They set themselves up as free, almost intuitive artistic processes in harmony with the focal nuclei of life. They are a kind of hymn to the banal, primary element (air, earth, fire, water) and to the physical and mental fragment that works by minimal incidences and models of displacement. Now the cut of the scissors opens a fissure or hole in the earth's crust, delimiting a natural space. The garment becomes camouflaged in the environment and transformed into a burst of energy linked to the vitality of a tree or a fish, a pumpkin or an epidermal excrescence, in the work of such artists as Piero Gilardi, Alighiero Boetti, Louise Bourgeois, Vito Acconci, Richard Tuttle, Franz E. Walter and James Lee Byars. In other

instances the garment takes on a shamanistic character, serving to exorcise the presence of the social, represented by the chaos of politics and the invasiveness of the media, reducing it to a state of perfect organization. With Joseph Beuys and Nam June Paik, clothing is transmuted into a wizard's or barker's tool, subtended by a ritualism that aspires to embalm the forces of society and the reign of mass communications.

By the 1980s, clothing's belonging to the realm of art is no longer a revelation, but a necessity, given that since 1950 fashion has become a global project for democratizing and aestheticizing appearance and self-presentation. What was once considered useless and frivolous, decorous and eccentric, has become the means to a search for identity, where what matter most are originality and constant change. The difference between art and fashion is tending to disappear, as if the cut that has defined the shape of both has actually succeeded, through a sequential process of collage, in superimposing and uniting the two. With Judith Shea, Rosemarie Trockel, Jana Serbak and Jan Fabre, clothing has become a disturbing device—at once automaton and mannikin, statue and machine, dream and nightmare, delirious simulation and paranoid-critical scenery—while with Charles Le Dray, Oliver Herring, Wiebke Siem and Beverly Semmes, it is transformed into the vector of an impulse to fantasy and marvel that revives the dream-logic of the garment as game and pleasure, life and spectacle, mask and disguise.

The magical instance of the cut that makes the garment has thus passed through all the various thresholds of artistic creativity. The time has now come for fashion to decipher its latent forces and desires and recognize itself as a free and original discipline, knowing full well that art will never lose sight of it, but only continue to respond with cuts and critiques.

Giacomo Balla, *Bozzetto di vestito da uomo*, 1914

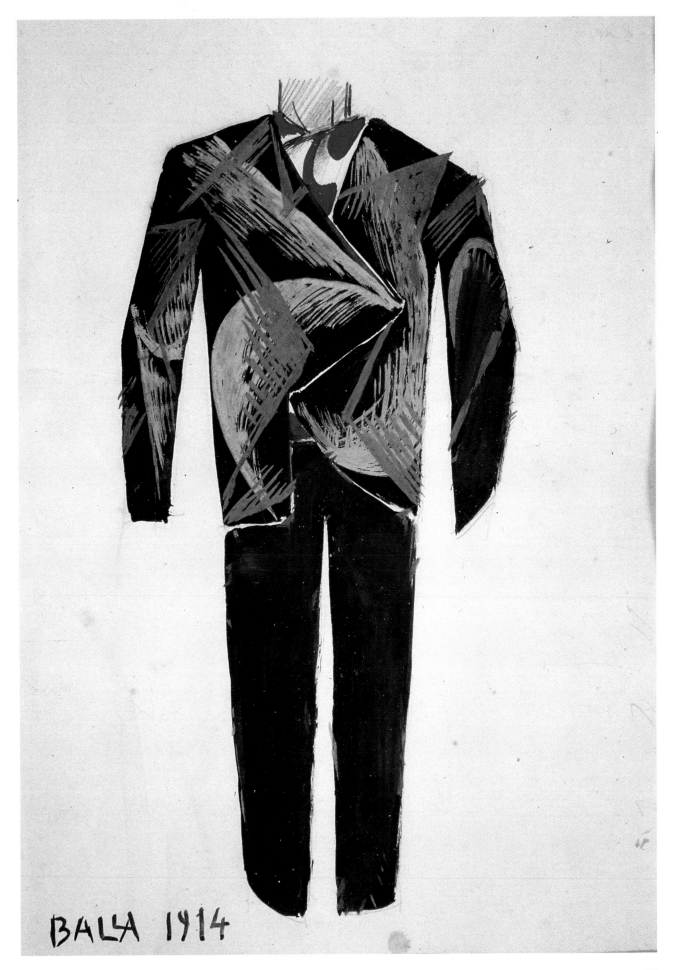

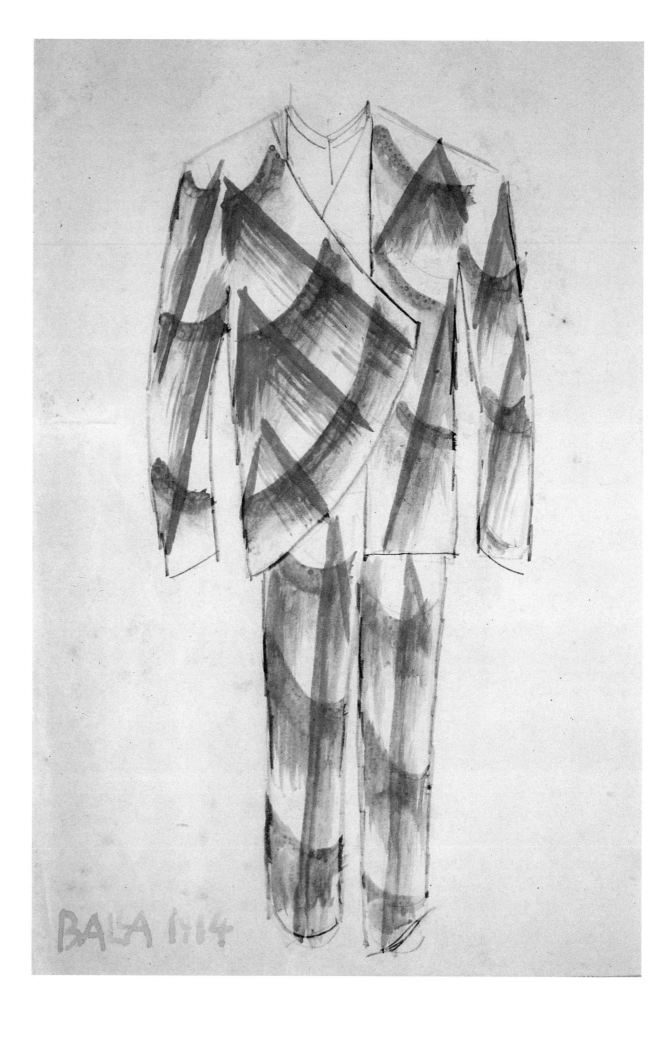

Giacomo Balla, *Bozzetto
di vestito da uomo*, 1914

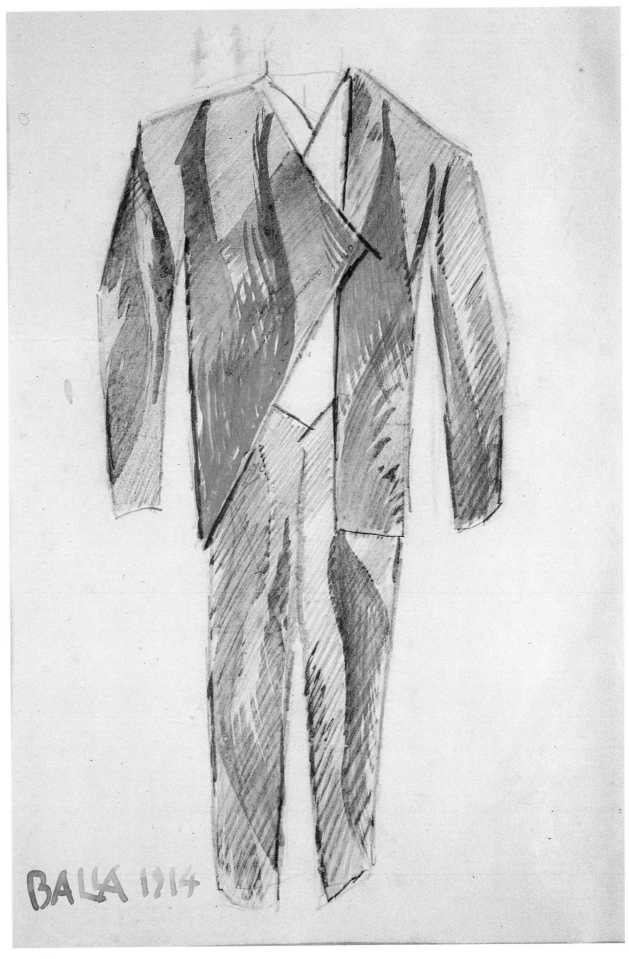

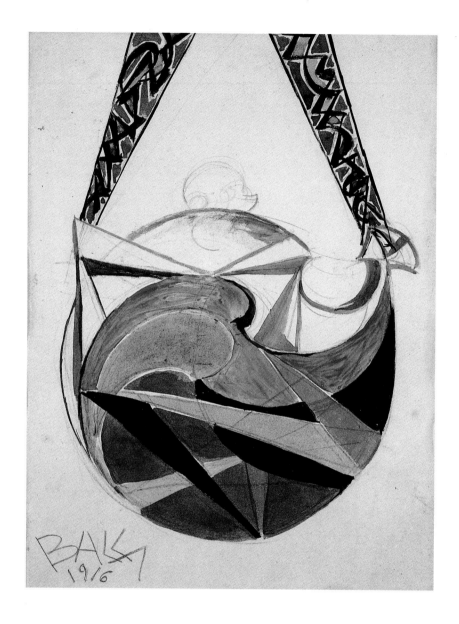

Giacomo Balla,
Bozzetto di golf, 1930

Giacomo Balla,
*Bozzetto di prendisole
"per mare"*, 1930

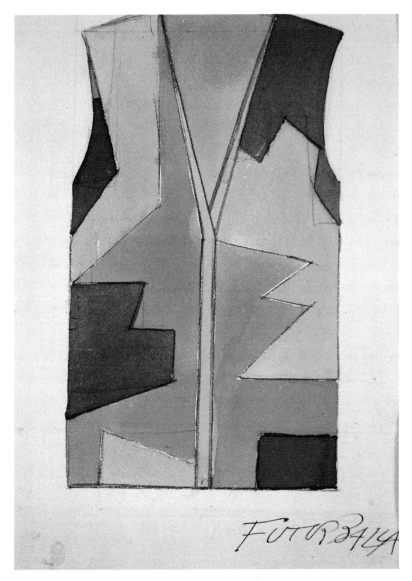

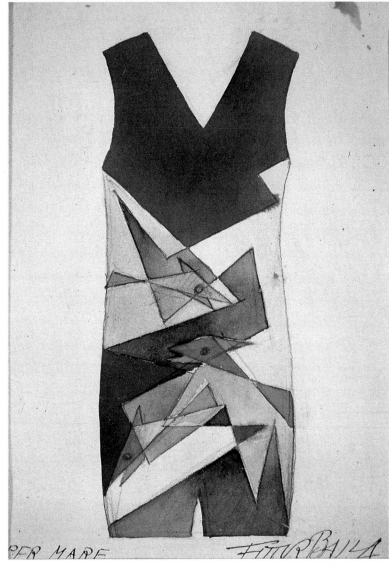

Fortunato Depero,
Filippo T. Marinetti,
Francesco Cangiullo,
congresso futurista,
Torino, 1924

Fortunato Depero, *Gilet futurista*, 1923

Fortunato Depero, *Gilet futurista di Azari*, 1923

Fortunato Depero, *Panciotto di Tina Strumia*, 1924

Fortunato Depero, *Gilet futurista di Marinetti*, 1923

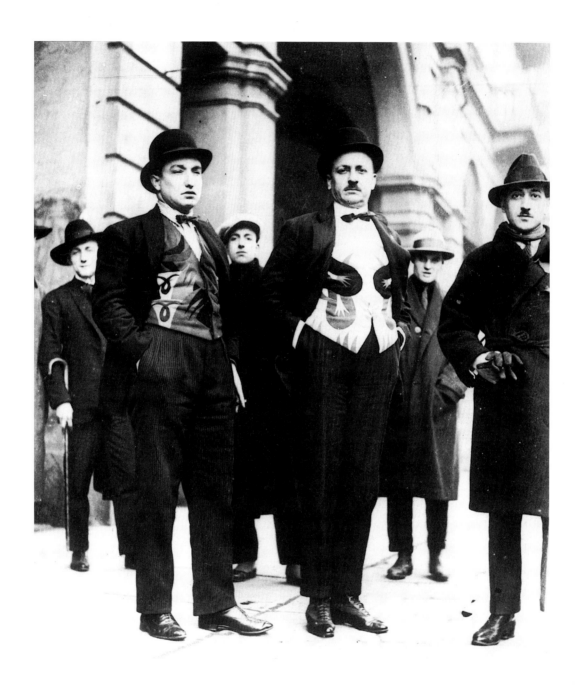

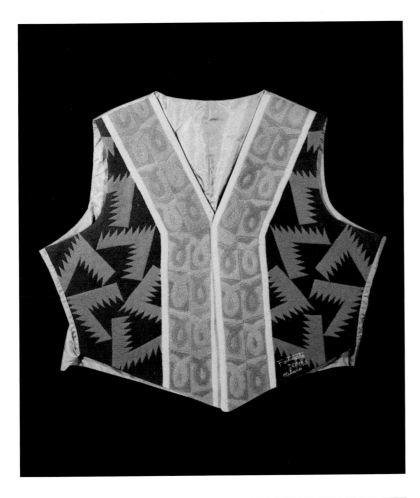

Giacomo Balla, *Studio
di vestito da donna*,
1928-1929

Giacomo Balla, *Vestito
per la figlia Luce*, 1930

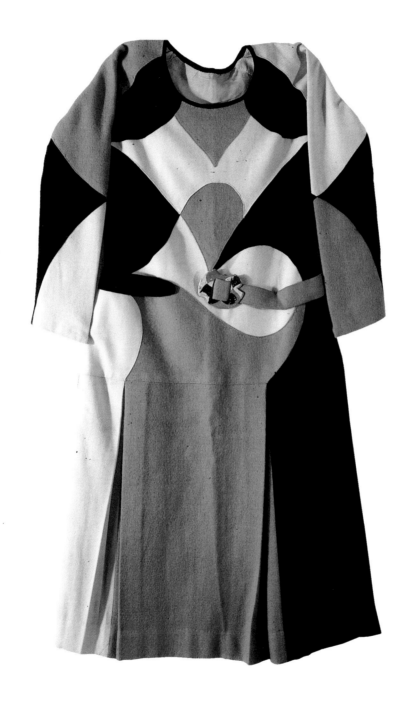

Giacomo Balla,
Si parlano, 1934

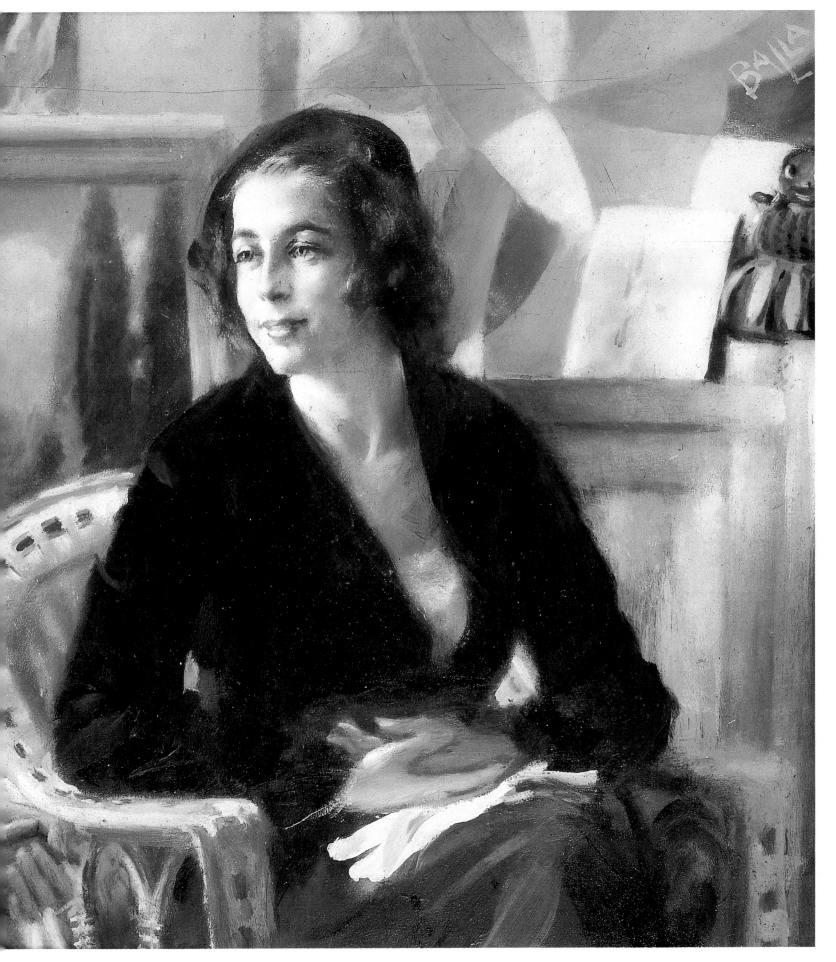

Natalja Goncharova,
Sketch for Costume,
1910 ca.

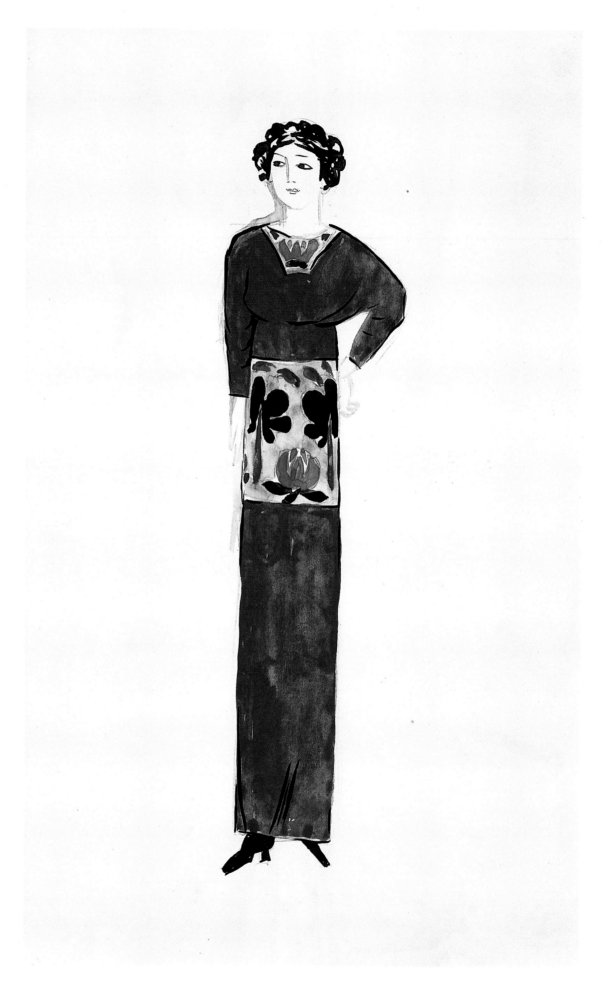

Natalja Goncharova,
Sketch for Dress, 1910
ca.

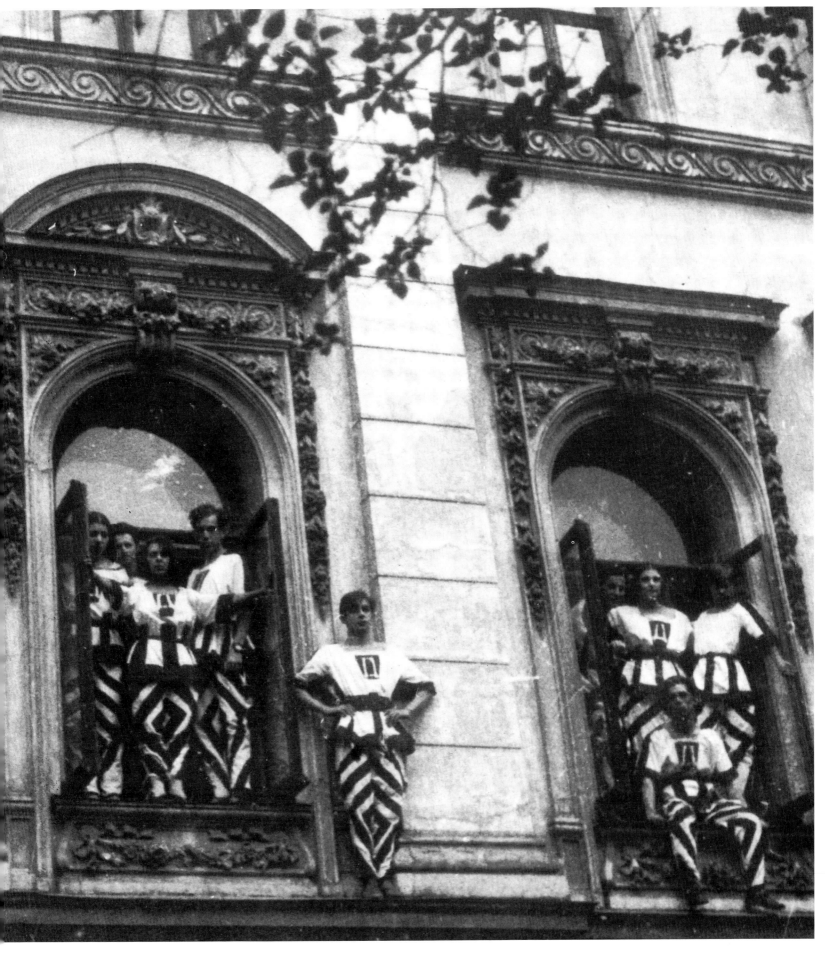

53

Ljubov Popova,
Summer, 1924

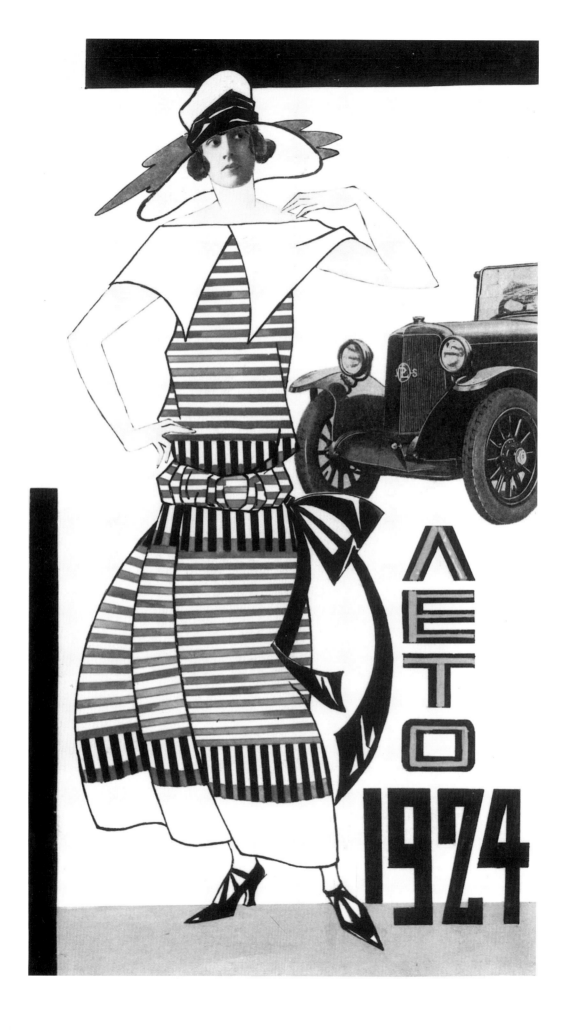

Aleksandr M. Rodchenko,
Sketch for Dress, 1924

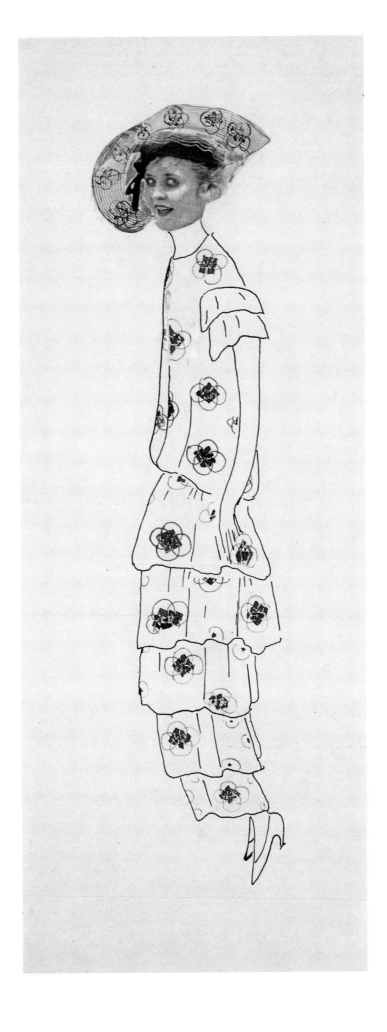

Lilja Brik, Foulard
designed by Ljubov
Popova, 1924

Aleksandr M. Rodchenko,
*Portrait of Varvara
F. Stepanova*, 1924

Sonia Delaunay, *Tissus
simultanés*, 1924

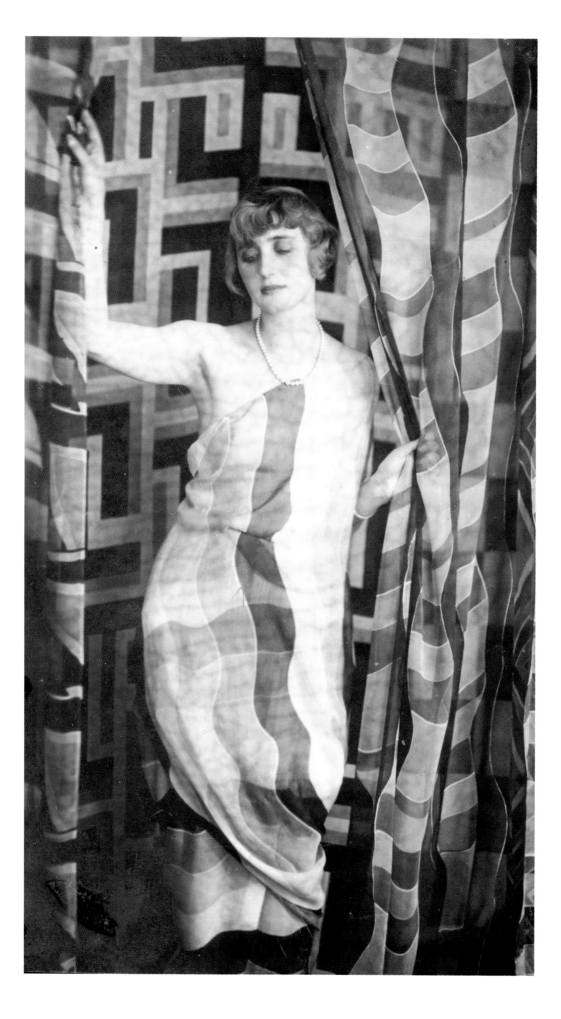

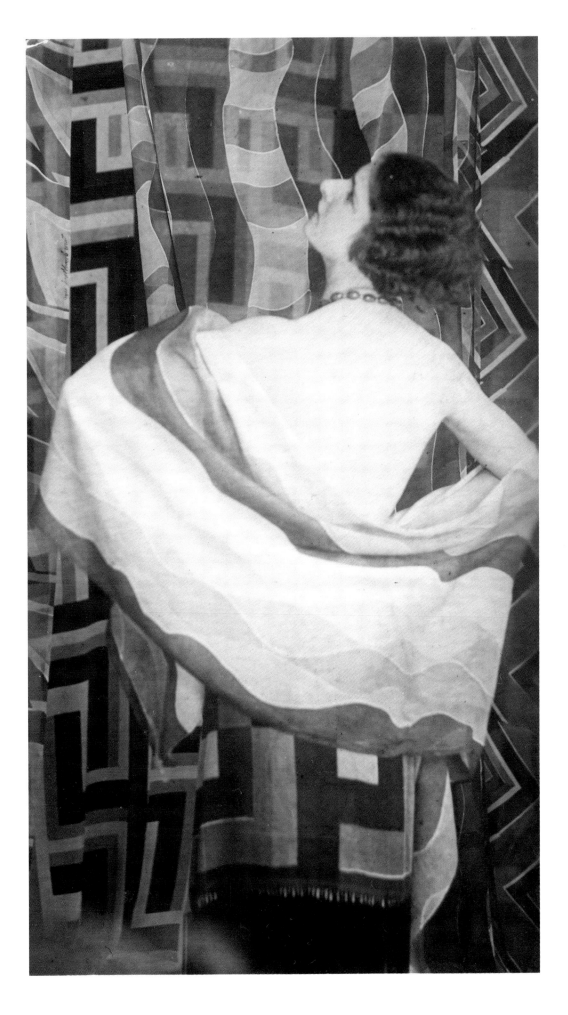

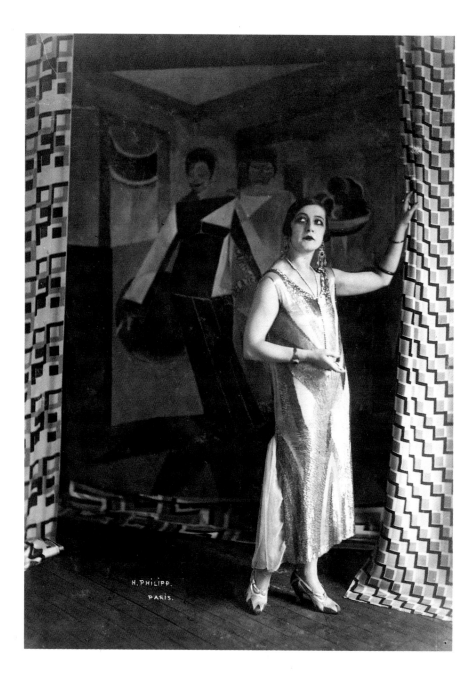

Sonia Delaunay, *Robe simultanée*, 1922

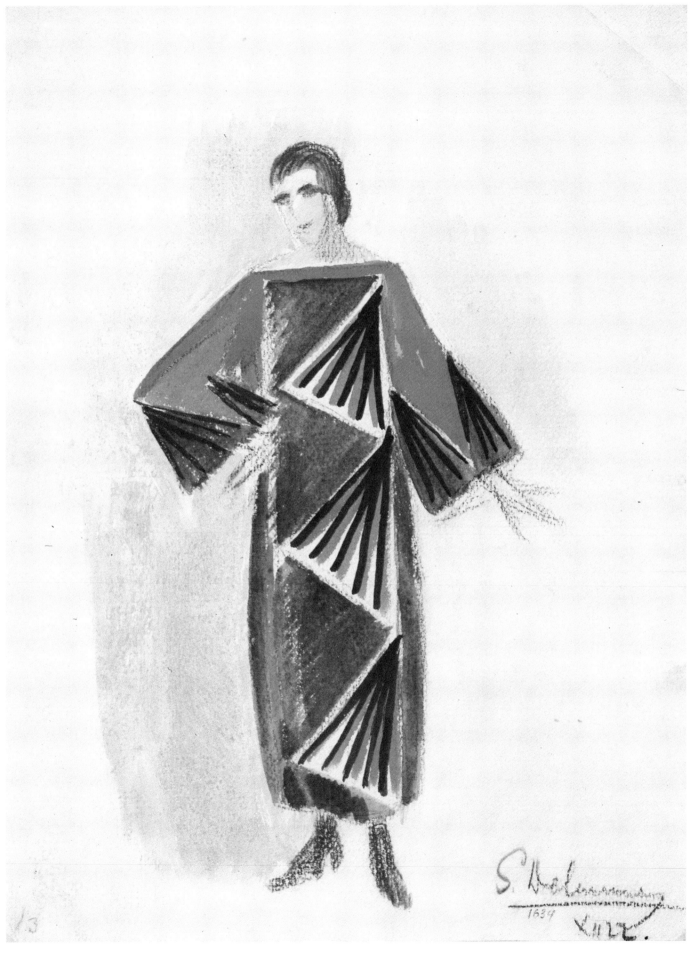

Sonia Delaunay,
Sans titre, 1923

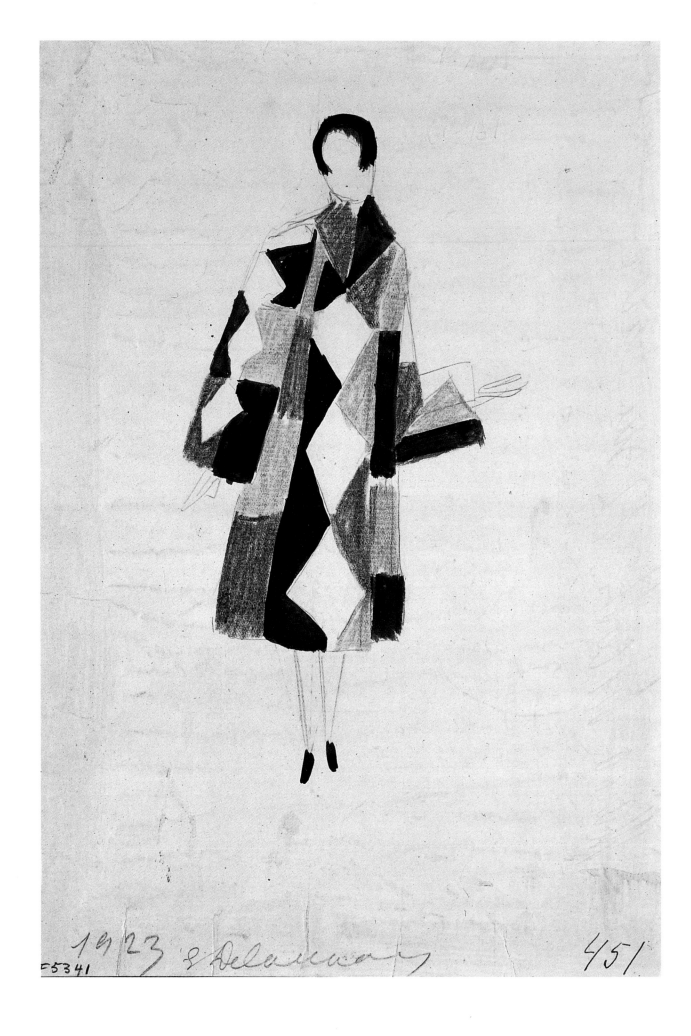

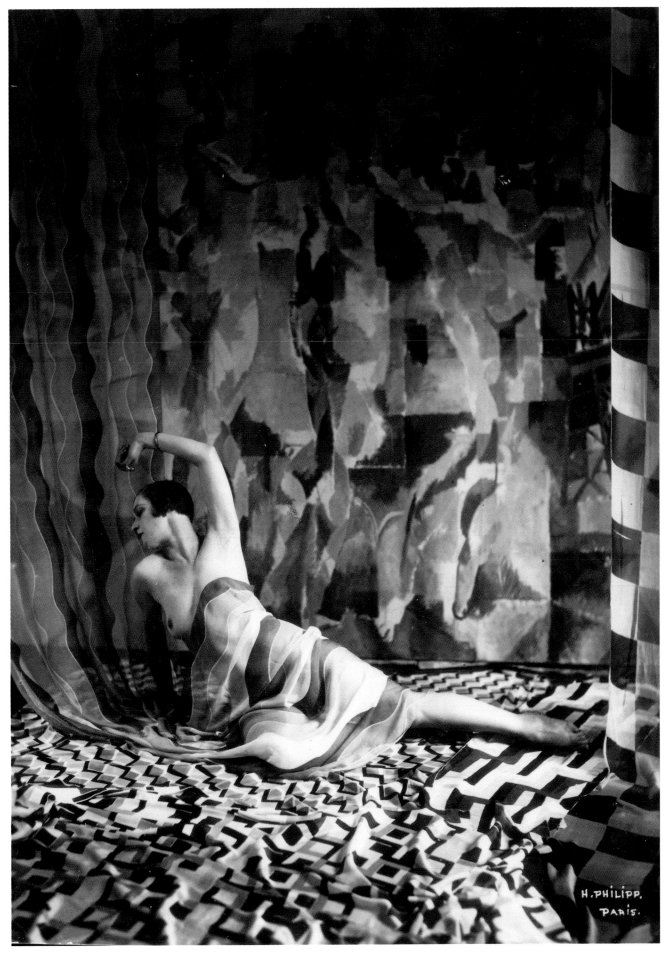

pag. 63
Sonia Delaunay,
Tissu simultané, 1925 c.
In the background:
Robert Delaunay,
Les trois Grâces, 1912

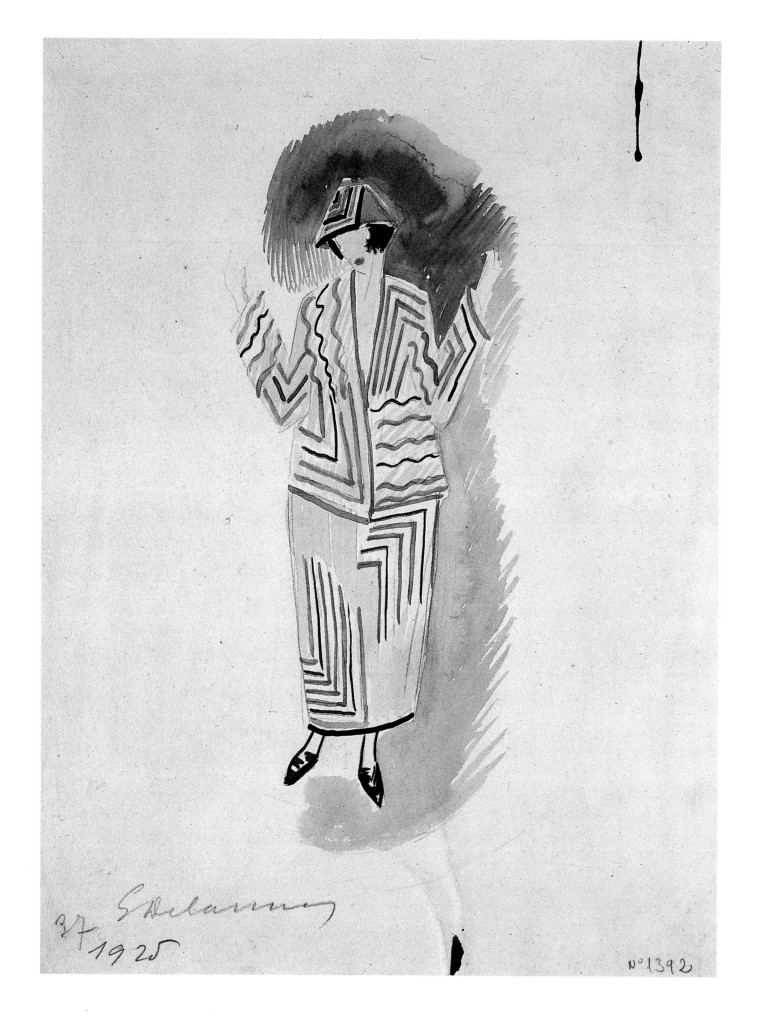

S. Delaunay

27/
1925.

N° 1392

Sonia Delaunay,
Sans titre, 1925

Sonia Delaunay,
Sans titre, 1925

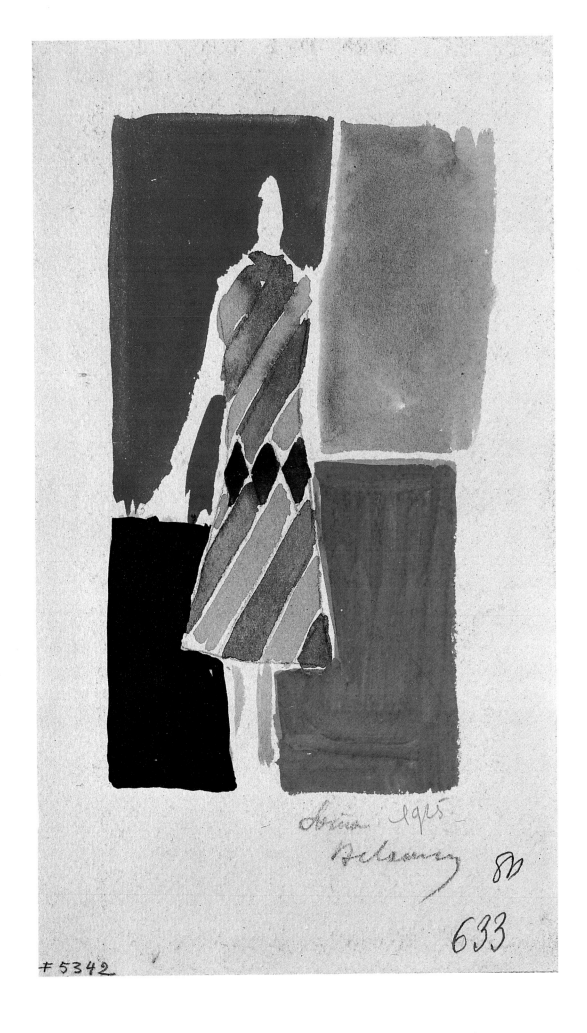

Sonia Delaunay, *Robe simultanée*, 1924-1925 ca.

Sonia Delaunay,
Costume de bain, 1928

Sonia Delaunay,
Golf, 1926-1927

Robert Delaunay,
*Étude pour le portrait
de Madame Heim*,
1926-1927

Florence Henri, *Portrait de Sonia Delaunay*, 1931

Florence Henri,
*Potrait-composition de
Sonia Delaunay*, 1931

Man Ray, *Femme liée*,
1928-1929 ca.

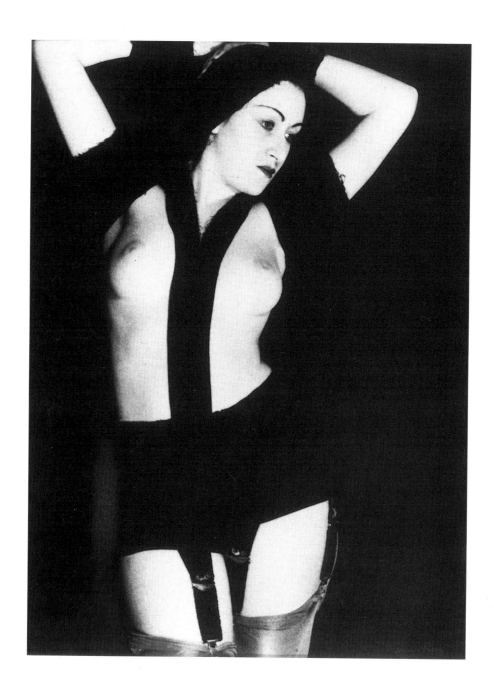

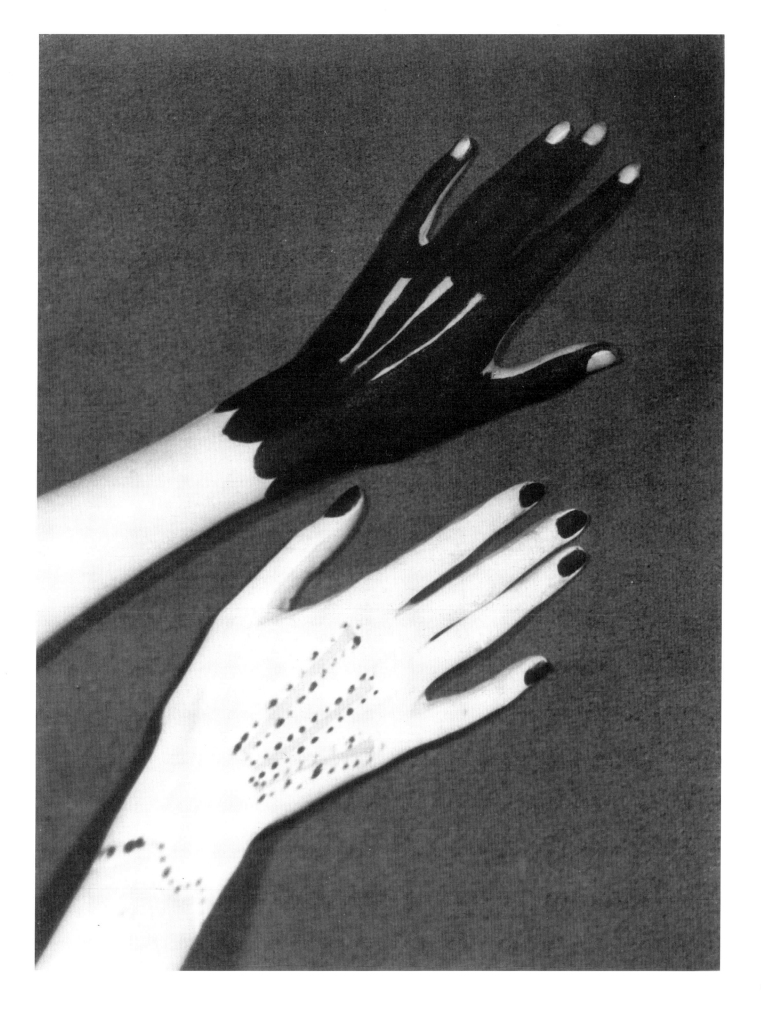

Man Ray, *Mode du Congo*, 1937

Man Ray, *Mode du Congo*, 1937

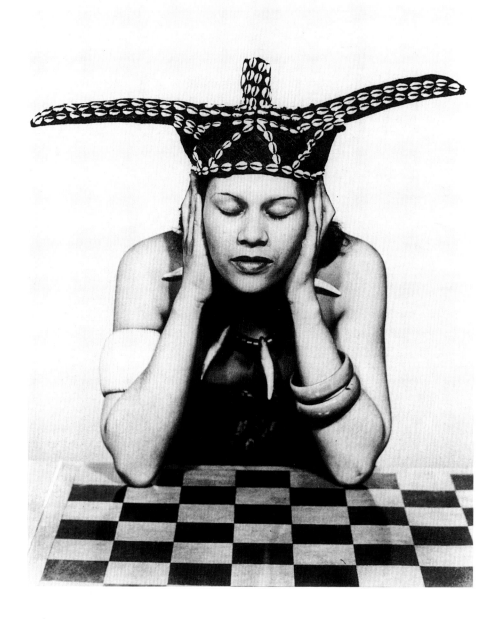

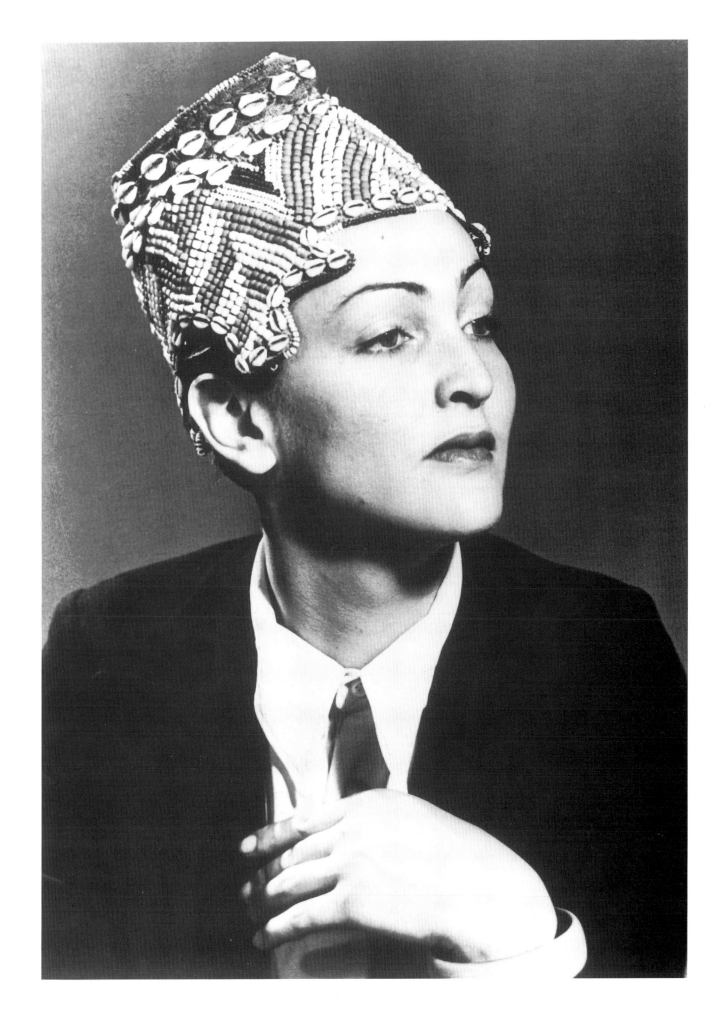

Man Ray, *Photographie de mode*, 1936

Man Ray, *Nancy Cunard*,
1926 ca.

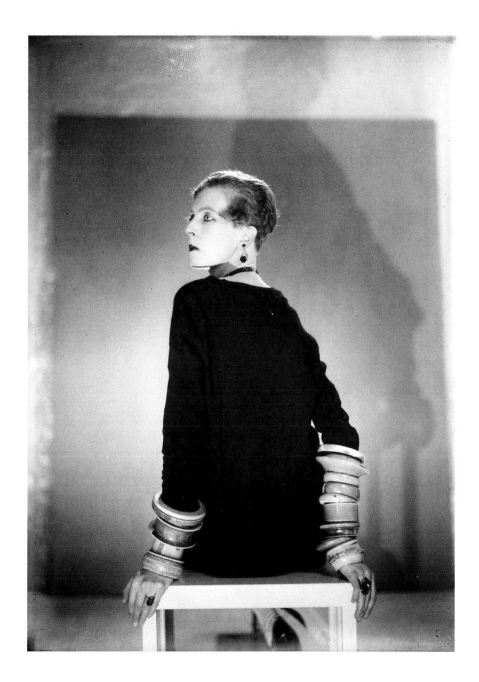

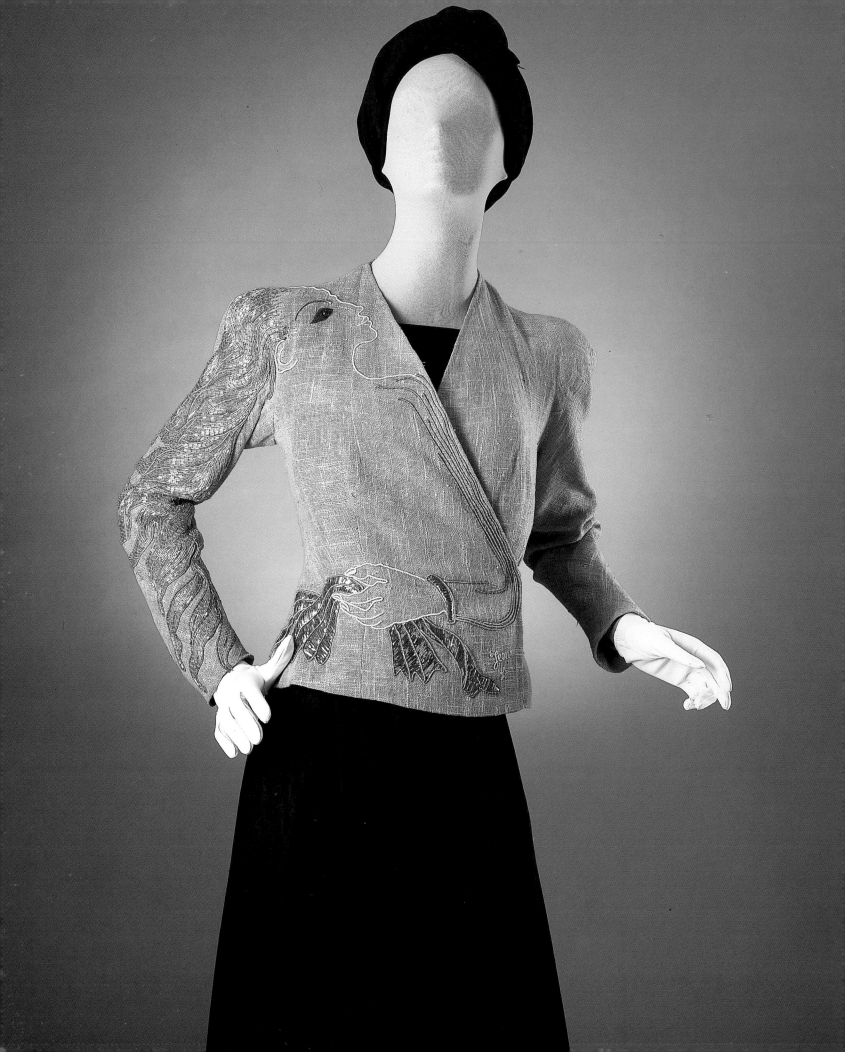

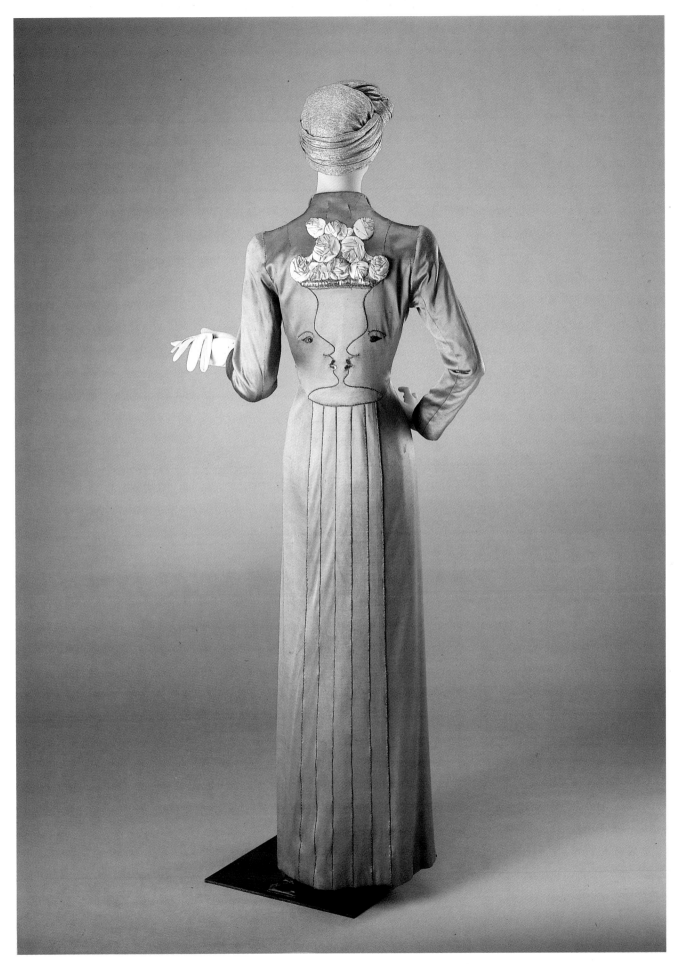

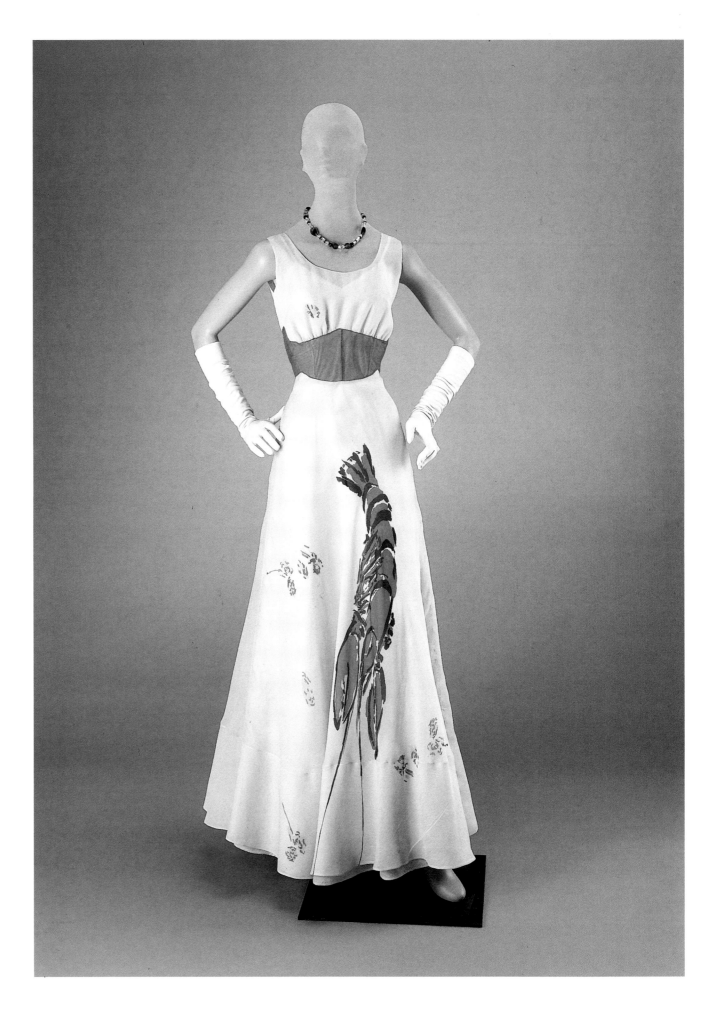

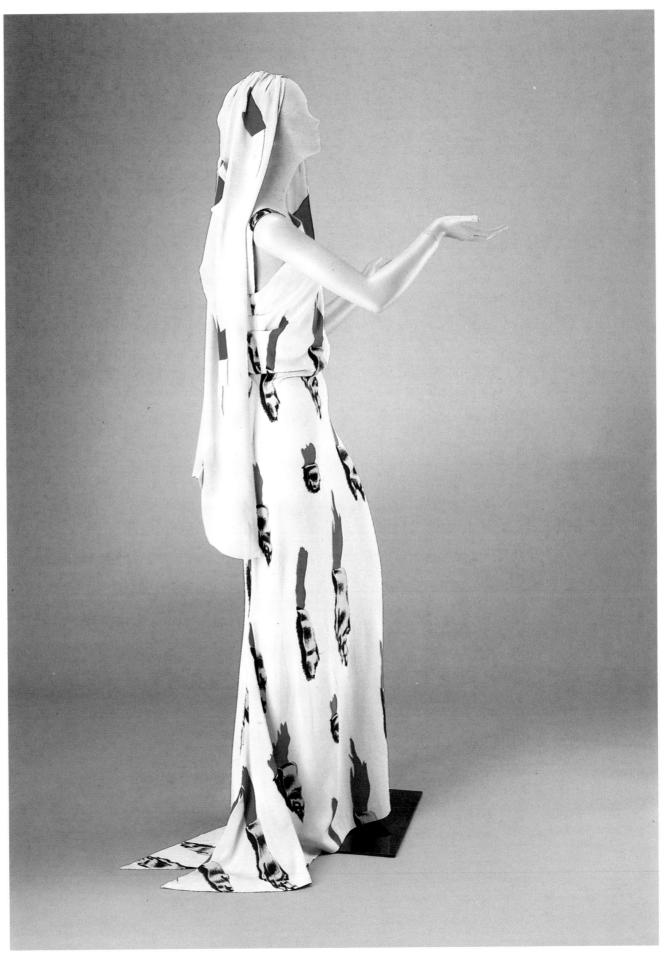

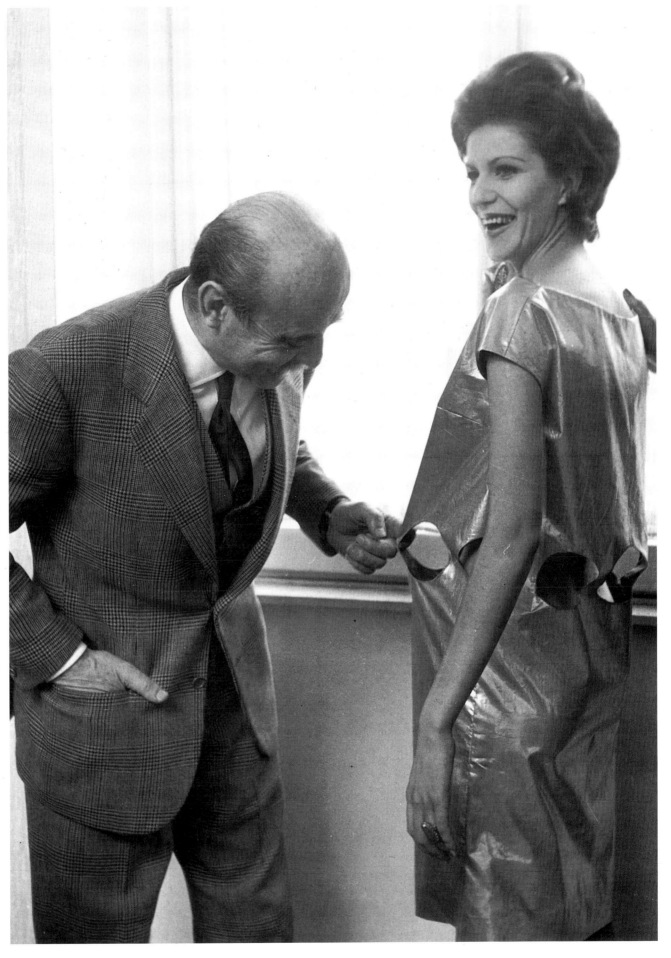

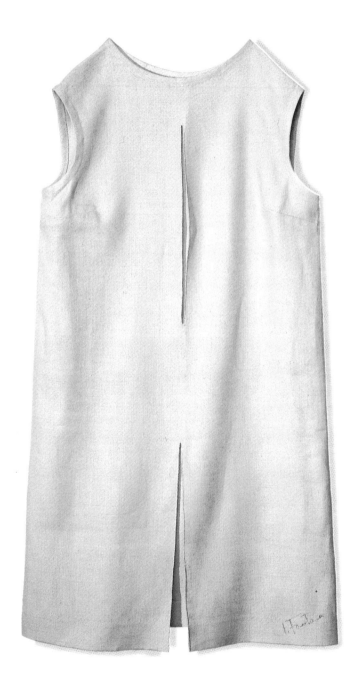

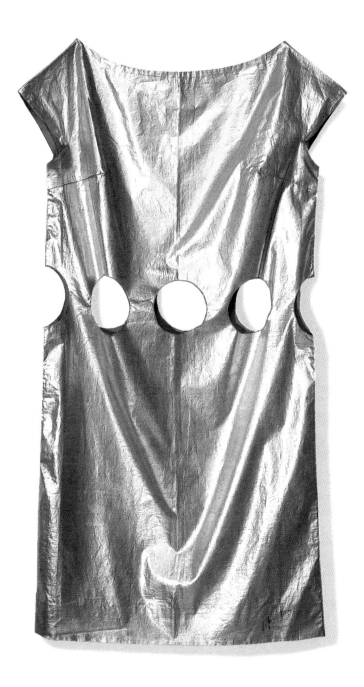

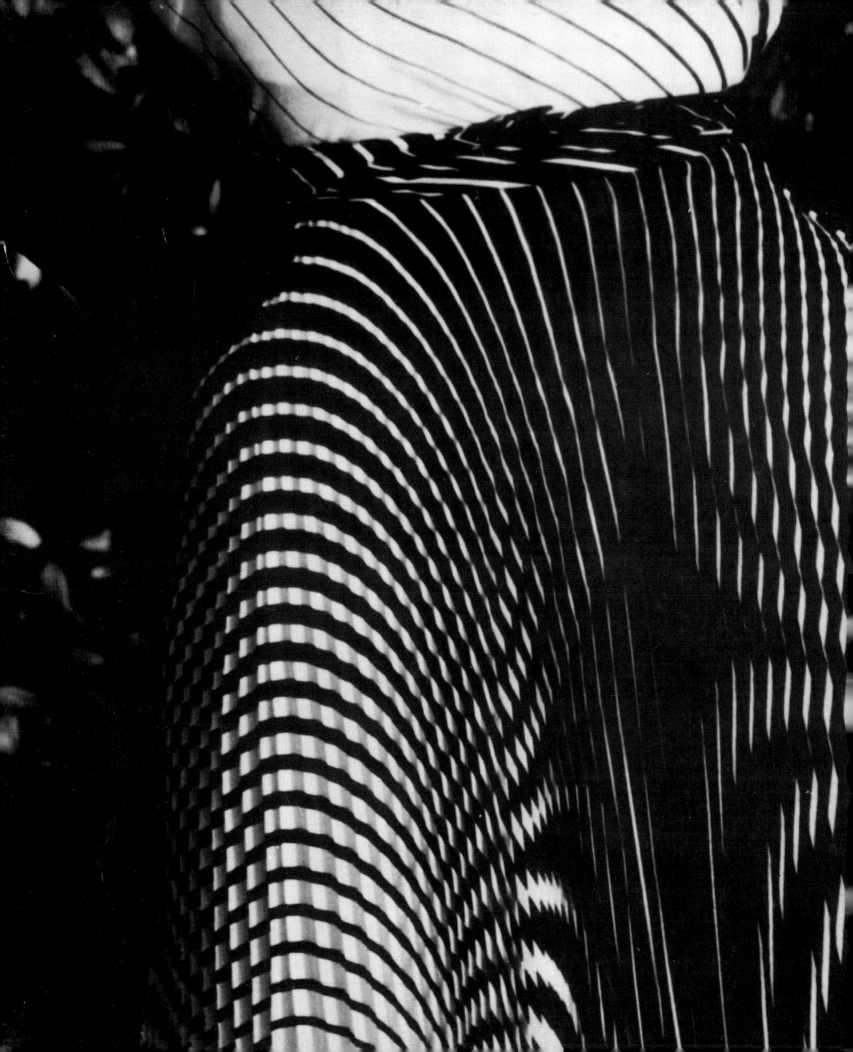

Getulio Alviani per
Germana Marucelli,
Abito cinetico, 1964

Getulio Alviani per
Germana Marucelli,
Positivo Negativo, 1964

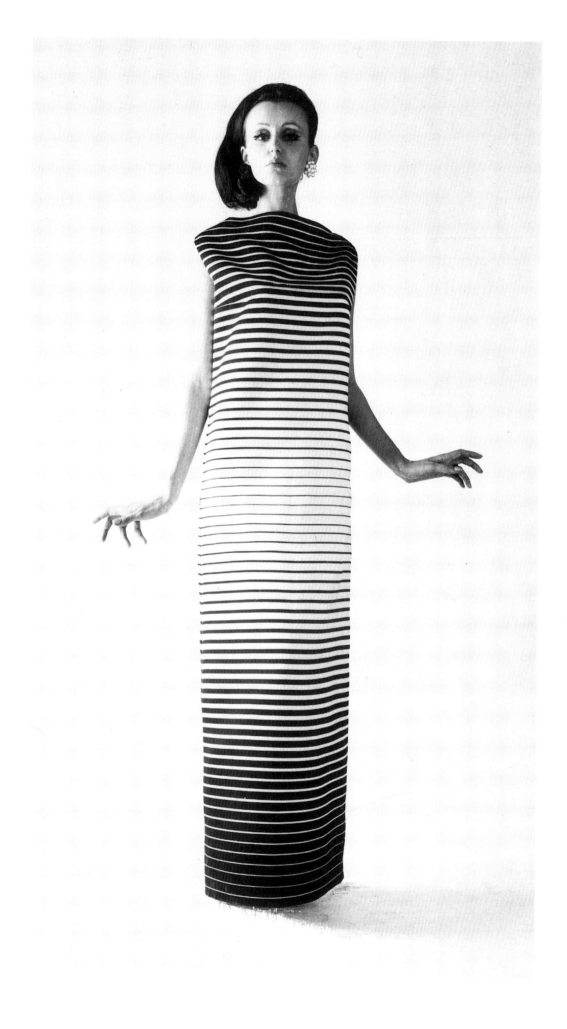

Getulio Alviani per
Germana Marucelli,
Cerchio+Quadrato, 1965

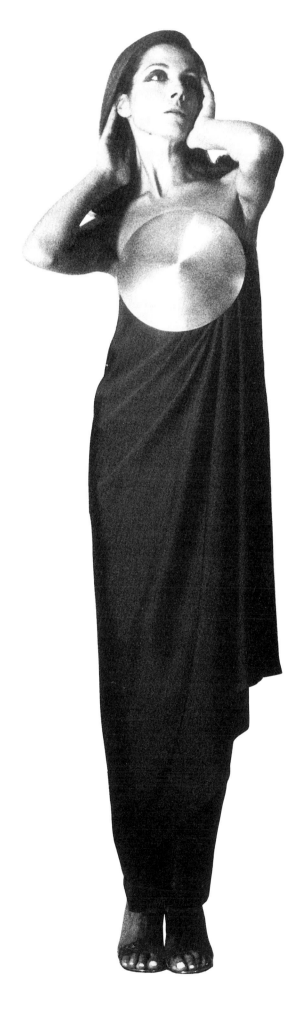

Getulio Alviani per
Germana Marucelli,
Abito cinetico, 1964.

Getulio Alviani
for Germana Marucelli,
Abiti cinetici, 1964

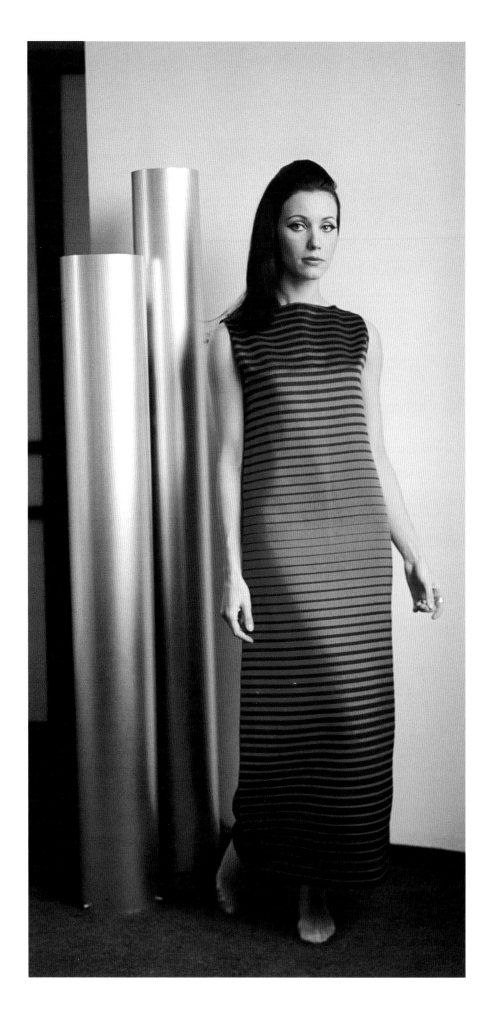

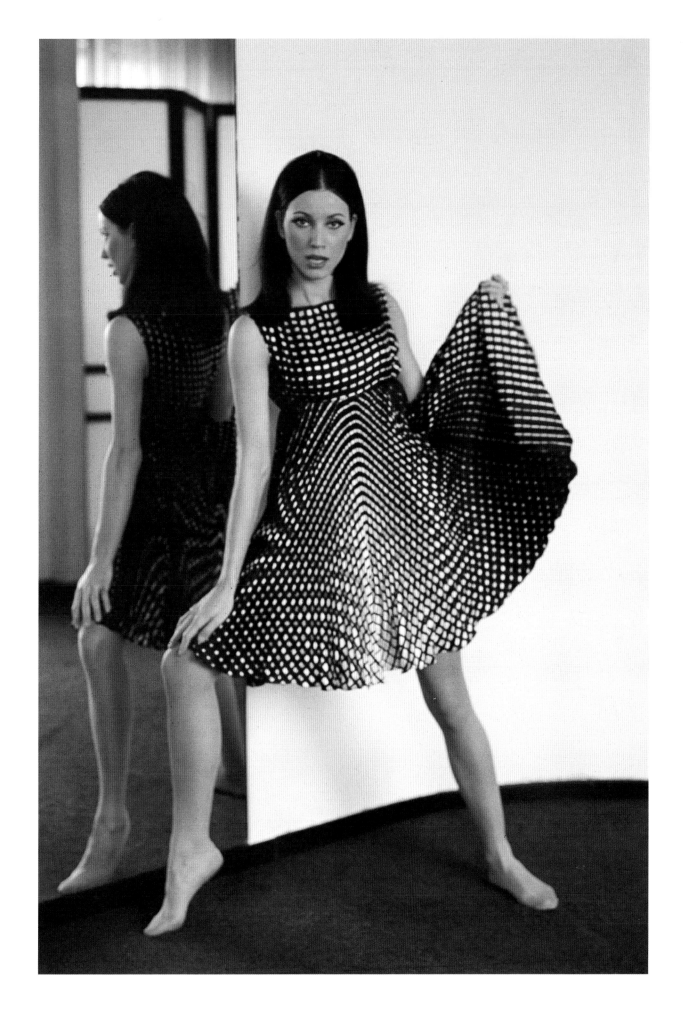

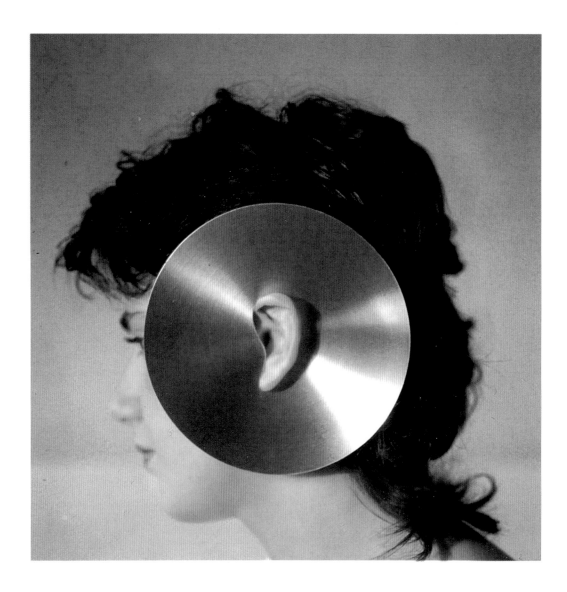

Getulio Alviani,
Bat(h)tape, 1966

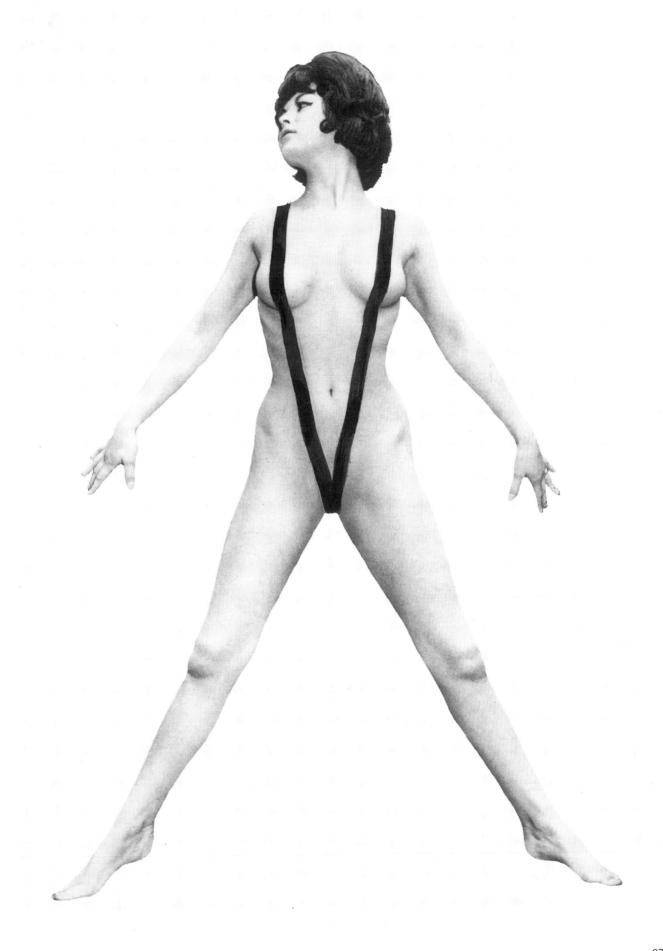

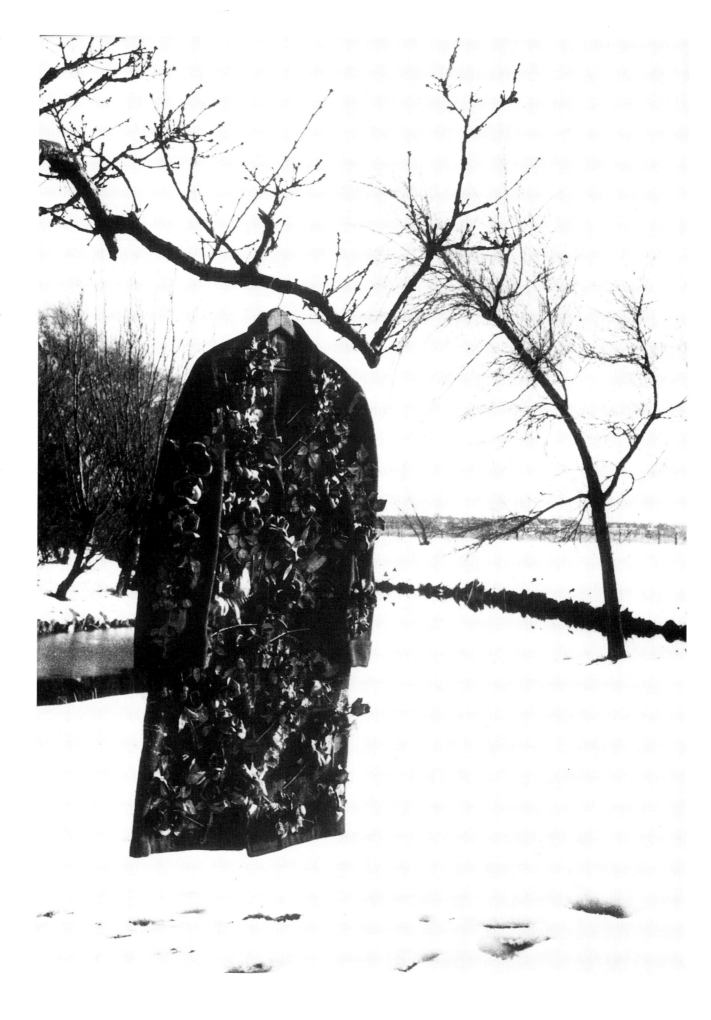

Andy Warhol, *Young Robert Rauschenberg*, 1962

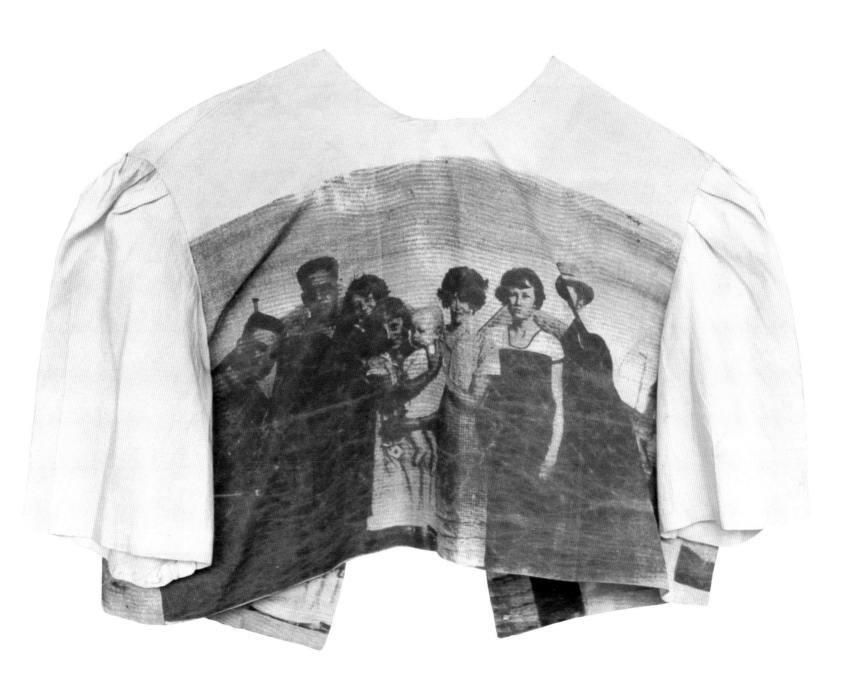

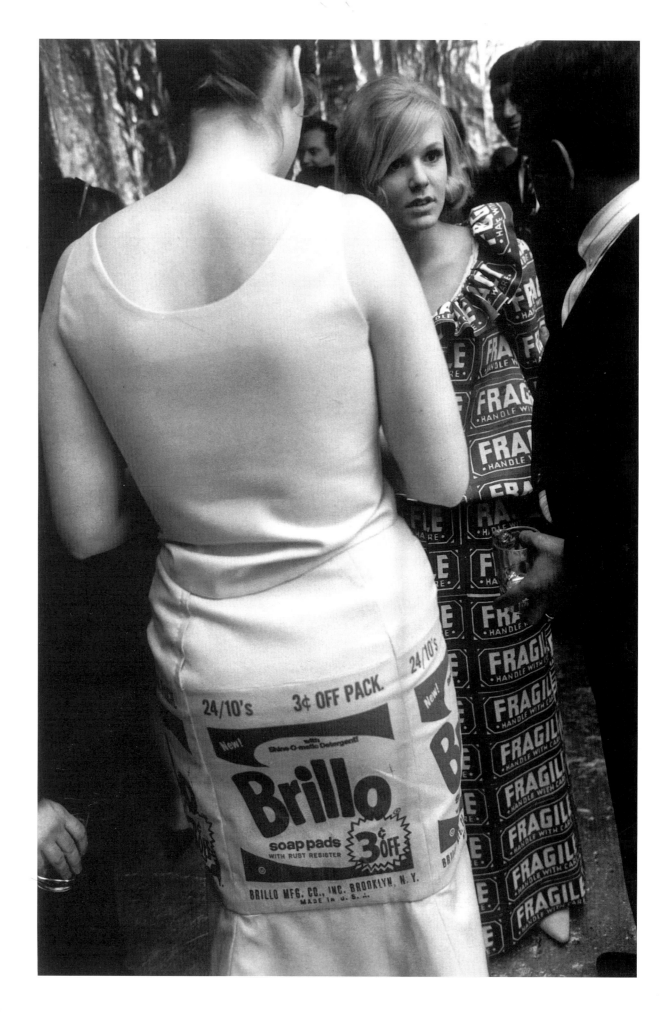

Andy Warhol, *Brillo* e
*Fragile, Handle With
Care*, 1962

Andy Warhol, *Fragile,
Handle With Care*, 1962

Christo, *Wedding Dress*,
1967

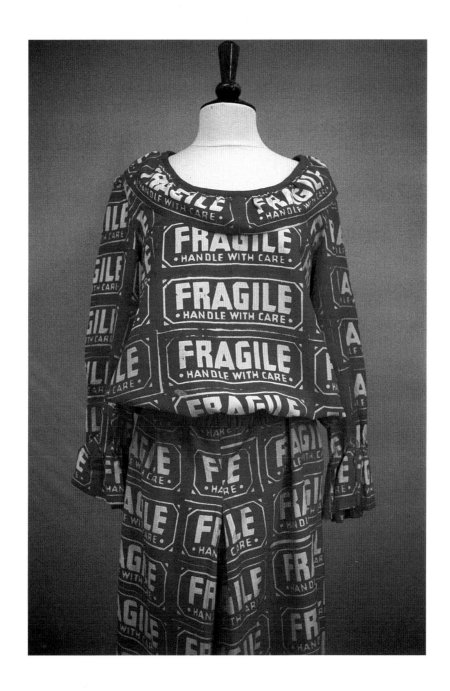

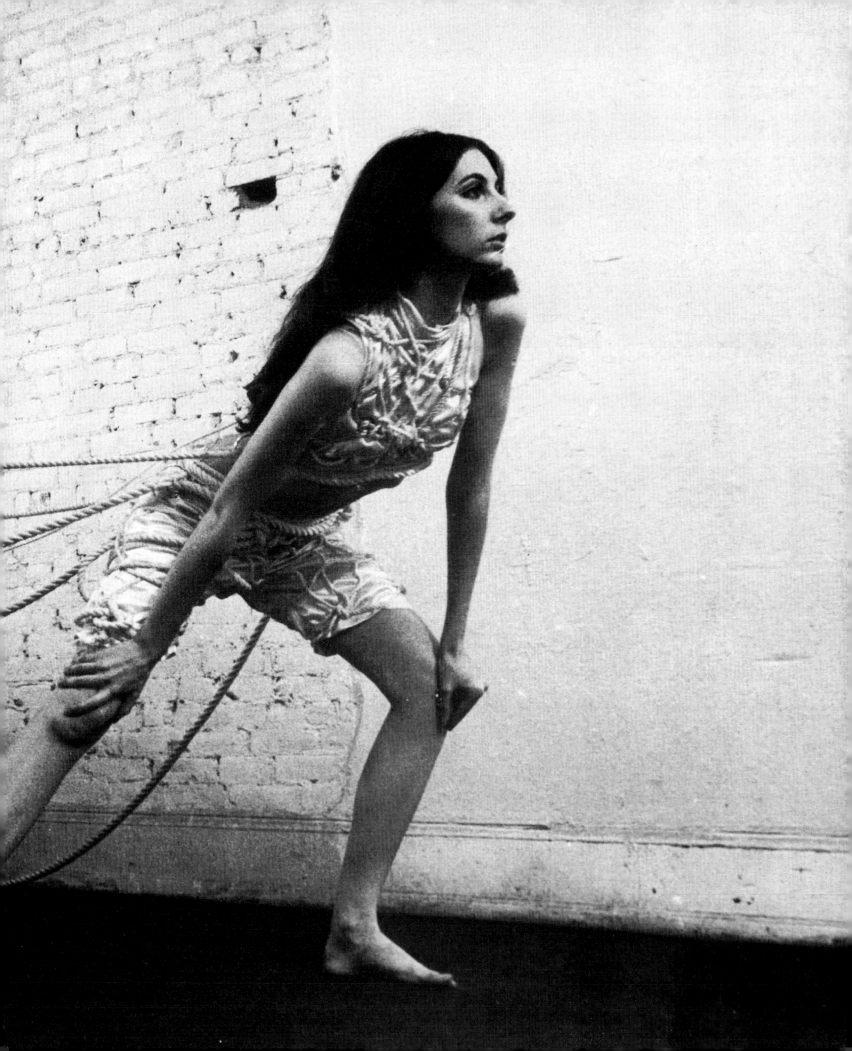

piper via XX settembre 15 bis torino tel. 53.71.00

SABATO 13 MAGGIO ORE 22
BEAT FASHION PARADE
MODELLI DI BOETTI, COLOMBOTTO, GILARDI, SAUZEAU
IRMA BOUTIQUE, TICRE SHOP, TOP TEN.
ZIPP ... POLIURETANO ... ACQUA ... GOLIA ...
POLIETILENE ... ALLUMINIO ... PLASTICHE ...
SOUND : DAVE ANTONY'S MOODS
VOCE : FORTEBRACCIO

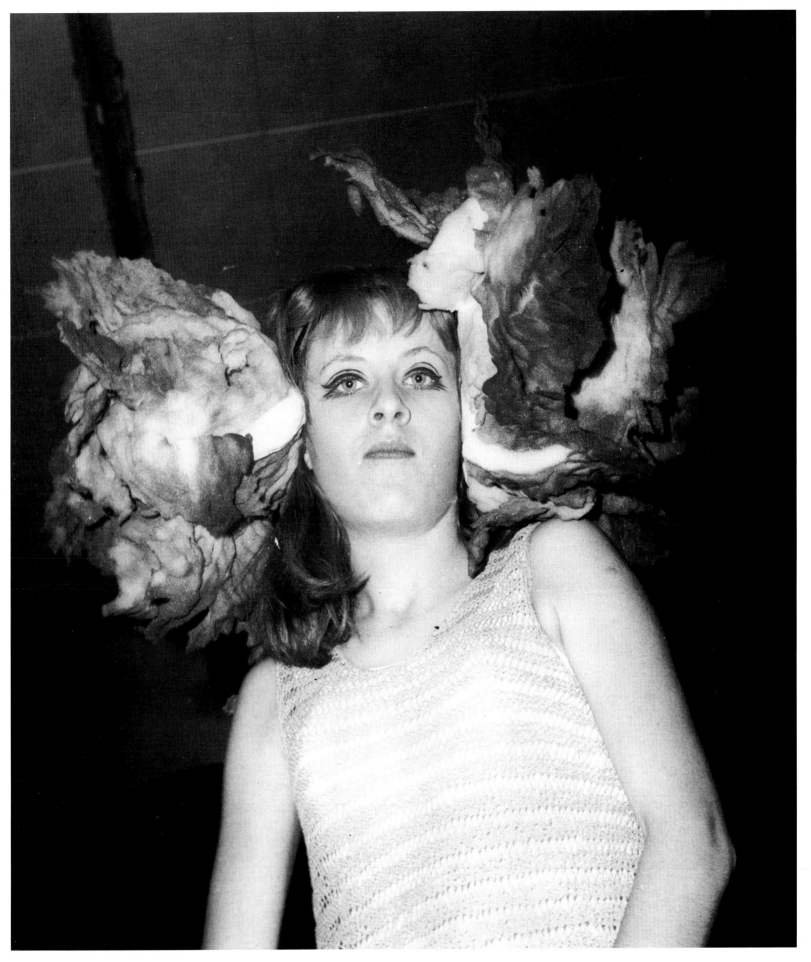

Alighiero Boetti,
Abito da donna, 1967

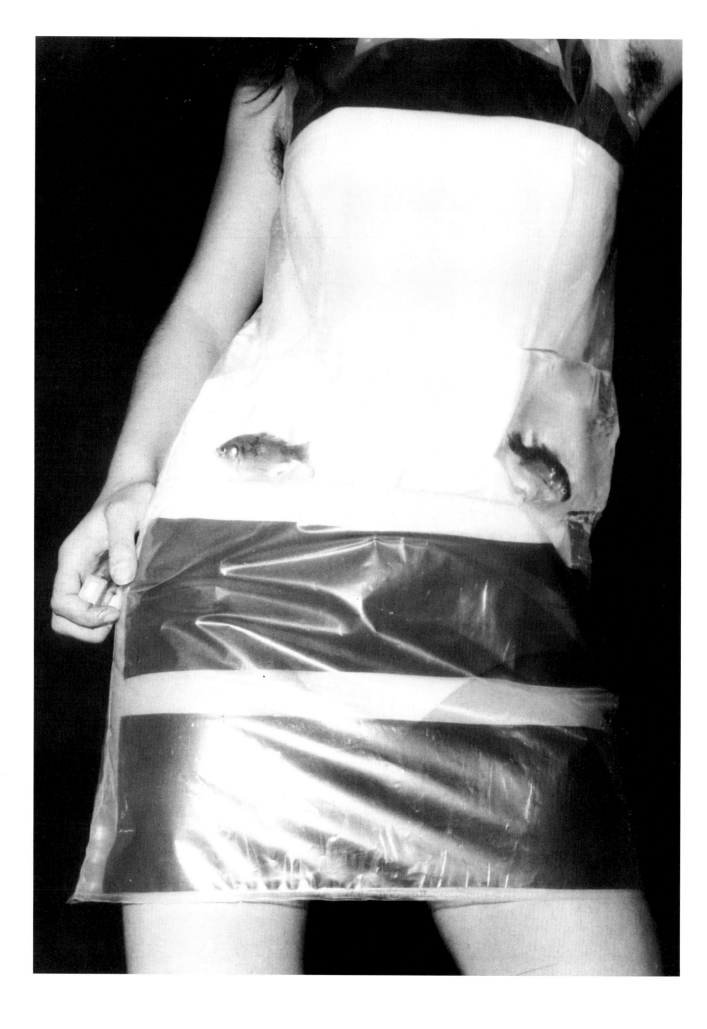

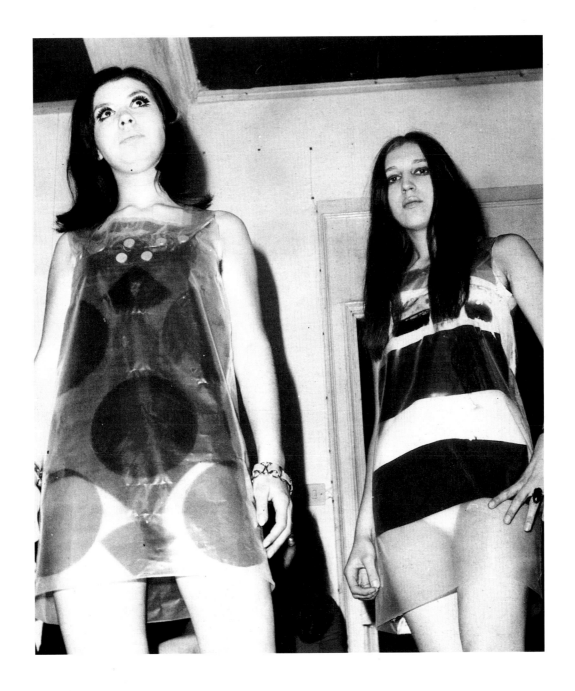

Piero Gilardi,
Abito da donna, 1967

Piero Gilardi,
Vestito-Natura Sassi,
1967-1996

108

James Lee Byars, *Four
in a Dress*, 1967

James Lee Byars,
Portrait of James Lee Byars, 1968

Robert Rauschenberg,
Maya (recto), 1974

Robert Rauschenberg,
Maya (verso), 1974

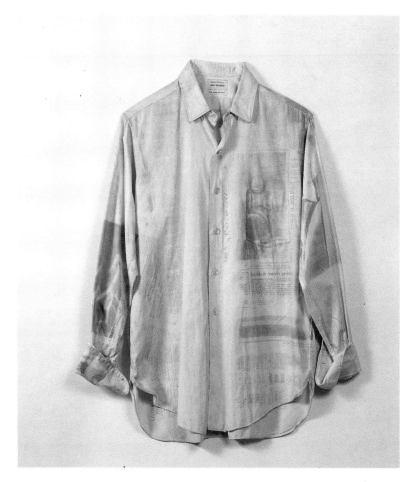

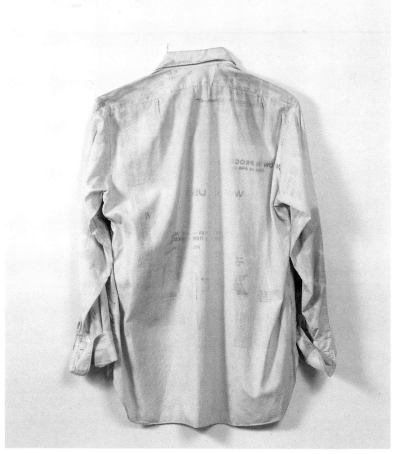

Joseph Beuys,
Filzanzug, 1970

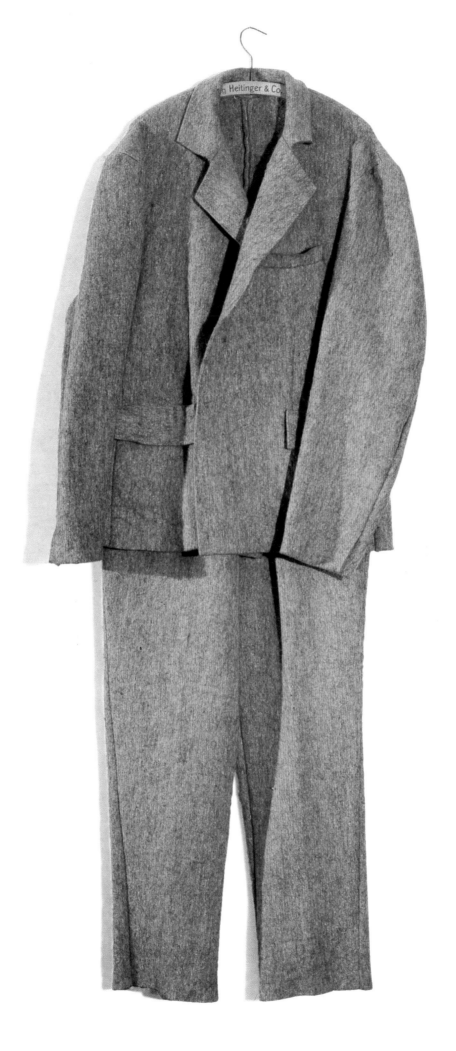

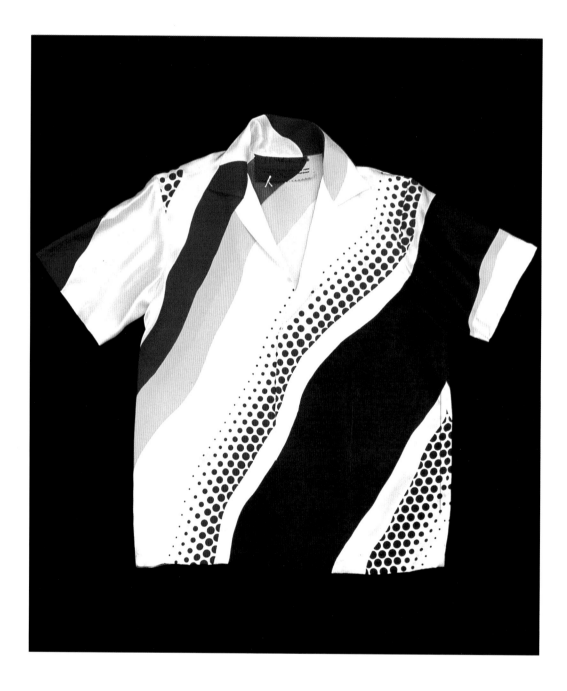

Daniel Spoerri, *La Chemise du chasseur d'oiseaux (Hommage à John Cage)*, 1976

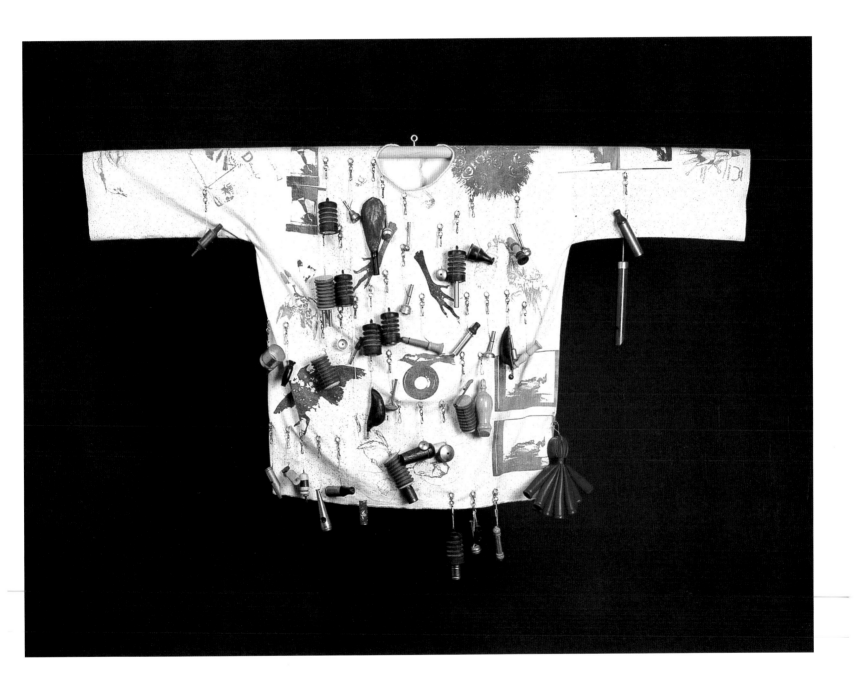

Franz Erhard Walther,
*Standstelle und
halbierte Weste I*, 1982

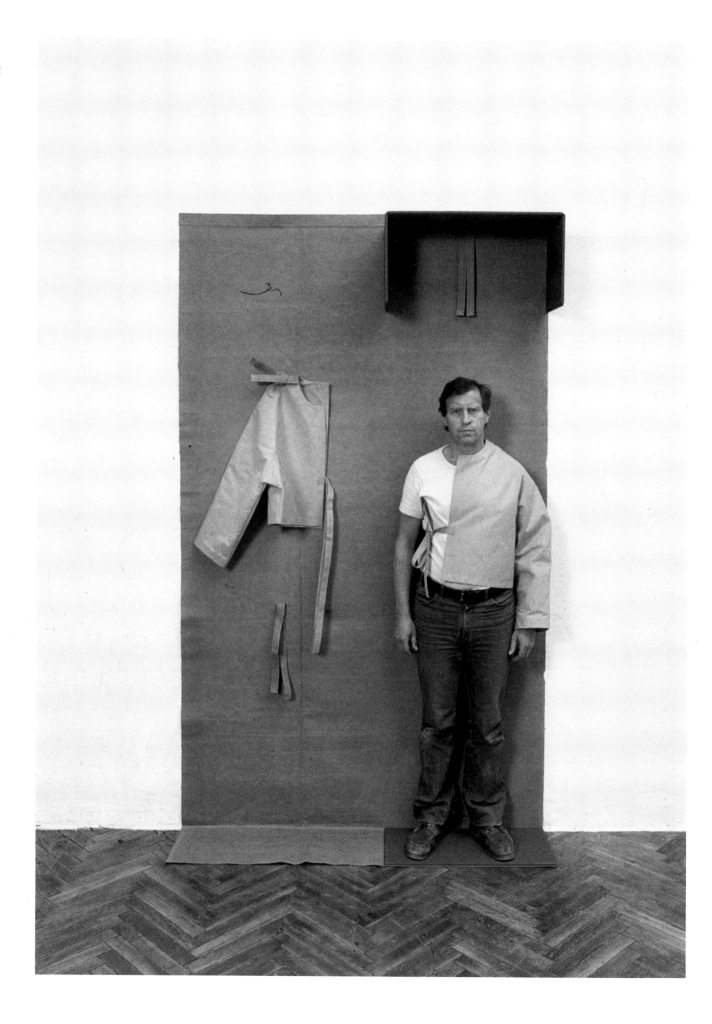

Franz Erhard Walter,
Standstelle und
halbierte Weste I, 1982

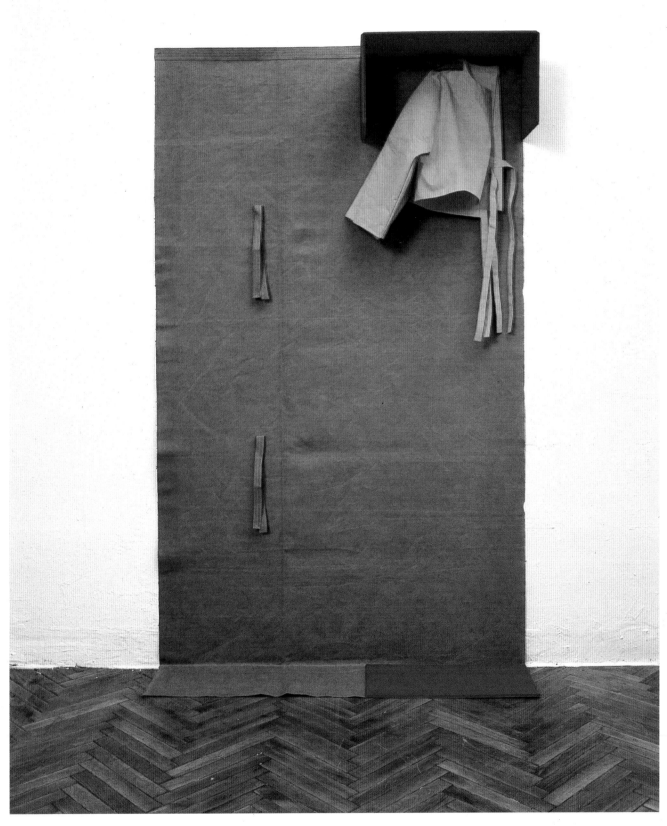

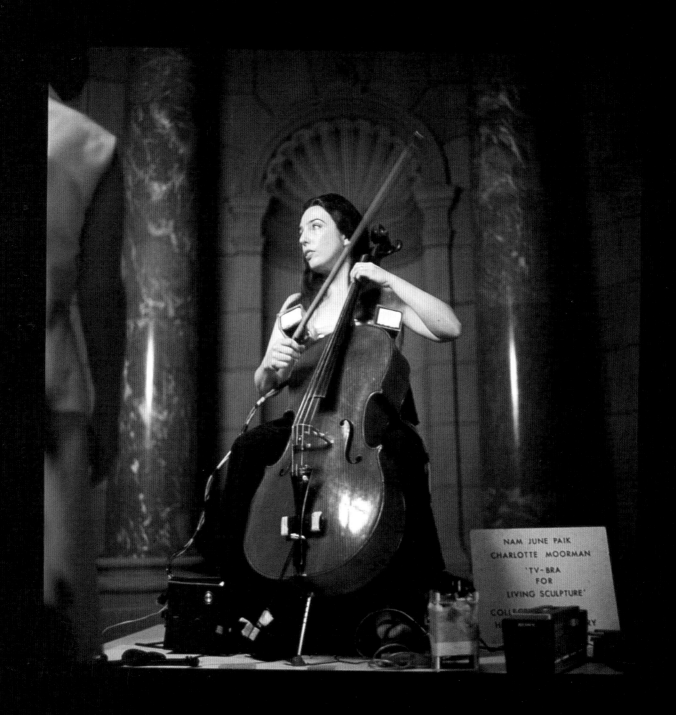

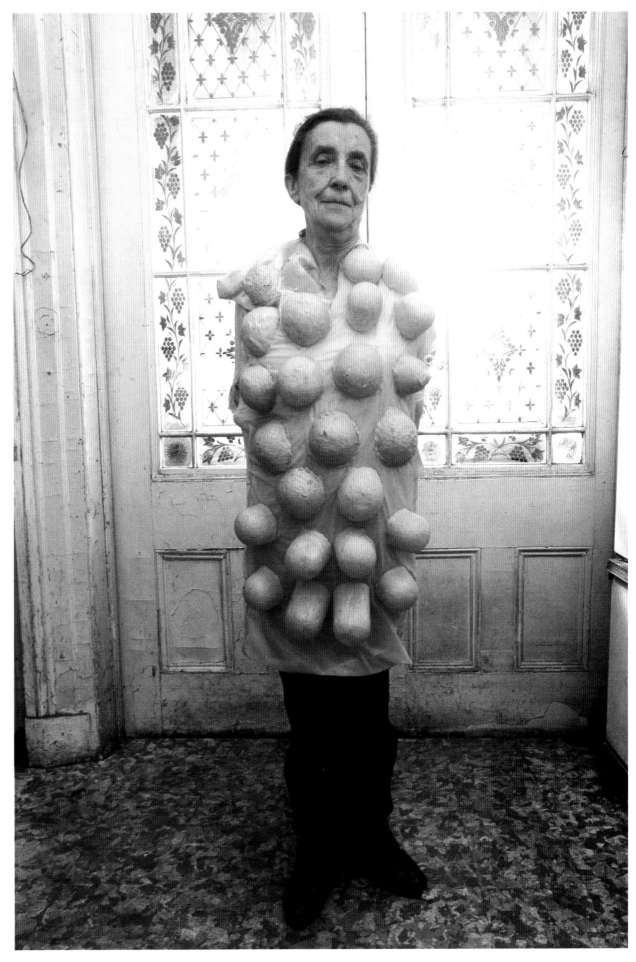

Vito Acconci,
Shirt/Jacket of Pockets,
1993

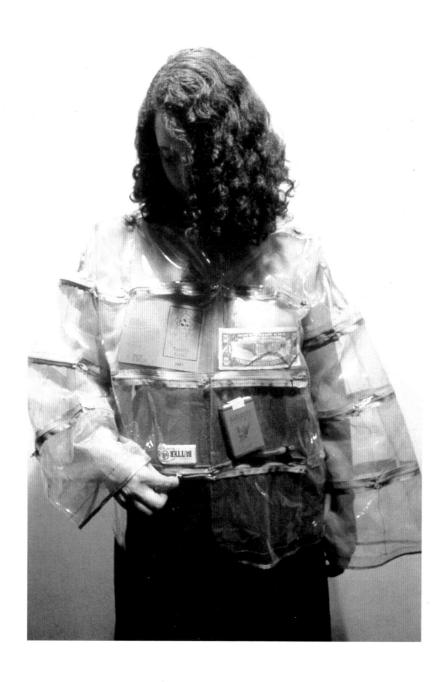

Vito Acconci, *Leaf Shirt*, 1985

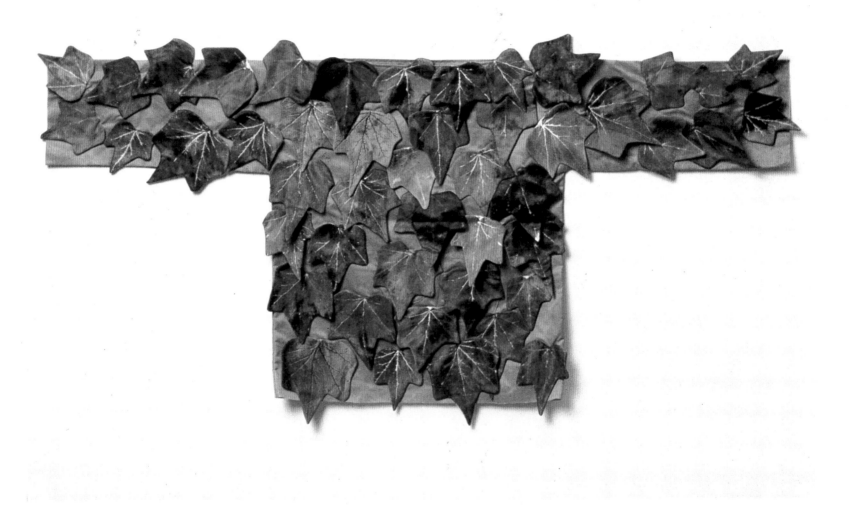

Judith Shea, *Four 3
Square Shirts*, 1977

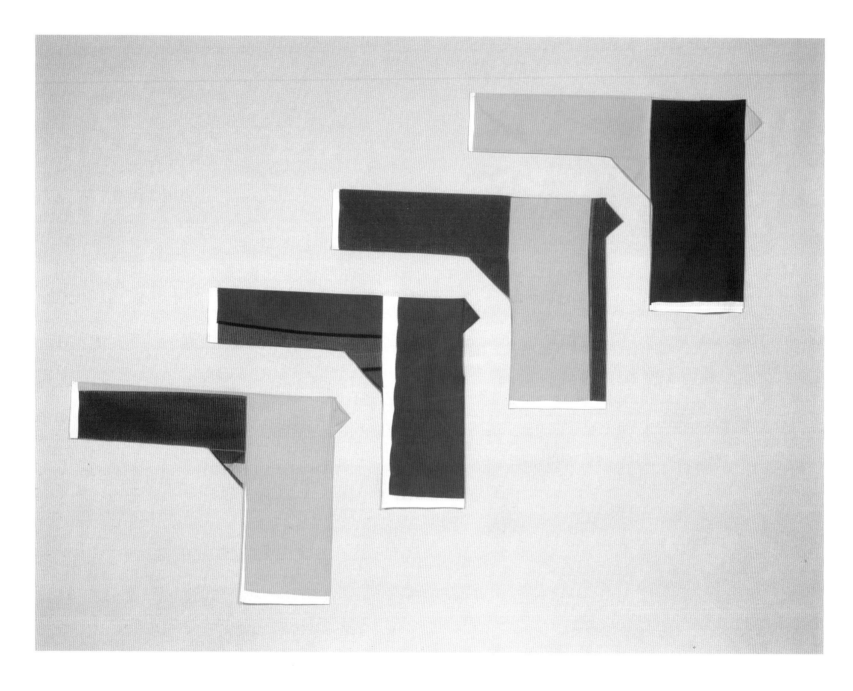

Judith Shea, *Mid Life Venus*, 1991

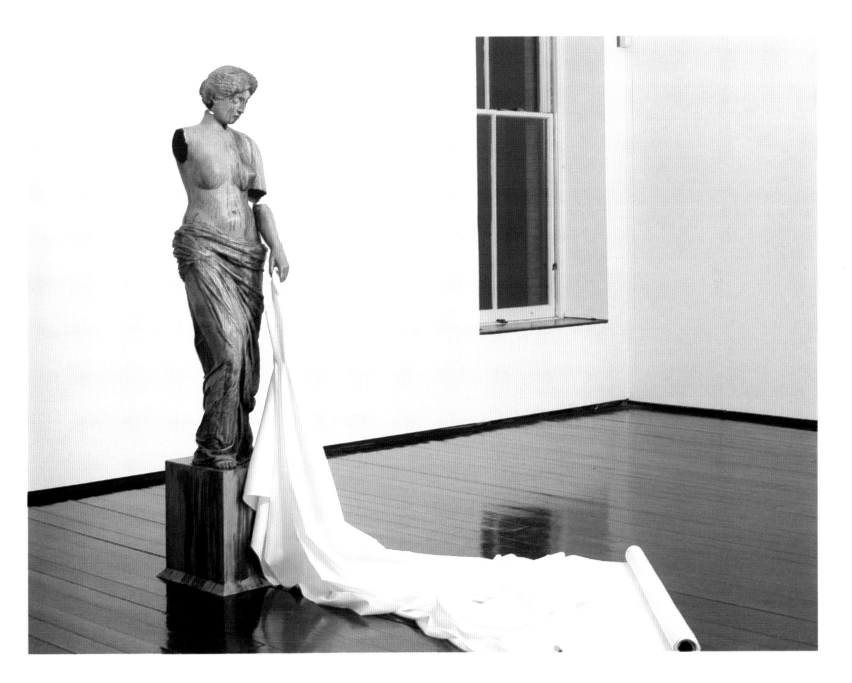

Rosemarie Trockel, *Ohne Titel* (Fleckenbild), 1988

Rosemarie Trockel, *Anzug*, 1986

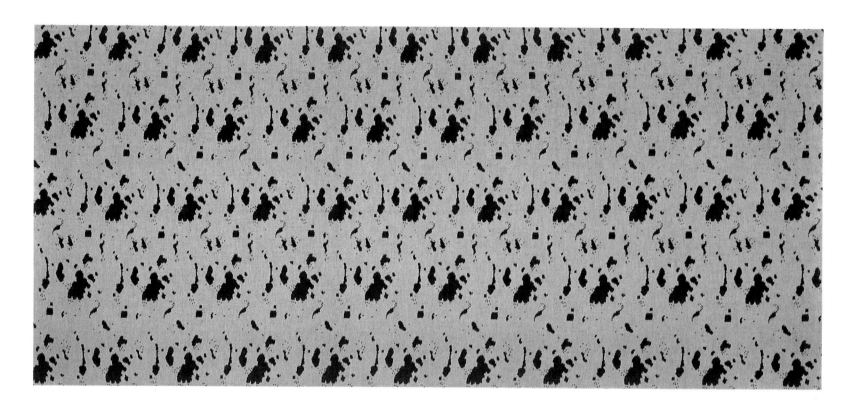

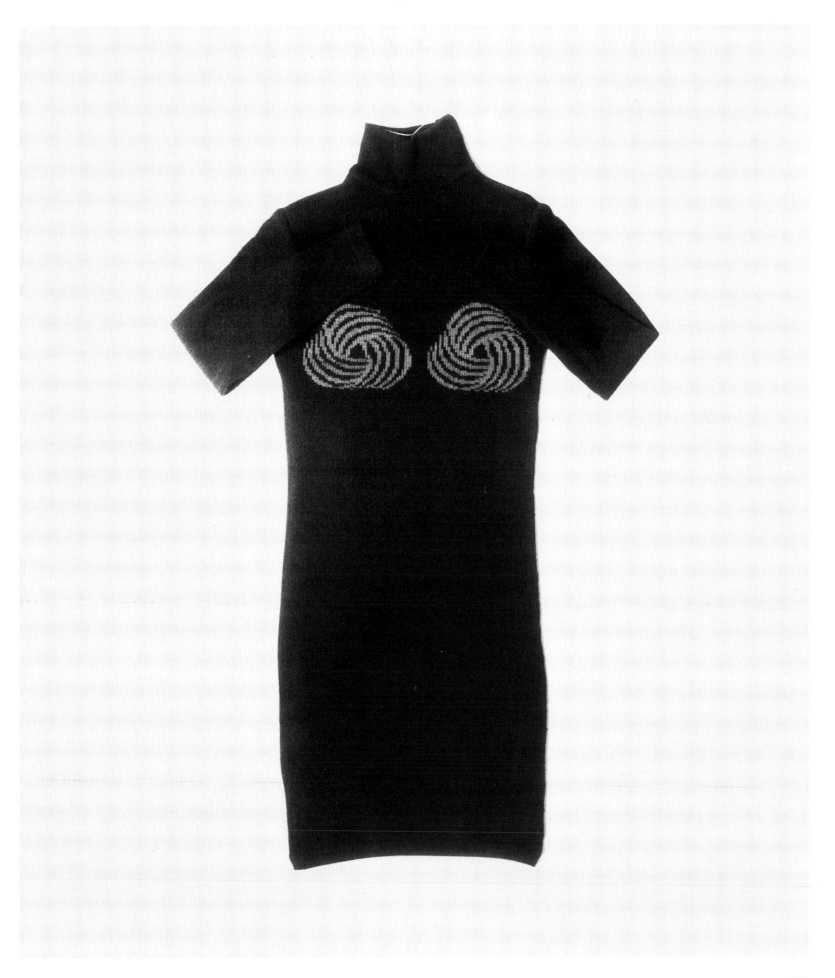

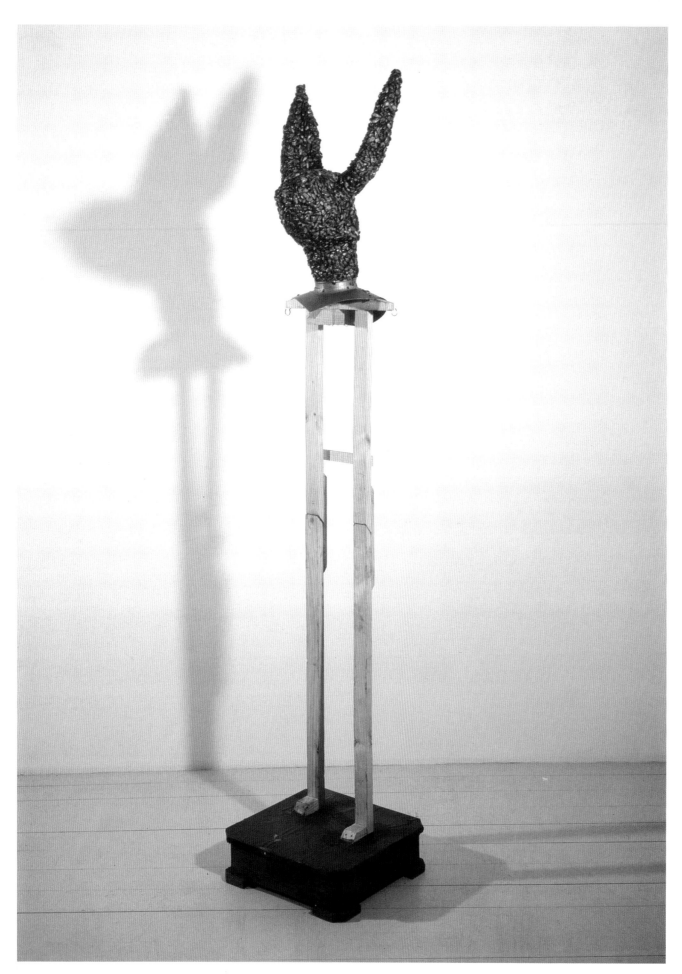

Jan Fabre, *Guerriers flamands*, 1995

Jan Fabre, *Mur de la Montée des Anges*, 1993

127

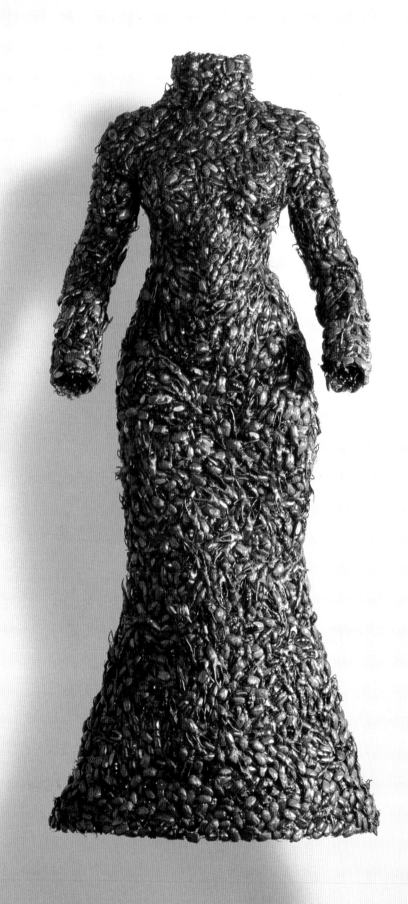

Jana Sterbak, *I Want You to Feel the Way I Do… (The Dress)*, (two pictures), 1985

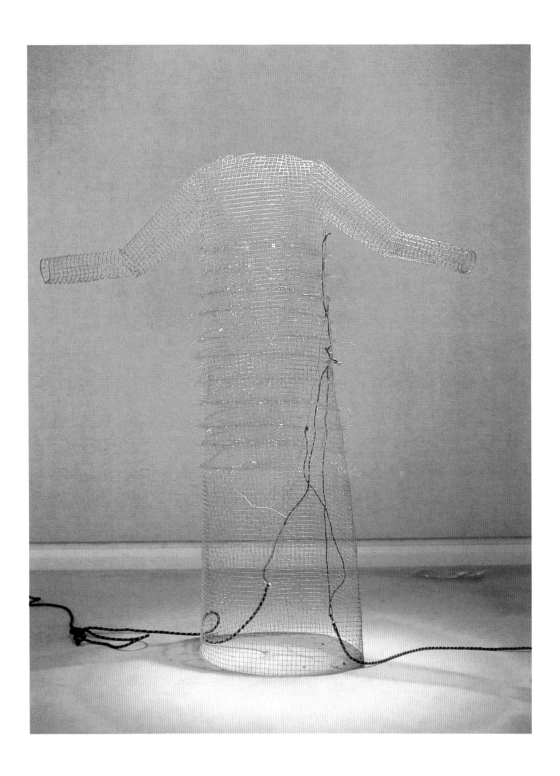

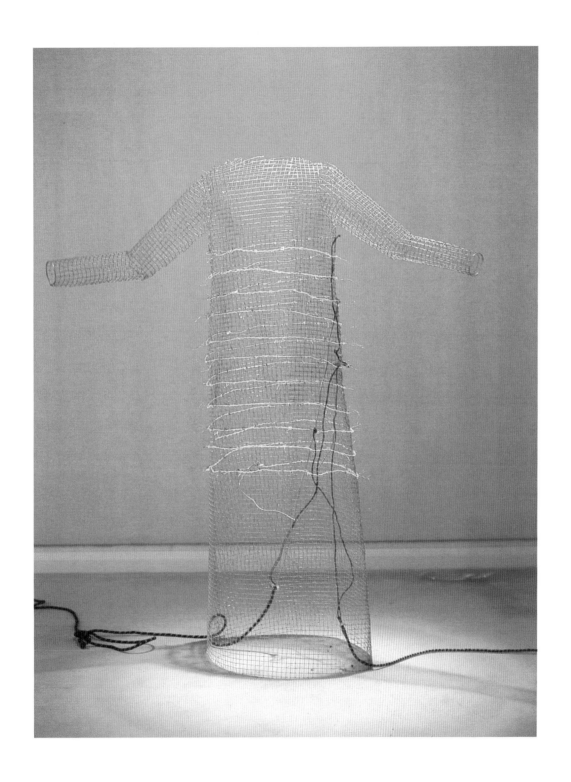

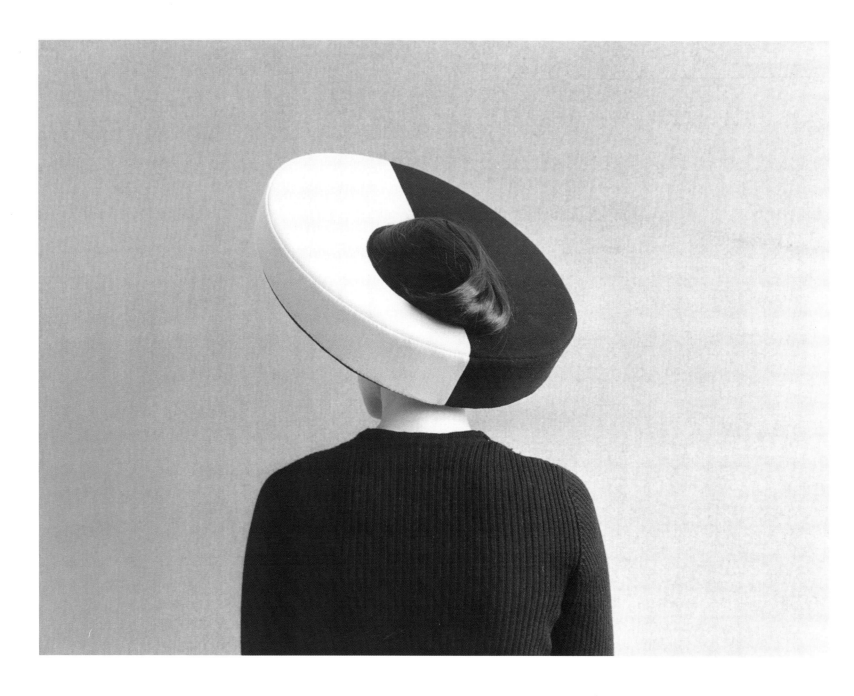

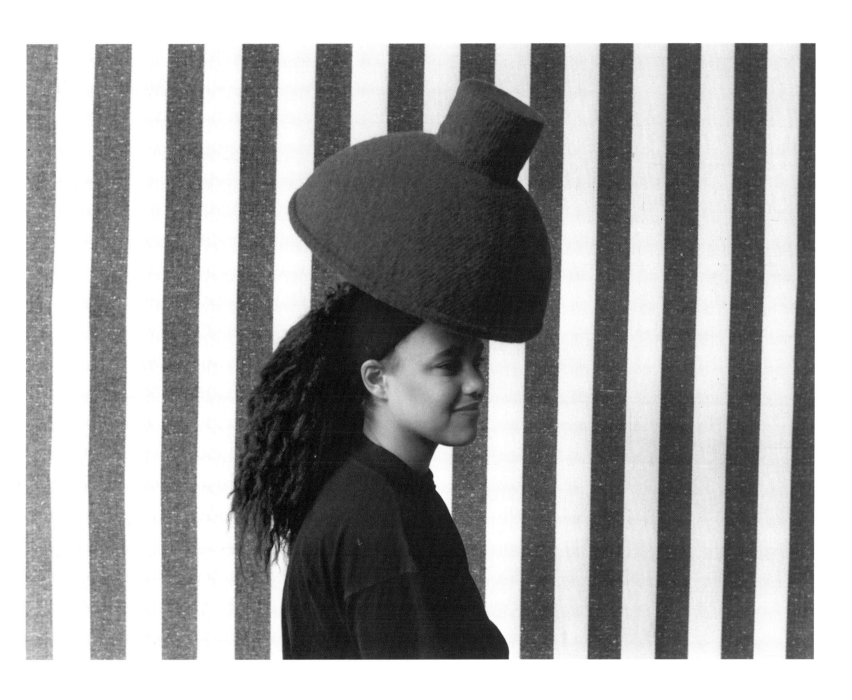

Wiebke Siem, *Hut*, 1988.

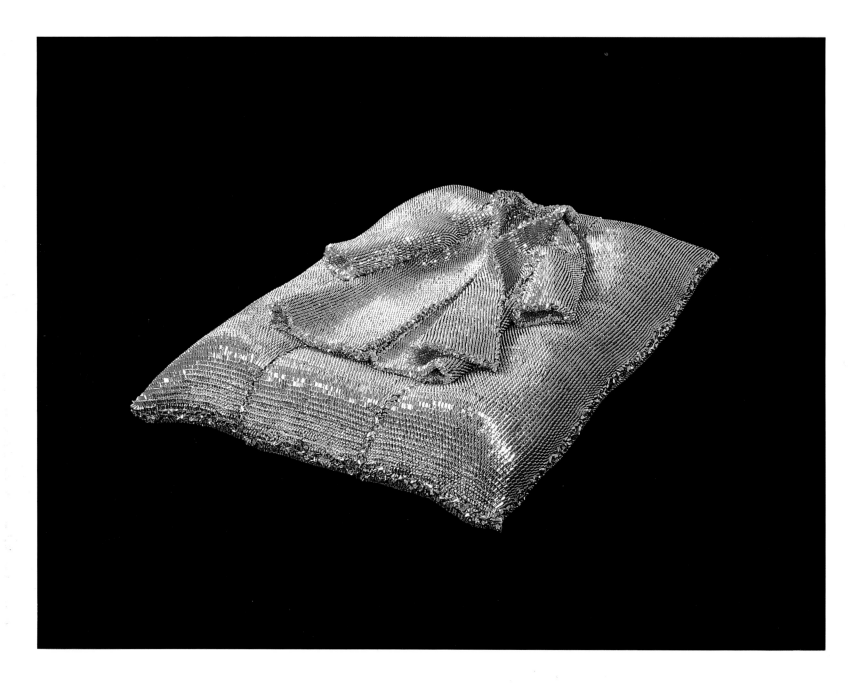

Beverly Semmes, *Figure In The Purple Velvet Bathrobe and Cloud Hat*, 1991.

Beverly Semmes, *Pink Arms*, 1995-1996.

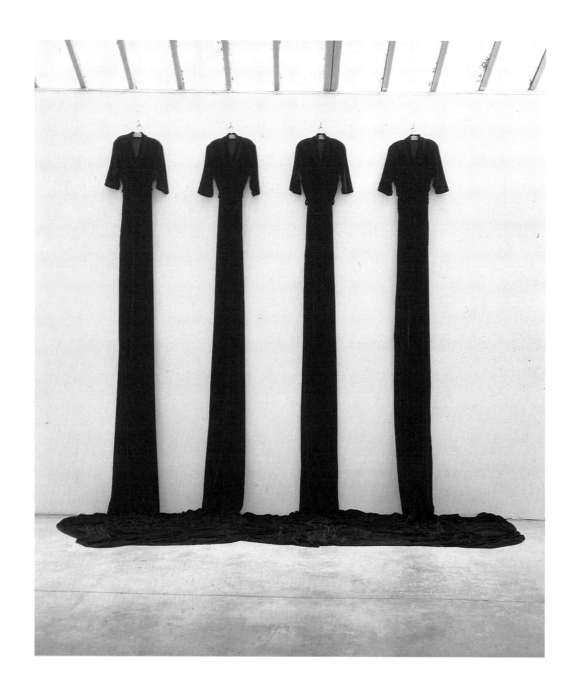

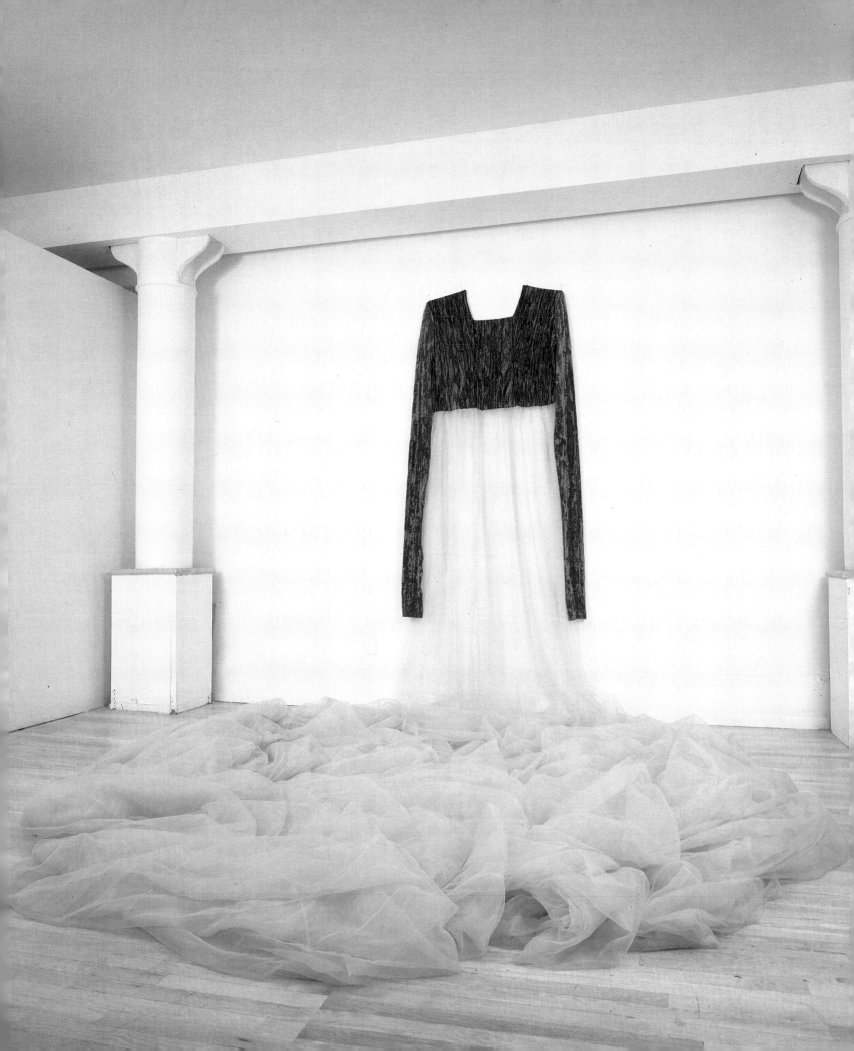

Art vs Fashion: A Vortex

The determining feature of the interactions of image and idea, of object and artwork, taking place inside the architectural structures designed by Arata Isozaki at the Forte Belvedere in Florence on the occasion of the *Art/Fashion* show, is the movement that arises between languages in harmony. This movement is based on the acceptance of a dialogue between art, architecture, and fashion. The principle behind it is the search for a radiant happiness that might lead to a conjunction of creative intents. At the same time, the hope is that an osmosis between visions originating in distant but sympathetic universes will give rise to an important, pregnant association that will shed light on the interrelationship of parallel disciplines and establish a give-and-take between them, either leading to a more synthetic condition for creative work, or confusing it and fusing it with other experiences. The common aspiration is toward an all-devouring gesture that will transform itself into a burst of pure intensity crystallizing the visual and spatial thought, past and future, material and immaterial, of the leading figures of contemporary culture.

We are witnessing the affirmation of an open definition of each person's work, thanks to the breakup of univocality in exhibition. Where these people always used to "exhibit" alone, the situation has now become more transitive, more inclusive of the great information network existing between research in the plastic and spatial arts, the arts of sound and touch, the arts of construction and performance.

The idea of bringing art and fashion together in one same energy field flows naturally from the continuation of an avant-garde tradition, ranging from Giacomo Balla, Salvador Dalí and Sonia Delaunay to Lucio Fontana, into the present day. The avant-gardes have effected a continuous transposition of art into all languages and forms, setting in motion a sequence of mediations and breaking down the barriers of "artistic" thought. Through their movement, seconded by the immediate response of renewal on the part of designers such as Paul Poiret, Elsa Schiaparelli, Bruna Bini and Germana Marucelli, the visual display of a dialogue between art and fashion has been realized. Their first steps have made possible the realization of an object for the body, an object of clothing, that has broadened the notion of "second skin." Today this transposition into an object has expanded into an architectural and spatial maelstrom in which art and fashion are seeking

a transparent medium not narcissistically linked to their own identities, but rather given to producing a common image ready to dissolve into the subterranean and perceptible current of an event.

An emancipation from all limits, a liberation from the obstacles of expectation, to create an exhibition that is an unconditionally versatile and open instrument. The disappearance of the single subject, be it art or fashion or architecture, in the realization of a maximum level of accomplishment and expansion.

Roy Lichtenstein's creative embrace of Gianni Versace, like the pairings of Tony Cragg and Karl Lagerfeld, Mario Merz and Jil Sander, Damien Hirst and Miuccia Prada, Julian Schnabel and Azzedine Alaïa, Oliver Herring and Rei Kawakubo, Jenny Holzer and Helmut Lang, revolves around the desire to plunge into a vortex of images and objects, of ideas and spaces, that will further open the fields of vision and sensation to where all trace of individuality will fade until it disappears.

This gathering and combining of opposites and differences for the purpose of arriving at a process of self-understanding of the arts, indeed brings about a dissolution of individual protagonism, favoring instead a dialectics of forms and signs, colors and actions, which shifts attention away from the "protagonist", the artist or designer, and toward the language produced, which is the true source from which spring the new experiences and transformations of old notions of making and exhibiting.

Giving priority to the aspect of unity and exchange over that of distinction and competition, this proposition aims at redefining the activity of art and fashion as a public operation and process analogous to that of scientific research, which credits results to teamwork. The only difference is that here the interchange is not subjected to the twists of function and use, of otherness, but rather spills over in a free flow of images. It asserts itself as a fusional entity that overwhelms and consumes in order to create a magnetic, incantatory situation at once magical and fluid. And if the main characters are cancelled out as individuals it is because the public is seduced and ensnared by this vortex, this new condition of being-present, which arises from the poetic impulse unfolding between art and fashion.

It is not a question, however, of dissolving the originality of the single, individual contribution, but rather of returning to the artwork as the construction and expression of a practice inscribed within the history of the other languages, thereby hazarding solutions and reflections. This does not imply a reduction of differences and a levelling of all forms and languages onto a single register, but rather an opening up to the dizzying prospect of dissolving identities in order to emphasize the value of a dimension that combines within itself all the features of an experience serving to transform relationships. The spell is cast by the architecture. The buildings designed by Arata Isozaki introduce an element of surprise and magic into the historical configuration of the Forte Belvedere. They are elementary forms and envelopes made complex by the intersection of pure volumes, which create a wholly unexpected landscape through the dialogue between Isozaki's minimalist architecture and the Renaissance architecture of Buontalenti, an encounter between contemporaneity and history, ephemerality and permanence, move-ment and stasis, lightness and strength. The essential, abstract quality of the volumes clearly evokes a formal rarefaction and sublimation, an inner breath, silent and rare. It is

an architecture of ideal refinement perfectly suited to the hypothesis of an ideal dialogue between art and fashion. The perspective on which Isosaki's architecture rests is based on the power of the encounter between elementary forms that trigger a spectacular, architectonic communion. This experience expands the centripetal force of art and fashion beyond proportion, making them converge at a central point, where they decant their theatricality in order to find something other. At times this other takes the form of a double—that is, fashion reflecting itself in art or vice versa, and spawning a new epidermal text. Such is the case with Roy Lichtenstein and Gianni Versace, whose encounter has unleashed a parallel flow on the theme of the surface image. Here the attention is focussed on an awareness of the power of the skin of a sculpture or article of clothing, as an apparatus of spectacle fraught with gesture, which in Lichtenstein takes the form of a dynamic energy and in Versace is concretized in the transparency of the materials and weaves, which are shot through with light.

The oscillation between the unbridling power of action on canvas and the culture of elegance find a strong nucleus in the collaboration between Julian Schnabel and Azzedine Alaïa. In embracing Isozaki's architectural "representation", Schnabel and Alaïa have taken their cues from a visual drama of volumetric verticality and created paintings and clothes whose impact lies in the upward sweep of the very body of the painting or the fashion. Here we witness the rigorous progression of a friendship and dialogue that dates back to the eighties, when Schnabel decorated the interior of Alaïa's atelier, and the designer designed clothing for people close to the artist. The mutual transfer of energy between the two is based on a delicate balance of mutual fascination, where the forms of the painting and the charge of the painter's gesture are interwoven with the dynamism informing the clothing, whether this dynamism is determined by clasps or by exotic ornaments.

A different sort of tension sustains the interplay between Tony Cragg and Karl Lagerfeld, who to a stage of camera-shaped architecture bring the portrait of their own linguistic complexity. Cragg entrusts Lagerfeld with the labyrinthine intinerary of the inside of his sculpture, inviting the designer to "dress" his works, which already convey the idea of a relationshiip between surface and form, skin and body. The gesture is a generous one, and dissolves the usual perceptions of art as "untouchable", entrusting it to the metaphoric flux of other people's gazes. Likewise, Lagerfeld breaks out of his customary role as designer in order to dive back into the open language of pure creativity. He relies on the profound intensity of his photographs and their spellbinding enchantment, which stems from his perceptible absorption in landscapes and architecture, stories and people. His is a visual appropriation of the world, whereby he is able to knock down all boundaries and call into question all privileged models of language. The mode of procedure is continually shifting, and this is also reflected in his designs, when he stages a total spectacle combining sensuality and the movement of bodies and clothes. He takes total control of his materials in order to regenerate them.

The same thing happens in his dialogue with Tony Cragg. Upon being offered to work with his sculptures, Lagerfeld responded with a total visual transformation, effected by a chromatic threshold that enhances the identities of the individual sculptural elements in order to transform them into splendid bodies. A body is highlighted from below, and

Cragg then responds with the visualization of other bodies sliding on the surface of photographs, in a corrosion of fixity that unleashes the latent volatility of things and figures, whether they be sculpted or photographed.

Interior space, the space of architecture and of the body, is the crystallization of an immateriality that Oliver Herring and Rei Kawakubo wish to shower with attention. Their offering moves in the sphere of an incorporeality conveyed in the lightness and transparency of the materials, which range from Mylar to muslin, from light to color. We find ourselves before a non-physical energy, condensed only by the luminous presence passing through it. Whether this is a woven figure or a landscape, the imperative here is absence, the acceptance of an emptiness that is fullness in as much as it is the manifestation of an interiority, the structure of dress as well as of feeling and seeing. In opposition to the weight of the flesh, which remains infused within the second skin, they offer a metaphysical notion of dress.

Jenny Holzer's and Helmut Lang's path toward a mutual integration of each other's languages passed through the zero- point that moves from dressing to undressing, from looking to smelling to thinking. The collaboration's first test was a film project in which the luminosity of the body had to undergo the experiences of love and horror, life and death, sensuality and bestiality, pleasure and suffering, before finally arriving at a union that might allow for the existence of a highly conceptual, sensory elsewhere, the encounter between word and fragrance as brought together on the neutral terrain of clothing: "I smell you on my clothes".

All is given over to a different reality, that of the language of sight and smell, which through their magnetism seduce and enchant us, and make us conscious of a form of existence that through reading and sensory perception can experience itself as different.

By contrast, the magnetism of the natural energy of air, made up of noise and silence, movement and stillness, turbulence and calm, is what attracted the attentions of Mario Merz and Jil Sander. Unlike the physical, bodily dimension of the other projects, their collaboration seeks to concretize an object and fleshliness that "fade away". It is an attempt to create a fantastical image, to give visual and formal shape to nothingness. They have focussed their sensibilities on refining the gaze, on what passes through the flow of air: the wind. They offer an appearance based on its swirling and calmness, made physical by the rippling and movement of natural fragments such as leaves and other things, or by a filiform structure, light and transparent, a tactile surface that gives form to the atmosphere. Inside Isozaki's unusual cylindrical architecture, two imagined universes of diaphanous and airy energy meet: on the one hand, the power of a charge in continuous, dramatic movement and transition, eluding all control; on the other, the clarity of a vaporousness becoming substantial form, the lowest substratum of an experience of the vitality of clothing.

The dynamics of the imaginary in Damien Hirst and Miuccia Prada involves yet another dimension of nature, the animal universe that underlies all primordial dreams. Here communication depends on the desire for a caress, a contact with the life pulsating uncontrollably and unpredictably in front of us. The invocation of nature is an appeal to the normality of a visual wonder that needs no artificiality to be elegant. It is an extreme gesture, where the thing displayed is not simply the vehicle of an intellectual or design

function, like a painting or an article of clothing, but makes itself manifest through its natural beauty and amiable sweetness, its subtle sensuality and distinct bearing.

In conclusion, it is clear from these seven experiences of of dialogue between art and fashion that the results come not from a quest for superiority among languages, but from an attempt to transcend the limits of one's own genre of expression, to harmonize with the other. In many of these cases, both the artist and the fashion desinger have "denied" themselves in the search for an affinity, merging their creativities in an intermediary realm. The key to understanding their union lies in the magnetism of the liberating process bringing their languages together. Both of these languages provide an envelope, a shell, to a set of sensory and spiritual desires and aspirations, helping to make them visible. Both artist and designer have tried to find a mutual resemblence, in which they might meet and mirror one another. This has given birth to a mimetic process where the identities of art and fashion at times have come close to each other without merging, and at times have become fused, taking on utterly unusual and unexpected characteristics.

In the final analysis, while the collaborations presented by the interaction of architecture, fashion and art have yielded a result ever mindful of the transition between clothing and body, they express this transition, this passage, through the movement of the elements that surround and document it. Whether it is photography, wind, forms, animals, painting, dust, clothing, words, light, volume, image, fabric or fragrance, all the implements used here intend to graft, in the audience's senses of sight and touch, a new sensibility onto the interplay between the outward forms of art, fashion and architecture. In this process, everything becomes "clothing", even if it does not assume its traditional form and substance. Building and sculpture, scent and writing, light-source and air, all are transformed into a "second skin". They help us to see and to feel the body through its infinite modes of being perceived, so as to see and be seen at once, in a transition, a transference, that can only be realized after the boundaries have been breached and the exploration begun.

Tony Cragg / Karl Lagerfeld

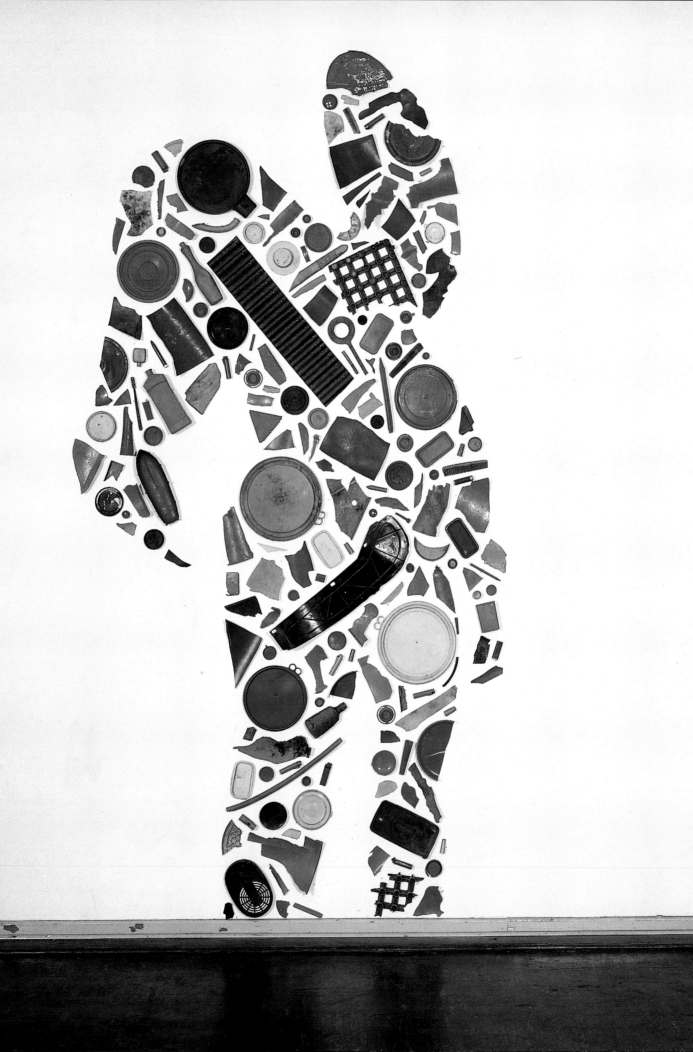

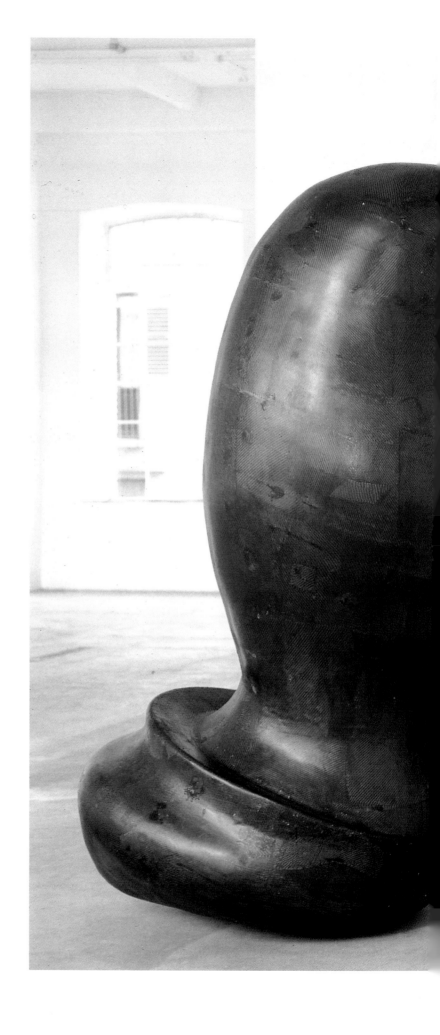

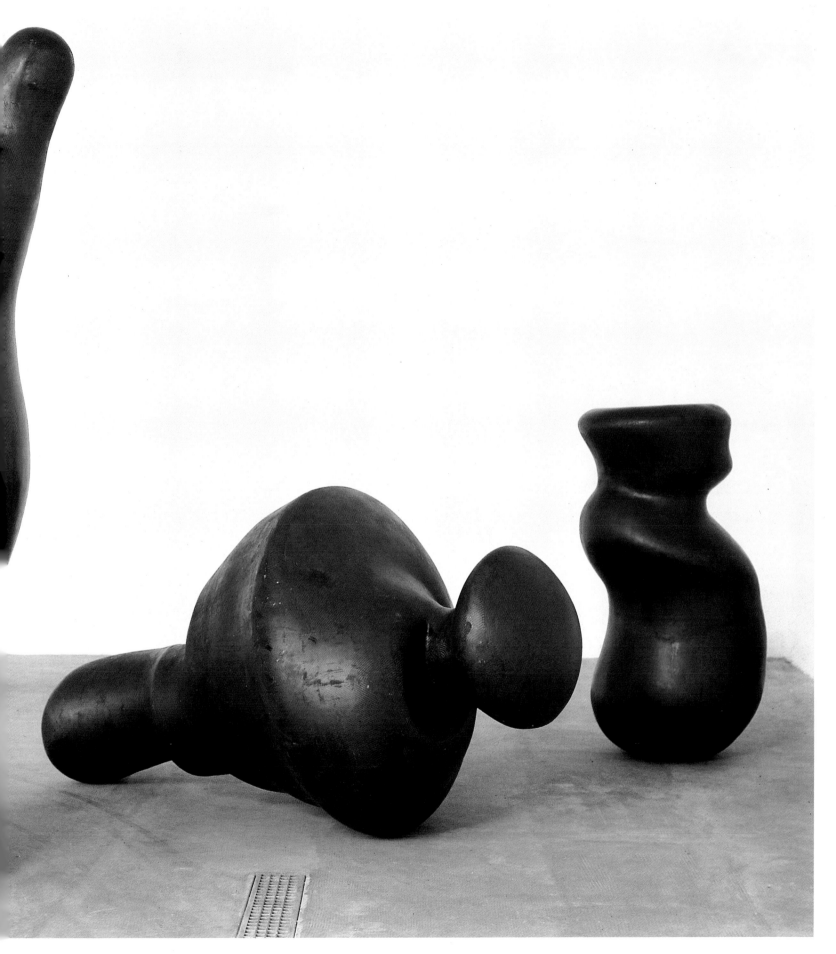

Beings created

by

TONY CRAGG

sketches by Kene Lagerfeld 96

152

153

TONY CRAGG

KL96

154

Jenny Holzer / Helmut Lang

I SMELL YOU O

N MY CLOTHES

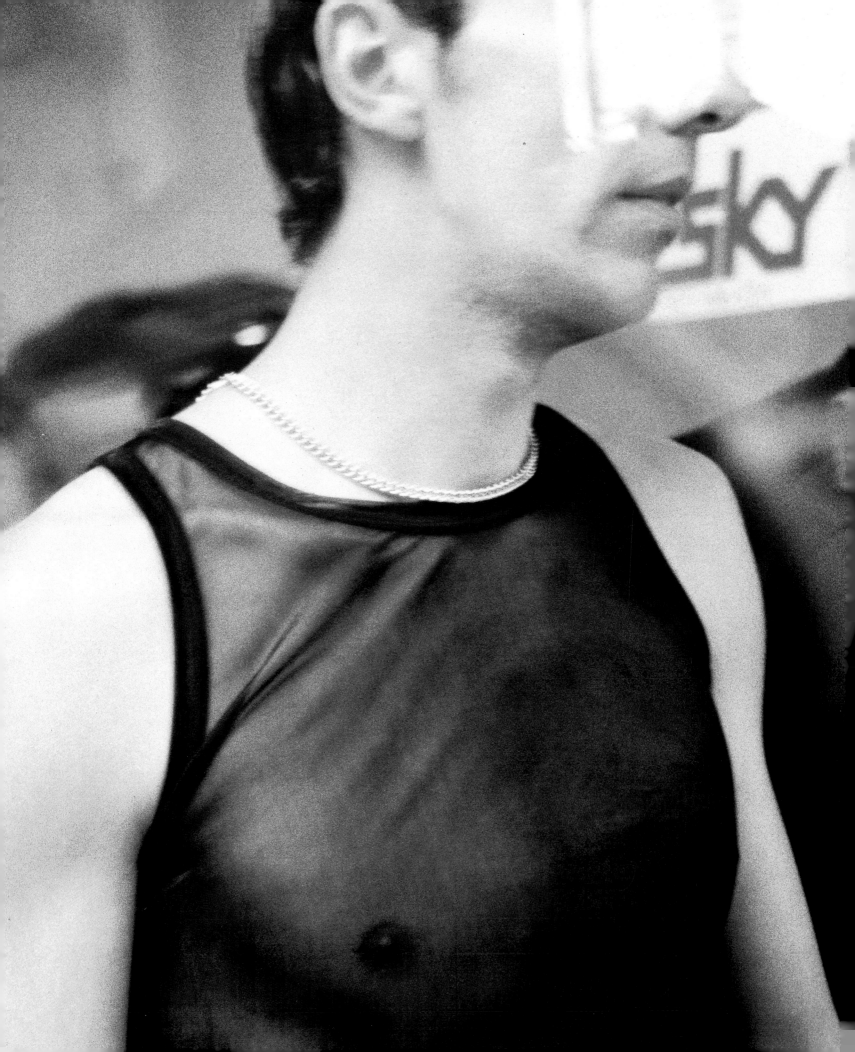

»Ich bin nur zufällig hier. Meine Kleidung ist mitgekommen, ohne mich zu fragen.«

Zitiert wird Helmut Lang ständig, da muß man nur die Kollektionen seiner Kollegen anschauen oder dem Gerede über Mode zuhören. Hier eine Seltenheit: O-Ton.

INTERVIEW: MORITZ VON USLAR

1 **SZ-Magazin:** Helmut Lang, was haben Sie gerade an?
Helmut Lang: O Gott... was habe ich gerade an... also, Jeans, Pullover, T-Shirt, reicht das? Nein. Reicht wahrscheinlich nicht. Man will das genau wissen von einem, der Mode macht: Die Jeans ist von Levi's, Model 501 – hat jeder, kennt jeder, eine Erklärung ist überflüssig. Der Pullover hat einen V-Ausschnitt. Ist blau. Aus Kaschmir. Vielleicht aus England. So ein englisches Traditionsding. Soll eng sitzen. Sitzt bei mir wohl wie etwas, das man kleingewaschen nennt.

2 **SZ-Magazin:** Was werden Sie heute abend anziehen?
Lang: Dasselbe. Was sonst? Was soll ich denn sonst anziehen? Für mich existiert diese Tageseinteilung morgens/mittags/abends nicht. Genausowenig wie für mich die Einteilung Job/Freizeit existiert. Oder arbeiten/ausruhen. Oder Jugend/Geld verdienen/Tod. Oder wie man sonst zu einer Reglementierung sagt, die einem das Leben, Sekunde für Sekunde, zur Hölle macht. Es gibt den Smoking-Abend und den Abend, den ich laufen lasse, wie er gerade Lust hat zu laufen. Den Abend heute werde ich der Arbeit überlassen.

3 **SZ-Magazin:** Besitzen Sie ein Kleidungsstück, auf das Sie stolz sind?
Lang: Nein... nein, wirklich nicht. Ich denke, meine Vorstellung von Stolz ist eh eine, die ganz allein mir gehört – reden wir nicht davon.

Ich mag Kleidung, die eingetragen ist. Sie geht dann mit mir eine Beziehung ein. Sie trägt sich mit mir ein – das kann mit einem Stück passieren, von dem ich selbst es anfangs am wenigsten erwartet hätte. Kennen Sie diese Armketten aus Silber? Mitte der Sechziger trugen sie die Filmstars der französischen Nouvelle vague. Ich trug so ein Panzerarmband um 1977, als ich in Wien als Kellner arbeitete. Ich bin stolz darauf, daß auf der Silberplatte bis heute kein Name eingraviert ist. Vielleicht werde ich es bald wieder tragen.

4 **SZ-Magazin:** Was heißt überhaupt »gut angezogen«?
Lang: Oh, oh... was für eine Frage! Können wir später darauf zurückkommen?

5 **SZ-Magazin:** Was machen Sie so in den fünf Minuten vor dem Einschlafen?
Lang: Ich denke fest an Uma Thurman. Ich glaube, daß ich sie mag. Ich glaube, daß ich sie treffen möchte. Und ich weiß, daß sie meine Sachen trägt. Vor gut einem Jahr gab mir jemand ihre Telephonnummer und sagte: Sie hat heute mit mir über dich gesprochen. Ruf sie an. Sie wird sich freuen. Ich sprach mit ihrem Anrufbeantworter. Noch mal anrufen fand ich nicht gut. Ich dachte: O Mann! Rufe ich sie noch einmal an? Dann traf ich sie zweimal – und traf sie doch nicht. Es war ein Abendessen der italienischen *Vogue* im Ballettsaal der Mailänder Scala, dann eine Ausstellung von Bruce Weber in New York – zwei Räume, groß genug für rund hundert Leute, zu groß für Uma und mich. >

Photographie: Linda und Johnny von Jürgen Teller, Willem Dafoe von Glen Luchford, Christy von Steven Meisel, Thomas von Elfie Semotan

HELMUT LANG FINEST CLOTHES SINCE 1986 PHOTOGRAPHED BY GUIDO PAULO DURING THE FITTING FOR THE HELMUT LANG 94/95 SHOW IN PARIS
SILK SHIRT WITH WHITE COLLAR AND TAYLOR-MADE SMOKING JACKET

Available in black only

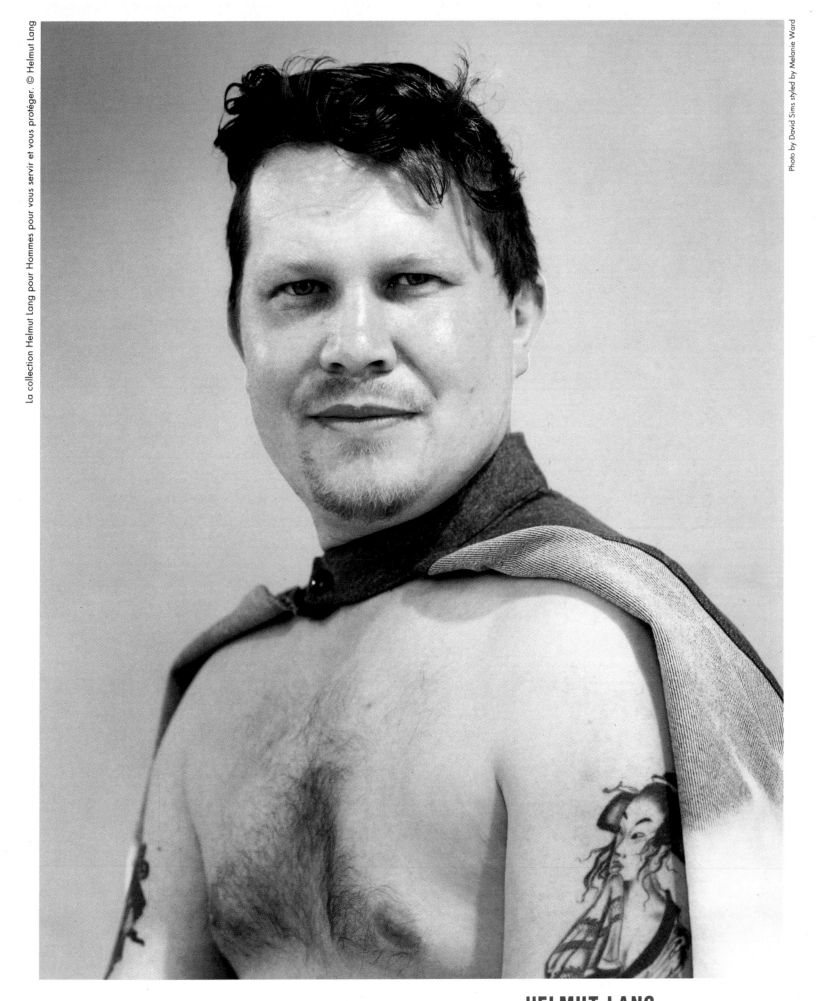

Helmut Lang Men Collection to serve and protect you ©HELMUT LANG **HELMUT LANG** PRETAPORTER **1995**

Roy Lichtenstein / Gianni Versace

Roy Lichtenstein,
Brushstroke V, Drawing
for Sculpture, 1985

Roy Lichtenstein,
Brushstroke, Study for
Sculpture, 1985

Roy Lichtenstein,
Brushstroke Nude,
Drawing for Sculpture,
1992

Roy Lichtenstein,
*Brushstroke Nude, Study
for Sculpture*, 1993

Roy Lichtenstein,
*Brushstroke Nude, Sheet
of Studies for Sculpure*,
1993

Roy Lichtenstein,
Brushstroke Nude,
1993

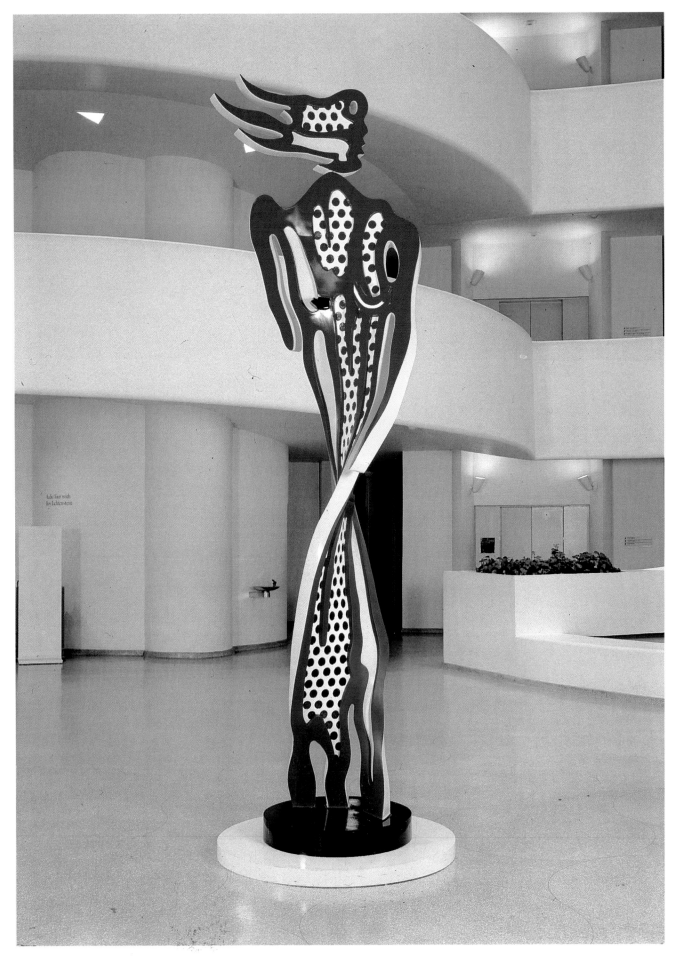

L'arte è sfida. L'arte è visione. L'arte è il gesto violento che rompe le barriere e costringe ad alzare gli occhi. L'arte è una guida che non si cura di chi la sta seguendo, perché ha in se le ragioni della sua esistenza, ma si apre generosa a chi vuole camminarle al fianco per attingere alle sue sperimentazioni.

Forma di espressione duttile, malleabile, la moda può ripercorrere queste strade adattandole a se e alle proprie esigenze, interpretandone lo spirito e non la lettera per non cadere in quelle operazioni da gadget museale - trasformare un quadro in vestito, l'omaggio a Vermeer, riaggiornare Rembrandt - che denunciano una paradossale povertà di ispirazione.

Ma il colloquio tra l'artista e l'abito - dunque, il corpo umano e la sua duttilità - ha sempre trovato nel tempo aspetti e accenti unici, emozionanti.

Raoul Dufy disegnò tessuti; Picasso scene e fondali per i balletti, ma anche costumi. Sonya Delaunay rivestì con i suoi cappotti di maglia multicolore le elegantissime degli anni Venti.
Ernesto Thayaht, il futurista che inventò la tuta femminile come vestito quotidiano, collaborò con Madame Vionnet.
Del resto, nella Ricostruzione futurista dell'Universo che quella banda d'artisti aveva in mente, l'abbigliamento, da Fortunato de

Pero a Giacomo Balla, ebbe un ruolo fondamentale, con le futurfarfalle svolazzanti tra farfalfiori su sciarpe e foulard.

Da anni anch'io vado esplorando i territori di una possibile collaborazione, convinto come sono che il nostro lavoro artigianale, integrato all'arte, si avvicinerebbe al valore e alla credibilità di una espressione artistica e potrebbe generare risultati sorprendenti anche nella tecnologia.
Personalmente sono stato attratto da Klimt e da Kandinski, da Picasso e dalla razionalità del Costruttivismo Russo.

Mi affascina questa volontà rivoluzionaria di cambiare il mondo che ritrovo oggi nella pop art e nelle correnti di avanguardia.

Per me il più fortunato e stimolante degli incontri: Frank Moore, Julian Schnabel, Jim Dine, Philippe Taaffe sono energia pura, folgorazione, l'entusiasmo di idee e sensibilità nuove, senza però dimenticare il lavoro per il teatro con altri grandi nomi come Arnaldo Pomodoro, Luigi Veronesi, Bob Wilson, né l'arte moderna italiana di Palladino, Cucchi, Boetti, Pistoletto, Rotella, Schifano, che mi hanno aiutato e trasmesso grandi emozioni.

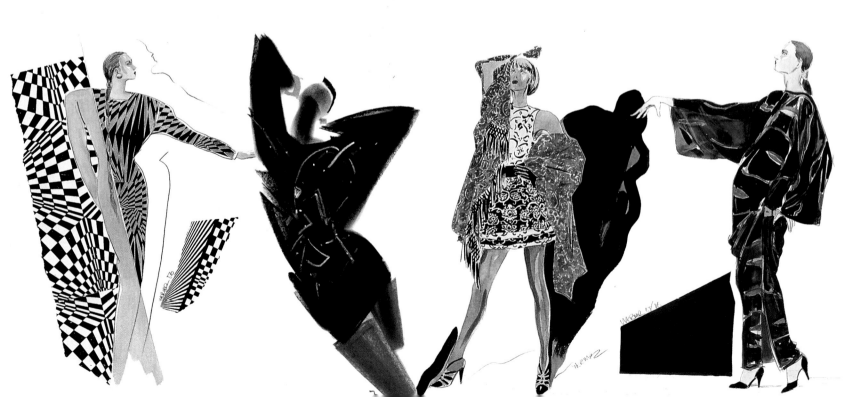

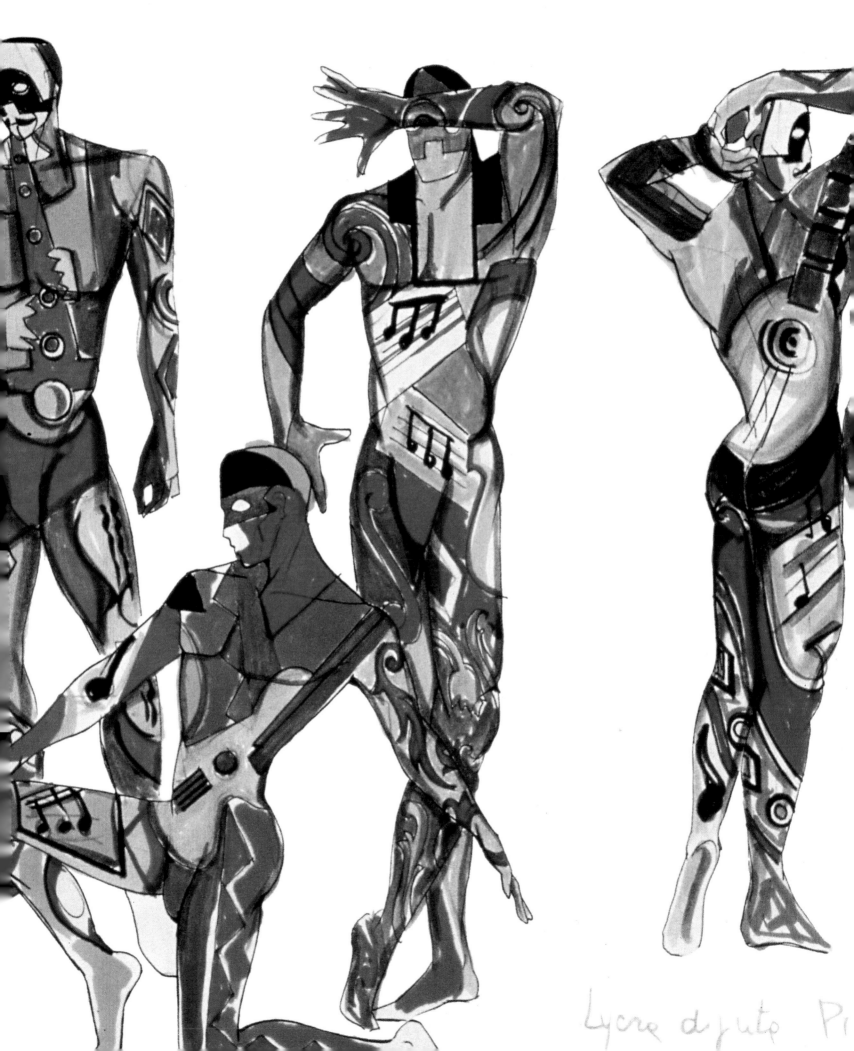

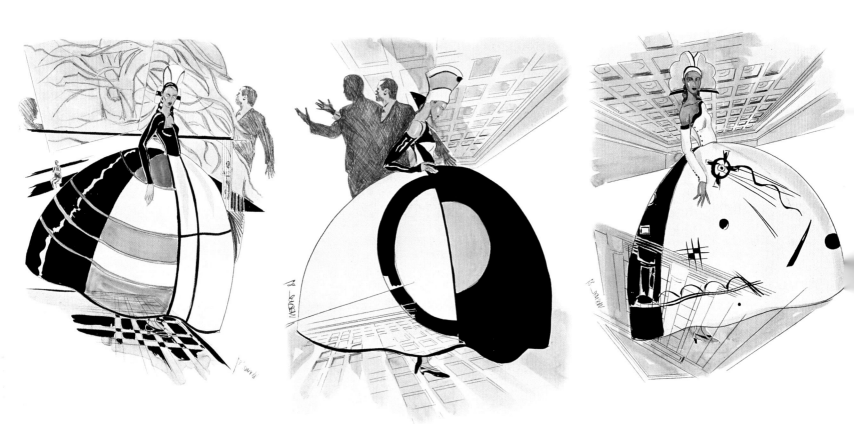

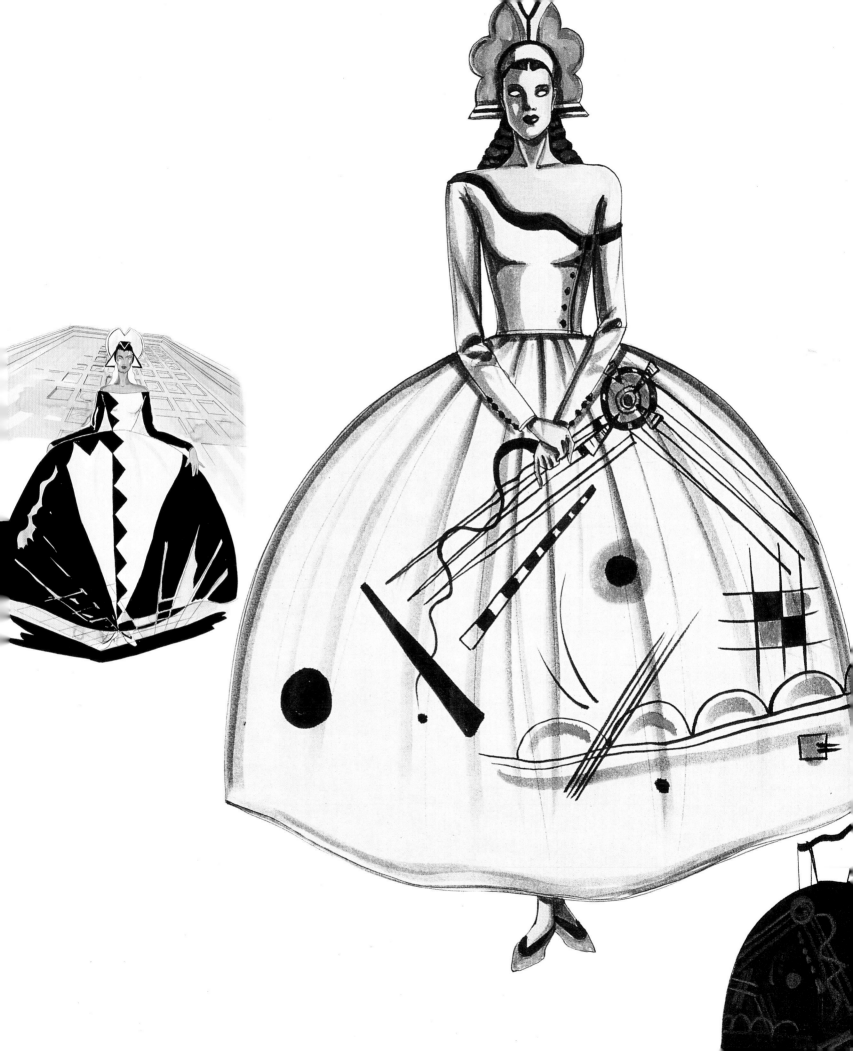

Julian Schnabel / Azzedine Alaïa

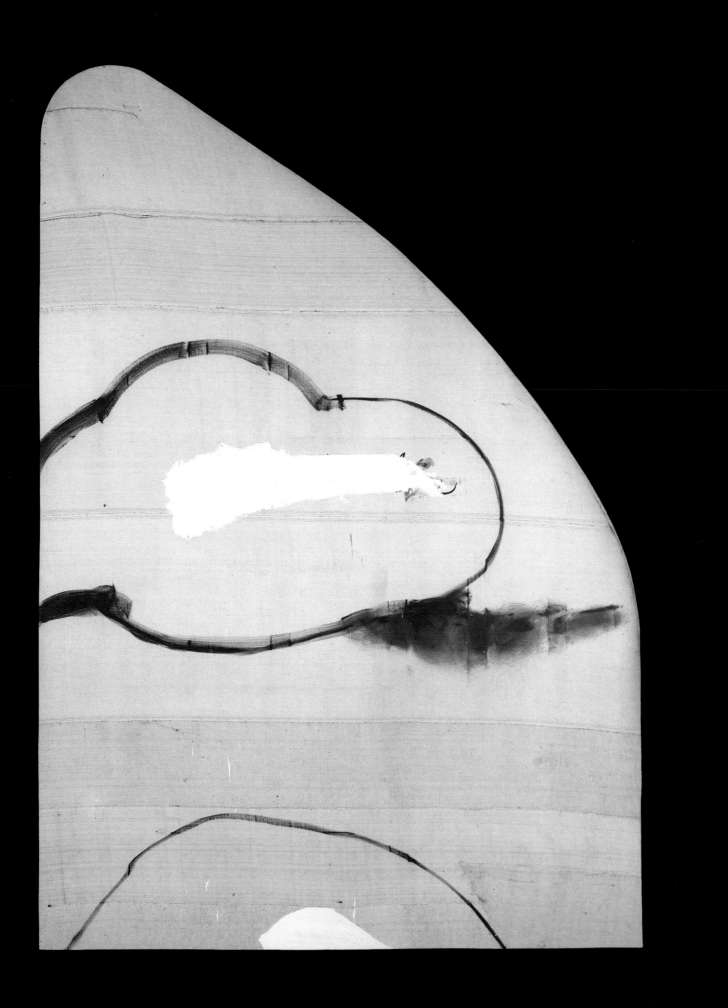

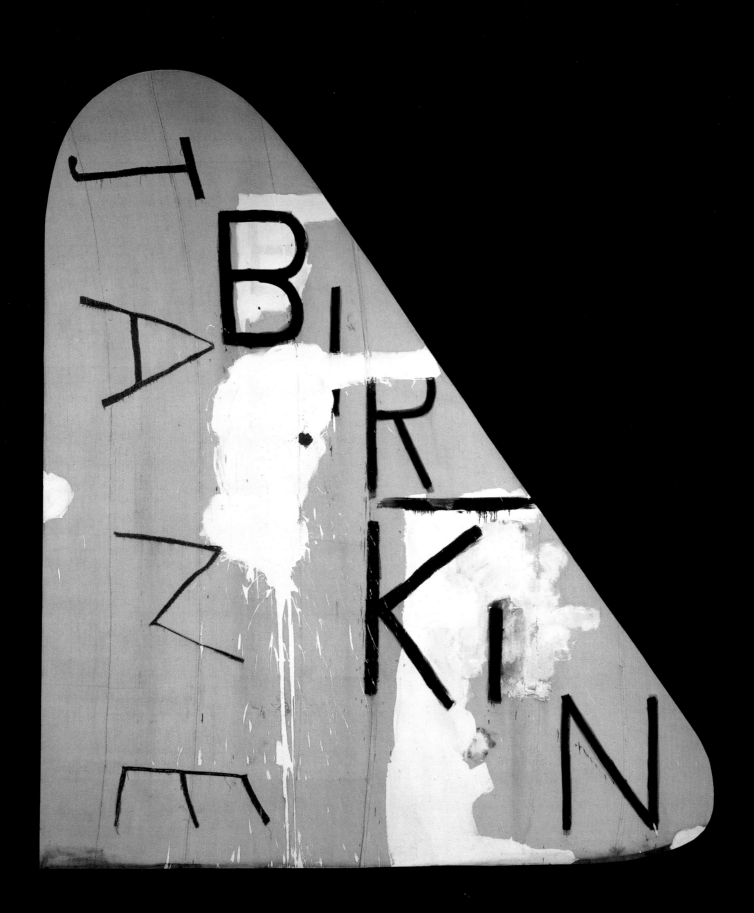

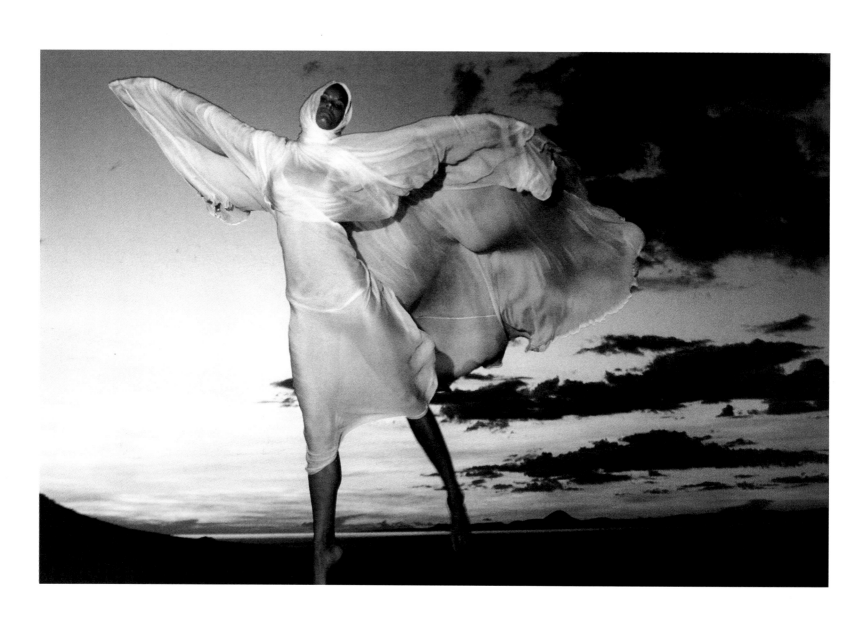

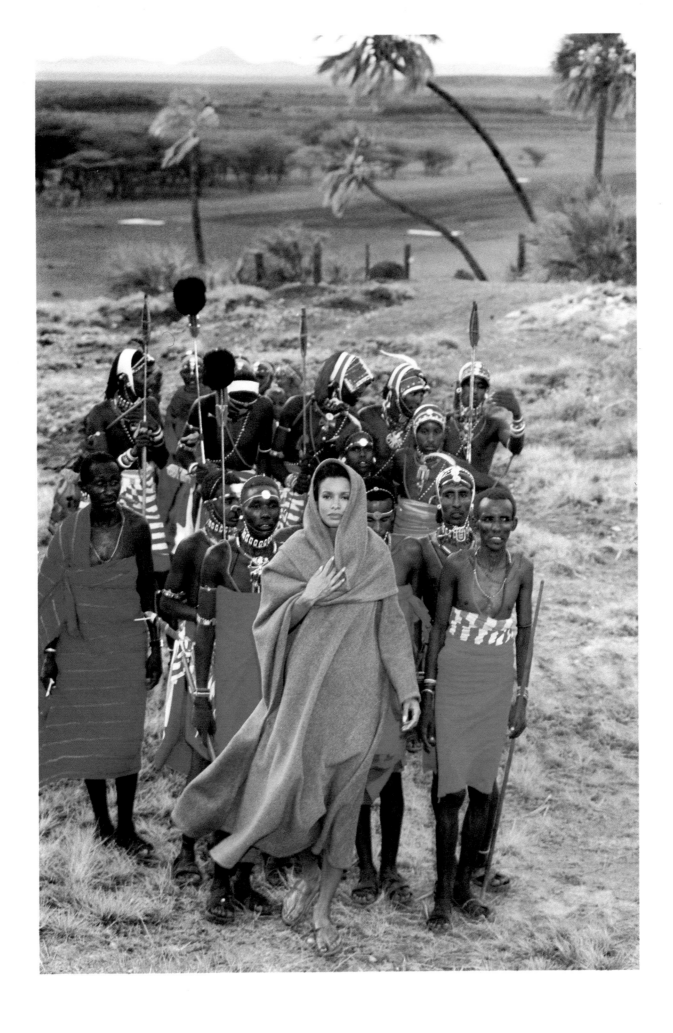

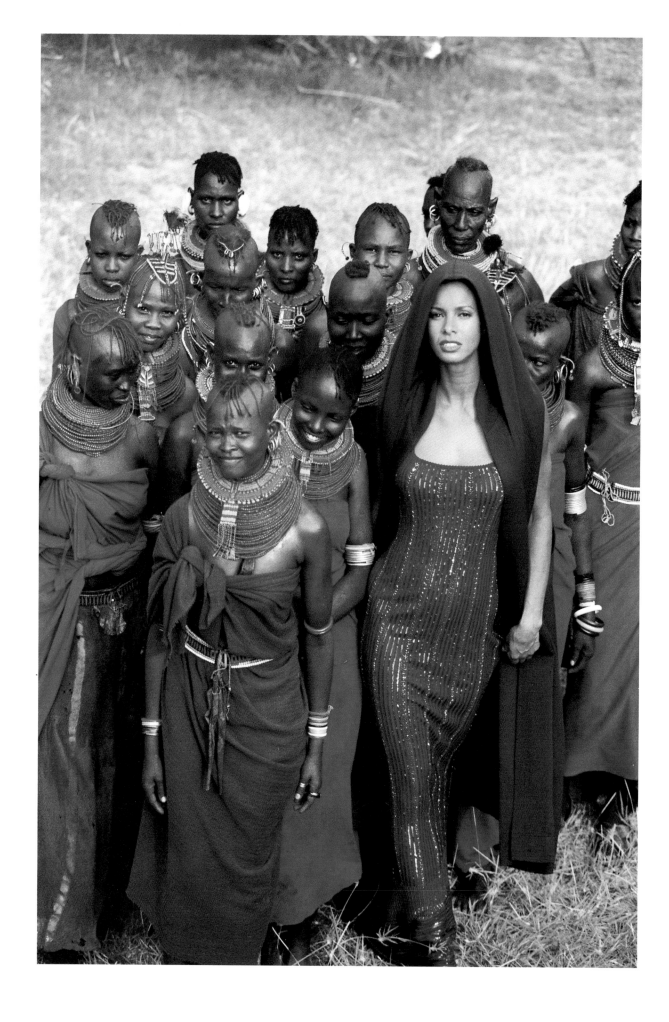

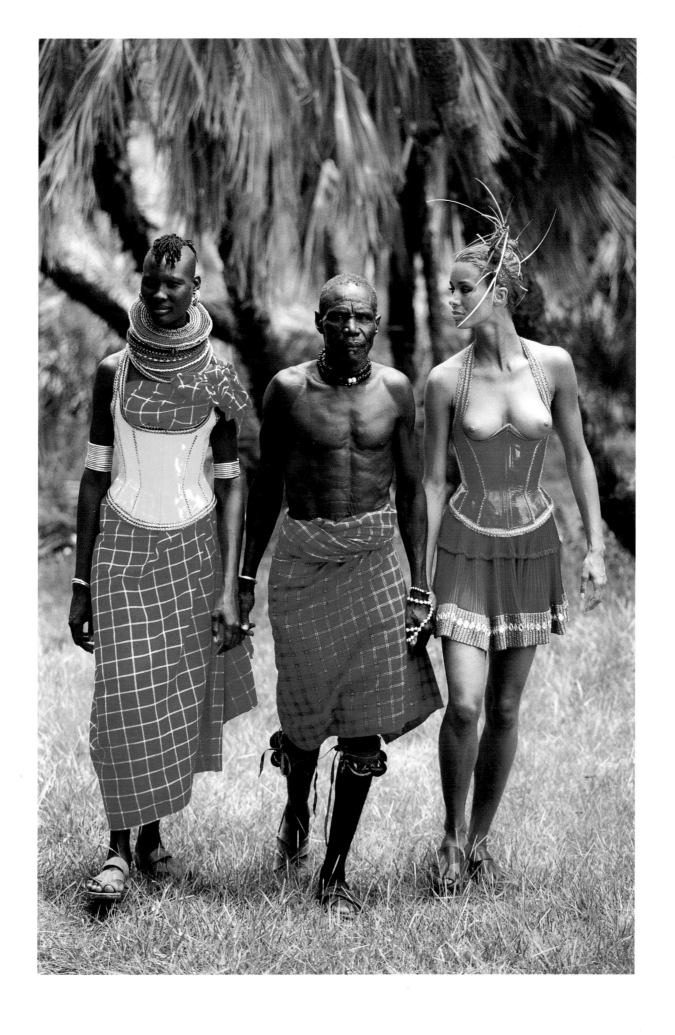

Mario Merz / Jil Sander

the inner space is
seen by peering through the
eye

Damien Hirst / Miuccia Prada

200

R E S P I R O

Thomas Eakins,
The Agnew Clinic, 1889

Oliver Herring / Rei Kawakubo

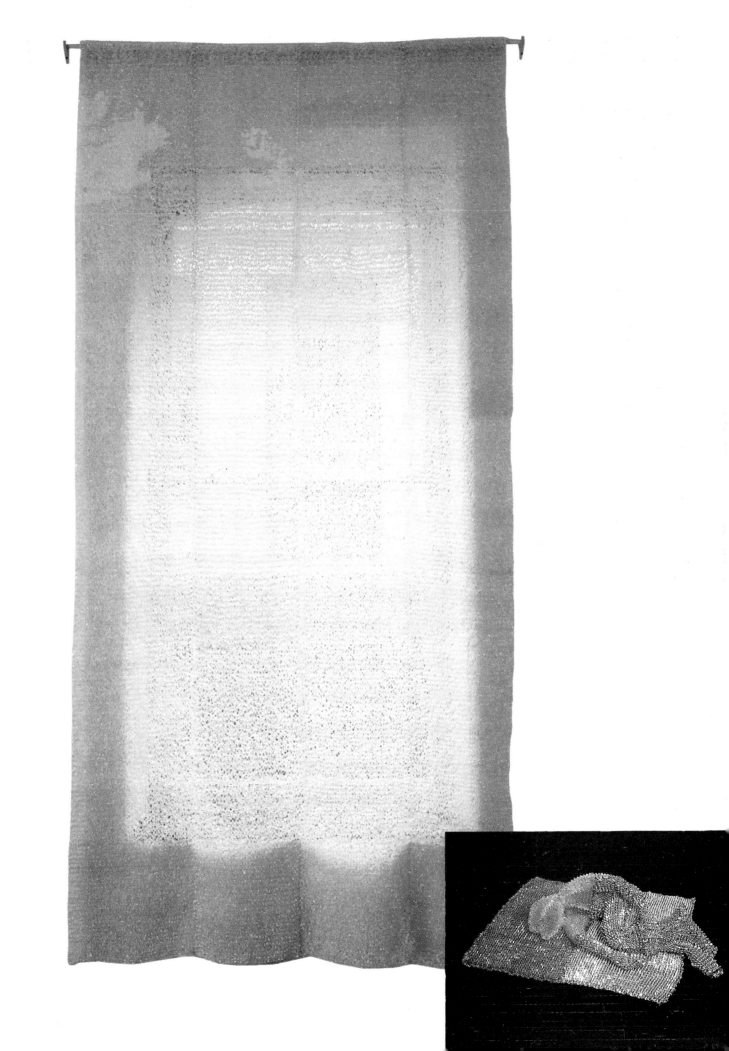

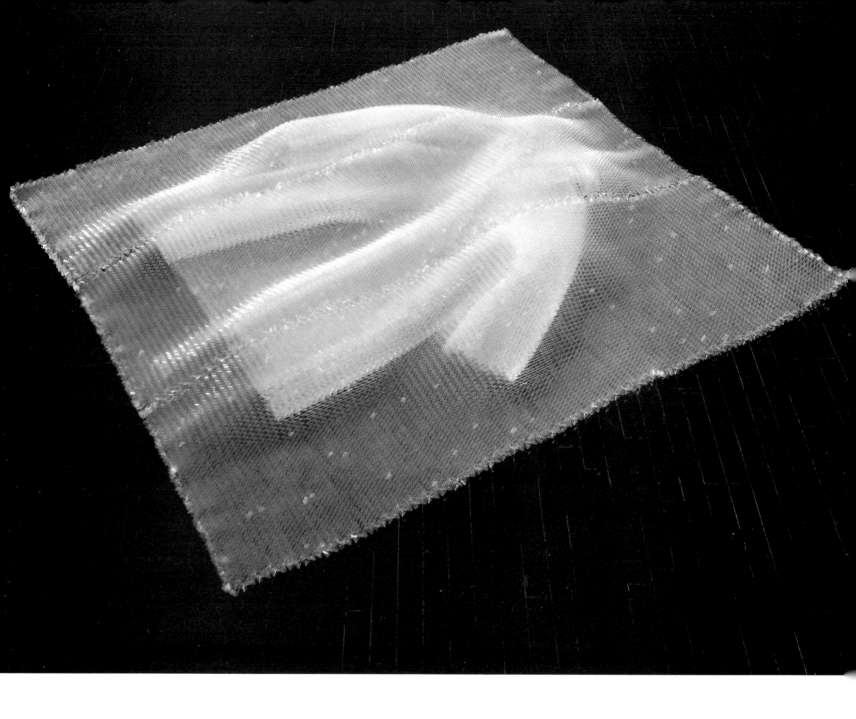

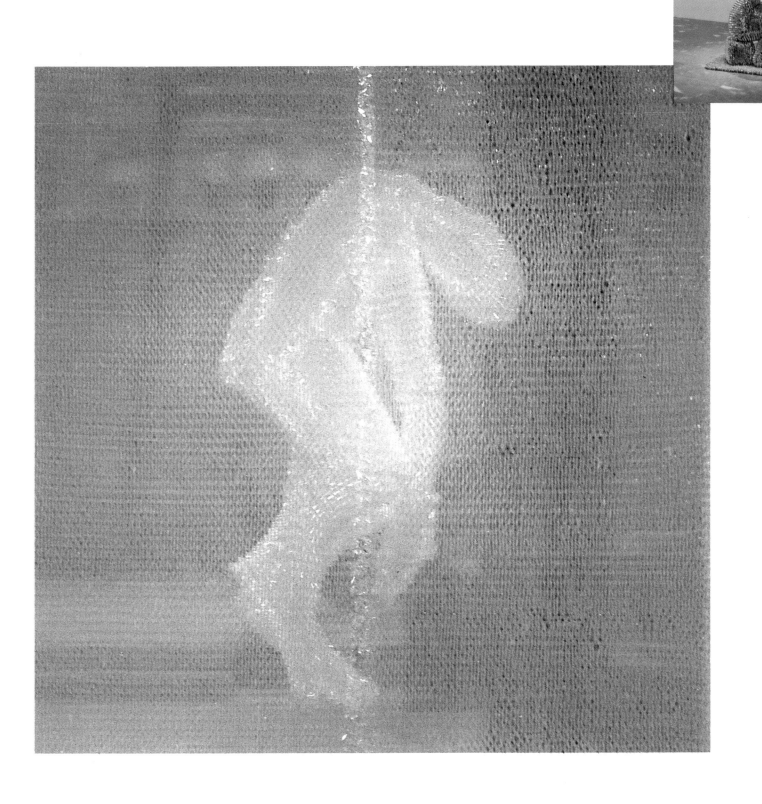

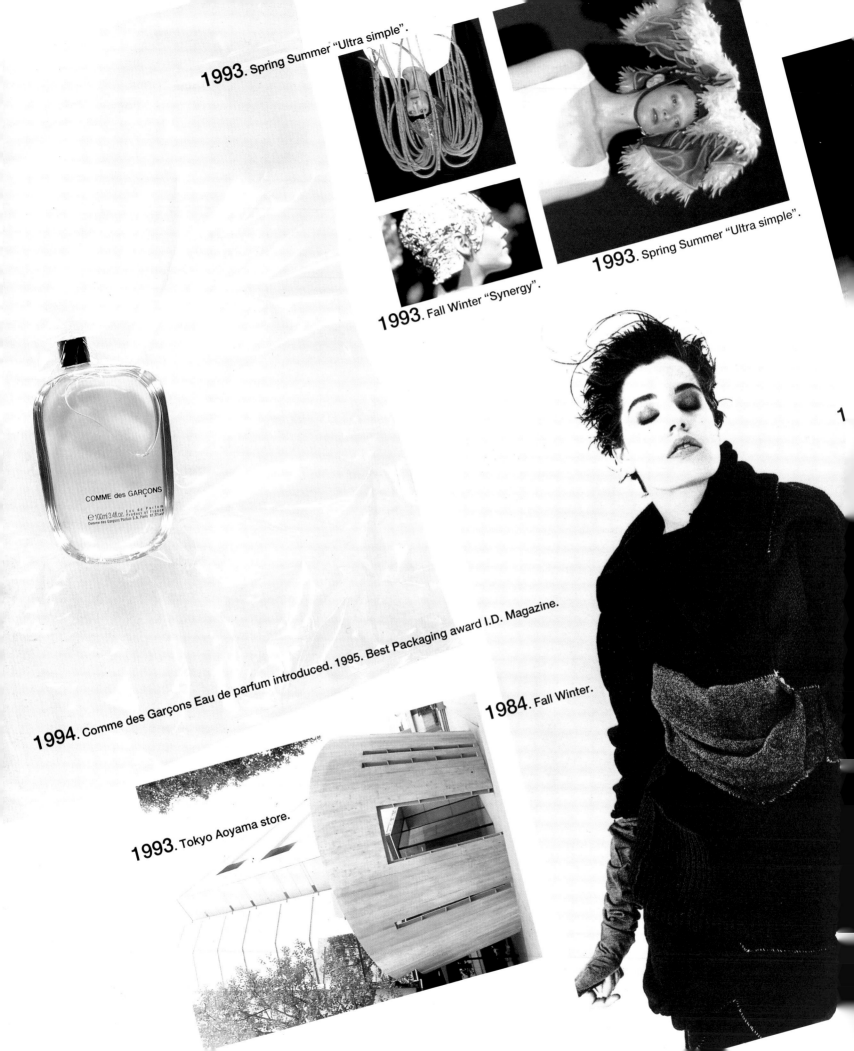

1993. Spring Summer "Ultra simple".

1993. Spring Summer "Ultra simple".

1993. Fall Winter "Synergy".

COMME des GARÇONS
100ml 3.4fl.oz. Product of France
Comme des Garçons Parfum S.A. Paris 91.5%vol.

1994. Comme des Garçons Eau de parfum introduced. 1995. Best Packaging award I.D. Magazine.

1993. Tokyo Aoyama store.

1984. Fall Winter.

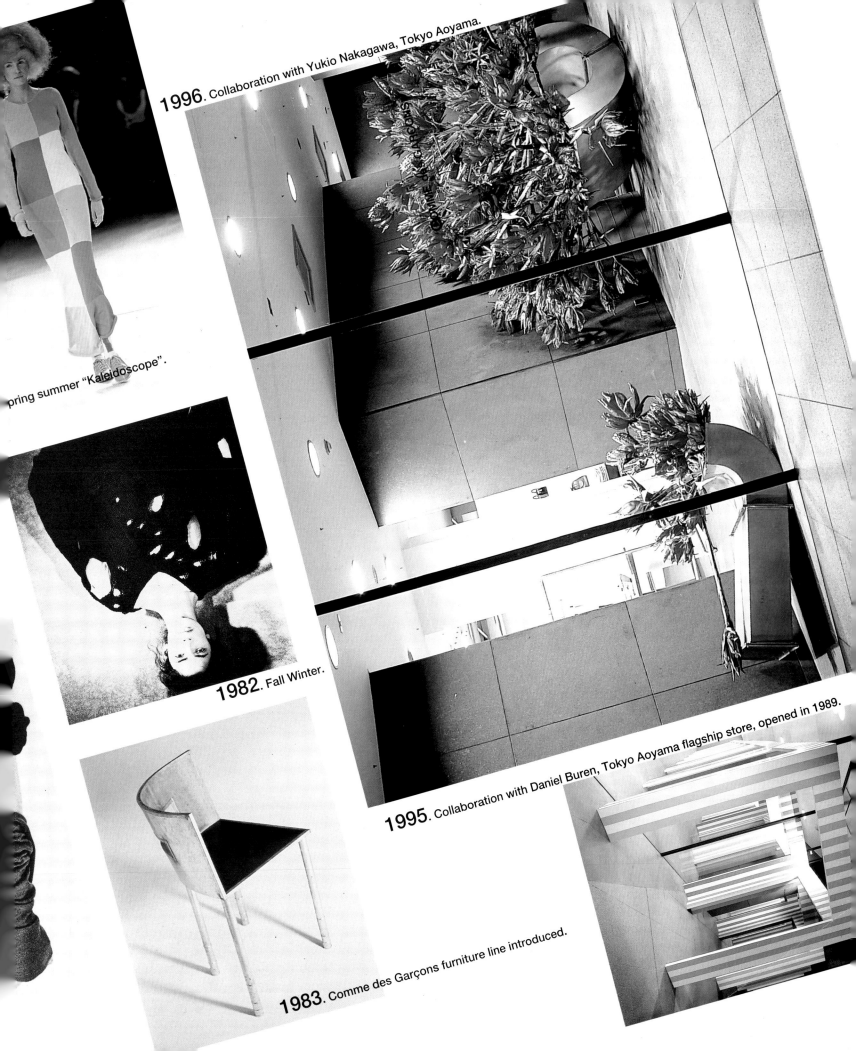

1996. Collaboration with Yukio Nakagawa, Tokyo Aoyama.

pring summer "Kaleidoscope".

1982. Fall Winter.

1995. Collaboration with Daniel Buren, Tokyo Aoyama flagship store, opened in 1989.

1983. Comme des Garçons furniture line introduced.

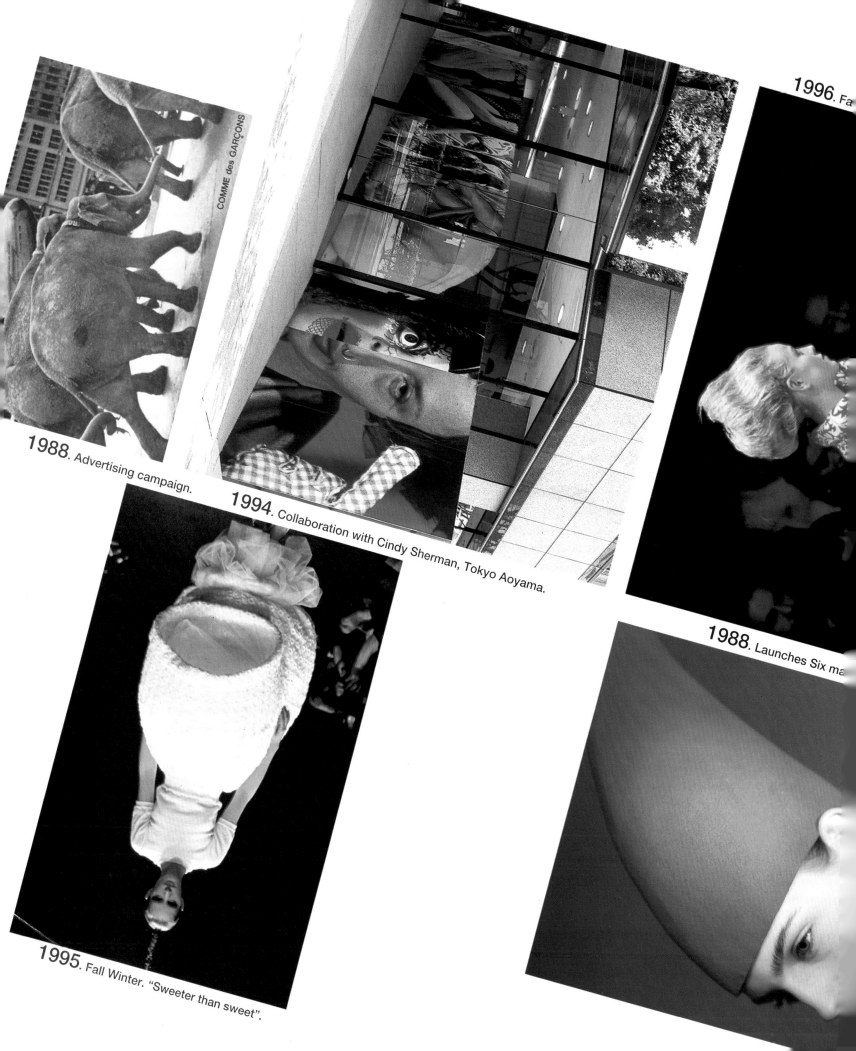

1988. Advertising campaign.

COMME des GARÇONS

1994. Collaboration with Cindy Sherman, Tokyo Aoyama.

1996. Fa

1988. Launches Six ma

1995. Fall Winter. "Sweeter than sweet".

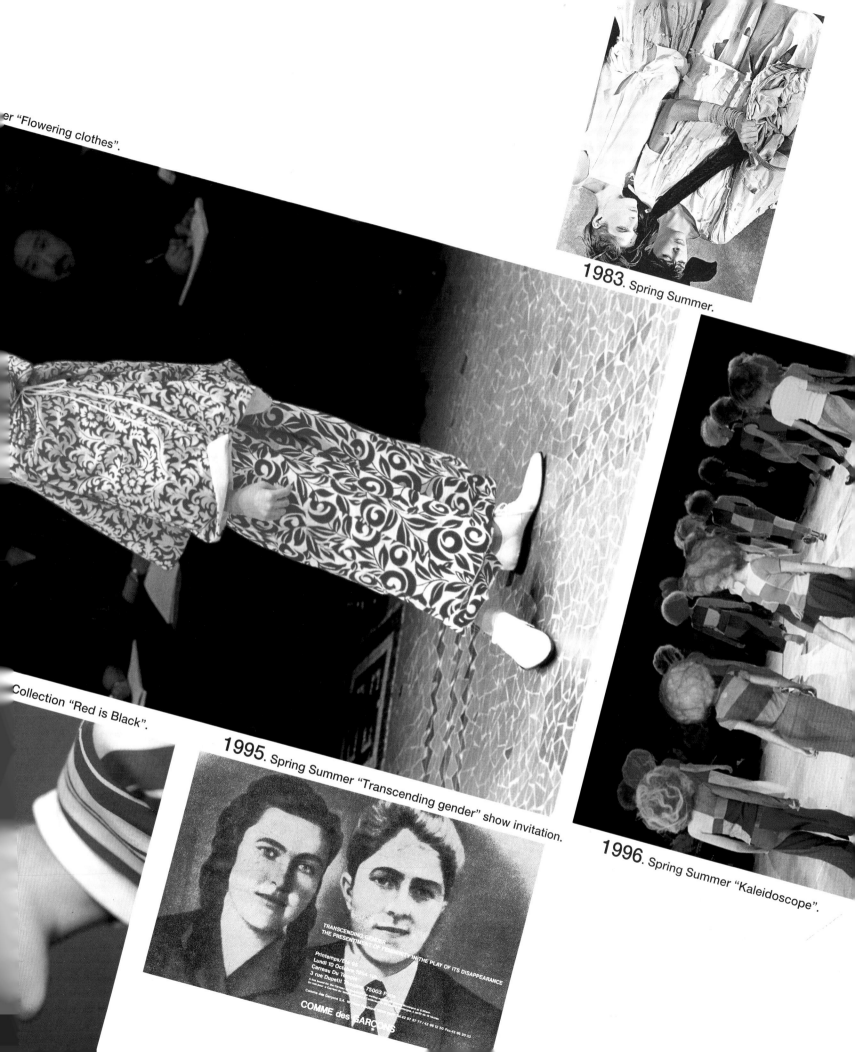

er "Flowering clothes".

1983. Spring Summer.

Collection "Red is Black".

1995. Spring Summer "Transcending gender" show invitation.

1996. Spring Summer "Kaleidoscope".

TRANSCENDING GENDER
THE PRESENTIMENT OF FEMININITY IN THE PLAY OF ITS DISAPPEARANCE

Printemps/Eté 95
Lundi 10 Octobre 1994
Carreau Du Temple
3 rue Dupetit Thouars 75003 Paris

COMME des GARÇONS

New Persona / New Universe

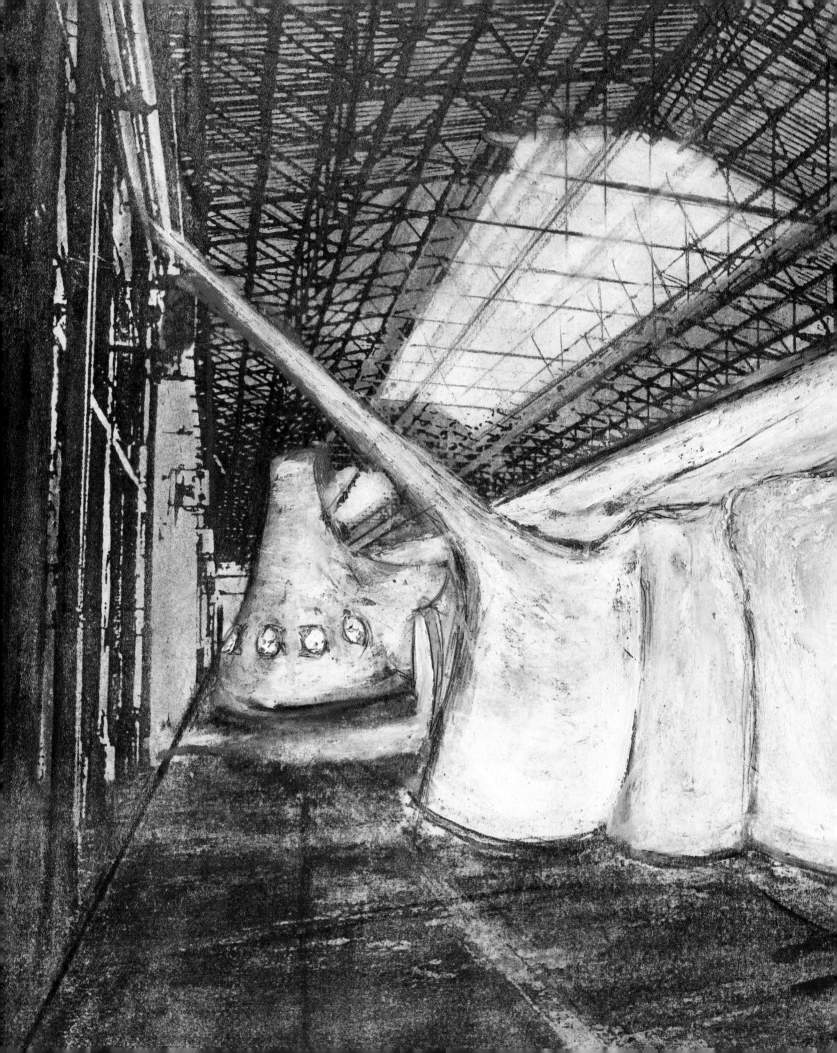

Florence
Stazione Leopolda

New Persona/New Universe
Curators
Germano Celant
Ingrid Sischy

Exhibition
Coordination
Livia Signorini
with
Lindsay Brant
Ilaria Pietrini

Overall administration
Anna Pazzagli
with
Giulietta Ciacchi

Secretariat
Stefania Signorini

Insurance
La Fondiaria-Florence

Transportation
Tartaglia Fine Arts Saima Servizi-Milan
TNT Traco-Milan

Installation
Design by
Denis Santachiara
with
Kazuyo Komoda

Technical supervision and installations
Pier Vincenzo Rinaldi
with
Martino Duni
Giuliana Robecchi
Peter Ryan
Marco Scala

Secretariat
Simona Turi

Technical consultants
Giancarlo Martarelli; Marco Stupani

Installations
GAD-Cremona; NDM Costruzioni
srl-Prato; Società Lampo-Milan

Lighting and Electrical systems
Watt Studio-Florence

Security systems
Elcon Italia-Prato

Catalogue
Edited by
Germano Celant

Coordination of production
Anna Costantini
Cecilia Torricelli

Editor
Livia Signorini
Maria Pia Toscano

Graphic design
Marcello Francone

Denis Santachiara,
sketch for the mounting
of the exhibition *New
Persona/New Universe*
at the Stazione Leopolda

An Initiatory Journey: New Persona/New Universe

I.G: The love affair between art and fashion inevitably leads one to recognize a whole series of incompatible relations and realities. It imposes an ethos that eschews opposites in favor of balancing and uniting them in a partnership where they might be fully reconciled and integrated with one another. Their present interaction coincides with the fall of still other barriers, those between sexes and separate universes. On the one hand, we have a questioning of sexual uniqueness that leads to a confluence of male and female, with the disappearance of their respective boundaries. On the other hand, we have the fall of a life-perspective focused only on the earthly species, in favor of a multiplicity of life-traces across millions of galaxies. *New Persona/New Universe* seems to have been developed as a complementary exhibition to *Arte/Moda*. Is it, too, focused on new forms of osmosis, those between the sexes and between the galaxies?

G.C. The forms of dress have always followed a code on the basis of which certain identities have been defined, such as male and female, Western and Eastern, rich and poor. They repeat certain forms of visual "packaging" that over the years have served to differentiate genders and classes. Fashion, in particular, has contributed to creating a continual metamorphosis of sexual visibility, whereby the alternative has remained masculine or feminine. Over the course of the last twenty years, however, the logic of separation and division has fallen into crisis, precisely because it is based on ideological laws instituted by the structures of power. Discourse and practice have now been directed toward a confusion and lack of differentiation between the genders, in order to re-establish a unity between masculine and feminine. The person has been re-generated in the commingling of the genders, and a kind of new persona has emerged whose energy is directly related to the intensity of excess and the hybrid condition. This being must not be seen as perverse, but as a vehicle through which humanity might conceive an ideal wholeness vital to the maintenance of its own inner and physical growth. We are at the end of a century, and sexual commingling is the prototype of a new humanity, like the cyborg. Both aspire to create an artificial, hypothetical universe capable of stretching the limits of the human being, in anticipation of an already verified stretching of the universe.

A.C. The disappearance of such stereotypes as "male" and "female" is making people refocus the question of difference away from the sexual—formerly the object of intense conflicts—and toward considerations of race and morphology. In what way, and in what areas, are people fighting now

Robert Mapplethorpe,
Self Portrait, 1980.

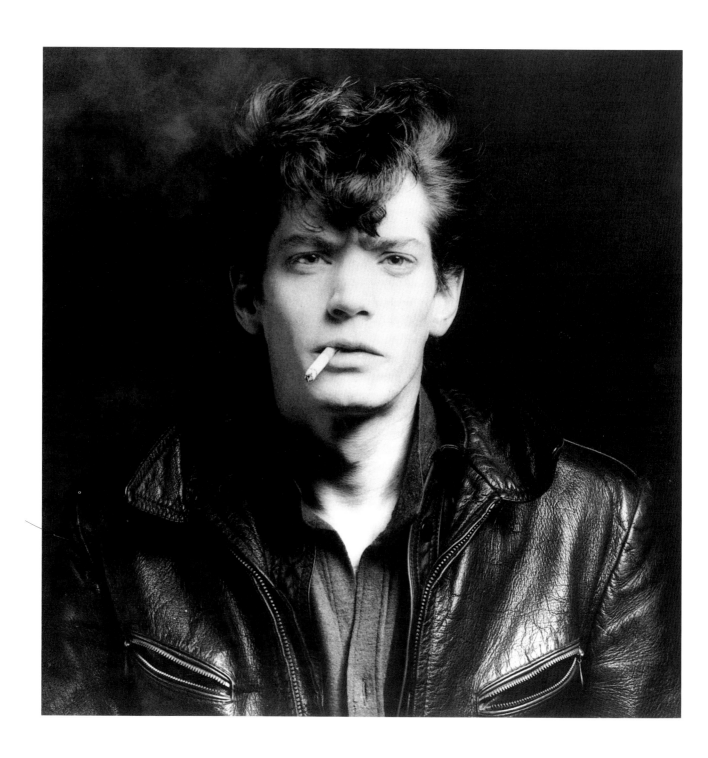

Robert Mapplethorpe,
Self Portrait, 1980.

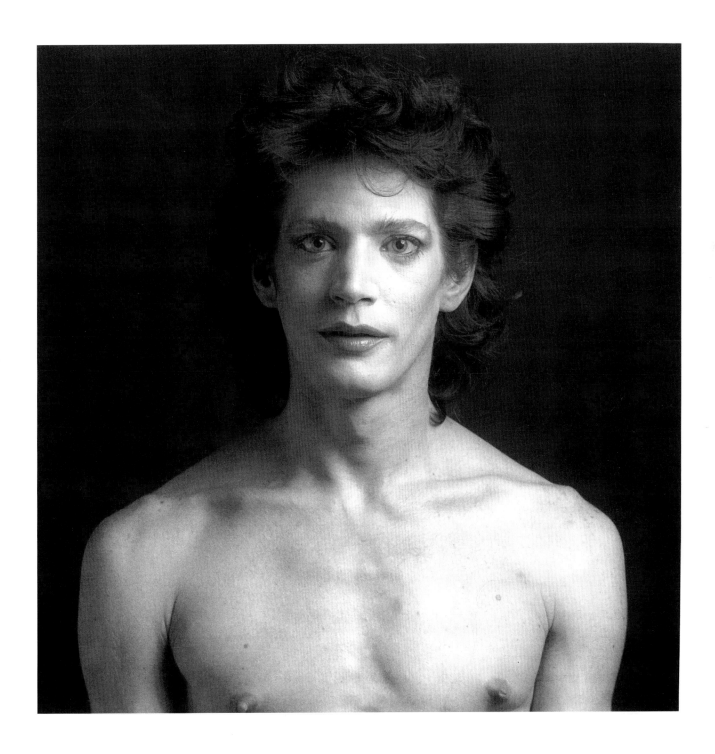

to prevent the reassertion of a new concept of normality?

G.C. "Normal" implies a norm, that is, a law, and all laws are fundamentally ideological. They are drafted in conformity with a culture, a sexuality, a belief, an ethnicity. The opposite—"abnormal"—is defined as chaos and disorder, and therefore as a return to a way of life and thinking without limits. Today the passage through the abnormal and the perverse is the true path of all discovery, because it starts from a primitive and hybrid condition of consciousness. The destruction of beliefs and values makes regeneration possible. The perverse and the abnormal are forces of sublimation, because they exercise the desire to become other, both technologically and sexually. The bisexual, the transexual, and the cyborg all internalize remote and contradictory abstractions. They represent idealized substitutes of the masculine and the feminine, the natural and the artificial, the mortal and the immortal. None of them accepts being what he (she) is, in a strict relationship with nature and its concreteness; rather, they are fascinated by the desire and dream of a new persona reaching toward new universes.

D.S. One can think whatever one wishes, and as badly as one wishes, of the new technologies, but there is no question that they make the very notion of the "five senses" seem approximative and quaint. Manipulating an action by means of a helmet and sensors has perhaps no metaphysical meaning, but it certainly is not the same as a real encounter. And in this sense, a "new persona" already exists. In what way is this shift in perception reflected in the circuit between the artist and the public? How does the artist conceive of his spectators? As human beings or as "new persona"—that is, as people equipped with a multitude of different instruments in large part yet to be explored?

G.C. The cyborg is a "glorious body", a victory against the will of nature. It is the technological cry of the human being that wants to be made immortal. Its existence is a sign of the revival of mysticism, for which the divine and the eternal are no longer outside the human, but within. And a sign of the definitive disappearance of metaphysical value for a body's mind and breath that are repeated to infinity and originate no longer from Above, but from below, from the new technologies. The implantation of prostheses tends to eliminate the asphyxia of death. Remade and purged of mistakes, the body can now regain possession of itself. In the face of this miracle, which pushes the body, and therefore its concept, toward an exhausting repetition of itself, what sort of discourse can the artist or creator possibly offer? And to what sort of audience of replicants? First of all, he will no longer be able to talk about the torments—caused by death, illness, power, politics, the family, or money—of his own life or that of others. Assured of perpetual regeneration, he will exclude from his vocabulary the drama and tragedy on which the growth of discoveries and languages has rested. Moreover, by duplicating himself, the cyborg or new persona unrealizes himself. What is happening at the end of our century is therefore something absolutely specific that is vampirizing life. There will no longer be any public, because each person will be his own public, intent on representing his own mutations and creations of unloved reality. The outside will be precluded and avoided; all will revolve around the reappropriation of the infinitesimal. Virtuality will consist of the phantoms of the physical and psychic worlds.

L.S. It is difficult to imagine that sensory slippages of this magnitude would not have immediate conceptual relapses. Visiting a dying person in the hospital implies a whole series of ideas about death that are not the same as those with which one was able to witness, by computer, the death of Timothy Leary. And following the signs of time, with a mixture of anxiety and emotion, over the face and body of a loved one, implies a certain vision of the world, while shouting in enthusiasm

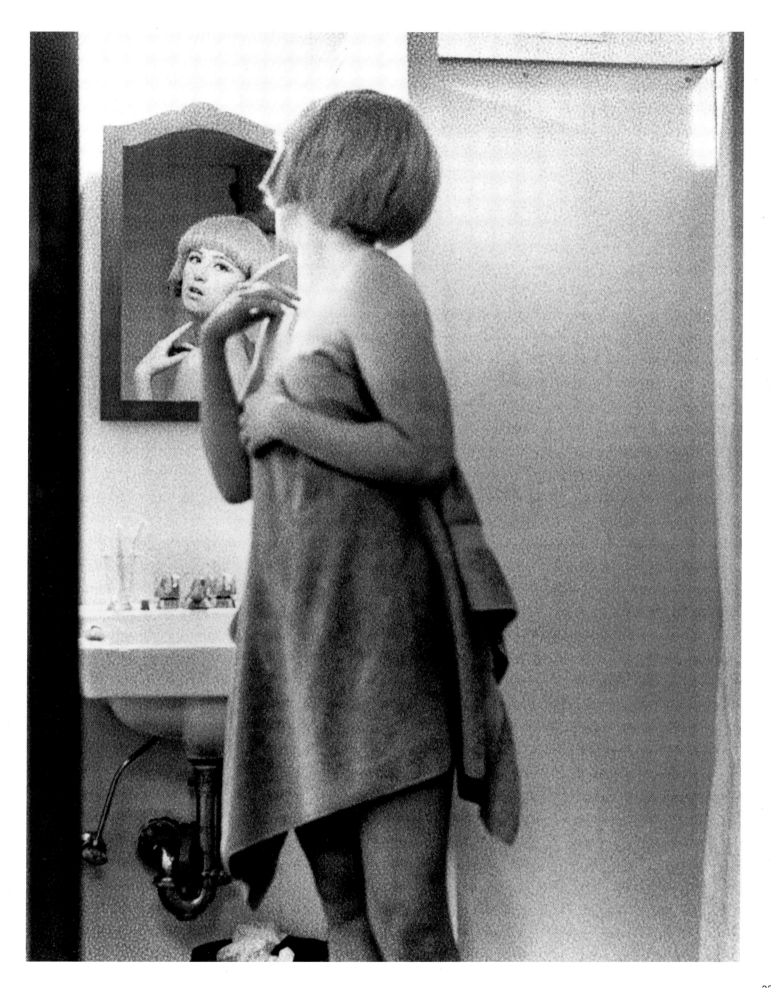

at a successful infiltration of collagen implies something entirely different. In other words, it seems that a great many of the concepts, even fundamental concepts, by which we define our behavior today will be rapidly replaced, and that the replacements are truly poised to build a "new universe". What exactly is happening?

G.C. Existence and the journey are being launched anew. They are no longer taking place inside the body, but outside. The scenic display of some puckering skin or a withering figure has to do with the drama of the human organism. Nowadays such transformations are reversed and cauterized through the use of plasticization and crystallization techniques. The body decries the error of its own creation, remakes itself of plastic and steel, of titanium and silicone, precludes the mobility of the flesh and tends to the perpetual. The lack of being that has marked humanity until our century is now confronting the danger of immortality and of "too much being".

L.S. All this might even lead one to think that in a few years the quotidian universe (and the aesthetic universe) that we have been dealing with until now will be replaced by another, parallel universe nevertheless rather similar to our own—with the same divisions, the same disciplines, the same confines. Is it unthinkable that a more profound restructuring could take place? That the categories used today could be abolished? That the new universe could prove to be a vast, unique and variform aesthetic experience in which the "new persona" will no longer even be able to distinguish between what was once known as fashion, art, music and film?

G.C. As I've already said, with the mingling and perversion of the different elements, barriers of distinction will fall. A new universe will be created demiurgically, in which roles can be reversed, interchanged and permutated. What meaning will the distinctions between film and music, theater and dance, art and fashion have? None whatsoever—as in a primitive age, when all that mattered was the perpetuation of life, which back then was finite, but today is infinite.

C.T. With the Hubble Telescope's discovery of billions of new galaxies, the extent of the unknown has greatly expanded, to the point of including questions of other forms of life like our own on distant planets. This radiant vision is forever imposing itself on human thought, but what does it mean for art and fashion?

G.C. It is not hard to discern that the destiny of creativity is heading once again into a neo-mystical phase. If today the individual is subject to the imperative of death and cruelty, of suffering and decay, his next journey will be marked by a positive dimension. It will be a journey in search of ecstasy and the sublime. The dark side of fashion and art, in which the two worlds have sought to meld the abject and the debased, the dirty and the unnatural, the pornographic and the obscene—one need only think of the punk and heavy-metal sensibilities, or the sadomasochistic rituals that have become decorative and visual cliches—will give way to the exercise of purity and positivity, of light and splendor.

I.G.: Beyond all frontiers lies the unknown, the different, from which we must protect ourselves. Today it seems that this boundary between beings and universes is more familiar, to the point where it has begun to enter into our everyday lives. How are boundaries crossed in the Stazione Leopolda exhibit?

G.C. The body's first gesture of metamorphosis may be that art which by its tendency toward transgression desires the end of an inoffensive and pleasant sexual confine. It has brought objects and images into the museums that seemed not to belong there, and has subjected the visitor to unsettling representations linked to the fermentation of physical and corporeal reality. *New Persona/New Universe* opens with some photographs by Robert Mapplethorpe and Cindy

Sherman. Mapplethorpe set himself the task of communicating to the world the aspiration to androgyny, the unique composite of masculine and feminine. He sought, through photography, to define the continuity between sexes and races, between man and woman, between white and black. His difference allowed him to surpass and expose limits, enabling him to occupy that intermediary zone in which the new persona is born. The fall of the mask in Mapplethorpe permits him to discover his whole being, represented by the double: male and female. Disguise is the weapon Cindy Sherman uses to reveal another deprivation of being, that of women. The feminine figure is always a representation of something masculine. Sherman points out the infinite stereotypes of femininity. The woman is flower and prostitute, mother and lover, dream and desire, actress and fruit, mediator and muse, object and trap, sex and soul, shrew and child. In her fluid identity, the artist scatters all the significations of limits and demarcations imposed from without. She is thus working toward a destruction and a metamorphosis in which the female figure is not a response to the male, but an enigma. Following these polarities, which are flanked by Jurgen Teller's photographic absolutizations of the subject of masculinity, the exhibit unfolds onto the theme of the double as the impossibility of existing in a one-sided, unique, state. It takes two different paths, that of art and that of fashion, which crystallize two different points of view about the body. The artists were asked to respond ironically, that is, to talk about the larval states of the union between male and female, natural and artificial. The fashion designers, who deal with this interaction almost daily, were asked instead to respond more abstractly and symbolically. On the one hand: the larval state and the fleshly ego as prisons of a conflict between the genders; on the other: the rejection of the plenitude of clothing in favor of a morphological state revealing the cogito of fashion.

D.S. Will this exhibit enter into the interstices of the body and of fashion?

G.C. The show was planned by Denis Santachiara as a labyrinth and an undefinable mass, an enigmatic structure in which we sought to bring together creative testimonies of a duality between technology and the body, between material and spirit, between abstraction and the figure. We tried to get fashion designers and artists to give shape to a hypothesis of the new persona and the new universe, to create something at once external, internal and poetic. To respond, in other words, to the outer shell, to the mediums that make up the outer system, such as materials and clothes, which both imply touch and sight. In certain cases the response is already alchemical, taking for granted a union of bodies and genders, male and female, and presupposing the further development of sensory and tactile high technologies having to do with sound and artificial life. The spectacle of the inside involves a reappropriation of the physicality and information of the technological incarnation that the human body is presently undergoing. The tradition of appropriating nature has now passed on to the fleshly human organism, which is no longer distinguishable from a machine. Some of the artists' and designers' installations on exhibit make the distinctions between natural and artificial, mind and body, physical and non-physical, totally ambiguous. They bring into the picture TV cameras, sensors, electronic projections and information, in a miniaturization of experience that is a prelude to dazzling interior adventures. Lastly there is the poetic response, which opens the door to a utopian, fantastical paroxysm, whereby illicit unions of male and female, present and future, human and animal dissolve all solidity that might still moor the body to an asphyxial, monotone state of being. The alternating rhythms that fill the spaces of the Stazione Leopolda transform *New Persona/New Universe* into a rite of initiation, to be enjoyed by all adepts and cosmonauts.

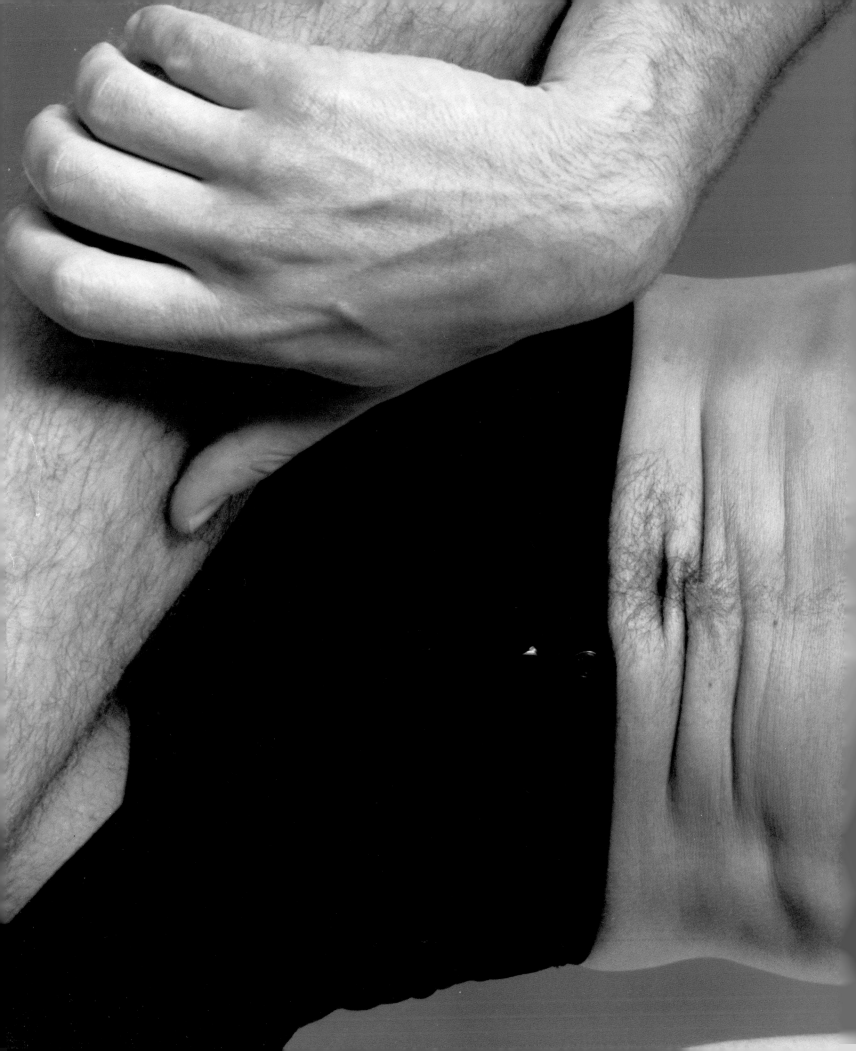

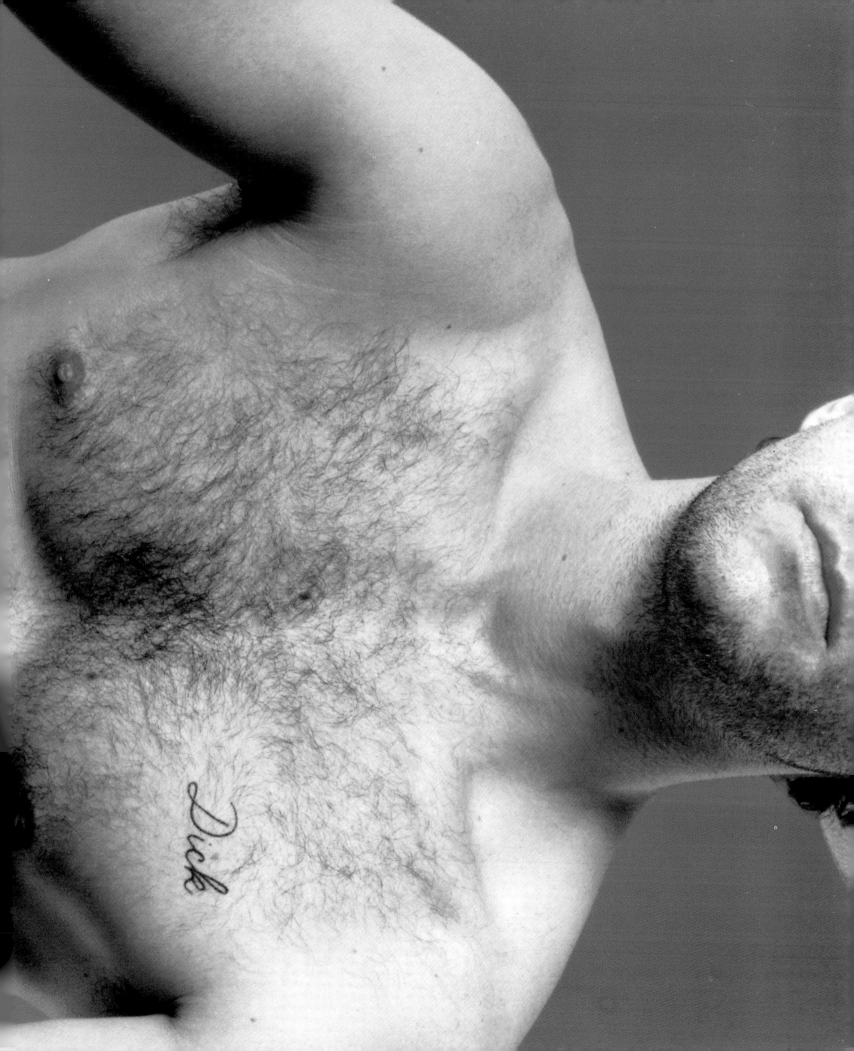

Ann Demeulemeester

Kortrijk 19-12-59 - Patrick 1976, Royal Academic Antwerp 1978-81 - Bio bij Lydon Dried 1987, Paris 1989, nos enfants, Victor 1986, Introduction A.P. Michele 1992 first fashion show Paris, around the world, 1996 Florence communication hope love faith

Kiki Smith

100 Arcseconds

16,300 LY

1 Arcsecond

163 Light-Years

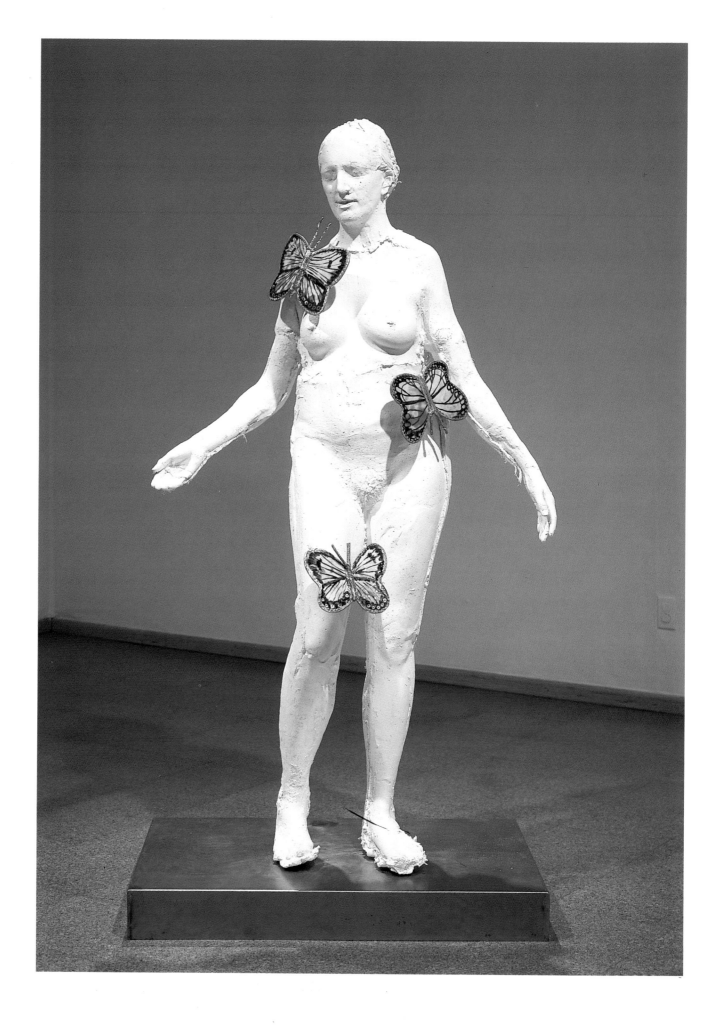

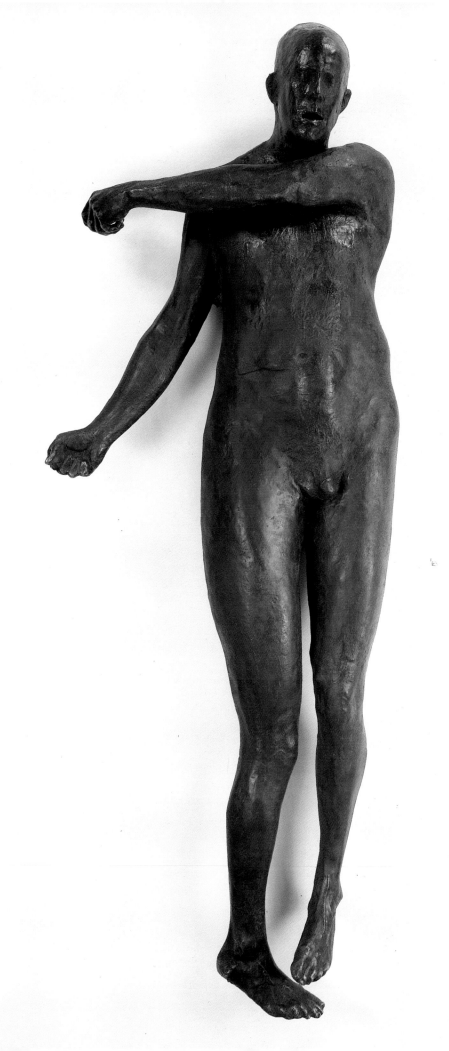

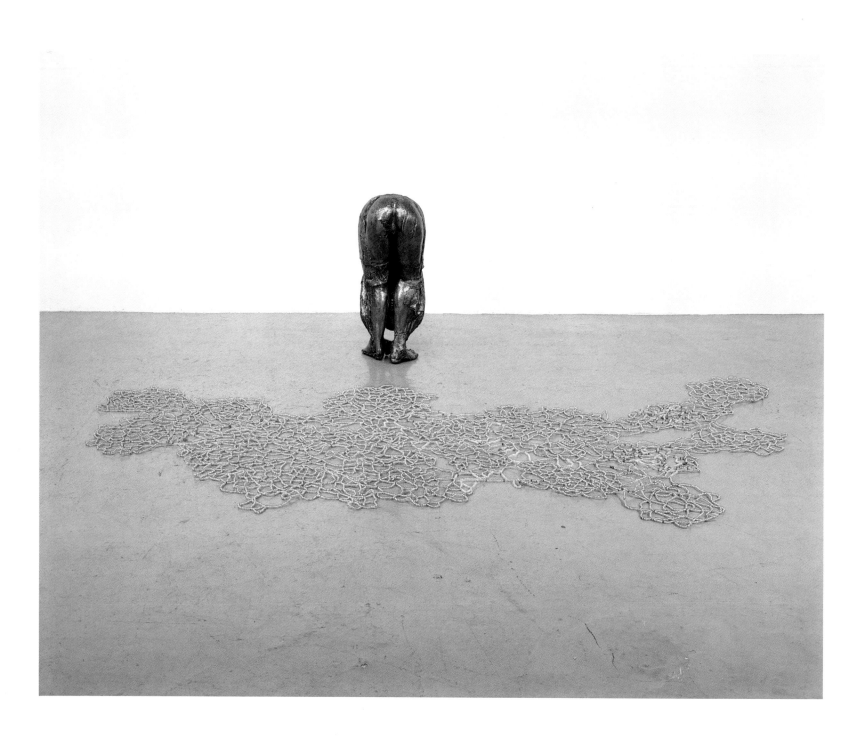

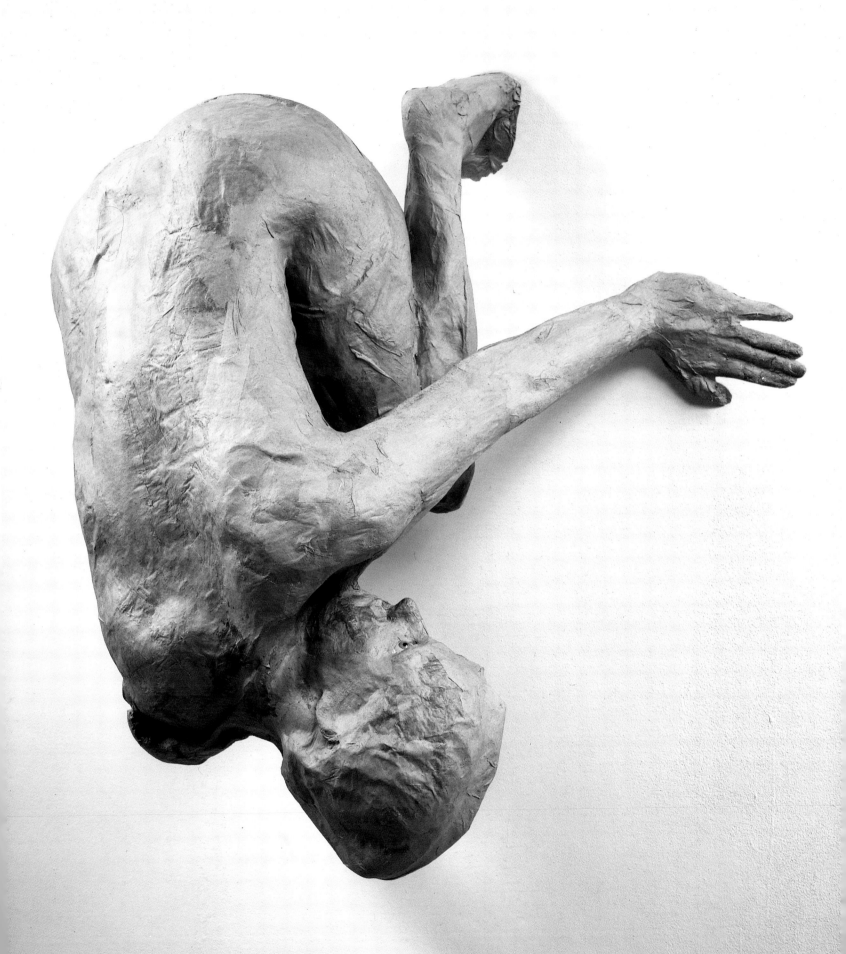

Karl Lagerfeld (of Chanel, and also of Fendi)

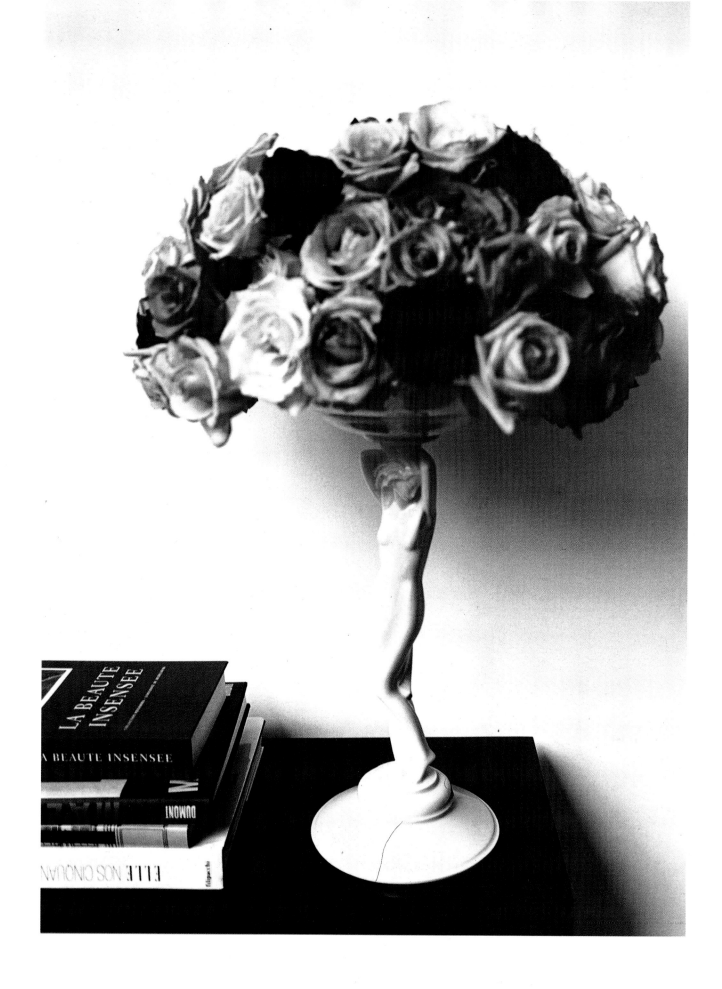

Giuseppe Penone

Giuseppe Penone,
Palpebre, 1989-1991.

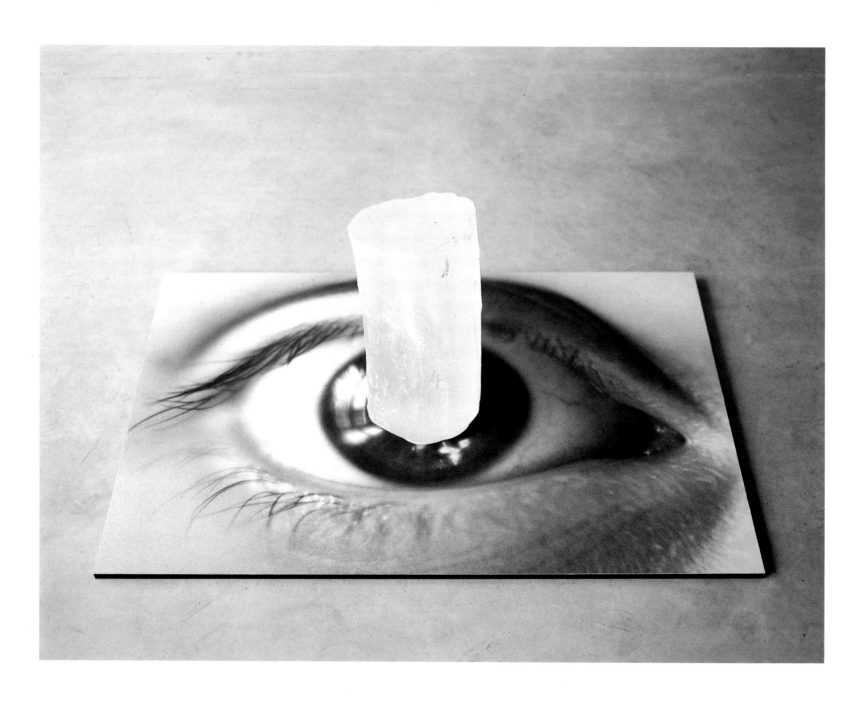

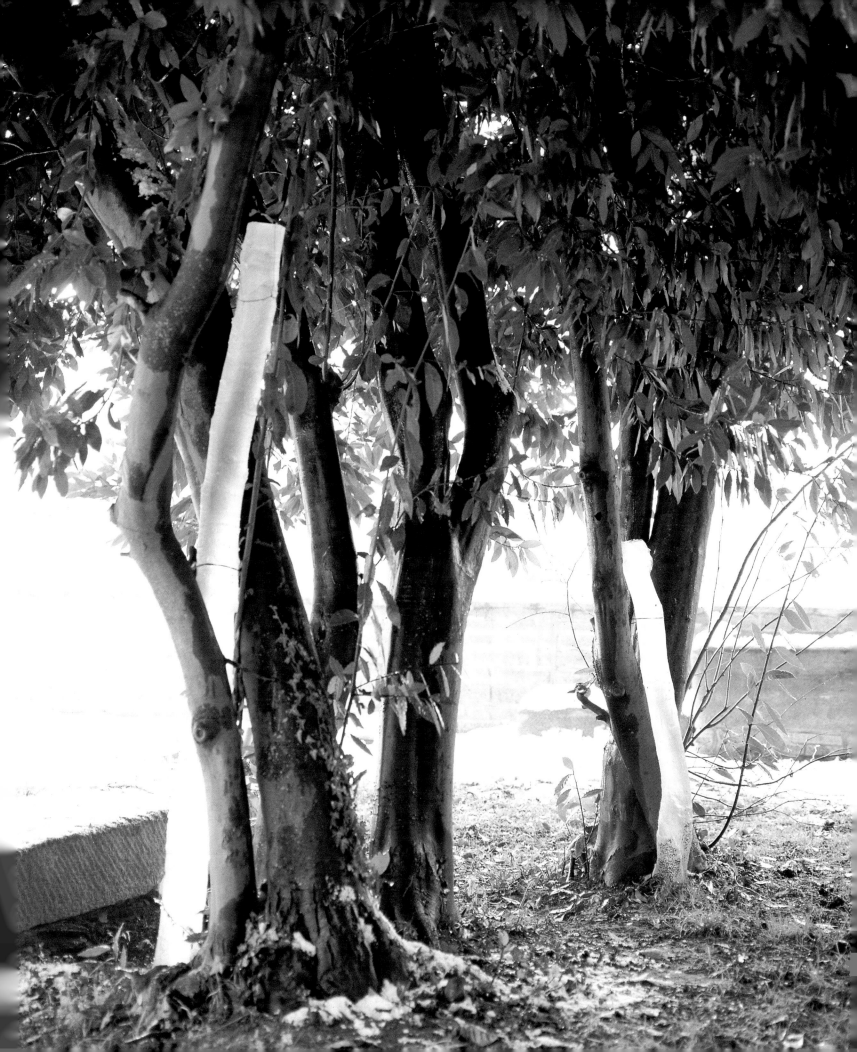

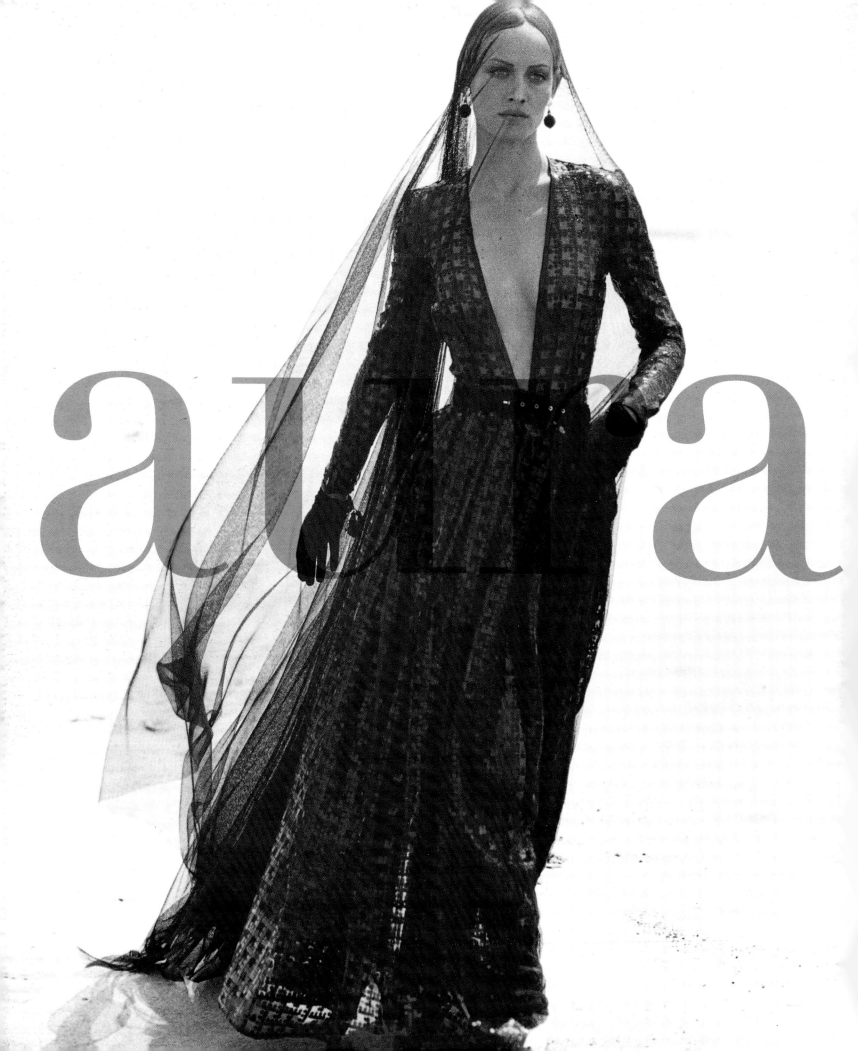

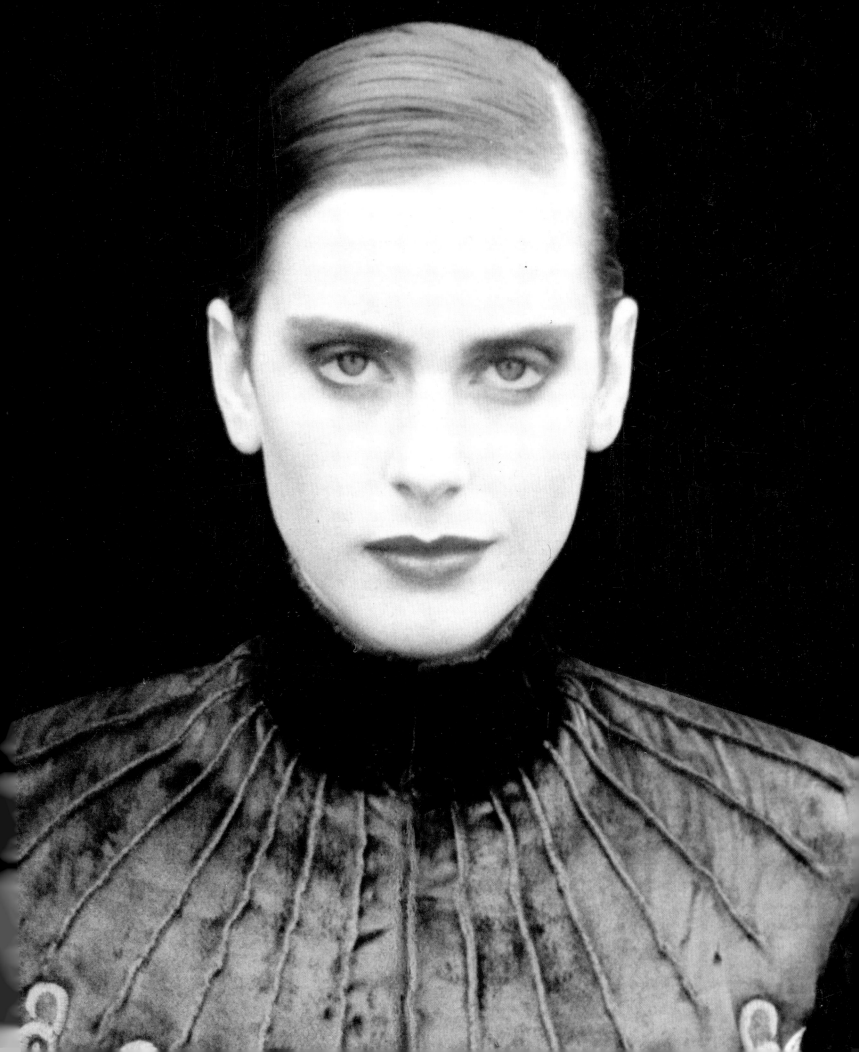

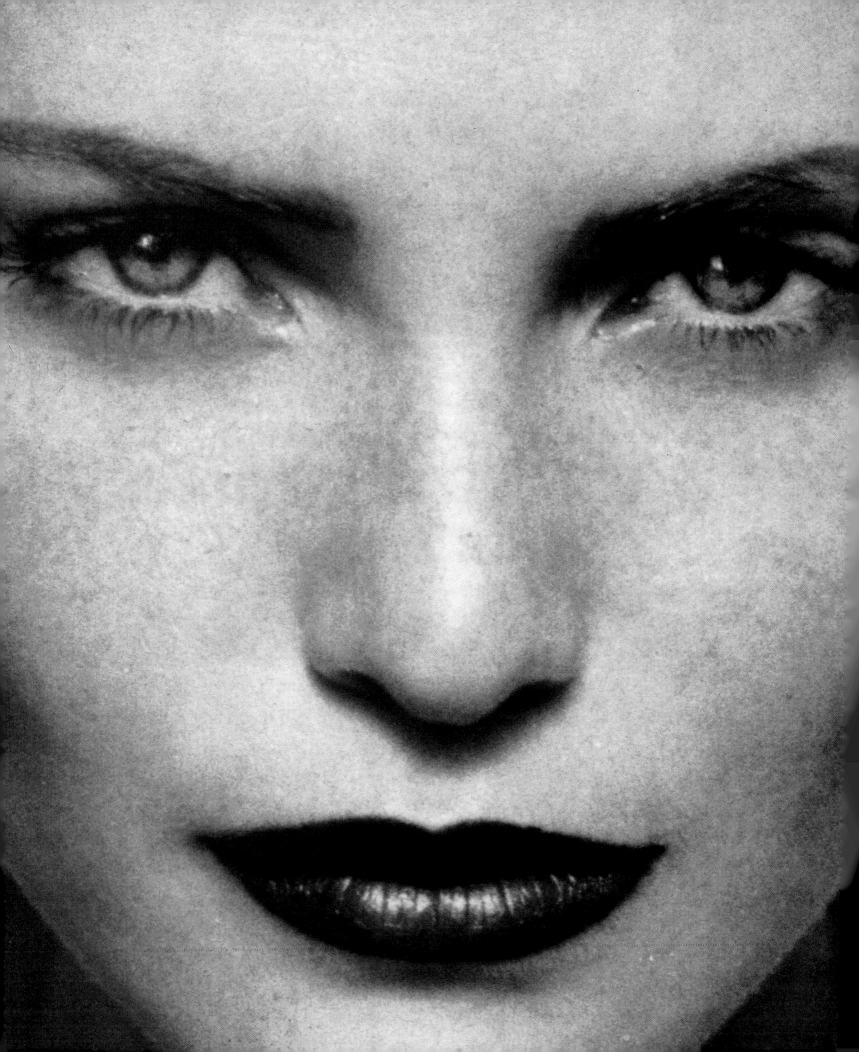

luce

Inez van Lamsweerde

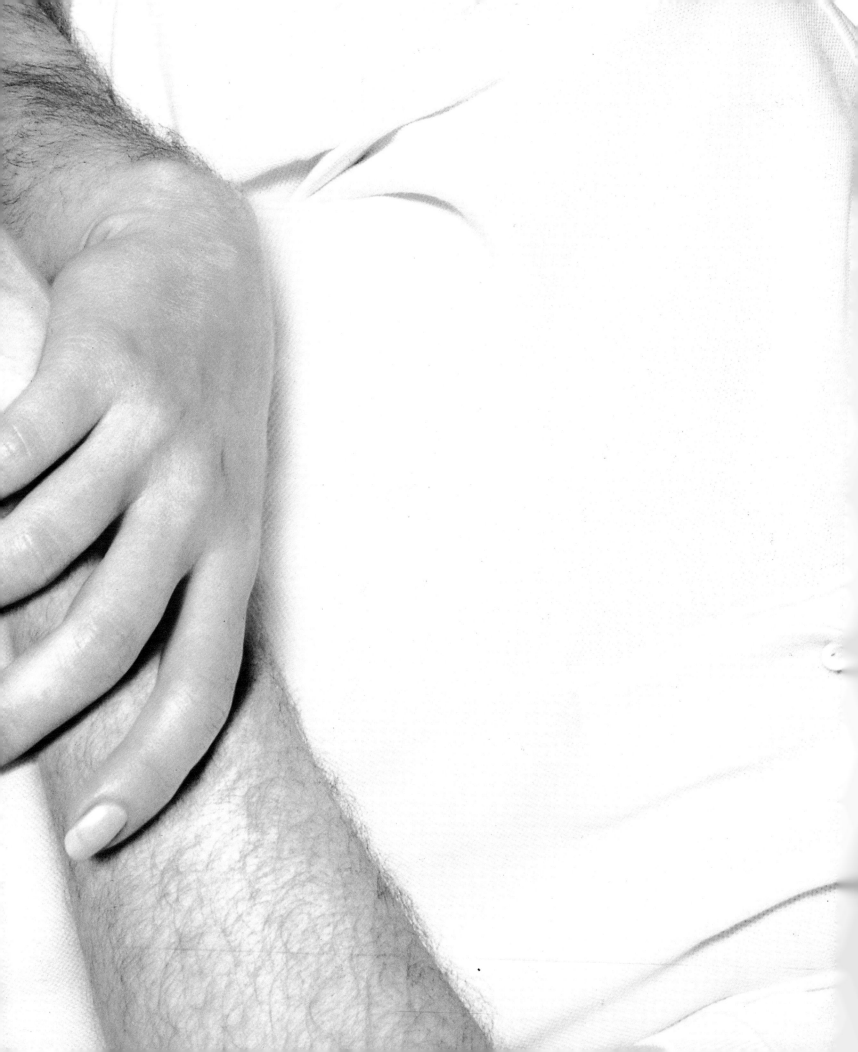

Inez van Lamsweerde,
The Forest-Rob, 1995

Inez van Lamsweerde/
Vinoodh Matadin, *Fur*,
1994

Inez van Lamsweerde/
Vinoodh Matadin,
Floortje, Kick Ass, 1993

Ground-Based Optical/Radio Image

380 Arc Seconds
88,000 LIGHT-YEARS

Matsuda by Yukio Kobayashi

HST Image of a Gas and Dust Disk

17 Arc Seconds
400 LIGHT-YEARS

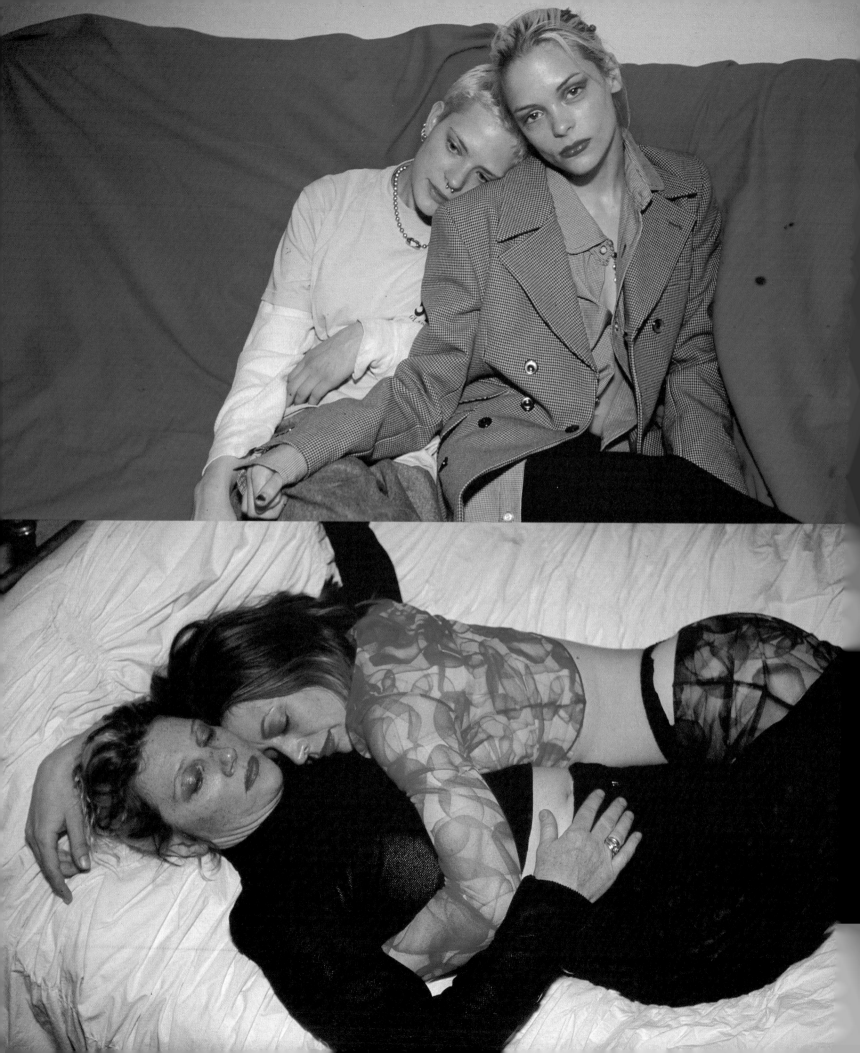

Mitsuhiro Matsuda, *chairman*
Yukio Kobayashi, *designer*

Hideki Nakajima, *art director*
Yukiharu Takematsu, *architect*
Hidefumi Sunada, *film director*
Toshihiro Morimoto, *sound director*
Encoding & Authoring by Digital
Authoring Studio, Sony Corporation

Special thanks to:
Nissin Corporation Japan
Mitsui & Co., Ltd.
Sakase Adtech Co., Ltd.
Misu Fabrics Corporation

MATSUDA is a fashion concept that offers ageless and genderless designs that break free of conventional style. The flagship of Nicole Co., an influential Japan-based fashion house, MATSUDA opened its first boutique in New York in 1982. As a major fashion presence, the MATSUDA collection premiered on the New York and Paris runways in the early 1980's and rapidly garnered popularity throughout Europe and the United States. With its participation in international collections during the past 14 years, MATSUDA has earned critical acclaim from the fashion community and amassed a multi-cultural consortium of fans.

Since 1983, Kobayashi has prospered as the chief designer for the men's collection known as MATSUDA by Yukio Kobayashi. Recognized for the originality of his exclusive designs, Kobayashi also assumed the position of chief designer for the women's collection starting with the Spring/Summer 1996 collection to generate a unified vision for MATSUDA. Providing a modern edge to the MATSUDA collections, Kobayashi has removed the boundary between the men's line and the women's line through his unilateral use of textiles and silhouettes. An example of Kobayashi's ability to transcend gender specific fashions is his application of a sewing technique, once used exclusively for men's designs, to the women's collection. Staying true to his design sensibility, Kobayashi successfully expresses his own world of fashion through his unique and current vision. "From my perspective fashion and art are inseparable, similar to human relationships, both need to be nurtured and developed to ensure they prosper over time," comments Kobayashi.

"During the creative process, I often develop colors and textures that are not as they appear. By manipulating light and shadows, I create illusions. Expounding on this concept, I have devised an installation which manipulates the human form through a 3-dimensional projector. This process is similar to the weaving technique that I utilize to create fabric. In this manner I am representing the innovations in textiles with images of human beings to make the connection between fashion, art and life," he concludes.

Further enhancing the MATSUDA connection to the arts, Kobayashi collaborated with renowned photographer Nan Goldin on a project entitled *Naked New York - Nan Goldin meets Yukio Kobayashi*. To capture the raw energy and artistic foundation of the Fall/Winter 1996 collection, Goldin documented the collection in the context of New York City's urban culture and explored the

Innovative concepts in fashion derived from art and technology

...ble of human vitality and fashion. Using these images for the *Time and Fashion* installation, Kobayashi presents the relationship of life, art, fashion and sexuality and the impact that each notion has on the other.

While the installation explores the relationship of art and fashion, it also reaffirms the MATSUDA connection with technological innovation. As represented in the Fall 1996 MATSUDA by Yukio Kobayashi collection, Kobayashi brings a modern dimension to the line with his sculpture inspired textiles and illusion based textures. To achieve these effects, Kobayashi has developed innovative processes which provide incite into the next generation of fashion design. His techniques, such as the development of a laminated polyurethane, create a "sponge" effect with several of the fabrics that adds density while providing freedom of movement. To create three-dimensional silhouettes, Kobayashi utilizes modest construction and uniquely combines stretch yarns of spun wool & nylon and wool & polyester to foster drapability.

Continuing to advance textile innovation, Yukio Kobayashi developed a technique called "needle punch" which is directed from the top of the fabric to create an ornamental pattern. Quilting techniques are also used to add depth to the fabrics and to provide softer edges to certain designs.

The polished combination of individuality and art distinguishes Yukio Kobayashi as one of the preeminent designers in the world today. His designs have become a magnet for individuals desiring a sophisticated level of self-expression not commonly found. Each collection reveals a statement of artistic sensibility and stylized technology that incorporate newly-developed fabrics and refined shapes created specifically for MATSUDA.

Emphasizing the MATSUDA belief that fashion is best expressed as art, Kobayashi integrates design with other artistic media to create an art form that is uniquely MATSUDA. In 1991, Kobayashi collaborated with the preeminent Czech photographer Jan Saudek to mount an exhibition of work that linked fashion design with cultural photography at the Merchantile building. He also participated in the 1994 "Modes Gitanes" and created objects inspired by the Gitane silhouette design by Max Ponty.

First linking fashion with art and now leading fabric technology with his industrial generated textiles, designer Kobayashi is a...

David Bowie

David Bowie, visual

artist. It says much about the conservatism that still pervades art

criticism that such a juxtaposition of words can cause eyebrows

to raise.

What a **paradox** it is that an age which noisily and expansively embraces multimedia, continues to pigeonhole artists and frown at their audacity in venturing to be proficient, let alone experimental and challenging in more than one art form. In earlier centuries, not least in Italy or for that matter Britain, such eclecticism was commonplace.

It is, though ironic that the musicians emerging from art schools in the sixties were so often commented upon as to become cliche, yet barely a handful have sought to return, even en passant, to their roots. That Bowie should choose to do so is, in retrospect, not surprising. His international success as a recording artist, composer and live performer is too well known to need any summary here; but what is sometimes forgotten is the visual exploration that informs much of his work, from his study and use of mime in his performances, to stage sets that were installation pieces ranging from the debris of urban squalor to a half finished artist's studio; from album sleeves that only now are being recognised as miniature artworks to the carefully stylised personae whose bodies he inhabited and whose exteriors he clothed and faces he painted with lightening
f l a s h e s .

Most recently he has been developing the use of CD Rom as an obvious if still under used material for combining music and image. To this medium he adds random improvisations of words and music. Part of his own composing style for a long time, it perhaps also reflects a visit with Brian Eno to Gugging Psychiatric Hospital near Vienna where a series of interviews and meetings, he was struck by the patients' **free and improvised artworks.**

An important collector of art since the last 70's and a maker of art since the 60's, he joined the editorial board of Modern Painters magazine in 1990, writing, reviewing and interviewing. But he did not exhibit wholeheartedly as a visual artist until Kate Chertavian Fine Art mounted a retrospective exhibition in Cork Street, London, last year. In this retrospective exhibition he exhibited paintings, watercolours, computer generated prints, sculpture, Dadaist wallpaper designs and installation works.

"Ora, dalla prospettiva del 1996, guardo indietro... e, naturalmente, avanti e rifletto su dove si trova quel me stesso più giovane. Il tempo vacilla nell'eternità come una moneta che ruota su se stessa. Ho il sospetto che questo lavoro sia leggermente ispirato dalla teoria del caos e del tempo elastico".

Collaboration is a natural process for musicians, less so for visual artists. Bowie never allowed the thrust of ego to get in the way of collaboration. South African artist Beezy Bailey and Britain's Damien Hirst are two that he has worked with and with great affection, has visually, yet comically, commented on the latter.

In Famous Blatant Handmade 100 Monkey's Multiple, for example, Bowie pursued his preoccupation with random images to produce a whimsical variation of Hirst's celebrated Dot paintings, even if the monkeys with their erect tails seemed to be cocking a snook.

At which point one calls a halt quickly. One can almost see Bowie's infectious grin and hear the cackle of laughter as he spies an analysis edging towards pretension. Drama and pomp have always played their part in his work but not pomposity. Perhaps the least noticed ingredient in every art he practices is a playful irony. It is certainly evident in the central work exhibited at the Florence Biennale: **Where do they come from? Where do they go?** Nearly 18 feet high, two optical boxes hang in the air. Between them a human fom is suspended. **It is strangely undersized, and has lifelike hands and feet and a face that is a cast of Bowie's own life mask from 1976.** He describes it thus: "Where do they come from? Where do they go? originates from two black and white video pieces that I made in 1974. At the time I was intrigued by the myth of making of Meret Oppenheim and Joseph Beuys. Now, from the perspective of 1996 I'm looking back . . . and forwards of course and reflecting on where that younger self is situated. Time vacillating through eternity like a spinning coin. I suspect it's lightly informed by chaos and 'elastic-time' theory".

The unexpected flirtation with physics is a fascinating one, both for Bowie and for contemporary art. It is also interesting that Bowie sees in Where do they come from? Where do they go? what he calls "a transformation and blurring of myths, where pop culture starts to be a cipher for religion". The rock star is probably the ultimate 20th century myth and as one, **Bowie knows fame, its hedonism and its paranoia in a way no living painter ever can.** The insights that Bowie can bring to canvas and installations are many.

The best musicians, Bowie prominently among them, absorb a range of musical styles and influences, yet still produce work that is distinctively their own. Visual artists perhaps have a greater need to stamp their own identity on their work even if this involves working in isolation from their peers. David Bowie delights in ever changing collaborations and assimilating new fashions and new cultures. His future direction as he continues to experiment, explore and build on his individuality as an artist, is intriguing.

David Lister and Karen Wright
London 1996

EVOL FOR THE MISSING
1996
acrylic on canvas
122 x 91 cms

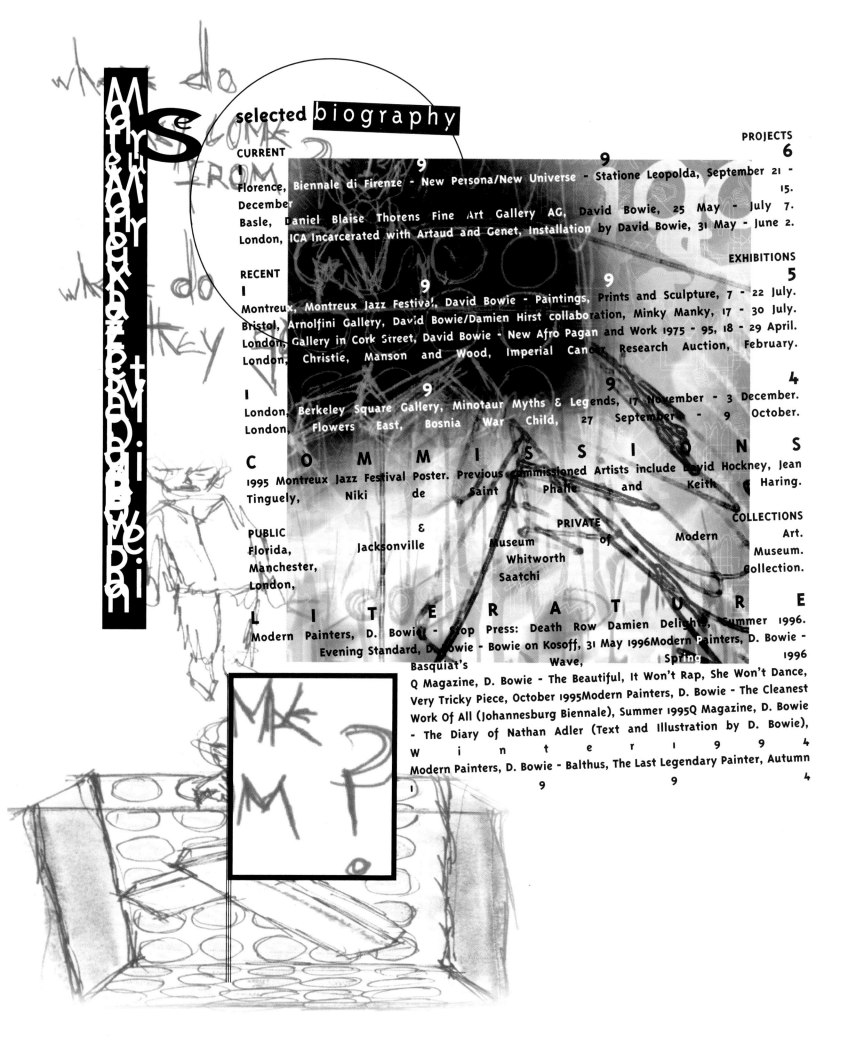

selected biography

PROJECTS

CURRENT

1 9 9 6

Florence, Biennale di Firenze - New Persona/New Universe - Statione Leopolda, September 21 - December 15.

Basle, Daniel Blaise Thorens Fine Art Gallery AG, David Bowie, 25 May - July 7.

London, ICA Incarcerated with Artaud and Genet, Installation by David Bowie, 31 May - June 2.

EXHIBITIONS

RECENT

1 9 9 5

Montreux, Montreux Jazz Festival, David Bowie - Paintings, Prints and Sculpture, 7 - 22 July.

Bristol, Arnolfini Gallery, David Bowie/Damien Hirst collaboration, Minky Manky, 17 - 30 July.

London, Gallery in Cork Street, David Bowie - New Afro Pagan and Work 1975 - 95, 18 - 29 April.

London, Christie, Manson and Wood, Imperial Cancer Research Auction, February.

1 9 9 4

London, Berkeley Square Gallery, Minotaur Myths & Legends, 17 November - 3 December.

London, Flowers East, Bosnia War Child, 27 September - 9 October.

C O M M I S S I O N S

1995 Montreux Jazz Festival Poster. Previous commissioned Artists include David Hockney, Jean Tinguely, Niki de Saint Phalle and Keith Haring.

COLLECTIONS

PUBLIC & **PRIVATE**

Florida, Jacksonville Museum of Modern Art.

Manchester, Whitworth Museum.

London, Saatchi Collection.

L I T E R A T U R E

Modern Painters, D. Bowie - Stop Press: Death Row Damien Delights, Summer 1996.

Evening Standard, D. Bowie - Bowie on Kosoff, 31 May 1996Modern Painters, D. Bowie - Basquiat's Wave, Spring 1996

Q Magazine, D. Bowie - The Beautiful, It Won't Rap, She Won't Dance, Very Tricky Piece, October 1995Modern Painters, D. Bowie - The Cleanest Work Of All (Johannesburg Biennale), Summer 1995Q Magazine, D. Bowie - The Diary of Nathan Adler (Text and Illustration by D. Bowie), W i n t e r 1 9 9 4

Modern Painters, D. Bowie - Balthus, The Last Legendary Painter, Autumn 1 9 9 4

La teatralità e il fasto hanno già giocato il loro ruolo nel suo lavoro, ma senza pomposità. Forse, il minimo ingrediente di cui ci si accorge in ogni arte che egli pratica è una giocosa ironia. E ciò è sicuramente evidente nel principale lavoro esposto alla Biennale di Firenze: Da dove vengono? Dove vanno? Due scatole ottiche sono sospese nell'aria all'interno di una struttura alta 18 piedi (circa 5 metri). Fra di esse si trova una forma umana stranamente più piccola, con mani e piedi verosimili e un volto che è uno stampo della maschera dello stesso Bowie fatta nel 1976.

FOCUS, TRAVEL, FEED: FOCUS I
1996
acrylic on canvasboard
16 x 12 cms

Yohji Yamamoto

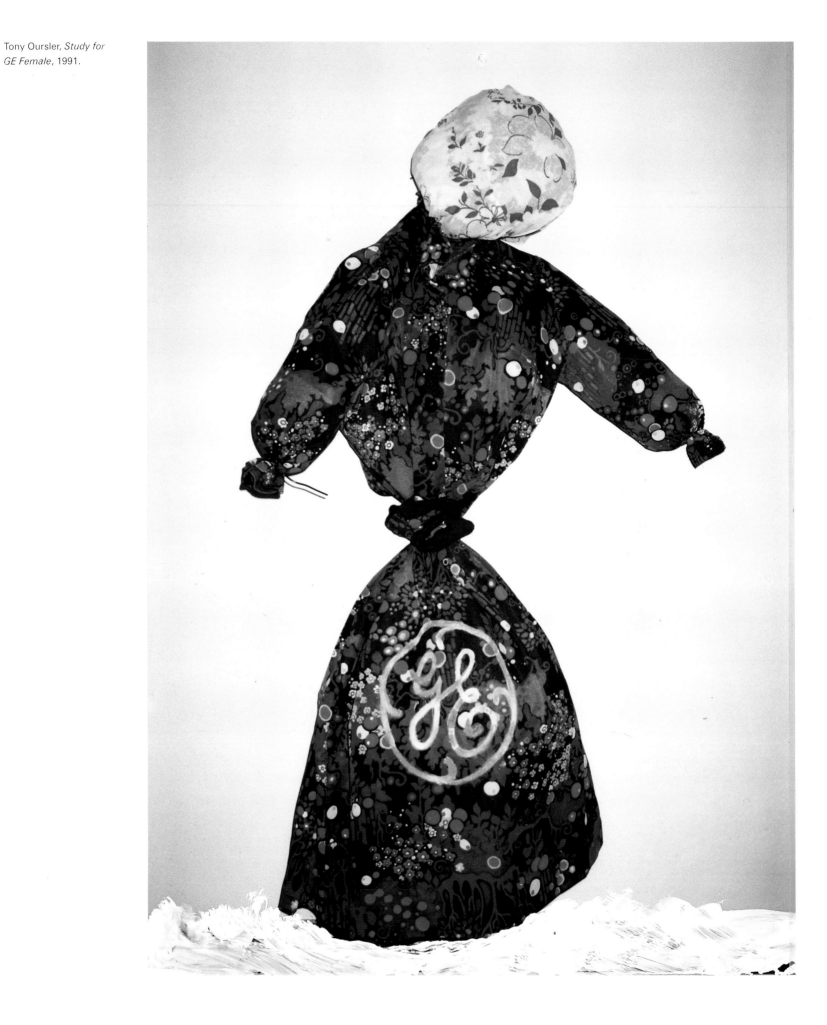

Tony Oursler, *Study for GE Female*, 1991.

Tony Oursler, *Escort*,
1996.

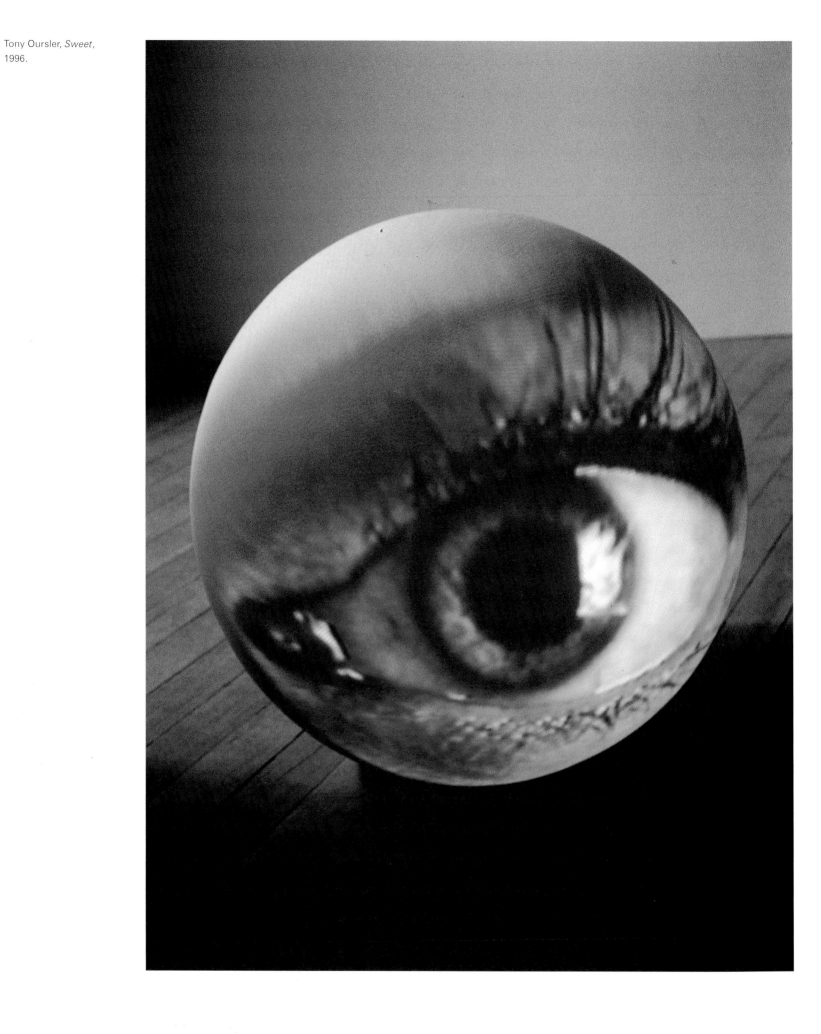

Tony Oursler, *Dust*, 1996.

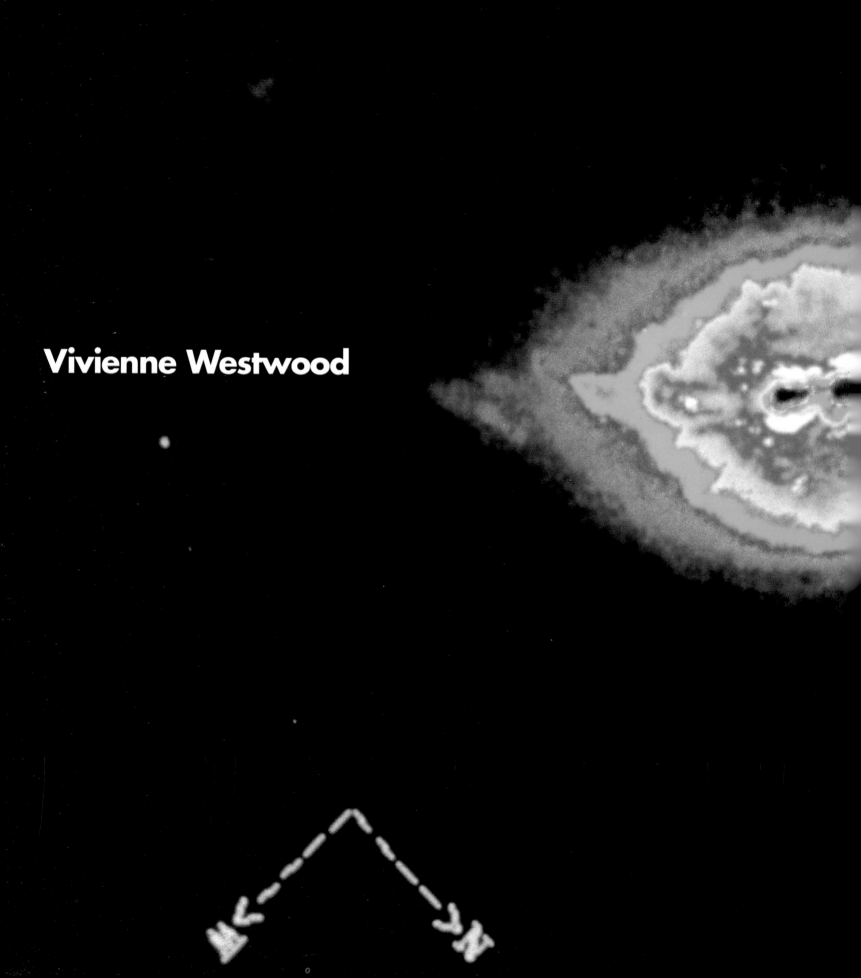

Vivienne Westwood

I have been 25 years in fashion and I came to realise early on that I would discover something new by exploring the stunning achievements of people before me. Thus I have been recognized as an innovator.

It is for this reason that I gladly accepted to take part in this year's festival of art and fashion, not because I wish to claim fashion as high art (fashion is an applied art and depends on the chic of the wearer) but because my craft is, at least, alive and this can hardly be said of pure art. I shall use my space in the exhibition to pinpoint some of the starting points, and the way in which my work has developed from them, as evidence that the creative process is rooted in tradition.

Having spent these years in cultivating my taste, I welcome this platform to express in more general terms my opinion regarding the future of art and culture: it is only by learning to copy that an artist learns to express himself, then, if he has talent, he will *inevitably* break the rules, for vision depends on knowledge.

People today have been let to believe that the past is irrelevant, that if you cut the links with tradition you will become free: the opposite is true, you will become hemmed in. Is it too late, Damien?

Poor, callow Youth, you are being flattered by academics and businessmen. Well, fuck them! Their power lies in being able to manipulate you - Don't make it easy. Can you learn to draw like Fragonard learnt? The past is yours and the future of art belongs to you.

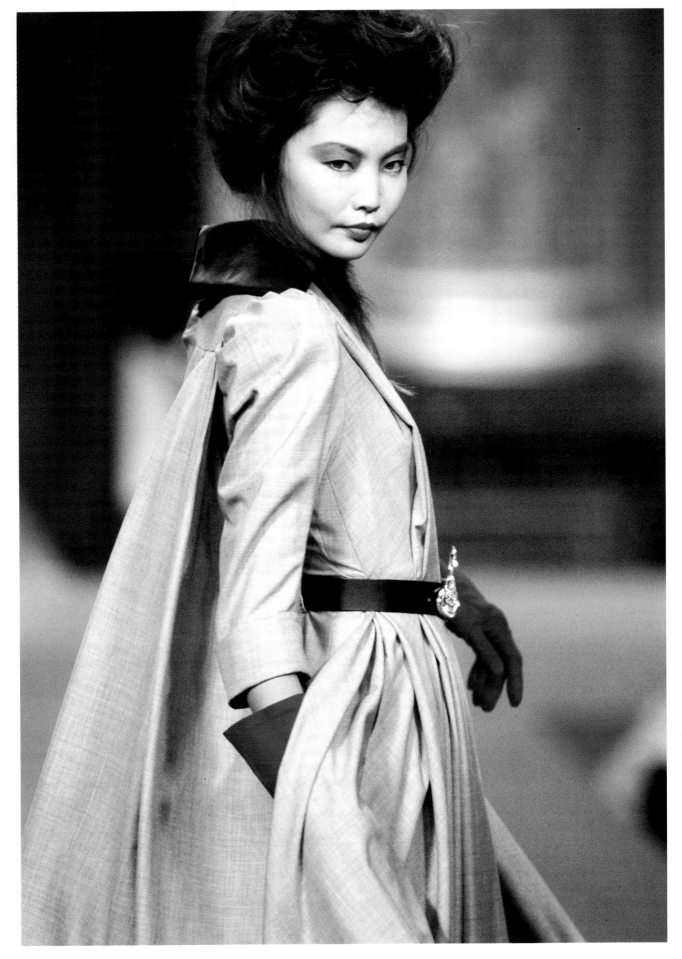

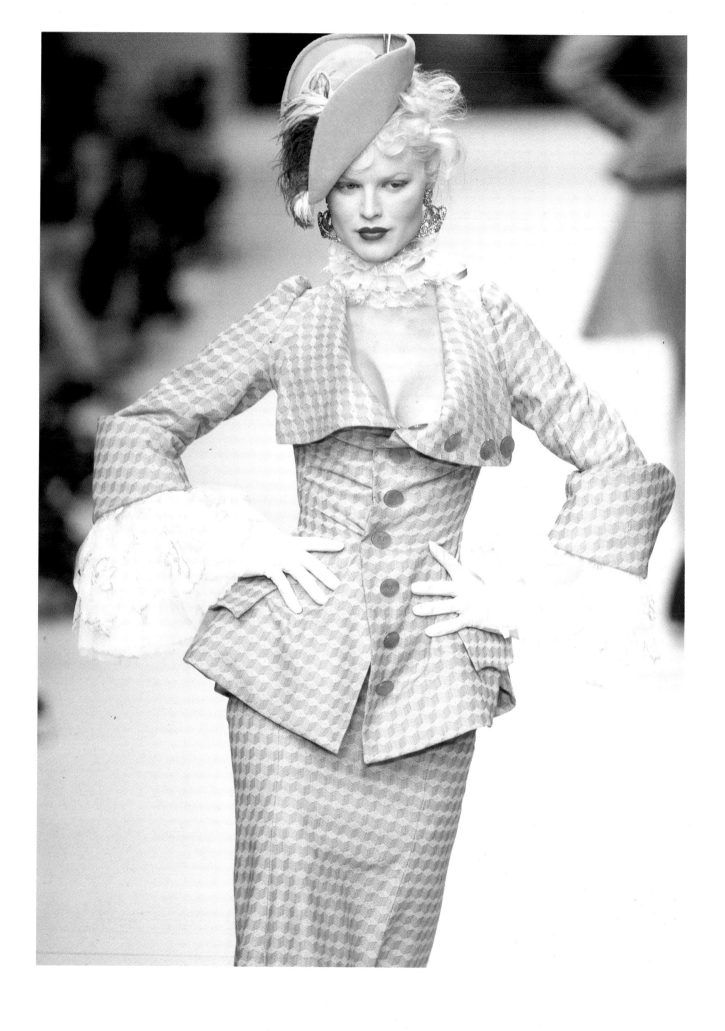

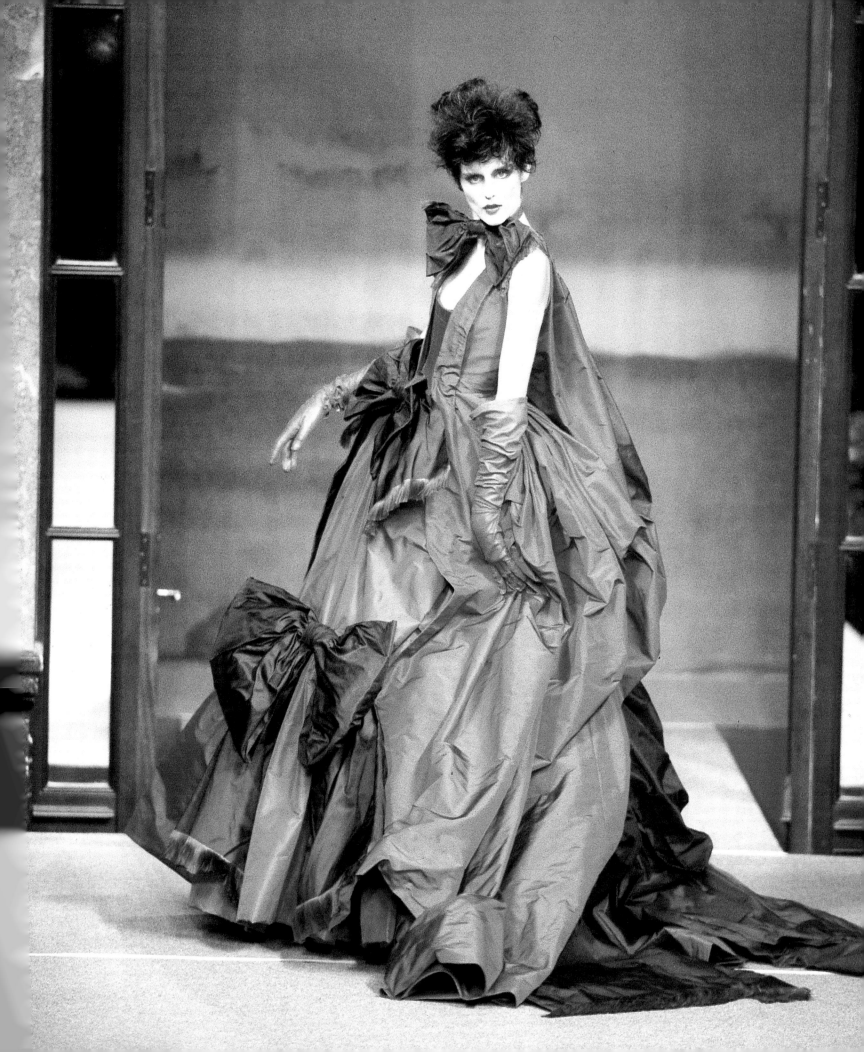

Vito Acconci

Vito Acconci, *Adjustable Wall Bra*, 1990-1991.

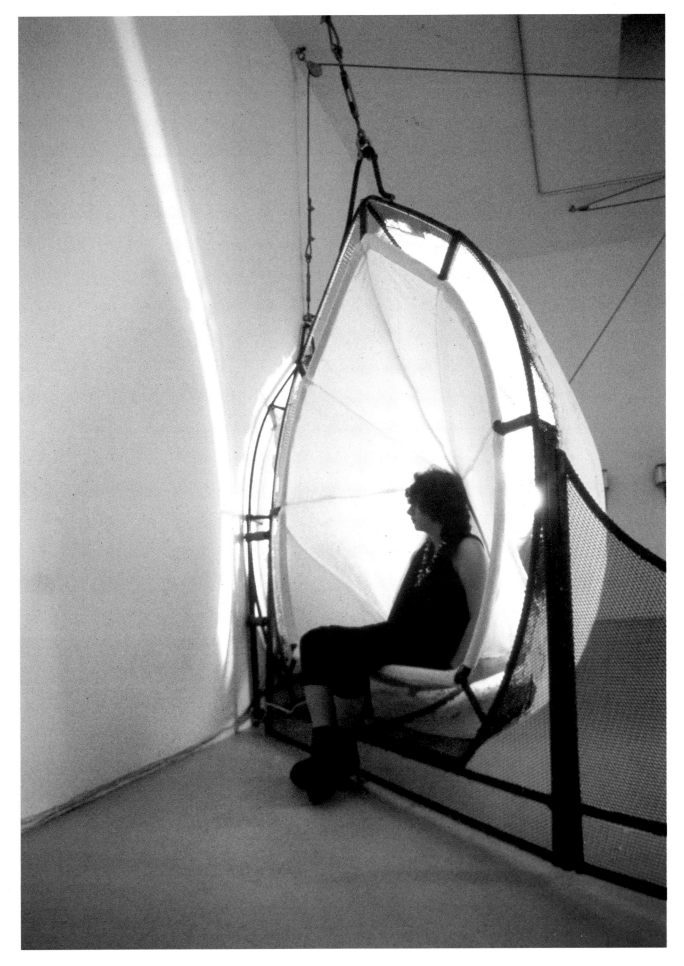

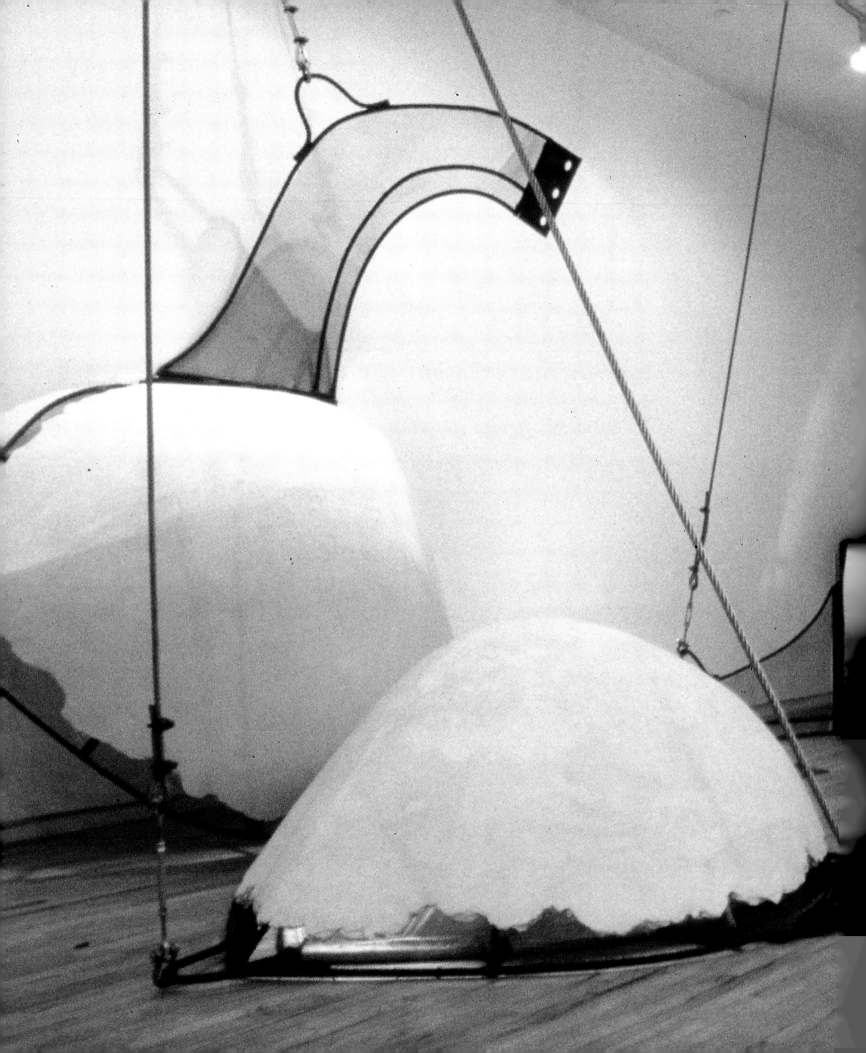

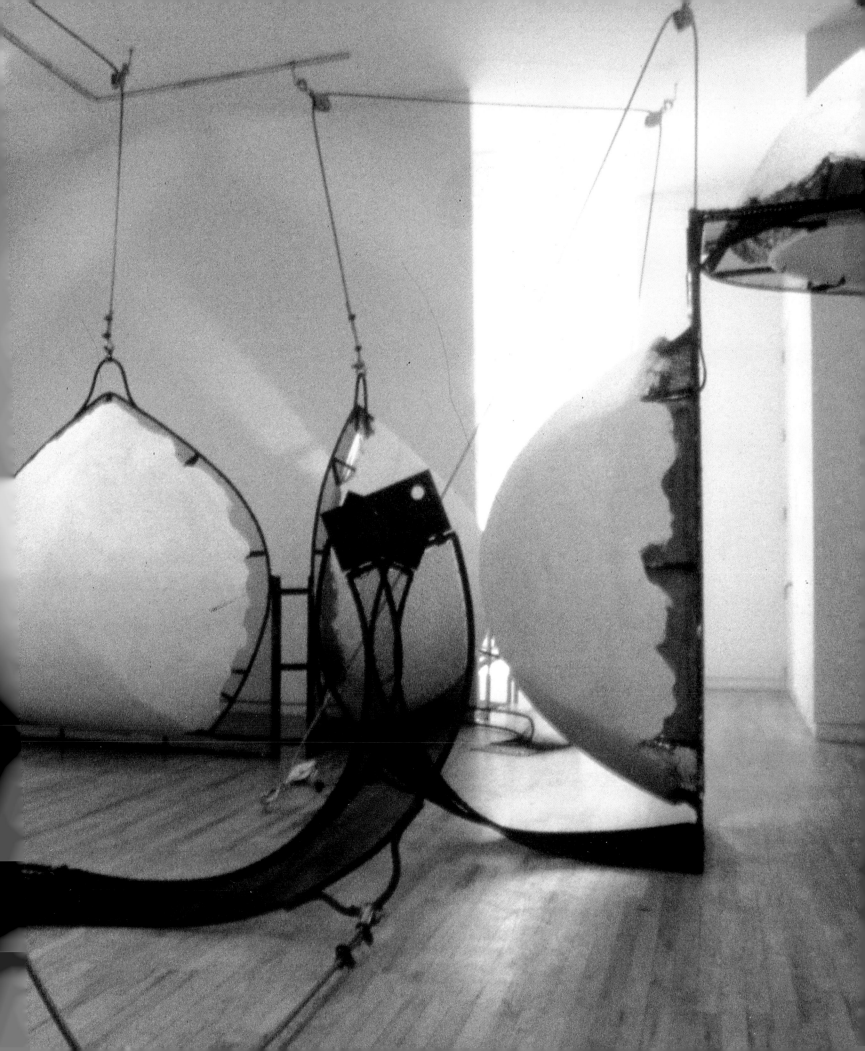

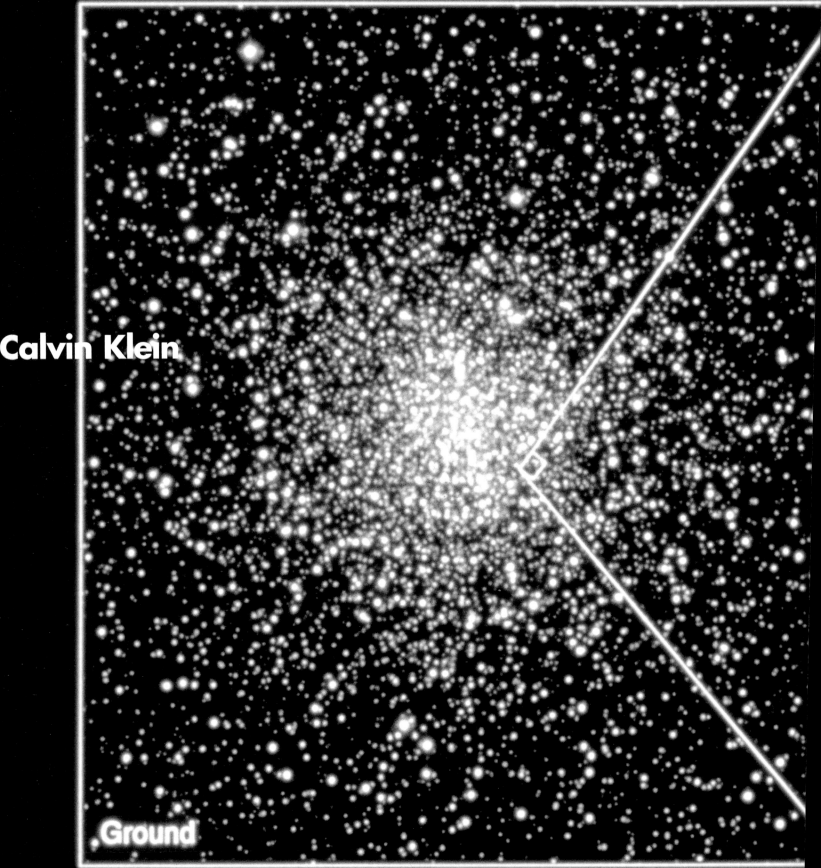

Calvin Klein Biography

Calvin Klein has been a dominant force in fashion for more than 25 years. Continually innovative since he launched his first ready-to-wear women's collection in 1968, Calvin Klein is one of very few American designers to build a truly international success both creatively and financially.

Calvin Klein taught himself to draw and sew as a child. He earned a diploma at the New York High School of Art and Design and went on to graduate from the Fashion Institute of Technology in 1962. He then worked as an apprentice at a Seventh Avenue coat and suit house by day, while creating his own portfolio in the evenings and on weekends. In 1968, he started his own label in partnership with his childhood friend, Barry Schwartz. Klein provided the creative direction, while Schwartz guided the financial aspects of the business.

Success came quickly – a chance meeting with a Bonwit Teller buyer led to what represented a substantial order for a young company. Klein's achievements soon earned recognition from the fashion world. In 1973, he was the youngest designer ever to win the Coty Award and he went on to win it again in 1974 and 1975. In 1982, 1983 and 1986, he won the Council of Fashion Designers award for outstanding design in womenswear. And in 1993, the Council of Fashion Designers of America named Klein outstanding designer of the year for both womenswear and menswear, the first designer ever to receive both distinctions concurrently. Most recently, in 1996, Klein was awarded the Management Medal for excellence in advertising and visual communication by The Art Directors Club of New York.

Calvin Klein says: "I design modern clothes for modern women and men." With clean lines and spare shapes, he has created a singularly modern architecture for simplicity and elegance. "Everything begins with cut," he has said, pointing out that line and shape are the function and the beauty of any design and this same spirit and sensibility are consistently woven through every collection and product line. Each item is designed to reinforce the Calvin Klein aesthetic of minimal, sexy and natural beauty.

Calvin Klein, Inc. today encompasses three lifestyle categories – the Calvin Klein Collection for women and men, cK Calvin Klein for women and men and cK Calvin Klein jeans for women, men and children. A diverse range of products is designed under these lifestyle categories, including apparel, accessories, shoes, underwear, sleepwear, hosiery, socks, swimwear, eyewear, coats, and fragrance, as well as products for the home.

In 1995, Calvin Klein realized a lifelong dream with the opening of the flagship Calvin Klein Madison Avenue Collection store in New York City as part of a retail expansion program that will see both Calvin Klein Collection stores and freestanding cK Calvin Klein stores opening in major cities around the world.

CALVIN KLEIN, INC. FACT SHEET

ADDRESS/PHONE...

Headquarters:
Calvin Klein, Inc.
205 West 39th Street, New York, NY 10018
T: 212.719.2600
F: 212.730.4818

Europe:
Calvin Klein Europe
29 Via Montenapoleone, Milan, Italy 20121
T: 011.39.2.76209206
F: 011.39.76209201

Asia:
Calvin Klein Asia
Suite 2-7, 23A-FL, Tower 1, The Gateway
25 Canton Road
Tsimshatsui, Kowloon
Hong Kong
T: 011.852.26296111
F: 011.852.2956.3630

NUMBER OF EMPLOYEES.....

1,300

COMPANY CHRONOLOGY....

1968: Calvin Klein and Barry Schwartz opened their first apparel company, a coat business, and created Calvin Klein women's ready to wear collection

1973: debuted first women's sportswear collection

1974: created Calvin Klein Accessories

1974: created Calvin Klein Furs

1978: created Calvin Klein Menswear

1978: created Calvin Klein Jeans

1979: launched Calvin Klein fragrance for women

1981: launched Calvin Klein fragrance for men

1982: created Calvin Klein Underwear for men

1983: created Calvin Klein Intimate Apparel

1983 created Calvin Klein Underwear for women

1985: created Calvin Klein Footwear

1985: created Calvin Klein Hosiery

1985: created Calvin Klein Sleepwear

1985: launched Obsession for Women

1986: launched Obsession for Men

1988: launched Eternity for Women

1989: launched Eternity for Men

1989: created Calvin Klein Swimwear

1990: created Calvin Klein Socks

1991: launched Escape for Women

1992: re-launched Calvin Klein Collection for men

	1992: created cK Calvin Klein men's collection
	1992: created cK Calvin Klein women's collection
	1992: created Calvin Klein Eyewear
	1993: launched Escape for Men
	1993: decision made to depart fur business
	1994: created cK Calvin Klein women's belts
	1994: launched cK one fragrance
	1994: opened Calvin Klein Collection store in Tokyo
	1995: created Calvin Klein Home Collection
	1995: opened Calvin Klein Madison Avenue Collection store
	1996: launched ck Calvin Klein Jeans Khakis
	1996: launched cK be fragrance
	1996: opened Calvin Klein Collection store in Seoul

AWARDS..

1973, 1974, 1975: Three-time winner of Coty Award, youngest designer to ever win this distinction
1982, 1983, 1986: Three time winner of the Council of Fashion Designers of America Award for outstanding design in women's wear
1984: Received Fashion Institute of Technology President's Award
1992: Honored at Seventh Annual California Fashion Industry Friends of AIDS Project Los Angeles Gala
1993: Winner of the Council of Fashion Designers of America award for outstanding design in both women's wear and men's wear, first designer to receive both honors in the same year.
1996: Received Management Medal from Art Director's Club.

AFFILIATIONS...............

Council of Fashion Designers of America, member of board of directors; Hazelden Foundation, member of advisory committee; Gay Men's Health Crisis, member of the president's council; The Hampton Classic, board member. Actively participates with. Design Industries Foundation for AIDS (DIFFA); Educational Foundation of the Fashion Industries (EFFI); AIDS Project Los Angeles (APLA); Pediatric AIDS Foundation, among others.

CALVIN KLEIN COLLECTION FLAGSHIP STORES....

UNITED STATES. Costa Mesa, California; Palm Beach, Florida; Dallas, Texas; New York City, New York. JAPAN: Tokyo. SOUTH KOREA: Seoul. SPAIN: Barcelona. SWITZERLAND: Zurich (boutique); Saint-Moritz (boutique); Basel (boutique)

cK CALVIN KLEIN FREESTANDING STORES.

HONG KONG. INDONESIA: Jakarta SINGAPORE

Carrie Mae Weems

Carrie Mae Weems,
details from: *From Here
I Saw What Happened
and I Cried*, 1994-1995
(edition 2)

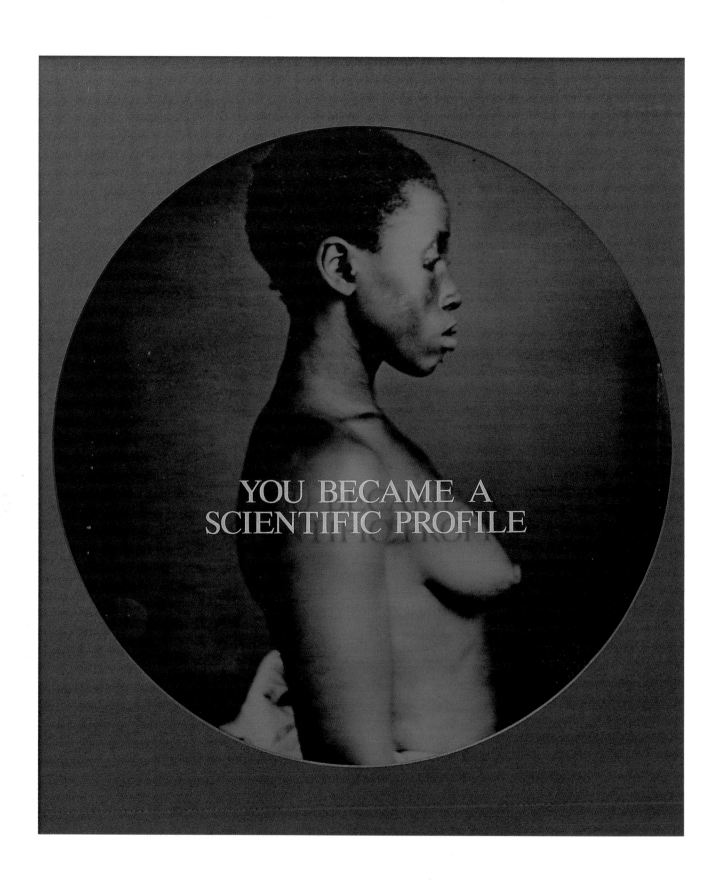

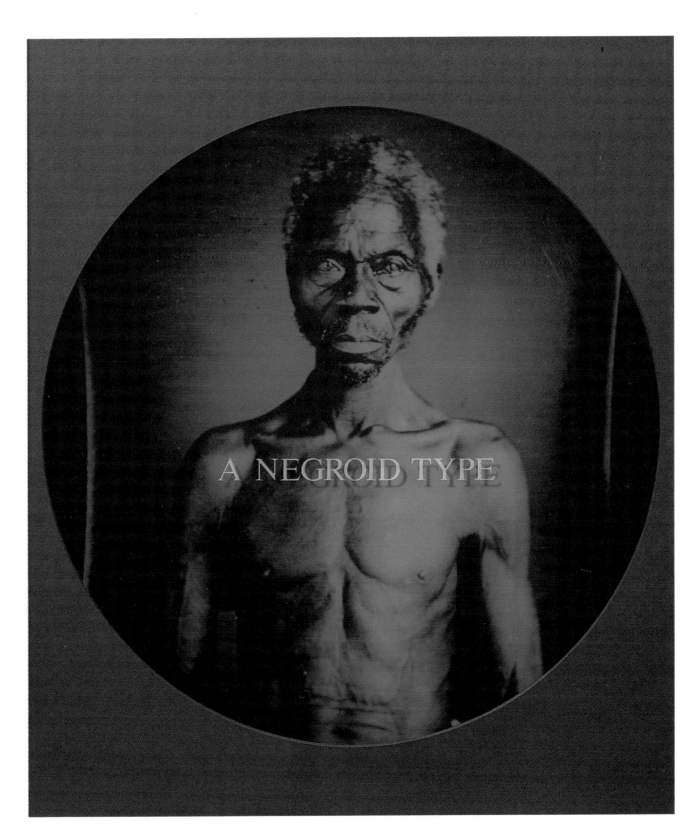

311

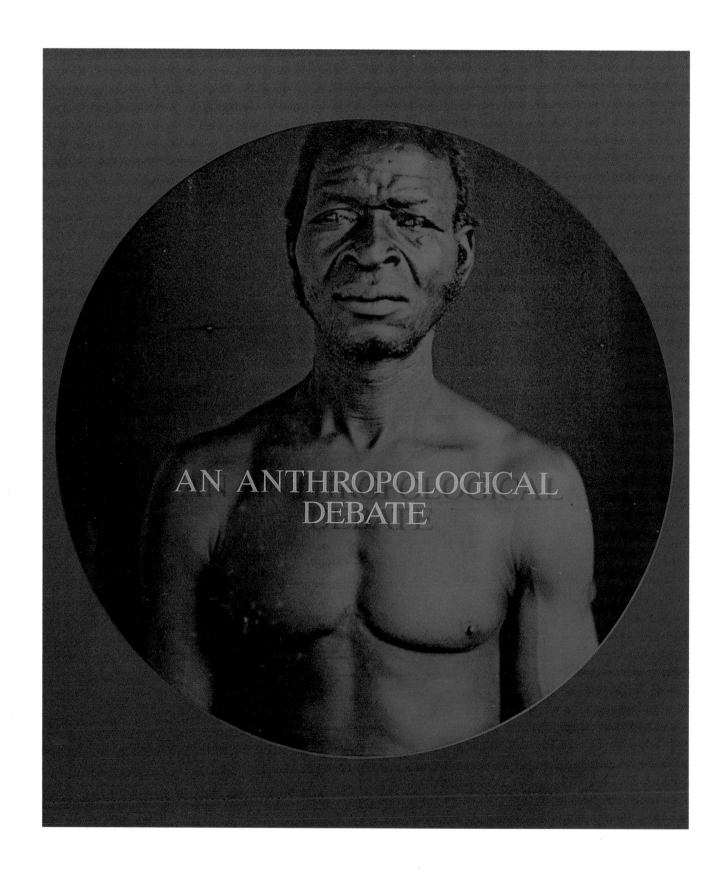

AN ANTHROPOLOGICAL
DEBATE

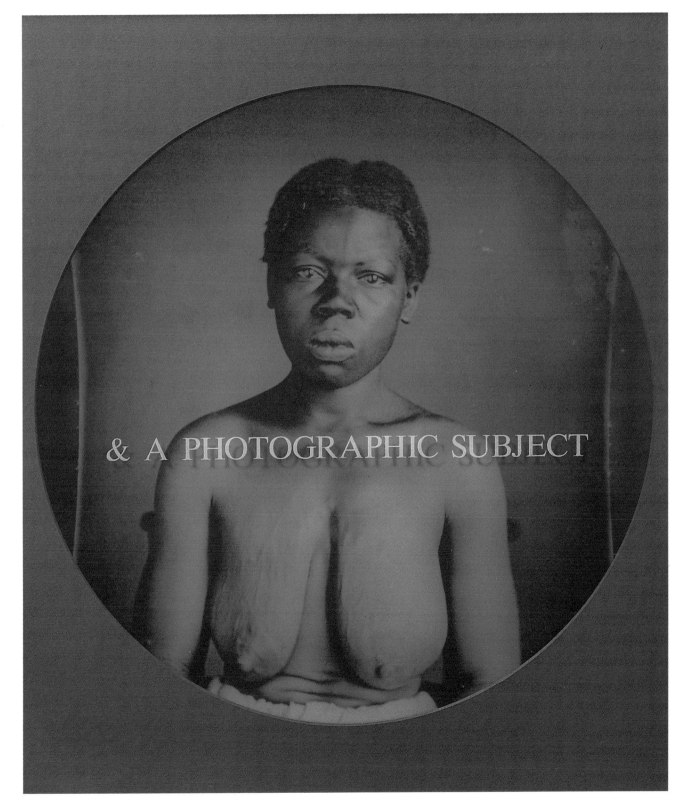

& A PHOTOGRAPHIC SUBJECT

Missoni

ctic

m

Ultraviolet

Ground-based
View

HST View

Ultraviolet

Quando un'attività porta il nome di una famiglia diventa qualcosa di più di un'attività soltanto, diventa un retaggio. Il retaggio Missoni è sinonimo di impegno di famiglia, di dedizione al lavoro e fierezza per aver creato un prodotto innovativo.

Nei suoi quarant'anni di attività nella moda, Missoni è arrivato a essere simbolo dell'essenza dei materiali, dell'arte del colore, della qualità della maglia.

Base essenziale del disegno Missoni sono la grafica e l'effetto di qualità dimensionale e intrigante generato dai motivi astratti.

Missoni ha le sue origini nel tessile e nella maglieria, in un'attività situata fuori Milano.

Quando Rosita e Ottavio si sposarono, nel 1953, costituirono un piccolo laboratorio di maglieria vicino a Milano.

L'attività si ingrandì e dopo quasi un ventennio il nome di Missoni veniva riconosciuto per l'inconfondibile marchio che si distingueva nella maglieria e nella moda.

Nel 1968, sotto la spinta incalzante di Diana Vreeland, Rosita organizzò per la prima volta a New York una collezione Missoni allestendo un palcoscenico per una nuova arena di riconoscimenti.

I primi anni settanta portarono successo e imponenza ai Missoni, che iniziarono a figurare fra i leader mondiali nella moda di quel momento.

Da quando nel 1978 i Missoni organizzarono una mostra retrospettiva per i loro venticinque anni alla Rotonda della Besana di Milano e al Whitney Museum of Art di New York il nome Missoni è diventato uno dei più autorevoli nel mondo del design.

Nel 1944 hanno celebrato i quarant'anni della loro attività con una mostra intitolata "Missonologia – Il mondo dei Missoni", a Firenze e a Milano.

Nel 1996 la mostra "Missoni Opera" viene presentata al Sezon Museum di Tokio.

I Missoni fanno parte di quel gruppo ristretto di designer che sono riusciti veramente a combinare il mondo dell'arte e della cultura con quello della moda.

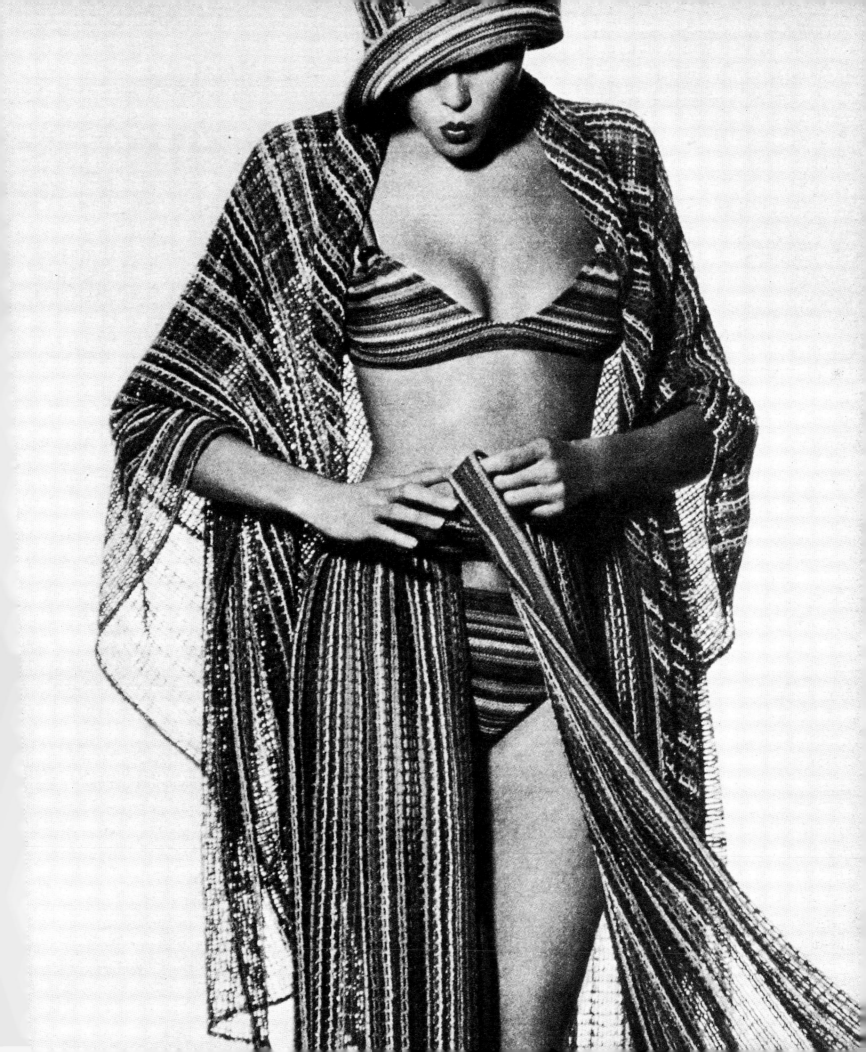

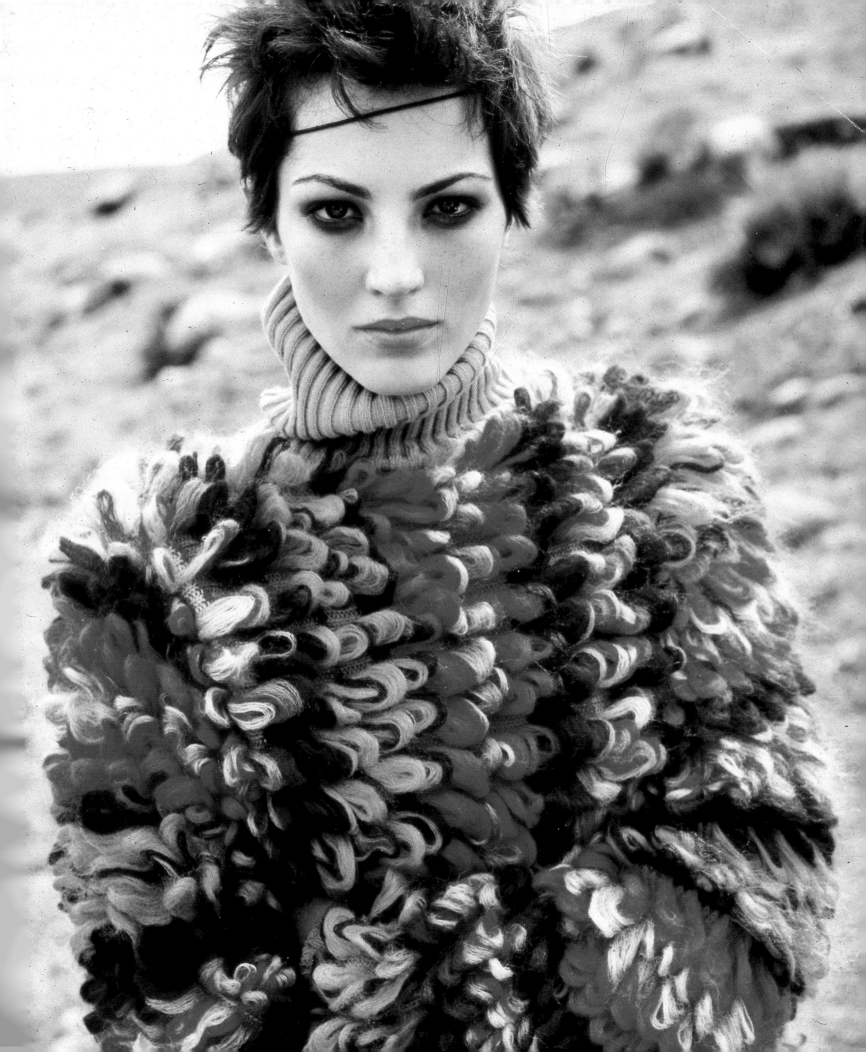

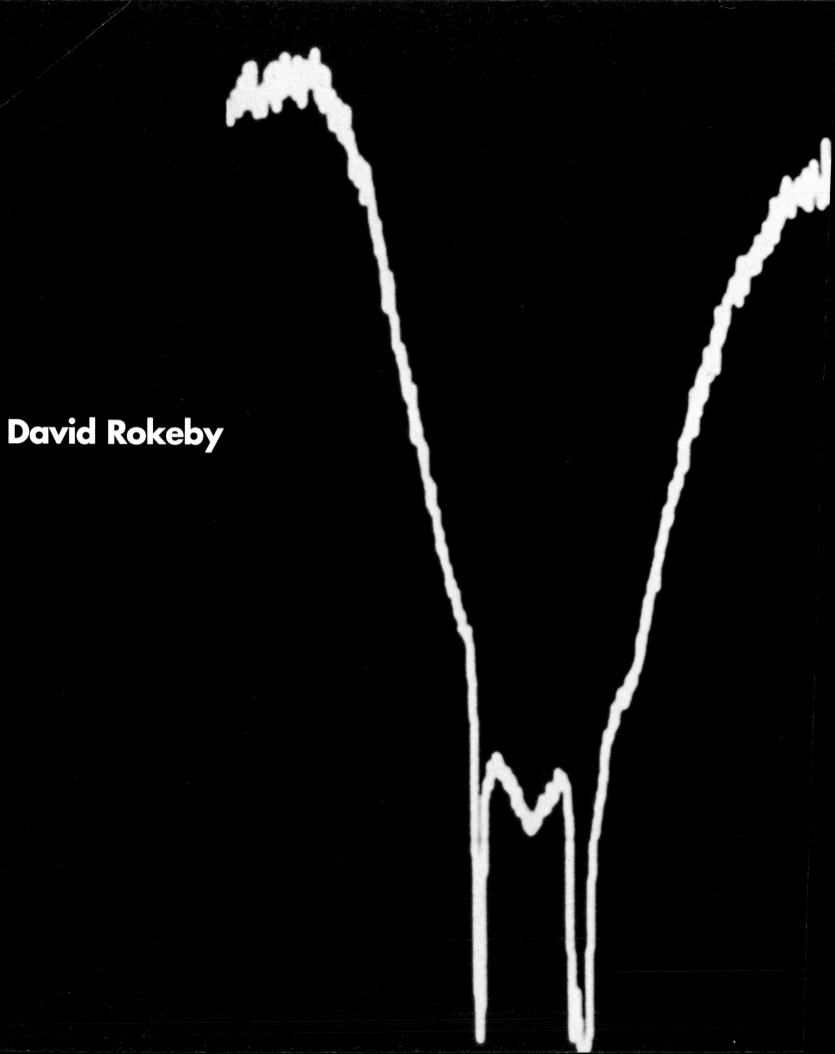

David Rokeby

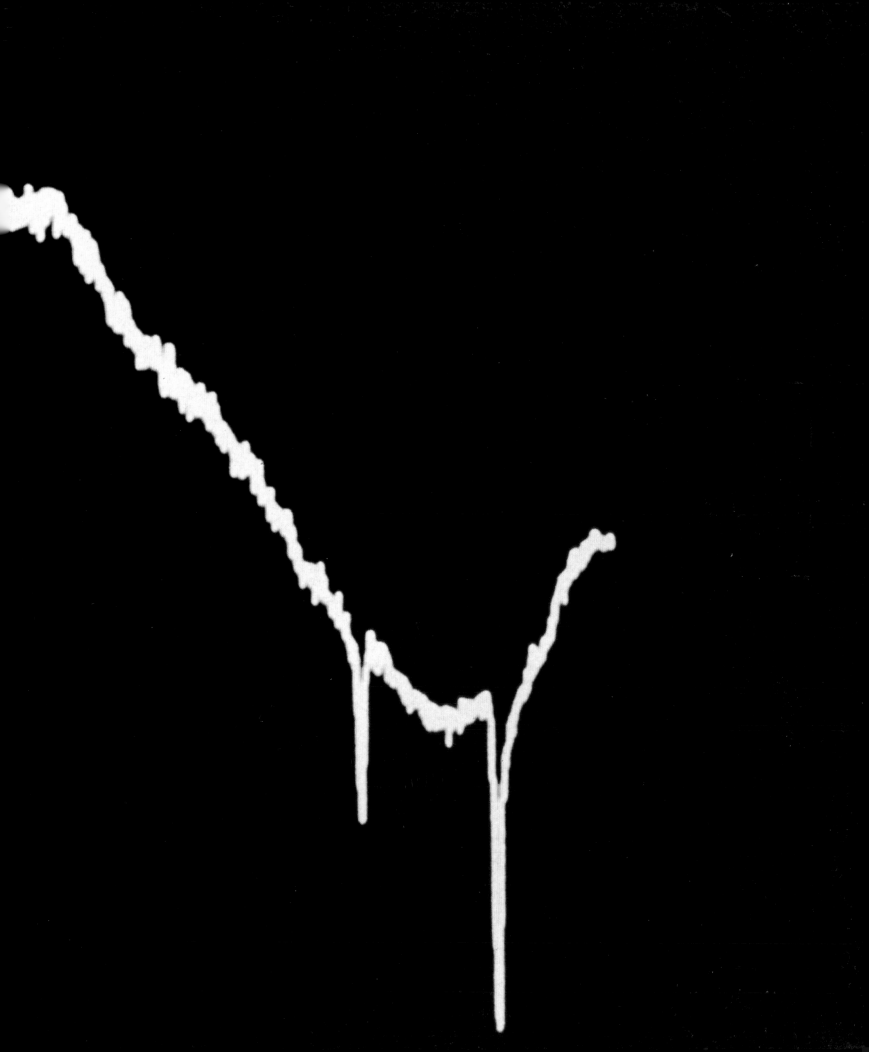

David Rokeby, *Echoing Narcissus*, 1987

David Rokeby
in collaboration with Erik Samakh, *Petite terre*, 1991

David Rokeby, *Watch:*
Richmond and Spadina,
1995-1996

Manolo / Arnaldo Ferrara

The mark of our time is its revulsion against imposed patterns. We are suddenly eager to have things and people declare their beings totally. In this attitude there is a deep faith to be found- a faith that concerns the ultimate harmony of all beings. Such is the faith in which this piece has been built. It explores the contours of our own extended beings in our technologies, seeking the principle of intelligibility in each of them. To look at life a new, accepting very little of the conventional wisdom concerning them.

This piece is about now, the new, to be worshipped for the changes it brings within ourselves, and outside ourselves as well. Although it supports the matrimonial concept of bonding in it; Religion has been substituted by science, technology replaces the magic, democracy replaces monarchy, change is in place of tradition, and finally the progress of promise elevates us to salvation as living beings. It challenges all authorities, accepting only the few that can accept rational criticism, as a result making rebellion more orthodox than obedience.

The idea of human bondage never changes, what alters is our always unperfected apprehension of it. The physical world around us is a body of energy. We must transform it, concentrate it, release it, and rearrange it to suit us better and better everyday of our lives. In the modern era mobility of individuality, the variety of social ethnic groups, their differences in culture, their reality staggering self-righteous hypocrisies, their unsteady-unclear, polluted but enduring sense of mission; does not control anything. In our new world, idea controls nothing. All things are revealed in absolute disorder of the way things are supposed to be. This in itself will cause movement.

As light alters in intensity of yellow hues and quality; the picture continues to act on you motionlessly: To look at it is to participate .

Manolo and Arnaldo's "New Universe"

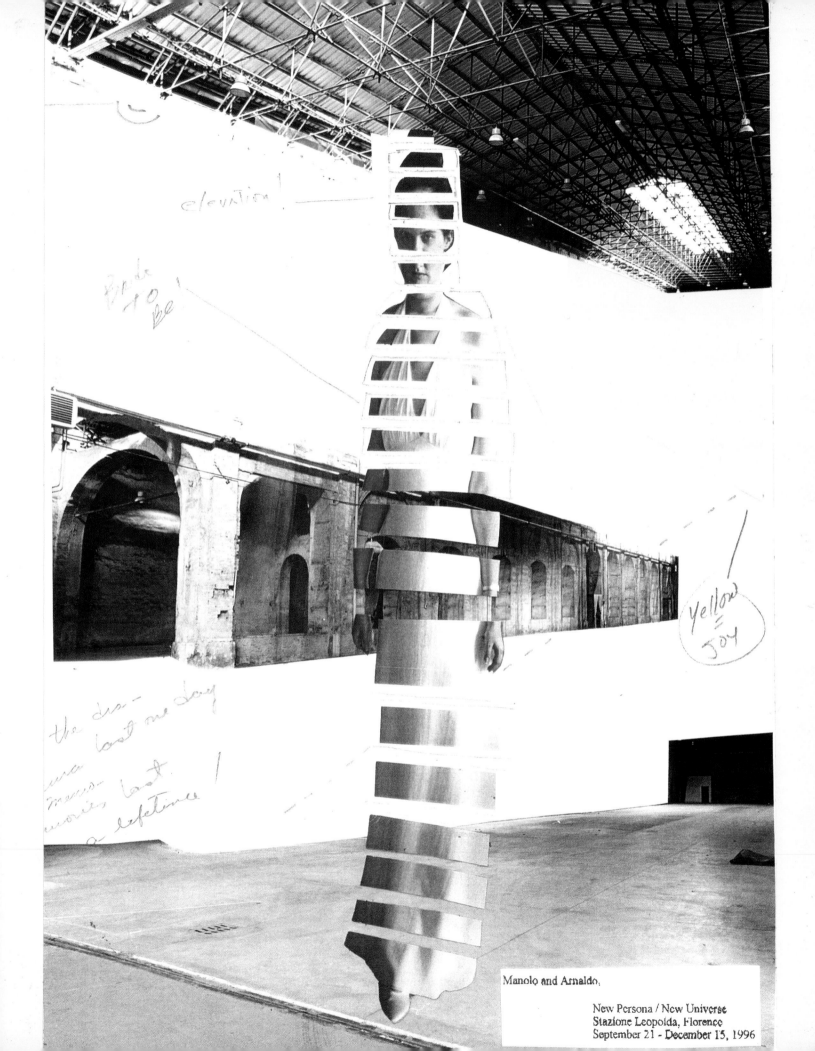

Manolo and Arnaldo,

New Persona / New Universe
Stazione Leopolda, Florence
September 21 - December 15, 1996

Alexander McQueen

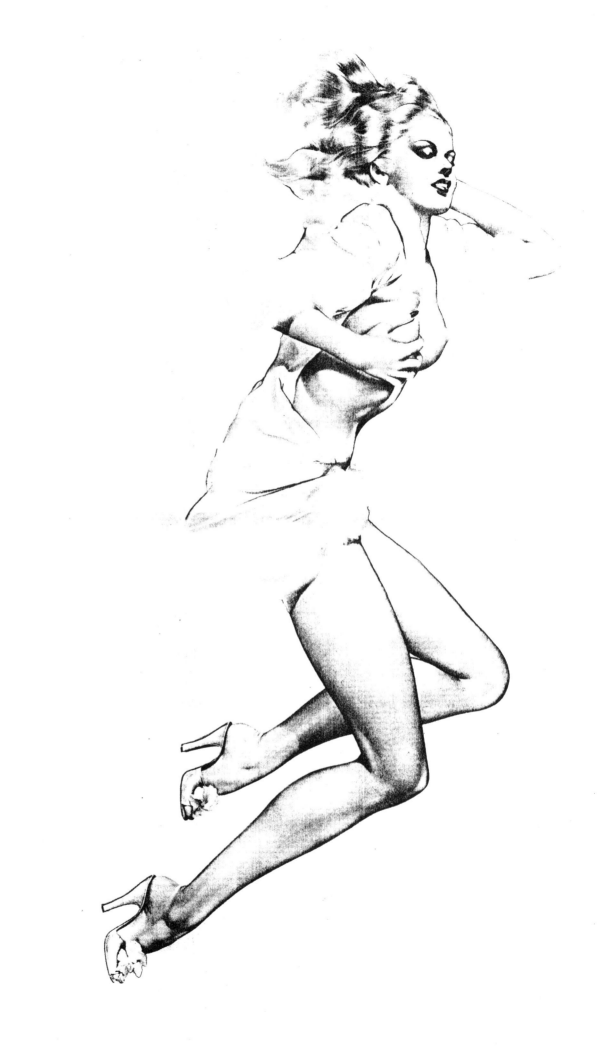

Mighty Hermaphrodity!,
1996.

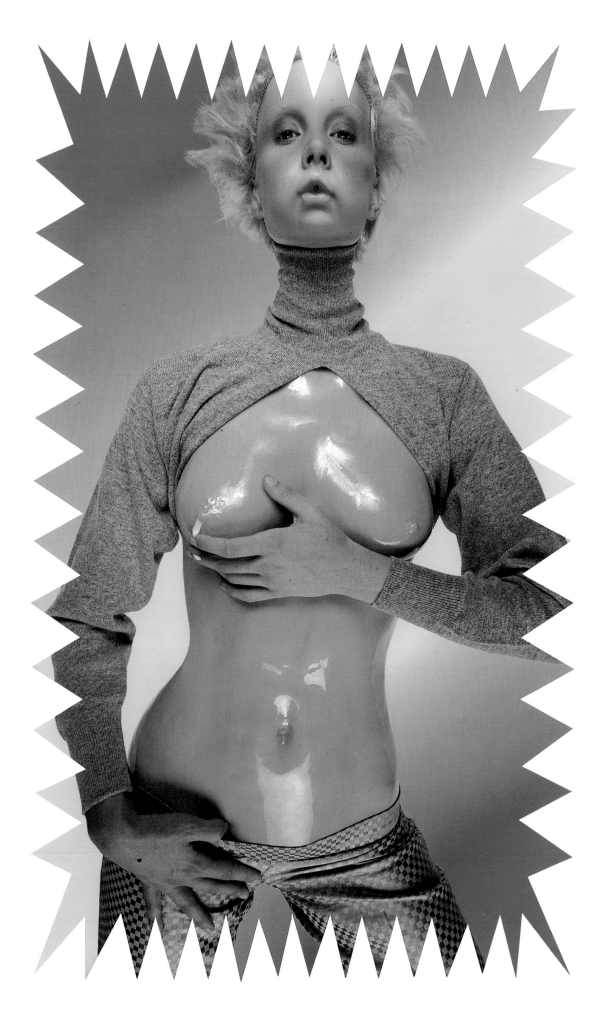

Carmen, 1996.

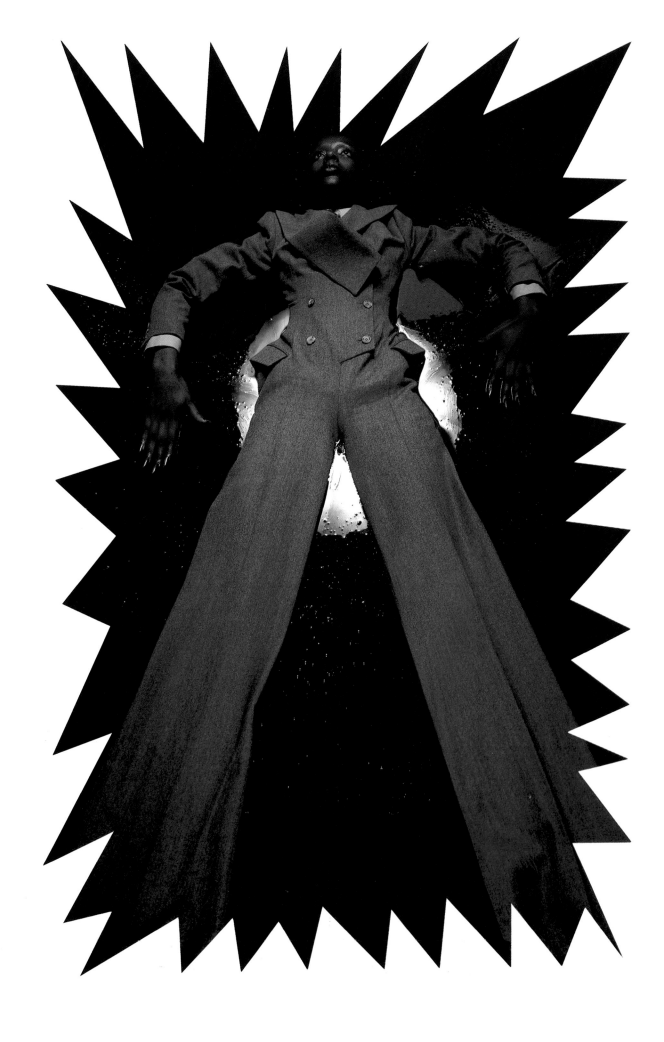

Adia, 1996.

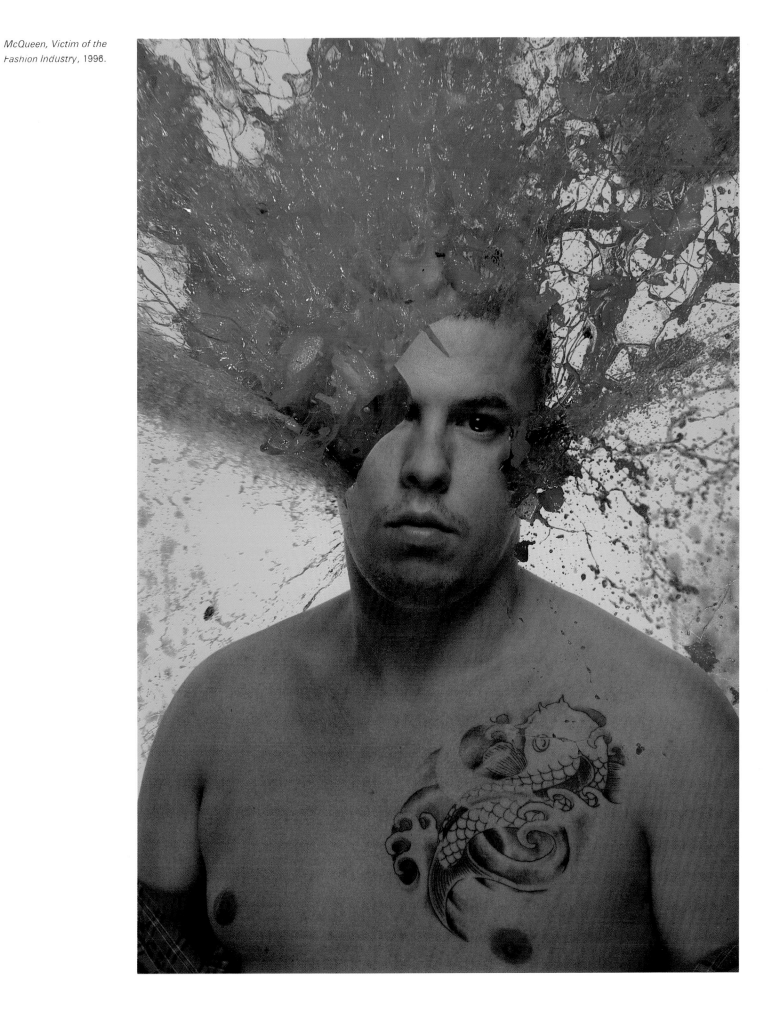

Jake & Dinos Chapman

Jake e Dinos Chapman,
Zygotic Exposure 1,1996.

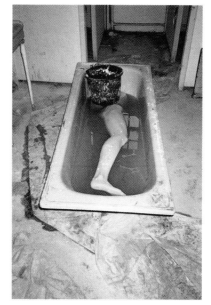

Moschino

Before Servicing

After Servicing

taliano, Pesci... qualche anno
all'Accademia di Belle Arti di Milano, tantissimi
lavori diversi, fino ad illustratore free-lance per
alcune stagioni. Questo è quanto ho vissuto prima
di sentirmi definire "Creatore di Moda".
Prima di cominciare con la Collezione Moschino nell'83, ho disegnato per
quasi 6 anni la Collezione di Cadette, che già presentava
diverse "anomalie" secondo gli schemi canonici della Moda,
soprattutto Italiana. Il concetto Moschino consiste nel lasciare la più totale libertà
di scelta a coloro che desiderano vestirsi.
Le imposizioni sono bandite, quello che usava l'anno scorso, se ti piace,
si userà anche quest 'anno e l'anno prossimo.
Se ti senti più felice con un vestito scomodo,.o scarpe belle ma strette fai pure,
se sei fashion-victim e vuoi essere rassicurata
dalle "firme", fai pure, se credi di avere buon gusto e non ce l'hai,
continua come vuoi tu!
Insomma Moschino vuol dire scegliere con la stessa sicurezza e la tranquillità
con la quale si sceglie qualcosa da mangiare!
... Sono come un ristorante che cerca di fare bene dei piatti classici già
inventati da chissà quale cuoco!

Italian, Pisces... a few years at the Academy of Fine
Arts of Milan, lots of different jobs, until
becoming a free-lance illustrator for several seasons.
This is what I experienced before being considered a
"Fashion Creator". Before starting the Moschino
Collection in '83, I designed Cadette's Collection for almost 6 years, which already
presented various "anomalies" towards the established
rules of fashion, particularly in Italy. The aim of Moschino is to give
the consumer a total freedom. The impositions are removed, if you still like
what you wore last year, wear it again this year
and even next year. If you feel better in an unconfortable dress or pretty shoes,
that are too tight, that's fine too, if you are a fashion
victim and are reassured by a label that's fine, if you think you have
good taste but don't, carry on! Basilically Moschino
means that you can choose our clothes with the same ease that you would choose
something to eat. I am like a restaurant who tries
to prepare good classic dishes created by who knows which cook!

I am *what* I am!

KAOS!

Originario stato di
disordine della materia
nel periodo antecedente alla
formazione del mondo.

IDEAL
DRESS
=
NO
STRESS
&
NO DRESS
?

JEANS MOSCHINO

?

STOP
THE
FASHION
SYSTEM
!

MOSCHINO

MOSCHINO

DE GUSTIBUS
NON
EST
DISPUTANDUM

by MOSCHINO.

Questa
è
una pubblicità !

Couture !

LASCIA STARE
LE MIE PIANTE !

...e io ?

MOSCHINO

Charles Ray

Charles Ray, *Tub with
Black Dye*, 1986

Charles Ray, *Rotating
Circle*, 1988

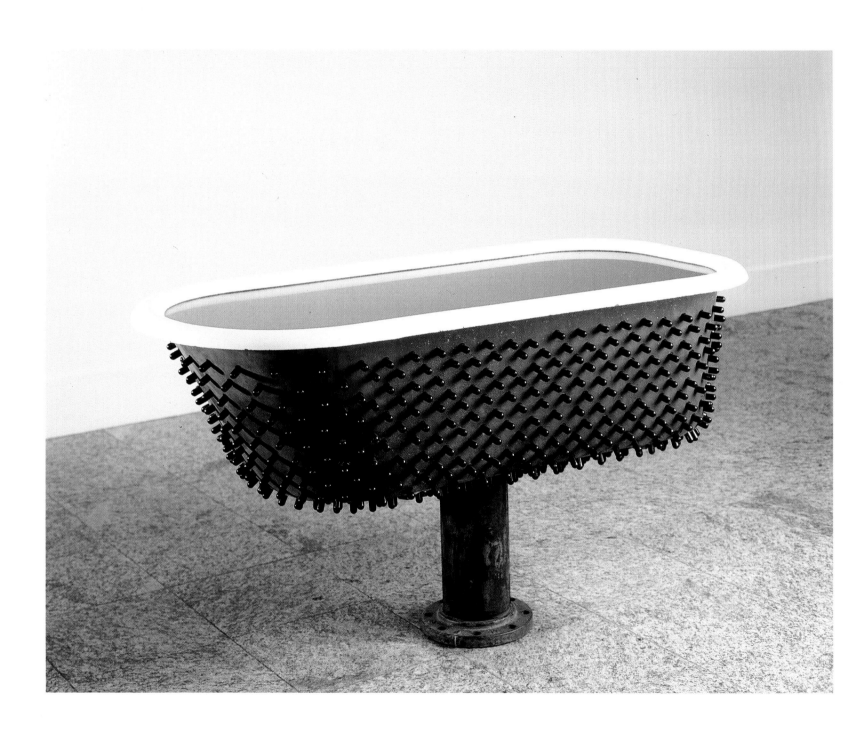

Charles Ray, *Self-Portrait*, 1990

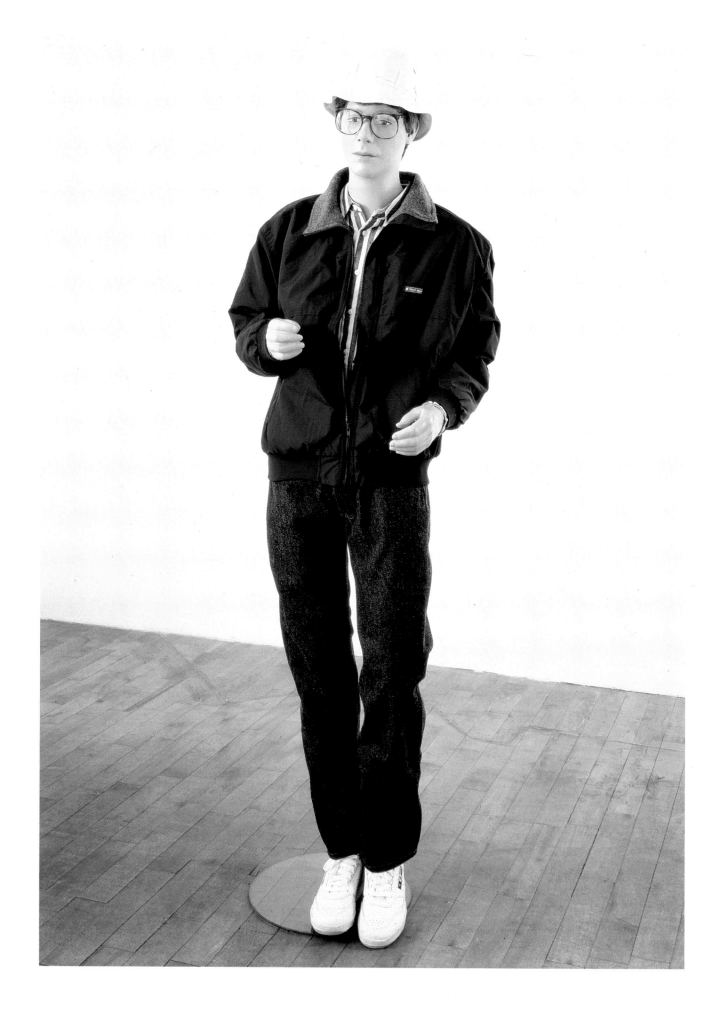

Charles Ray, *7 ½ Ton
Cube*, 1990

Cindy Sherman

1"

1"

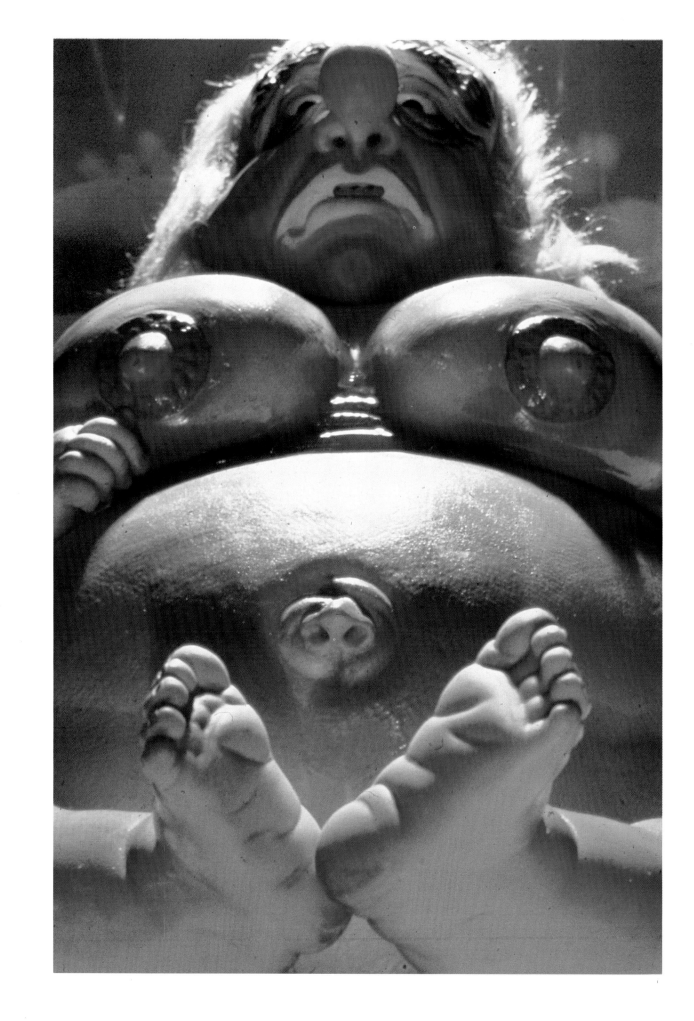

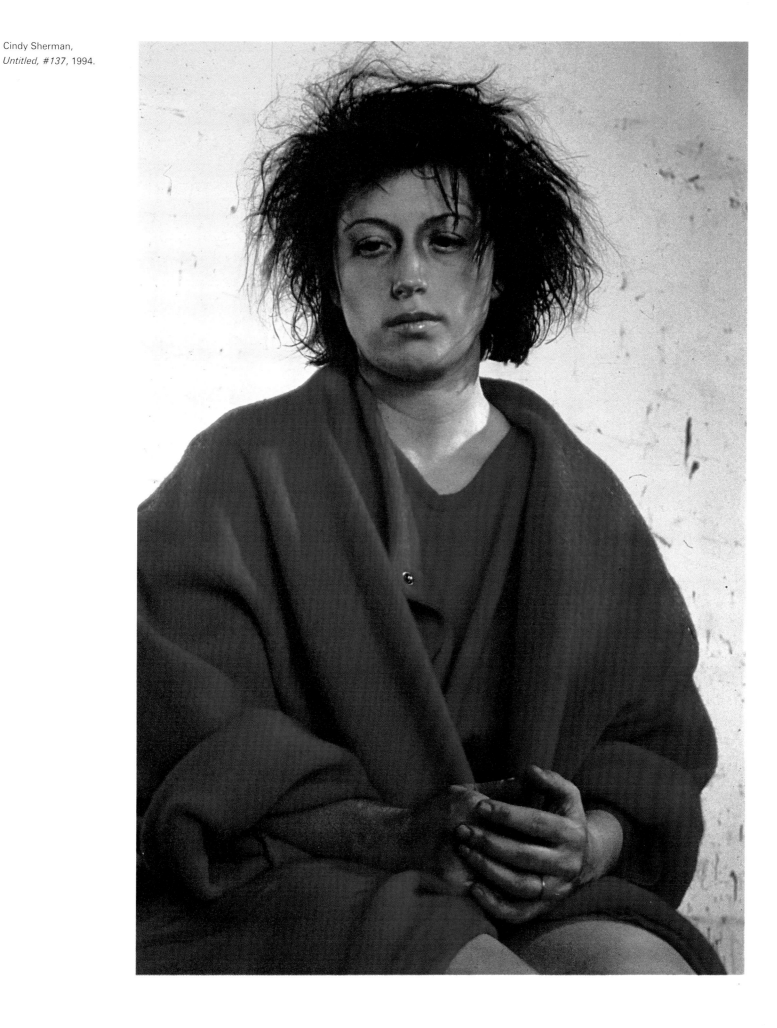

Cindy Sherman,
Untitled, #137, 1994.

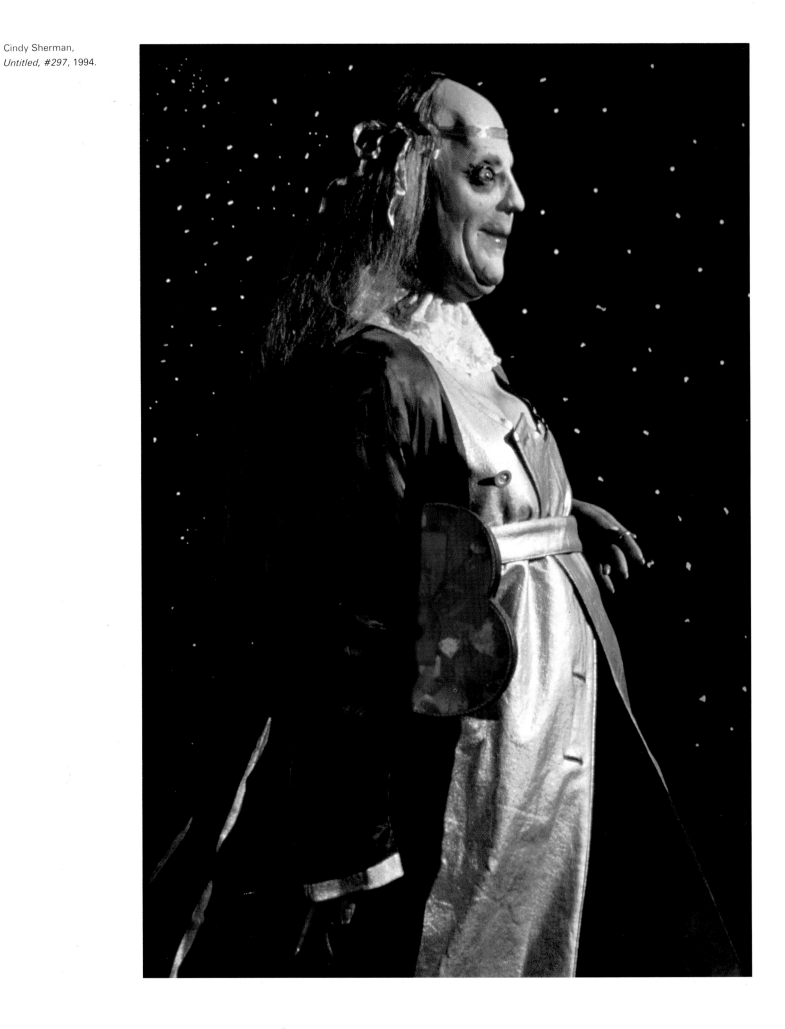

Cindy Sherman,
Untitled, #307, 1994.

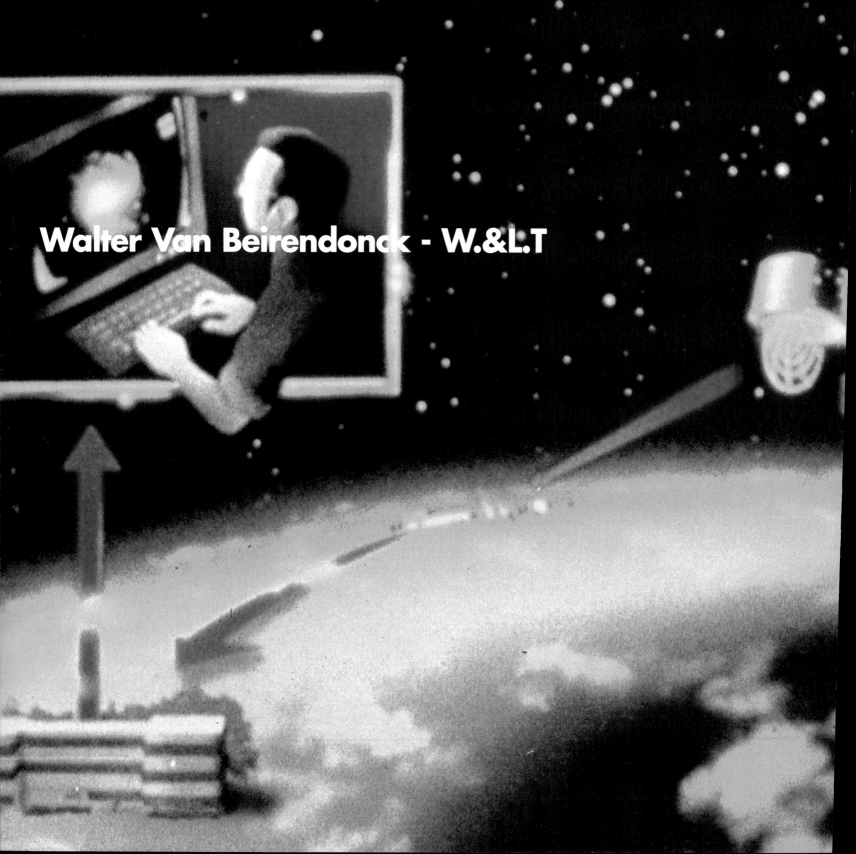

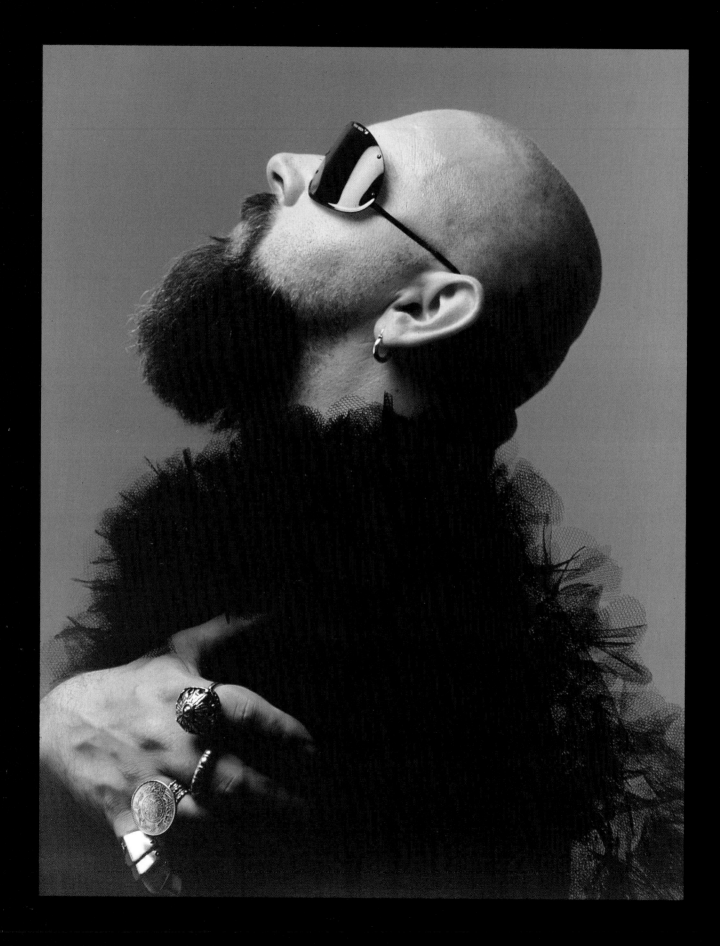

• A PURE PLEASURE PRODUCT • SYNTHETIC HELL • RAINBOWLAND •

EXTRACTS CD-ROM 1 - COLLECTION WINTER 95-96

• DEEP KICK • ULTIMATE EARTH BEAUTY • VIRTUAL CROSS DRESSING •

EXTRACTS CD-ROM 2 - COLLECTION SUMMER 96

• LITTLE EARTHLY RELICTS • ASTRAL BEAUTY • 4DHiD • EVEN LOVE CAN KILL •

EXTRACTS CD-ROM 3 (IN CONSTRUCTION) - COLLECTION WINTER 96-97

• SPACE BAMBIE • KINKY KINGS • SHARING VISIONS • COLOR STARS •

EXTRACTS W.&L.T.-INTERNET SITE - COLLECTION SUMMER 97

WELCOME LITTLE STRANGER • CREATE YOUR AVATAR • KISS THE FUTURE! •

• SERIAL KILLER • KILL • KILLER • YOU CAN KILL TOO! •

KILLER!
KILL!

STUPID COW
COW
COW
COW
COW
COW

? ?

REACT!

• FATAL ATTRACTION • TICK TICK • POOR Hi-D • LUST •

SEX
LUST
HORNY AS HELL!
SEX
DIGITAL ORGASM
BORN TO BE WILD
PIG!

• SUNSET DOESN'T MEAN WE LOSE THE SUN • BLOW JOB •

KISS
ME
QUICK

TERROR TIME!
BLOW
KISS
QUICK
DO THE WORLD!

KISS THE FUTURE!

• GET OFF MY DICK • HELLRAISER • TRUE ROMANCE •

I'M ⑪⑪⑪!

I'M

I'M A MONSTE
I'M A MONSTER! CUTE!
I'M A MONSTER
M A MONSTER!

EXTRACTS CD-ROM 2 - "THE MOOD MACHINE"

• I'M CUTE • I'M BEAUTIFUL • I'M A MONSTER • KISS THE FUTURE!

Back | Forward | Home | Reload | Images | Open | Print | Find | Stop

Location: http://www.walt.de/fa_sum97/mib/zoom10.html

fashion | interactive | contact | puk puk | interview | press.
summer 97 | winter 96/97 | summer 96 | prev collections |

M.I.B.
E.T.
UFO

M.I.B.
AT THE STRIKE OF THE LIGHTNING FLASH

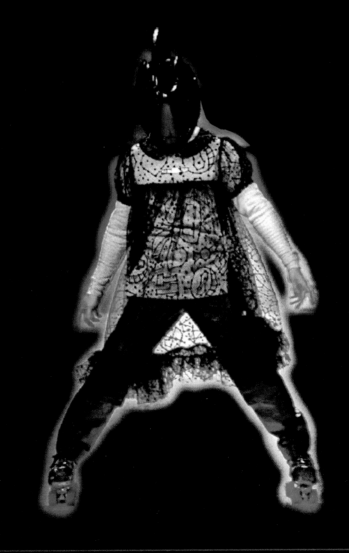

fashion | interactive | contact | puk puk | interview | press |
summer 97 | winter 96/97 | summer 96 | prev collections |

Ground View

Studio Azzurro

Hubble Space Telescope View

Io non mi lascerò calpestare
dice il Pavimento della
Sala di Maat.
Poiché sono silenzioso e
sacro.
Inoltre io non conosco
il NOME dei tuoi PIEDI
che si apprestano a calpestarmi
Parla dunque!

(il libro dei morti degli antichi)
egizi

Studio Azzurro, *Coro:*
studio per le
inquadrature dei corpi.

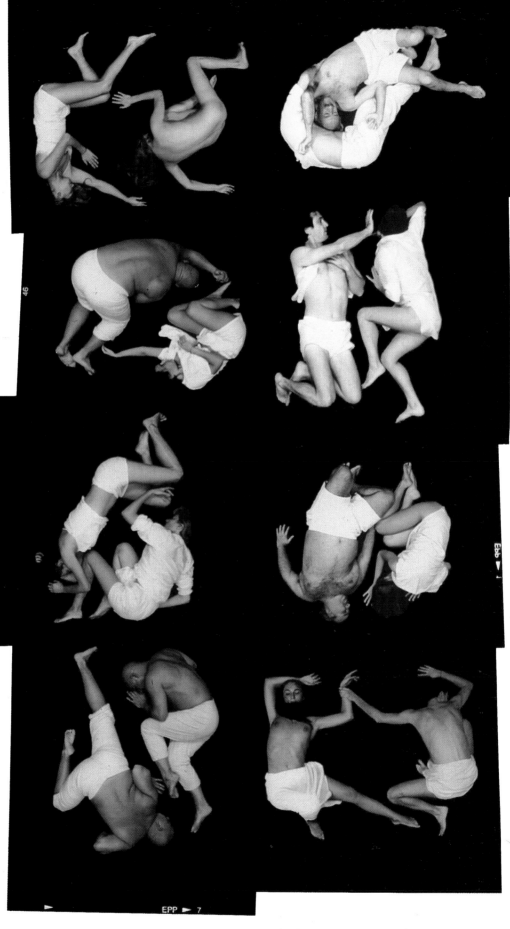

Studio Azzurro, *Progetto per la realizzazione di "Coro".*

Studio Azzurro, *Studio del sistema interattivo*

Studio Azzurro, *Coro, Tappeto sensibile,* 1995-1996

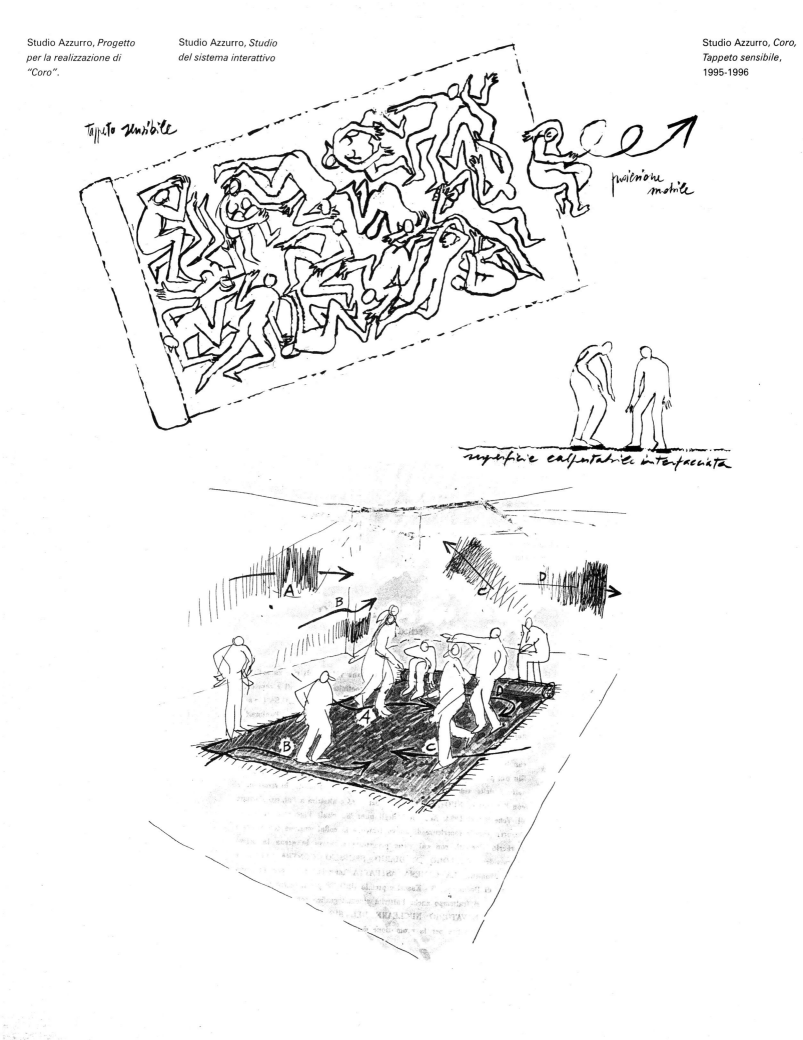

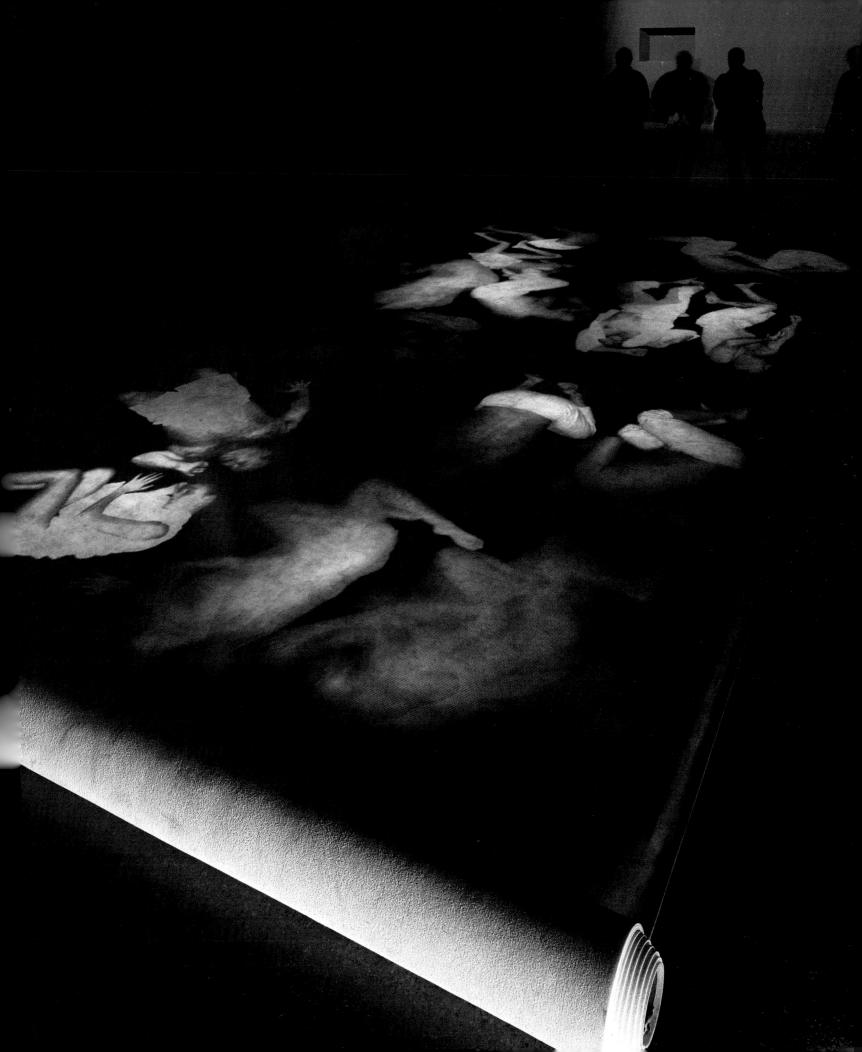

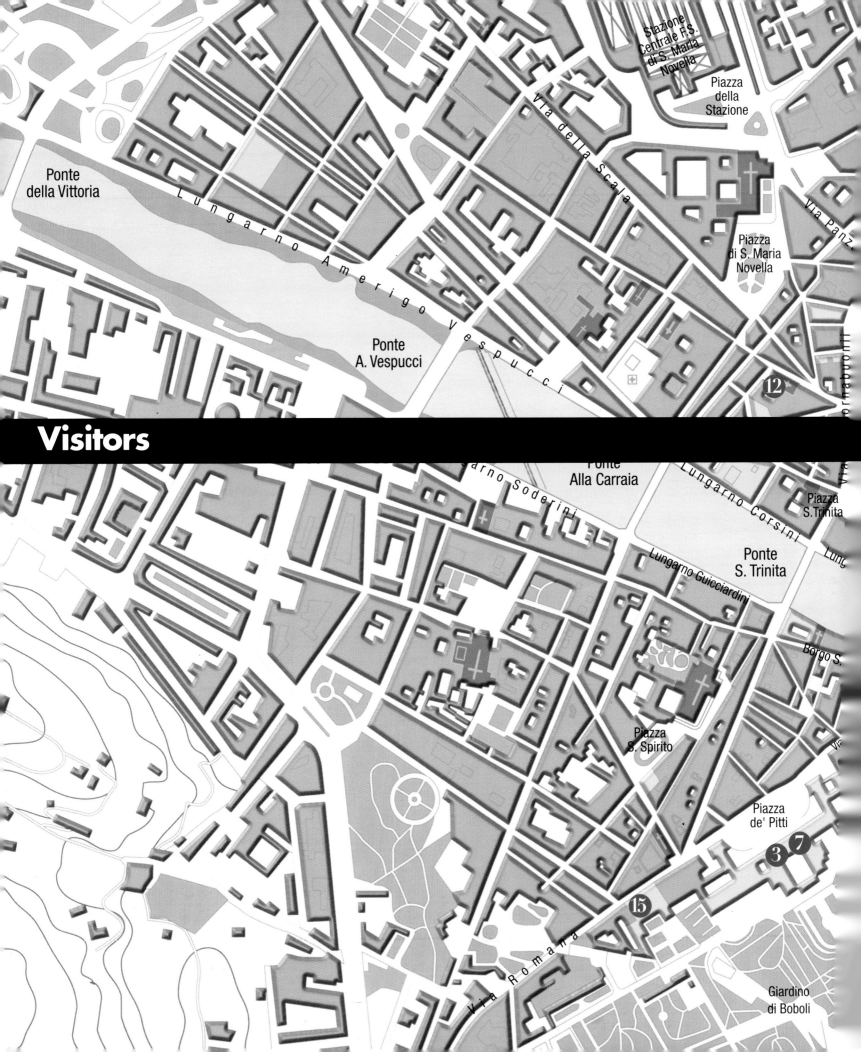

Ponte
della Vittoria

Lungarno Amerigo Vespucci

Ponte
A. Vespucci

Via della Scala

Stazione
Centrale F.S.
di S. Maria
Novella

Piazza
della
Stazione

Via Panz.

Piazza
di S. Maria
Novella

12

Visitors

Lungarno Soderini

Ponte
Alla Carraia

Lungarno Corsini

Piazza
S. Trinita

Lungarno Guicciardini

Ponte
S. Trinita

Lung.

Borgo S.

Piazza
S. Spirito

Piazza
de' Pitti

3 7

15

Via Romana

Giardino
di Boboli

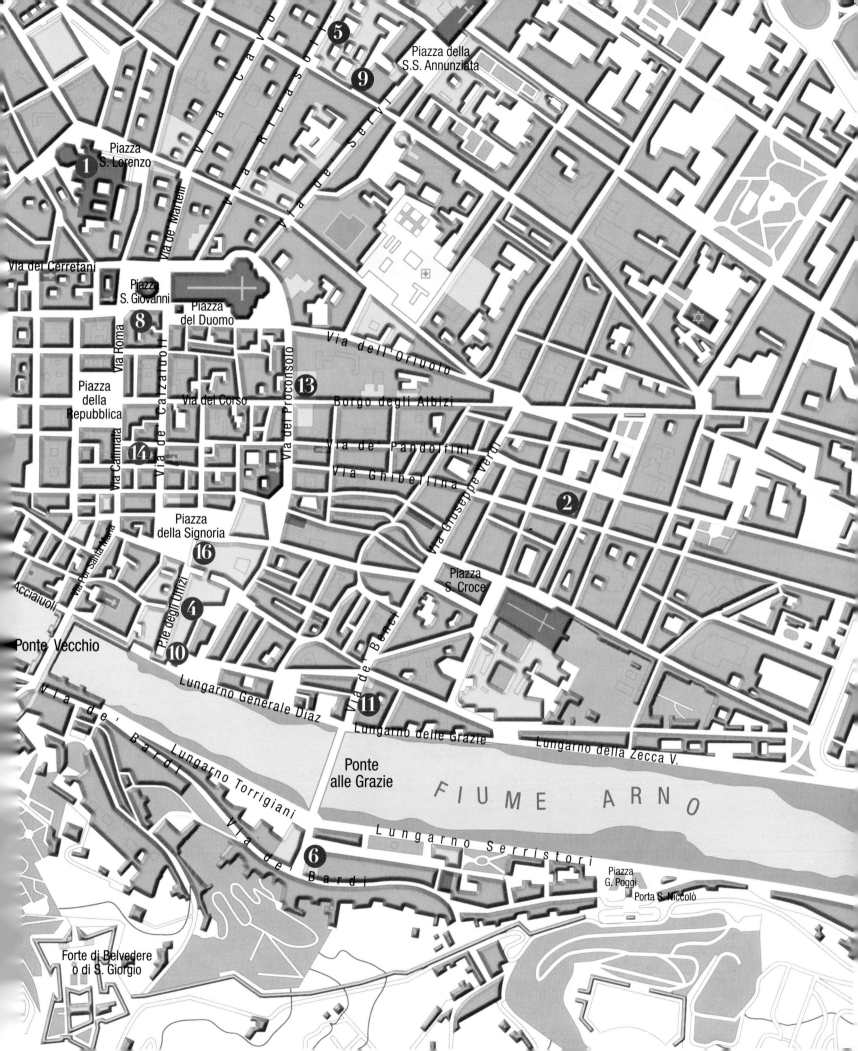

1 Piazza
S. Lorenzo

5

9

Piazza della
S.S. Annunziata

Via del Cerretani

Piazza
S. Giovanni **3**

Piazza
del Duomo

8

Via Roma

Via dell'Oriuolo

Piazza
della
Repubblica

Via del Corso

13

Borgo degli Albizi

Via de' Pandolfini

14

Via Ghibellina

Via de' Calzaiuoli

Via del Proconsolo

Via Giuseppe Verdi

2

Via Calimala

Piazza
della Signoria

16

Piazza
S. Croce

Accaiuoli

Via Por Santa Maria

P.le degli Uffizi

4

Ponte Vecchio

10

Via de' Benci

Lungarno Generale Diaz

11

Lungarno delle Grazie

Lungarno della Zecca V.

Via de' Bardi

Ponte
alle Grazie

Lungarno Torrigiani

Lungarno Serristori

F I U M E A R N O

Via de' Bardi

6

Piazza
G. Poggi

Porta S. Niccolò

Forte di Belvedere
o di S. Giorgio

Florence
Cappelle Medicee; Galleria d'Arte
Moderna di Palazzo Pitti; Galleria
dell'Accademia; Galleria degli
Uffizi; Museo Horne; Museo
Bardini; Museo degli Argenti;
Museo del Bigallo; Museo
dell'Opificio delle Pietre Dure;
Museo di Casa Buonarroti; Museo
di Orsanmichele; Museo di Storia
della Scienza; Museo Marino
Marini; Museo Nazionale di
Antropologia e Etnologia; Museo
Zoologico "La Specola"; Sala dei
Gigli e Studiolo di Francesco I,
Palazzo Vecchio

Prato
Museo Civico di Prato

Visitors
Curators
Luigi Settembrini
Franca Sozzani

Exhibition
Coordination
Francesca Sorace
with
Piergiorgio Leone
Marina Caterina Longo
Secretariat
Laura Chimenti

Overall administration
Anna Pazzagli
with
Giulietta Ciacchi
Simonetta Mocenni
Secretariat
Stefania Signorini

Insurance
La Fondiaria-Florence

Transportation
Tartaglia Fine Arts Saima Servizi-Milan
TNT Traco-Milan

Installation
Design by
Gae Aulenti
with
Vittoria Massa

Technical supervision and installations
Pier Vincenzo Rinaldi
Francesca Sorace
with
Piergiorgio Leone
Marina Caterina Longo
Secretariat
Laura Chimenti

Lighting
Targetti spa-Florence
Watt Studio-Florence

Electrical systems
Watt Studio-Florence

Mannequins
Bonaveri Artistic Mannequins-Ferrara

Installations
Bertini & Biagiotti-Florence; Scenotek
srl-Florence

Catalogue
Edited by
Franca Sozzani

Direttore artistico
Luca Stoppini

Visitors: but which Ones are the Aliens

As all science fiction fans must surely know, "visitors" are those odd-looking individuals from other, distant planets, who pay calls on this world from time to time. They range in approach from the timid overtures of "E.T." to the rather more aggressive moves of "Invasion of the Body Snatchers" to the really vicious acting-out of "Independence Day," the latest American export, the highest-grossing film of all times, in which the aliens actually destroy both the White House and the Kremlin. Although there is an evident relationship of host to guest between the eighteen museums in Florence and Prato and the twenty fashion designers involved in this remarkable operation, we wondered however which group truly corresponded to the "visitors," and which corresponded to the astonished planet Earth. In short, who was alien, and from whose point of view? Which of the two groups was more likely to be truly astonished? And, moreover, if we are willing to extend and even complicate the matter a bit more, let us look at concepts such as "fashion" and "museum," when taken in their exceedingly terrestrial current meaning—are they really as peaceful and familiar as they seem? Contemporary fashion usually does not go to museums. Or let us put it this way: contemporary fashion may go to a museum, and indeed, it has often used museums as showcases, as enchanting locations for photo shoots that usually fall short of true originality. The corridors of the Louvre or the spiraling ramp of the Guggenheim, as backdrops for sixties revival fashion collections, will certainly say something quite different from, say, the colorful human misery of a marketplace in Cuzco (vintage third-world Eclecticism), the dark brooding of the Bronx or its counterparts throughout the world (Neo-Gothicism), or the tone-on-tone wards of a hospital (Minimalism). In conceptual terms, however, it all amounts to much the same thing: these are settings for close encounters of the fourth type, characterized by a wham, followed by a bam, and ending in a curt and hasty thank-you-ma'am. Not much intellectual curiosity; plenty of makeup-smeared kleenex scattered around the set. Fashion has never had much of a problem with glorifying itself; the eighties induced a quasi-autistic state of self-adoration and obsession with its own rites. None of us can truly claim to be exempt from guilt. Guilt for the void that emerged, but also complicity in the great mass of landfill

upon which fashion developed to unheard-of levels. The void in communication, invention, and newness, in artistic terms and in terms of contemporary culture; the solidity of the mass discovery of the body, of its forms of primary expression, of the possibility of designing—via the body—of a plurality of personal identities (identities ready-to-wear); all of this found a particularly willing partner in the world of fashion. And fashion produced new and creative aspects both in design and manufacturing and in marketing and consumption. What fashion DID NOT attain was cultural legitimation; it seemed not to be empowered by an awareness of the importance perceptual and cognitive role it had taken on. Too often, it seemed that fashion's awareness of the cultural work it was doing seemed to dwindle into the nudges and winks of star-preening, spectacular publicity stunts and promotional scandals, petty tantrums over who would have their runway presentation first, second, or last, and ponderous philosophical discussions about topics such as "Top Models: Yes or No?" All of this being taken disgracefully seriously by the various protagonists. Successful and misunderstood, looked at askance by official culture, overlooked even by legions of fashion followers, victims of the gilded reflections of its superficiality—fashion has nonetheless become that which it now is: the most direct and universal language, at once learned and accessible to all, calibrated freely to the mentality and the pleasure of countless individuals, ranging from the stock phrase to the exquisite lyric poem. It is from the cultural solitude imposed by this spectacular success that fashion has developed its self-referential habits, and that certain imperialistic attitude that characterizes it. These aspects have, thus far, prevented fashion from speaking to the world at large in terms other than hard-eyed utilitarianism, in languages other than those of self-praise, and the worship of designers. Museums, on the other hand, have never welcomed fashion gladly. When they have, it has always been to sterilize it, cordoning it off as "costume," thus relegating it to the tranquil backwaters of the applied arts, along with porcelain collection and antique furniture, or else as part of the body of "material" culture, clearly not quite up to the level of the culture that has somehow been classed as "ideal." In the face of the structural ephemerality of fashion and its excessively evident relationship with manufacturing, marketing, and consumption, the museum has always erected a double firewall between itself and fashion: one of time and the other of status. Actually, the sense of cultural superiority that the museum waves as a banner has been in crisis for something like two hundred years, and has never really recovered from the wounds incurred in a running battle with the artistic avant-garde. The paradigm of progress (a paradigm that features the museum as one of its proudest institutions) has now been replaced by the paradigm of complexity, with all its cultural baggage of disorder among the traditional hierarchies of the disciplines and among the various classical references of culture and ideology: in/out, above/beneath, high/low, right/left. Hovering over the museum as institution is a spectre, a spectre that the museum itself evokes: the spectre of museification. This spectre is evoked precisely by the inertia and apartheid of the museum as institution, as opposed to the dynamic freedom of movement of modern society; it is evoked by widespread doubt concerning the actual cultural and educational effectiveness of the museum, an effectiveness which dwindles, leaving only the museum's role as a bulwark of protection for the artistic heritage in the face of indifference and oblivion. The museum defends our artistic heritage from these moral assaults, as well as

the physical attacks (actual or potential, but increasingly serious) of mass tourism. The inability to deal with new cultural demands, which require new and more open, more flexible critical attitudes and technical instruments than in the past, will condemn the museum as institution to the limbo of distinctions and categories that crystallize and force into straitjackets the forms of creative culture. Thus the museum continues to offer a passive analysis of the creative arts, reverent, but decidedly less than respectful. This means contributing to the consumerization of culture, against which the museum as institution claims to be fighting; and then it means sitting and complaining about the fetishistic cult worship that seems to be prevalent both among the chain-gangs of the art world and among fashion victims everywhere. Allow me to open a brief parenthesis. I look into a dictionary of the English language and find the word "museum"—the definition speaks of preservation, documentation, education, and "enjoyment." When I look into an Italian dictionary, there is no mention whatever of that last, exceedingly important term. In Italy, the theory whereby the museum is the hair-shirt of knowledge is standard. Not only does this theory discount entirely the idea of the pleasure of knowledge; it eliminates pleasure entirely. Pleasure is thought to be a dangerous distraction. And so, in Italian museums, there is no place to rest your feet and your eyes, or drink a cup of coffee, or leaf through a catalogue, or write a postcard, or buy something nice or even—why not?— something awful. All of this is made even more rigid and parochial by the well-known organizational disfunctions whereby Italian museums, when they are open, are open on schedules that allow them to be visited only by tourists, the unemployed, and the retired. Even for those limited categories, the experience is usually neither easy nor exalting—with a hundred people jostling in front, and another hundred pushing at your back, it is difficult to enjoy the one canvas that you can see. These are "tactile values" far different from what Bernard Berenson had in mind for the direct perception of art. And now allow me to close this parenthesis. Given this state of affairs, and being perfectly aware of having to navigate amongst shoals, as it were, and rapids, I accepted the task of assembling the project that we have entitled "Visitors" with a shiver of curiosity mixed with dread. The idea of bringing twenty fashion designers to places like the Uffizi or the Accademia, museums that are forced throughout much of the year to dole out art to the vast masses of tourists and sightseers, or to the Museo del Bigallo in Piazza del Duomo, known to few visitors, and even to few Florentines, did not mean—at least in our intentions—paying tribute to the designers, nor was it meant to be a gracious if condescending favor, a bone tossed to fashion by official culture. The idea, rather, was to establish a form of communication between two worlds that have always been remote one from another ("alien" is the term that we used above); the idea was to establish a workshop where fashion, in relation with the works and documents of art, with the science and culture of the past, could demonstrate its present-day capacity for creative invention, above and beyond its commercial dimension. There was to be no identification of fashion with other disciplines; there was no desire to eliminate conceptually the respective differences and peculiarities of idiom and visual language. Rather, there was to be an attempt to reformulate, on a blank slate, without prejudice, all of these categories, at a higher level, on a plane that might include all of the forms of creative expression proper to our contemporary culture. We asked the designers invited to partici-

pate in this exhibition to provide ideas more than clothes, or at any rate, ideas of clothing more than just clothing. And it is this critical and experimental approach, for that matter, that distinguishes all of the shows and events of this fashion-centered Biennale; this approach is what makes this a truly new kind of event. Before we began work, the idea of trying this approach in the context of museums—and here, in the city that in some sense invented the museum—seemed, in a sense, like tasting forbidden fruit. That was true here, but also outside of Florence, and even outside of Italy. In 1982, *Artforum,* which is perhaps the most authoritative magazine of contemporary art, caused quite an outcry by devoting its cover to a photograph of a jacket designed by Issey Miyake. The two masterminds of that scandal—Ingrid Sischy and Germano Celant, who were respectively the editor-in-chief and a contributing editor to the magazine at the time—have mentioned the episode repeatedly in the years since then. And, I repeat, this happened in 1982, not 1882, and not in some small village of the Sicilian hinterland, but in New York City, the New York of MoMA, the Guggenheim, the Whitney, PS 1, and the avant-garde art galleries in SoHo. The fact that we were able to assemble a show like "Visitors" is a clear sign that much has changed in the world of culture, as well as a sign that the museum as institution is seeking out new ways to make the experience of the museum-goer (guests) more full and more satisfying, more critical and more fruitful; and in some sense, the same is true for the experiences of those who run the museum (hosts). I found the hosts (directors and curators) to be remarkably interested in and well-informed about fashion and its most recent trends; they immediately grasped that this project offered an opportunity to present—in an array of museums, some world-renowned and some little-known—an unprecedentedly rich cultural and artistic treasury, a hoard that is not even known in its entirety to the inhabitants of Florence itself. The "red line" that has been drawn, theoretically linking eighteen museums in Florence and Prato, offers a precedent that—if it is pursued in future events, and if it is enlarged and explored in both logistical and organizational terms and in terms of communications—may open new horizons for the modern image and integrated and rational use of an artistic and cultural heritage that is known and loved throughout the world. And the surprises that came from the designers constitute the concrete point of interest of this exhibition. All of the fashion designers involved in the show immediately showed enormous interest in the project. Several of them flew to Florence, crossing the ocean to do so, and spent many hours inside the museum in question, to which they had been "assigned" in accordance with the sage judgement of Franca Sozzani, and they took copious notes, drew numerous sketches. This direct relationship with the museum unquestionably added something to their own personal research, through affinity or through contrast. The traditional context for the development of ideas for clothing, free of the narrow constraints of functional and economics, had long been high fashion—alta moda—where a designer was working for princesses and queens, millionaires and movie stars. For many years now, however, high fashion has lost this aspect of free creativity and has become the high-profile billboard for the more democratic activity of *prêt-à-porter.* If we wish to reconquer this exceedingly valuable space for creative freedom, whose sole but considerable stimulus was the possibility of interacting with artworks and museum settings of great fame and great beauty, then that, in my opinion, is one of the most notable benefits of this exhibit, of this remarkable and unprecedented journey.

Gae Aulenti - Franca Sozzani: the Birth of a Project

Vogue Italia Office, Milan, 11/12/1995

G.A. Franca? Hello, it's Gae. They've just called me from the Biennale di Firenze: it looks as if we're going to be working together this time, did you know?

F.S. Yes, they called me too. I'm delighted: I've always dreamed of working on a project with you and this seems the ideal opportunity at last. I'm enthusiastic.

G.A. Me too. We've talked about it for ages, and now... But we'll have to start right away. Shall we meet next Monday, here in my studio?

F.S. Fine. We'll meet in your studio. Bye.

G.A. Bye.

Studio Aulenti, Milan, 18/12/1995

F.S. How are you? I've been thinking over and over these past few days. It's a big challenge, this. Putting the artistic heritage of Florence side by side with that crazy variable fashion isn't going to be easy: especially if we don't want to fall into the banal, which we certainly don't, do we?

G.A. I absolutely agree. When I made my first recces in the Florentine museums I became convinced of one fundamental thing: the show can only be conceptual, it must reveal the imagination of the stylists, of which the clothes are simply the products...

F.S. To avoid the show-room effect...

G.A. Right. The public must be given the instruments to understand the spirit of each of our people. I also realised I can't give them fixed structures, I can't be the one to define the spaces, they must do it themselves: we'll assign them each a museum and let them get on with it. We'll wait and see how they relate to the spaces. I'll handle the fitting out, and you as curator can handle the dealing with them. You're used to it, after all...

F.S. I'll call them all, explain the idea, and then we'll prepare a letter with the details, for the catalogue, too. It's important, because I'd like not just to do a simple catalogue, but a book in progress, with sketches, plans, cuttings, phrases...We're running a big risk, me with the fashion world and you with the fitting out.

G.A. I know, I know.

F.S. Anyway, if the response of the stylists is in line with their creativity there'll be some very powerful stuff... Better that way... Know what we'll do? Now I'll tell you a bit about them, I'll describe their ideas, their imagination, and how they get to the end product; that way we can decide which museums to assign right away. I suggest using affinities or contrasts, taking creative needs into account as well.

G.A. Fine. There are sixteen museums plus one in Prato. But there are two areas in the Palazzo Vecchio, the Studiolo of Francesco I and the Sala dei Gigli, that makes eighteen.

F.S. Do you know Manolo Blahnik? He does marvellous shoes, tiny works of art. He's been chosen because he stands out from the crowd: he'll need a small space, but one suited to highly refined creations...

G.A. The Studiolo of Francesco I: what do you reckon? The prince's private corner, it's a jewel with that collection of paintings...

F.S. Perfect. We'll send Manolo the material, but I'm sure he'll like it. Then let's see... Philip Treacy. He's the authentic Mad Hatter, very good. He'll need plenty of space, an area without huge infrastructures, because his hats can only go on manikins or be hung up...

G.A. Why don't we put him in the Museo degli Argenti at Palazzo Pitti? Those frescoed vaults, sixteenth-century structures...

F.S. That could do fine. Then let's see... ah yes, there's Nigel Atkinson.

G.A. I don't know him.

F.S. He does splendid fabrics: he uses velvet, taffeta, chiffon and reworks them with his own techniques. He's worked with Azzedine Alaïa, Issey Miyake, and he's very interesting. He'll be working with Kris Ruhs.

G.A. The Opificio delle Pietre Dure? What do you say? Maybe with the fabrics it could create a pathway, a link between the various elements...

F.S. That could do fine, because it's a single-theme museum that celebrates craftsmen, and Nigel's a craftsman too. Yes, I think it's perfect. Dolce & Gabbana. Well, you know them: they've used fashion as an instrument of research, you know, their emphasis on Sicily, black, the coppole...

G.A. The Museo Antropologico, then...

F.S. Perfect. You know Gaultier, too, I expect...

G.A. Of course, he's so good. Corsets, bodices, pointed busts...

F.S. He's played with the body, exaggerating it and showing it off: what would you say to La Specola?

G.A. It's the first place that came into my mind, too. Sections of women, the study of the body: it's a beautiful and important museum, even if not too much is made of it. You know, with the Biennale people we also chose lesser-known museums, with few visitors but really interesting. Just think of the chapel of the Museo del Bigallo in Piazza Duomo: it's small, sacred, very clean lines. I think even a lot of Florentines don't know it.

F.S. I remember it well. You know, I was thinking it would be ideal for Donna Karan. Her women are without frills, more intimate, less showy. Her house is dominated by white, too, every detail well thought out...

G.A. From what you say it sounds perfect.

F.S. Let's see, then: there are another three stylists that represent young America, street life reinterpreted and sent on to the catwalk. You know, Marc Jacobs, Todd Oldham and Anna Sui: maybe for them a single space, but a very big, luminous and important one...

G.A. What about the Museo Civico di Prato? It should be big and roomy enough...

F.S. Okay. Then there's another American, Richard Tyler, very romantic and simple.

G.A. The Museo di Storia della Scienza? Galileo's instruments, telescopes, lenses...

F.S. That seems right. And Saint Laurent? He's one of the greats of the century: what about the Sala dei Gigli in Palazzo Vecchio, it's so French. It should be ideal, don't you think?

G.A. No doubt about it. And Miyake?

F.S. He's a true contemporary artist. Sculptured, defined, essential in his own way...

G.A. We could go for a contrast and offer him the Galleria d'Arte Moderna in Palazzo Pitti with its Signorinis, its Fattoris and the other Macchiaiolis...

F.S. It'll work, I'm sure. I'm certain he'll understand the idea. Then there's John Galliano, true genius and no rules. He hides from journalists, is ironic about the world of fashion and then provokes with modern clothes, almost futuristic in an unholy mixture. He himself is a real character.

G.A. And we could put him in Casa Buonarroti. Galliano and the good Michelangelo: it seems a good match...

F.S. Isn't it a bit daring?

G.A. Let's be honest, this whole operation is daring and also provocative, so...

F.S. That's true: let's put Buonarroti with Galliano. At the end of the day, he can't but be happy to be next to Michelangelo...

G.A. Who's next?

F.S. Well then, now there's...

Vogue Italia Offices, 22/2/1996

F.S. Gae, it's Franca. I tried to get you yesterday too. I've talked to all our stylists, and they seem enthusiastic. I've also had the letter sent with the photos and information about the museums. Apparently Miyake's coming in from Tokyo because he wants to see the Galleria d'Arte Moderna for himself. Donna Karan might be coming too. They're all very involved.

G.A. Fine. Call me as soon as the first sketches get here, I'm very curious. As are the superintendents of the museums. Actually, some of them are also worried: they're expecting mayhem...

F.S. I don't see why...

G.A. Anyway, let's wait to see the projects.

Studio Aulenti, Milan, 26/3/1996

G.A. Franca, they told me you called but I was out of town. Has anything arrived?

F.S. Yes, the first roughs. They're beautiful. Lacroix, for example. I told you he was very interested in costumes, that he often works for the theatre, and you thought the Museo di Orsanmichele with all that glass work would be perfect? Well, it was. He's thought up a kind of wooden catwalk with mannequins suspended round it... it's incredible.

Then there's Ozbek. He's dug into his Turkish origins and for the book he's done a sequence of covered women on rotating platforms, it's bizarre, but gorgeous, you'll see. He wrote me a note saying the Horne Museum had to be his. Ferré's arrived too. We couldn't have chosen a better match. The Cappelle Medicee suit him perfectly: they bring out his structuredness, his architect's soul, with these drapes suspended from above that fit in nicely, respecting the architectural structure. It's brilliant, it's Ferré by Ferré. Martin Margiela's arrived, too, we put him in the Museo Bardini. I told you about his passion for white, didn't I? His project is a triumph in white, it goes up from the staircase at the entrance, like a pathway leading to the final surprise... Then let's see, there's Romeo Gigli's project, which practically covers all the restructured parts of the Museo Marino Marini, adding figures that are very light hanging fabrics, like shadows giving a lightness to the whole setting...

G.A. They sound lovely, I can't wait to see them. When will you send them?

F.S. Tomorrow I should also have those of Armani, Blahnik, Treacy and Gaultier. As soon as they get here I'll come and see you in the studio.

G.A. Fine. I hope I don't have to go to Barcelona, but call me anyway...

Vogue Italia Offices, 11/4/1996

F.S. Gae, I'll bring you up to date. The other four have got here too; then tomorrow Nigel Atkinson's coming here, he's just been to Florence. Donna Karan was here too, she came specially from New York: she loved the Cappella del Bigallo and she assured me we'd have her project within ten days.

G.A. When shall we meet, then?

F.S. Is Wednesday okay?

G.A. Sure. I'll be waiting for you...

Studio Aulenti, Milan, 17/4/1996

F.S. Aren't they magnificent? It's surprising how so far they've all managed to stand back from their work and go for truly artistic ideas. Look at Philip Treacy, he's constructed bird cages and put his hats inside as if they were birds, as if they were suspended, immaterial...

G.A. Manolo Blahnik has done a homage to Luchino Visconti...

F.S. He's his inspiration. He told me he'd certainly never have entered this profession if he hadn't met him. He's taken Romy Schneider's black velvet costume from Ludwig and he's made a shoe for it. Look at the drawings.

G.A. Very delicate, they'll be perfect on the pages of the book...

F.S. You're right. You know, I think the book's perfect for the show. They've all launched themselves into ideas that are so personal you recognise them straight off. Look at Giorgio Armani. He's played with the black and white of the floor but he's also used the colours of the frescoes: it's an incredible match between his austere style and the magnificence of the Galleria degli Uffizi.

G.A. I think where they're all so clever is that they haven't tried to suffocate the museums with fashion. They've gone beyond their work, but the result is certainly identifiable with the style of each one.

F.S. I think they've done a superb job too. The book will be splendid, too, a real work in progress...

G.A. I hope the museum directors don't make problems for me... I'm going to Florence this week, to show them these first sketches. I'll let you know.

F.S. I hope to get Valentino, Saint Laurent and Galliano soon. The two from Paris left yesterday, I'll call you as soon as they arrive.

G.A. We're waiting.

Vogue Italia Offices, 24/5/1996

F.S. Gae, they've arrived. I must say that Valentino's been fantastic, he's outdone himself. You know, at the end of the day he's up against the Galleria dell'Accademia and the David. Yet his fashions stand out without being disturbing, he's very coherent, with that dominating red of his. It's very theatrical, too. But how did things go with your directors and superintendents?

G.A. It was a heavy day, but it went well in the end. The projects I showed them in Florence went down very well, but there are some worries over details, Treacy's rods and the scaffolding to take down from the Cappelle Medicee. But all in all, I'm satisfied. It wasn't easy, but I expected more doubts and reservations.

F.S. We've said right from the beginning it was to be an experimental show, one that got away from the catwalks and the shop windows. At the end of the day, nobody has ever tried to do all this before, and it was bound to be very disturbing. The stylists have understood the show-room risk.

G.A. We've only seen the projects, the real shock will be seeing them put into practice. Just think of the project of Saint Laurent and that artist that worked with him, Roberto Plate, just think of the mirror reflecting the ceiling of the Sala dei Gigli...

F.S. Speaking of mirrors, I need a dozen of them, antique ones, for Galliano...

G.A. So we've got everything, even Galliano's?!!

F.S. Yes, I got it yesterday. You must see it as soon as you can: he's using three rooms of Casa Buonarroti, past, present and future all together. And I also have to find a sail, and old skateboard... are you in this afternoon?

G.A. Yes, could you come over? Perhaps we could look at them all together.

Studio Aulenti, Milan, 24/5/1996

G.A. I'm surprised, really surprised. It's a real box full of wonders. They've all taken our invitation incredibly seriously: they've given it all they've got.

F.S. And they're very recognisable, you couldn't mistake one for another.

G.A. Seeing all those roughs here together, it seems impossible that only a few months ago we were afraid of taking this risk.

F.S. You're telling me... anyway, the incredible thing is that already from these roughs you can see how art and fashion can mix together, how they're worlds that have a mutual attraction for each other.

G.A. Have you noticed that in almost all of them there's the concept of flight: clothes hanging up, lifted above the ground or flying; as if research were a dream-like thing, and lightness a creative point of arrival, or perhaps getting to the essence of one's imagination, an abstraction...

F.S. True. Who knows what the finished projects will look like... Meanwhile, let's examine one by one: they're in alphabetical order by museum...

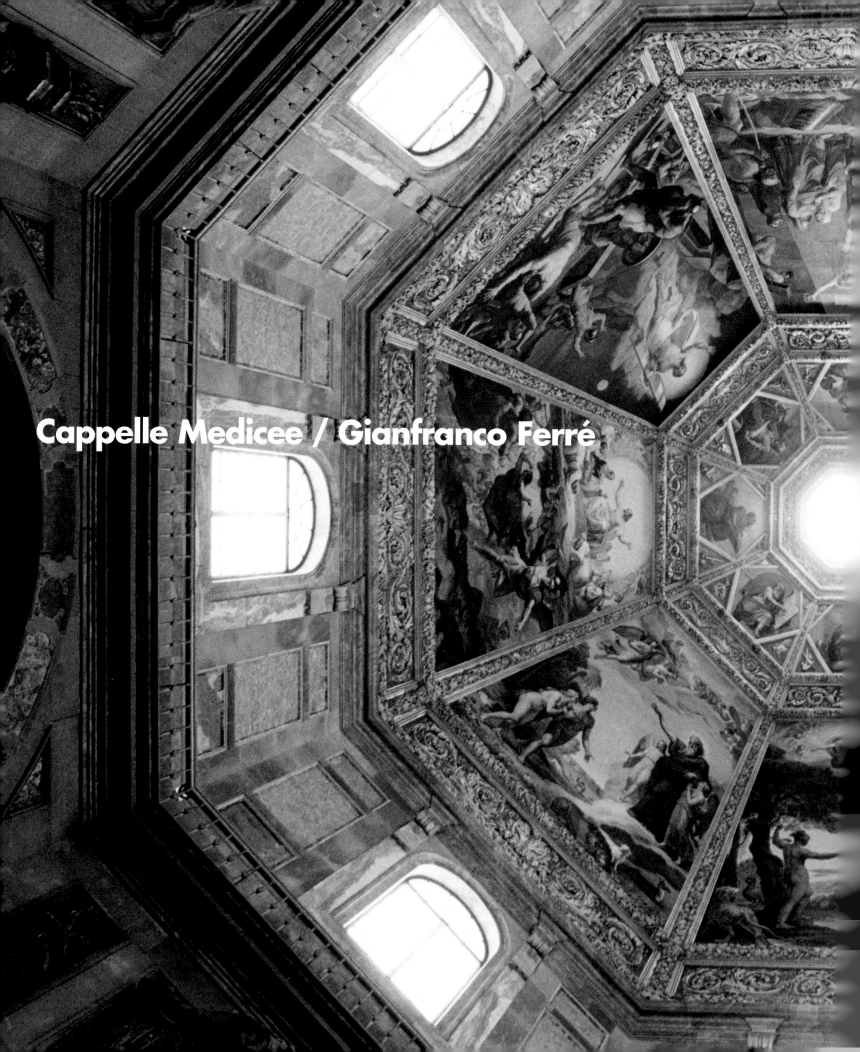

Cappelle Medicee / Gianfranco Ferré

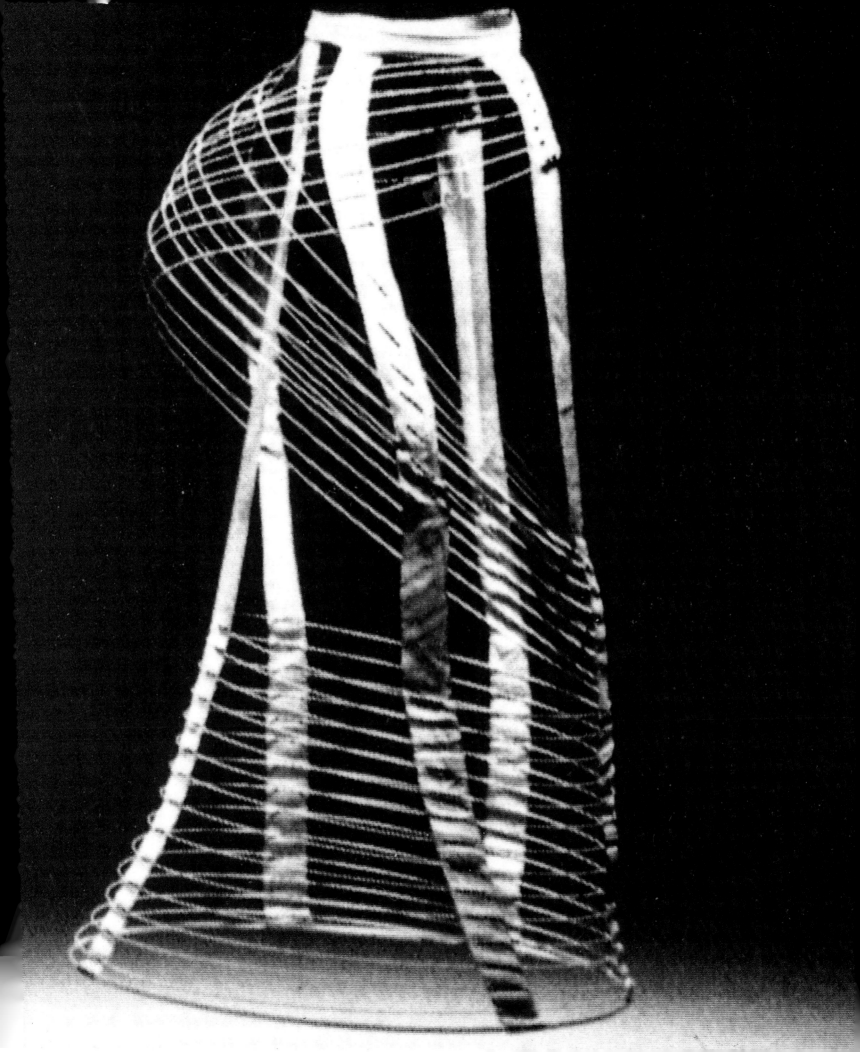

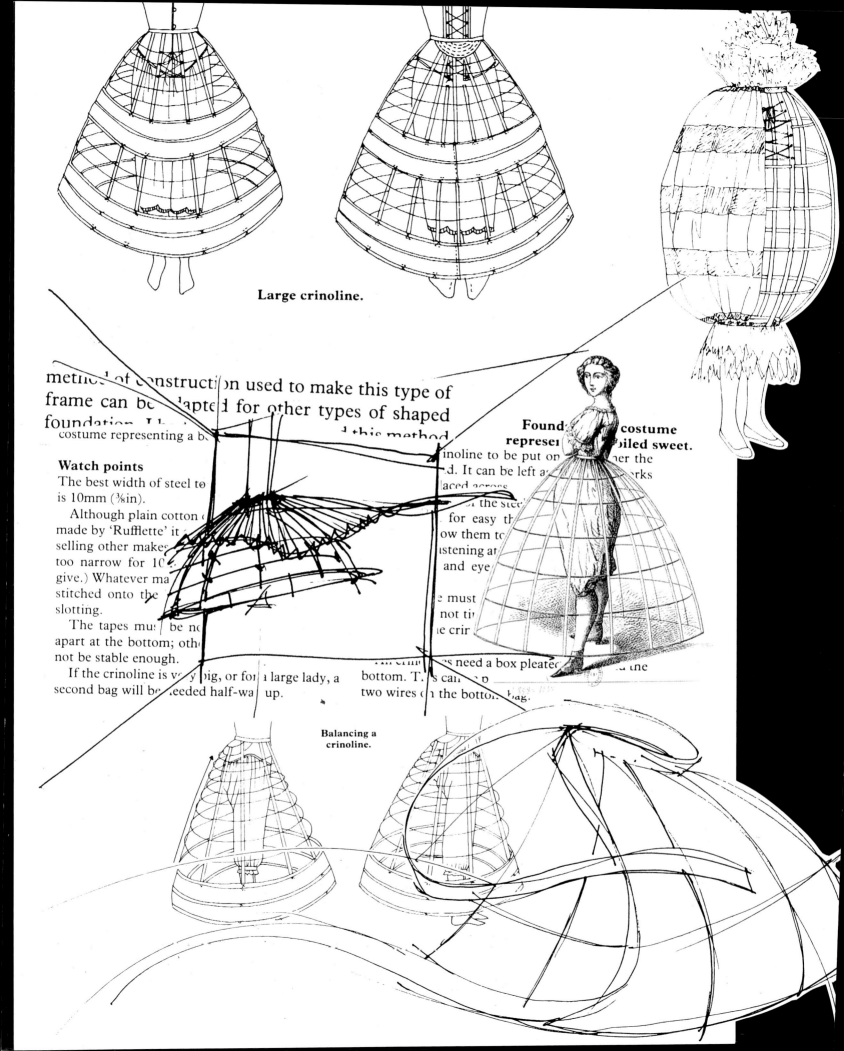

Large crinoline.

method of construction used to make this type of
frame can be adapted for other types of shaped
foundation. I ha... this method
costume representing a b... ...

**Found... costume
represe... ...iled sweet.**

Watch points

The best width of steel t...
is 10mm (⅜in).

Although plain cotton ...
made by 'Rufflette' it ...
selling other makes ...
too narrow for 10 ...
give.) Whatever ma...
stitched onto the ...
slotting.

The tapes mus... be n...
apart at the bottom; oth...
not be stable enough.

If the crinoline is v...y big, or for a large lady, a
second bag will be...eeded half-wa...up.

...inoline to be put on ...er the
...d. It can be left a... ...rks
...aced across
...f the stee...
...for easy th...
...ow them to ...
...stening at...
...and eye...
...e must...
...not ti...
...e cri...

...es need a box pleate... ...e
bottom. T...s can...p...
two wires ...n the bottom bag.

**Balancing a
crinoline.**

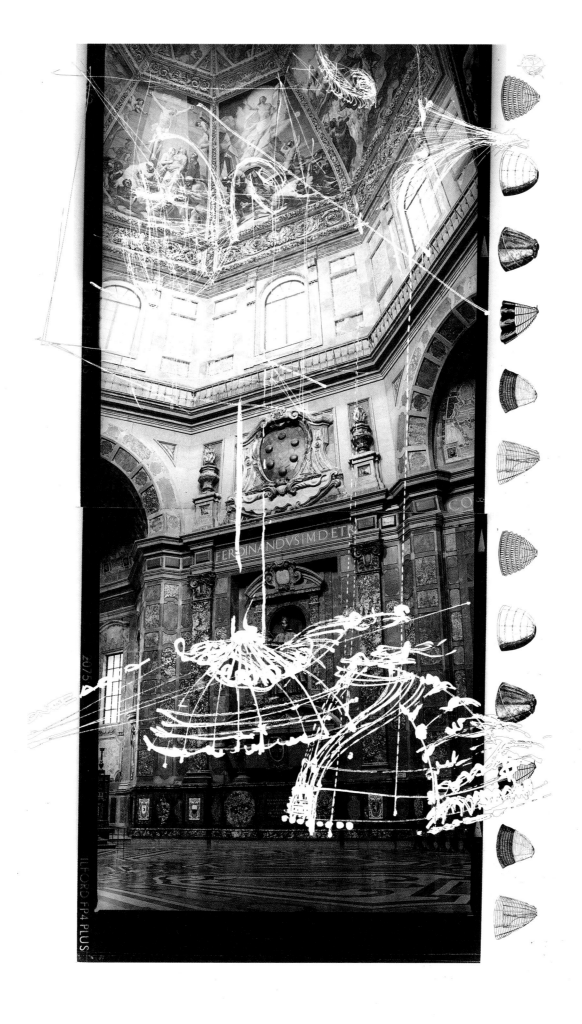

399

Casa Buonarroti / John Galliano

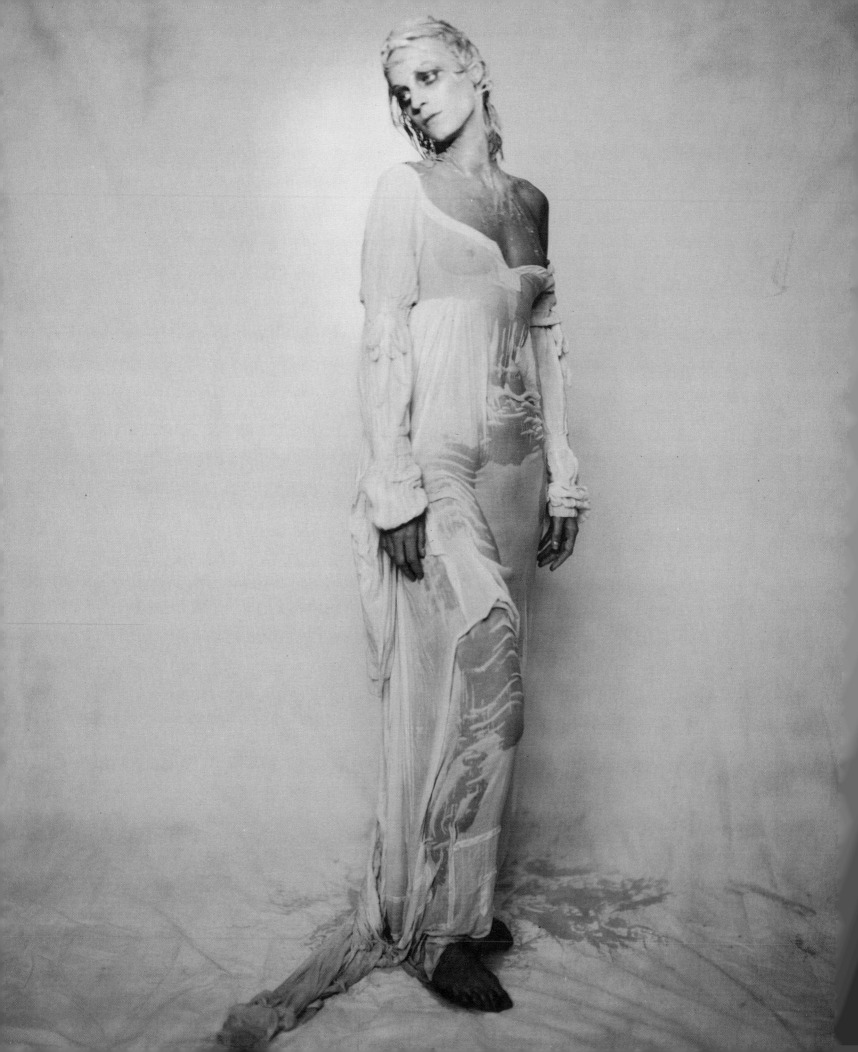

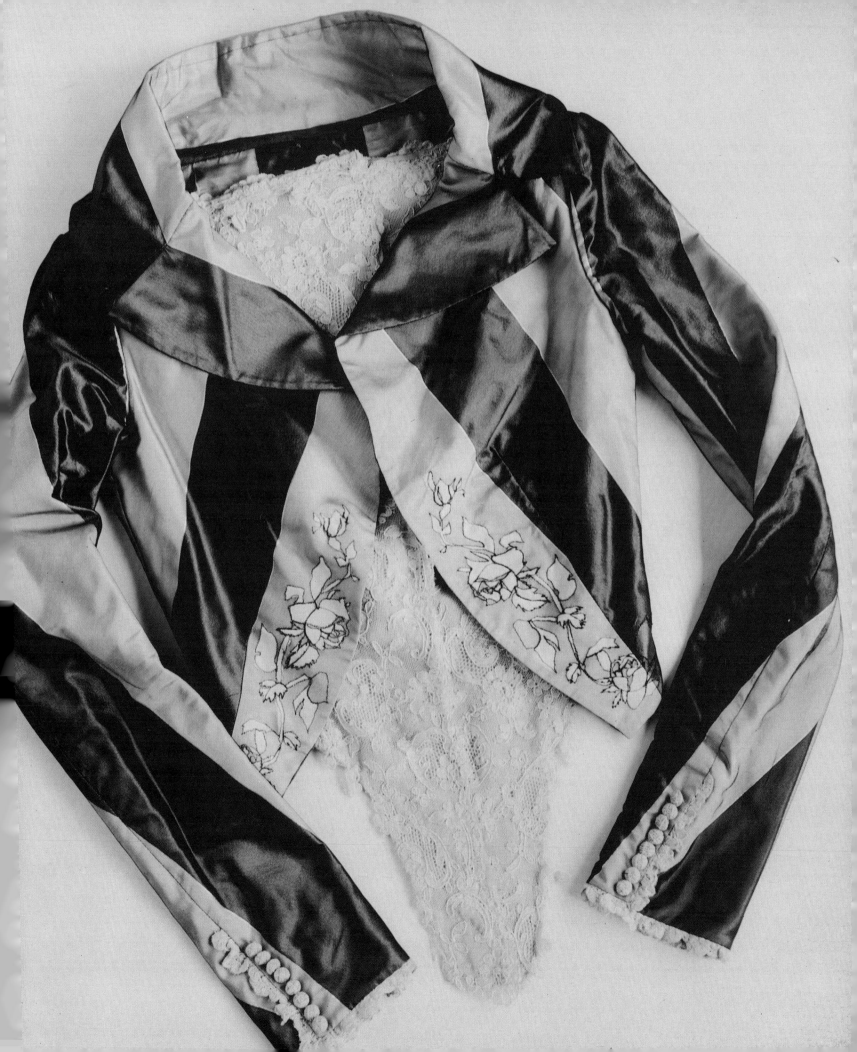

Galleria d'Arte Moderna / Issey Miyake

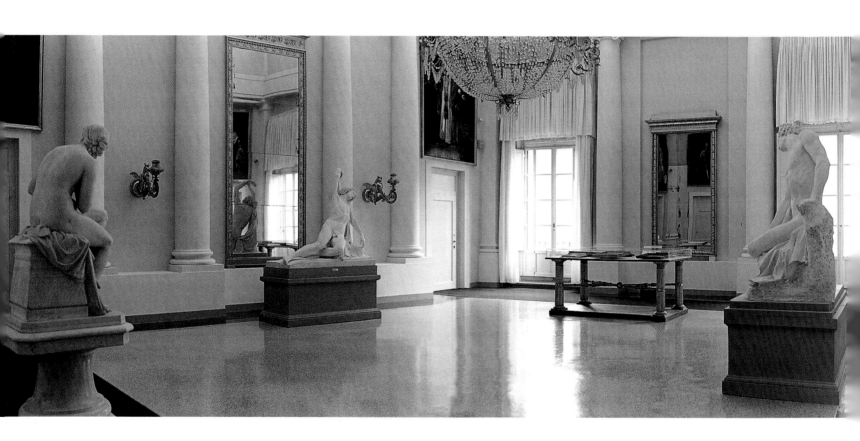

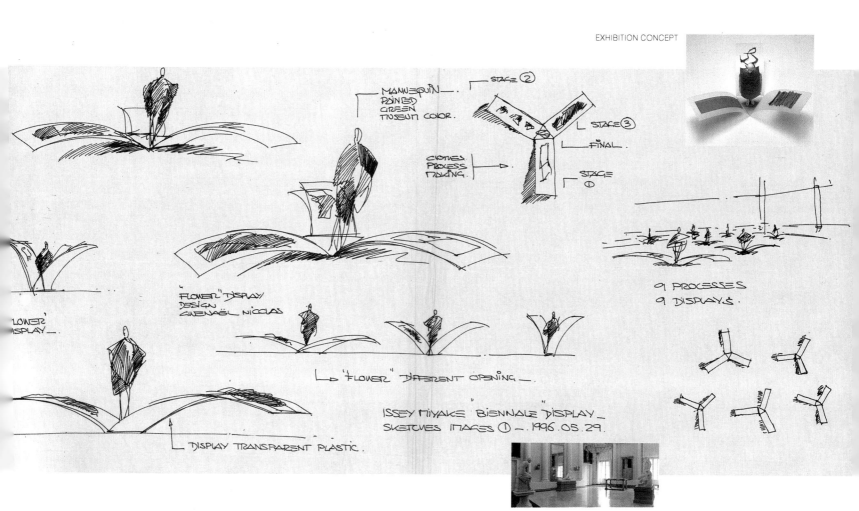

MANNEQUIN
PAINED
GREEN
MUSEUM COLOR.

STAGE ②

STAGE ③

FINAL.

CLOTHES
PROCESS
MOVING.

STAGE ①

"FLOWER" DISPLAY
DESIGN
GWENAËL NICOLAS

9 PROCESSES
9 DISPLAYS.

"FLOWER" DIFFERENT OPENING

ISSEY MIYAKE "BIENNALE" DISPLAY
SKETCHES IMAGES ① — 1996.05.29.

DISPLAY TRANSPARENT PLASTIC.

RHYTHM PLEATS

FLYING SAUCER

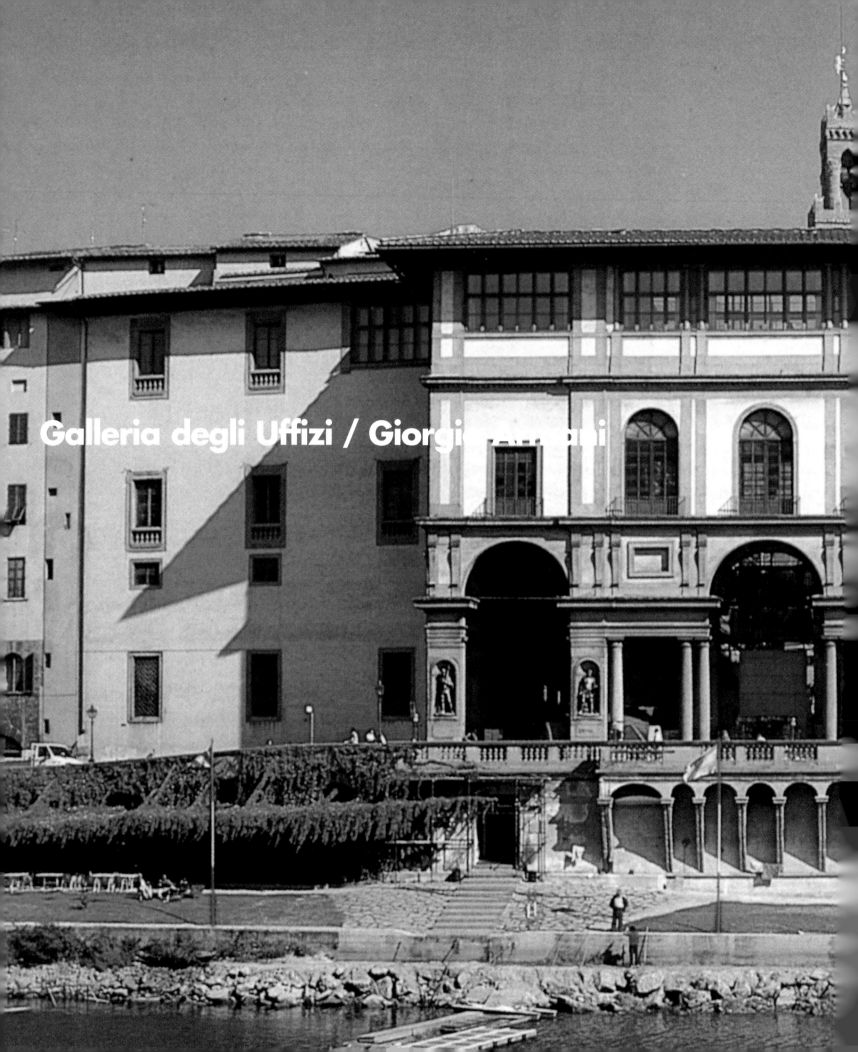

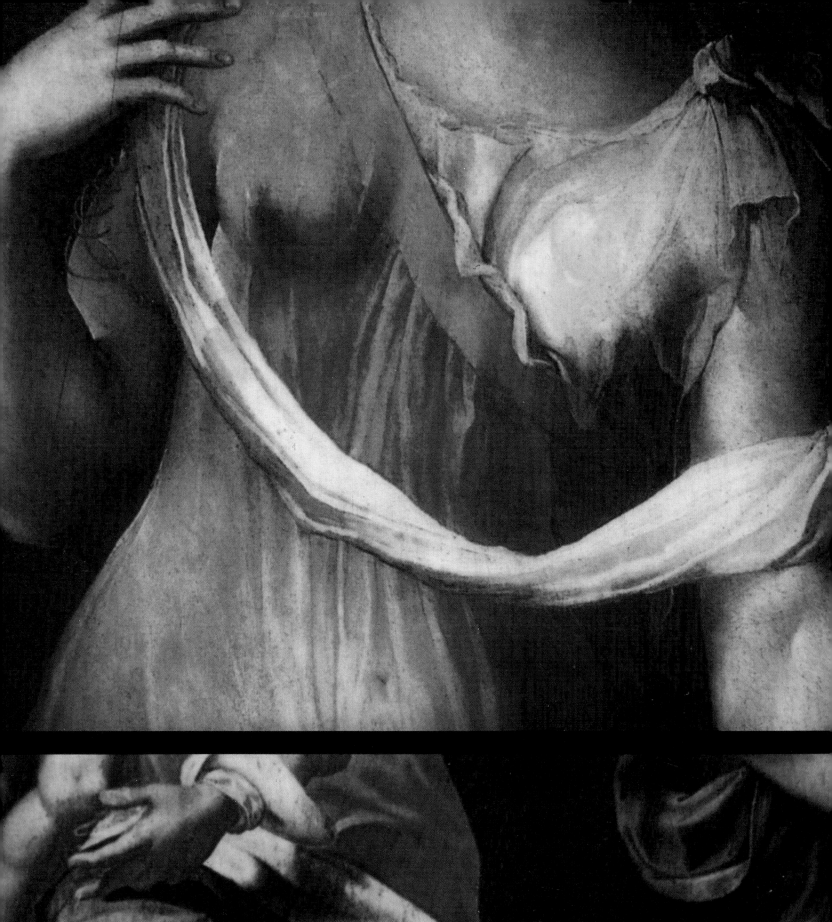

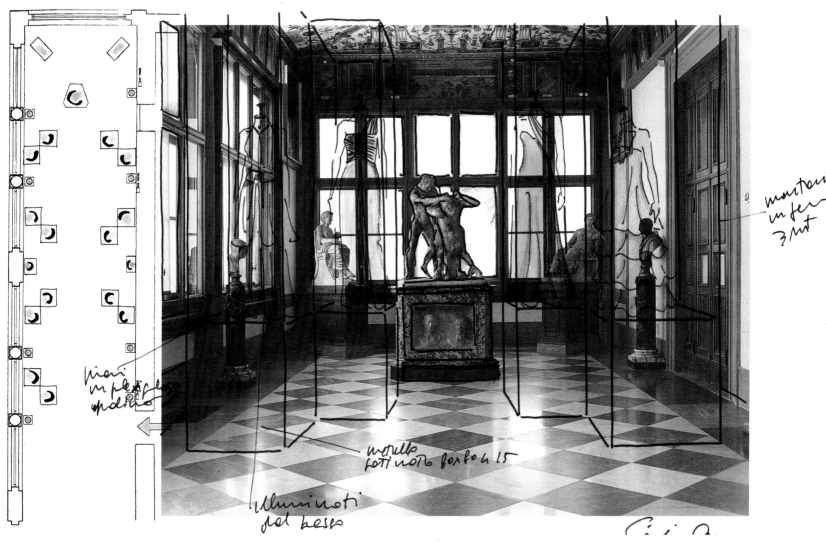

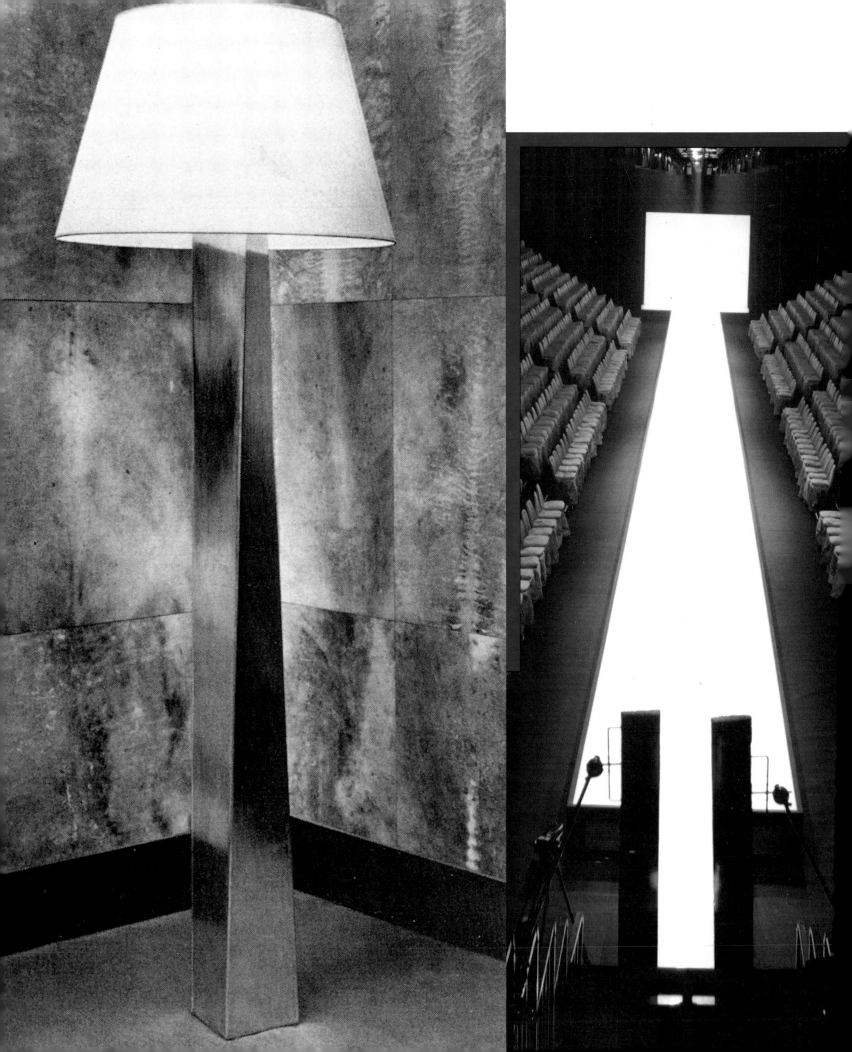

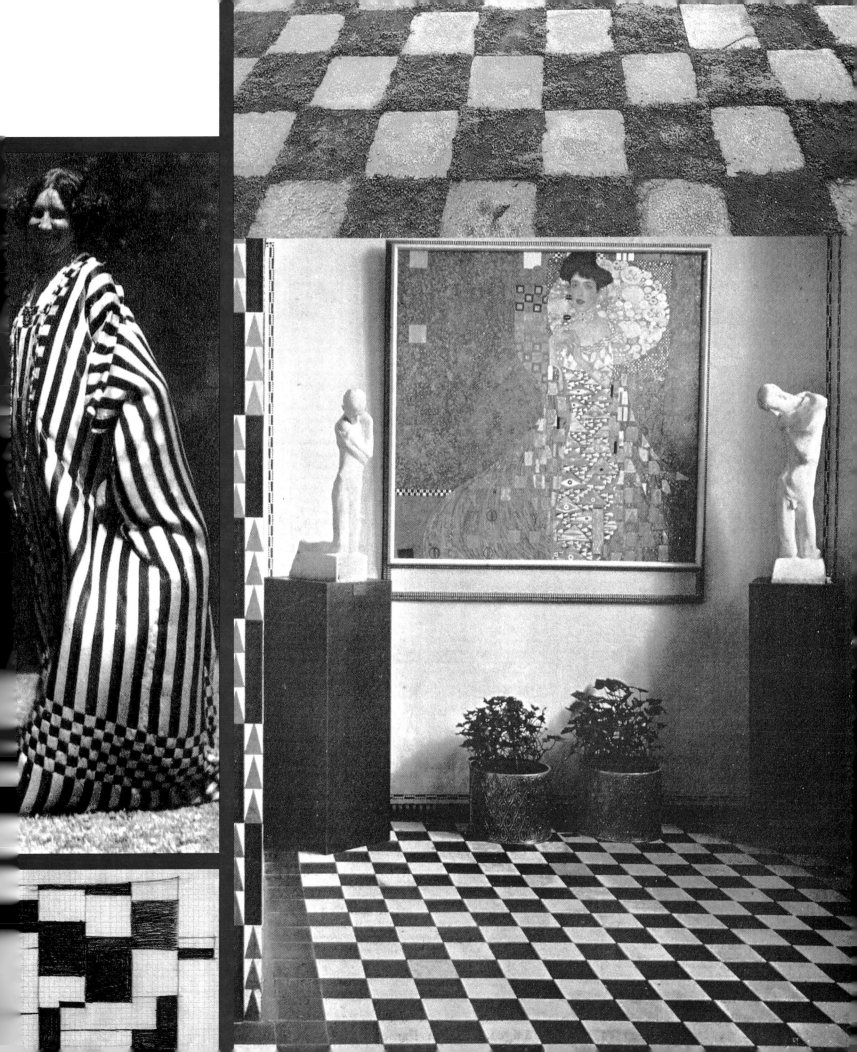

Galleria dell'Accademia / Valentino

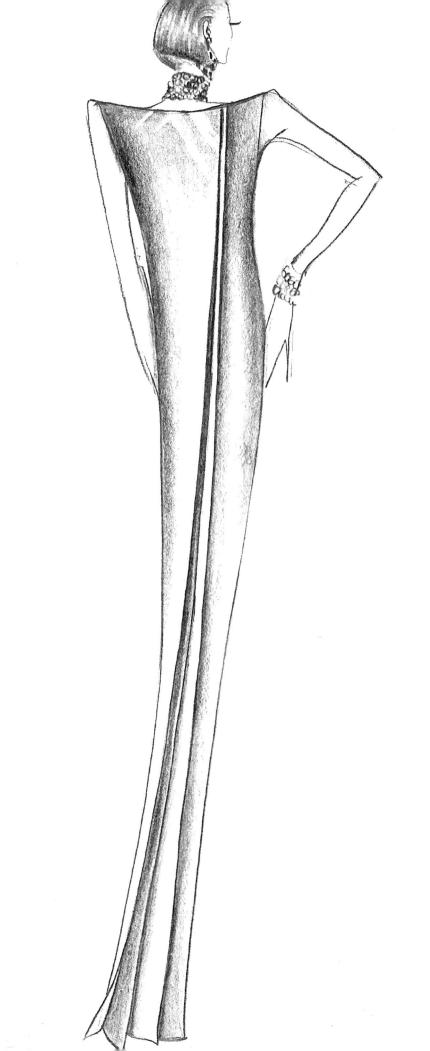

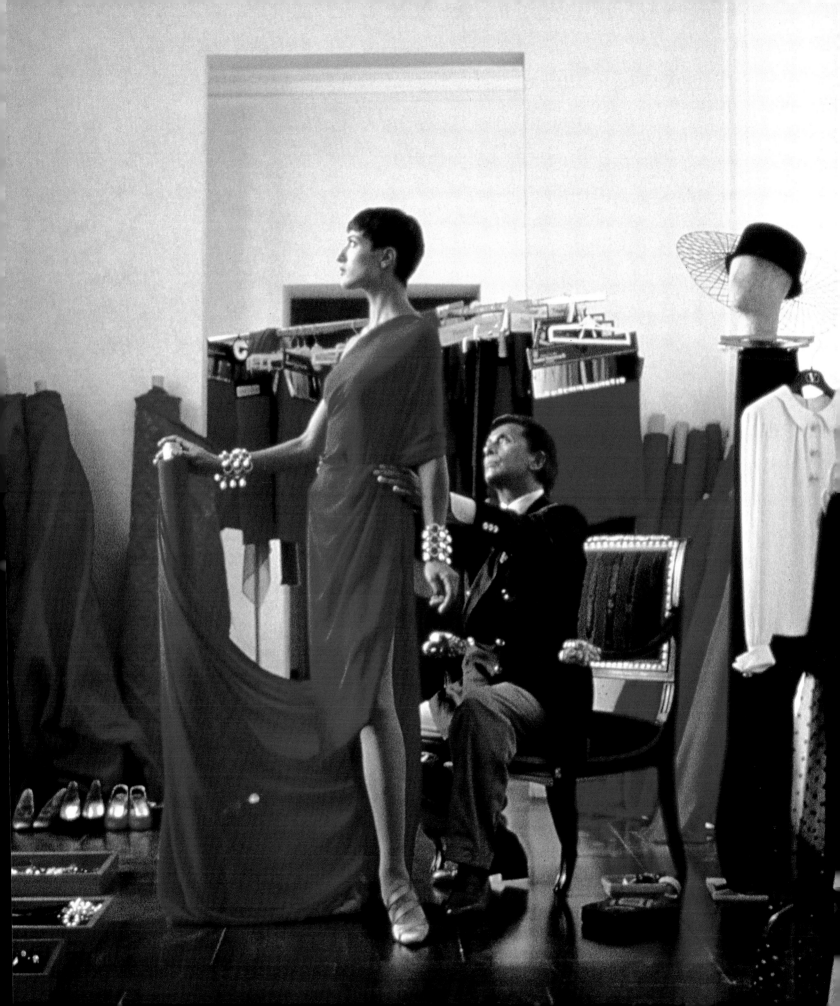

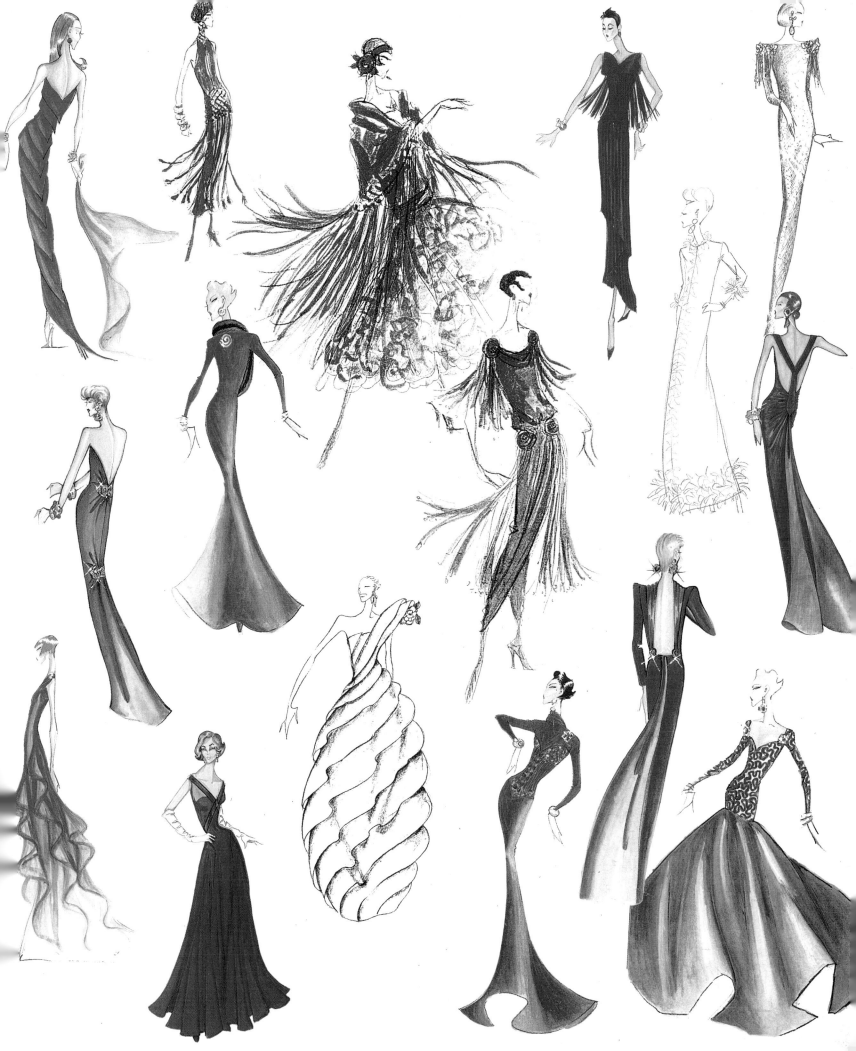

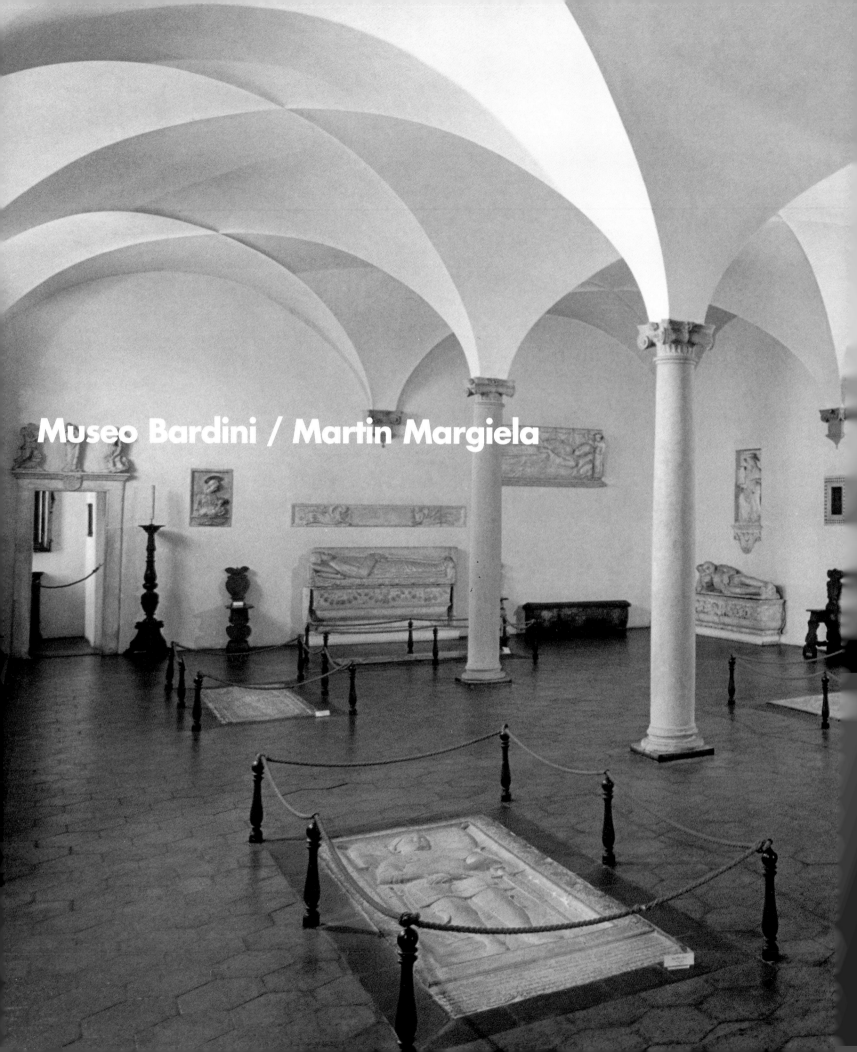

Museo Bardini / Martin Margiela

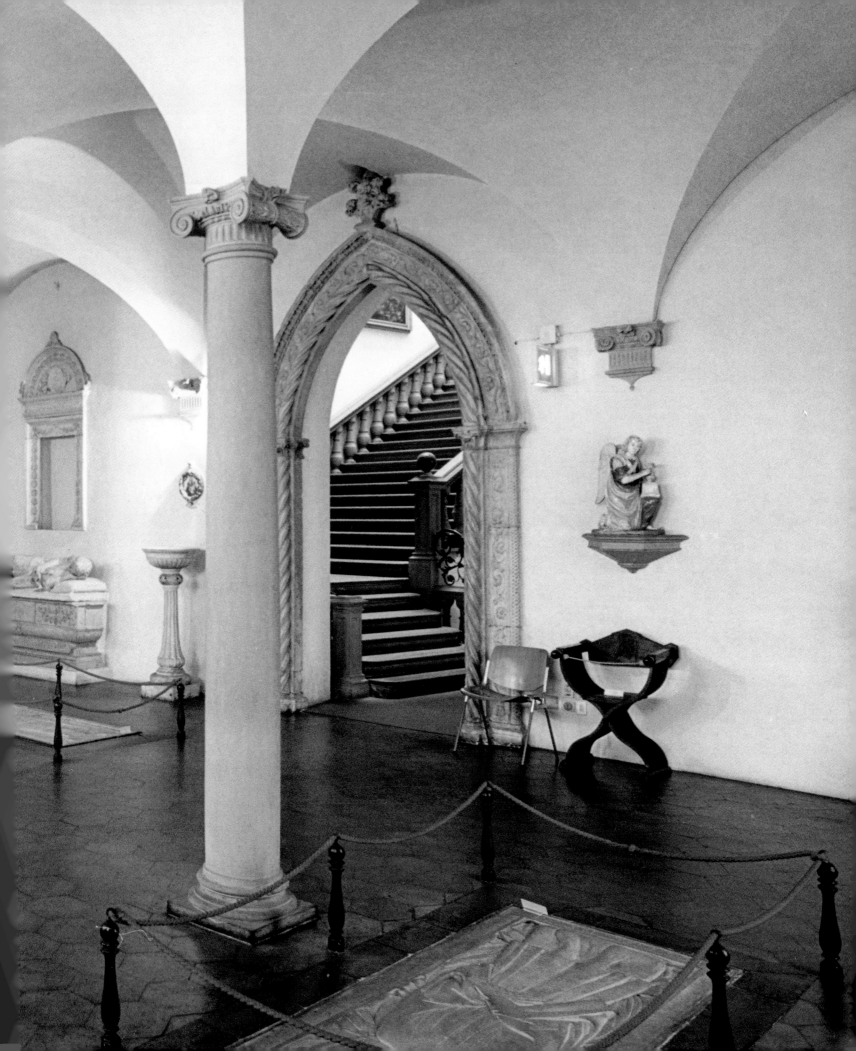

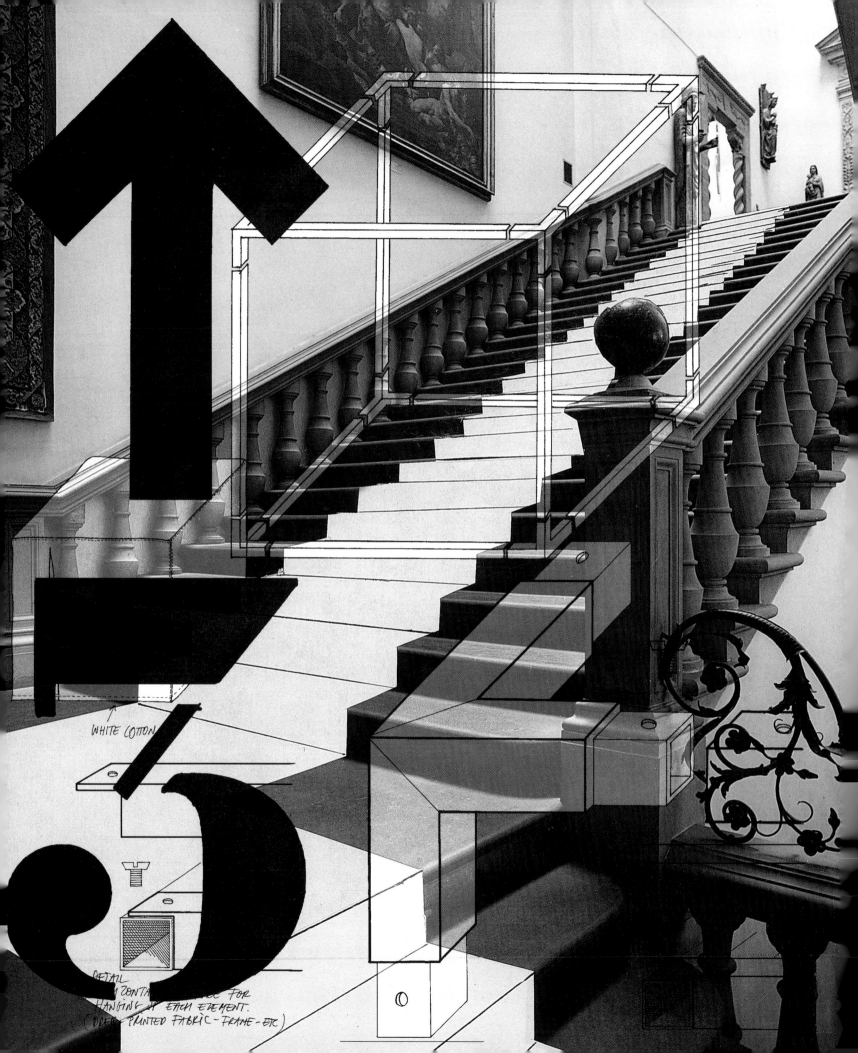

WHITE COTTON

DETAIL
...ZONTA... ...LE FOR
...HANGING ...EACH ELEMENT.
(...PRINTED FABRIC - FRAME - ETC)

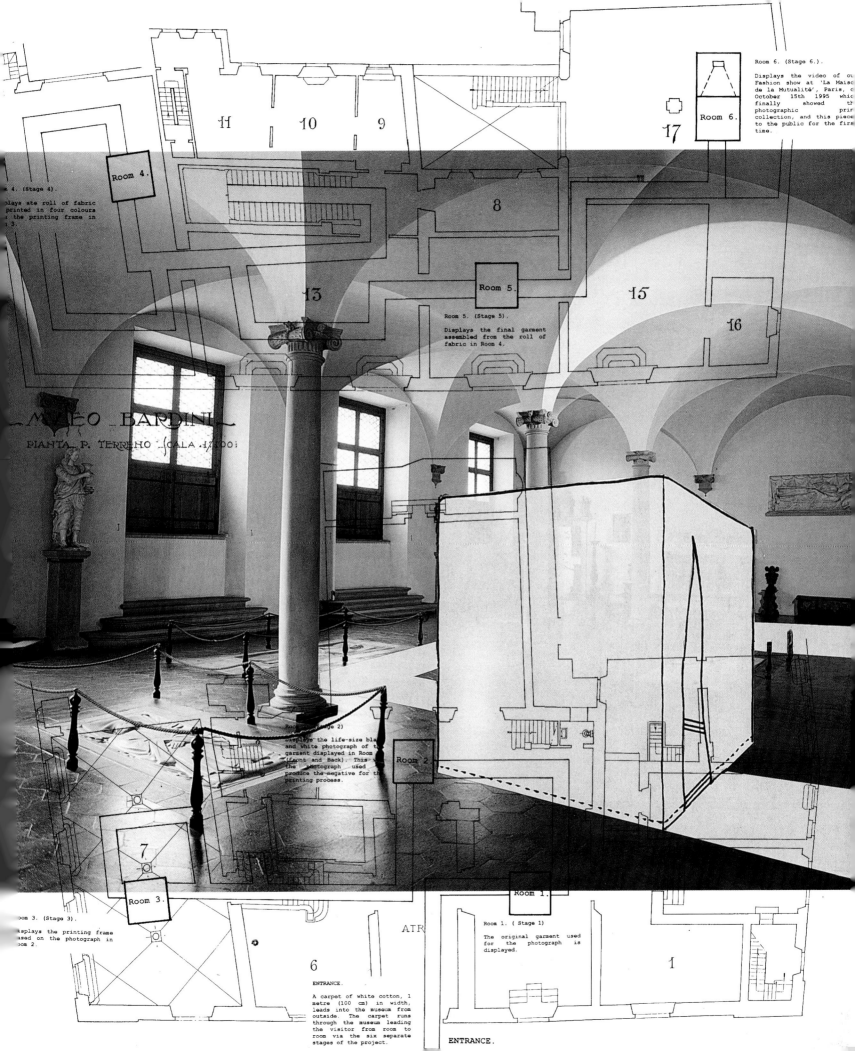

Room 6. (Stage 6.).

Displays the video of ou[r] Fashion show at 'La Maiso[n] de la Mutualité', Paris, o[n] October 15th 1995 which finally showed th[e] photographic prin[t] collection, and this piece[n] to the public for the fir[st] time.

Room 6.

17

[Roo]m 4. (Stage 4).

[Di]splays ate roll of fabric printed in four colours [and] the printing frame in [Room] 3.

Room 4.

11 10 9

8

Room 5.

Room 5. (Stage 5).

Displays the final garment assembled from the roll of fabric in Room 4.

13

15

16

MVSEO BARDINI

PIANTA P. TERRENO SCALA 1/200

Roo[m 2.] (Stage 2)

[Di]splays the life-size bla[ck] and White photograph of t[he] garment displayed in Room [1] (Front and Back). This w[as] the photograph used [to] produce the negative for th[e] printing process.

Room 2.

7

Room 3.

[R]oom 3. (Stage 3).

[Di]splays the printing frame [ba]sed on the photograph in [Ro]om 2.

Room 1.

Room 1. (Stage 1)

The original garment used for the photograph is displayed.

ATR[IO]

6

1

ENTRANCE.

A carpet of white cotton, 1 metre (100 cm) in width, leads into the museum from outside. The carpet runs through the museum leading the visitor from room to room via the six separate stages of the project.

ENTRANCE.

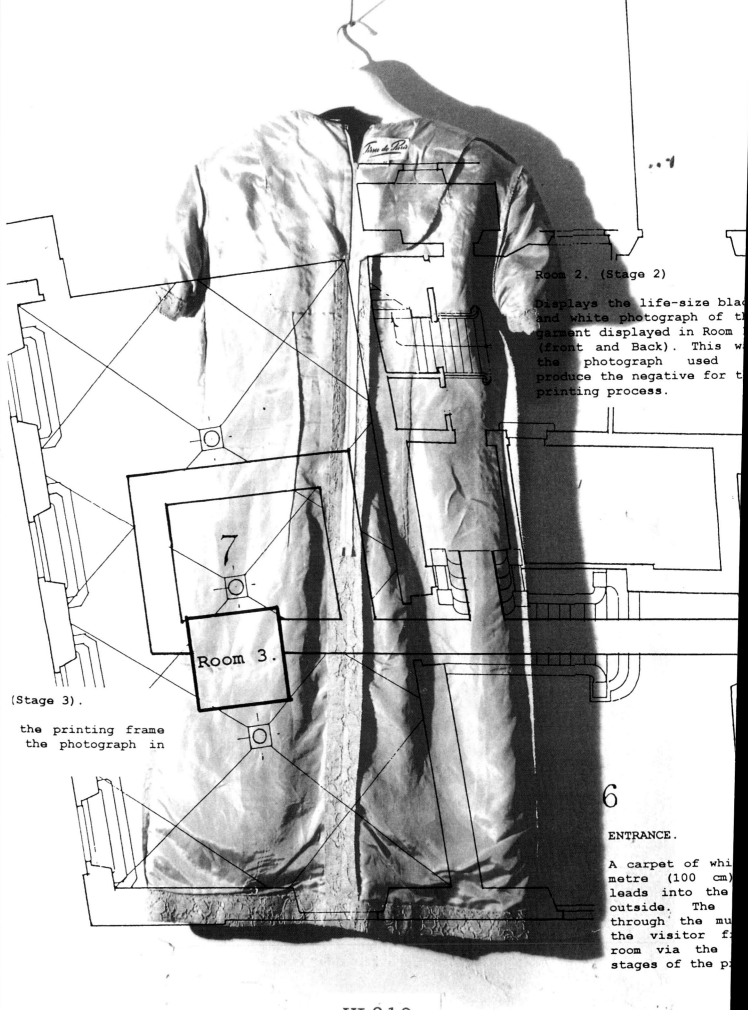

La fotografia stampata ha sempre determinato le proporzioni finali di ogni capo.

Per questo procedimento é necessario tagliare ogni capo a mano.

Room 2. (Stage 2)

Displays the life-size black and white photograph of the garment displayed in Room (front and Back). This w the photograph used produce the negative for t printing process.

(Stage 3).

the printing frame
the photograph in

Room 3.

7

6

ENTRANCE.

A carpet of whi
metre (100 cm)
leads into the
outside. The
through the mu
the visitor f
room via the
stages of the p

VL013

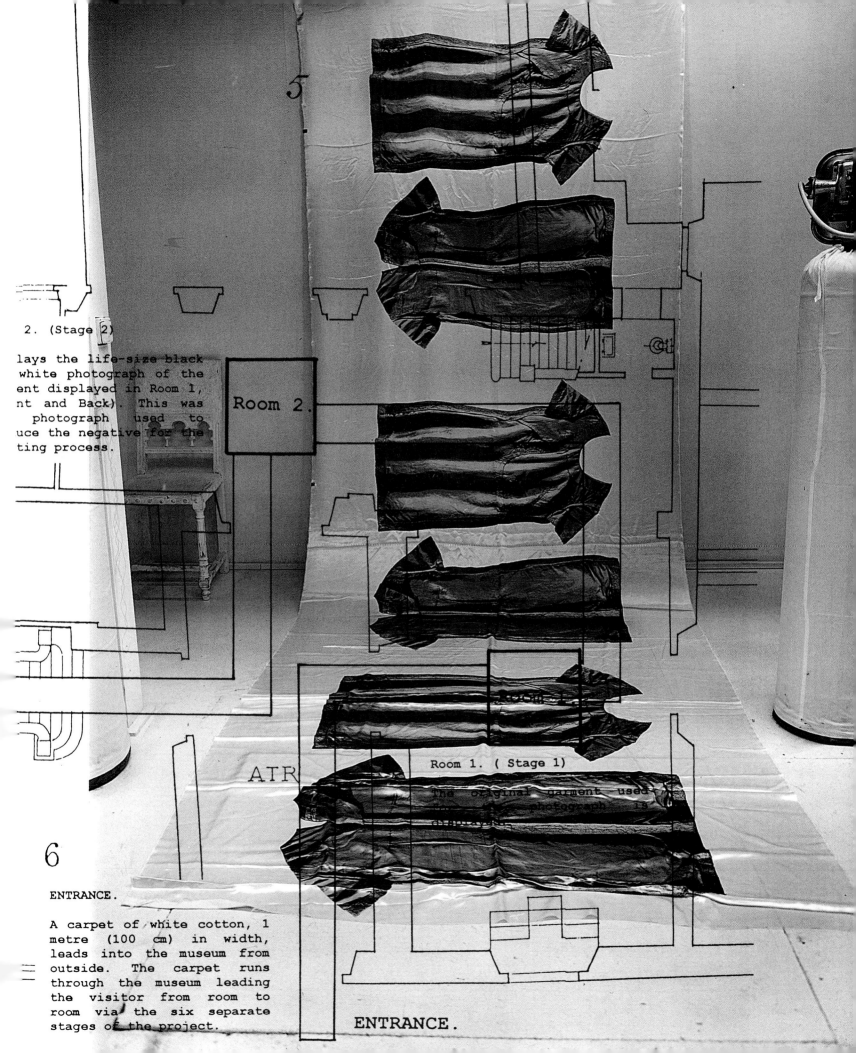

2. (Stage 2)

lays the life-size black
white photograph of the
ent displayed in Room 1,
nt and Back). This was
 photograph used to
uce the negative for the
ting process.

Room 2.

5

Room 1. (Stage 1)

the original garment used
photograph is
displayed

ATR

6

ENTRANCE.

A carpet of white cotton, 1
metre (100 cm) in width,
leads into the museum from
outside. The carpet runs
through the museum leading
the visitor from room to
room via the six separate
stages of the project.

ENTRANCE.

Museo degli Argenti / Philip Treacy

PHEASANT
LARGE
PROFILE
HAT.

LadyAmerhurst PHEASANT
FEATHER.
MOTORING toque.
TWISTED COLOURED
PHEASANt FEATHERS

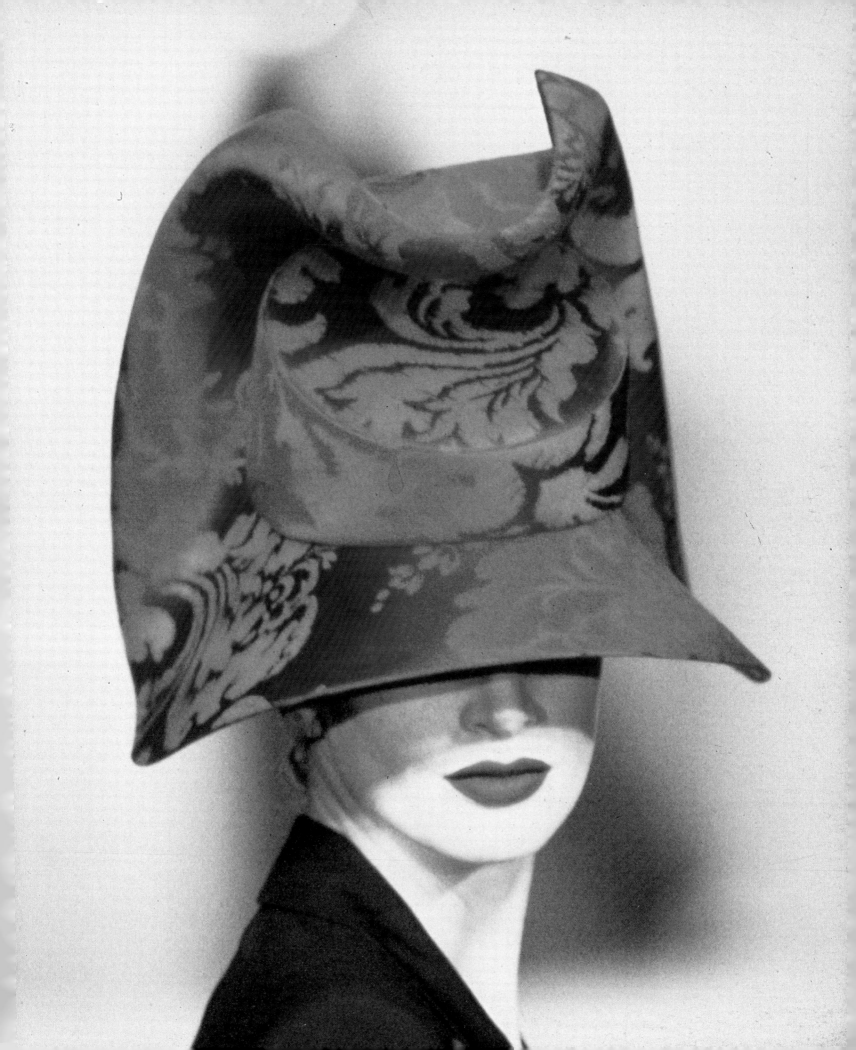

Museo del Bigallo / Donna Karan

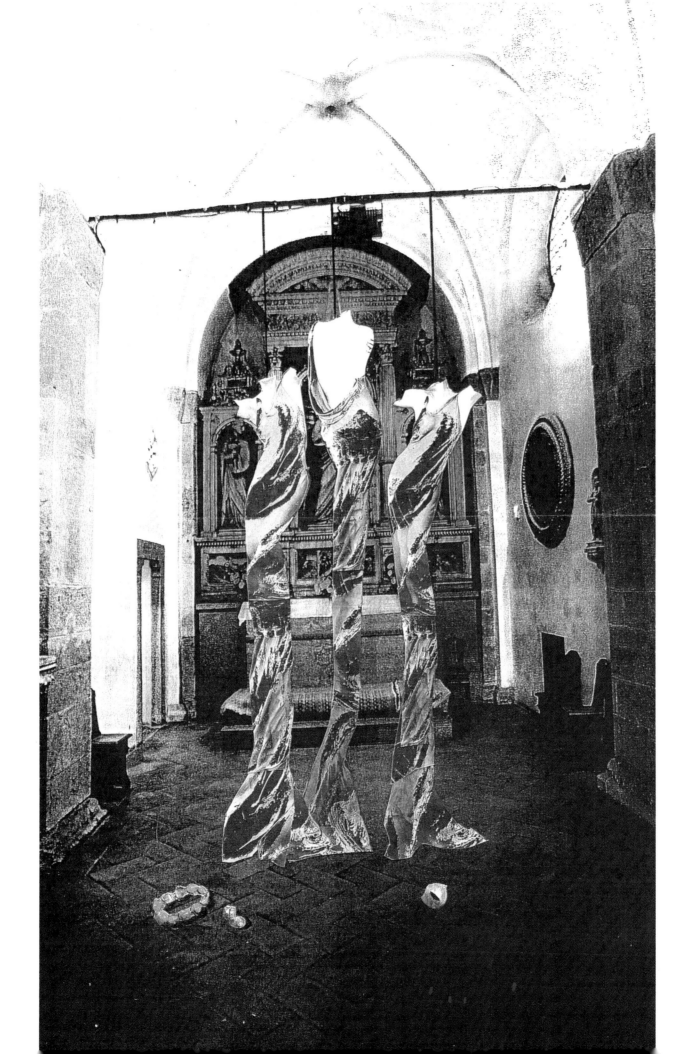

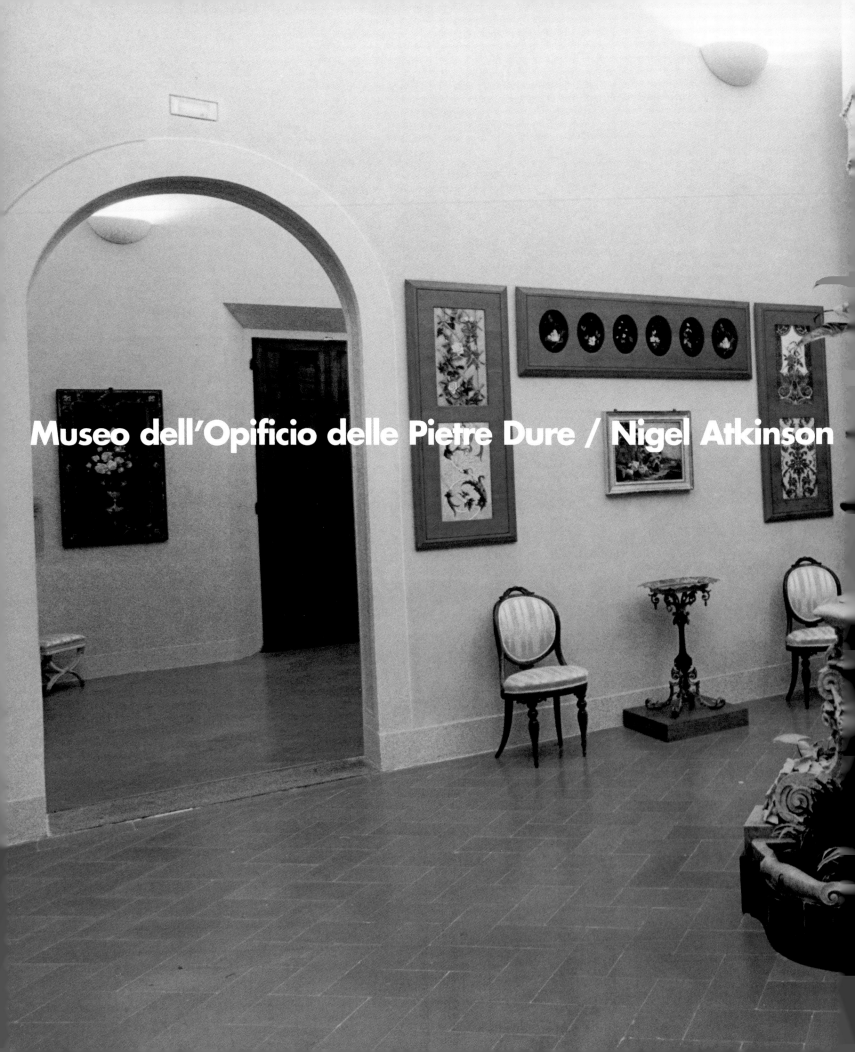

Museo dell'Opificio delle Pietre Dure / Nigel Atkinson

Museo di Storia della Scienza / Richard Tyler

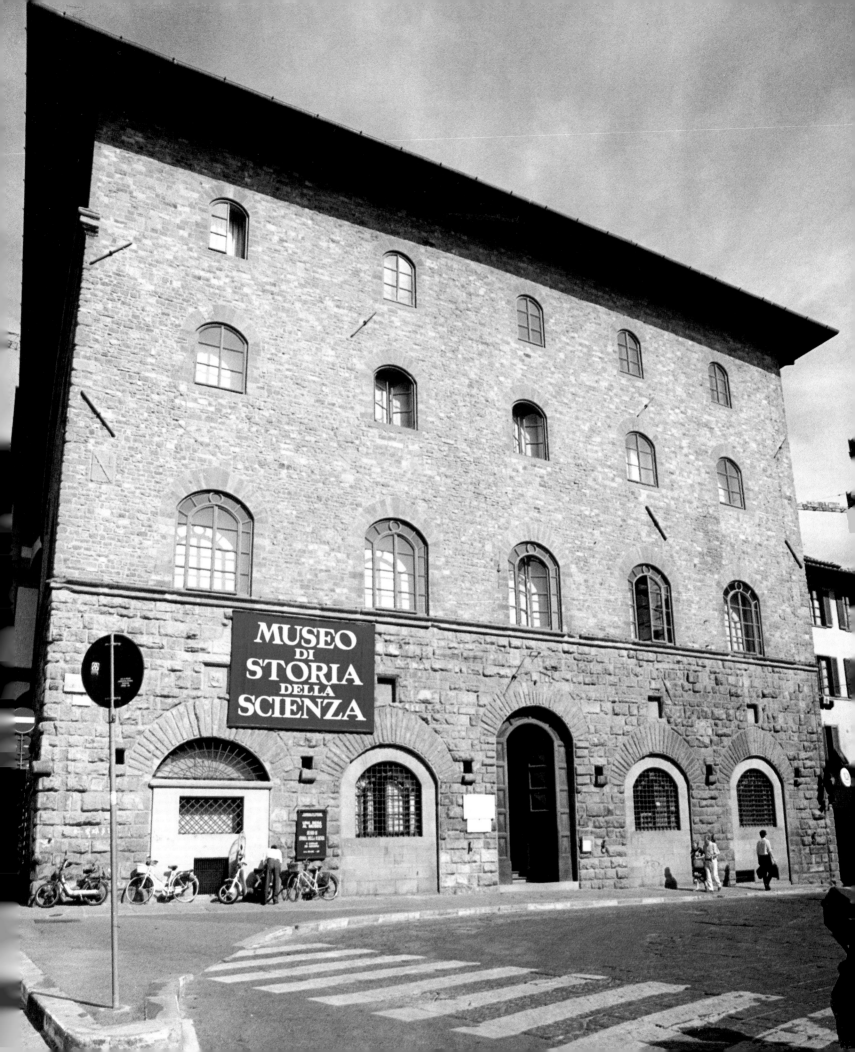

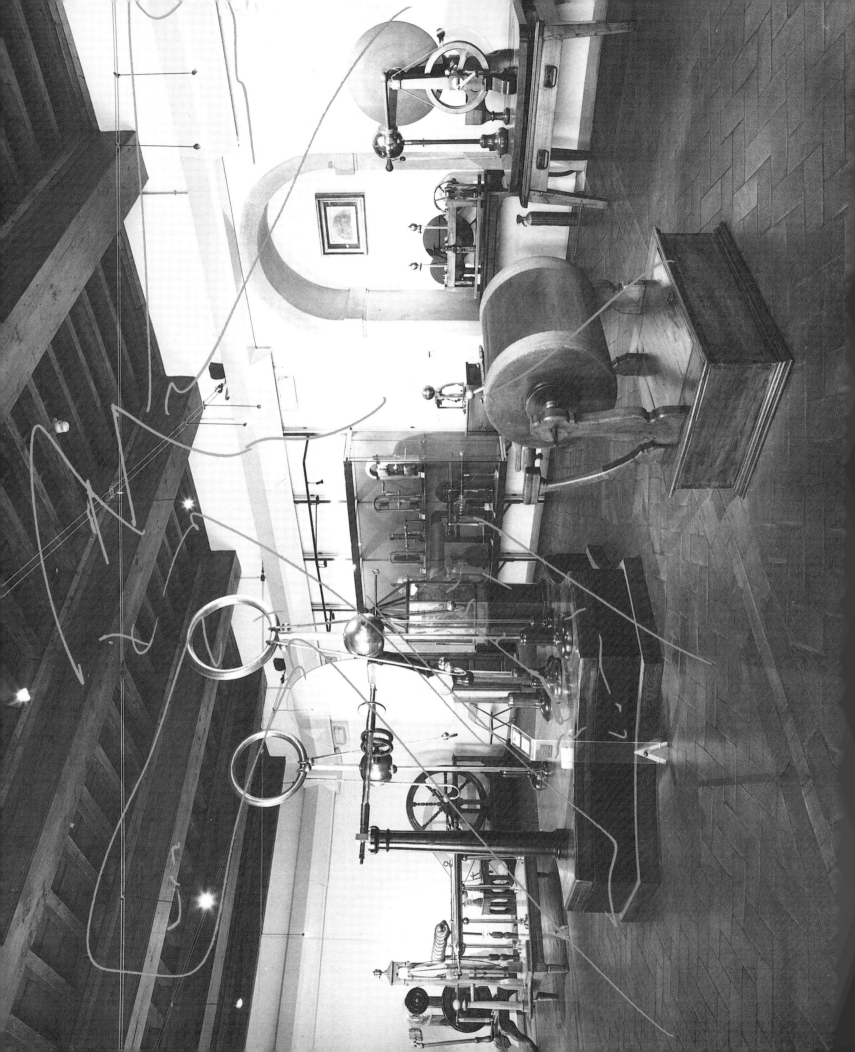

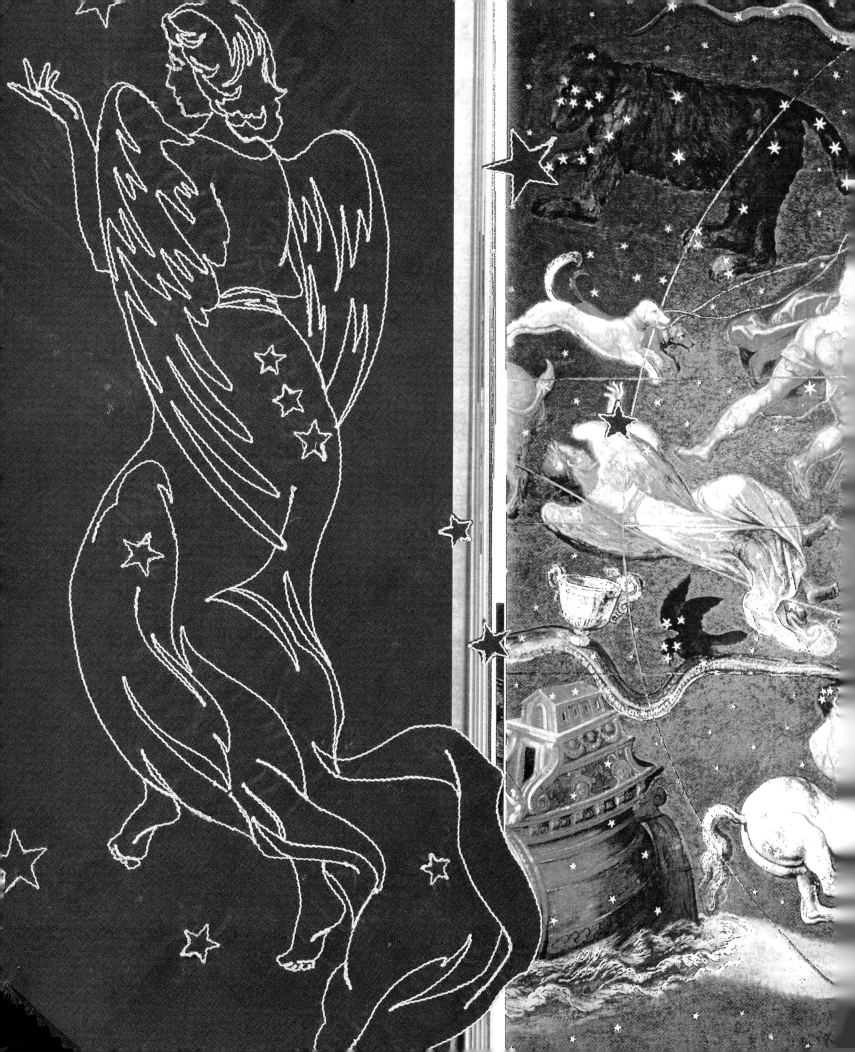

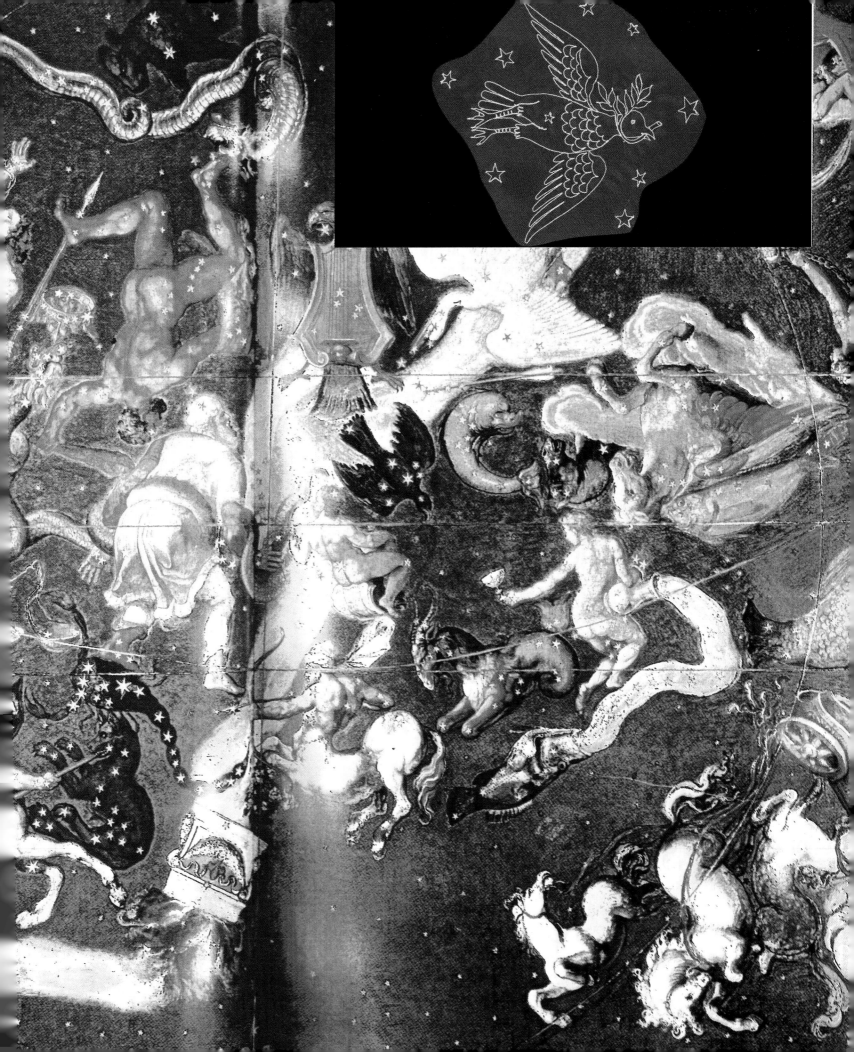

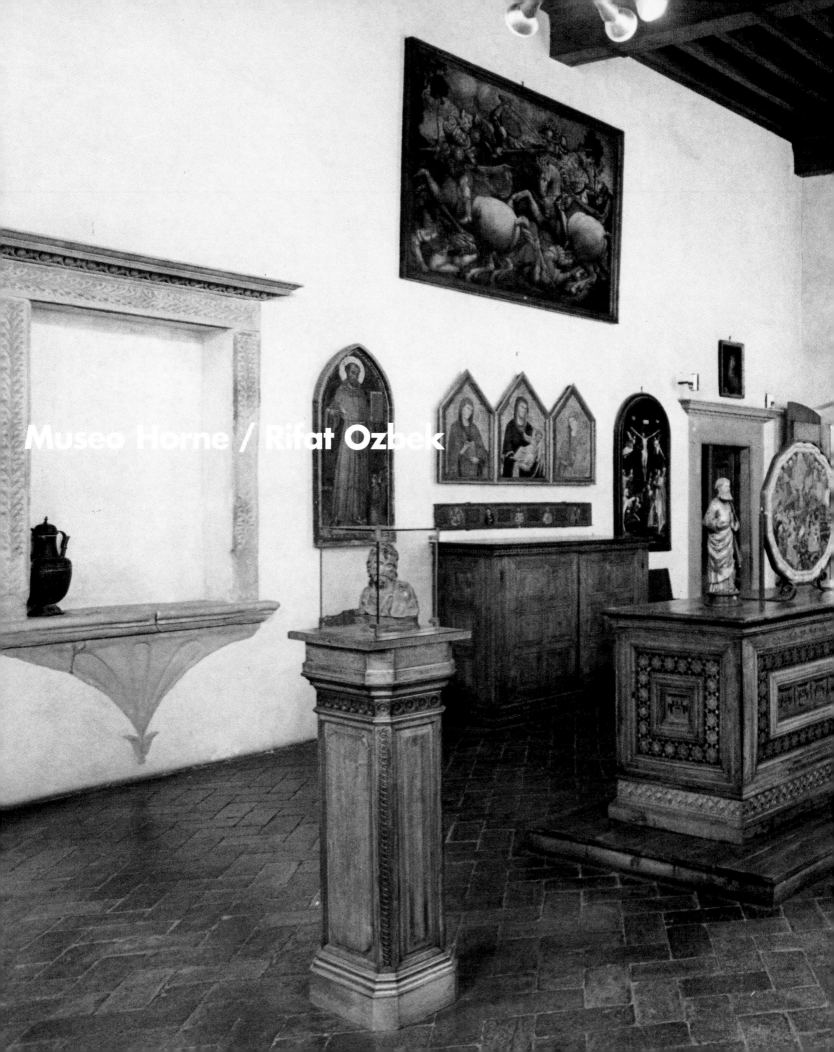

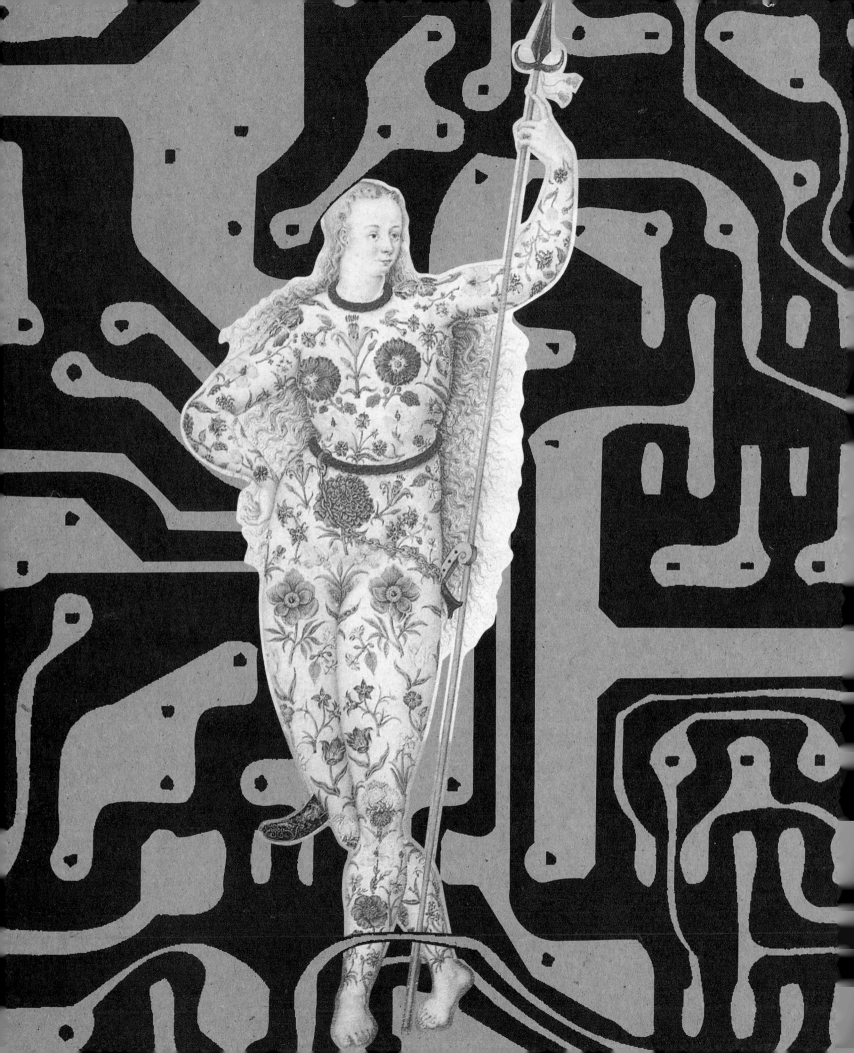

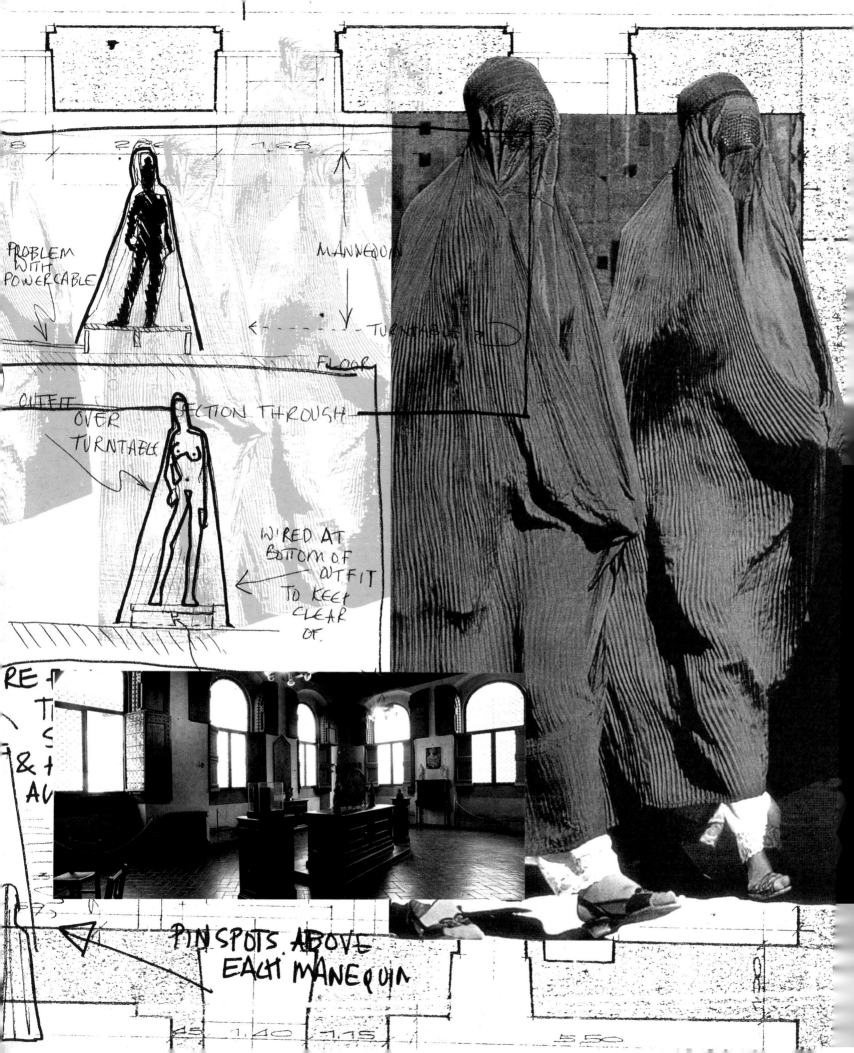

PROBLEM WITH POWERCABLE

MANNEQUIN

TURNTABLE

FLOOR

OUTFIT OVER TURNTABLE

SECTION THROUGH

WIRED AT BOTTOM OF OUTFIT TO KEEP CLEAR OF.

PINSPOTS ABOVE EACH MANEQUIN

PAINTINGS SOMETIMES
THICK , 30D , HEAVY BRUSHSTROKES
use wall
paint brushes

SOMETIMES
AS FLAT AS
SILKSCREEN

SILK SCREEN
small

ALWAYS VERY BIG 6'x6' or
bigg
OR VERY SMALL — small as
postcard size

Museo Marino Marini / Romeo Gigli

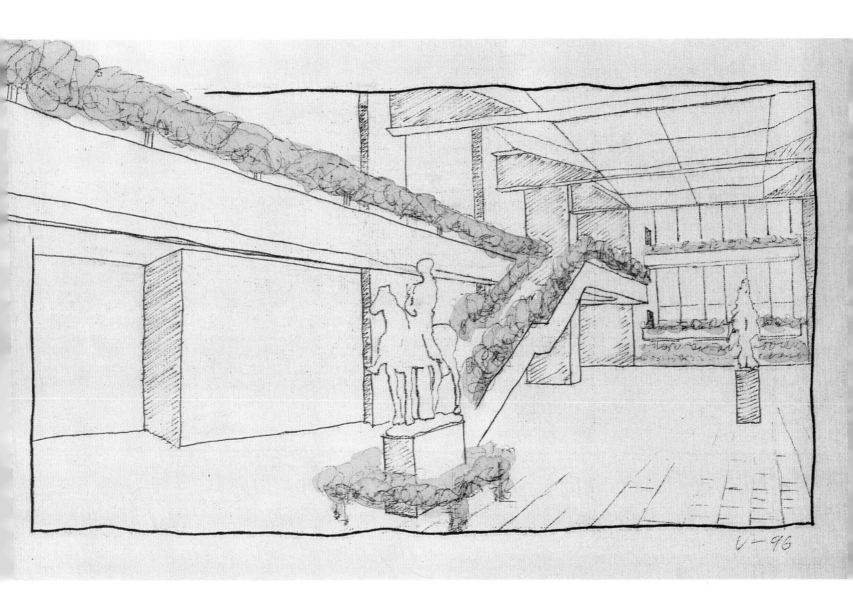

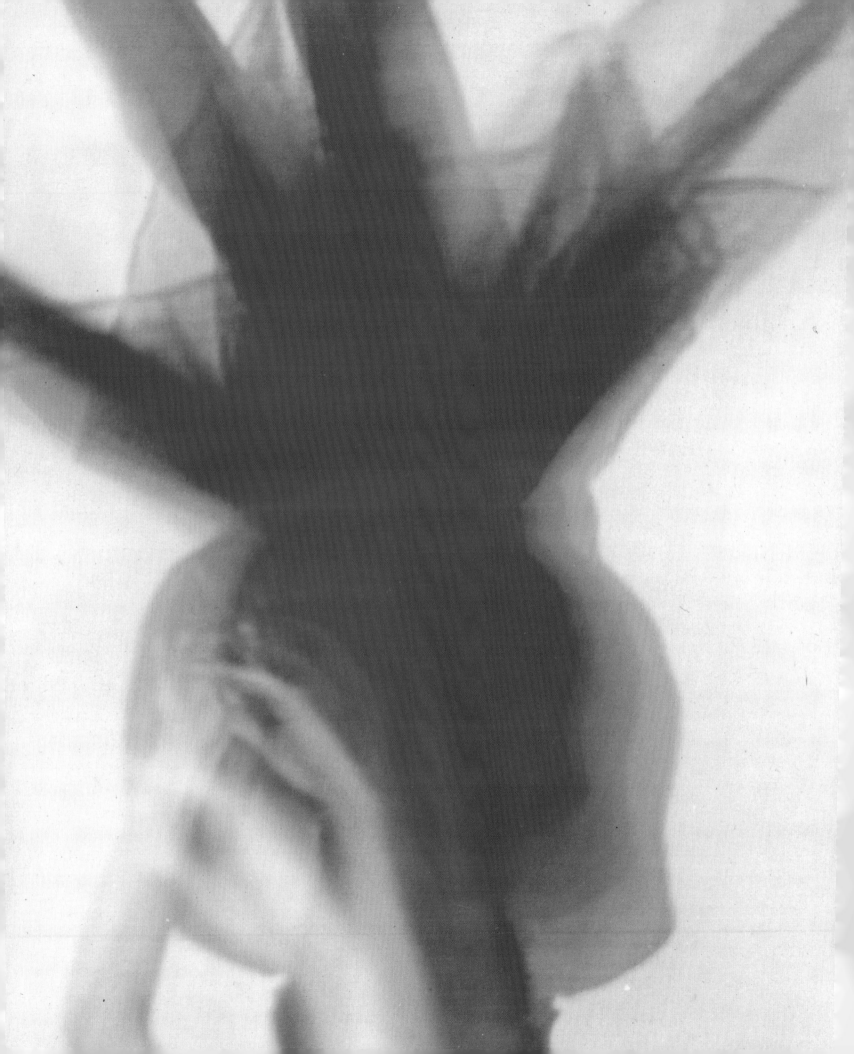

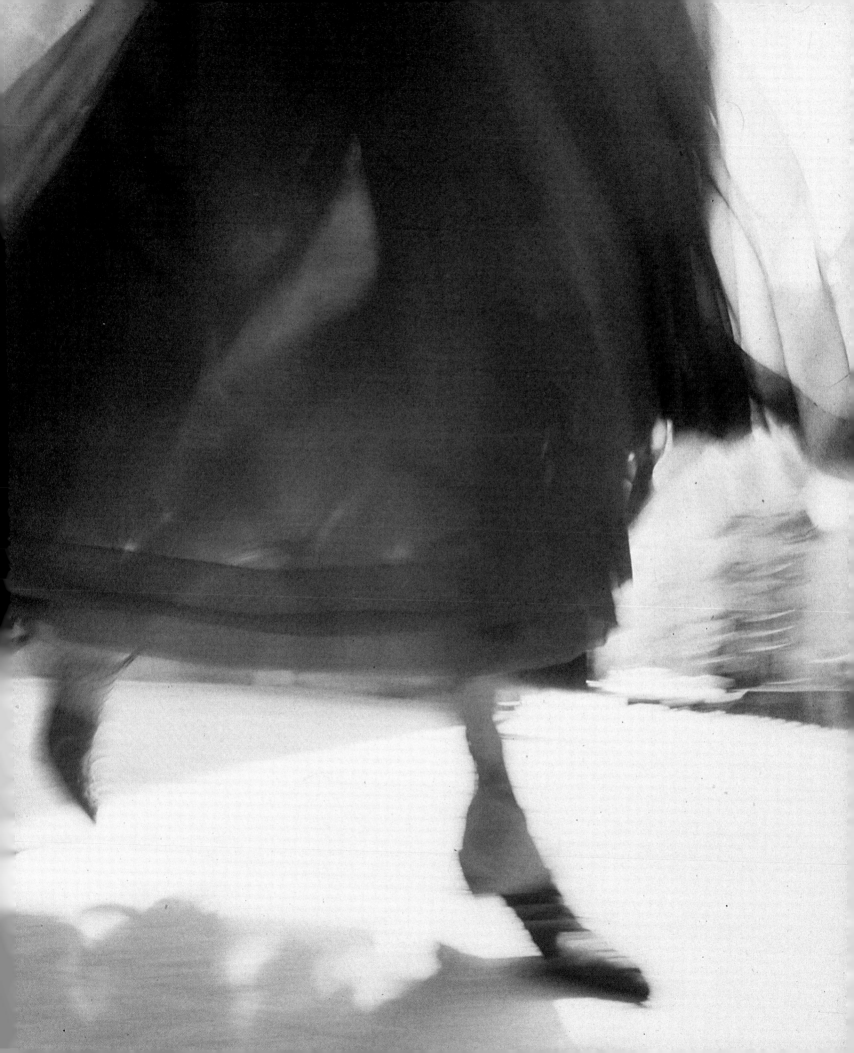

Museo Nazionale di Antropologia e Etnologia / Dolce e Gabbana

D. CYRVS CHRISTI MARTIR EGREGIVS
MARINENTIV PATRONVS &

Museo Orsanmichele / Christian Lacroix

CÁ

CHRISTIAN
LACROIX

Manteau XVII

CHRISTIAN LACROIX - 73, rue du Faubourg Saint-Honoré Paris 8e Tel. (1) 4
S.N.C. au capital de 35.000.000 F - R.C.S. Paris n° B 341265858 n° Siren

(fantasy)

peut-être préférer le dessin
le plus épuré
et le plus

seris
rouge
noir

très beau
Serge/no
avec

nouvelle

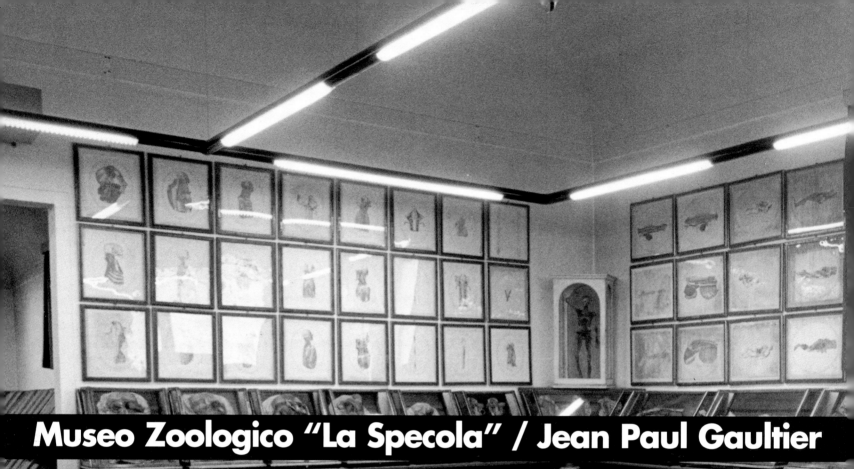
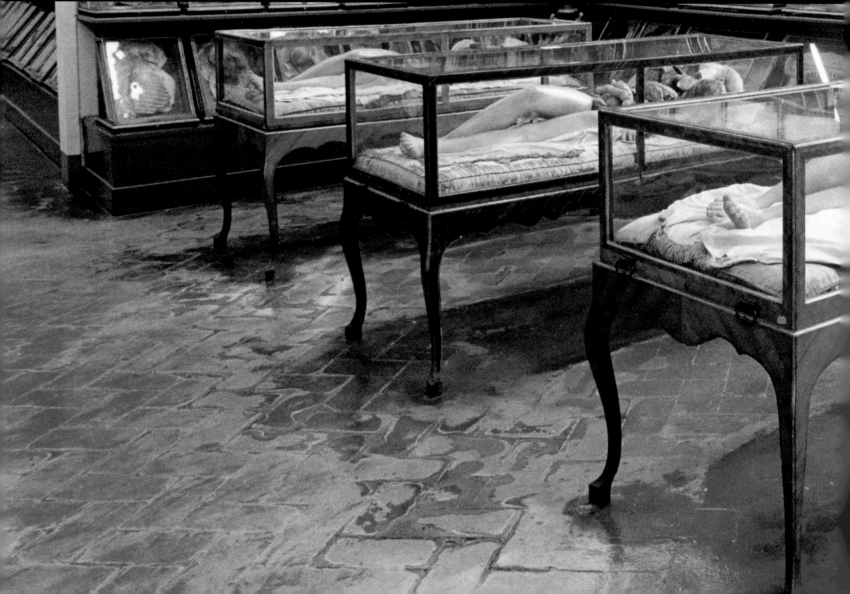

Museo Zoologico "La Specola" / Jean Paul Gaultier

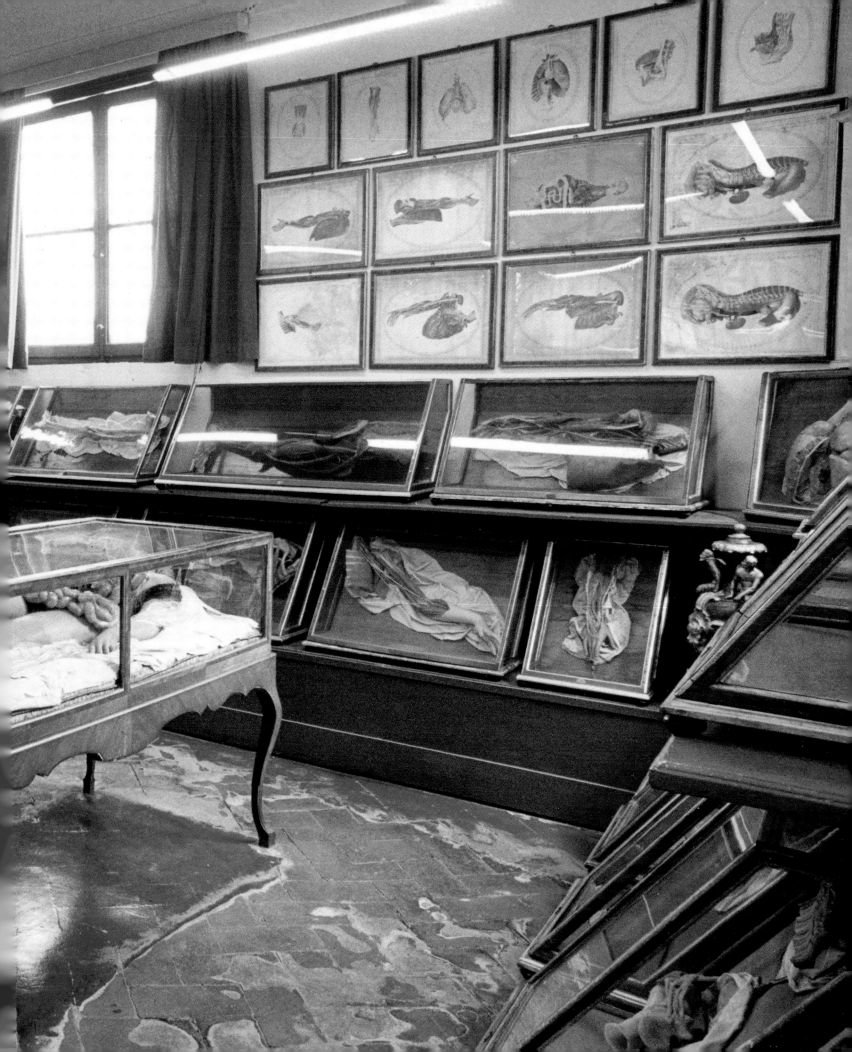

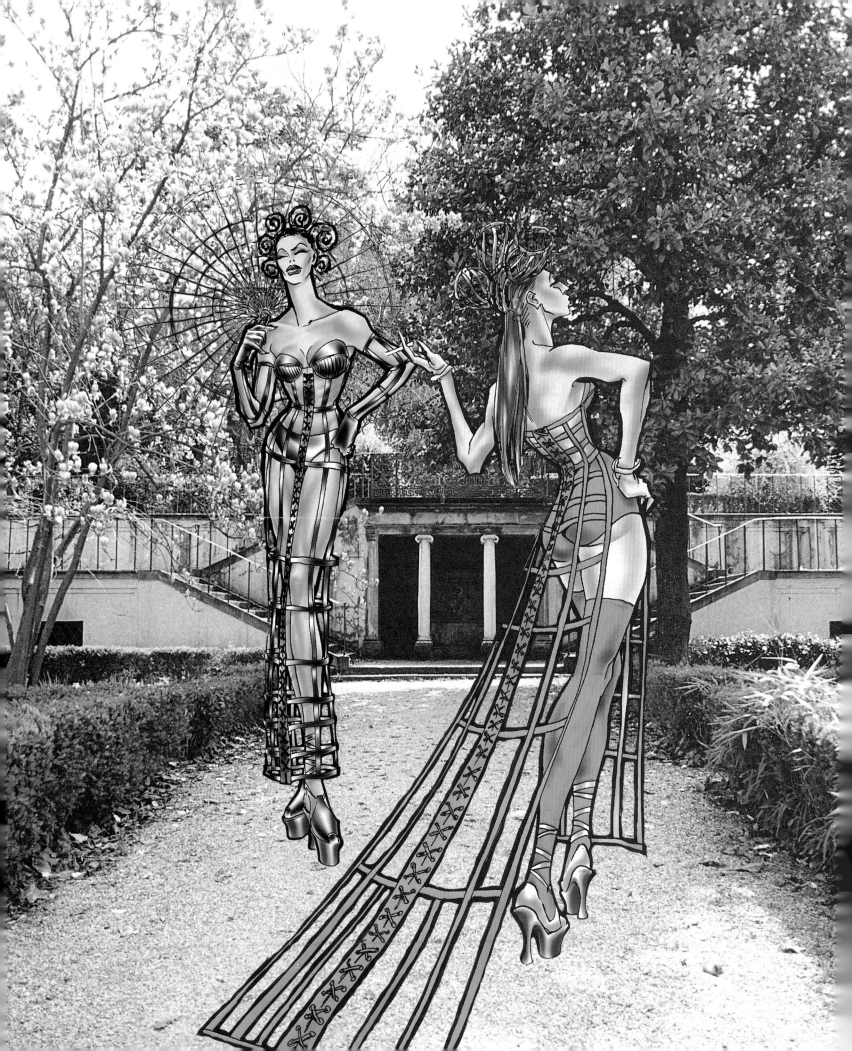

Autour du Miroir

roir

TULLE
Sous la cage de Verre
Autour du Meuble

Palazzo Vecchio Sala dei Gigli / Yves Saint Laurent

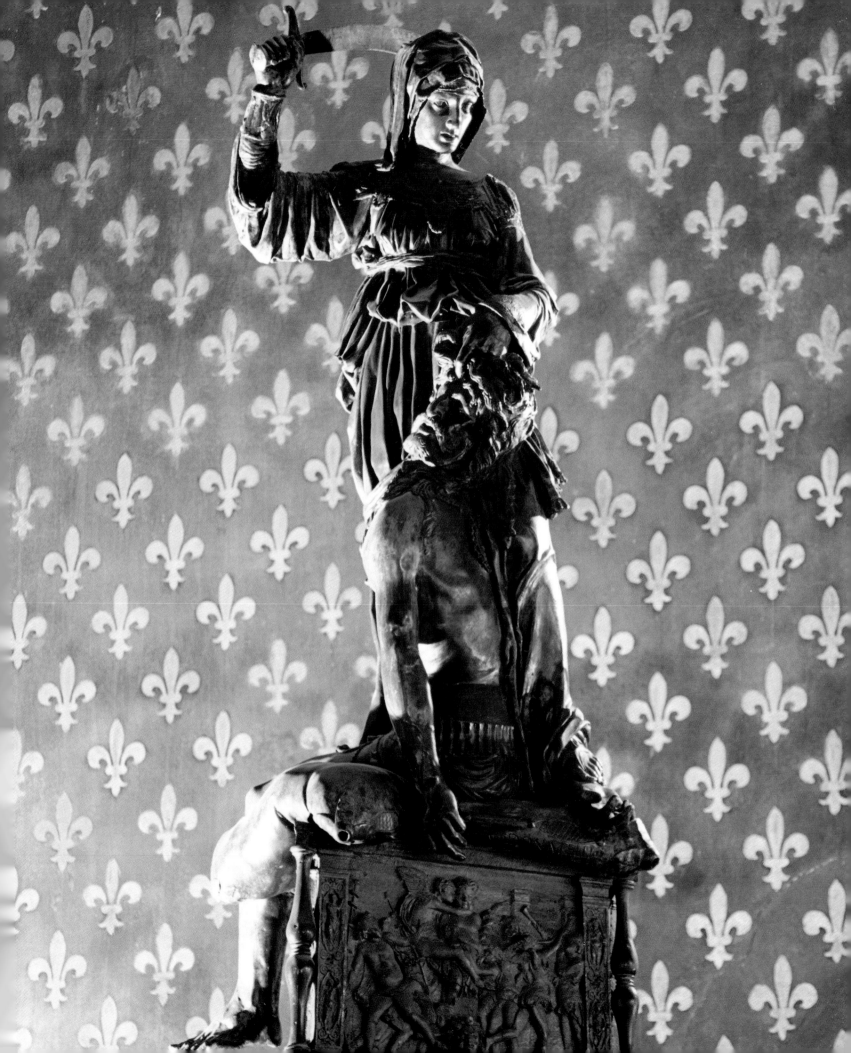

L'or parce que c'est la pureté
et la coulée de la source qui
moule le corps jusqu'à n'en
faire qu'une ligne

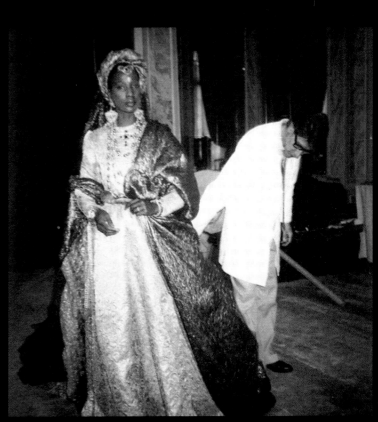

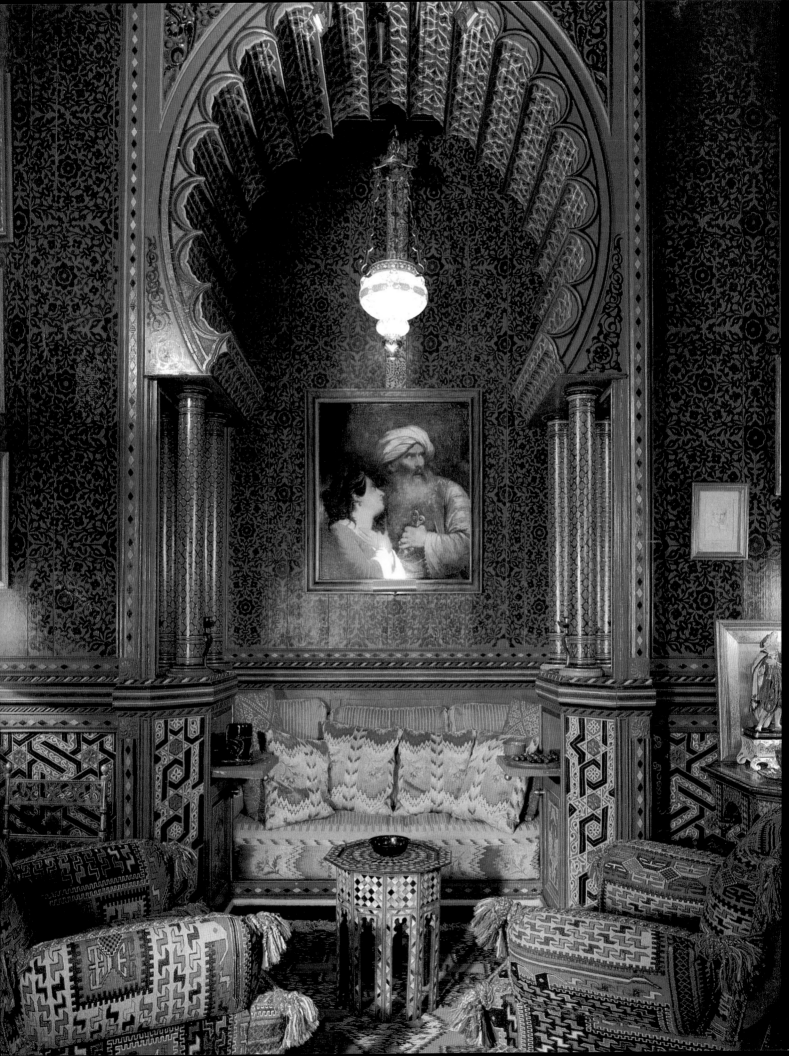

Palazzo Vecchio Studiolo di Francesco I / Manolo Blahnik

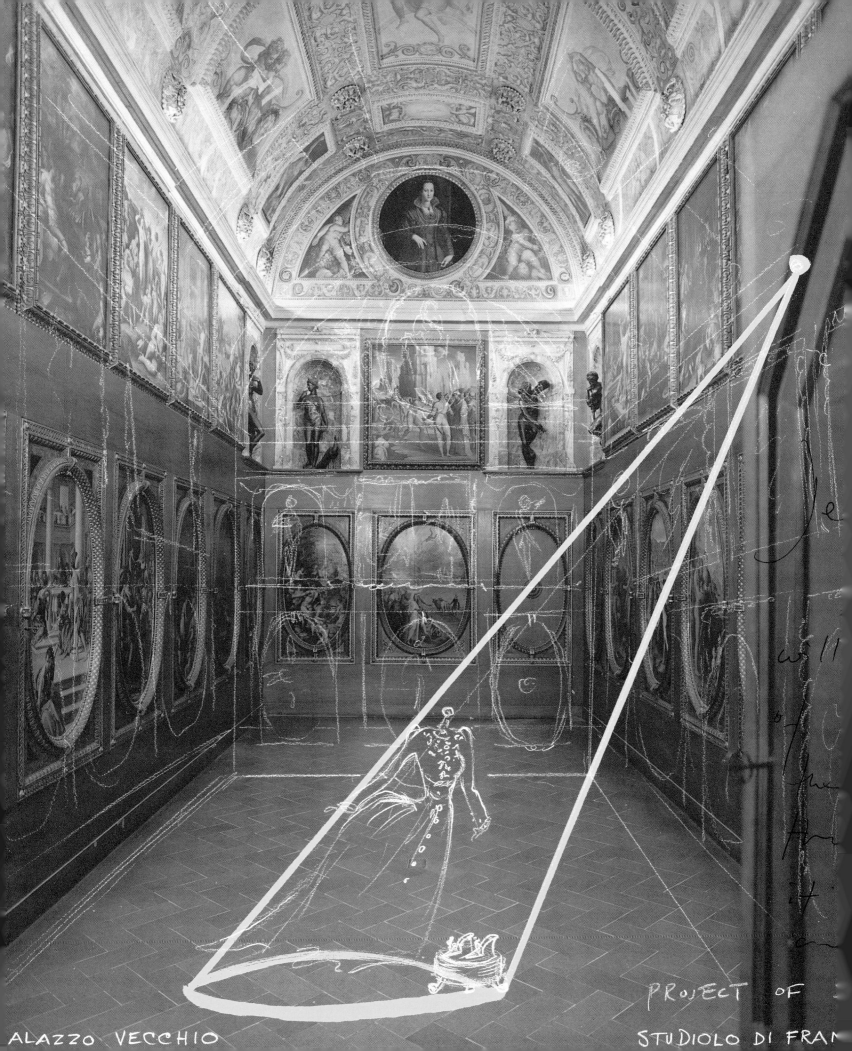

ALAZZO VECCHIO

PROJECT OF

STUDIOLO DI FRAN

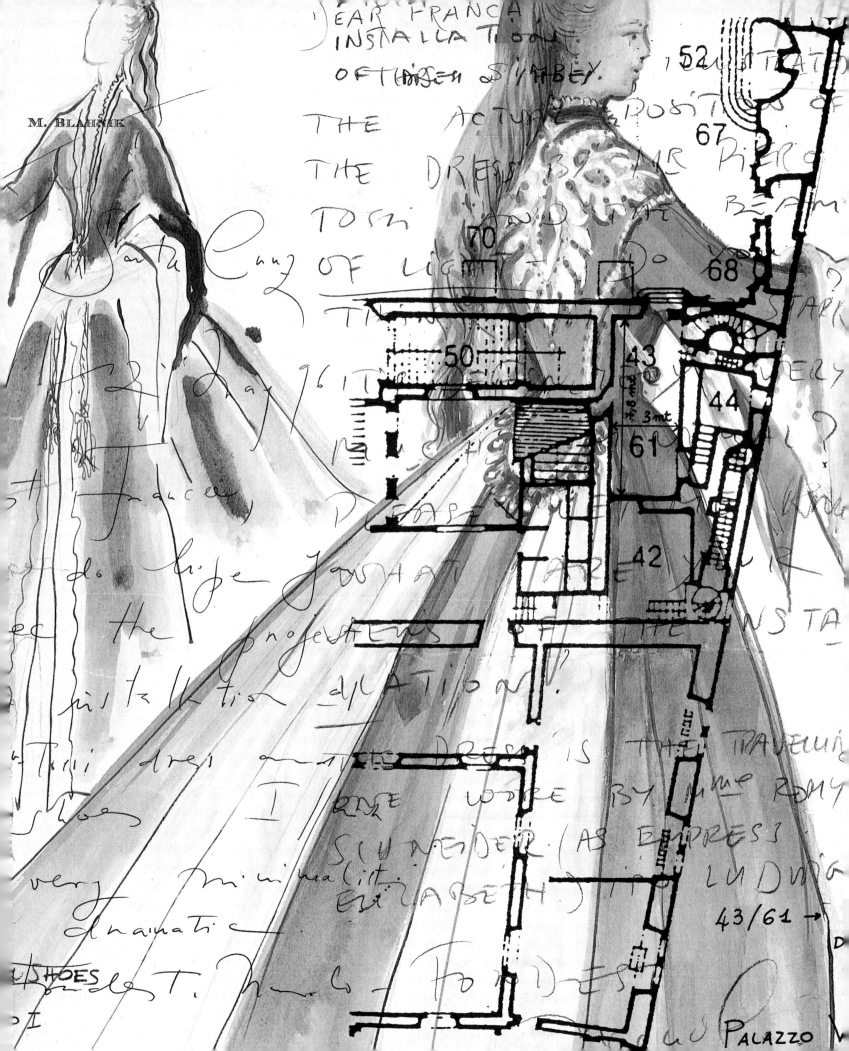

Museo Civico di Prato / Marc Jacobs - Todd Oldham - Anna Sui

Marc Jacobs.

Tom ...

Anna Sui

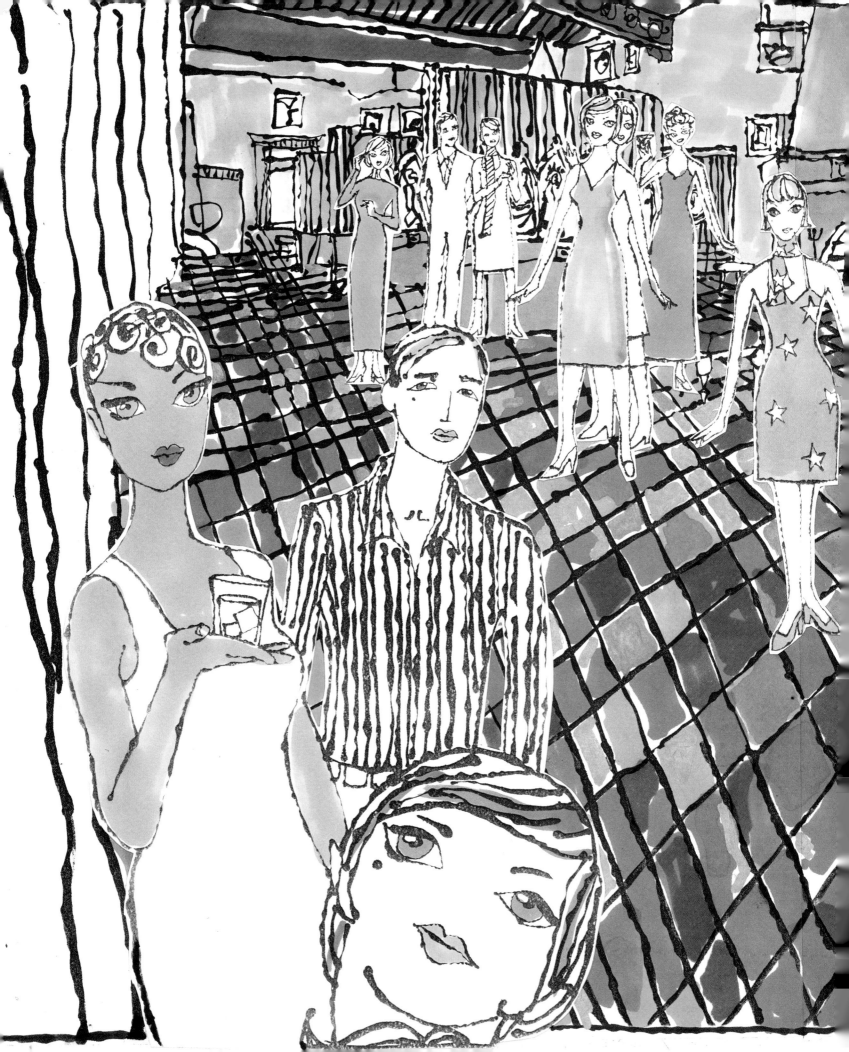

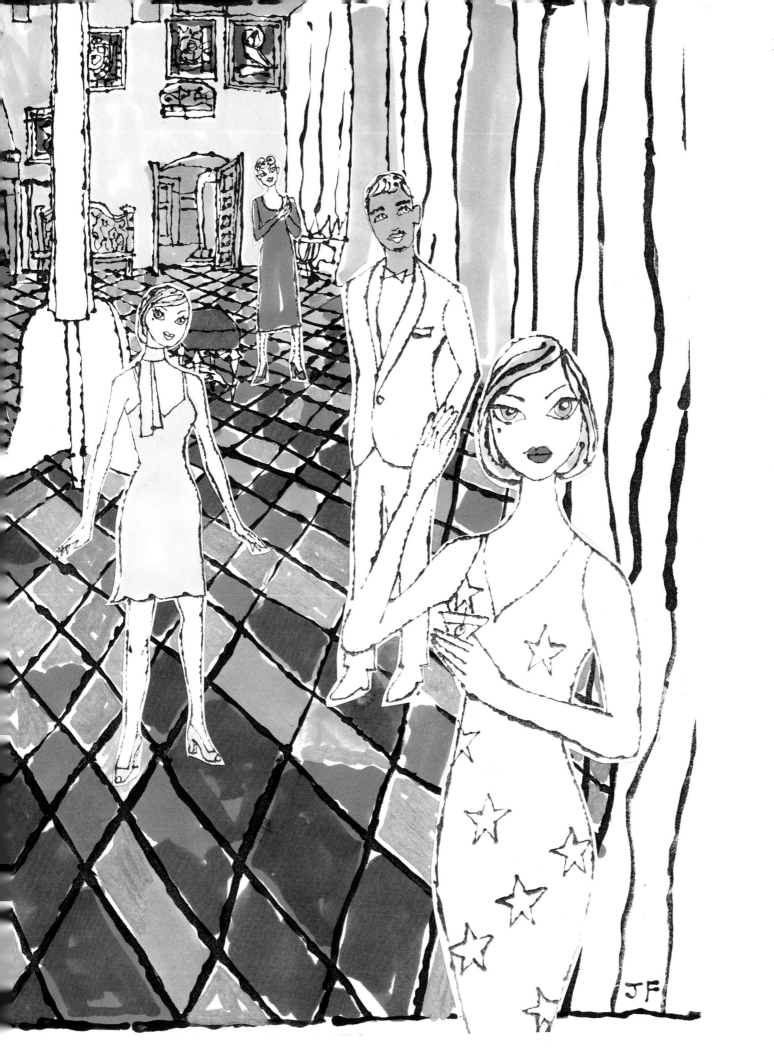

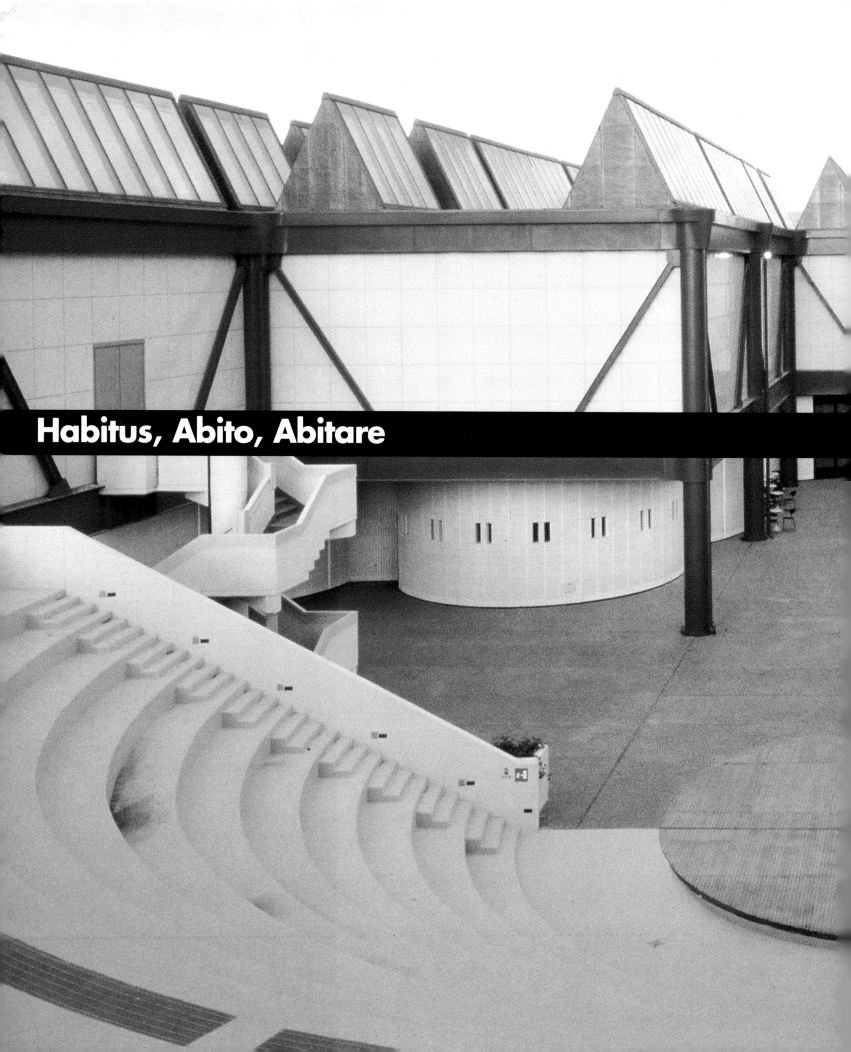

Habitus, Abito, Abitare

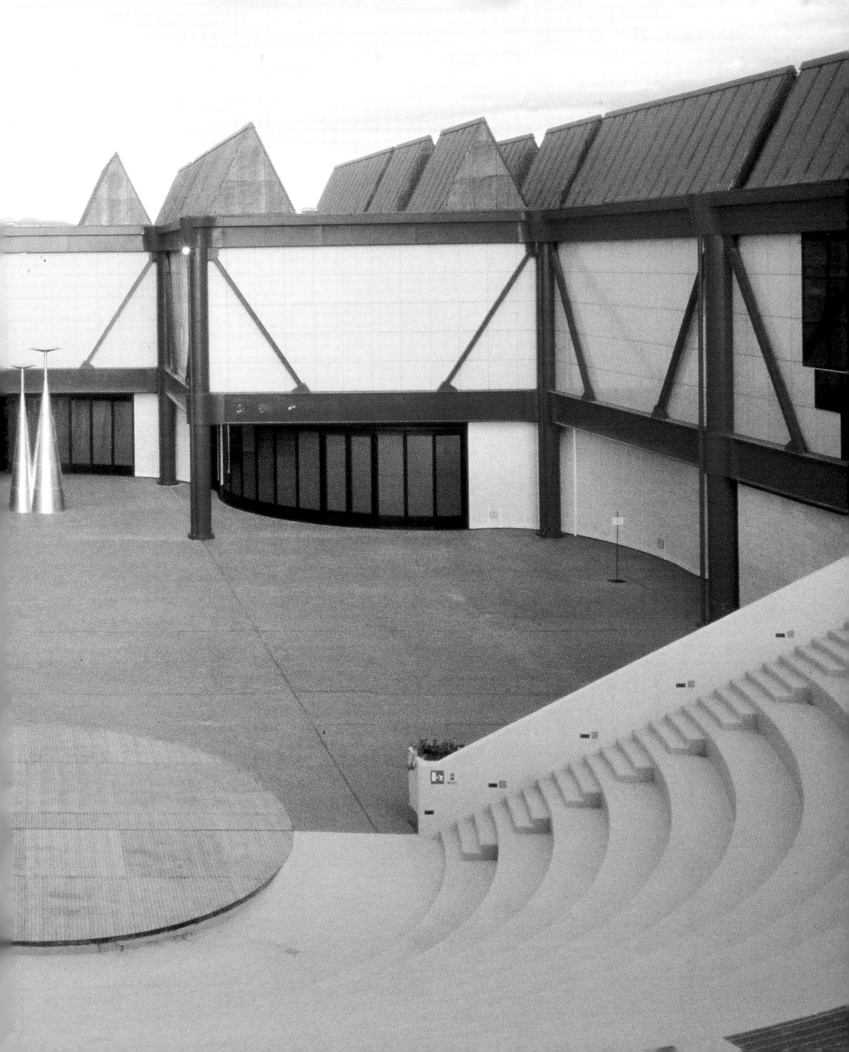

Prato
Centro per l'Arte Contemporanea
Luigi Pecci / Museo d'Arte
Contemporanea, Città di Prato

Habitus, Abito, Abitare
Progetto Arte
Curators
Bruno Corà
Michelangelo Pistoletto

Exhibition
Coordination
Stefano Pezzato
Maria Pioppi
with
Raffaele Di Vaia

Overall administration
Bruno Corà
Michelangelo Pistoletto

Secretariat
Daniela Agresti
with
Ilaaria Fornaciari
Silvia Oltremari
Donatella Sermattei

Administrative coordination
Beatrice Casaglieri
with
Elisabetta Dimundo

Press office
Ivan Aiazzi

Communications and Public relations
Guelfo Guelfi-Area Grande 90

Insurance
Nordstern-Colonia

Transportation
Gondrand-Torino

Installation
Design by
Bruno Corà
Michelangelo Pistoletto

Technical supervision and installations
Piero Cantini
with
Salvatore Archidiacono
Carlo Chessari
Roberto Fattori
Roberto Innocenti

Technical consultants
Barbara Conti
Riccardo Farinelli

Electrical technicians
Antonio Bindi
Marco Bini

Catalogue
Edited by
Bruno Corà
Michelangelo Pistoletto

Coordination of production
Maria Pioppi
Liana Mattacchini

Graphic design
Marcello Francone

Bruno Corà
Michelangelo Pistoletto

Habitus, Abito, Abitare – Progetto Arte
Conversation between Bruno Corà and Michelangelo Pistoletto

Bruno Corà In *Zarathustra*, Nietzsche, defining poets, says of himself: 'I am of today and of a time, he said later; but in me, there is something that is of tomorrow and of the day after tomorrow and of the future."[1] So in this way he announces a projection into the future of his identity as a poet, but announces above all a new configuration of the identity of the human being that recent aesthetics, after having suffered the weightiness of the term "superman," tends to translate as "ultra-man." So one can begin to maintain that the ultra-man Nietzsche spoke of was the human identity of the miseries that marked preceding eras right up to the present. It seems to me that *Progetto Arte*, and hence this new episode that we have denominated 'Habitus, Abito, Abitare*"* is taking into consideration a new hypothesis of conduct on the part of the artist, that suggests art as a catalyst for the creation of a new man.

Michelangelo Pistoletto It seems to me that the terms in which *Progetto Arte* has been presented, right from the first announcements, are explicit in this sense. I think there are also very precise references in what I was looking for in past works. Here I would like to pinpoint the salient aspects, those that refer to the relationship between the individual artist and the world; the world understood as a structure that is spiritual, economic, political and so on. Think, for example, of works like the *Giudizio Universale a dimensione reale* of the seventies, which contain parts such as "the hour of judgment," which in turn contain the affirmations expressed in *L'arte assume la religione*. All these parts are connected with the spiritual foundations of the past, with one, just one vision, one projection both of art and of humanity towards the movement that is to come. So it is a life-sized universal judgment:

[1] F.W. Nietzsche, *Così parlò Zarathustra*, Newton Compton editori, Roma 1980, p. 102.

506

since I had reached, with the reflecting pictures, the life-sized dimension, both of human presences, in the pictorial icon, and of all the spaces and all the times that were directly reflected, I found myself having to think, for example, of the theme of the Universal Judgment and make of it a fresco of our times. And this fresco could only have the true dimensions and proportions of the subjects. I realised that to render a contemporary image of those antique forecasts, I had to think of the real time of the Universal Judgment, reaching its one to one scale. Today we are at the level of absolutely direct confrontation, between the real and the virtual, where one directly influences the other. So this artistic condition opened up for me a vision of the situation that was both, let's say, illusory and physical; and if I look at the physical situation of our times, it is a very complex response between a huge negative and a possible positive and, in some cases, a positive that produces a big negative, a huge negative situation. In this sense, beyond that ancient judgment, we have to assume our responsibilities, as producers of images, for conceiving a new humanity.

B.C. In that passage from *Zarathustra*, Nietzsche also speaks of the fact that the poets have lied. What does this mean, what does it signify? I think that our epoch requires a humanity that is capable of tackling a new complexity. So many ways of looking at life, reality and relationships between people and with objects are going to have to be reformulated. From this point of view, sure the poet is going to have to recreate a language suitable for communicating. As a result, this episode that we are about to tackle with our creative and artistic work seems to me to be both very important and exciting; above all the concept of *habitus*, which each one of us has inside, and simultaneously this is also *abito*, that is our external physiognomy, our actions, our behaviour and the world we inhabit.

M.P. Or at least we, speaking of *abiti* [clothes], wish to touch and to impinge on this artistic phenomenon.

B.C. You felt the need to propose to everyone to formulate their own sign, their own art-sign, and that seemed something one could agree on as a possible relationship within individual diversity. Indeed, the dimension of individuality is very important in this exhibition. Having made this observation, we must also face up to the other contradiction, that stems from the relationship between being creative people, being artists and society, which tends to categorise and pigeon-hole people for economic, religious, hygienic and disciplinary reasons. While individuality is also an affirmation of freedom and thus very often the art-society relationship has been difficult, has foundered. This contradiction between art and society, which is also the opposition, let's say, between what has always been held to be esoteric, and so the privilege of the few, known to the few, hidden, a hidden tradition, and the exoteric, that is explicit activity, explicit formulation; this contradiction must be brought back into discussion today,

starting from the fact that currently social structures are breaking up in the face of religious, ethnic and economic problems and in many other ways. And we are witnessing the enormous needs that humanity is expressing: the great conflict, for example, between humanism and technology. Faced with technological development, much of humanity has remained behind and there is an enormous gulf.

M.P. Big human communities no longer have the means of survival that once worked, and they don't even have a new method; they are scattered, mentally and physically, and they no longer have a terrain on which to work, this is the point.

B.C. And since they don't have cultural means, means of acquiring self-knowledge, they no longer even have resources, so they tend to move, to satisfy their needs, to those countries where there seems to be everything.

The dressing of the walls
Forty-one of the city's textile companies were invited to take part in the dressing of the ancient walls of the city of Prato, and sent multicoloured fabrics together with numerous individual art signs of the industrialists. These signs were traced in very large dimensions on the fabric fixed to the city walls. The segments of wall dressed by the fabrics covered the entire perimeter of the city.

The companies taking part
Appel Spa, Artelana srl, Bellucci Spa, Binicocchi spa, Bisentino spa, Cangioli sas, Caverni & Gramigni spa, Cecchi Lido spa, Ciatti & Baroncelli, Coiano spa, Compagnia Tessile spa, Emmetex spa, FA.I.SA srl, Fortex spa, Franceschini spa, Imta Desii Mode spa, Industria Tessile Sanesi spa, Marino Olmi spa, L.D.S. spa, Lanificio Bechi spa, Lanisa spa, Linea Tessile Italiana spa, Manifattura tessile Il Giglio, Manifattura tessile pratese spa, Manteco spa, Marcolana srl, Masterloom spa, Milior spa, Modatesse spa, M.T.S. spa, Natural Cloth srl, Nello Gori spa, Nova Fides spa, Novitas snc, Pegaso spa, Profilo spa, R. Allegri & F.lli, Rexlane spa, Sarti Faliero & Figli spa, Tessiltoschi spa, Texmoda srl

M.P. One of the important operations to carry out, is to give a new stimulus to the kinds of production and sustenance that in certain parts of the world have kept people alive and also to the ways of thinking that we need to reintroduce today: and hence to recreate ancient production methods alongside new ones. But this calls into play the economic phenomenon, especially financial and power speculation by certain regions of the earth. And this is certainly moving towards that propensity for telling lies when it maintains that there is only one direction in the progress of humanity. And at that point the poet who supports this kind of mechanism is lying.

B.C. Sure. This kind of lie has got to the point of threatening the basis of civilisation and Western culture. That's why *Progetto Arte* becomes central: either we introduce the principles of art to reformulate and redesign the whole of existence into the global reflection, or we ll

remain the victims of those systems that, in their use of resources, are leading to the total contamination of the habitat. We have to do something about all this.

M.P. So the *habitus* inside our heads links up again with the *habitat* that is abitare.

B.C. I'm convinced of it! We have to bring the art-society contradiction back into a central position, and I think the time is ripe to do this. At the same time we have to avoid the errors of the past in this relationship, in this attempt to solve things. We have to go further ahead, we have also to find the ways of resolving the contradiction between the esoteric and the exoteric. Nobody says that art has to abandon the terrain of the esoteric, of profound speculation, of signs, the pathway of signs, of meditation, of introspection, but nobody is saying that it mustn't go down into its opposite, that is into the exoteric, and find ways to relate to ordinary life.

509

M.P. I, for example, see a gulf between art, which is what you define as esoteric, and the world of mass information and images, the world of production and economic, religious and productive speculation, which you define as exoteric. It is hard to speak of identity between creative forms that lie beyond this gulf and forms that seem creative if you are beyond it (but they are creative only in the sense of technological and financial speculation). That's right, we have to create bridges between these two banks, there's a need for signals of wanting reaching out to the other side to come from both. Then there could come into being a civilisation as beautiful as the image of Venice, where there are many canals but also a large number of bridges that form a network of interruptions and communication. I think it is very important to take into consideration the differences, rather than the equivalences; to make the differences come out, as you were saying earlier, so that the individual can become

Several moments in the seminar held by Gianni Pettena and Michelangelo Pistoletto at the Centro per l'Arte Contemporanea Luigi Pecci, in the period January-June 1996

Antonella Sgobba, *Membrana*, 1996

Car park project
Centro Luigi Pecci per l'arte contemporanea, Prato
Architecture-sculpture seminar in collaboration with the Faculty of Architecture of the Università degli studi, Florence and the Accademia di belle arti, Florence, organised by Gianni Pettena and Michelangelo Pistoletto. Museo Pecci, Prato, 1996. The experience had been analogously carried out by Michelangelo Pistoletto in August-September 1995: on being invited by the Architektur Zentrum of Vienna to hold a course at the 6th Seminar of Architecture, he decided to participate with *Progetto Arte*, inviting the architect Christos Papulias to collaborate with him. On this occasion—and for the first time— the Art Sign became the research work for an individual sign on the part of each of the seminar's participants: by way of the

interpenetrations on their Art Signs the young architects arrived at the planning of sculpture-architectures to be placed in the motor car parking area in front of General Motors in Vienna, a site considered among the most practicable spaces available to the Seminar. "Working to demolish processes, grills as iron bars, finding possible freedoms, coordinating with one's own biology. Reconnecting impossible sequences, fragments of the design of one's own living, painting oneself with a decoration, a diagram of one's project and extending it to something other than ourselves. There, living has a meaning when one lives, but recounts, is able to recount the manner of living, memorise the environment, the landscape of man, and is willing to tell one's own story and let oneself be reused recounting the stories of those who have passed by earlier, of those who

have given it physical shape or interpreted it as an extension of themselves." Gianni Pettena, 1996.

Projects carried out:
Luca Anastasia, Stefano Braccelli, Chiara Capaccioli, Silvia Caringi, Nicola Caroppo, Michael Dejori, Silvia Falugiani, Paolo Fiori, Mirko Giorgetti, Guido Gori, Rebecca Hayward, Emanuele Milanini, Giuliano Nannipieri, Francesco Paoletti, Pietro Romano, Lucia Tiralongo, Antonella Sgobba, Omar Toni. Others taking part in the seminar: Corrado Baglieri, Tommaso Barni, Maria Barone, Francesco Buzzacchelli, Valentina Ciolini, Cosimo D'Aprile, Marco Giambi, Giacomo Gori, Benedetto La Fata, Elsa Mersi, Giulia Nassi, Assunta Preziosi, Lapo Ruffi, Gerardo Sannella, Paola Vezzulli, Pareskeva Yannakis.

as autonomous as possible. This is the point: the differences as the basis. It's fine to be on this side or the other of a canal, but we need to be able to cross from one side to the other.

B.C. What on the one hand has made society ready to accept the artist and on the other extremely diffident towards him has been the fact that the artist has delivered his testimony, through his actions, his way of living, behaving and acting, in a state of freedom. Freedom of thought, of relationships between oneself and the world, between oneself, reality and the world. The job of art is the quintessence of this existential feeling. Inventions and works came into being. Sometimes, in the past, they were works that illustrated a history, a genesis, a trace, a pathway; in this century, on the other hand, it has been precisely this liberation from all the recounting that has permitted an individual experience, between that which is visible and that which is not. Society has defended itself against this subject in a very simple

way: it has ostracised it, it has maintained that it was not useful. So the artist has been identified as a subject who is not useful to society. Or society has considered him as a jester. Choose which you like of the two options, but basically these were the two physiognomies: the artist as decorator or the artist as madman.

M.P. There is a third dimension: that which has made it possible to hold modern art in great esteem, sometimes attributing to it great economic value and offering it a lot of space in which to exhibit; since, in spite of everything, in this century we have seen a reappropriation of art on the part of the economy. You have to take into consideration the fact that modern art has a significant role in the world of today, but you must also consider the fact that the epilogue of a part of its history has taken contemporary art to the prologue of a new part of its history.

B.C. If I went to extremes it was because still today I can see that the space devoted to art in people's lives is very small. Not just the space, but also the extraordinary possibilities it has to transform society. In fact there exist manuals on the history, the criticism and the sociology of art that say that art is superstructural and that it does not have an effect on reality; while certain philosophers in their time have affirmed that art, since it occupies itself with beauty, could have transformed vital conscience and relationships. And this is exactly where the problem could come in with *Progetto Arte* and this *"Habitus, Abito, Abitare"* episode. If the weight that art has in everyday life is still tiny, it is because the social, economic and political orders have held (and hold) that this activity is not functional, is not productive, is not equivalent to a value. They underestimate this activity and maintain that only the production of goods, of goods to exchange can have a value in terms of social transformation.

M.P. So why do they put a price on art?

B.C. The price they put on art is the fetishistic value of rare goods, signed goods.

M.P. Art in our century has found a condition of autonomy, in parallel with an industrial era in which the entrepreneur professed an individuality inherited from the illuministic

512

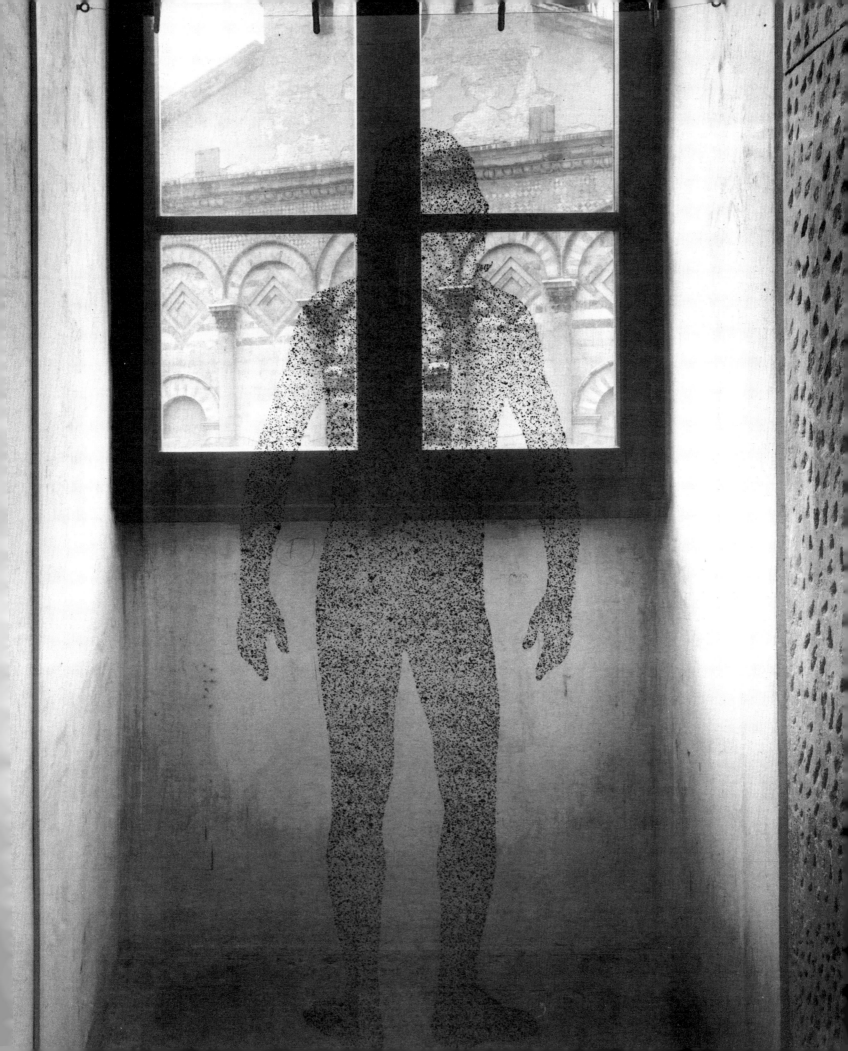

passage of history. The museums of this century were created by the drive of great entrepreneurial characters, and authoritatively determined collectors. Industry has also given us the illusion that progress was an absolute guarantee with respect to any other form which was not held to be sufficiently civilised, advanced and worthy. Currently the entrepreneurial sphere is run by groups of people, and the globalisation and depersonalisation of power has transcended that sense of guarantee. So beyond all these many illusions, we find ourselves facing a new reality in which we can perceive a general decadence of civilisation.

B.C. The world economic and political orders, that act precisely on the principle of massification of the greater part of humanity, are absolutely reticent before the message that arantee that was absolute with respect to any other form that was not held to be sufficiently

Michelangelo Pistoletto, *Rotazione dei corpi*, 1973-1979. Galleria G. Persano, Milan

Segni Arte (literally, art marks), customized, for the participants in the seminar, *Art Project*, Architektur Zentrum, Vienna, August-September 1995

civilised, advanced or worthy. Today, globalisation and depersonalisation have abolished all sense of illusion in the possibility of progress, so we find ourselves confronted by a reality in which we perceive a decline of civilisation.

B.C. The world economic and political orders, that act precisely on the principle of massification of the greater part of humanity, are absolutely reticent before the message that art brings...

M.P. Precisely...

B.C. They are reticent because art communicates that all subjects are potentially free, thinking, creative and capable of expressing an identity; art makes individuals authoritative and from this point of view there is the clash between massification and the freedom that art proposes. It is in this sense that I was saying that the space given to art in everyday life

is still very tiny, because they are afraid... the political and economic orders still in some way fear this radicalisation of the individual identity.

M.P. Let's hope that, like the atomic bomb, it's reached a point of terror... the image of the atomic bomb has created such fear that it consumes in itself the possibility of going to war, for a certain period of time, just as Russian communism became so swollen up inside itself that it consumed itself. I hope that this total blindness that relates to the abstract mechanism of modern finance gets to the point of consuming itself, and thus of rendering another situation evident. But art must in any case be the proposer of this other situation.

B.C. The energy that transforms society in the future can only be this one, because all the others have already been used. The only energy that we haven't had recourse to—though you can't make use of it solely in an artistic sense—is that of art that could give a horizon

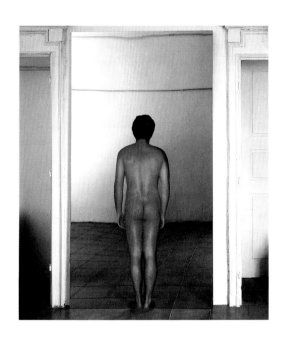

to the ultra-man...

M.P. And there you have the project workshops...

B.C. One of the problems we have to face now is this: over time, there has already existed a relationship between art and all the activities of human culture, economics, politics, religion and so on. How can we today reconfigure this relationship and make it possible again? Where should we start again from, what can we do to allow art to establish a newly authentic relationship with these activities?

M.P. I don't know whether art should, as some people hope, be prepared to become figurative again in the sense of proposing images, using for example the mass media as in other times religious frescoes were used. I'm referring to our Western civilisation, of course, which is catholic christian in its origins...

Chris Sacker,
The River, 1995.
Etched into the skin
of the artist. Tatoo
artist: Robert Hoyle

Chris Sacker,
Skin of the Soul I,
1994. Etched into
the skin of the artist.
Tatoo artist: Robert
Hoyle

Chris Sacker,
The Way, 1996.
"Teatro Anatomico,
Canto III, Rerum
Natura"

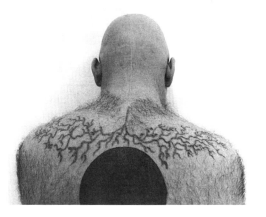

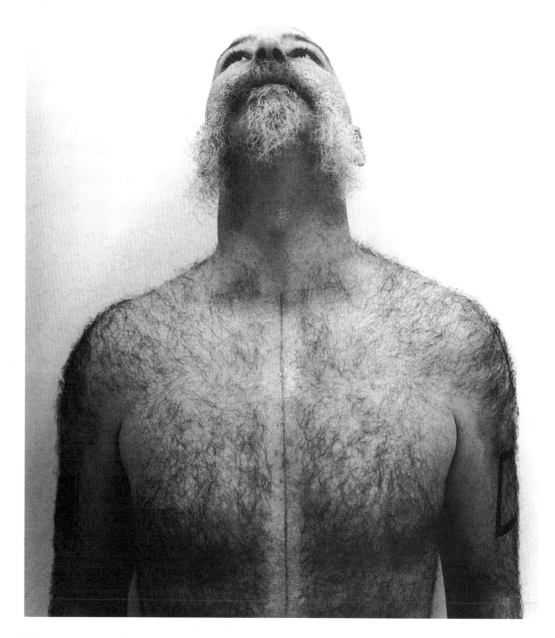

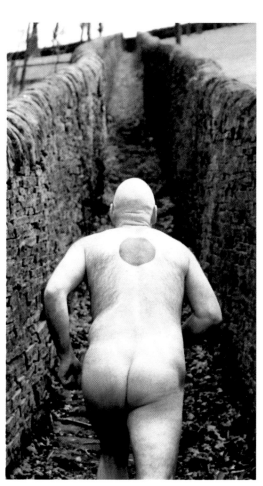

Chris Sacker,
Skin of the Soul II,
1995. Etched into
the skin of the artist.
Tatoo artist: Robert
Hoyle

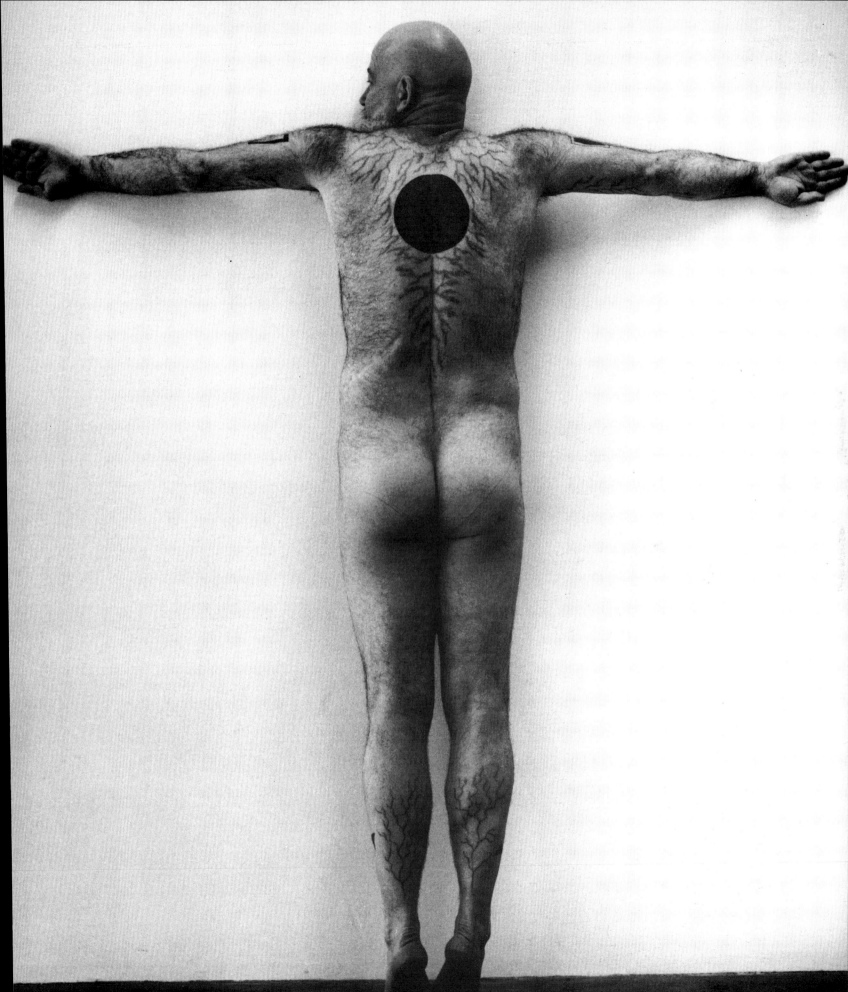

B.C. The media are by definition the instruments that put you into communication with the masses. So here the problem of the importance or of the individual identity wouldn't work... It's no accident that many artists are suspicious of using the media...

M.P. And yet art has never got to be so free and autonomous as it has in our century, thanks precisely to the assumption that the media have made of the image. The conquests that art had made in this century have never happened before; technology has freed it from the utilitarianism of representation, but it's also excluded it from the broad circuit of communication. So this art today takes on itself a central position even if it is not completely addressed to the single individual, today the artist, after the sixties, also includes a certain objectivity in his work... However, in our century, art has reached an essence. Of the same value found in ancient times when creativity and spirituality coincided. The Prophet was

also an artist and the artist was also the Prophet. When they put the memorial stones in the middle of the spaces where the people gathered, that was where the marvel happened. It was the happening around the sculpture that was at the same time the altar, it was the society's place for communicating... There dance, song, at contemporaneously the social structure were born. Art today has rediscovered that original monument, that fundamental point in which the artist is a prophet... I can't today make this fact emblematic; today I make my thoughts and my deeds active.

B.C. Yes, but this assumption of activity as a vehicle of communication, in some ways could evoke the tendency to preach, to proselytise, like for example Beuys. What would be the significance, according to you, of abandoning the work as a communicating entity, in favour of carrying out this activity of yours in a context where the work is no longer sufficient, but

wouldn't there need to be a discussion, a debate, a reflection, an involvement?

M.P. I was saying before: the work as a product has been accepted by modern society in relation to a modern economy. It still belongs to a futurist idea, in which the artist thought that progress was all that was needed to guarantee any kind of intellectual and practical relationship with society, and the politician and the industrialist who manufactured the cannons, the aeroplanes, the cars and the typewriters thought the same way too. Today we've reached the physical saturation point with cars and with products that didn't exist before industry; in the same way, for me the idea of art as a product is at saturation point too. At this point I'm not thinking so much of the disappearance of the product, but of a different necessity that we have to activate with new drives. You mentioned Beuys, and somebody said that Beuys and I, after Duchamp had broken the spell of the product, were the ones

who carried forward both individual work and an operation of activity in relationship with society. I started this in the sixties, without ever stopping creating works... For example, out of "oggetti in meno" was born the work I did in the street, and my studio was opened to the participation of others, encounters happened, above all the Zoo was created, "the ones on the other side of the bars," in which personalities from the world of music, of the theatre and several young people converged. And this happened not just in the spaces designated for art or theatre, but in the street and in other places.

B.C. But at this point?

M.P. At this point an activity is born. You spoke of an emblem, my emblem is the mirror. It opens up to the total fluidity of events, an emblem that becomes a place of continuous transition between opposites; it is the place of communication and encounter, it's not a

fixed declaration as a sermon could be.

B.C. The reflection gets to be very interesting here: this point of contact that could exist between art and society; from what you are telling me it becomes clear that everything always happens in the light of a linguistic invention, which makes use of a material and of a transformation of the ways of elaborating it. In your case the "mirror pictures," and then the things that derived from those... The mirror reflects and reveals all the dynamics of the society that stands before it. I wanted to ask you something: how can one, despite going in this direction that led you to *Progetto Arte*, distinguish that which is artistic action, which involves a certain responsibility in the formulation of the messages, from a different activity like for example the production of electrical goods, of fabric or of the many other goods that belong to our lives, but that I cannot see as being considered analogous to a work of art?

On this and on the following page: Henrik Kreutz, *Notes*, 1996

M.P. I always come back to the principle of a monument, to the principle of graffiti in the cave... In the graffiti in the cave there was everything, in the monument there was everything and I can say that in the mirror there is everything. If the monument opened up a parabola, the mirror closes it and opens another one. The impact of the mirror produces another mentality which contemplates the maximum dynamism.

B.C. I understand, but my question was a different one.

M.P. Yes, but I don't want to go as far as to speak of the object, of the product and so on: I am speaking of a dynamic principle in which everything can be present, everything can happen, a dynamic principle that is the principle of the mirror, from which I enter or exit and it's there that the encounter with others begins.

B.C. But you must take into consideration that this work of ours envisages other ways of being and intervening on the part of other artists and other thinkers. For you the mirror has provided the key for a relationship with reality, but others have found it in their own ways. And besides, I always feel that the operation of linguistic formulation that the artist carries out is very distinct from the transformation of material in industrial production.

M.P. I understand perfectly, industrial production exists and it is also thanks to it that I arrived at the mirror. You can't split the things up...

B.C. Okay, but the mirror becomes a meaningful object thanks to you, any old mirror you buy from the glass merchant is not art...

M.P. It's not art... but we always come back to the same point, which is this: water is not religion, but baptism is. So what counts is the intention with which you use objects. In

certain literary and philosophical logical systems, they say that the word creates, physically. They say that the Madonna gave birth a virgin because the angel spoke certain words to her and so fertilised her with them, and this is something that makes me think that at the basis of religion there is the "concept," which is considered just as productive as material... a generator. This is an artistic fact, so we have to start again from the point in which I way that "art assumes religion."

B.C. But for you is the work of an artist equivalent to the industrial product?

M.P. It depends, if I certify the industrial product I give it an artistic and cultural motivation and it can become sacred.

B.C. This is Duchamp...

Pietra,
Abito mezza-luna, 1996

Pietra, *Maglia calze*, 1996

Pietra, *Sposa*, 1996

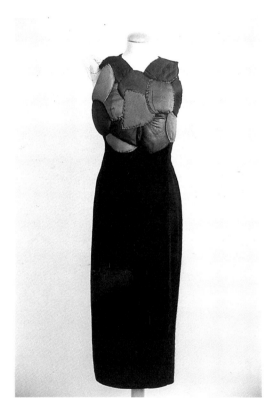

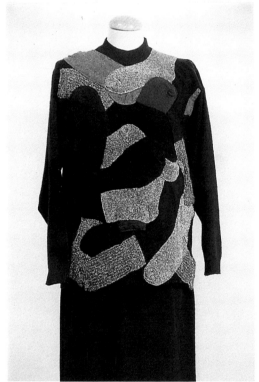

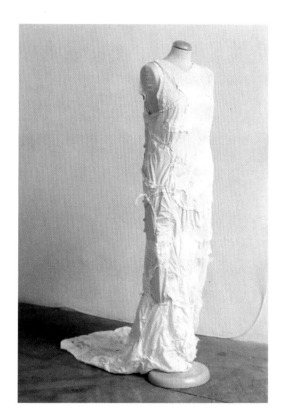

Pietra, *Mezzegiacche,*
(front and back), 1995

Fabio Sorano, *Sedia
appendi abiti,* 1996

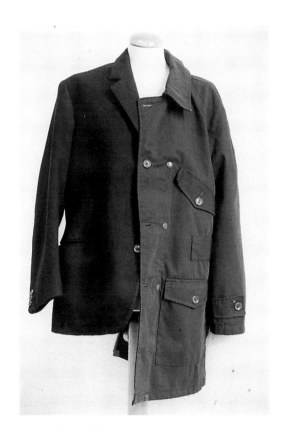

M.P. It can become sacred because I am the one to certify it, but since today this certification isn't given by the artist but is given by the industrialist... but he doesn't have the authority to certify the artistic nature of his product if he doesn't call in an artist. So the artist is the Prophet, we need to be clear about this...

B.C. That's what I wanted to hear...

M.P. The artist is the concept, the artist is the one who produces...

B.C. What is it that makes him this, the fact of managing the concept? The managing of a memory? It's important to establish where this figure comes from...

M.P. It comes from the fundamental creative capacity of man, who as he gradually becomes human becomes conceptual.

B.C. And the more conceptual he is the more ultra-man he is...

 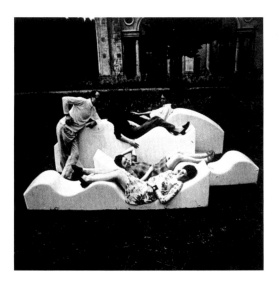

M.P. In society, there's a false and contradictory idea of what is human. Instincts are positive and negative energies which man has to understand how to put together, like the reality in front of the mirror, and make them the energy of civilisation. They say that art is dead, while for me art starts living from the time when a certain type of art dies. There has never been Art so real as in our century. Now we have to go ahead with this Art.

B.C. In the conception of *Progetto Arte*, I feel an ancient need of an illuministic kind; I feel, that is, that reason, that thought must stitch back together a whole series of aspects that relate to the complexity of life and knowledge in the broad sense, and so these aspects have to get back to communicating with each other through a common denominator that regulates them and harmonises them, and this common denominator is Art. In the twentieth century itself, through some traumatic events, the breaking out of the first and second world

Andrea Branzi,
easy chair and sofa
from the collection
Animali Domestici,
1985. Production Zabro

wars, reason entered into a crisis of unprecedented dimensions. The crisis continues to be grave and profound when, as has happened and as continues to happen in the wars of recent years that have a nationalistic, ethnic and religious matrix, the aim is the physical annihilation of the adversary because he thinks and acts in a different way. So there is a crisis of tolerance, of differences, and so on, while on the other hand *Progetto Arte* is reestablishing this need to consider all the differences and the environments in which they operate and to cross each one of these by means of this vehicle that regulates, fertilises and expands experience, i.e. Art. And so, as we have already spoken of ultra-humanity, of ultra-man, we need to talk about this new escalation of thought towards an essence in the opening. From this point of view, it's very important to introduce our debate in Turin on "concept and spirit" into "Habitus, Abito, Abitare"; at this point I set myself this problem: how can we

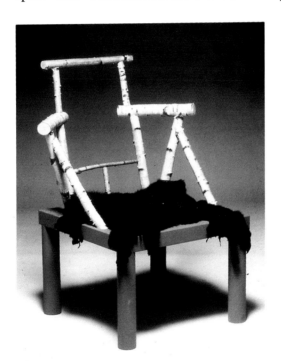 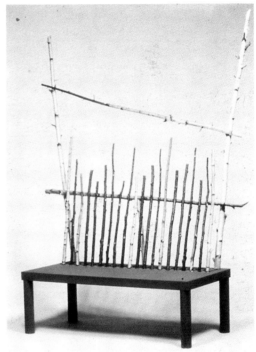

communicate to the others taking part in "Habitus, Abito, Abitare," the neo-illuminist need that inspires our actions? I'm talking about that quality that could become a kind of DNA in our behaviour? How can we communicate this need to the others as well? Basically, all of the participants come to take part in this initiative with their own points of view. You remember the discussion with Oliviero Toscani, who invited us to consider his objections to the mass media system, to television? His criticism of the use of artistic ideas relegated to museums compared with the more external action that he creates through the photographic advertising message? From this point of view a lot of differences still remain, for example a consideration between a certain kind of action that formalises the visual message on the street and other operations which, as you put it, happen the other side of

Claudia Weinhappl,
*Composition for Four
Instruments*, 1996.
Akademie der
Bildenden Künste,
Vienna

Claudia Weinhappl,
*Composition for Four
Instruments*, (detail)

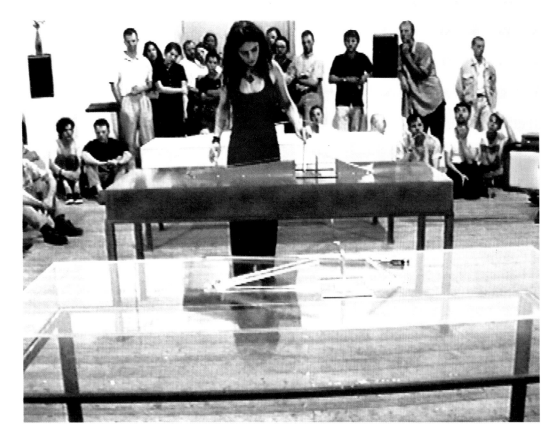

Claudia Weinhappl,
*Composition for Four
Instruments*

On 2 December 1995, in the context of the *Art Project*, at the Marstall in Munich, T. Bepperling, W. Gasser, H. Holzfeind, R. Kaaserer, P. Murer

Claudia Weinhappl presented together for the first time, under this name, their video projects, done separately

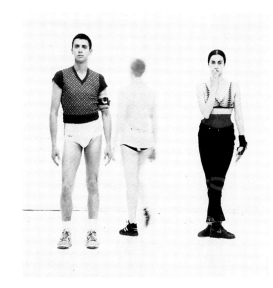

Kinkaleri, *Doom*, 1996; in the photograph, Marco Mazzoni, Gina Monaco, and Cristina Rizzo, Stazione Leopolda, Florence

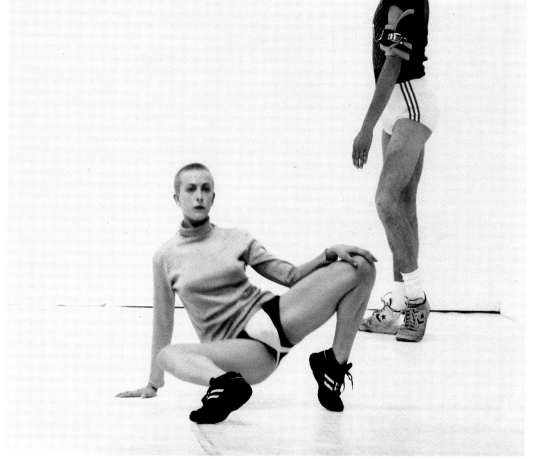

the ditch, that is within the already laid out space of art? What bridge can we use to reach this relationship of communication? How do you find these bridges?

M.P. I think that it is important to have material that lies in between these various positions and the material is raw, it is not yet formed; young people must shape their future, they have an enormous need to find fundamental reasons, and also superficial ones, for living. And that is what *Progetto Arte* is doing. As we were saying with Toscani, *Progetto Arte*—with the students of the university faculties and the *accademie*—and Fabrica perhaps start out from different points of view, but they end up by signalling necessities that are very close to each other and common. And it is in the environment of the workshop that things can order themselves on the road towards discoveries. So I believe that the bridge is made of human material. It is to be found in the areas where individual commitment has not yet

Franz West, *Untitled*, 1990, Spoleto, 1996

arrived or is no longer inexorably subjected to the rules of productivity. So there are two ages that are important in this sense: one is the age of youthful formation, and the other is the age of after being pensioned off, that is, old age. In the young and in the old there is a position very similar to that of the artist, because he, although he is a part of society, does not have to answer directly to someone who is above or below him, so he has this freedom. So there is a chance for the old to redeem themselves; even those who have got into trouble, have created problems and have lied to themselves all their lives can reach an area of freedom in which they can find new interests to transmit to the young. Pensioners, those who have finished working interrupt the hierarchy and become free, like the contemporary artist. Old people, from the same position as the artists, can today start to demonstrate a real necessity of the human being precisely by living in that area that is considered useless to society, as

the artist's area is generally reckoned to be. Old people, who today reach an age that would have been unthinkable in ancient times, make it clear that that span of time that was considered useless can be extremely effective—like art—in creating a new condition of life. What used to be considered useless becomes useful, because it sets out an unprecedented basis of thought that is indispensable for existence.

B.C. There's a very interesting term in the German language that we could combine with *übermensch*, of which we were speaking, and it is the term *Aushebung*, which means the passage from something that must be conserved and something that must be taken away; I believe that we are in this phase: something needs to be conserved, that is an ancient concept of the relationship with rules, and something that needs to be taken away, in the sense that it has to disappear so the new can attain conscience and perspective.

M.P. Basically, if we look at the ancient temples, we realise that something has been conserved and something has gone, for example the daily hassles, the negative tension of speculation. The temple itself remains a work of art, decanted by all that has happened to it. It transmits to us the DNA of history purified of all the illnesses; it is on this foundation that we can still count, thanks to the ability of art to create the temple. First I was at the level of monuments, now I am at the temple... Today's temple is perhaps the ironworking monument, the monument of the factory or the company, what are the monuments? Are the rocket or the sight of space through satellites and information the monuments of today? In the time of Buonarroti the dome of San Pietro was the highest attainment of technology. The exploration of interplanetary and cosmic space and the mass of satellites orbiting round it are the dome of today. Technology is not something to make a monster of, but we shouldn't

Adam Broomberg,
Fabrizio Andreella,
Aurora Fonda, Carlo
Spoldi, Alfredo
Albertone, *Fear*, 1996

Antonio Fernandez
Ros, Adam Blooberg,
Fabrizio Andreella,
Francis Kuipers,
Giorgio Collodet,
Alessandro Favaron,
The Shower, 1996

place too much value on it either; it is the condition of maximum tension of our times, the measure of what is happening today under this dome. We live on the earth in a cosmic dimension, and it is for this reason that I say that we have, in the universe, a responsibility equal to a one to one scale. We have to lose those things from the past that kept us squashed into a mentality whose outlet was the continiritual structure that has been constructed. The various aspects of spirituality in the world represent an enormous richness: Buddhism, Confucianism, Hebraism, Christianity, Islam and so on. But they are also charged with tremendous responsibilities. From the point of view of their presence over the centuries, we now have to relate to it as to a mythology. Every religion should represent a marvel for each and every one of us, one that allows us to visit our past on a higher level, and learn to eliminate theiritual structure that has been constructed. The various aspects of spirituality

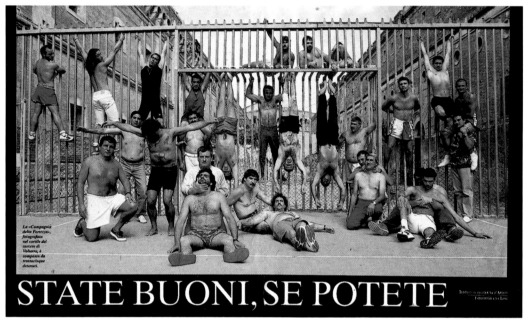

in the world represent an enormous richness: Buddhism, Confucianism, Hebraism, Christianity, Islam and so on. But they are also charged with tremendous responsibilities. From the point of view of their presence over the centuries, we now have to relate to it as to a mythology. Every religion should represent a marvel for each and every one of us, one that allows us to visit our past on a higher level, and learn to eliminate the grosser defects.

B.C. We have evoked Nietzsche's ultra-man, but it wouldn't be a bad thing to get back to the basic conception of the human being. The concept of man is connected to the ability to project oneself. The self projection of man is the ability to have a perception between himself and the moon; to decide to go there and to find all the means for getting there. *Progetto Arte* shows us that we need to project ourselves in the light of art...

M.P. It seems to me that in art there is the force that crosses everything.

B.C. Projecting in the light of art or through art brings up the problem of ethics, in so far as it is a reflection on man, on the criteria of his behaviour and his customs. Today's ethics ask a question in a crucial way: advanced technology almost as an end in itself, driven towards a fatalism that aims to build the man-machine, or safeguarding of certain fundamentals that, although they embrace the novelties bound up in technology, seek out the pathways of complex equilibriums. There is a lot of talk about the transformation of the body, of the human person, through bio-engineering; even a certain kind of art, the so-called post-human art, concentrates on this aspect, but it's not the conception of the ultra-man, but rather the possibility of substituting human organs by emphasising artificial prostheses and calling into question some of the fundamental elements of the notion of "Nature."

M.P. The prosthesis is important if you see it in a different light; I, for example, think that

it is precisely through prostheses that we can reach an understanding of what the Ego is. If, when you change your liver, your eyes, your heart, your tongue, you remain yourself, it's still you, it means that there is an absolute foundation of the Ego that remains in the memory of itself. We start perceiving ourselves from when we are born, and having an awareness of our Ego. It is indispensable to have this individual entity, above and beyond all the corporeal prostheses, and is for this reason that, faced with the conception of the post-human, I advance the proposition of the individual Art Sign, which each person can decide to place above the social prostheses, the signs of religion, of political parties and companies. A tiny individual sign in a society that is made up above all of individual signs. This awareness does not subsequently exclude the possibility of belonging to those social groupings.

B.C. One definition of the term language reads: "In general, language is the set of signs

that permit communication among subjects; from the philosophical point of view questions have been asked about the foundation of this hypersubjectivity and the following responses were given: 1. language as nature, choice or chance; 2. language as communication.

In the first hypothesis it is maintained that there is a direct, objective relationship between the object and the linguistic sign. In the second that that relationship is the product of contact for men. "That's very significant, when you are talking about the production of signs.

M.P. If it is a representational sign, that is a sign that means the object, in the case of the Art Sign it means two things: 1. art; 2. person. Indeed, it is called that because it is from the sign that the art is created, and the personal sign is Art plus Ego. And the Ego is always different in relation to the mnemonic and perceptual condition that shapes it.

B.C. The business of all these individual logos also raises a question of etymology: after the evocation of language, logos, from legein, means to put together, to gather and to enumerate. Enumerating also means expressing thoughts and meanings: it is thus the Art Signs that, "put together," can express the new thinking and the new project of civilisation. Then you have to consider the magnetic element of communication. Art also expresses a magnetic phenomenon of attractive communication. You yourself said that in the centre of this community enclosure the artist once erected monuments. But didn't this gesture also qualify him as a witch doctor? Magic is linked to the ability to produce phenomena, to make things appear and show what is not evident. Shall we tackle this aspect, which at one point we started talking about?

M.P. Unfortunately a very crude use has been made of magic. In spite of this, the term

Monika Wührer with
actors and participants
in the event, *Clothing,
Kitchen.
Object - Art Project*,
at the Akademie
der Bildenden Künste,
Vienna, May 1995

magic shows that the concept of faith is not sufficient for tackling the dimension of the unknown. Art, like science, tackles the problem of the unknown simply in so far as it is not known. But when an element appears and defines itself in some way, it becomes known and pushes the phenomenon of the unknown elsewhere or on to a different front. So a movement is generated, a dynamic line that answers the deeply felt need of human beings to project themselves. The need to discover is fundamental. Science has gone as far as studying the memory of natural elements, DNA, the biological memory that makes up our selves and makes us realise that there exists a memory in nature that is so rich that it can contain within itself all the moments of the beginnings of the universe. The desire to know the beginnings of the history of the Universe is one of the highest ambitions of man, who has always aspired to be something different from a rock, a vegetable, an animal. The

memory of the universe, this famous memory is the Ego. It's inside me, it's the God Ego that has no need for these appearances, has no need of these legs, this sexual organ, of these hands or these lips; these are prostheses that have been shown to be interchangeable. It only needs that memory that connects itself with its own origins.

B.C. You are separating the moment of physical perception from that more spiritual one, but this passes through the body too...

M.P. For me, the spiritual passes through the body, but loses it in the waves of the biological memory of the universe, it loses its appearances completely. The only human drama is that of reducing the memory of one's self to zero with death. The search for the origin lies in our future, just as the computer was in yesterday's future. We become computers, but not only this, we become radios, television, cellular telephones and all those media that communicate

Tina Bepperling,
*Living Object -
The Vienna Moving
Kitchen*, Akademie
der Bildenden Künste,
Vienna, May 1996 -
Kulturmanagement
Häusler, Munich, June
1996

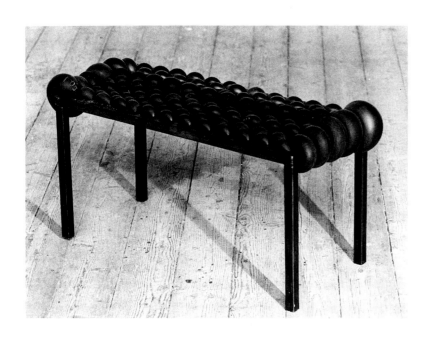

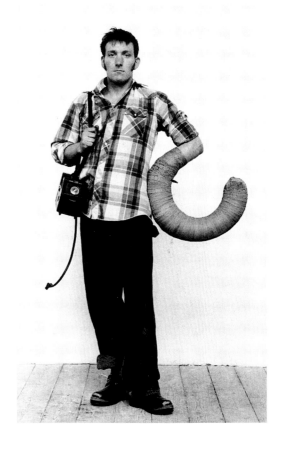

536

M. Chiara Capaccioli,
Piano di dialogo, 1996

Phillip Hämmerle,
Camere d'aria,
1995-1996

"Market," in *Prologue,
Art Project,* Marstall,
Munich, 30 November
1995

Carlo Balducci working
on the construction
of the textiles loom,
built on a 1:10 scale,
between 1995 and
1996, and perfectly
functional, shown
in Market, Centro per
l'Arte Contemporanea
Luigi Pecci, Prato

Lanificio Fratelli Balli,
Prato

through waves that exist but are invisible. So magical marvels have become visible and physical, magic becomes scientific reality through the waves of the memory in the profundity of all things. I can lose all of my appearance, all the prostheses of this life, but if I manage to preserve my memory by making it pass through the channels of the universal memory, I come and go as I wish beyond the confines of my present form of existence. With the manipulation of DNA I am taking the first steps in this sense. And then it doesn't matter whether one or a thousand people reach the moon or make the discovery of the origin of the universe; anybody, when they come back, as they came back from the moon, makes us share their knowledge. It's not even a question of wanting to survive for infinity, if it is possible to make these voyages, because it will be precisely them that make us realise that not even the Ego is necessary or perhaps that it is fundamental. By now we are in a condition in which

"Market" in *Prologue, Art Project*, Marstall, Munich, 30 November 1995

M. Pistoletto, R. Giorgetti, B. Corà at Linea Tessile Italiana (Prato), while discussing the project "Clothing the Walls" (Vestizione delle Mura)

creative thought is beginning to see a new conception of existence.

B.C. If we want to identify the target of the sign in this activity of ours in an even more stringent way, we will have to refer to the object that we have in our minds and in our feelings; that will make the action of the Art Sign even more explicit in *Progetto Arte*.

M.P. We will tackle this complex dynamic of the sign in every kind of relationship during the experience. But meanwhile it's already important to get the individual action moving on the trace of its own sign. The individual baptises himself in art on his own, then, and there is no need for certification, in the total difference of the signs.

B.C. That would seem to contradict and send into crisis that part of contemporary philosophy that has developed around the crisis of the subject.

M.P. The crisis of the subject exists in so far as the subject does not know that he has to

find his own identity.

B.C. But with this proposition the solution of that crisis would be announced... the project is also a process that has to be developed...

M.P. That is the basis of *Progetto Arte*, the Art Sign. It is a sign that comes even before art itself, because the Art Sign is not the art of the sign. It is a sign that conceptualises the same artistic phenomenon that is already of itself conceptual. Getting into the substance of "Habitus, Abito, Abitare, "there is an episode that exemplifies what we have said so far. The dressing of the ancient walls of Prato, with the participation of the industrialists of the city, conjoins the personal Art Sign with the production that they carry out. In this way we set up a possible solution of the contradiction between art and the commercial product, not in a simulated way but in a real one.

B.C. Besides, Kogler as an artist develops on walls a sign that, multiplying itself many many times, becomes an ambientation. He too traces his art sign by designing a tile and then multiplying it to fill the surround space, and that sign becomes a tile on the wall in a space you can live in.

M.P. For me it's important to find this kind of relationship too.

B.C. Sacker, as well, when he has tattooed on his body certain geometrical shapes, like the circle, the triangle and the square, and then by using colour on his forehead and on his temples, traces on the wall the epidermal sign of his body, is responding to this relationship sign-body-space-habitat.

M.P. Indeed it seems to me very important that, after the first room, which is the one of the Art Sign of everybody, there should be the sign on the skin of the person himself, that

Enrico Rava

Enrico Rava visiting
the plant of Sarti
Faliero e Figli,
for the preparation
of the concert of
the group Rava Electric
Five (Enrico Rava,
trumpet; Domenico
Caliri, guitar; Roberto
Cecchetto, guitar;
Giovanni Maier, string
bass; U. T. Gandhi,
drums)

is Sacker, who incorporates the sign on his body in a definitive way, he makes it become his *abito* [clothing], his *habitus* and his habitat, and this is in an immediate, direct comparison. I think that the development of these signs is equally important, as the Art Sign first drawn on paper and then on the carpet by Laimanee; that carpet with its sign became the place of physical contact between his hands and the body of others to reawaken the internal potential energy. In these cases the body is not dismembered, but is considered in its completeness. The body is the first residence of the Ego.

B.C. An Ego that should continuously express itself in the sign of otherness...

M.P. In this pathway of "Habitus, Abito, Abitare," we meet Pietra: her way of conceiving articles of clothing is different from that proposed by the clothing industry. It is the reproposing of creative handiwork. Every item of clothing is personally made, without

Cavea of the theater of the Centro per l'arte Contemporanea Luigi Pecci, Prato

Autograph of the first page of *Senatus*, musical composition by Giorgio Taricco

Senatus - Prologue, 1994-1996, by Cristina Pistoletto and Giorgio Taricco, Marstall, Munich, 30 November 1995; in the photograph a few of the participant citizens of Munich

excluding the former nature of the recycled material, integrating elements from the past in a work that is a new composition. This is continuously putting yourself at the centre of the "Abito" operation.

B.C. There is a relationship in the reusing of material that is counter to the consumerism economic conception.

M.P. Strangely, one uses the term collection in the fashion world every time one presents groups of models, even though one knows that they will immediately become obsolete: this is different from the concept of a collection of works of art, which are maintained for very long periods of time. I noticed that Pietra has dated her clothes, which I don't think is something that is normally done. Evidently, in them there is a question of the relationship with time which is closer to the customs of art rather than those of fashion.

Enzo Mercuri

B.C. Other situations, too, which follow on in the spaces after Pietra, develop a close relationship with the creation of the object. It is a way of operating in which the author continues to be protagonist of his action even in the interpersonal relationship. In the "market" this aspect is particularly clear.

M.P. The market is a place for encounter, exchange, and direct bargaining is very important for getting to know each other.

B.C. In the market, the relationship between seller and buyer takes us back to an ancient method of primitive societies, the exchange of gifts... But there is the demonstration that everyone, if they keep feeding certain individual interests, is capable of producing, of creating something with their own hands and offering it to others...

M.P. The opposite of the market model is the supermarket, that place where people are no

longer one in front of the other, but are all lined up in front of the product, as in modern industry pigs, cows and hens are in front of their fodder.

B.C. A singular aspect of the *Progetto* develops the potential of the Art Sign, the idea behind the whole programme of the architecture-sculptures in the car park.

M.P. The decision to use the car park for the idea of putting the architectural-sculptural elements in between the cars comes precisely from the consideration that the car is a habitat, that permits us to move around. Indeed, anyone who comes in to this exhibition will penetrate into sensible contact and will have access to places that are experienced on the basis of the criterion of a continuous activity during the three months the exhibition runs. Together with the names of recognised professionals like Branzi, Toscani, West, Rava and others, there will be dance, theatre, music, object and dress design workshops.

B.C. To start moving towards a conclusion, since I have been asked to express a project for the Biennale of Florence, I thought that the relationship between fashion and art should be tackled and resolved by an artistic conception. I thought this in the light of the experience that had already passed between us and that needed to be developed. I felt that, faced with every reality and discipline, it should be possible to provide artistic solutions to the problem of art with the profundity that art had already conceived and built.

M.P. Besides in "Le porte di Palazzo Fabroni" in Pistoia the encounter between the various expressions of the social structure, from religion to politics, from architecture to design, from literature to theatre, had tackled the same specific problem of the *abito* that was already considered as a work in the first room of the Museum. "Le porte di Palazzo Fabroni" appeared as the threshold of art that makes thing communicate. In a different but fitting

way, in this new episode of work the space dedicated to the sociologist Kreutz is next to that of the creations. The sociologist is a subject that could be considered to be on the other side of the ditch and one that comes to art with his luggage. He does not present himself in the double-face guise of the artist and the scientist, but is an individual who, coming from the things of the world, enters a place where he has to measure himself directly with art, so it is the sociological nomenclature that through this room is showing itself to the world of art. His is a presence that is not born with the charisma of art, but which enters into the space of art to measure itself. It is a delicate operation, but it is a part of this project that does not qualify itself specifically in the definitive product, but offers participation in a process, a movement, and in this sense "Habitus, Abito, Abitare - Progetto Arte" is a revolutionary workshop.

546

B.C. I have always thought that the external, that which is defined as external, which it crosses the threshold of art could disturb art's delicate balances; but I have also always thought that if it is the artist who guides this passage it means that he feels the need for it and so has already adopted all the necessary measures for the event to satisfy some profound new need that has cropped up in the artistic action and strategy. So, from this point of view, there are two aspects, one of great delicacy and one of great responsibility. We have often criticised the confusion caused by some external person hungry for conquest in the territory of art; while on the other hand we have maintained to the utmost that if the artist controls this entrance it means that new energies can enter into the interior of art, it means that art is feeding itself, that it is taking on fuel to reestablish a new conception and vision of work and activity.

ALBERTO CASCIANI Thomas ROSELLA QUORGETTI MATTEO MANTELLASSI FRANCO MILIOTTI

M.P. Since I maintain that the threshold of the mirror is fundamental, and I have declared that I will remain the guardian of the mirror with *Progetto Arte*, and I underline Arte, I feel myself to be the active guardian of this new opening of art on to the world. Indeed, the stripping of art is in progress, and so for me its coming close to the world of society has the aim of reinvigorating it. But I would not like it to happen that with the history of clothing one strips art. There needs to be, in the entrance and in the exit, through these doors, a search for balance and proportion and it is here that the design of the new classic is born.

Elton John Metamorphosis

Florence
Reali Poste, Uffizi

Elton John Metamorphosis
Curators
Germano Celant
David Furnish

Exhibition
Coordination
Francesca Sorace
with
Piergiorgio Leone
Marina Caterina Longo
Secretariat
Laura Chimenti

Installation
Design by
Adolfo Natalini
with
Giovanna Potestà

Technical supervision and installations
Pier Vincenzo Rinaldi
Francesca Sorace
with
Piergiorgio Leone
Marina Caterina Longo
Secretariat
Laura Chimenti

Set design/mannequins
Natascia Ugliano

Set design/eyeglasses
Cosimo Vinci; Antonio Ulivieri

Lighting and Electrical systems
Baroni Luci-Florence

Video-projections
Natali Multimedia-Florence

Mannequins
Almax International-Como

Installations
Biagiotti & Bertini-Florence;
Tappezzeria Renzo Ruggeri-Florence

Catalogue
Edited by
Germano Celant

Coordination of production
Anna Costantini
Cecilia Torricelli

Graphic design
Marcello Francone

Elton John: An Artist in Transition

Without a doubt, rock and pop music exert a profound influence on style. They are also important as a testing ground for all sorts of new projections about identity. Rock and pop are focused worlds in which one can observe contemporary behavior and changing sensibilities. Against this background, Elton John stands out as a vital figure, not only for the quality of his music, but also for his vision which embraces the relationship between image, identity and message. For many years now, Elton John has been a charismatic and symbolic figure, a provocative example of self-creation and self-representation and liberating self-expression, able to convey his own beliefs in a particularly creative and original way.

Elton John. Metamorphosis exhibition will attempt to show his worldly influence and remarkable personal transition, observed through an overview of his colorful and highly individual stage costumes and eyewear.

As the product of a strict, English upbringing, Reginald Dwight created Elton John as the ultimate act of rebellion. The combination of a strong desire for escape and reinvention, coupled with a passion and love of rock music inspired by the likes of Little Richard and Elvis Presley, helped to create one of the world's most outrageous and original musical talents.

Borrowing from the great tradition of flamboyance established by England's vaudeville performers, Elton tapped into the creative expressionism of London's swinging sixties fashion scene to create his own inimitable style. Using hot pants, flying boots and glittering jumpsuits, Elton John launched himself onto the American music scene in 1970. His exuberant use of fashion provided an interesting and sometimes bizarre dichotomy between that, and the genius of his gifted songwriting and musicianship.

Fashion provided Elton with the ultimate form of self-expression as he used a colorful stage wardrobe to live out the rebellious period he was never allowed or enjoyed during his teenage years. His hyper-kinetic stage acrobatics and unique sartorial flair served as an inspiration for the many designers who gave Elton his unique and memorable look during the past twenty-six years. The *Elton John. Metamorphosis* exhibition will feature a cross-section of the stage wardrobe created by the designers Annie Reavey, Bill Whitten, Tommy Nutter, Bobo Mackie, Bruce Halperin and Gianni Versace.

Platform shoes, wild and outrageous fabrics, multicolored effects and finishings like feathers and sequins have all become synonymous with the Elton John style. His adoption and celebration of feminine stereotypes helped advance the design of men's fashion, whilst pushing back the barriers of sexuality itself.

The exhibition will also feature a retrospective selection of Elton John's original and highly influential eyeglasses. It is here where he completely revolutionized the wearing of eyeglasses by embracing the new technologies available in optical manufacture and design. With the use of multicolored lenses and frames, Elton helped to transform eyeglasses from being a purely functional object, to the ultimate expression of an individual's personality and style.

By observing the transition and development of Elton's stage wardrobe, one can observe the remarkable transition of an artist through the ups and downs of his personal life. In the early seventies—where one can observe a newfound excitement and exuberance over his chart—topping success around the world—fashion became a celebration of life itself. In the eighties, where drugs, alcohol and the pressures of worldwide celebrity began to take an increasingly tight stranglehold over his life the fashion he chose could be seen as a mirror of what was going on inside the performer. Elton used extravagant wardrobe to hide his fluctuating weight, and dark glasses to hide a battle with low self-esteem. And in the nineties, where his most recent stage clothing shows a still colorful, yet more elegant and refined silhouette, one gets a view perfectly in sync with a happier and centered artist enjoying a creative renaissance and new-found popularity.

Elton John: The Art of Being Present

The relationship between music and fashion is based on the need to make the invisible visible, to give shape to the sounds and words of songs. Fashions must find a way to become visible, to establish a link between the lyrics and the person, between the music and the singer, band or orchestra. Hypervisibility enhances the stage props—the lights, background, clothes, and gestures. After the 1960s, the movements, costumes, figures and stages of rock concerts slowly shift away from the human dimension and toward a celebration and ritualization of artifice based more and more on special effects, on sumptuous clothing, on a liberating manner of conduct that reaches the point of linking eroticism and spectacularity. The body and the music become a single whole, confer presence on one another and manage to visualize something incommunicable and unrepresentable. At this point the musical subjectivity of the individual performers acquires an identity and style through their dress and makeup, their movements on stage, their gesticulations and way of expressing text and sound through their own bodies. This emphatic self-display passes from repetition to mutation, from the angelic to the demonic, from the spiritual to the sensual: dress and movement break free from all models and become an extreme form of originality that leads to a cult-like veneration. And since the height of eroticism on stage is manifested in the interrelationship between clothing and body, the history of contemporary rock music must sooner or later include an analysis and interpretation of the aesthetic representations and the fashions created by the music itself. The transformations that gestures and clothing have undergone during thousands of concerts seen by billions of people have emancipated our way of thinking and feeling about our bodies, our sensuality, and our difference, and they have enriched the relationship existing between manners of being present and manners of being seen, thanks to creative uses of makeup, costumes, movement, and mime.

For Elton John, the battle cry of existential and human freedom, of sexual and aesthetic, musical and emotional emancipation, is the cult of difference. His entire career as singer and performer has been marked by the originality and extreme distinctness of his self-presentation. Since 1970, he has been rejecting dogmas and constraints, isolating himself in a personal universe made up of sounds and images, from which he emerges

for his concerts with a lucid self-awareness as a creator capable of subverting the stereotypes of contemporary music and performance dress.

His eccentricity has always been a way of inventing his own rules of appearance and of forcing the limits and restrictions of behavior. His attitude is one of non-codified independence in the "art of living," which Elton chooses to manifest and highlight in his separateness and solitude. The ostentatious display of essentialism and redundancy, of irony and elegance, of dandyism and kitsch, of heresy and conformism, of innovation and ingeniousness, that inform his stage costumes—from the *Spaceman* costume, designed in 1972 by Bill Whitten for his American tour, the 1972 *Day-Glow Jumpsuit*, the 1974 feathered *Chicken Outfit*, and the 1976 *Clarence Rabbit* costume, to the 1979 Yves Saint-Laurent jacket, the *Donald Duck* costume for the 1980 Central Park concert, the *Baseball Outfit* he wore at Dodger Stadium in Los Angeles, and the *PVC Green Outfits* designed by Gianni Versace in 1994 for his American tour with Billy Joel—express the sort of reflection on exteriority and interiority, on society and the self, on the collective and the individual, that accompanies the adventure of every successful pop singer.

These polarities, which concern the public and the private, the iconographic vicissitudes of a society and the emotional and human vicissitudes of a person—Elton John—can be seen as a documentation of the creative process of popular culture, as well as a struggle for the assertion of a living, present being as a specific, different entity. In both cases, the approach and standard of "transfiguration" on stage lead to a general intoxication, created from a palette of materials and colors, fabrics and hats, shoes and glasses that can be considered "vulgar" (from the Lat. *vulgus*, "the people"). At the same time, however, this bold self-illustration through fantastic, eccentric props also underscores a narrative of the artist's relationships with his own body and his audience.

One might say that Elton John, in his euphoric search for freedom of expression, has sought to break out of the prison of himself. Without harm to his personality and way of life, he has managed to survive the multiplicity of a difficult and diversified existence. David Furnish, in his television documentary, "Elton John: Tantrums and Tiaras," broadcast in 1996 by the BBC, as well as in his introduction and dialogue with Elton John and in his notes on the images portraying the singer's stage costumes, points out how the vividness, richness, extravagance and variety of the costumes correspond to an emotional itinerary constantly wavering between happiness and sadness, loneliness and popularity. They are a private form of compensation for admiration or rejection, whereby he is able to make every prop correspond to an existential moment.

Taking an opposite approach, one might also study how the profusion and astonishing display of images taken from films and television—from *Donald Duck* to *Clarence the Rabbit*—or the creation of the frivolous, fateful images "worn" by Elton John, serve as presentations of a "spectacular fashion," as the dazzling event of a person wishing to distinguish himself from the common run of mediocrity and univocality. In this sense, the stream of pomp and grandiosity is an attempt to place himself above the calm uneventfulness, the simplicity, smoothness, modesty and banality of everyday life. It is here that the singer becomes the symbol of an affirmation of life and its pleasures, against the deathliness of a drab existence. Through his appearance, he seems to be searching for a positive response to his independence and freedom to present himself as he wishes.

This penchant for camouflaging oneself through the exhibitive and spectacular dimension of dress is also consistent with the new electronic society. Elton John, like David Bowie and Brian Ferry, belongs to a generation of performers who have accepted the electronic universe of television and the media. They have adjusted to life's acceleration by working on the dizzying effects of image-consumption, the glamour of which lasts but a few seconds; they have harnessed this speed by presenting themselves as examples of a sensory and optical multiplicity. They have taken upon themselves the notion of absolute transitoriness, both in an iconographic and sexual sense. They have camouflaged themselves to arrive at a transitional stage between male and female, a transsexuality that is mirrored in the dizzying interplay of makeup and dress. They have succeeded in forcing our eyes to see the splendor of "difference" in an erotic, behavioral sense, dispensing with the traditional forms of movement and self-presentation and giving us an erotic, eroticized "alien" form whose presence on stage and on the world's television screens has unsettled, surprised and enchanted the world audience with its very difference.

With their display of transgressive sexuality, where the sexual impulse of the music, with its dynamic of pleasure and sin, took the form of a body halfway between male and female, these artists played a part in giving meaning to the new person no longer identifiable in a single gender. This contribution ushered in an endless universe of interchanges of behavior as well as dress. The fashion world was quick to follow suit, when in the 1970s, in the work of many designers from Armani to Lagerfeld, the distinction between men's and women's wear was eclipsed, bringing about a profound, unprecedented change in everyone's manner of dress. Thus aside from his exceptional songs and music, Elton John can be considered a supreme example of how the concepts of seduction and erotic effect have been dissolved through dress. Through his melodics and voice, his gestures and clothing, he displays an "open" narcissism—that is, a narcissism not limited by the predominant reigning style. The message he sends is that we can be different, unique, and special. He thus suggests a rebellion and aggressivity against conformism and the organization of the music industry. And since existential death lies in an impending future, Elton John attempts to initiate his audience and fans to an unbridled vitality. Carried onto the level of dress and hairstyle, and its implications for fashion and creativity, this self-production as an everchanging phenomenon, in continuous metamorphosis, enriches and broadens the notions of fantasy and charm. The multiple meanings of Elton John's costumes bear witness at once to the personal history of one man's passions and affections and to a whole society's venerations and transgressions. They are a way of saying "Yes" to oneself, and open the world up to everyone's dreams: a displacement that is also an enthrallment, as well as a response to everyone's potential for existence and difference. Elton John's surprising fluctuations began in 1970 in a puritanical British society, self-contained and oppressed, that aspired to distraction and self-preservation while the rock music world was moving toward a more urban and proletarian aggressiveness. Alongside the progressive soul music of Rod Stewart and Joe Cocker, and the hard rock of Led Zeppelin and Cream, a new dandyism was emerging in rock music, much of it based on the nuances of extravagant, eccentric clothing. These were the early days of David Bowie and Elton John, who rejected the drab, commonplace dress of the workaday world, and resorted to a showmanship based on odd styles of clothing and hats, makeup

and oddly colored hair dyes. The unvarying pants, shoes, boots, jackets and hairstyles that rock and pop groups were wearing suddenly began to explode. Tailors and costume-designers were suddenly called upon to abandon such considerations as comfort and modesty. Anne Reavey, in particular, began designing wardrobes for Elton John which represented pop "landscapes"—such as the "cake" costume with candle-shaped hat, with "Elton John" written on top of the icing, or the outfits bearing musical notes or the vista of a green field with exotic birds.

In the 1970s, pop iconography at times found room for cinematic and optical effects. Elton John turned to designers such as Bob Mackie and Bill Whitten, who until 1980 made stage costumes that, by reflecting the light show, created spectacular refractive chromatic effects capable of heightening the audience's perception of the performer's gestures at the piano, and enhancing the richness and fluidity of the songs.

The need for these body-props stems not only from the need for a renewal of the performer's persona and his narcissistic cargo; they also arise from the need to make the presence of the singing pianist—who is bound to his instrument (*Don't Shoot Me, I'm Only the Piano Player*)—tangible to the audience. He cannot move, and thus his clothing must become the metaphor for an explosion of gesture. This is the reason behind the use of dynamic elements such as the spheres in the 1973 *Balls Outfit* or the fluttering feathers of the 1974 *Chicken Outfit*, both designed by Bill Whitten. Sometimes, to conceal his "enslavement" to the piano, Elton will break into wild gesticulations that always remain, however, bound to the keyboard. This leads to the creation of sport suits such as the *Jumpsuit*, made of reflecting fabric and designed by Bob Mackie.

In the 1980s, this showy ostentation of a body bound to the piano, wavering between pop imagism and sport reductivism, attains Baroque levels of oddity and whimsy. Elton John's costumes become representations of angels or generals, of sultans or statues, montages of materials and colors, of curled feathers and plastic, of iridescent fabrics representing birds' wings or crests, military decorations and medals, where the dominant theme is always excess.

This was a period in which Elton John alternately took delight and displeasure in physical and bodily redundancy, seeking to glorify it or to mask it through a metaphorical equivalent, the desire to be light as an angel or bird (as in *I'm Still Standing* or *Candle in the Wind*). The use of reflective materials is itself an attempt to dissolve, through luminousness, the burden and otherness of the body, an unrepresentability that becomes translated into an iconic representation through, for example, the exotic-animal costumes designed by Bob Mackie for the 1986 Australian Tour.

If, in the 1970s and 1980s, the seductive effects obtained by stage costumes seemed to vacillate between a happy and unhappy fate, between public success and personal loneliness, expressed in extravagant and moody fripperies indicative of an inner struggle marked by melancholy and apathy, by 1990 Elton John seemed to have overcome a sensitive, tortuous phase of his personal and musical adventure. After imposing on himself a program of self-control that liberated him from his former "addictions," he once again seems able to love himself and others: *Love Songs*.

His wild exploits and dissolute sexual behavior, which flouted all rules, have disappeared; his body has taken on a slimmer, more elegant shape; the music has grown sweeter and

lovably gentle (*Can You Feel the Love Tonight*). In the wake of a dandyism in the manner of Oscar Wilde and Lord Byron, Elton John has been reborn. Even his stage costumes have become more refined and simplified. This new status is reflected in the Gianni Versace outfits, which with their graphic lines and geometry, no longer clothe a whimsical character but a human being, the singer and performer, whose presence no longer needs to be imposed, but only allowed to be heard and seen. Now the stage dress lightens the spirit; it no longer underscores difference and pretence, aspiration and desire, confrontation and escape, renewal and abhorrence. Rather, it is a normal part of the artist himself. It ensures, without excess, the continuation of his own universe, making him like everyone else who wears fashionable clothes: one among the many who are distinguished only by what they do, in this case, by making marvelous music.

London, England, 1972
*Elton performs during
Christmas at London's
Hammersmith Odeon*

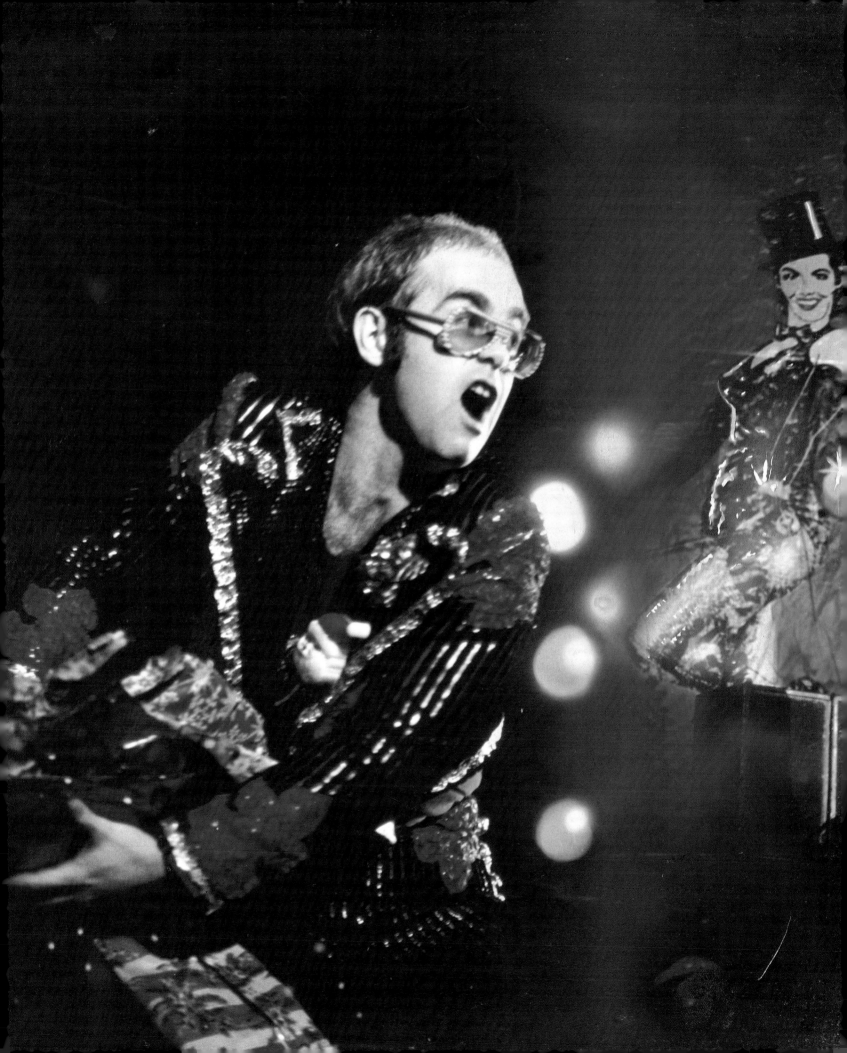

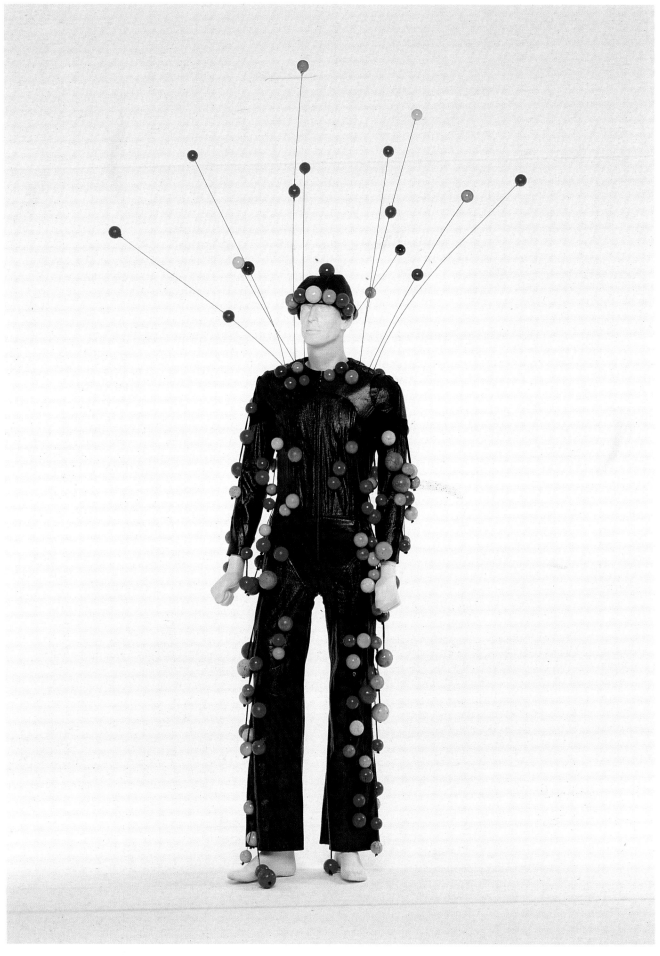

*With the help of a
day-glow jumpsuit, Elton
explodes on tour*

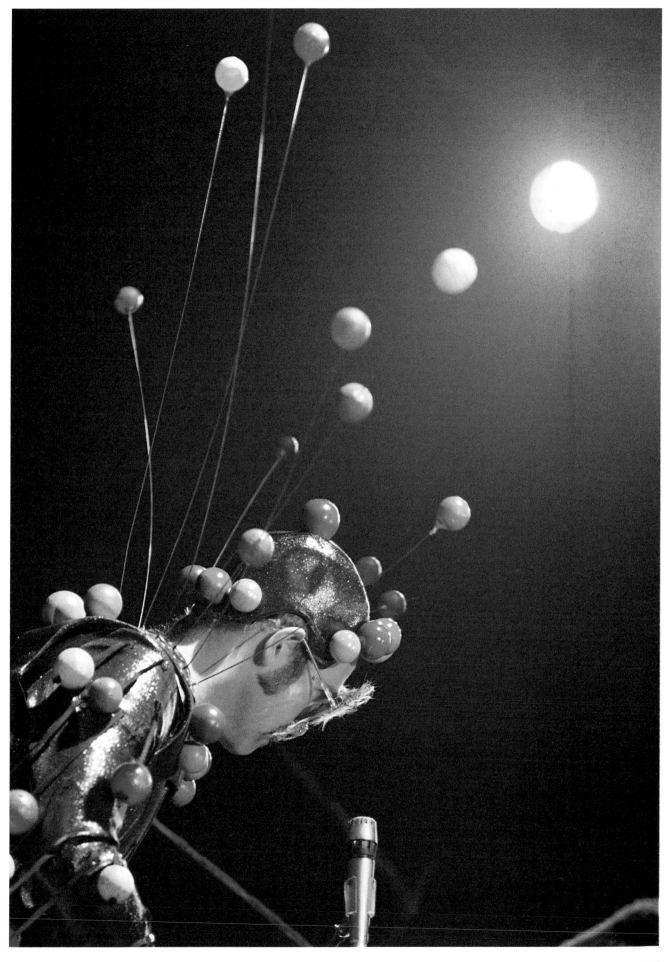

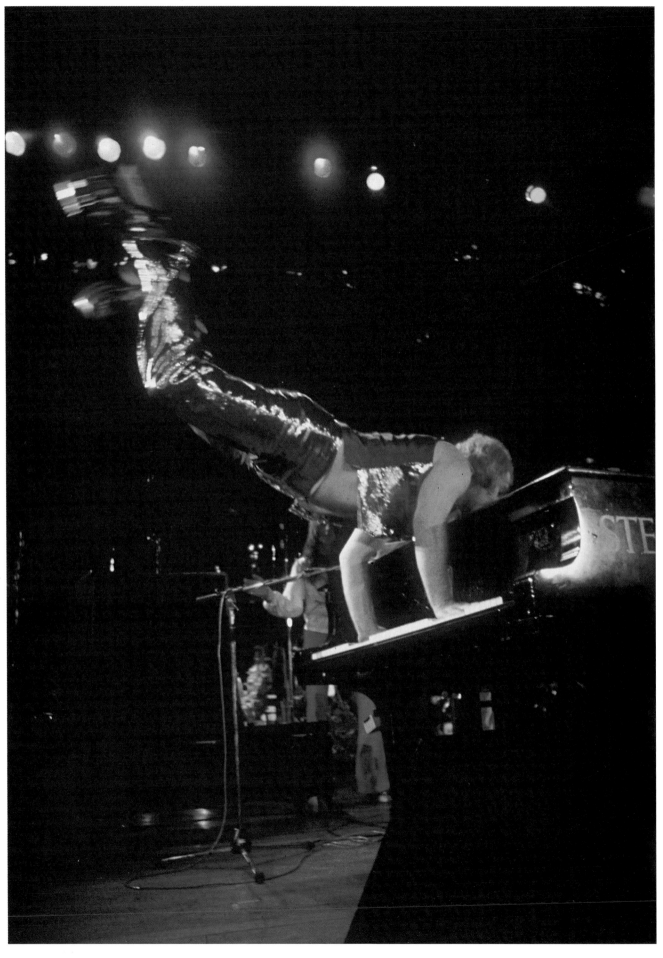

Los Angeles, California,
1974
*His hyper-kinetic style
served as an ispiration
for many of his
outrageous stage
creations*

Clothing designed
by Tommy Nutter, 1976
*One of Elton's famous
piano key lapel suits*

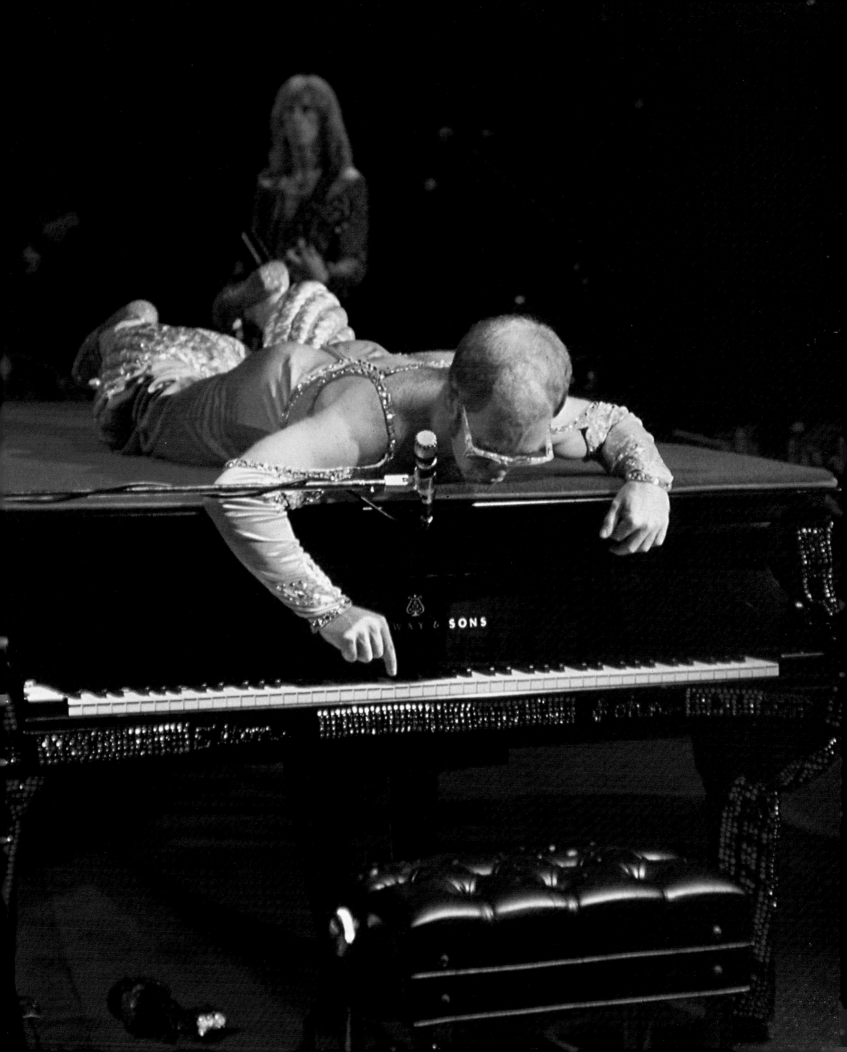

Jacket designed
by Tommy Nutter, 1979

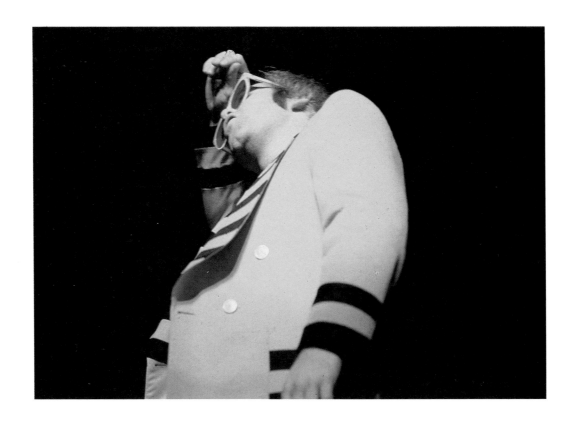

pp. 566-567

Los Angeles, California,
1975
*Elton conquers Dodger
Stadium in a sequined
baseball outfit. It was
later sold at auction
by Sotheby's in 1989*

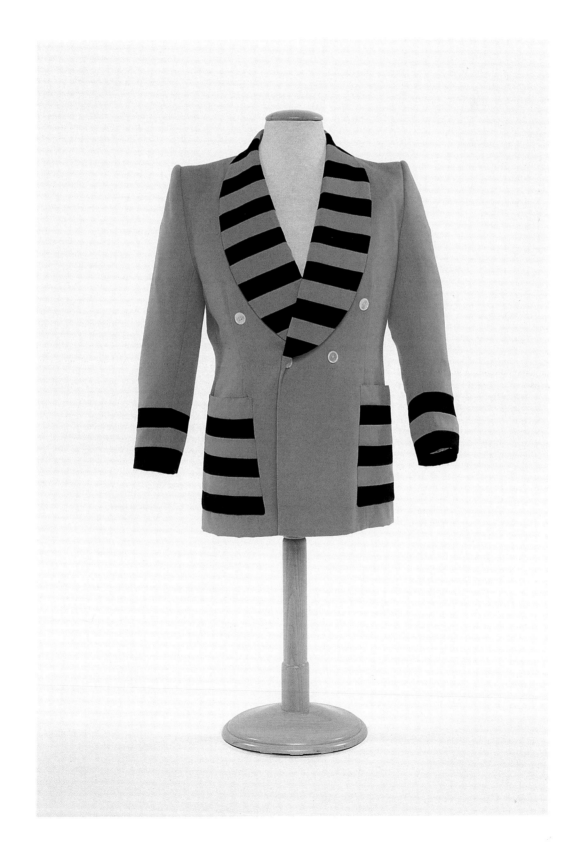

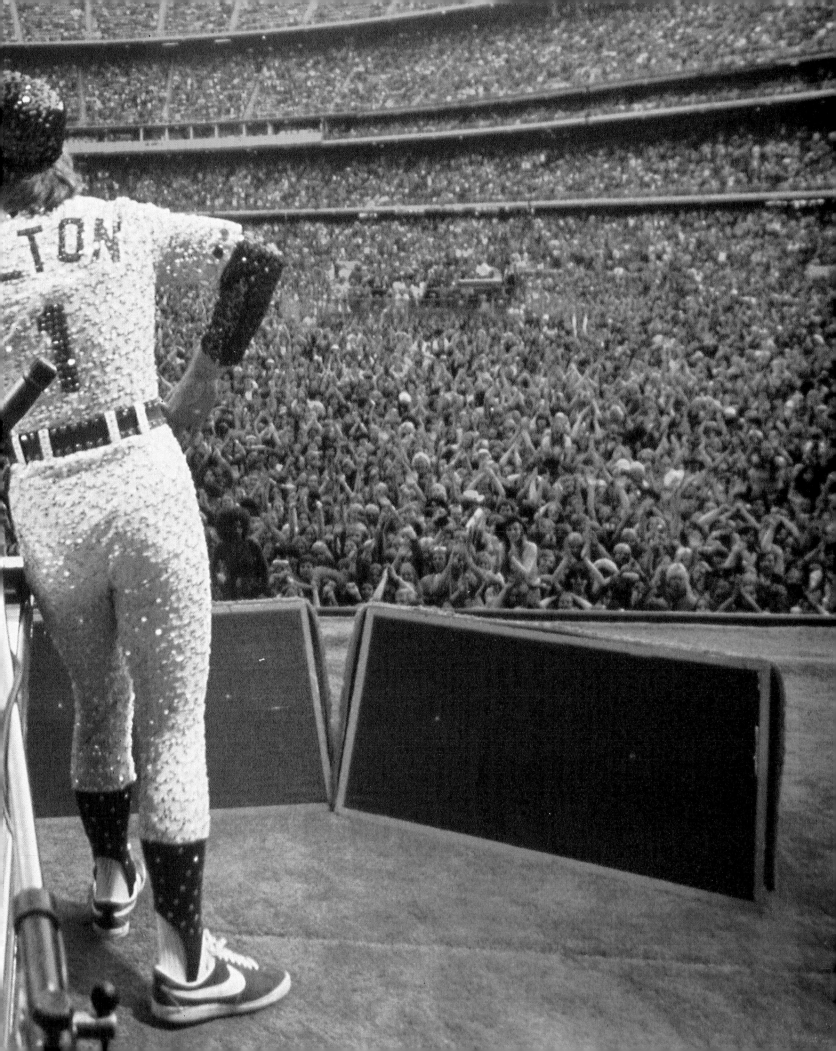

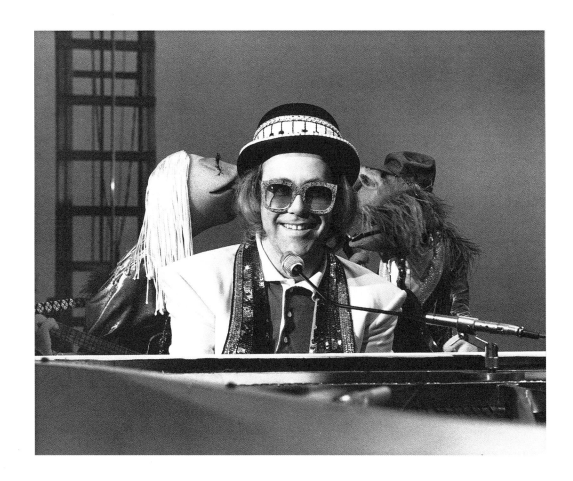

Bob Mackie Yellow
Jumpsuit Outfit, 1974

pp. 570-571
Clothing designed
by Bob Mackie, 1974

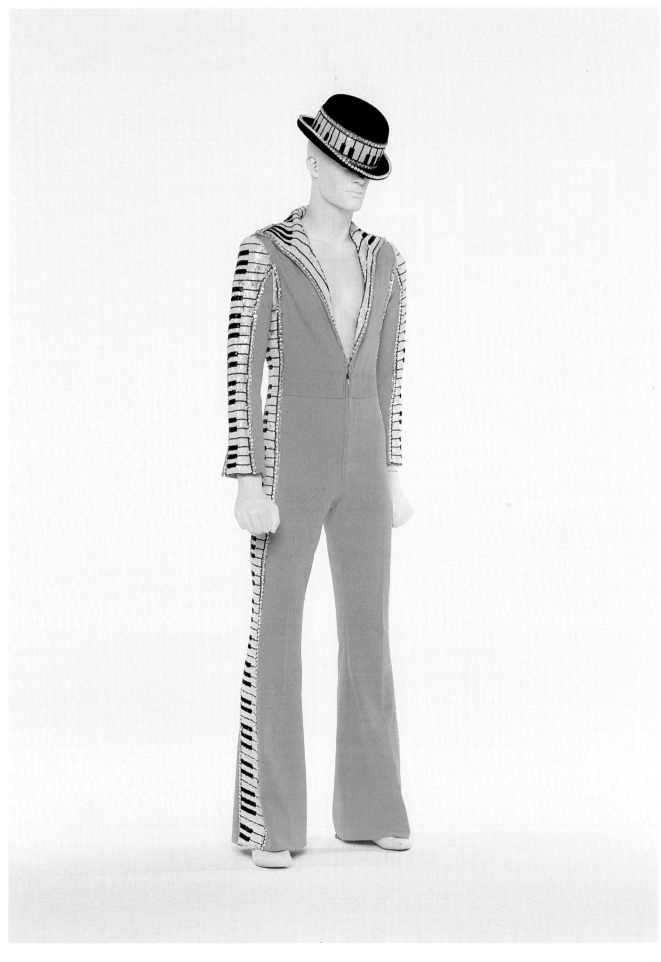

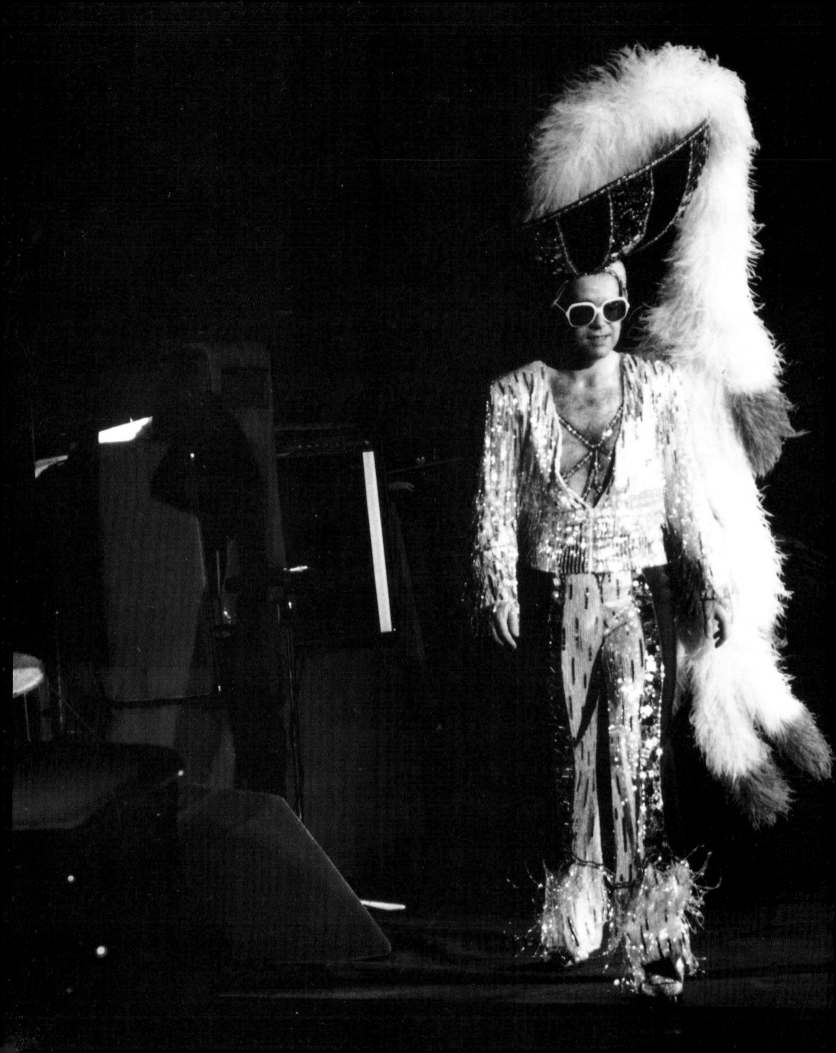

"I don't feel complete on stage unless I'm dressed up"

Staten Island, New York,
1982
Clothing designed
by Bob Mackie

pp. 576-577
Sad Songs video, 1984

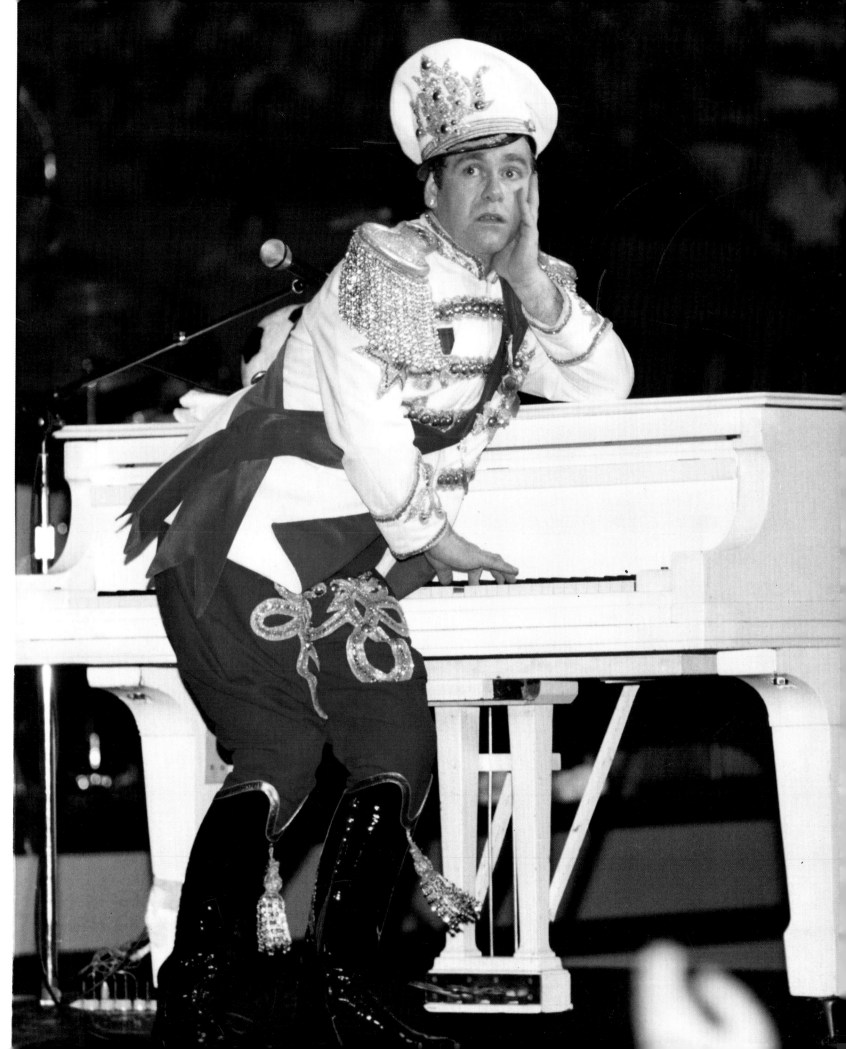

Bob Mackie's original
concept sketches for
the Australian tour
in 1986

"I can now look at those outfits and laugh"

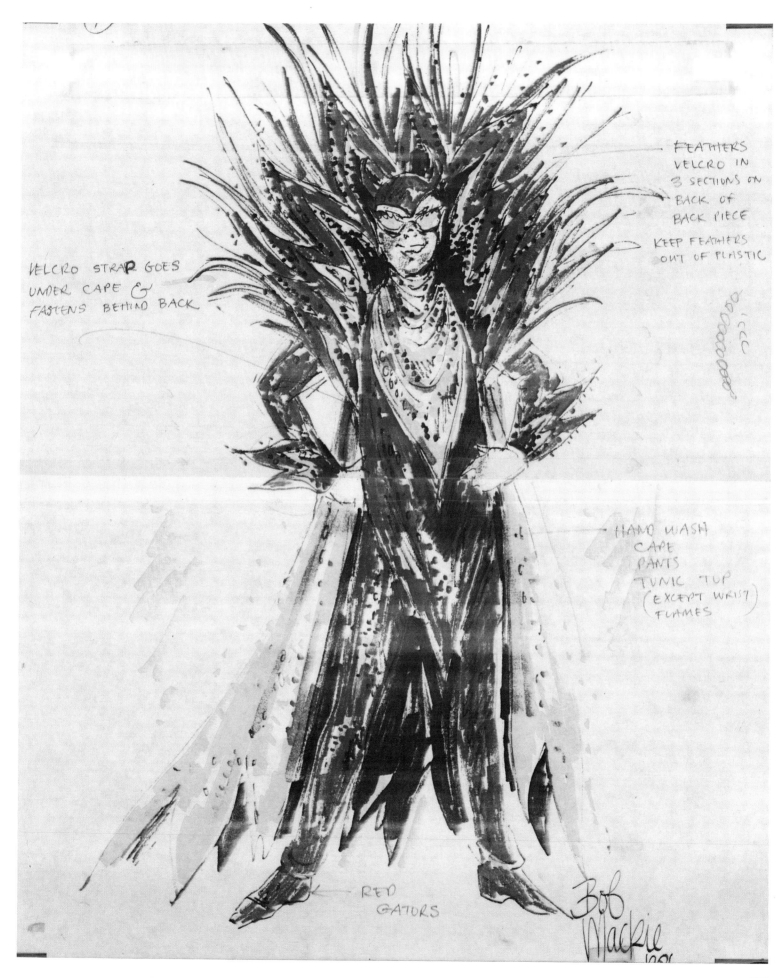

FEATHERS
VELCRO IN
3 SECTIONS ON
BACK OF
BACK PIECE

KEEP FEATHERS
OUT OF PLASTIC

VELCRO STRAP GOES
UNDER CAPE &
FASTENS BEHIND BACK

HAND WASH
CAPE
PANTS
TUNIC TOP
(EXCEPT WRIST)
FLAMES

RED
GATORS

Bob
Mackie

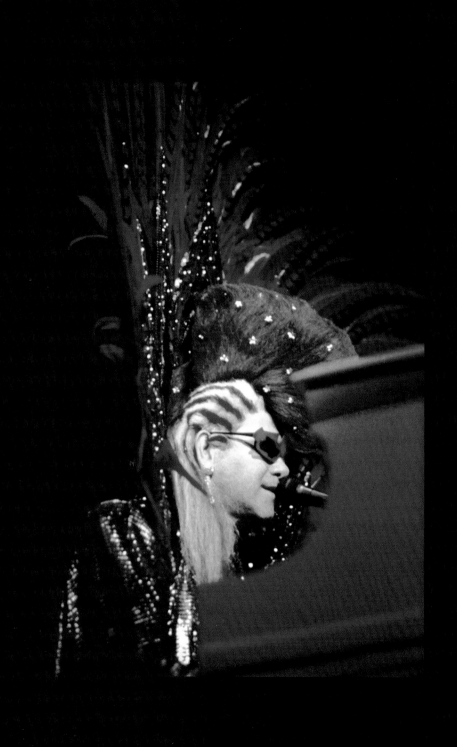

Clothing designed
by Bob Mackie, 1986
*"It was really a horrible
psychedelic dream" said
Elton about this troubled
and unhappy period
of his life*

Bob Mackie Devil Outfit,
1986

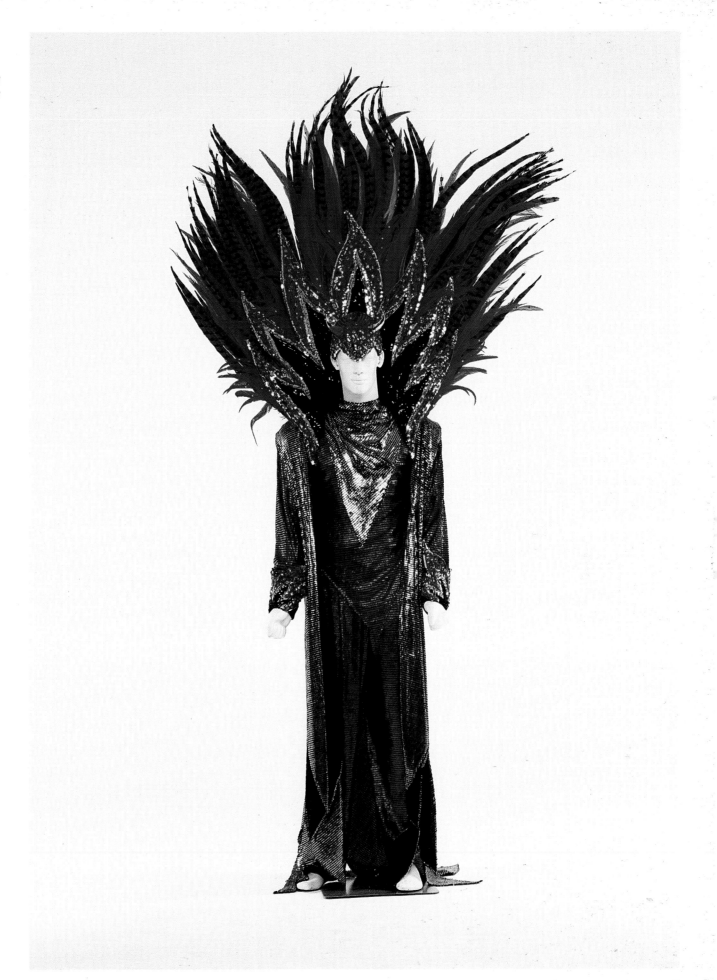

giacca gialla.
+ pant. Jeans. B/N.

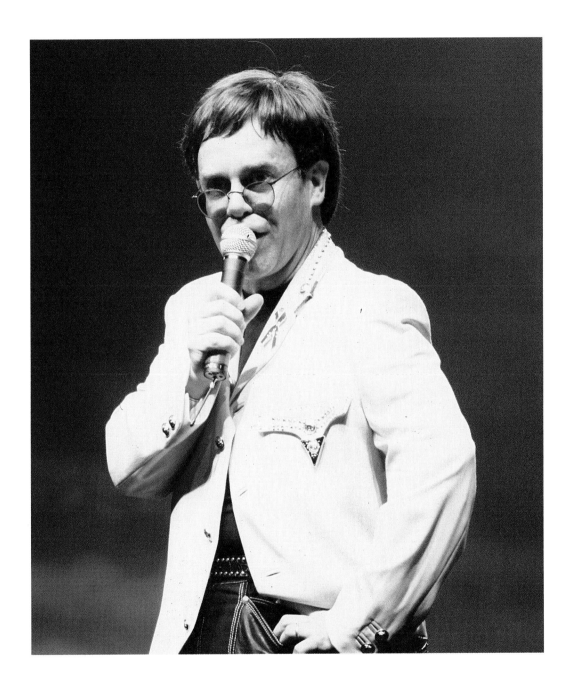

Versace green P.V.C.
outfit, 1995

New York City, 1995
*Richard Avedon
photographed Elton
wearing this green P.V.C.
Versace suit from
the 1994 U.S. tour
with Billy Joel*

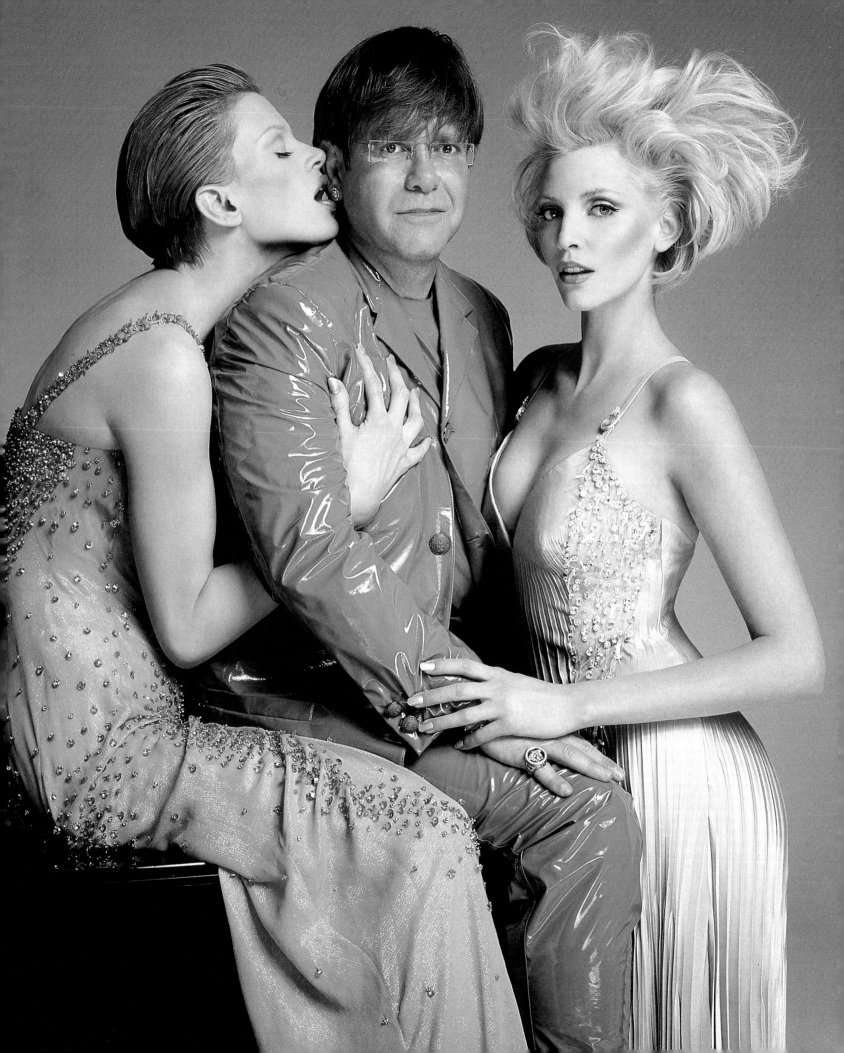

Emilio Pucci

Florence
Sala Bianca and Sale del Fiorino,
Palazzo Pitti

Emilio Pucci
Curators
Katell le Bourhis
Stefania Ricci
Luigi Settembrini

Exhibition
Coordination and overall administration
Anna Pazzagli
with
Simonetta Mocenni
Secretariat
Stefania Signorini

Insurance
La Fondiaria-Florence

Transportation
TNT Traco-Milan

Installation
Design by
Pier Luigi Pizzi
with
Massimo Gasparon

Technical supervision and installations
Anna Pazzagli
with
Simonetta Mocenni

Costume styling and arrangement
Giovanna Buzzi
with
Silvia Aymonino
Enrico Lanari

Technical consultants
Giancarlo Martarelli

Lighting
Gigi Saccomandi-Milan
Baroni Luci-Florence

Mannequins
Ponte Vecchio srl-Florence

Installations
FPN srl -Florence; Ideattiva-Florence;
Julie Guilmette-Florence; Linoleum
Gomma Zanaga-Florence; Rubechini
Carlo srl-Florence; Scenart srl-Prato;
Scenotek srl-Florence; Teatro
Comunale di Firenze

Catalogue
Edited by
Luigi Settembrini

Coordination of production
Anna Costantini
Cecilia Torricelli

Editorial coordination
Claudio Nasso

Graphic design
Marcello Francone

Lessons at the Sherry Netherland

The Biennale di Firenze is chiefly interested in exploring phenomena of the present; it is–paradoxically–in the present that this retrospective of the work of Emilio Pucci finds its significance and its principal interpretive key.

Though dated (like all visual language developed in the sixties, from the films of Antonioni to the remarkable hairdos), the style of Emilio Pucci remains miraculously up-to-date. For the past forty years, those patterns have been imitated, copied, recycled, revised, cited, and emblazoned by legions of scarf-manufacturers who sell to hurried tourists, and by grand fashion designers, in their collections of clothing, accessories, and objects for the houses of the nouveau riche.

Pucci, in the final analysis, is one of the very few truly original fashion designers of this century. In the thirties, Coco Chanel helped to invent the modern woman. Well, Pucci, at end of the Second World War, was one of the few who truly understood the way in which life had changed. Pucci, like few others, grasped that the visual language in which the body expresses itself had to be radically renewed, rejuvenated, and simplified. Perhaps it may seem odd that this need/desire for a newly democratic fashion should be personified by a high-born Florentine marchese; in the end, however, it makes perfect sense. The name Pucci is an ancient and illustrious one; Emilio Pucci himself, on the other hand, was an exceedingly modern man, a man who knew the world, and man who traveled the world and used it with a pragmatic and international flair. He was especially well acquainted with North America; he chose the women of the United States–strong-minded and with careers of their own–as his psychic and physical ideal. They were the intended target of his fashion; they responded passionately, and made him fabulously wealthy and world-famous.

Now, it is odd to note that, despite Pucci's unrivalled standing among the fashion designers of the postwar period, there has never been a serious exhibition devoted to his life and to his work. Museums and institutes of the highest order had approached him more than once; Pucci had always delayed, deferred, and gratefully declined. Sometimes he was too busy; at other times he thought ill-advised, or the location ill-suited, or who knows what else.

Actually it was quite simple: Emilio Pucci felt that a retrospective of his work, held during his own lifetime, would have been a form of self-adulation, a violation of his privacy, perhaps even an exercise in bad taste. Once again, the Marchese Pucci displayed his exquisite snobbery, his profound difference from the herd of fashion designers, of the present and the past.

Now, as we inaugurate the first major event institutionally dedicated to the culture of fashion–an event being celebrated in the city that was home and birthplace to Emilio Pucci–Cristina Pucci has decided that the time is finally right to accept our invitation to hold and exhibition that will explore a fundamental part of her late husband's life-work.

I remember: it was 1976, and I was in the midst of what had become a personal adventure. I had just quit my job and my career. I had broken with my wife; we had tried but things just weren't working. I had left Milan and Italy, and I had gone to live in New York. I say that I left; actually I fled, I could no longer stand the work I was doing, the life I was leading, the friends I loved deeply but with whom I simply had nothing left to say. New York City was a place where I had always wanted to take refuge, to hide out. A few years before this I had taken part in a convention held in the headquarters of an American advertising agency in which I was a shareholder. The hall was on the 61st floor, and it overlooked Central Park. It was fall; the leaves were red and yellow and here and there still green. The park, seem from our lofty viewpoint, seemed like some huge soccer field; along the sides, instead of bleachers, there were endless lines of skyscrapers. It was a stunning, triumphant spectacle. And, in that instant, I told myself that if I could not find some way of living in New York City, it would truly mean that I was a nonentity. In short, it was a challenge, a bet that I made with myself in the romantic tradition of Stendhal's Julien Sorel–Sorel, who in one of the after-dinner rituals under the great spreading linden tree in the garden of the Rênal home, decides suddenly to win the hand of the unsuspecting–and for the moment, innocent–mayoress.

The years that followed brought a series of twists and turns in my destiny that I will leave out; but I soon found myself reaching out for the hand of the city I had dreamed of; and that hand reached back, and clasped mine. With a group of friends who were also businessmen, I was about to purchase a company in North America that manufactured and marketed lingerie throughout the United States. The purchase went through without a hitch. From one day to the next I found myself in New York. I was young, I was free, and I was ready in spirit and mind. Like in any self-respecting dream, the company offices were on Fifth Avenue, at the corner of 44th Street; I had an office with a fine corner window. In the U.S.–which may be the last place on earth where form truly coincides with substance–this meant that I had really amounted to something.

I had never met Emilio Pucci, but of course I knew his reputation; I was very pleased to learn that my new company's designer collection had been created by Pucci. At that time I understood very little about fashion (and about lingerie). I was even surprised to learn that, since this was a company that manufactured women's underwear, the halls were always full of beautiful girls wearing nothing but panties and bras, and that executives were expected to act as if this were the most natural thing in the world.

I was particularly pleased to be a friend of Emilio Pucci. I did not realize at the time what a piece of good luck it was to find a teacher like him. Seeing him work, and speak, and persuade people, was a great education. He was an organizer and a promoter of the first order, a man who had a deep and abiding respect for image. Pucci knew just how important image is for any product, including the product that is Italy. When we made presentations of our new collections to the sales force–about a hundred people, mostly women, of all ages and from every state in the Union–we would serve up Emilio Pucci as the main dish. He would climb onto the stage with the loose-limbed grace of a toreador entering the ring. His relaxed and supple agility was truly unique. Then he would begin to speak, in an English that was much better than that spoked by most of the American sales force. The salespeople (again, mostly saleswomen) were stunned by Pucci's grace and presence, by his impeccable English, and they would gaze up at him, eyes wide open and dreamy. And he, smiling and perfect (a perfect Italian Marchese), would tell little anecdotes, stories from his remarkable life, one of the countless stories of his countless lives: he had been a champion skier, an aristocrat without a Palace, a fighter pilot, a war hero, an amateur couturier, the founding father of Italian style, a great international name in design, an aristocrat again, but this time with a Palace, or rather a Palazzo, and so on and so forth.

Emilio was very pleased that the company for which he was designing lingerie had been purchased by Italians, and he would explain to me that Italians have a different sensibility; when he would say that, I, who did not feel this different sensibility in the least, felt in some way inadequate–and, for just a moment, I would feel slightly unhappy next to this incredibly happy and entirely adequate man.

When Emilio was in New York, he lived in his apartment at the Sherry Netherland; this of course was the most chic place in the city. I would often come to see him there, to talk about life, fashion, America, Italy, Italian women and American women. Emilio Pucci had a remarkable understanding and respect for women, for all women–this understanding and respect was almost professional, I might say vaguely automatic. He knew his work thoroughly and well, and when he was trying out a collection and there was something not quite right, he would immediately spot the precise problem. He would pinch the defect or problem between thumb and forefinger, and–poof!–the problem would disappear.

At first, when I was still looking for a place to live, I would stay at the University Club, Emilio would tell me that the place was elegant but, in his estimation, just a little drab, and more than once he had offered to let me stay at the Sherry Netherland when he was away. He had always been kind and generous with me, and the fact that I was an Italian who had left Italy pleased him somehow. For him, Italy was an endless source of love and hate. Italy was the most wonderful country on earth, with the most marvelous people anywhere, but it was also the country with the worst politicians and the worst bureaucrats. Emilio had singled out Italian bureaucracy as the worst bureaucracy on earth. He would say to me. "Beware of Italian bureaucrats! Bureaucrats and corporations will kill us in the end." Then he would smile and say, "But then, what do you care? You have escaped from Italy, you life in New York City." Then he would smile, and then, finally, at the end, he would grow serious again and say, "Still, it's a pity." You

could see that he really couldn't get over that nasty little Italy of bureaucrats, provincials, parvenues, and politicians who didn't even speak a word a English–the whole band of what he would call the "unexportables." If that little Italy–that "Italietta"–made him suffer, it was because he had an enormous respect for the real Italy, or for what could have potentially been the real Italy. Perhaps he had too much respect for that potentially real Italy.

As I have said, the thing that Emilio Pucci knew how to do best, the thing that he loved and understood most, even more than designing his collections, was promoting events, ideas, occasions. Without a doubt, Pucci was the most remarkable promoter that I ever met. If I have learned even a little bit of the stuff that is required, and above all the spirit that it takes, I certainly learned it from him. This is just one more reason why I am pleased that this first retrospective of the work and life of Emilio Pucci should be presented by the Biennale di Firenze.

When Emilio Pucci rode down Fifth Avenue on a prancing white horse, wearing a hat with a long plume and the cuirass of "calcio in costume," the crowd went mad with delight. He knew it perfeclty, and he wore that medieval costume with the pride of a Florentine aristocrat; and yet he was also keenly aware of the value of the image in terms of marketing. And the felt and knew both things at once, in perfectly good faith; indeed, one aspect was child to the other, and both were inextricably, indissolubly linked.

One day, Emilio and I left the office together, and we walked up Fifth Avenue toward the Sherry Netherland. It was a bright, sunny day, and the wind was blowing and the sky was blue the way that it can be only in oceanfront cities. The many American flags were tossing in the wind, and the sun was glinting off the roofs and the gold domes of New York City. At a certain point, Emilio stopped and said: "Think about it! What if we could have the procession of the Palio here on Fifth Avenue? What if we could run the Palio in Central Park?! What an incredible promotion that would be for Italy!" And he was not kidding. He immediately began planning, and scheming. He said, okay, we would have to start the procession from Washington Square north, toward the park, which means heading against the normal direction of traffic... already he was visualizing (and making me see) the colors, the banners, the costumes of the "contrade," or quarters–the Nicchio, the Onda, the Oca, the Aquila, the Pantera, the Liocorno, and the Istrice (each banner depicting an animal or object, symbol of the quarter: the Fish, the Wave, the Goose, the Eagle, the Panther, the Unicorn, and the Hedgehog). He was already imagining (and making me imagine) the procession as it passed before us, with the flag-tossers and banner-wavers, who would stop when the procession halted, and as trumpets sounded, they would toss the banners pinwheeling into the air, up to the second floors of the skyscrapers, in an explosion of fluttering cloth and spinning flaming colors.

Emilio started walking again, and as he walked he mused, saying "Not a bad idea... the Palio in New York," and he told me (though I knew it perfectly well) that he had already featured the Palio in one of his most famous collections. Finally he said that if I liked the idea, it was his gift to me, and I was free to try and make it come true. By that time we had reached the Plaza, and so we walked off together to have a drink at the Oyster Bar.

Katell le Bourhis

Emilio Pucci: an American Success
1948–1992: the Socio-Cultural and Fashion Context
of Pucci rise and Triumph in the United States

Emilio Pucci, Marchese di Barsento, was born to an illustrious Florentine family.

He spent his childhood in palazzi and villas, studying with tutors and in religious boarding schools. A gentleman athlete in the period between the two world wars, he was chosen in 1934 to compete as a member of the Italian national ski team. Flying a bomber in the Second World War, he became a hero of the Italian Air Force. He gained the reputation of a lady's man, as well.

With the education and the personal history described here, how on earth could Emilio Pucci, Florentine aristocrat, bomber pilot, and dashing adventurer, have become—and remained for thirty years—"The Prince of Prints," at least according to the English-language fashion press?

This remarkable story began in 1948. The December issue of *Harper's Bazaar* published a splendid photograph of a stylish skier, none other than Emilio Pucci, and his ski outfit was designed by none other than himself. This high-society photograph immediately caught the eye of American fashion professionals—at White Stag and Lord & Taylor—and marked the beginning of the surprising and spectacular career of the Marchese Pucci, fashion designer. "The Neatest Thing on Two Skis," was the headline over a story that appeared in "Harper's Bazaar" in January 1950 about the creations of the Marchese Pucci. In 1949, while he was vacationing on Capri, a sort of latter-day earthly paradise, he set out to design, for a girlfriend of the time, a wardrobe of clearly Mediterranean inspiration: cropped pirate pants, straw hats, thong sandals, mannish blouses, and sun dresses. He set local seamstresses and craftspeople to work manufacturing simple styles, using natural materials that he purchased on the site.

The American press dubbed him "Emilio of Capri," and he became the symbol of a fresh and fun style, wrapped up with the image of sunny beaches and idle luxury.

In 1961, Emilio Pucci received the American Sports Illustrated Award.

These were the years of the baby boom, of outsized pink refrigerators, of enormous station wagons, with AM radios blaring out *Don't Step on My Blue Suede Shoes*, Elvis Presley's latest hit.

Country clubs were the focus of social activity in the suburbs, and their members were

595

subject to a strict dress code. It was the time of cocktail parties and dinner-dances; once again women danced in swirling strapples gowns, based on the latest Parisian fashions.

Emilio Pucci, with the considerable advantage of his alluring image as a Florentine aristocratic, was able to profit from this vacuum; he was further benefited by the mistrust of the leading American department stores in the fashion design of their own nation.

Pucci was an enthusiastic traveler, and as such he was keenly alive to the needs of other heavy travelers. These were the years in which civilian air travel was becoming popular; this new way of moving from beaches to ski slopes, from snow to sun and back, made mass tourist migrations faster, more international, and with new needs for dressing.

The department store chain of Lord & Taylor's, having introduced Pucci's skiwear collection, was the first to distribute the Capri line; soon other major retailers followed in their footsteps, among them Neiman-Marcus and Sak's Fifth Avenue.

So what did the Pucci collections consist of? Sun or shirtwaist dresses, slim pants and full skirts in light poplin, cotton satin or gauze, often printed in naive, figurative pattern on a white background. The patterns featured motifs taken from Mediterranean culture: Doric columns, hieroglyphics, Sicilian carts, the heraldic devices of the "contrade," or town quarters, that raced in the great Palio of Siena…

Emilio Pucci was one of the first designers to allow fashionable women to wear slacks at meals, in the countryside or at the seashore. Pucci's slacks were always narrow, unbelted, and fastened with a zipper along the side; they enhanced the feminine shape, and flattered the figure. They were made of solid-colored Shantung silk, in a broad and subtle range of colors: Tirias pink, Neapolitan yellow, Veronese green, Nile blue… fabrics from the silk mills of Como, the same mills that supply the "Haute Couture" of France. The slacks were worn with mannish shirts, made of printed silk twill, and could be worn loose, or else knotted in the front, or gathered with a wide belt. It was simple, neat, and elegant: a formula for success in the United States.

When Emilio Pucci started selling his first printed jersey dresses, did he realize what a goldmine he had stumbled upon? The first dresses weighed 248 grams, and cost their precise weight in gold (200 dollars). To protect his label and reputation, the prints at this point began to bear signatures: "Emilio." With that, the media began to call the Marchese Pucci the *Signature Prints Prince*.

In 1959 Emilio Pucci—then one of the most incorrigible and eligible bachelors around—met a young Roman baronessa in his boutique on Capri. Her name was Cristina Nannini. Pucci married her, and later said of her: "I married a Botticelli." Lovely and graceful, the young Marchesa Pucci became a muse for her husband. The couple constituted a perfect "showcase" for the creations of Pucci; their image contributing notably to the label's publicity value. It seemed as if Emilio Pucci wished to intoxicate American society and the American media: his prints were everywhere.

The Marchese and the Marchesa Pucci lived in Florence in an immense palazzo that they had restored, with production on the first floor, and sales in the second floor ballroom. Their staff was numerous, skilled, and stylish—and the eye of the owner was on them always! American fashion journalists and buyers, hungry for the noble and princely touches that were lacking in the American republic, were captivated. Seduced and bewitched, they purchased *en masse*.

In the sixties, one-third of the population of the United States was not yet old enough to vote. These were the years of Pop Art, the Swinging Sixties. And it was in this context of rebellion and of "youthism" that Pucci, a refined aristocratic of more than fifty, had to measure himself with a gaggle of young fashion designers who sprung up spontaneously out of this counterculture.

Pucci was at the same time a forerunner and an exception. The lightness and simplicity of his fashion, the cheerful optimism of his colors (especially the printed silk jersey minidresses and the printed shirts and the matching shantung slacks), were all perfectly suited to the shifting desires of the public.

Despite the generation gap, Emilio Pucci and his revolutionary new *Capsula* were both well ahead of their times ("Barbarella" was not made for another seven years). Pucci thus allowed the establishment, which formed the core of his traditional clientele, to pursue the new modernity without conflict and without awkwardness, far from the radical styles of the street.

These were the years in which Puccimania filled the headlines of American magazines and newspapers, and raged through the United States. Pucci designed everything, from pants to pantyhose, to towels and linen.

The final spark that truly set off the Puccimania, in a widespread collective feeding frenzy, was struck in 1965 with the introduction of the Pucci perfume *Vivara*, dubbed with the romantic name of a desert island not far from Ischia. The print fabric that sheathed the box—an abstract composition in which sharp-edged geometric forms were set adjacent of kinetic wave patterns, in a harmonious composition of ultramarine and Chinese blue, on a white background—was itself a spectacular success.

It is safe to say that the Marchese Pucci was one of the first to have achieved, in his business life, a true symbiosis between creativity, communications, and marketing, so as to develop a global image, necessary to the identity needed to sell luxury products.

In 1973 the oil crisis cast a shadow over society, and over the great dream of endless progress. The recession engendered widespread pessimism, a retreat into oneself, and a yearning to flee into nature, spirituality, or any of the artificial paradises. There was an immediate fragmentation of community, an end of shared desires and dreams.

Extremists in black ski caps began to engage in terrorism; fashion magazines announced: "There are no more rules: Anything goes."

Fashion took refuge in nostalgia. This meant success for Neo-Victorian designers like Laura Ashley, or the American Ralph Lauren, with his Prairie Style, taken from the early American pioneers.

Puccimania had given way to jeansmania. A "schizophrenic" non-fashion took over, reflecting the confusion of the moment: maxi overcoats were worn in the daytime, with velvet or satin "hot pants" and with platform boots.

In this socially and ideologically ravaged America, traumatized by the Watergate scandal and by the end of the Vietnam war, there was little room for the elegant and light-hearded brightness of Pucci. The demand for print fabrics dwindled and died. Department stores such as Lord & Taylor's, Sak's, and Neiman-Marcus, strongholds of Puccimania, reduced and finally discontinued entirely their standing orders.

A hard-headed businessman, Emilio Pucci decided at this point to do his own distribution.

He opened a Pucci boutique in New York, and sold his creations to the faithful, who still sought out a certain form of casual elegance. The boutique was located on the upscale East 64th Street, in a handsome building decorated with framed scarves, which even covered a double door. The rear-guard of Pucci women, still numerous throughout the U.S., made this boutique a sort of shrine.

In the late seventies, Pucci's style became less and less distinctive. In the prints, the abstract now mingled with the realistic.

In these more difficult years, the Marchese continued all the same to be busy and incredibly productive. He visited Cape Kennedy, where he met the astronaut David Scott; Scott, in 1971, to Pucci's immense surprise and even greater pleasure, asked him to design the insignia of the Apollo XV moon mission. On 25 July, in *The New York Times*, the Marchese Pucci stated that his abstract insignia symbolized "the three astronauts flying in formation. I wanted to give the feeling… of an object moving in space, in a streamlined capsule." In this period, the Marchese Pucci designed household creations of all sorts; now in New York a shopper would find, alongside Pucci's Spring Mills towel line, sheets, pillow cases, and framed scarves. He even designed a pen for Parker. In 1977 he was invited by Ford, the huge Detroit-based manufacturer of automobiles, to design the "Lincoln Continental Mark IV." Ford, with its Pucci-designed luxury car, joined with Sak's to launch in Detroit a joint promotional campaign of fashion and cars.

A number of American fashion journalists, too close to the Pucci phenomenon to be objective, quickly attributed the decline of Pucci's popularity to the fact that he had spread himself too thin.

In America of the eighties, style was influenced by the presidential couple, Ronald and Nancy Reagan, whose White House receptions were marked by a conservative style, power, wealth, money, and all that glitters.

In 1985, over seventy years old, Pucci, accompanied by his daughter Laudomia, with whom he was working at this point, appeared at the exhibition "Italia – The Genius of Fashion," which opened at the Fashion Institute of Technology: his intellectual curiosity had in no way diminished… Interestingly enough Emilio Pucci is probably the only fashion designer to have witnessed, while still alive, his own resurrection: the Pucci Revival!

Suzy Menkes, with her unfailing flair, was the first fashion journalist to understand that the return to the spotlight of Emilio Pucci's fashion was not the result of capricious and eccentric stylemongers, but that this was a piece of mainstream fashion.

On 6 May 1990, *The New York Times* confirmed the Pucci Revival, based on photographs taken by Bill Cunningham in the streets of New York. "When Pucci Met Lycra, It Was Love at First Sight", runs the headline, with an article presenting the new fashion of Pucci print pantyhose—both real and fake. That same year, when Emilio Pucci was already quite ill, the Council of Fashion Designers of America awarded him their special prize. Laudomia, his daughter and, in some sense, standard-bearer, accepted the award on her father's behalf, during a deeply moving ceremony at the Metropolitan Museum of New York.

On 10 October, "The Los Angeles Times" ran a long article on the Pucci Revival: Madonna, the extravagant new star of the nineties, wears Pucci! When the Marchese Pucci died, on 29 November 1992 in Florence, Carrie Donovan wrote for "The New York Times": "He personified a moment, rather a long one in history."

Emilio Pucci
on the ski slopes,
in a photograph
from the forties

Emilio Pucci wearing
a Renaissance
costume for the annual
"Football in costume"
parade in Florence

In a page from
"Harper's Bazaar",
December 1948,
reproductions of Pucci
ski outfits worn
by glamorous women
of the period

AN
ITALIAN SKIER
DESIGNS

TONI FRISSELL

• Visitors to the Alps report that the smartest women on the ski slopes are the Italians. The ski clothes on these pages were designed in Italy by Emilio, himself an expert and passionate skier, and photographed in Zermatt. They have been reproduced by White Stag for Lord and Taylor.

1. Miss Sally Booth in a poplin parka with a zippered pouch placed in the front like a yoke. Chamois, white, navy, gray. $19.95.

2. Emilio and Mme. Poppi de Salis. Emilio's "Streamliners," heavy worsted gabardine with a gathered cuff fitted *over* the boot top and battened down with leather straps under the arches. Black or gray. $39.95. With them, a matching shirt tailored to a skier's dream—its wing collar buttoned over a separate hood. $35.

3. Emerging from between the layers of Miss Booth's sweaters, another glimpse of Emilio's remarkable wing collar—here in blue and white striped cotton, the wing tips standing out sharply. $12.95.

• Opposite: Mme. de Salis in a yellow tie silk version of the ⟶ poplin parka. $45. The pants, in lightweight worsted gabardine, cut with extra fullness but not an ounce of bulk in their whittled grace. Emilio makes a point of pre-shrinking the fabric of his ski pants so that they keep their shape though soaked day in, day out. Navy, beige, gray. $35. For skier's tan: Elizabeth Arden's "Sun Gelée."

Madame Poppi
de Salis wearing a new
ski outfit designed
by Emilio Pucci
for Lord & Taylor's,
Zermatt, winter 1948

Ski outfit, 1957, with
slacks in "Emilioform"

Emilio Pucci with
the Princess Maria Pia
di Savoia, on Capri,
in the early fifties

Beach outfit: rafia and
straw hat and sandals
in Thong style, 1953

Sketch of Emilio
Pucci's boutique,
near the *Canzone
del Mare*

Emilio of Capri, cotton
bikini from the *Palio*
collection, 1957

Scarf with
the *Padiglione*
(Pavillon) pattern,
inspired by Botticelli's
*Madonna del
Padiglione*, 1959

Two outfits from
the *Palio* collection,
1957

In the restored ball
room of the old Pucci
family palazzo,
a model presents
the *Vivara* line

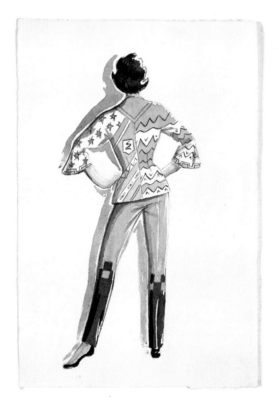

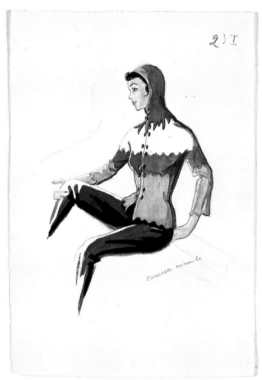

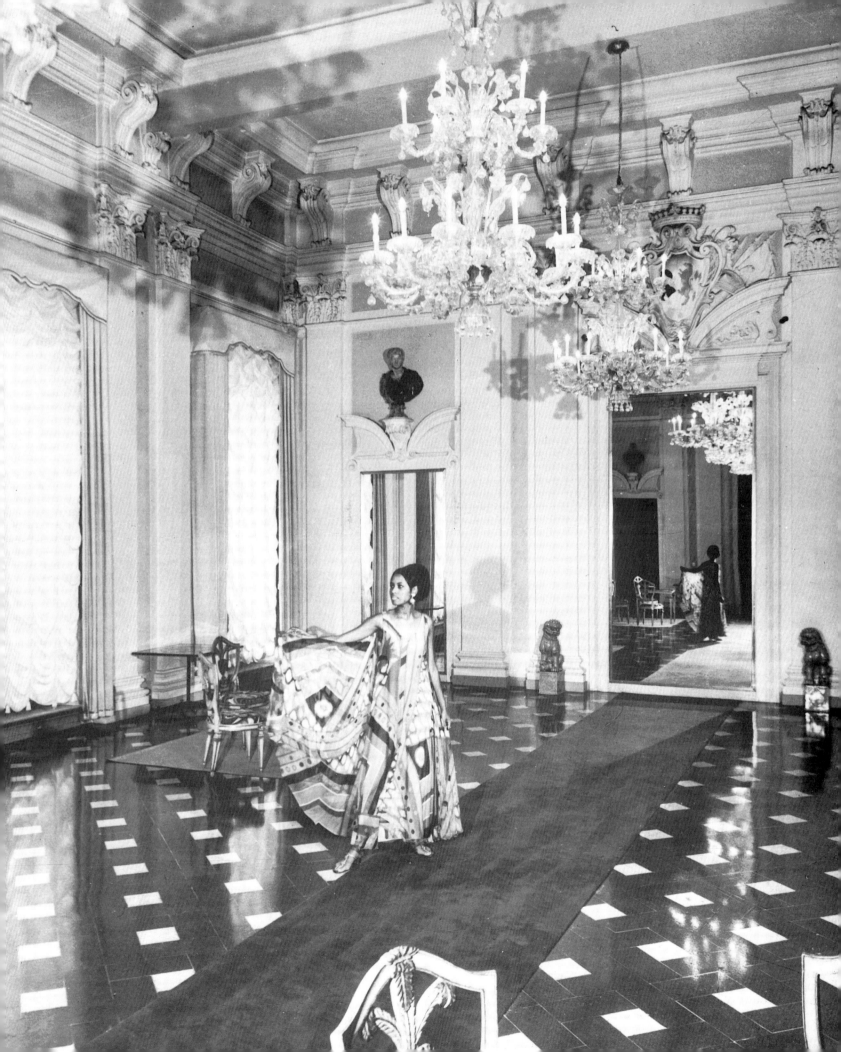

Capsula in
"Emilioform", 1960

Window arrangement
at Lord & Taylor's,
with Pucci outfis
and accessories, 1967

Chiaro di Luna outfit,
in printed silk crepe,
with the *Pesci* (Fish)
pattern

The stewardess Emma
Lee Pettibone wearing
a uniform designed
by Emilio Pucci in 1966

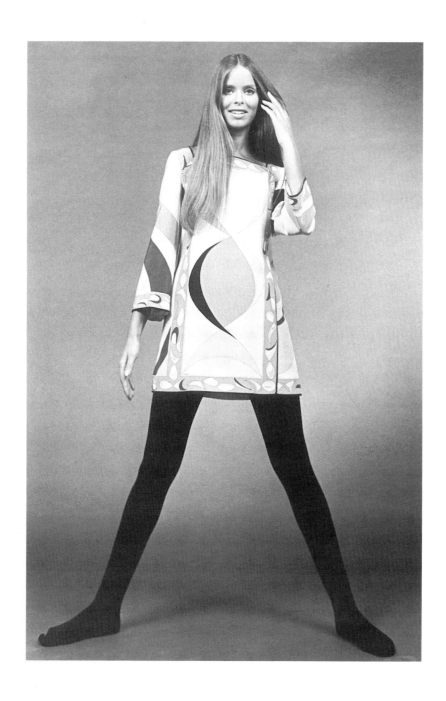

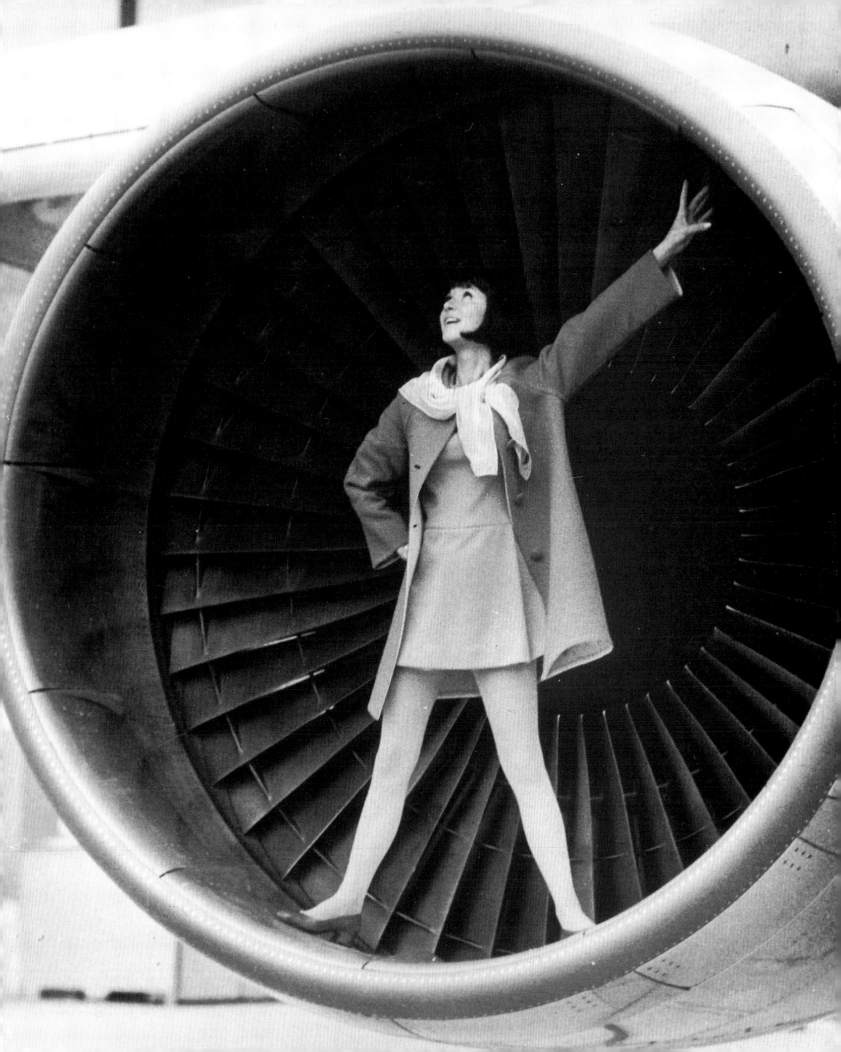

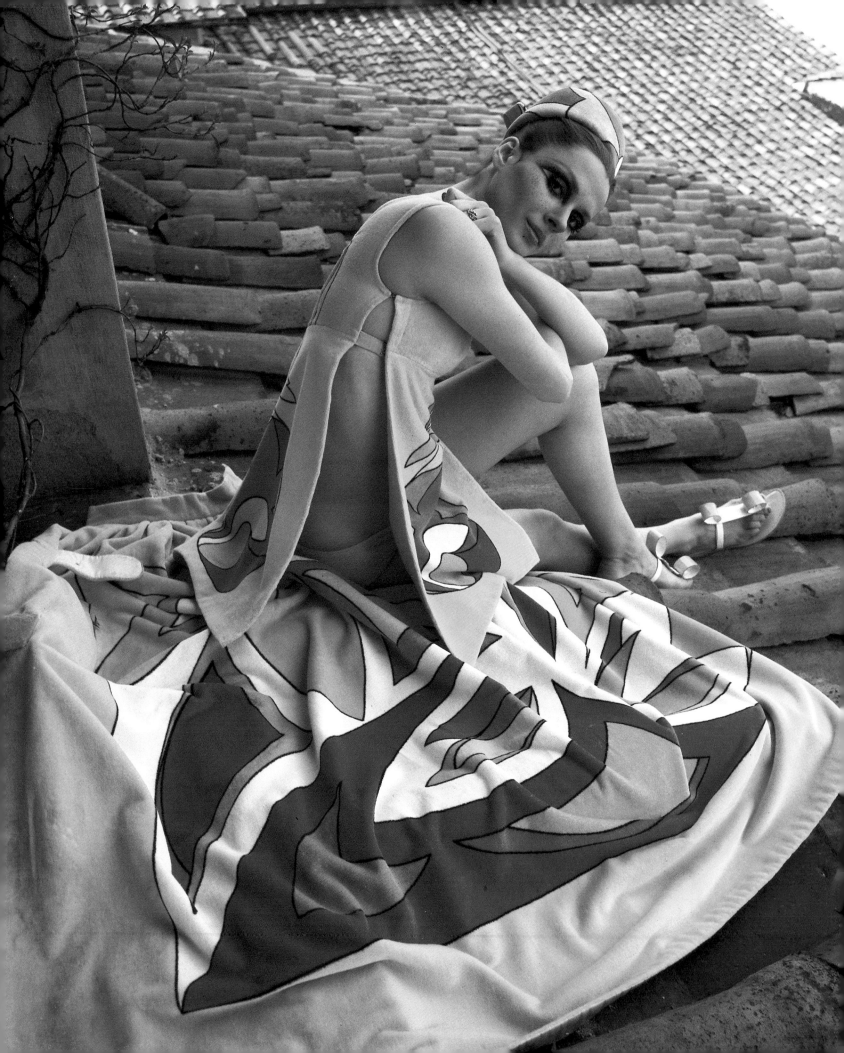

Terry cloth item
for Spring Mills

Lady Look collection,
spring-summer, 1992

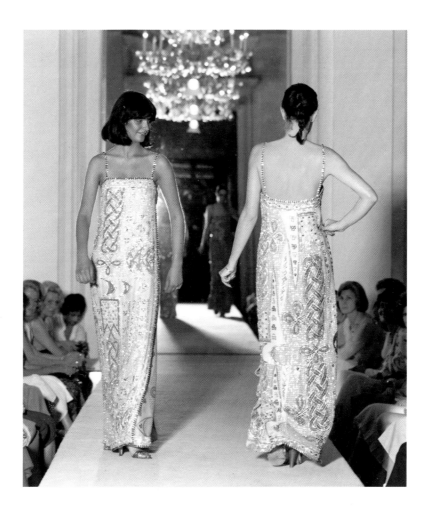

Van Johnson
with several models,
one of them wearing
the Capsula, by Emilio
Pucci, 1961

Alberto Sordi
with Gina Lollobrigida,
wearing a Pucci outfit
for the Film Festival
of Sorrento, 1966

Montage
of photographs
of the Pucci collections
from the period
of Puccimania, 1970

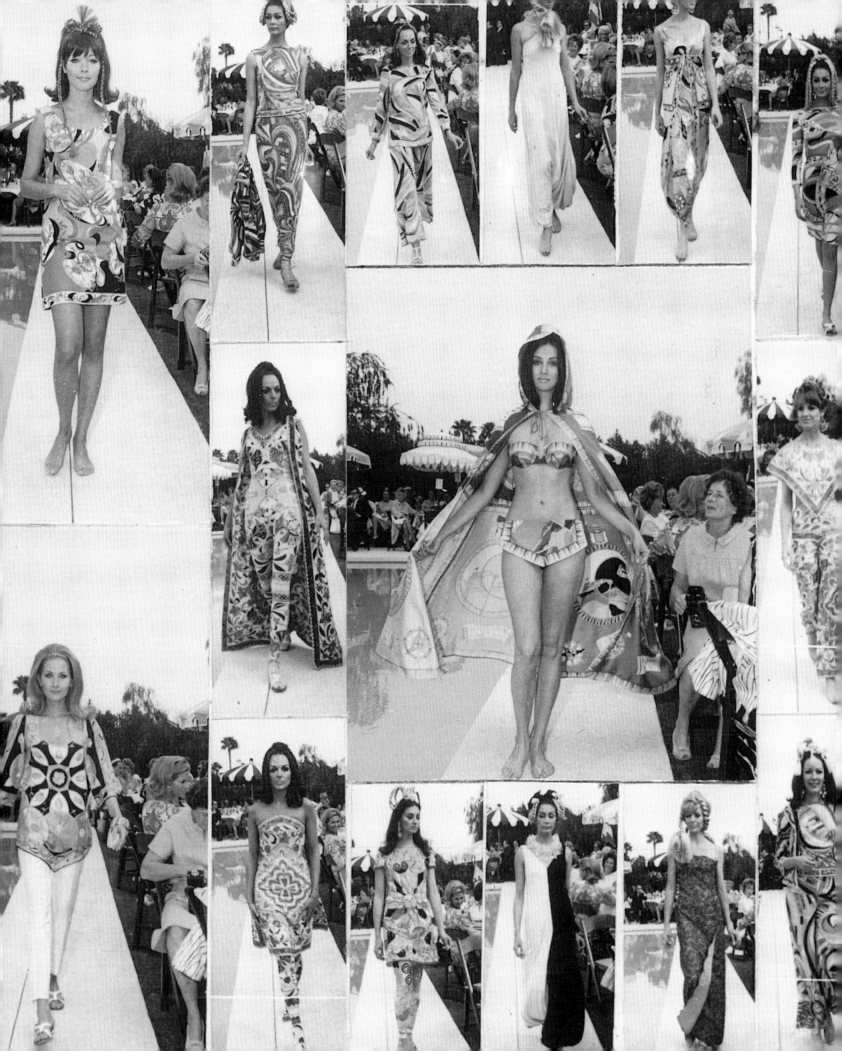

Bruce Weber Secret Love

Florence
Museo Salvatore Ferragamo,
Palazzo Spini Feroni

Bruce Weber Secret Love
Curators
Germano Celant
Martin Harrison

Exhibition
Coordination
Francesca Sorace
with
Dolores Guzman
Piergiorgio Leone
Secretariat
Laura Chimenti

Insurance
La Fondiaria-Florence

Transportation
Tartaglia Fine Arts Saima Servizi-Milan
Masterpiece-USA

Installation
Exhibition design
Adolfo Natalini
with
Giovanna Potestà

Technical consultants
Ufficio Tecnico Ferragamo

Catalogue
Edited by
Germano Celant

Coordination of production
Anna Costantini
Cecilia Torricelli

Graphic design
Marcello Francone

Germano Celant

Bruce Weber's Flashback

If one analyzes the statements Bruce Weber makes, in his various books of photographs,[1] to define the essence of his language, one notices that all the things he says are about remembrance and memory. They are stories and images of adolescence that have never faded and still have resonance. Murmurs and events of a past life that is still present and suspended in his visual and imaginative universe. They emerge from the recessed areas of family scenes and games and inform a photographic language that presents itself as an updating of bygone images, a coming-and-going from present to past that leads back to the present: "I want my photographs and my work, life, and everything around my photographs to have the same feeling I had as a kid growing up, with my grandmother photographing, and my dad and mom dressed up to be photographed, and my grandfather working in the garden being photographed, and all the dogs running around being photographed, and my sister yelling a lot and running around with a little movie camera. I want my photographic life to be an extension of that."[2] Past existence renews us in images, and photographs serve to reincarnate a "missing" feeling. They are flashbacks of vulnerable moments that represent a renewed encounter with oneself as child and dreamer.

Rather than bursts of new information, Weber's images are glances cast into the layers of his own interiority. They portray not the fashion or music world, not a love-scene or natural setting, but rather the depths of the human organism as it plays at its own regeneration. As we look at his photographs, we notice that his "actors" float in the landscapes, like shadows of flesh and sex, society and culture; sucked into Weber's gravitational field, they reflect the subjective universe of the artist, who has never cut the umbilical cord linking him to his adolescence.

Starting from an awareness that his work consists of "photographing your own life and your own feelings,"[3] Weber does not want to reconfirm the known and express the meaning of reality. Rather, he prefers to flutter around the missing, the things that belong to his inner, photographic eye. In this sense, his language can be defined as organic or whole, in that it aims to rediscover the genesis of his own growth as body and spirit. It catches flame and palpitates atop the profoundly layered inward and outward vision of a human being in process, Weber himself, as he establishes within himself the rhythm of existence. For Weber,

[1] *Bruce Weber*, Twelvetrees Press, Los Angeles 1983; Bruce Weber, *O Rio de Janeiro*, Alfred A. Knopf, New York 1986; Bruce Weber, *The Andy Book*, Shotaro Okada Publisher, Tokyo 1987; Bruce Weber, *Let's Get Lost: a Film Journal*, Little Bear, New York 1988; *Bruce Weber*, Alfred A. Knopf, New York 1988; *Bruce Weber*, Treville Co., Tokyo 1991; Bruce Weber, *Gentle Giants. A Book on Newfoundlands*, Bulfinch Press-Little, Brown & Company, New York 1994.

[2-8] All quotations are taken from *Hotel Room with a View: Photographs by Bruce Weber*. Smithsonian Institution Press, Washington and London 1992.

taking photographs means "photographing ourselves, our past and our future."[4]

All his photographs produce a surplus reality, since they extend his passions and frienships, his meetings and memories, to the point where they burst onto the stage of the present. As we line them up we perceive a journey through love and affliction, through happiness and sorrow, through sensuality and detachment. They do not describe, but rather participate and offer an affective vision of reality. They are narratives of often banal, everyday situations, presented as though "suspended," as if they had originated in a universe of dream, uncontrollable and undefinable.

Weber's very love of encounters with "unpossessable" subjects—such as dogs or children—is a way of discovering himself: "I used to put my dogs in every single possible picture I could because it was a way for me to find some kind of truth and some kind of passion." But it is also part of the search for an autonomous reality. Like dreams, these subjects elude any laws of control, and produce images of disconnected, unpredictable gestures, the movements of an obscure feeling and knowing that demand to be illuminated. In photographing them, Weber ventures onto an unknown path, that of an image that cannot be controlled because it is dominated by the irrationality given off by its actors. He accepts the challenge, conscious of "seeing things" both in terms of bodily comportment and in terms of his photography and imagination: "I learned a lot from my dog Rowdy just about people's body attitudes and a freedom of expression in motion and how they related to Muybridges's motion studies... So that's why I like photographing my dogs—they've been an inspiration to me."[5]

One could say the same for Chet Baker and Andy Minsker, for the newfoundlands, the teddy boys, the boy scouts, the Olympic athletes, and the surfers—exceptional subjects whose self- representativeness is spectacular in and of itself. In photographing them, Bruce Weber helps bring them to center stage, makes them valid just for being what they are. At the same time, however, their untouchability gives rise to a photography of life's astonishing germination: "I've always been interested in capturing that very vulnerable moment when boys are on the verge of becoming men, and the moment when a girl's on the verge of becoming a woman."[6] The photograph fixes their living fullness, articulates the infinitesimal breath of a sigh, a gesture, a look; it documents the plenitude of energy of a sublime or corroded body whose skin exudes happiness or pain.

This power, in both its positive and negative forms, is made to burst forth not through a simple "realistic" shot, but through an oneiric vision of the subject. The bodies' fits and starts come through a black-and-white element in a less than absolute form, almost dissolving, as though the image originated in a deeper, darker, state like that of dream. This sense of the past's emerging into the present, of absence becoming manifest, is particularly tangible in *Let's Get Lost* (1988), Weber's film and journal on Chet Baker. Here the cinematic takes and photographic shots merge and intertwine with filmic and photographic documents of the musician's life, eventually solidifying into a personal relationship based on remembrance and history as communicated by memory-images, snapshots and mementos. Here distinctions between banal and extraordinary, subjective and objective, become relative. They depend on a constant connection with, and detachment from, the image, which at times releases an autonomous force, at other times reflects a past experience of the photographer.

The intensity of the images lies in the balance Weber is able to establish between the real and the imaginary, where the two move about on the same threshold. They embody the power of the photographed object, whether this be a body or a room, an animal or a landscape, as much as they reflect the ardent, passionate vision, at once romantic and childish, of the person photographing them: "You are always proving yourself,"[7] says Weber. They let themselves be gently possessed by the desire of an elusive situation that allows them to be photographed and seen but never defined, because they are fleeting and transitory.

Flashbacks of a moment of beauty or happiness, of a love or a game, thus become mirages or apparitions objectifying the oneiric dimension of a perfect body, polished and harmonious, whose physicality and sensuality will vanish with time. They are film-moments that recount emotions and reactions, situations and visions of a journey in a train, a furtive kiss, a moment of drunkenness, a boxing match, a carnival, a dive or a concert, where the distinctions between before and after, memory and presence, become confused. In this sense, Weber's "cinematic photographs," those in which two different shots of the same scene are superimposed on the same negative, are indicative of this movie-like fusion and confusion of time and memory, here and elsewhere, in their continuous transit from one to the other. While the figures of athletes and models, of children and dogs, of nudes and clothed bodies, of actors and musicians, of heroes and champions, may be unusual, they belong nevertheless to the everyday world. They are scenes of the everyday world. Weber lets them exist without forcing or emphasizing them, as though they were an extension of the album-snapshots of his family, taken on Sunday afternoons: "I recently discovered my Dad's photographs of my family and I realized how much they influenced the way I look at things."[7] And in fact his images always are about family, in a sense, since the people and objects he photographs are part of his personal universe, and the friends or encounters, physicality or gestures, vistas or scenes they portray are every bit as valid as the artist's own back yard, his father's athletic body, the beach games with his sister, his dog Rowdy, his parents' displays of affection to each other.

At times these images come out in his books and movies—as in *Backyard*, 1994—as testimonies of a psychological relationship between past and present that reminds the viewer that the power of Weber's photographs is not purely intellectual and social, but rather profoundly linked to an intuition whose roots lie deep in a remembered past that the artist wants to recapture whole in the present. For this reason, his main contribution to the reinterpretation of the male body and its beauty not only passes through the neo-classical ostentation of the power of the muscular, well-proportioned figure sculpted by bodybuilding; it also lies in the lost and then recaptured melancholy and sweetness of jokes among friends, dangling swings, bursts of laughter, the pleasure in athletic leaps and childish gestures.

Such situations constitute a deviation from the traditional paths of photography—such as fashion photography, photojournalism, portraiture or scene photography. They open up a new, enigmatic dimension for the art, colored by an authenticity that comes out of the past and can produce a memorable vision of the present. A flashback of yesterday that by gazing on the stunning, perfect bodies of today, makes them the dreams and memories of tomorrow.

Open Secrets

Getting Bruce Weber to discuss his own photographs is not easy—though he will happily enthuse at length about the work of others. But so much of himself is invested in his photographs that they already hold the clues to anything we might care to know. Such is the breadth of their cultural reference that analysis is liable to miss the point—and the subtleties. (Though he is fond of adding words to his published photographs they function obliquely, complementing rather than explaining the images). And so, since I have always been a great admirer of what he does, this is not an academic treatise, rather some notes from a long-time fan…

Over the last thirteen years Bruce and I have talked on many occasions about our shared passion for photography. The conversations often turn toward an attempt to re-define what constitutes a fashion photograph. One thing we always agree on—it need not be limited to a picture published in a high-fashion glossy, showing a supermodel in a couture dress. Bruce has consistently stood against any narrowing of his own role, and is quoted regularly stating that "I can see a photograph on the cover of a newspaper which to me is a fashion photograph," or "There are some wonderful photographs in the *National Geographic* and I sometimes find a lot of fashion in them." Fashion, for him, has to do with people, with the style of a person. And the role of "fashion photographer," is one he is willing to accept if it is inclusive of someone who operates across the broadest cultural spectrum.

Something he said the second time we met I shall never forget. It was 1983, and we were sitting in his New York loft overlooking the Hudson river, on a dark, wet, winter's afternoon. Having asked him to name some photographers whose work he admired, he reeled off an incredibly long and broad list: it ranged from the classic perfection of Edward Weston to Bunny Yeager's glamorous pin-ups of the fifties, from Slim Aaraons's impeccably crafted glimpses into the homes of the famous to Saul Leiter's soulful portraits of children. It became clear that his receptiveness, his openness to different experiences, was part of the secret of his own extraordinary diversity. He is still perhaps best known for his fundamental re-visioning of the way we look at men. This is indeed a major contribution, but no one should overlook the full scope of his photography, which encompasses men and women of all ages, sensitive studies of childhood, touching and

witty images of animals, and evocative landscapes and interiors.

T.S. Eliot said that in striving obsessively for originality we had lost sight of the fact that, for most of art's history, tradition was regarded as something to be built upon, not discarded: in the past, the apprentice was expected to learn from the master. Equally, when Bruce draws inspiration from an artist whom he admires, he *builds* on their foundations, transforming the source into an expression uniquely his own. Earlier this summer we were discussing modern poets—Bruce had just shown me some marvelous photographs he had taken of his friend Allen Ginsberg, and in his loft I had noticed a framed poem that Patti Smith had written specially for Bruce about one of his favorite breeds of dogs, Newfoundlands. I began to consider how literary inspirations are almost as important for him as visual ones; even as far back as one of his first ever *Vogue* series, which was based on the novels of Willa Cather, this was true. Besides, he's always reading—though I still have no idea, in his crazy life with its impossible work-schedules, how he finds the time. But the writer who, above all, Bruce's work most often recalls for me, is another American original and free spirit, Walt Whitman. Both men warmly embrace the land and its people, and many of Bruce's photographs, though I'm sure it's not intentional, are like a visual tribute to the poetry of Whitman's *I Sing the Body Electric*. Both flourish within the context of the freedoms of the New World, respecting, yet ready to break with, tradition. In Bruce's case we see a native American distilling and celebrating the essence of Americanness—a poet of the lens. Parallels can be drawn with John Ford, Andrew Wyeth, or Andy Warhol, but his images can be situated within other extra-photographic traditions. They recall, for example, in their richness and density of reference, the multi-layered symphonies of the *avant-garde* composer, Charles Ives, another great celebrator of American life.

To stress Bruce's American-ness is not to suggest his vision is limited, or parochial. In fact he has photographed all over the world, from Vietnam to South Africa to Ireland. Here is a recent case-history, which I think explains something of his *modus operandi*. Earlier this year, while working in London, he shot a short film about Teddy Boys; at the same time he took more than fifty remarkable still photographs. It happened that, at the same time, I was re-reading Richard Hoggart's *The Uses of Literacy*, a study, written in 1957, of mass (working-class) culture. I was struck by the contrast between Professor Hoggart's conde-scension towards what he called the "depressing" Teds, with their "drape-suits, picture ties, and an American slouch," and Bruce's empathy, forty years on, with their descendants-in-style. Bruce had driven over to the Tennessee club in Tottenham, North London, where the Teds meet to jive to an authentically time-warped combo—all glistening suits, Fender guitars and winkle-pickers—and also buy vintage records. The photographs show racks crammed with rock 'n roll, rockabilly and doo-wop—*Ice Cold Baby, She Bops A Lot*, and *Baby Let's Platy House*. In spite of their American musical roots, the Teddy Boys might have appeared a fairly alien culture to Bruce. Yet the record-collecting was something they had in common, for as a teenager, Bruce told me, he himself had trawled record fairs across Pennsylvania, searching for elusive records. It was intriguing that he had sought—and found—a point of identification with his subjects, a way to document what they represented that was not only truthful, but meaningful in his own terms. He would surely acknowledge the inherently voyeuristic and exploitative aspects of photography, but seeks within this—and here is another important characteristic of his work—not to be judgmental.

Bruce was born in Greensburg, a small farming town twenty-five miles from Pittsburgh, Pennsylvania. I have never been there, and I know next to nothing about the place. But we can all feel we know something about how it was for at least one person to grow up there, for both Bruce's photographs and his films seem to be suffused with the story of his life. His childhood was not, by all accounts, an easy one. But it had its compensations, not least the thrill of sharing in both his father's and his grandmother's amateur addiction to photography. Then there were his father's home movies, the link to his fantasy life, growing up in the 1950s with an adolescent fascination with Hollywood heroes and heroines. This translates directly into the heart of Bruce's photography today. Sometimes his subjects are famous. Just as often, though, they are unknown, yet he imparts on these ingenues the same heroic quality, as if to underline that there is the potential in almost everyone.

There is a similar generosity in his attitude toward exhibiting his photographs: "I want people to say, even if they end up not liking me, 'Hey, I *know* this guy'." He wants, too, to do away with the mystique: "What I would most like someone to take away from a show of mine would be the inspiration to go out and do it for themselves. I totally reject the idea that you have to have a famous model, or need expensive designer clothes, to be a photographer. There are so many things to photograph out there. People should be encouraged to take a picture of their favorite flower, their kid, a car—anything. Sometimes we are too serious about photography. It can be many things—even serious—but don't forget it can also be playful, funny, or crazy."

A small town is, as Lou Reed said, somewhere you have—physically if not spiritually—to leave. So Bruce hit the road in the American tradition, like a second generation beatster. He still works pretty much that way today, constantly on the move, living as he himself puts it, "like a gypsy." There was the year he spent in Paris in 1969, hard-up, struggling to establish himself as a photographer. In what sounds like almost a self-imposed isolation, we see the development of the rigor and devotion to the cause that enables one of the kindest, most affable of individuals to see through to fruition his powerful visions. Like many great photographers, Bruce had no formal training in photography (though he majored in Art and Theatre at Denison University and studied film-making at New York University). But when he returned from Paris to New York he enrolled—with the encouragement of Diane Arbus—in a class with Lisette Model.

The association with two of the century's leading photographers is, no doubt, another significant clue to understanding Bruce's career. He learned that having an opinion, and the strength of conviction to see it through onto film, was more important than a facile gimmick or a slick technique: "Lisette taught us not to hang around waiting for people to hire us, but to do stories for ourselves; what I got from her was a belief in myself, the realization that I must only photograph what I really felt, what I was experiencing." He's no slacker at the technical aspects of the medium, nor at the graphics and dynamics of filling the frame, but what he's really about in his pictures is *emotion*. You always get the feeling from a Bruce Weber photograph that he has created, or encouraged, a scene which stems from his vision of the world, a kind of mini-drama in which he participates as photographer, sharing his open secrets with us all.

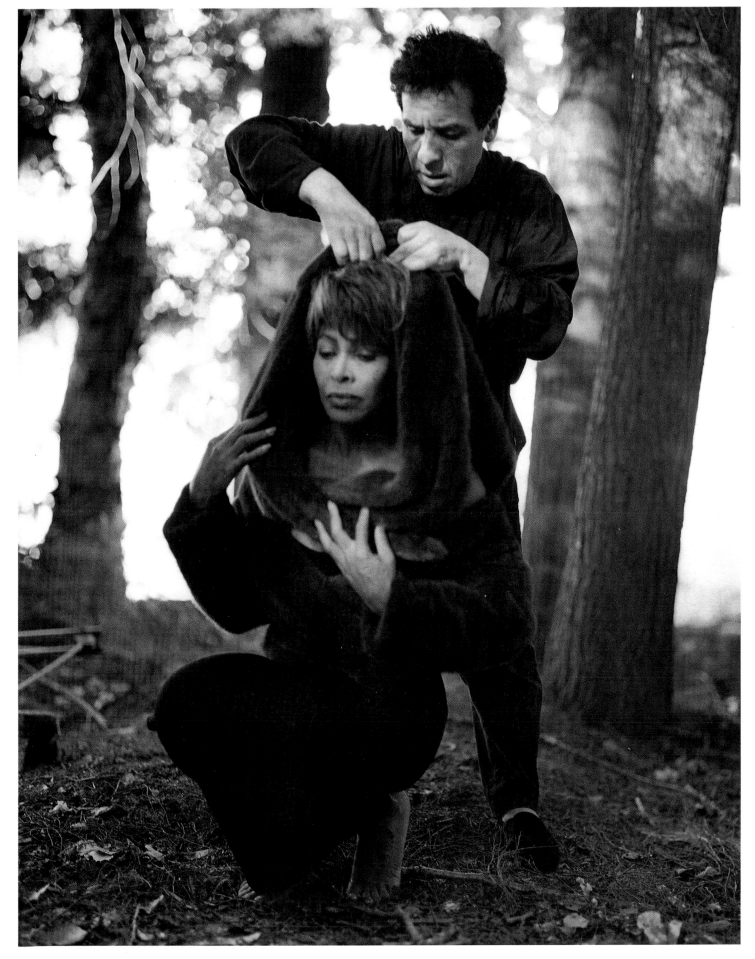

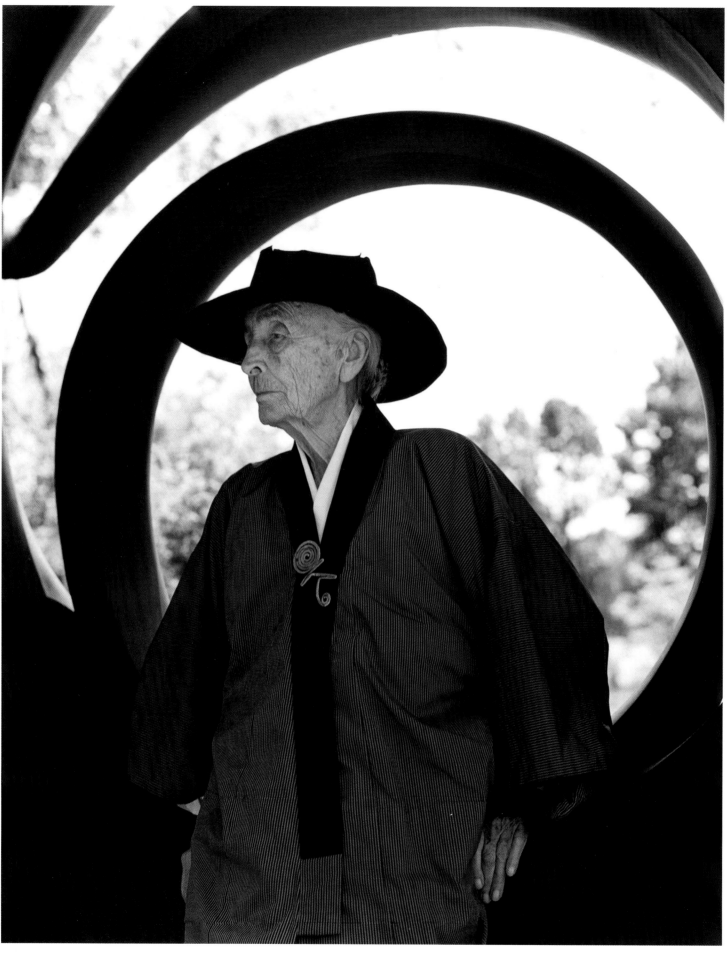

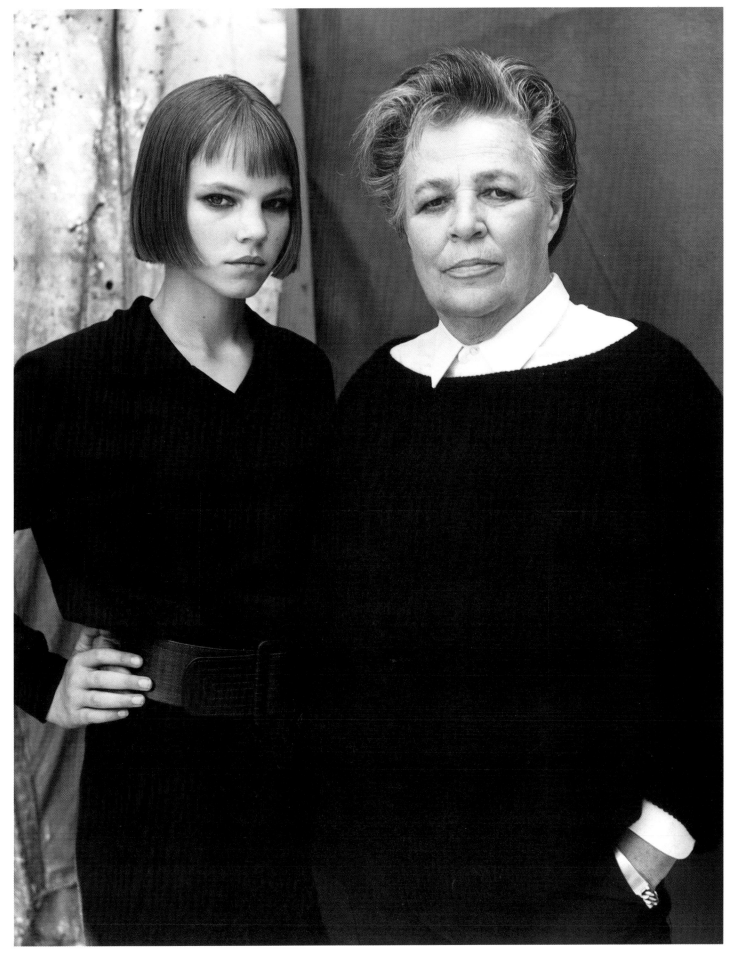

Bruce Weber, *Betty & Palm*, Bellport, New York, 1962

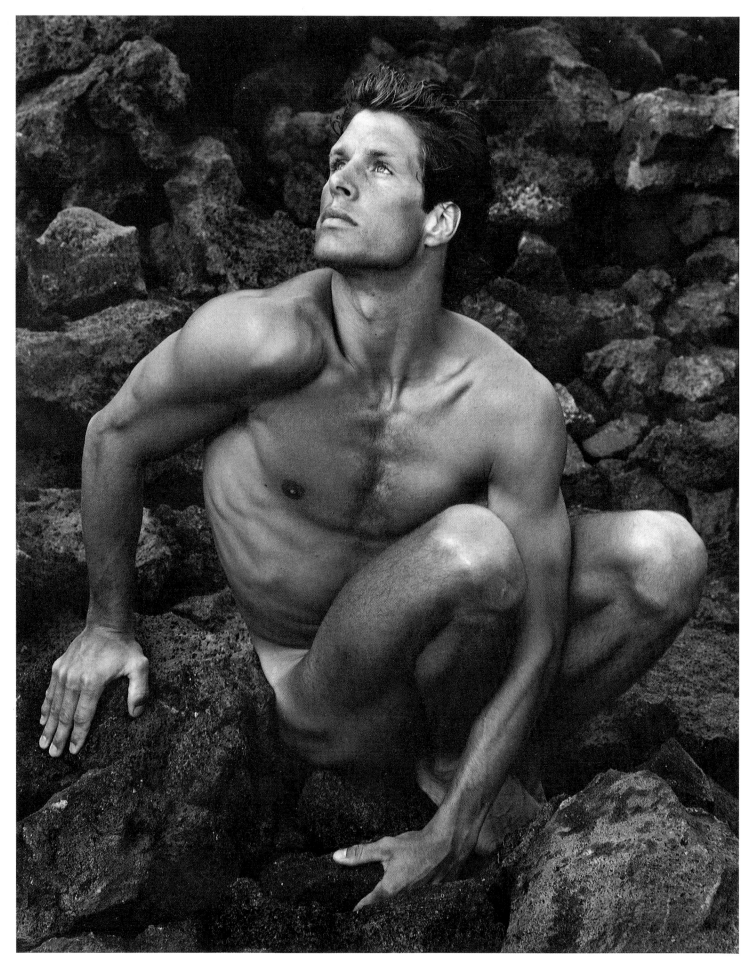

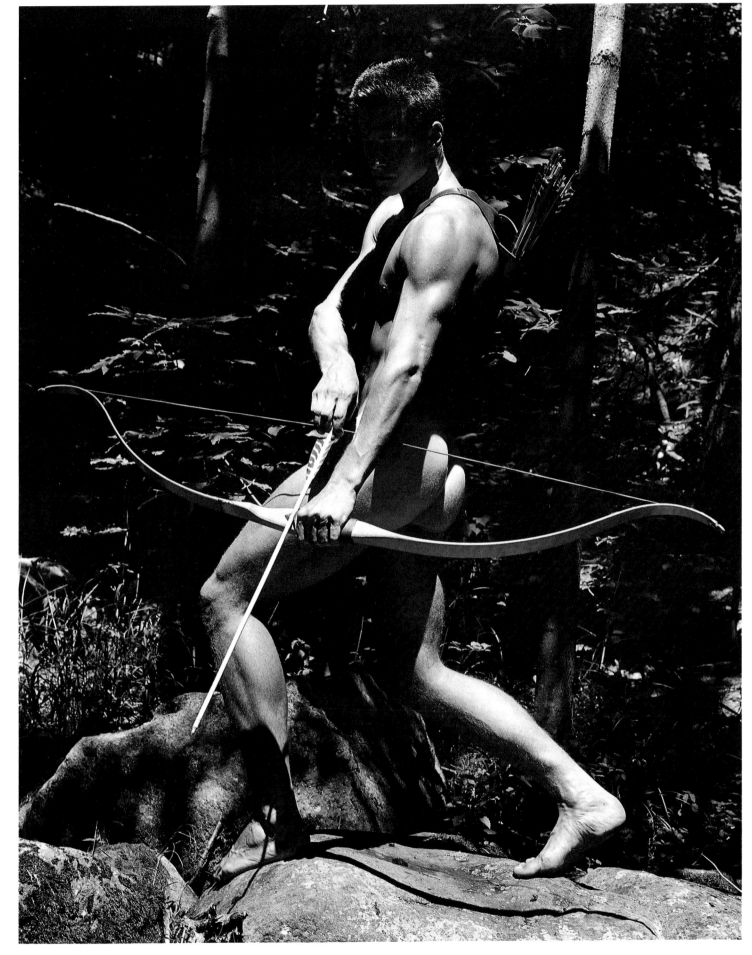

Bruce Weber, *Chris Ives*, Adirondack State Park, New York, 1983

635

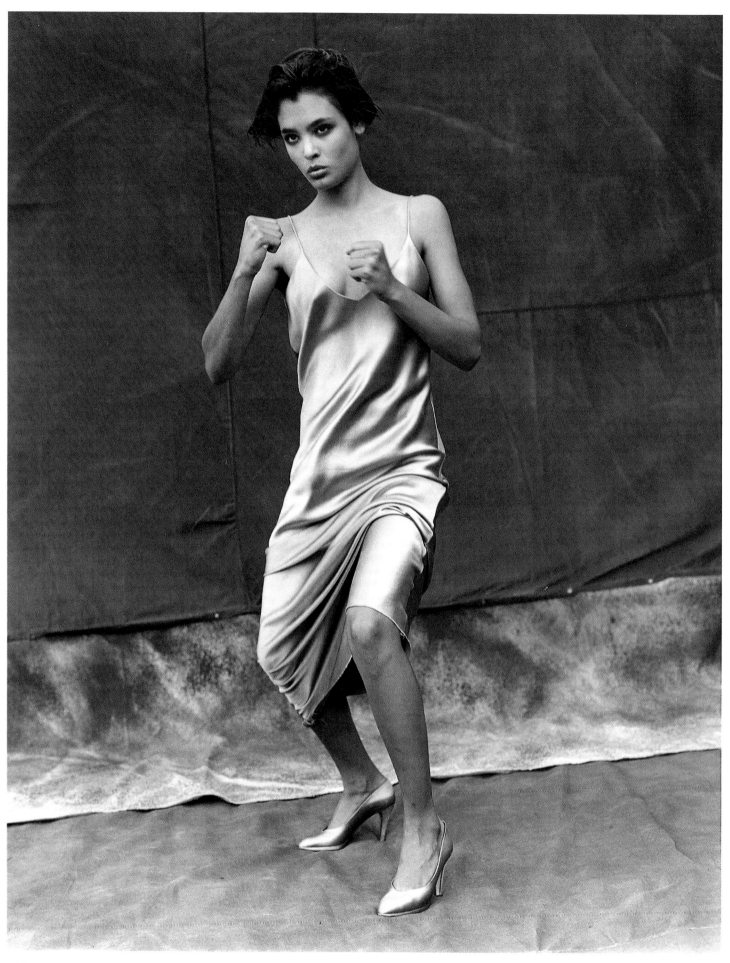

Bruce Weber, *Talisa, Bellport, New York*, 1982

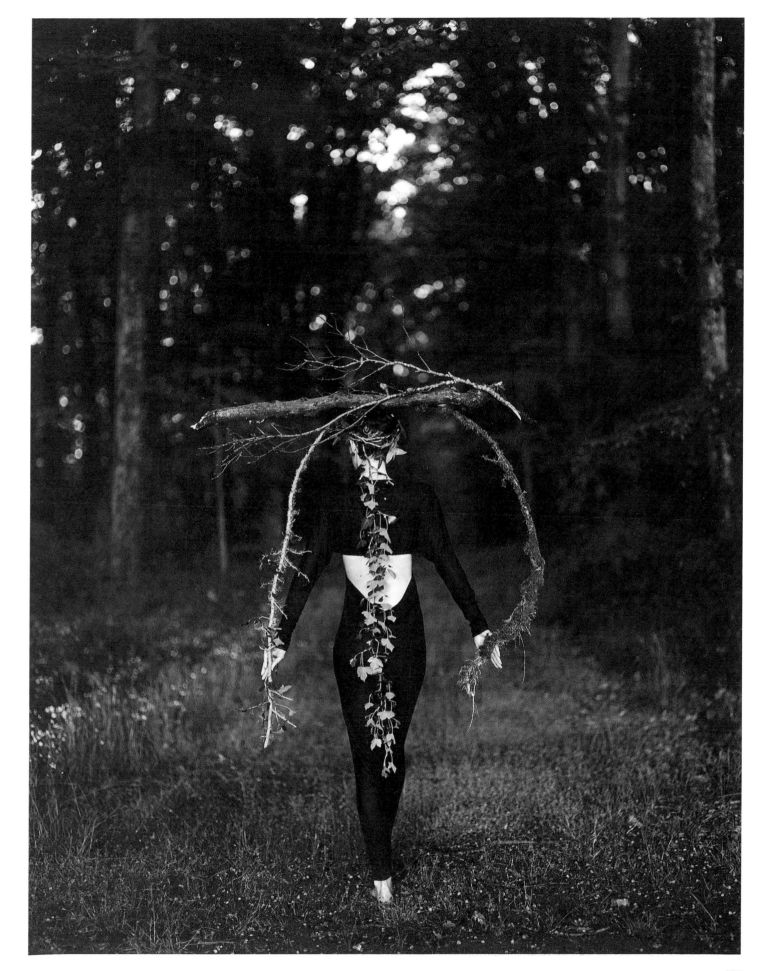

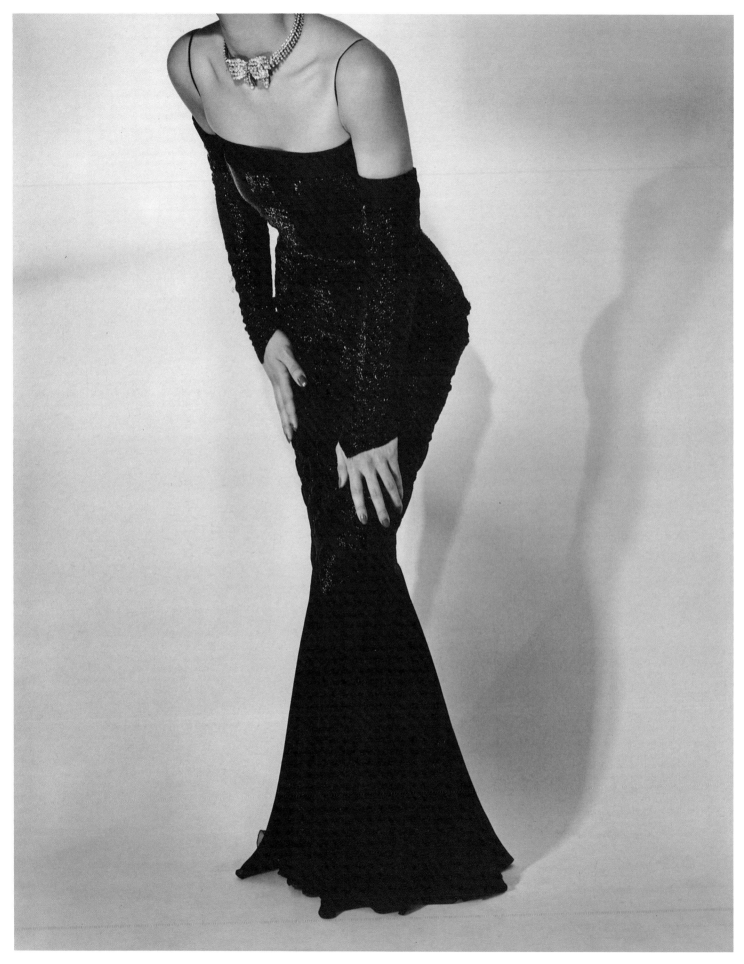

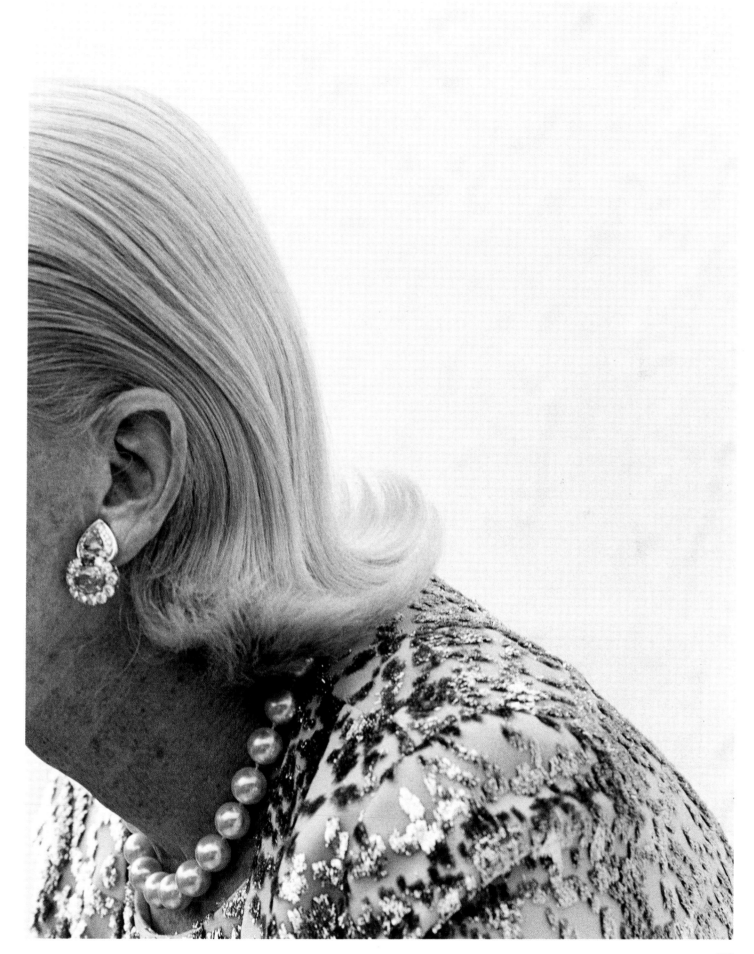

Bruce Weber, C.Z. *Guest*, Old Westbury, New York, 1989

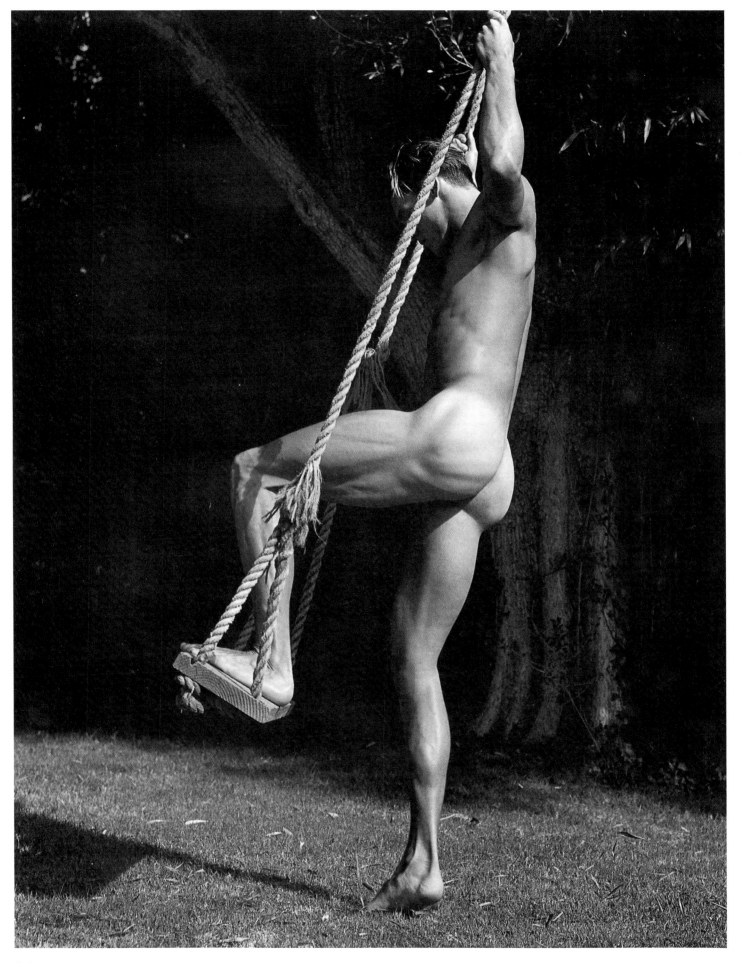

Bruce Weber, *Ric, Villa Tejas, California*, 1988

Bruce Weber, *Melanie in the garden*, England, 1984

Bruce Weber, *Charles James Dress, New York*, 1991

644

Bruce Weber, *Flea & His Daughter*, California, 1991

645

Bruce Weber, *Aretha Franklin, Bellport, New York*, 1991

Bruce Weber, *Marky Mark & His Bodyguard*, Miami, Florida, 1992

Bruce Weber, *My Golden Beach Studio*, Florida, 1994

Bruce Weber, *Paul Cadmus*, Connecticut, 1992

Bruce Weber, *The Gant at Little Bear Ranch*, Montana, 1995

656

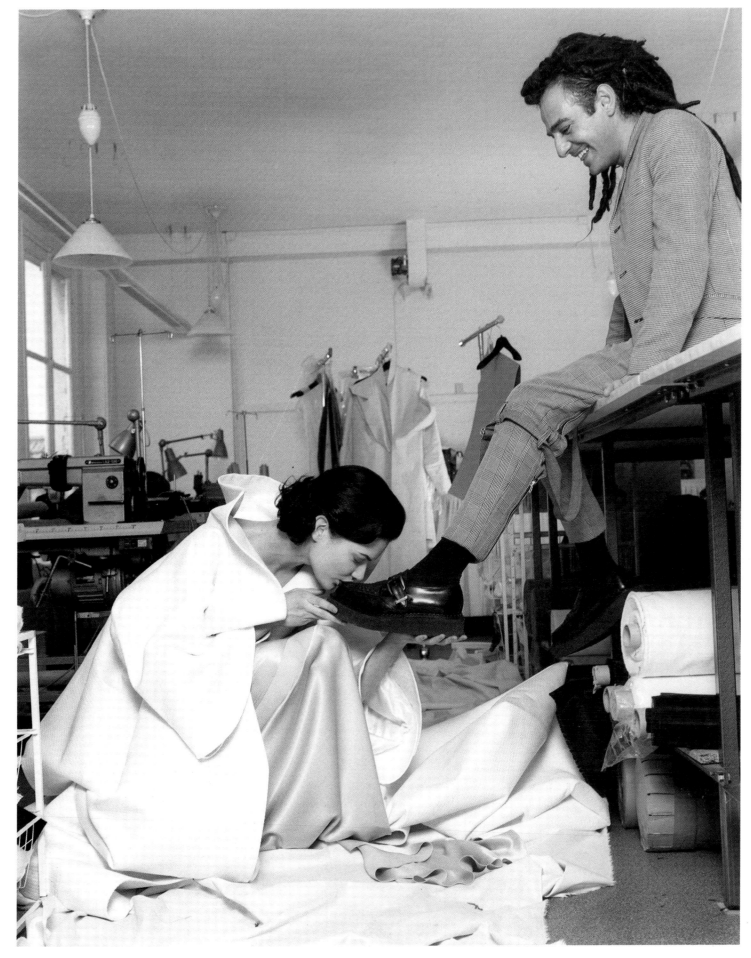

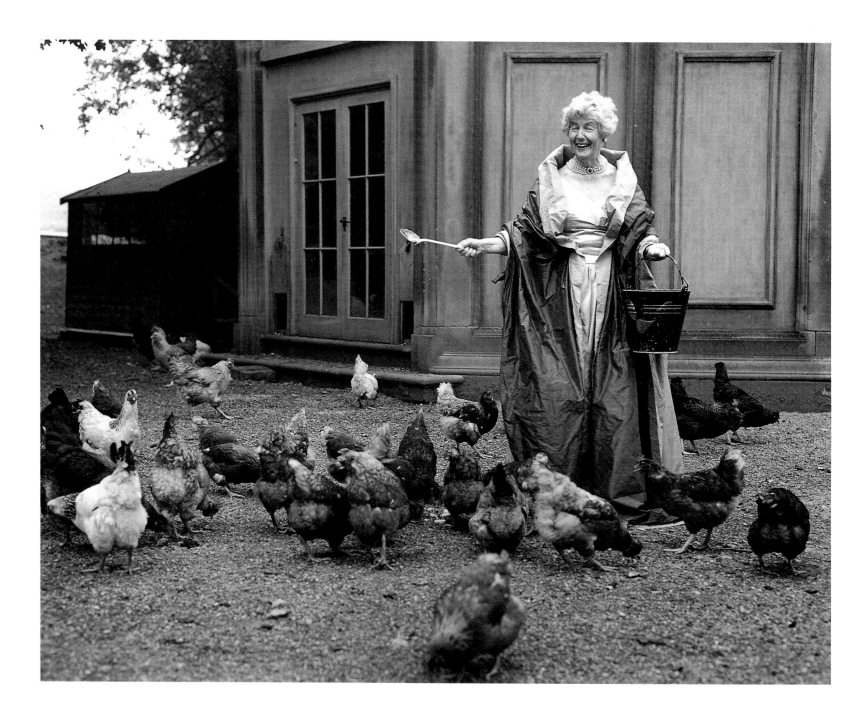

Bruce Weber, *Dublin*, Ireland, 1995

659

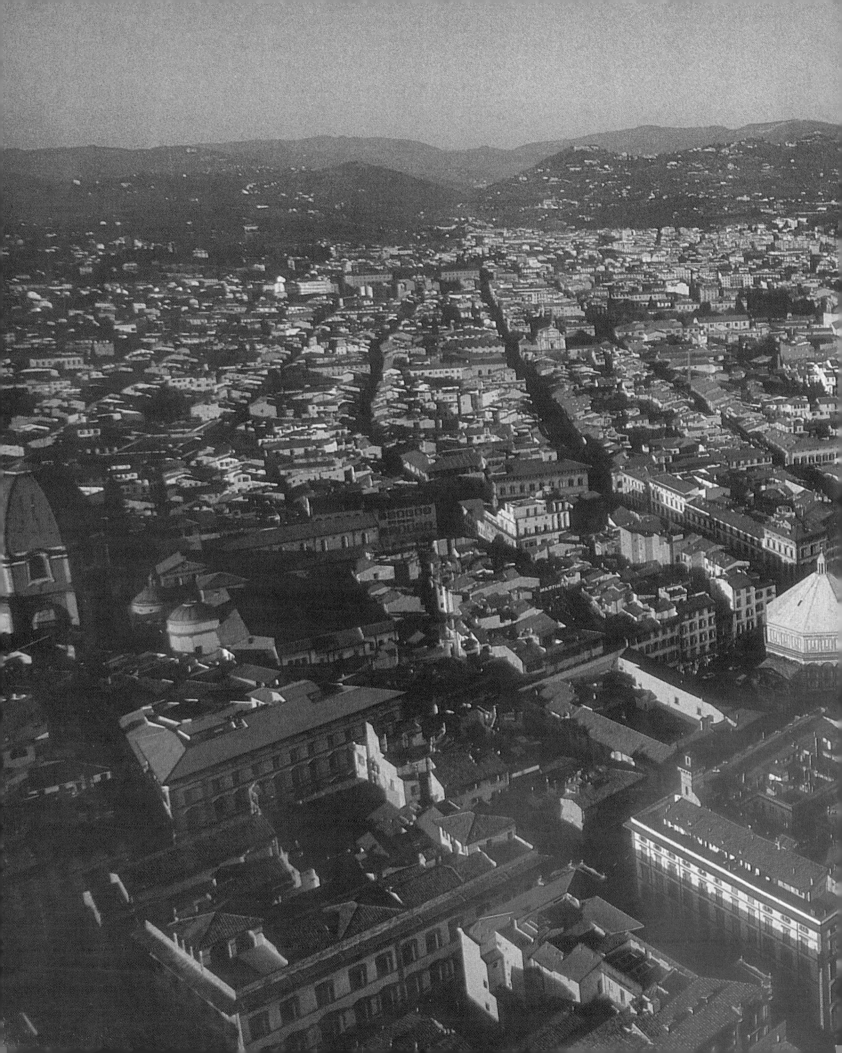

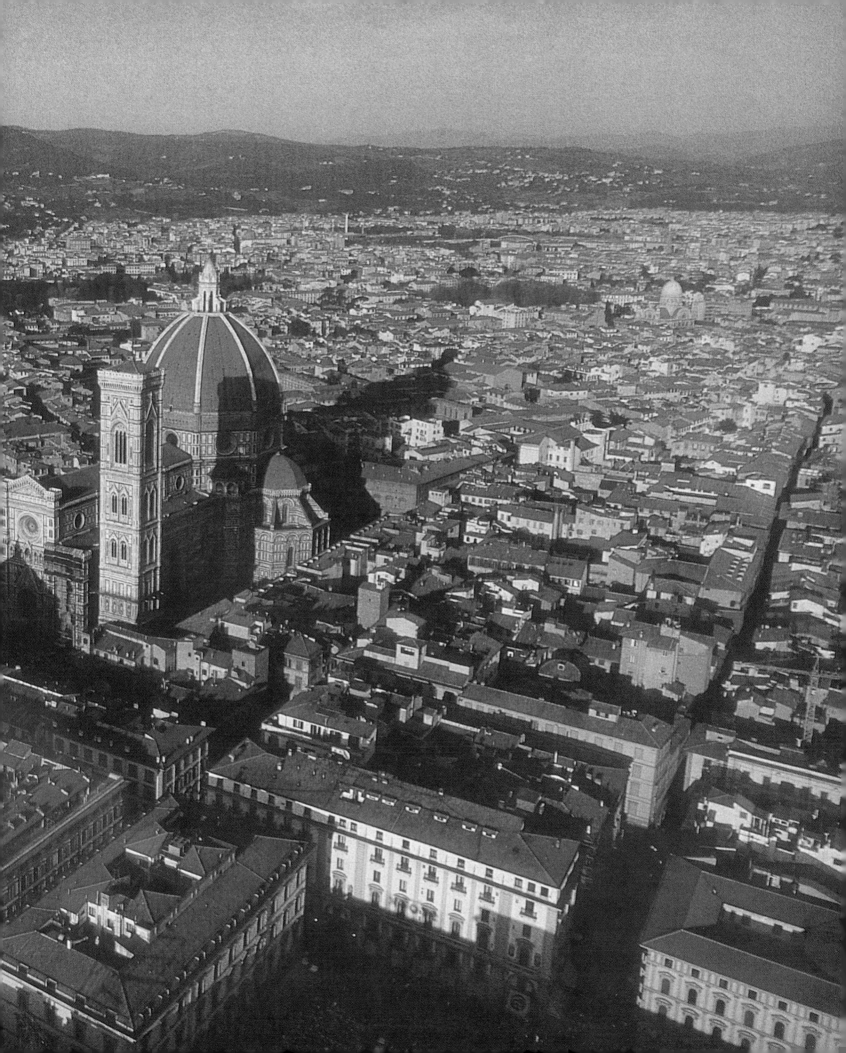

Gianni Pettena

Architectural Thinking and Projects

One often thinks of Florence as a historical, crystallized city where everything has by now been completed. After the great fifteenth-century dome, and the focal, definitive role it represents, there should no longer be any available space, be it conceptual or physical. And yet Florence, like the rest of Europe and its historical cities, is able to accommodate contemporary culture, naturally with all the limitations that exist in Italy with regards to architecture. If in the sixties and seventies Italian architectural thinking and projects made their mark on the world with subtle and spectacular themes, exporting an image of lively culture in their very particular cocktail of Nordic and Mediterranean ideas, the eighties and nineties have only presented marginal opportunities for the strongest forces in architectural thinking and projects. Like luxury emigrants, if one builds, one builds elsewhere, and Italy, which still produces culture, design and projects appreciated throughout the world, finds its cities in decay and lacking a translation of their future into significant pieces of architecture.

The last great chances of producing choral architecture in tune with the future were in the thirties, and were grouped under the term "rational architecture"; still today, this is admired, studied and considered exemplary in the architectural culture of this century. Who knows if, after having lost the testimony in terms of architectural constructions of the generations that emerged after the war, these will be the years when our political and financial classes will mature. Recent years have shown that this has been possible in the USA, in France, Germany, Austria and Japan: we shall see if, albeit very late in the day, Italian architectural culture will be afforded space in its own country.

Florence today, with the initiatives of its first Biennale, seems to be producing and reactivating a magnetic field that is capable of directing energies and channeling them towards the dignified greatness that our history recalls, and of which there is currently no organic vision. And the chances for architecture that it affords bring this to mind, when one thinks of the quality of the initiatives and those invited: Isozaki, Natalini, Aulenti and Santachiara are the sign of a wide selection that expresses the various orientations of the architectural culture of our time. And the settings, the splendid fortifications of Forte Belvedere, the Stazione Leopolda, the Reali Poste, the great

Arata Isozaki,
sketch for seven
pieces of architecture,
for the exhibition
Art / Fashion,
Forte Belvedere,
Florence, 1996

666

museums of the Florence of the Medici, are spaces that are being revisited and reinterpreted under the guidance of some of the most lively architects of our time.

Isozaki, simultaneously the most European and the most Japanese, has been given the hardest task, at Forte Belvedere, a difficult comparison/challenge, resolved by the construction of seven archetypal pieces of architecture. Extremely pure forms that evoke in our memory spatial modulations but whose matrix and origin we cannot recognize perhaps because they came from his subconscious—well-proportioned forms, seen as perfectly balanced extracts from the history of architecture. Arata has performed a measured and refined task of spatial control, of extracts, of simple functions. The sequence of perceptions, the exercise of meditation and control of rarefied elements, lead to the construction of archetypal architectural elements, in which it is permitted to enter and to mark-remark each delicate perception in order to reconstruct an emotional method which gathers from our memory that rationality it needs in order to catalogue. From this the made-remade emerges, composed in the perspective of his-our conceptual and strategic origins. The years of the readmission of emotion to the overall strategy of the project, of the will to revisit and turn inside out like a glove the block of inherited history, are those that propose identical intentions. Attention paid to the past, that is not to monumentalize like a block of ice or stone, as it might appear from the hands of those who handed it down to us, but rather a place to rediscover and bring out enthusiasms, love affairs and discoveries, also under the providential control of reason that is understanding and tolerant of strategies, but rigorous in its methodologies.

Forte Belvedere spreads out star-shaped from the original wall on the protuberance-promontory towards the walled city from which other archetypes of architecture emerge, and the magnetic focal point of what was then the known universe. The dome acts as the magnetic pole that shows our orientation. From the Forte and from the entire city, it announces where it is, it speaks of its role... And thus Arata places his fragments on the sloping meadows of the Forte, and orients all of them towards the magnetic pole, which is still functioning and still creates a field that orients energies of beauty, art and nature. Working in this way the architect is an interpreter rather than a seismograph, he is the bearing compass designed to tell us courses and itineraries, to make us understand our direction, to permit us to come back from deviations, drifts, and off-course wanderings. To help us understand whether the instruments we have with us are working, and, if they are not, whether they can be repaired or must be replaced. When one follows a course one knows from which point to another it has been plotted. But during the voyage what is more important, what is essential is the orientation that allows us fully to understand, without neurotic anxieties over what will happen after we get there, the conditions, the messages, the stories and the tales of our physical surroundings.

Concepts, the pathways of our emotions, are, when they are present, the structure in which matter takes on eternal, living, comprehensible form.

The rituals for tuning in to the frequencies, the flows of energy are always the same, and Arata understands them and gives his own, contemporary version of them in the language of architecture, caring little about giving a physical eternity to these materializations. Be careful, rather, to understand the courses, the winds and the waves.

Looking round Denis Santachiara's project at the Stazione Leopolda is like passing

Arata Isozaki,
sketch for pieces
of architecture,
for the exhibition
Art / Fashion,
Forte Belvedere,
Florence, 1996

Arata Isozaki,
sketch for two
pieces of architecture,
for the exhibition
Art / Fashion,
Forte Belvedere,
Florence, 1996

Arata Isozaki,
sketch for
pieces of architecture,
for the exhibition
Art / Fashion, Forte
Belvedere, Florence,
1996

Arata Isozaki,
sketch for a
piece of architecture,
for the exhibition
Art / Fashion, Forte
Belvedere, Florence,
1996

Denis Santachiara,
sketch for the
installation
of the exhibition
*New Persona /
New Universe*,
Stazione Leopolda,
Florence, 1996

through a space in the imagination, the evocation of fantastic worlds that seem close to science fiction literature and illustration, but only in appearance. In reality all is practical, human, soft and sweet. It takes you on a sequential showcase journey in an atmosphere of strong expressive images, a mix of art and fashion that influence each other and become one both on the conceptual and linguistic levels. The parameters that are traditionally useful for "understanding" seem obsolete right from the start. What transpires instead is the will, the atmosphere of Santachiara, made up of suffused light, of slow movements, of silences or subdued voices, a dream, or prenatal memories (nostalgia?).

The sequence of spaces is marked by brickwork, and thus, if you like, in the most reassuring, traditional way. But then these "spaces", these rooms, do not follow the strategies of rationalist memories that can be more or less evoked or transgressed—this game is habitual and by now boring—instead they almost "indicate" the route, a route that, in the end, describes a body, a "biology".

And you can feel this body pulsating not as in a system of veins (the visitors are the "blood" that runs through this expository "system" in all its episodes and specializations), but in the extremely light upper membrane, a ceiling that, as in the body of a drowsy cetacean, moves slowly in synchrony with its peaceful and restful breathing. The large elastic covering sheet is a membrane anchored to the walls, to the perimeter, to those hints of spatial episodes that as they declare themselves deny themselves, deny relationships and memories of past stories and go back to being an episode of fantasy given physical form, made tactile and colored. Supporting this skin-covering are long poles which, moving slowly in their sinuous evolutions, continually create a new scenario of spaces and luminous reflections.

The itinerary has two central "episodes" that mark a pause in the expository sequence. These too are designed and composed as the "organs" of a living body, and occupy part of a broad central area of the exhibition route: one of them is protected, a veritable room for studying and looking at books, catalogues, films and CD Roms; the other is an open refreshment area that slowly rotates, given that it is placed on the old turntable used to rotate railway carriages and locomotives.

Dedicated as he is to designing and producing city zones in The Hague, Groeningen and Leipzig, and also in the suburbs of Florence, Adolfo Natalini, whose one-time membership of the radical Florentine bohemia is by now a distant memory, takes a route that is for him an active one in museum organization in his two projects at the Palazzo Spini-Feroni and at the Reali Poste.

The redefinition of spaces like those of the Florentine Museo della Scienza and the Opificio delle Pietre Dure leads Natalini to consider his proposals as a chance to destine those spaces to future expository uses. These therefore become "places" that are furnished with equipment, with a strategy for the use of the space in a dialogue with its context, that is flexible enough to accommodate future exhibitions but has become definitive in terms of its use and organization.

In Palazzo Feroni we are on the ground floor of an old, majestic building and, at the corner of Via Tornabuoni and the Lungarno Acciaioli in front of Ponte Santa Trinita and the Statua della Primavera, placed to admire and be admired in the light of the sunset. Inside, splendidly restored rooms, precious floors and ceilings, induce the architect to

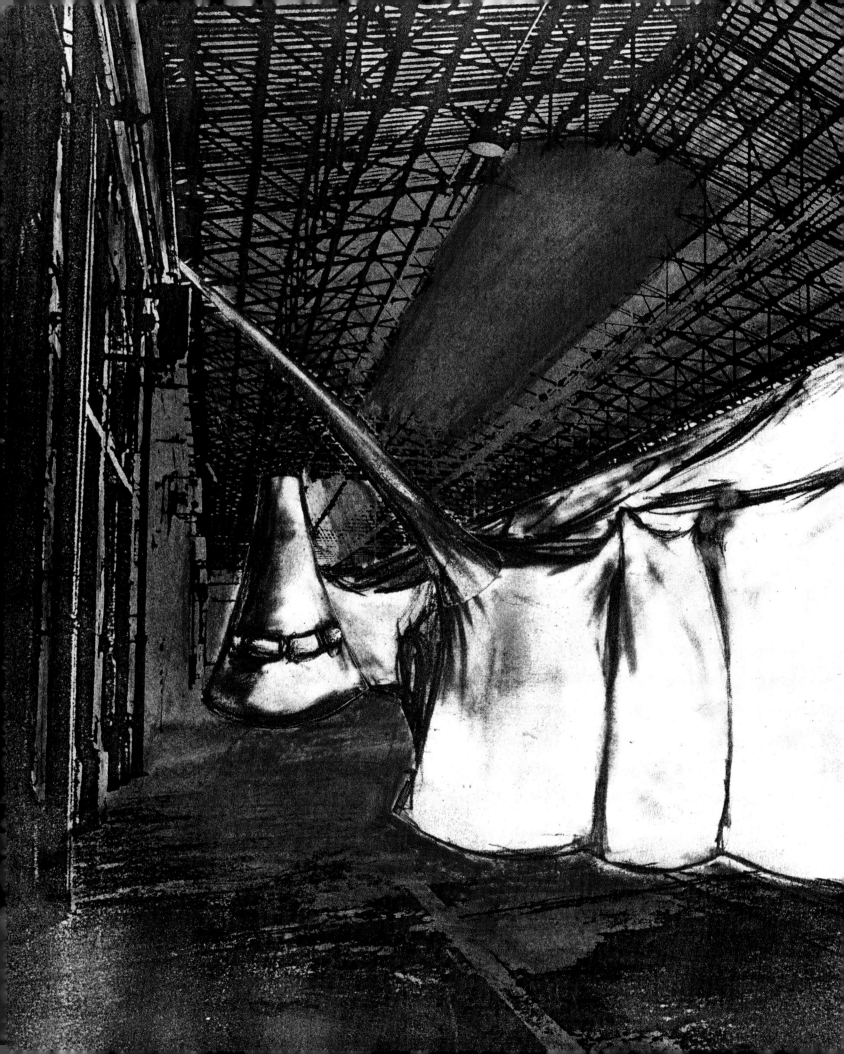

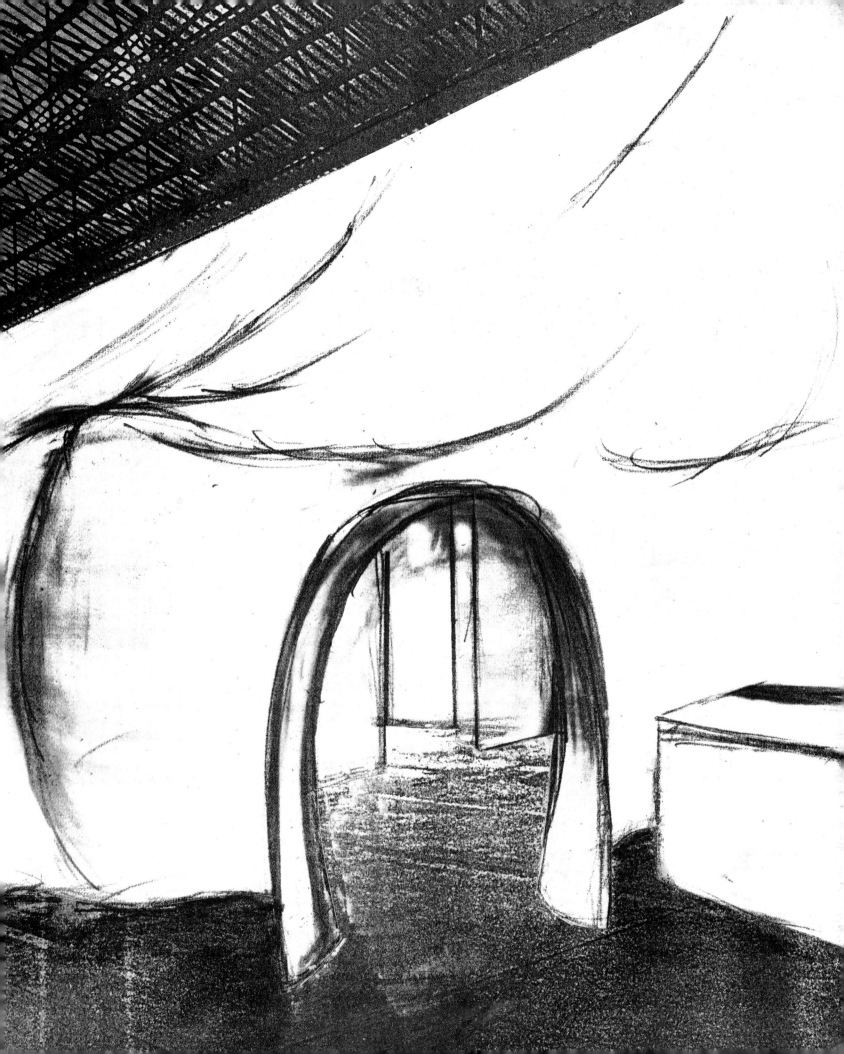

respond with walls paneled in the highest quality wood that terminate in a frame that hides the technical apparatus and the illumination system. The exhibition of Bruce Weber's work is thus "concluded" in a space that breathes history, dignity and richness and to which the project brings further qualities: sensibility of integration and understanding of the context.

In the Reali Poste of the Uffizi, Natalini is aware of the occasion offered to him by this unusual, ambiguous and intriguing space. After all, although it is accessed from the Piazzale of the Uffizi, we are in an internal courtyard: the balanced facades preserve the memory, the intention of facing up to an exterior space but "work" now in the interior space closed in by the large skylight. In the Carlo Felice Theater in Genoa, reconstructed by Aldo Rossi and Ignazio Gardella, we have the mention of a piece of the city: the usual walls of the theater containing the openings of the boxes and the galleries (or gods) become the facades of buildings, as in an exterior. The stalls consequently becomes a square and the stage an aspect of this, an urban fitting, in the same way as for events held in the open in a Mediterranean village.

This is a declaration of intentions, a philosophy, innovatory and causing imbalance, a protest and a claim, a declaring the theater an instrument that is something living, a focal place of the public life of the city by way of simple and usual architectural instruments although with thoughts that are a little less commonplace. An intriguing piece of role-playing into which Natalini ventures with wisdom, while still bearing in mind that the exhibition space to fit out is for… Elton John! The large skylight made it necessary to filter and regulate the luminosity, and this was done by a dark gray iron veil, which will remain as a permanent device, as a service to the future use of a space that has been used already for shows and concerts. A stage is made up of drapery and pedestals, a scenario with its focal point in a large *grand piano*, the "place" of origin of Elton John's music. And also a place to accommodate the thousands of pairs of glasses and the famous wardrobe of the celebrated guest.

Gae Aulenti's job was to coordinate and advise the twenty stylists who, in seventeen Florentine museums, from the galleria degli Uffizi to the Cappelle Medicee, from Orsanmichele to Casa Buonarroti, from the Museo di Storia della Scienza to the Opificio delle Pietre Dure, the Specola and the Studiolo of Francesco I in Palazzo Vecchio, proposed, as in an allegory, ideas and principles of their work. True artistic installations often came up against the specific museum themes and, as in the case of Dolce & Gabbana at the Museo Antropologico, actually took the place of part of the collections in some display cases, with their "anthropological" citations that merged completely into the context.

Although their collaboration was dedicated to temporary exhibitions, the architects involved in this Biennale signalled a mature relationship with the historical context of a magnificent Florence, inherited and to be revisited in a contemporary interpretation.

In Isozaki's work the relationship with the city is interpreted through constructions, "crazy" symbols, but in an open dialogue with the fabric, the emergence, the topography and the most classical landmarks of the great city of art.

Natalini ventures inside this ancient fabric, assimilates its thematic aspects, its needs and the possibilities of revitalisation, with projects of a quality that reveals his acquired ability

Denis Santachiara, project for the installation of the pavilions for *New Persona / New Universe*, Stazione Leopolda, Florence, 1996

Denis Santachiara, project for the installation of the pavilions for *New Persona / New Universe*, Stazione Leopolda, Florence, 1996

Pier Luigi Pizzi, sketch for the installation of the exhibition *Emilio Pucci*, Sala Bianca, Palazzo Pitti, Florence, 1996

Adolfo Natalini,
sketch for the
installation
of the exhibition
*Bruce Weber Secret
Love*, Museo Salvatore
Ferragamo, Florence,
1996

to conceive extracts of the city but also to arrive, in the creation of it, at fine points of detail.

Santachiara takes advantage of the possibility offered to him by the "rediscovery" of the space of the Stazione Leopolda, a strange giant who enters the immense space and makes himself comfortable, reconciling himself to its being visited in its interior. Gae Aulenti has dedicated herself to these spaces that re-emerge from a past of collections and science which, through her work, rediscover the necessary values of contemporary revitalisation and awareness which are needed to recuperate the system of these places for hopes that are by now delegated to the next millennium.

Photo Credits and Lenders

Art / Fashion

Giacomo Balla
Sketch for man's suit,
1914
Collection Biagiotti-Cigna, Guidonia

Giacomo Balla
Sketch for man's suit,
1914
Collection Biagiotti-Cigna, Guidonia

Giacomo Balla
Sketch for man's suit,
1914
Collection Biagiotti-Cigna, Guidonia

Giacomo Balla
Sketch for small bag, with speed lines, 1916
Collection Biagiotti-Cigna, Guidonia
Photo Giuseppe
Schiavinotto, Rome

Giacomo Balla
Sketch for sweater ,
1930
Collection Biagiotti-Cigna, Guidonia

Giacomo Balla
Sketch for a sundress "for the beach," 1930
Collection Biagiotti Cigna, Guidonia

Fortunato Depero,
Filippo T. Marinetti,
Francesco Cangiullo
Futurist Congress,
Turin, 1924
Courtesy Museo

d'Arte Contemporanea
di Trento e Rovereto

Fortunato Depero
Futurist vest, 1923
Private Collection,
Cavalese
Photo Polo Predazzo

Fortunato Depero
Waistcoat of Tina Strumia, 1924
Museo dell'Areonautica
"Gianni Caproni",
Trento

Fortunato Depero
Marinetti's Futurist vest, 1923
Collection Ugo
Nespolo, Turin

Fortunato Depero
Azari's Futurist vest,
1923
Collection Renzo
Arbore, Rome

Giacomo Balla
Sketch for woman's suit, 1928-29
Collection Biagiotti-Cigna, Guidonia
Photo Giuseppe
Schiavinotto, Rome

Giacomo Balla
Sketch for his daughter, Luce, 1930
Collection Biagiotti-Cigna, Guidonia
Photo Giuseppe
Schiavinotto, Roma

Giacomo Balla
Si parlano, 1934

Collection Biagiotti-Cigna, Guidonia

Young women students
at the Institute of
Pedagogy, Moscow,
1923
Courtesy Archives
Rodchenko
and Stepanova,
Moscow

Michail Kaufman
Aleksandr M. Rodchenko in Working dress, 1922
Courtesy Archives
Rodchenko
and Stepanova,
Moscow

Aleksandr M.
Rodchenko
Nurse, 1929
Galerie Gmurzynska,
Cologne

Ljubov Popova
Summer, 1924
Galerie Gmurzynska,
Cologne

Aleksandr M.
Rodchenko
Sketch for Dress, 1924
Galerie Gmurzynska,
Cologne

Lilja Brik
*Scarf design by
L. Popova*, 1924
Courtesy Archives
Rodchenko
and Stepanova,
Moscow

Aleksandr M. Rodchenko
*Portrait of Varvara
F. Stepanova*, 1924
Courtesy Archives
Rodchenko
and Stepanova, Moscow

Natalja Goncharova
Sketch for Dress,
1910 c.
State Gallery Tret'jakov,
Moscow

Natalja Goncharova
Sketch for Dress,
1910 c.
State Gallery Tret'jakov,
Moscow

Natalja Goncharova
Sketch for Costume,
1920 c.
State Gallery Tret'jakov,
Moscow

Natalja Goncharova
Sketch for Costume,
1910 c.
State Gallery Tret'jakov,
Moscow

Sonia Delaunay
Tissus simultanés, 1924
Private Collection, Paris

Sonia Delaunay
Tissus simultanés, 1924
Private Collection, Paris

Sonia Delaunay
Robe simultanée, 1922
Collection Giorgio
Marconi, Milan
Photo Paolo Vandrasch,
Milan

Sonia Delaunay
Sans titre, 1923
Collection Missoni,
Sumirago

Sonia Delaunay
Tissus simultané
Private Collection, Paris

Sonia Delaunay
*Robe, chaussures,
tissus simultané*s
Private Collection, Paris

Sonia Delaunay
Sans titre, 1925
Collection Missoni,
Sumirago

Sonia Delaunay
Sans titre, 1925
Collection Missoni,
Sumirago

Sonia Delaunay
Robe simultanée, 1925
Private Collection, Paris

Sonia Delaunay
Costume de bain, 1928
Private Collection, Paris

Sonia Delaunay
Golf, 1926-27
Collection Missoni,
Sumirago

Robert Delaunay
*Etude pour le portrait
de Madame Heim*,
1926-27
Galerie Gmurzynska,
Cologne

Florence Henri
*Portrait de Sonia
Delaunay*, 1931
Galleria Martini &
Ronchetti, Genoa

Florence Henri
*Portrait-composition de
Sonia Delaunay*, 1931
Galleria Martini &
Ronchetti Genoa

Man Ray
Femme liée, 1928-29 c.
Collection of Giorgio
Marconi, Milan

Man Ray
Les mains peintes, 1935
Collection of Giorgio
Marconi, Milan

Man Ray
Mode du Congo,
1937-81
Collection of Giorgio
Marconi, Milan

Man Ray
Mode du Congo,
1937-81
Collection of Giorgio
Marconi, Milan

Man Ray
Nancy Cunard, 1926 c.
Collection of Lucien
Treillard, Paris

Man Ray
Photographie de mode,
1936
Collection of Lucien
Treillard, Paris

Elsa Schiaparelli
Veste, 1937
Philadelphia Museum
of Art, gift of Elsa
Schiaparelli

Elsa Schiaparelli
Manteau, 1937
Philadelphia Museum
of Art, gift of Elsa
Schiaparelli

Elsa Schiaparelli
Robe avec langouste,
1937
Philadelphia Museum
of Art, gift of Elsa
Schiaparelli

Elsa Schiaparelli
*Robe au larme avec
foulard*, 1937 c.
Philadelphia Museum
of Art, gift of Elsa
Schiaparelli

Anne Weber wears a
dress designed by
Ellsworth Kelly, Sanary
1952
Photo Ellsworth Kelly
Courtesy of the Artist,
New York

Giancolombo
Lucio Fontana, 1961
Collection of Bini-
Telese, Milano, 22
March 1961
Courtesy Giancolombo,
Milan

Lucio Fontana
per Bini-Telese
Woman's suit, 1961
Collection Bini, Milan

Giancolombo
Lucio Fontana, 1961
Collection Bini-Telese,
Milan, 22 March 1961
Courtesy Giancolombo,
Milan

Lucio Fontana
for Bini-Telese
Woman's suit, 1961
Collection Bini, Milan

Giancolombo
Lucio Fontana, 1961
Collection Bini-Telese,
Milan, 22 March 1961
Courtesy Giancolombo,
Milan

Lucio Fontana
for Bini-Telese
Woman's suit, 1961
Collection Bini, Milan

Getulio Alviani
for Germana Marucelli
Kinetic Outfit, 1964
Photo Ettore Sottsass
Jr.

Getulio Alviani
for Germana Marucelli
Positivo Negativo, 1964
Private Collection,
Udine

Getulio Alviani
for Germana Marucelli
Cerchio+Quadrato, 1965
Collection of the Artist,
Milan

Getulio Alviani
per Germana Marucelli
Kinetic Outfits, 1964
Courtesy of the Artist,
Milan

Getulio Alviani
Orecchino a cerchio,
1965
Courtesy of the Artist,
Milan

Getulio Alviani
Bat(h)tape, 1963-66
Courtesy of the Artist,
Milan

Yayoi Kusama
Flowers Overcoat, 1964
Collection Harry Ruhé,
Amsterdam

Andy Warhol
*Young Robert
Rauschenberg*, 1962
Collection Gary and
Sarah Legon, Los
Angeles

Christo
Wedding Dress, 1967
Collection Christo
and Jeanne Claude,
New York

Courtesy Josy Kraft
Photo Ferdinand
Boesch

Andy Warhol
*Brillo and Fragile,
Handle With Care*, 1962
Photo Ken Heyman

Andy Warhol
*Fragile, Handle
With Care*, 1962
Collection of Gary and
Sarah Legon, Los
Angeles

Piero Gilardi
Orecchini, 1967
Courtesy Architect
Pietro De Rossi, Turin

Alighiero Boetti
Woman's suit, 1967
Courtesy Architect
Pietro De Rossi, Turin

Alighiero Boetti
Women's suits, 1967
Courtesy Architect
Pietro De Rossi,
Turin

Piero Gilardi
Woman's suit, 1967
Courtesy Architect
Pietro De Rossi, Turin

Piero Gilardi
Vestito-Natura Sassi,
1967-96
Collection of the Artist,
Turin

James Lee Byars
Four in a Dress, 1967
Courtesy Michael
Werner Gallery,
New York/Cologne

James Lee Byars
*Portrait of James
Lee Byars*, 1986
Courtesy Michael
Werner Gallery,
New York /Cologne

Robert Rauschenberg
Maya, 1974
Scognamiglio & Teano
Agenzia d'Arte
Moderna, Naples
Courtesy Luciano
Pedicini/Archivio
dell'arte

Roy Lichtenstein
Untitled Shirt, 1979
The Fabric Workshop
& Museum,
Philadelphia

Daniel Spoerri
*La Chemise du
chasseur d'oiseaux
(Hommage à John
Cage)*, 1976
Collection of the Artist,
Seggiano
Photo Massimo Baccetti

Josef Beuys
Filzanzug, 1970
Private Collection,
Naples

Franz Erhard Walther
*Standstelle und
halbierte Weste I*, 1982
The Marciano
Collection, Los Angeles
Photo Jens Rathmann,
Hamburg

Franz Erhard Walter
*Standstelle und
halbierte Weste I*, 1982
The Marciano
Collection, Los Angeles
Photo Jens Rathmann,
Hamburg

Nam June
Paik/Charlotte
Moorman
*TV Bra for Living
Sculpture*, 1969
Galerie Hauser & Wirth,
Zurich
Courtesy of The Art
Gallery of New South
Wales, Sydney

Louise Bourgeois
*A Banquet/A Fashion
Show of Body Parts*,
1978
Robert Miller Gallery,
New York
Photo Duane Michals

Vito Acconci
Leaf Shirt, 1985
The Fabric Workshop &
Museum, Philadelphia

Vito Acconci
Shirt/Jacket of Pockets,
1993
MAK-Österreichisches
Museum für
Angewandte Kunst,
Vienna

Judith Shea
Mid Life Venus, 1991
Collection of the Artist,
New York
Courtesy John
Berggruen Gallery,

San Francisco
Photo Dennis Cowley
Judith Shea
Four 3 Square Shirts,
1977
The Fabric Workshop &
Museum, Philadelphia
Courtesy of the Artist,
New York
Photo Will Brown

Rosemarie Trockel
Ohne Titel (Fleckenbild),
1985-88
Barbara Gladstone
Gallery, New York

Rosemarie Trockel
Anzug, 1986
Monika Spruth Galerie,
Cologne

Jan Fabre
Guerriers flamands,
1995
Collection of the Artist,
Antwerp

Jan Fabre
*Mur de la Montée
des Anges*, 1993
Galleria Galliani, Genoa

Jana Sterbak
*I Want You to Feel
the Way I Do ...
(The Dress)*, 1985
National Gallery
of Canada, Ottawa
Photo Paul Orenstein

Charles LeDray
workworkworkworkwork
1991 [detail]
Collection Robert
J. Shiffler, Greenville,
Ohio
Courtesy Jay Gorney
Modern Art, New York

Charles LeDray
workworkworkworkwork
1991 [detail]
Collection Robert
J. Shiffler, Greenville,
Ohio
Courtesy Jay Gorney
Modern Art, New York

Wiebke Siem
Hut, 1988
Collection Fond National
d'Art Contemporain,
Paris
Courtesy Galerie
Chantal Crousel, Paris

Wiebke Siem
Hut, 1987

Galerie Chantal
Crousel, Paris
Courtesy Galerie
Crousel, Paris

Oliver Herring
*Queensize Bed
With Coat*, 1993-94
Collection of Eileen
and Peter Norton,
Santa Monica
Courtesy Max Protetch
Gallery, New York

Oliver Herring
Wounded Knee, 1995
Collection of Eileen
and Peter Norton,
Santa Monica
Courtesy Max Protetch
Gallery, New York

Beverly Semmes
Pink Arms, 1995-96
Michael Klein Gallery,
New York

Beverly Semmes
*Figure In The Purple
Velvet Bathrobe
and Cloud Hat*, 1991
Courtesy Michael Klein
Inc., New York

*The sequences from
page 146 to page 214,
conceived and
designed directly by the
artists and the fashion
designers, are
reproduced courtesy of
the artists and the
fashion designers*

Tony Cragg
Matrushka, 1989
Rivendell Collection,
New York
Photo Jörg Sasse,
Düsseldorf

Tony Cragg
Self Portrait, 1989
Courtesy Galerie
Bern Klüser, München
Photo Jörg Sasse,
Düsseldorf

Tony Cragg
Rational Beings, 1995
Courtesy Tucci Russo
Photo Jörg Sasse,
Düsseldorf

Roy Lichtenstein
*Brushstroke V,
Drawing for Sculpture*,
1985

Copyright Roy
Lichtenstein

Roy Lichtenstein
*Brushstroke, Study
for Sculpture*, 1985
Copyright Roy
Lichtenstein

Roy Lichtenstein
*Brushstroke, Nude,
Drawing for Sculpture*,
1992
Copyright Roy
Lichtenstein

Roy Lichtenstein
*Brushstroke Nude,
Study for Sculpture*,
1993
Copyright Roy
Lichtenstein

Roy Lichtenstein
*Brushstroke Nude,
Sheet of Studies
for Sculpture*, 1993
Copyright Roy
Lichtenstein

Roy Lichtenstein
Brushstroke Nude, 1993
Courtesy Solomon R.
Guggenheim Museum,
New York

Thomas Eakins
The Agnew Clinic, 1889
Courtesy
of the University
of Pennsylvania
School of Medicine,
Philadelphia

**New Persona / New
Universe**
*The sequences,
conceived and designed
directly by the artists and
the fashion designers,
are reproduced courtesy
of the artists and the
fashion designers*

Interior
of the Stazione Leopolda
Photo Giovanni Corti

Denis Santachiara,
sketch for the installation
of the exhibition
New Persona / New
Universe
at the Stazione Leopolda

Gaseous Pillars in M16.
Eagle Nebula
Photo J. Hester

and P. Scowen (Arizona State University); NASA

Hubble Deep Field. Photo Robert Williams and The Hubble Deep Field Team (STScI); NASA

Robert Mapplethorpe
Self-portrait, 1980
Copyright 1980
The Estate of Robert Mapplethorpe Foundation

Robert Mapplethorpe
Self-portrait, 1980
Collection of the Artist
Courtesy Robert Miller Gallery, New York
Copyright 1980
The Estate of Robert Mapplethorpe Foundation

Cindy Sherman
Untitled Film Still, n. 2, 1977, New York
Courtesy of the Artist and Metro Pictures

Juergen Teller
Dick Page,
New York, 1996
Photo Juergen Teller

Supernova 1987
AS 319, n. 17
Photo P. Jakobsen (European Space Agency);
NASA

Ann Demeulemeester

NGC 6543:
the Cat's Eye Nebula
AS 234, n. 12.
Photo J.P. Harrington and K.J. Borkowski (University of Maryland);
NASA

Kiki Smith

Kiki Smith
Untitled, 1994
Courtesy
PaceWildenstein, New York
Photo Ellen Page Wilson

Kiki Smith
Ice-Man, 1995-96
Courtesy

PaceWildenstein, New York
Photo Ellen Page Wilson

Kiki Smith
Lilith, 1994
Courtesy
PaceWildenstein, New York
Photo Ellen Page Wilson

Kiki Smith
Untitled III (Upside-down Body with Beads), 1993
Collection of the Artist
Courtesy
PaceWildenstein, New York
Photo Ellen Page Wilson

Active Galaxy NCG 1068 AS 239, n. 22
Photo NASA

*Karl Lagerfeld
(of Chanel and also of Fendi)*

Cygnus Loop AS 234, n. 13
Photo Jeff Hester (Arizona State University); NASA

Springtime on Mars AS 234, n. 1
Photo Philip James (University of Toledo), Steven Lee (University of Colorado, Boulder); NASA

Giuseppe Penone

Giuseppe Penone
Sguardo vegetale, 1995
Collection of the Artist

Giuseppe Penone
Palpebre, 1989-91
Private Collection
Copyright Gérard Rondeau

Giuseppe Penone
Trappole di luce, 1995
Collection of the Artist

Giuseppe Penone,
Trappole di luce, 1995
Collection of the Artist

A Deep View
of the Early Universe

AS 234, n. 18
Photo Roger Windhorst and Simon Driver (Arizona State University), Bill Keel (University of Alabama); NASA

Giorgio Armani

Photos by Peter Lindberg, 1993; Aldo Fallai, 1990; Peter Lindberg, 1996

R136 - Computer Enhanced Image AS 293, n. 15.
Photo NASA

Inez van Lamsweerde

Inez van Lamsweerde
The Forest - Rob, 1995
Courtesy Torch Gallery, Amsterdam

Inez van Lamsweerde/ Vinoodh Matadin
Fur, 1994
Courtesy Torch Gallery, Amsterdam

Inez van Lamsweerde/ Vinoodh Matadin
Floortje, Kick Ass, 1993
Courtesy Torch Gallery, Amsterdam

Core of Galaxy NGC 4261 AS 319, n. 4
Photo National Radio Astronomy Observatory; NASA

Yukio Kobayashi for Matsuda

Naked New York
Photo Nan Goldin

HST Retrieval AS 319, n. 7
Photo NASA

David Bowie

Hubble's View of Neptune, AS 234, n. 8
Photo H. Hammel (Massachusetts Institute of Technology); NASA

Yohji Yamamoto

Orion Nebula,
AS 319, n. 20

Photo C.R. O'Dell (Rice University); NASA

Tony Oursler

Tony Oursler
Study for GE Female, 1991
Courtesy of the Artist and Metro Pictures, New York

Tony Oursler
Escort, 1996
Courtesy of the Artist Metro Pictures, New York

Tony Oursler
Sweet, 1996
Courtesy of the Artist and Metro Pictures, New York

Tony Oursler
Dust, 1996
Courtesy of the Artist and Metro Pictures, New York

R Aquarii: Nova Gas Cloud AS 314, n. 7.
Photo NASA/ESA

Vivienne Westwood

Antoine Watteau, drawing
Graphische Sammlung Albertina, Vienna

The outfits by Vivienne Westwood were photographed by Niall Mc Inerney

HST Image of Mars AS 314, n. 1
Photo Philip James (University of Toledo); NASA

Vito Acconci

Vito Acconci (Acconci Studio: Luis Vera, Browie Johnson, Jenny Schrider; fabrication: David Kennedy)
Adjustable Wall Bra, 1990-91
Courtesy of the Artist

White Dwarf Stars in M4 AS 234, n. 11
Photo Kitt Peak National Observatory 0.9-meter

telescope, National Optical Astronomy Observatories, courtesy M. Bolte (University of California, Santa Cruz); Harvey Richer (University of British Columbia, Vancouver, Canada); NASA

Calvin Klein

NGC 2440 with Superhot Star AS 314, n. 11
Photo NASA

Carrie Mae Weems

Carrie Mae Weems
From Here I Saw What Happened and I Cried (details), 1994-95
Courtesy P.P.O.W., New York
Photo D. James Dee
The quadriptych is based on daguerreotypes taken by J.T. Zealy in 1850. Ms. Weems photographed reproductions of the daguerreotypes which were provided to her by The Peabody Museum at Harvard University.
Ms. Weems's photographs of the reproductions have been toned.
The copyrights to the daguerreotypes were registered with the Library of Congress in the name of the President and Fellows of Harvard College in 1977.

2C273 Spectrum: Explanatory Diagram AS 314, n. 20
Photo Bahcall & NASA/Goddard High Resolution Spectrometer

Missoni

Beta Pictoris Spectrum AS
Photo NASA/Goddard

Space Flight Center

David Rokeby

David Rokeby
Echoing Narcissus, 1987
Photo David Rokeby

David Rokeby
with Erik Samakh
Petite terre, 1991
Photo David Rokeby

David Rokeby
Watch: Richmond and Spadina, 1995-96
Photo David Rokeby

Supernova 1987A AS 239, n. 20
Photo P. Jakobsen (European Space Agency); NASA

Manolo/Arnaldo Ferrara

Photos by Anita Antonini

Four Views of Saturn's Storm AS 314, n. 4
Photo NASA

Alexander McQueen

Mighty Hermaphrodity!, 1996

Carmen, 1996

Adia, 1996

McQueen, Victim of the Fashion Industry, 1996

Concept: Alexander McQueen. Photographer: Nick Knight. Art directors: Alexander McQueen and Nick Knight, assisted by Katy England. Hair: Malcolm Edwards. Make up: Val Garland. Models: Honor Fraser, Carmen Hawk, Adia Coulibala. Silver thorn jewellery: Shaun Leane for Alexander McQueen. All clothes by Alexander McQueen. Co-ordinated by Charlotte Wheeler. Photographers' assistants: Solve Sundsbo and James Dimmock. Special effects: Mattes & Miniatures. Very special thanks to Metro Studios

Comet Shoemaker-Levy 9 Impact Site AS 234, n. 2
Photo Heidi Hammel (Massachusetts Institute of Technology); NASA

Dinos and Jake Chapman

Dinos and Jake Chapman
Zygotic Exposure 1
Courtesy Dinos and Jake Chapman

Comparison of M100 Nucleus AS 319, n. 13
Photo NASA

Moschino

A Very Small Star!
Photo C. Barbieri (Università di Padova); NASA

Charles Ray

Charles Ray
Tub with Black Dye, 1986
Collection of United Yarn Products

Charles Ray
Rotating Circle, 1988
Courtesy of the Artist

Charles Ray
Self-Portrait, 1990
Collection Newport Harbor Art Museum

Charles Ray
7 1/2 Tone Cube, 1990
Collection of Agostino and Patrizia Re Rebaudengo, Turin

HST Image of Jupiter AS 314, n. 2
Photo Philip James (University of Toledo); NASA

Gucci

First Light: Stars in the Cluster NGC 3532 AS 293, n. 10
Photo: Ground based image from Eric Persson of Las Campanas Observatory

(Carnegie Institution of Washington); Hubble image courtesy NASA

Cindy Sherman

Cindy Sherman
Untitled n. 187, 1987-91
Courtesy of the Artist and Metro Pictures, New York

Cindy Sherman
Untitled n. 137, 1994
Courtesy of the Artist and Metro Pictures, New York

Cindy Sherman
Untitled n. 297, 1994
Courtesy of the Artist and Metro Pictures, New York

Cindy Sherman
Untitled n. 307, 1994
Courtesy of the Artist and Metro Pictures, New York

HST Data Path to Earth AS 293, n. 9
Photo STScI and NASA

Walter Van Beirendonck-W. & L. T.

W.&L.T. is designed by Walter Van Beirendonck and realized by Mustany Cybermanaging and Webdesign: Andreas W. Vichr (Medialab GMBH).
Portrait of Walter Van Beirendonck: Ronald Stoops

Core of 47 Tucanae AS 314, n. 12
Photo NASA/ESA and Georges Meylan (ESA/STScI)

Studio Azzurro

Studio Azzurro
Coro: sketches for the framing of the bodies
Courtesy Studio Azzurro, Milan

Studio Azzurro
Design for the composition of Coro
Courtesy Studio Azzurro, Milan

Studio Azzurro
Sketch for the interactive system
Courtesy Studio Azzurro, Milano

Studio Azzurro
Coro, 1995-96
Courtesy Studio Azzurro, Milan

A Gravitational Lens AS 234, n. 20
Photo W. Couch (University of New South Wales), R. Ellis (Cambridge University); NASA

The pictures from the Hubble Space Telescope are produced and distributed by The Astronomical Society of the Pacific, San Francisco

Visitors
The sequences, conceived and designed by the artists and the fashion designers, are reproduced courtesy of the artists and fashion designers

Habitus, Abito, Abitare
The photographs illustrating this section are reproduced courtesy of the Museo Luigi Pecci of Prato
Aurelio Amendola, Pistoia
Gianni Attalmi, Prato
Giuseppe Bartolini, Florence
Elena Carminati, Treviglio
Cary Cleaver, Atlanta
Carlo Chiavacci, Pistoia
Roberto Enrietti, Turin
Fabrica, department of photography, Catena di Villorba, Treviso
Martine Gaillard, Lausanne
Carlo Gianni, Prato
Marion Gray, San Francisco
Guelfo Guelfi, Prato
Peter Holling,

Halifax, England
Lisa Irving, Atlanta
Marek Kozera, Vienna
Salvatore Licitra, Milan
Stephen Miller, Bradford, England
Moderna Galerja Ljubljana, Ljubjana
Günten Panth, Vienna
Chiara Paoletti Prato
Paolo Pellion, Turin
Gianni Pettena, Florence
Cristina Pistoletto, Turin
Giovanni Ponzano, Turin
Margherita Spiluttini, Vienna
Anna Stöcher, Vienna
Studio Branzi
Lindell Thorsen, Munich
Greville Worthington, Richmond, England

Elton John Metamorphosis
The commentary on the pictures is by David Furnish. The photographs and illustrations are reproduced courtesy of the Elton John Archives, Windsor

London, 1972. Elton performs during Christmas at London's Hammersmith Odeon

Bill Whitten Balls Outfit, 1973

Tour in the United States, 1973.

Los Angeles, California, 1974.

Clothing designed by Bob Mackie, 1973

Clothing designed by Tommy Nutter, 1976.

Jacket designed by Tommy Nutter, 1979

Los Angeles, California, 1975. Elton conquers Dodger Stadium in a sequined baseball outfit. It was later sold at auction by Sotheby's in 1989

Los Angeles, California, 1977. Clothing designed by Bob Mackie

Bob Mackie Yellow

Jump Suit Outfit, 1974

Clothing designed by Bob Mackie, 1974

Bob Mackie Donald Duck Outfit

Bob Mackie General Outfit, 1984

Staten Island, New York, 1982. Clothing designed by Bob Mackie

Sad Song Video

Bob Mackie's original drawing for the australian tour, 1986

Clothing designed by Bob Mackie, 1986.

Bob Mackie Devil Outfit, 1986

Milan, 1991. Clothing designed by Gianni Versace

1992-1993. Clothing designed by Gianni Versace

Gianni Versace Leopard Outfit

Gianni Versace Red & White Checker

Gianni Versace P.V.C. Outfit, 1995

New York City, 1995. Richard Avedon photographed Elton John wearing this green P.V.C. Versace suit from the 1994 US tour with Billy Joel

Emilio Pucci
Emilio Pucci on the ski slopes, in a photograph form the forties
Photo Toni Frissel for Harper's Bazaar

Emilio Pucci wearing a Renaissance costume for the annual "Football in costume" parade in Florence
Photo Andrea Bezzechi

In a page from "Harper's Bazaar", December 1948, reproductions of Pucci

ski outfits worn by glamorous women of the period
Photo Toni Frissel for Harper's Bazaar

Madame Poppi de Salis wearing a new ski outfit designed by Emilio Pucci for Lord & Taylor's, Zermatt, winter 1948
Photo Toni Frissel for Harper's Bazaar

Ski outfit, 1957, with slacks in "Emilioform"
Photo Relang

Emilio Pucci with the princess Maria Pia di Savoia, on Capri, in the early fifties
Photo Pucci Archives

Emilio Pucci "signs" one of his carpets
Photo Pucci Archives

Sketch of the Emilio Pucci's boutique near the *Canzone del mare*
Photo Pucci Archives

Emilio of Capri", cotton bikini from the *Palio* Collection, 1957
Photo Pucci Archives

Scarf with the *Padiglione* (Pavilion) pattern, inspired by Botticelli's *Madonna del padiglione*, 1959
Photo Pucci Archives

Two outfits from the *Palio* collection, 1957
Photo Bertoni

In the restored ball room of the old Pucci family palazzo, a model presents the *Vivara* line
Photo Pucci Archives

Capsula in "Emilioform", 1960
Photo Pucci Archives

Window arrangement at Lord & Taylor's, with Pucci outfits and accessories, 1967
Photo Pucci Archives

Beach outfit: rafia and straw hat and sandals in Thong style, 1953
Photo Pucci Archives

Tha launch of the perfume *Vivara*, Acapulco, 1966
Photo Pucci Archives

Silk palace pajama printed with the Astrolabio (Astrolabe) pattern, near the Fontana del Carciofo, in the Boboli Gardens, Florence, sping-summer 1964
Photo Pucci Archives

Chiaro di luna outfit, in printed silk crepe, with the *Pesci* pattern, 1968
Photo Sandro Morriconi

The stewardess Emma Lee Pettibone wearing a uniform designed by Emilio Pucci in 1966 Braniff International, Dallas

Terry cloth item for Spring Mills
Photo Richard Avedon

Lady Look collection, spring-summer 1992
Photo Pucci Archives

Montage of photographs of the Pucci collections from the period of Puccimania, 1970
Tony Frissel for Harper's Bazaar

Van Johnson with several models, one of them wearing the *Capsula* by Emilio Pucci, 1961
Photo Pucci Archives

Alberto Sordi with Gina Lollobrigida, wearing a Pucci outfit for the Film Festival of Sorrento, 1966
Photo Pucci Archives

Bruce Weber
Secret love
All photographs are courtesy of Bruce Weber, New York

Bruce Weber, *Azzedine Alaïa & Tina Turner*, Adirondacks

Bruce Weber, *Georgia O'Keeffe*, New Mexico, 1980

Bruce Weber, *Betty & Palm*, Bellport, New York, 1962

Bruce Weber, Jeff Aquilon, Hawaii, 1982

Bruce Weber, *Chris Ives*, Adirondack State Park, New York, 1983

Bruce Weber, *Talisa*, Bellport, New York, 1982

Bruce Weber, *For Karl Lagerfeld*, Brittany, 1984

Bruce Weber, *Talisa in Sequin Dress*, Paris, 1982

Bruce Weber, *Sam Shepard & Jessica Lange*, New Mexico, 1984

Bruce Weber, *Ric*, Villa Tejas, California, 1988

Bruce Weber, *Rob and Little Bear*, Adirondack, New York, 1989

Bruce Weber, *C.Z. Guest*, Old Westbury, New York, 1989

Bruce Weber, *Melanie in the garden*, England, 1984

Bruce Weber, *Charles James Dress*, New York, 1991

Bruce Weber, Flea & His Daughter, California, 1991
Bruce Weber, Aretha Franklin, Bellport, New York, 1991

Bruce Weber, *Stan*, Feld Ballet Studio, New York, 1993

Bruce Weber, *Robert Mitchum*, Santa Barbara, California, 1991

Bruce Weber, *Marky Mark & His Bodyguard*,

Miami, Florida, 1992
Bruce Weber, *My Golden Beach Studio*, Florida, 1994
Bruce Weber, *Paul Cadmus*, Connecticut, 1992

Bruce Weber, *Linda Evangelista*, New York, 1994

Bruce Weber, *Lonneke*, Buenos Aires, 1995

Bruce Weber, *On the Way to Little Bear Ranch*, Montana, 1995

Bruce Weber, *The Gant at Little Bear Ranch*, Montana, 1995

Bruce Weber, *Jason Shaw*, Argentina, 1995

Bruce Weber, *Shalom & John Galliano*, Paris, 1995

Bruce Weber, *Duchess of Devonshire Feeding Her Chickens*, England, 1996

Bruce Weber, *Dublin*, Ireland, 1995

Bruce Weber, *Members of the Tennessee Club*, #2, London, 1996

Bruce Weber, *Member of the Tennessee Club*, #1, London, 1996

The two aerial views of Florence are by Guido Alberto Rossi